WILLIAM HENRY JACKSON and the Transformation of the American Landscape

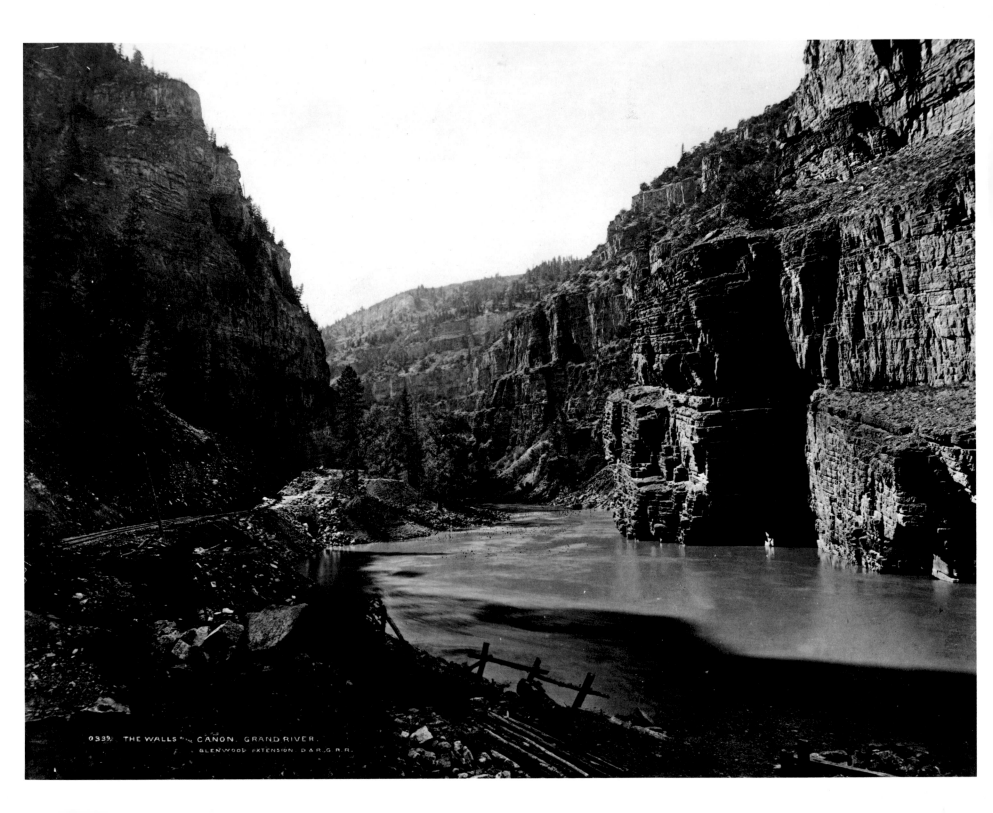

0339. THE WALLS OF THE CANON. GRAND RIVER.
GLENWOOD EXTENSION. D. & R. G. R. R.

WILLIAM HENRY JACKSON

and the Transformation of the American Landscape

Temple
University
Press |
Philadelphia

PETER B. HALES

Temple University Press, Philadelphia 19122
Copyright © 1988 by Temple University. All rights reserved
Published 1988
Printed in the United States of America

Designed by Arlene Putterman

Library of Congress Cataloging-in-Publication Data
Hales, Peter B. (Peter Bacon)
 William Henry Jackson and the transformation of the American landscape /
Peter B. Hales.
 p. cm.
 Bibliography: p. 335
 Includes index.
 ISBN 0-87722-478-1 (alk. paper)
 1. Jackson, William Henry. 1843–1942. 2. Photography—United States—
Landscapes—History. 3. Photographers—United States–Biography. I. Jackson,
William Henry, 1843–1942. II. Title.
TR140.J27H36 1988
770'.92'4—dc19 CIP 87-17182

This publication has been supported by the National Endowment for the
Humanities, a federal agency which supports the study of such fields as history,
philosophy, literature, and languages.

Sources of the Illustrations

ANS	Academy of Natural Sciences, Philadelphia
CHS	Chicago Historical Society
CSHS	Colorado State Historical Society, Denver
DPL	Denver Public Library, Western History Department
ID	Museum of the Interior Department
IMP–GEH	International Museum of Photography at the George Eastman House, Rochester, New York
LC	The Library of Congress, Prints and Photographs Division
NA	National Archives
NAA	National Anthropological Archives of the Smithsonian Institution
NGC	National Gallery of Canada, Ottawa
NPS	National Parks Service, Scott's Bluff National Monument, Nebraska
OM	Oakland Museum, History Department, Oakland, California
PC	Private Collection
USGS	United States Geological Service, Denver

Captions and Titles

Attentive readers and scholars of Jackson will doubtless note minor variations in the titles of the photographs used in this book. The captions to the illustrations comprise the most accurate version of titles of the photographs, insofar as such titles can be accurate. Often there are two, three, or more captions or titles appended to a single image: in the case of the United States Geological Survey negatives Jackson made in the 1870s, for example, there were the "original" captions or titles etched on the negatives; there were also, in some cases, other or more elaborate captions or emendations scratched into the far edges, where they were meant to be cropped out in printing; in addition, there were the "official" captions supplied in Jackson's own *Catalogue* to the photographs (which itself went through several editions, with corrections and alterations in each); finally, there exists a set of "clarified" captions which were appended to the images by the United States Geological Survey at some later date—these often contain corrected geographical references and the like. For this book, I have given the titles etched onto the visible face of the image first priority and used the "official" titles, where the images lack titles. The same principle has been applied to Jackson's photographs from the commercial years: I have used published titles only when titles were lacking on the original images. The photographs from Jackson's round-the-world trip with the World's Transportation Commission have provided a more complex problem, and there I have depended heavily on the captions provided for *Harper's Weekly*, where they were published. In all cases, when I have felt further information to be necessary, I have included it in brackets in the captions. For the sake of editorial smoothness, I have chosen to truncate many of the titles in the text itself; in a few cases, I have included the longer titles if they supply needed further information.

To Taylor John Hales,
great Westering spirit,

and Molly Kate Hales,
pathfinder,

for whom, each night,
we reinvent that landscape
of hope, possibility,
and dreams

Contents

Acknowledgments

Over the past thirteen years I have had the benefit of support of all sorts from all directions. A Rockefeller Foundation Fellowship in 1977 allowed me to research Jackson's urban photographs and enabled me to begin work on the Denver and World's Transportation Commission work. A summer grant from the University of Illinois in 1981 funded travel to Colorado and Washington, D.C., for further research. Grants from the National Endowment for the Humanities—one a Summer Fellowship, the other a Travel to Collections Grant—both supported the final stages of archival work. The writing was completed while I was a Fellow at the Institute for the Humanities at the University of Illinois, Chicago. The University Scholar's Program also generously underwrote many of the incidental expenses.

Libraries and archives, and the people who staffed them, were vital to my work. At the Colorado State Historical Society, Curator Eric Paddock and his predecessors, Diane Rabson and Rachel Homer, and Mercedes Buckingham of the Society's library, were tremendously encouraging and generous. Eric, especially, searched out rare Jackson photographs and obscure facts with a telling eye for what I might find significant, read and commented with great tact on an early draft of the manuscript, and was enthusiastic throughout. At the Library of Congress, the list seems endless: Tom Beecher, Beverly Brannan, George Hobart, Jane Johnson, Annette Melville, and Helena Zinkham were kind and helpful in the extreme. The heads of the Prints and Photographs Department during the decade this study encompassed were supportive as well: Oliver Jensen, and more recently, Stephen Ostrow. At the Amon Carter Museum, in Fort Worth, Texas, Carol Roark showed me important disputed images, setting me straight on their attribution. I am grateful for her clear-eyed help.

Other facilities I wish to acknowledge with gratitude are: The International Museum of Photography at the George Eastman House; the National Gallery of Canada; the Newberry Library of Chicago; the Scott's Bluff National Monument (and staff member Audrey Barnhart); the Rare Books and Manuscripts Collection and the Prints and Photographs Collection of the New York Public Library; the National Anthropological Archives of the Smithsonian Museum; the National Archives; the Edison Institute of Henry Ford's Greenfield Village; and the Western History Collection of the Denver Public Library. In addition, the staff of the

Library of the University of Illinois, Chicago, accepted my requests with grace and humor; special thanks go to the interlibrary loan staff, Kathy Browne and Jill Lin, and circulation librarian Robert Daugherty. Writing a book about the West from an urban university in the Midwest would not have been possible without their commitment.

This book began as a graduate seminar paper in 1974; its development from that unambitious start is proof to me of the value of intellectual collectives. Colleagues and friends had a vital hand in making the project possible. Rosemary Eakins, then an editor at MacDonald and Co. of London, urged me to write a short précis of Jackson's life and work for a picture book her firm had begun. David Sokol persuaded me that an ambitious, full-length study of Jackson would make an important contribution to knowledge in the field. My colleagues at the Institute for the Humanities at the University of Illinois, Chicago, read early drafts of two chapters and provided the challenging intellectual atmosphere in which my work took place. My friends Melissa Pinney, Pam Steinle, and David Tanner all provided valuable sounding boards for my ideas. My fellow members of the History of Architecture and Art Department were supportive and enthusiastic. Finally, I am especially thankful to those who read the manuscript and offered valuable (if sometimes disregarded) counsel: William H. Goetzmann, Bradford Collins, Victor Margolin, Robert Bruegmann, Carol Roark, Marni Sandweiss, my father Milton Hales (Utah-bred, he corrected my geography in that state), Eric Paddock, and Jeffrey Meikle. My thanks as well to those at Temple University Press who cajoled, guided, corrected, and supported the book through all its many stages: David Bartlett, Janet Francendese, and Mary Capouya.

William Henry Jackson: A Chronology

1843 Jackson is born in Keeseville, New York, to George Hallock Jackson and Harriet M. Allen.

1858 Jackson goes to work as a photographic retouching artist.

1862 Jackson volunteers for the Civil War.

1863 His enlistment up, Jackson returns to photographic retouching.

1866 After a fight with his fiancée, Jackson abruptly leaves the East.

1867 After a transcontinental journey, Jackson settles in Omaha, Nebraska, where he founds Jackson Brothers' Studio, and begins his career as a photographer.

1868 Jackson begins a series of Indian portraits and studies of reservations in the regions around Omaha and westward as far as the moving terminus of the unfinished Union Pacific Railroad in Utah.

1869 Jackson marries Mollie Greer, then sets off for the summer to photograph along the line of the Union Pacific Railroad. In Cheyenne, he meets Ferdinand Vandeveer Hayden, head of the United States Geological Survey of the Territories.

1870 Hayden returns to Omaha and offers Jackson a position as unpaid "correspondent" with the Survey, which is to travel to the far southwest end of the Wyoming Territory. Jackson accepts and spends the summer with Hayden's Survey.

1871 Jackson becomes an official member of the Hayden Survey, which, with artist Thomas Moran as guest, explores the Yellowstone region.

1872 The Survey returns to Yellowstone after exploring the Grand Tetons. Mollie Jackson dies in childbirth.

1873 The Survey shifts to the Colorado region and study of the Rockies; Jackson photographs the Mount of the Holy Cross. In October, he marries Emilie Painter, whom he has known since 1868.

1874 Survey work in southwestern Colorado includes photographing the Ute Reservation at Los Piños and discovery of a series of cliff ruins in Mancos Cañon near Mesa Verde.

1875 Survey work in Colorado involves further exploration of the Mesa Verde region.

1876 Jackson is assigned by Hayden to supervise the Survey's exhibit at the Centennial Exposition in Philadelphia.

| 1877 | Jackson is freed to do special work in southern Colorado, Arizona, and New Mexico; all the photographs are ruined when his experimental dry-process negative technology fails. |

| 1878 | This, the last year of the Hayden Survey, sends the team back to the Grand Tetons, the Wind River Mountains, and the Yellowstone. |

| 1879 | Jackson opens a commercial studio in Denver, Colorado. For the next fifteen years, Jackson presides over one of the largest and most prestigious national view companies, specializing in landscapes and Western views. |

| 1892 | Jackson travels for the Santa Fe route and the B&O, the former with his old Survey friend Thomas Moran, and the latter with Joseph Gladding Pangborn, who suggests a future global junket with Jackson as official photographer. |

| 1893 | The Depression has struck deeply at Jackson's business; he is hired by architect Daniel Burnham to photograph the World's Columbian Exposition in Chicago, and produces a series of much-reproduced images. |

| 1894–96 | Jackson travels with the World's Transportation Commission; the itinerary takes him through the Near and Far East, Australia, China, Siberia, and Russia. |

| 1897 | Jackson moves to the Detroit Photographic Company, a mass-market postcard and "view" company, taking with him the bulk of his vast negative collection. |

| 1903–24 | Jackson makes his last "professional" photographs; he moves into plant supervision for the Detroit Company thereafter. |

| 1924 | The Detroit Publishing Company, successor to the Detroit Photographic Company, goes bankrupt. Jackson moves to Washington, D.C., begins to paint again, and starts to collect material for his memoirs. |

| 1929 | *The Pioneer Photographer: Rocky Mountain Adventures With a Camera* is published by World Book Publishing Company, in a series of inspiring stories for boys. Jackson moves to New York, where he has been appointed "Research Secretary" of the Oregon Trail Memorial Association. |

| 1936 | Jackson is hired by the Roosevelt administration's Works Progress Administration to paint a series of murals depicting the various Surveys. |

| 1937 | Jackson is transferred to the National Park Service to produce paintings for distribution to the various parks. |

| 1940 | Jackson's autobiography, *Time Exposure*, appears. |

| 1942 | Jackson dies in New York City at the age of ninety-nine. |

WILLIAM HENRY JACKSON and the Transformation of the American Landscape

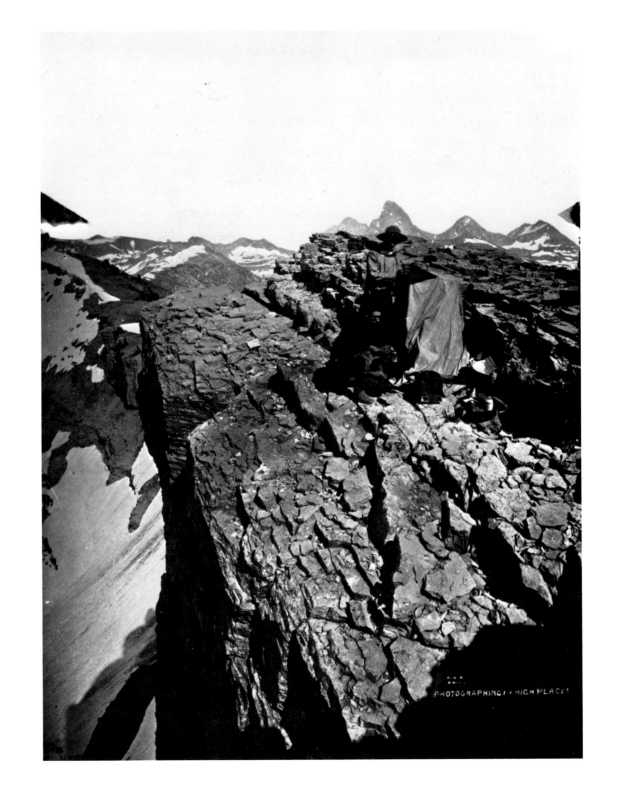

PHOTOGRAPHING HIGH PLACES

Introduction

What is the United States of America. It is a
country of a great size in the center of which
there is a great deal of land. Upon this land live
those who can do and do whatever they have to
do.
—GERTRUDE STEIN,
*Scenery and George Washington or
A History of the United States of America.*[1]

In 1940, *Look* magazine sent one of its representatives to make a portrait of the legendary nineteenth-century American landscape photographer William Henry Jackson, then ninety-seven years old. Setting up camera and lights, choosing the setting and the pose, *Look*'s photographer did a creditable job of fitting the photograph to the conventions of the popular picture magazine (illustration 2). But today the resulting picture seems subtly wrong. Ostensibly portraying a man who was once a central force in exploring and opening the American West, it shows instead a nattily dressed amateur painter in front of an easel in a book-lined room. The only trace of the landscape that was once Jackson's purview is found in the dimly rendered image on which the painter was supposedly working before the intrusion of the camera. There the casual viewer might see two men crouched in some obscure activity on what may be a rocky hilltop. Indeed, the painting was evidently less than central to *Look* and, by implication, its picture-hungry audience of millions. Instead, the focus is firmly on the kindly looking old man who is graciously living out his years in cultivated leisure—reading, daubing, reminiscing, among the souvenirs and mementoes of a long and fruitful life.[2]

Look's picture indirectly represented the end of one myth of American space and its replacement by another. We can see this best by comparing the image with the original photograph from which Jackson derived his painting (see illustration 1). Made in 1872 and entitled "Photographing in High Places," it was originally a stereoscopic image taken while Jackson was photographer for the U.S. Geological and Geographical Survey of the Territories. Seen in the exaggerated three-dimensionality of the then-popular stereograph, it portrays a profound respect for the awesome, monumental, inhuman sublimity of nature and is also an ingratiating self-advertisement suggesting the heroics necessary to discover, claim, and bring back some trace of that monumentality. It is, then, an image rich in nineteenth-century American Romanticism and its relation to the Western landscape. It celebrates two of the central myths of the American past—the free, heroic individual and the free, redemptive land that challenges, defines, and enlarges that individual, endowing his tasks with significance. Photographing in "high places," this individual

1. (*opposite*)
*"515. Photographing in
High Places," 1872. Half
of stereograph pair.* NA

3

is a point man for his culture; his role is to represent his civilization and to represent the object of its attention—the space it wishes to understand and to occupy.[3]

Behind the man and his assistant, we can see the land itself. Viewed in a stereoscope, this image is vertiginous. The high rocky outcrop on which Jackson kneels leaps at us while the mountain walls behind swoop precipitously down and away. We are—as Jackson worked skillfully to make us—drawn in, enthralled by the scene, moving deeper and deeper until at last we reach the point of a hazy infinitude, where land becomes space and then, in the nineteenth-century conception, Potential—a place awaiting further exploration, definition, exploitation. What we are meant to perceive is not simple topography but land endowed with meaning, significance, and implication. Constructed by a sort of negotiation between the individual photographer and the surrounding culture that has given him its system of meaning, sent him out on an errand of discovery, and served as the audience of his productions, this Romantic landscape represents a core myth of American civilization: the fabled ground upon which could be enacted American destiny.

Against this image, the photograph of Jackson in *Look* magazine some seventy years later portrays a far different, though equally powerful, relationship between individual and space. Then (in 1940) a genre painter of the American West and muralist to the National Parks Service and the Museum of the Interior Department, William Henry Jackson was being honored as a living symbol of the American past.

Although to *Look*'s photographer it was apparently little more than a prop, the painting on which Jackson allegedly worked during the photo session stood for the living history that *Look* suggested Jackson offered to modern America. Yet the painting, drawn from that 1872 photograph, differs from its source in significant ways. The harsh, even hostile lighting has been opened up, made generous. The photographer's task of exploration has been clarified, simplified to be easily grasped by an audience no longer familiar with either the difficulties of the wet-plate process or the purpose of the Survey and its photographs—Jackson has added a camera on a tripod at the top of the rock cliff, which explains the activity of the two figures huddled below it. The mountain backdrop, powerfully, even overwhelmingly present in the original, has been pushed from the center, and it now recedes gracefully into a hazy, atmospheric backdrop. Finally, the photographer-turned-painter has added several details to bring the finished product into congruence with the twentieth-century myths of the Western past. Two burros or horses have been added to one side; more important, Jackson has introduced a long-barreled rifle, which leans against a box in the right center of the painting—the rifle is a tool popularly associated with mountain men and explorers, and it has been added to guarantee that ordinary citizens will understand the context of high adventure and romance surrounding the event Jackson has memorialized.

The painting, interesting though it is, is only a part of the 1940 photograph that replaces Jackson's earlier self-portrait. This new image of Jackson records the old man reminiscing over a glorious past, it and he deserving of the respect given to monuments. But *Look*'s photographer did not make a picture of Jackson during one of his frequent forays to Yellowstone or the Grand Tetons, Independence Rock, or any of the other remnants of the open West, trips that were a continuing feature of the old man's life and would easily have provided the magazine with appropriate pictures—of Jackson photographing "Old Faithful" with a Leica, for example. Intead, the *Look* photographer portrayed him in an urban room, drawing his inspirations from memory and from "history."[4]

Turning the pages of *Look*, a reader then would probably have intuitively understood the reason for Jackson's graceful retirement. He had passed on the baton to a new form of visual chronicler, just as his romantic but outmoded frontier had been replaced by challenging new ones. *Look* itself, glossy informant of American democracy, picture maker to a nation, organizer and narrator of the significant myths and events of American life, took Jackson's charge and brought it up to date, leaving him, and his landscape, to the backwaters of nostalgia.[5]

The space between these two pictures, the differences in their meanings and the worlds surrounding them, and the transformations implicit in the landscapes they describe, form the subject of this book. I am interested not simply in William Henry Jackson but—more broadly—in the sizable segment of American mythology he staked out for himself, tenaciously explored, propagandized, and defended during a career as a cultural spokesman that began in the 1850s and lasted without interruption until

his death in 1942. My purpose is to delineate the twin myths of the radical individual and the free landscape as they were contained, experienced, and engendered by a single man. But the individual and the landscape were not unchanging myths—in fact, they are significant precisely because of their fluidity and adaptability. So William Henry Jackson—photographer, painter, diarist, author, and public figure—has enabled me to explore the transformation of these myths between the middle of the nineteenth and the middle of the twentieth century.

I have deliberately included in the title of this book the potent and enigmatic word *landscape*. In the context of American cultural history in general, and in the realm of American art history in particular, the term has come to cover a wide variety of meanings—from John Brinkerhoff Jackson's definition of "a composition of man-made or man-modified spaces," to the art historian's notion of a painting in which nature is the primary subject, to the vague cliché by which social scientists refer to all that is "out there." In this work, however, I wish to use *landscape* to describe the land, the space, and the larger ecosystems surrounding an individual as they are understood, organized, and transformed by the act of perception. In this sense, all landscapes are man-made, because they exist only as filtered through the matrices of organization, the webs of significance, that comprise human perception. *Landscape* as I mean it in this book is a mental as well as a physical phenomenon.[6]

Beginning with this thesis, I have sought to understand what landscape contains that is (or was) peculiar to a given culture; in particular, I see the concept of *landscape* as a culturally shared construction—a myth—that was taught and learned, that motivated action, that transformed the human and natural surroundings onto which it was projected, and that was itself transformed over time.

In this book, myth, too, takes on a larger and more peculiar definition than it usually has for us. A myth, as it appears in my reading of Jackson and his culture, is a broad, amorphous, and often invisible entity, something that surrounds and subsumes the obligatory, uplifting stories we learn in school. It is a system of belief that organizes the data of everyday life with such compelling clarity and deep resonance that it seems to its adherents to be even more basic than fact. It seems, in essence, *natural*—so integral to the organizing assumptions that make up a culture that we who have learned to behave within its system of meaning can rarely, and only with great effort, recognize it at all. But as systems of meaning imposed on the world, myths can and must change as the circumstances surrounding their function also change.[7]

Again, that is the principal subject of this book: the fluid construct that Americans defined as *landscape,* along with its boundaries and its meanings and its transformation from a myth enabling action on a grand scale—the settlement and exploitation of the American West—to a nostalgic myth giving impetus to behavior at a greater and still greater remove from its original sources of potency and meaning, finally redeeming, through the voices of history and authority, what might otherwise have been lost.

In that sense, this book is the second in a trilogy of works exploring the American landscape as a cultural phenomenon. In the

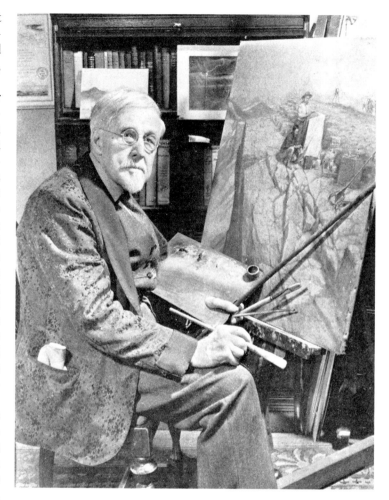

first, *Silver Cities,* I investigated the process of urbanization, using the widest possible aggregate of visual sources and emphasizing especially the place of anonymous photographs in reorienting the American consensus about the promise and peril of the city. The third book will examine the artifacts of a postatomic American cultural

2.
William Henry Jackson at age 97; a photograph made by Look *magazine in 1940 and reproduced as the inside front cover of Jackson's autobiography,* Time Exposure.

landscape—the spaces of everyday life after 1945, and the ways we have described and inscribed them.

This second work attempts to show how a single individual—albeit an extraordinary one—was immersed in the American landscape myths of the mid-nineteenth century, became a spokesman for them and for the cultural forces whose power and definition were derived at least in part from those myths, and became, through his photographs, paintings, memoirs, and other productions, a major force in the transformation of that American landscape from the mid-nineteenth to the mid-twentieth century.

But though this book approaches biography, it in fact records a different type of investigation. Jackson's importance lies in his production of culturally significant work and in his relationship as a producer to the wider civilization that constructed him and received his messages. I have made little attempt to speculate on his interior life; to do so would, I decided at the outset, only confuse an already complex story. My decision was based not only on my interests, however. Jackson was an assiduous diarist, but his diaries, like those of many nineteenth-century middle-class American men, are almost entirely concerned with food, money, sleep, and miles traveled. And to further complicate matters, he, his son Clarence, or others destroyed a great deal of personal material, leaving his public persona to bear the weight of reputation. This only confirmed my reticence about moving my story from a rich and significant area to one less promising.

In his public and influential position as a photographer, Jackson's role was far different from that of, say, the essayist Ralph Waldo Emerson or even the painter Albert Bierstadt. Not a figure whose interior vision gave coherence to a public image, he was instead a masterful interpreter and assimilator of communal preoccupations, translating, clarifying, and defining them in images of wide popularity. His medium was central to American landscape, however, in large part because of its ability to intervene smoothly between art and science, knitting the two together in a synergistic unit that could explain both the microcosm of geological facts and the macrocosm of divine purpose—and to do so in a popular medium most Americans believed they could understand directly and intuitively. Photography's peculiar appropriateness to the task of explaining and transforming the American landscape lay in its ability to present an utterly convincing illusion of factuality while providing a repertoire of techniques that enabled the photographer to make a powerful statement. Jackson's photographs were thus superb vehicles of cultural mythology: they presented complex ideas as laws of nature, as facts as incontrovertible as the rocks or lakes in which their meanings were supposedly embedded. And these photographs could be adjusted to the transformations in those larger meanings so that they reflected the process by which the landscapes they delineated became bounded, "civilized," and redefined.[8]

As a believer in the forces he served, Jackson was actively engaged in moving those forces to the center of American culture, embedding them in institutions, and then aiding in the necessary accommodations between those institutions and a changing cultural arena. Neither a heroic individualist nor a cynical propagandist, Jackson, like most significant figures of his culture, was capable of being utterly purposive in his productions without necessarily being conscious of the range of meanings or implications behind his acts or the artifacts they created. Like his audiences, who came to see the messages in his photographs as statements of natural fact, Jackson came to see the themes he embedded in his work as laws rather than constructions.

Of course, William Henry Jackson was by no means the only American photographer of the American West or the American landscape during his time. The regions he delineated were peopled by others, some of them very good, a very few of them great. Readers searching for a history of American landscape photography will not find it here, though I have been diligent in crediting Jackson's influences wherever possible. But that has not been my purpose. Jackson's importance, I have argued, lies not simply in his role as a government photographer of the West during the decades after the Civil War but in the entire sweep of his career and its extraordinary connections with a wide variety of American institutions, events, and myths.

For recent viewers, Jackson has been a hard figure to assess and a harder one to like. His utter rejection of the role of the outsider as heroic artist; his accommodation, even celebration, of the forces of development and exploitation, and the ease and seeming unconcern with which he moved from stage to stage in the modernization of America and its landscape all grate on the critical consciousness of our later age. We

are aware of the ambiguous fruits of Western development and wary at best of the artist who embraced its beliefs and the corporate structures (railroads, mining interests, banking conglomerates, and the like) that existed or came into being to expedite that development. But that wariness is, I think, not only an imposition of the present on the past but also a misunderstanding of the tenuous relationship between the individual and the surrounding culture. My task as a historian has been to immerse myself and the reader in the thick description of cultural context, to provide the tools necessary to enable us to understand those times in their own terms.

As an intelligent, ambitious, and gifted individual working in a medium of great influence, Jackson became a powerful progenitor of the changes in the American conception of the West and of landscape in general. This he did while immersed in a wide variety of significant cultural institutions; thus his work resonates as part of the complex process of negotiation that defines the way his American culture adapted to changing conditions and drew its individual members along with it. Just what that negotiation entailed, its limits and possibilities for Jackson's time and ours, are issues this study addresses.[9]

This, then, is the aim of my work: to map a history of the transformations of American landscape, from its central position in the mid-nineteenth century to its very different, but perhaps equally powerful, place in the middle of the twentieth; to do so by examining a single individual and the body of profoundly influential artifacts he produced; and to look at the man and his work as repositories of cultural meanings in order to see the forces that engendered those meanings, the way those meanings were embedded in man and objects, and their effects on the culture that surrounded them.

Still, this has been a deeply personal investigation, and it has produced an equally personal result. I hope I have created something like one of Jackson's own photographs—a persuasive description, yet only one among an infinitude of possible pictures, each made from a different vantage point, each containing its maker's affections and prejudices, each the product of some engagement between the self and the world we insist must lie out there, beyond and before us.

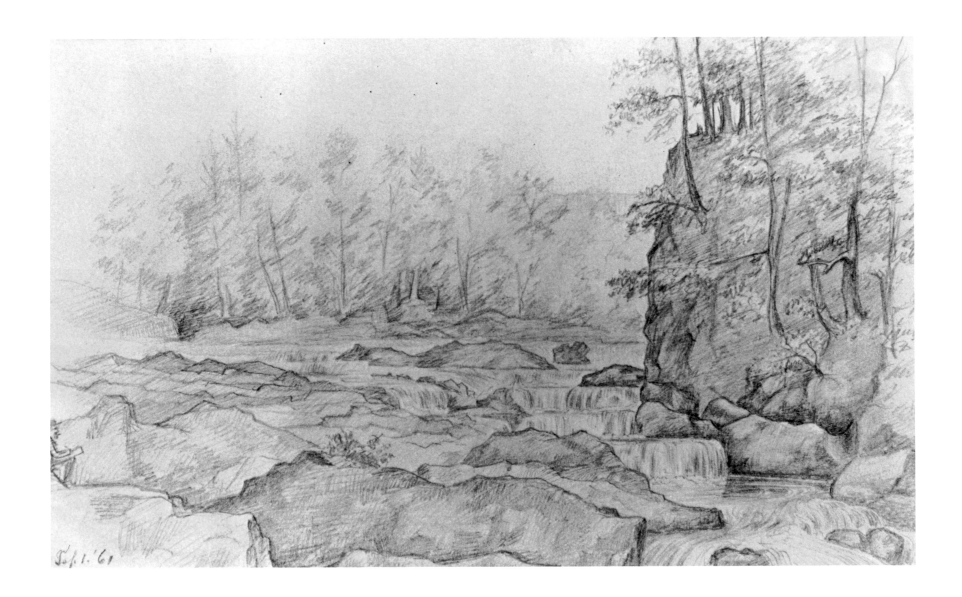

Sep 1. '61

What, then, is the American, this new man?
—J. HECTOR ST. JOHN DE CRÈVECOEUR,
Letters from an American Farmer, 1782[1]

William Henry Jackson's earliest memory combined two themes that would lie at the center of his life for the ninety-nine years it spanned: uprootedness and wild landscape. His family, removed from upstate New York in an unsuccessful emigration to the Georgia frontier, was returning to the North on a boat on the Chattahoochie River when Jackson's uncle Ed carried him up on deck. There, "under a bright full moon I gazed out over dark waters, palmettos, and moss-draped trees." This dreamlike image of mysterious wilderness intersected with an unremembered reality: the restless search that had brought his father and his new family from the settled Northeast to the reaches of the Chattahoochie and now caused them to return.[2]

William Henry's father, George Hallock Jackson, was born into the middle of the generation for whom Andrew Jackson was legend and spokesman, and he lived the quintessential Jacksonian life. He was a man on the make, willing to move himself and his family across geographical, professional, and cultural boundaries in quest of an upward mobility that was never quite realized. At the same time, he combined the occupations of planter, farmer, mechanic, and laborer that Andrew Jackson had singled out in the 1830s as constituting the "real people" of America. By the time he and his family returned to Plattsburgh, in upstate New York, from Georgia in 1847, he had "traveled around the country considerably," in his son's words. He had emigrated to the American Western frontier of the 1830s, ridden the Mississippi River to New Orleans, and then returned to open a blacksmith shop in Keeseville, New York, where he met and married Harriet Maria Allen, the child of colonial New Englanders herself, an artist and graduate of the Troy Female Academy. By the time William Henry was ten, his father had engaged in five occupations and seven businesses and had moved the family no less than six times, in a pattern of escape from, and return to, upstate New York that included Virginia and Philadelphia as well as Georgia among its stopping places. Meanwhile, his family continually hovered just within the edges of the middle class, the father sometimes a prosperous farmer or factory manager, sometimes an unsuccessful daguerreotypist or a hard-up carriage builder operating a candy and cigar shop out of the front room of the family house.[3]

William Henry Jackson grew up in the peculiar environment that resulted from the contradictory desires of his father—and of

3. (*opposite*) "September 1, 1861." *NPS*

9

his father's generation—modified by the stability of his mother and her family. Jackson's mother was a "city girl," in her son's words, from a prosperous Troy family. Educated as were most socially secure middle-class American girls of the era, she had learned music, letters, dancing, handiwork, and painting in watercolors. Whenever failure or dissatisfaction ended one of George Jackson's sojourns, Harriet Allen's family provided the locus for return—they were, in the child's memory, "methodical" and "settled."[4]

Given the pattern of the Jackson family's life until William Henry set out on his own at sixteen, one significant anomaly stands out: the Jackson family never emigrated to the West. This is not simply odd in retrospect. It is also an aberrance, considering both the era and the condition of upper New York State. For during that time the entire Northeastern region was suffering from a debilitating disease: depopulation, a result of the diminished richness of the land, the attraction to young men and women of the new regions to the West, and an equally important migration from country to city that followed the historic shift toward industrialization affecting the entire Eastern portion of the nation. Not simply a fiction of census reports, this phenomenon was visible to the attuned observer as early as the mid-forties, in the form of abandoned farms, shuttered shops and houses, and a steady lowering of hopes among those who remained. The emptying of the land was particularly severe in the areas where the Jacksons lived.[5]

Considering this massive exodus from the Eastern lands, the fact that the Jackson family never emigrated to the Western frontier demands explanation. But, in fact, the Jacksons' pattern reflects a more realistic if less romantic side of the depopulation and mobility in the decades between 1840 and 1860. George Jackson's profession as wheelwright and blacksmith made him more likely to look to the urban industrial centers for economic mobility, as indeed he did. In addition, the times during which the Jacksons had sufficient money to stake such a trip did not coincide with the peak years of emigration fever. And, finally, the force of family ties to that region served to limit the father's restlessness. For his son, however, the ties would be weaker, the impulse to escape greater.

Outside his immediate family, Jackson received the typical cursory cultivation offered by American education at midcentury. Attending school when it was convenient for him, he learned to read, write, and do sums. In addition, he was required to learn the history of the United States and to memorize and recite the great rhetorical documents of his time in an exercise known as declamation—"Daniel Webster and William Cullen Bryant, Whittier and Longfellow" provided the sources for speeches delivered in front of the entire school. Along the way, Jackson began to draw, following the lead of his mother, who had continued her painting in what time she had for herself after her marriage. He later reported that he drew "with a burning zeal" but with no idea how to produce "correct" scenes or images. When he was about ten, his mother encouraged him by giving him a copy of J. G. Chapman's *American Drawing Book*.[6]

Chapman's was more than a simple drawing tutor. It was a means by which the visually gifted boy could organize, comprehend, and communicate his own perceptions; it was also his first open doorway into the cultivated world of urbane, upper-class education and behavior. The *American Drawing Book* provided detailed instructions in the way drawing and painting could introduce the student to the entire world of Western civilization—as Chapman himself understood it. In the world of American art, his book was Benjamin Franklin's *Autobiography* in a visual format: the most popular of a small list of "bibles" for amateur, vernacular, and self-taught artists (the majority of artists during the period when Chapman had his heyday—the thirty years after 1847). And Chapman's argued for art not only as "a beautiful accomplishment" but as "utility" and patriotism.[7]

For Jackson the *American Drawing Book* was, most important, a set of instructions about how one might construct oneself and the world so that the two fit together well—it provided laws of composition and design that were in essence keys to the ways an entire civilization constructed and communicated its beliefs, its meanings. Perfection in humanity was imitation of the Greek gods; in an artist, it was correct imitation of Greek, Roman, and Renaissance models. And these examples provided not only good art—they made the artist good, civilized, as well. Ideal landscapes contained unalterable proportions of sky and earth, universal qualities of timelessness and order; these universals could be used to order the world into a painting or to order the self into a more

ideal being. "I drew or painted every day," Jackson wrote in his autobiography, "and for a while I did almost nothing but landscapes, either real or imaginary."[8]

Although it aped a cherished European system of artistic values, Chapman's book was American in its thrust. With respect to landscape especially, it reflected the values of its culture, which placed landscape and genre scenes at the top, marking them as the history paintings of a young, democratic nation and as the mythological works of a culture defining itself by the individuality of its citizenry and its privileged relationship to pristine nature and the God behind and within it:

Of all the application of art to the purpose of the amateur, landscape occupies a deservedly high place; and its study should, therefore, be begun and prosecuted, with due deference to its importance . . . so liberally diffused, and available to all. . . . Nature beckons to him, and invitingly spreads forth her varied charms, to tempt him to her sunny fields—at once his teacher, and bountiful provider of all that he requires.[9]

The book's idealism, its conventionality, and its elevating tone formed one pole of Jackson's early artistic notions. The other was a more appropriately American practicality, pragmatism, and concreteness. If Chapman exemplified the contributions of Jackson's mother's cultivated influence, there was still the force of his father and its diffusion in the rough everyday life of working-class and lower-middle-class provincialism in the 1850s America his family occupied.

By the age of thirteen, Jackson had begun to earn something of a living as a painter. He was a generalist, producing advertising placards and display cards, family portraits, and stage scenery. He also painted landscapes on window screens:

At that time (and for many years afterward) window screens were . . . the medium for displaying some of the most astonishing pictorial art ever known to man. . . . Here were . . . parlor windows parading the virtues of home life among the Romans; there were . . . travels through the Black Forest and an idyllic honeymoon on Lake Lucerne . . . , grazing cows, old mills, and waterfalls. . . . My usual fee was fifteen cents a screen.[10]

These commissions reinforced and elaborated what Chapman's had taught him, particularly concerning the proper subjects, styles, and themes for popular American art. These window screens were quintessentially democratic artworks. Both public and individual, they were the products of an aesthetic consensus constructed of hearsay and common knowledge about artistic subjects and styles, friendly competition among neighbors to outdo each other in cultivated taste, and the fashion among locally available artists, who usually worked from a limited repertoire of images that they varied according to the demands of their customers.

Neighbors, books, popular illustrations, and the work of competing vernacular artists all substituted for formal artistic training, providing a collective artistic vision that included other artists but emanated profoundly from the tastes of Jackson's middle-class, provincial clients. At the same time, the list of subjects he rendered testifies to the presence of influence chains leading to New York and Boston, where these same subjects were being created and exhibited by America's best artists, then converted to wood engravings or other popular printmaking media for distribution throughout the new nation through popular periodicals, art lotteries, and the like.[11]

Jackson's earliest surviving drawings date from his adolescence. Apparently the records of his weekend outings with friends into the famous landscape of the White Mountains and their surroundings, these small sketches are typical studies of the Vermont landscape rendered in picturesque fashion after the requirements of Chapman (illustration 4). They are evidence of Jackson's successful education in the prevailing aesthetic of American landscape art at midcentury—whether rendered by famous American painters of the time, like George Inness, John Kensett, and George Caleb Bingham, or by middle-class town and city dwellers desiring the respite and regeneration promised in nature by hosts of popular writers from Emerson to Whittier. Jackson's drawings describe not only the source of such regeneration—that is, the picturesque, largely unaltered natural geography—but also the actual act of entering that environment to be reinvigorated. In most of Jackson's drawings of this period, he took great pains to include human figures on the mountaintops or hillsides, sitting at water's edge or leaning against trees, alone or in small parties, described in the act of contemplating the landscape.

These images represented the best that Jackson was to do as a graphic artist. "My ambition was to study art for the sake of art," he later recalled; but without funding to make the necessary next step and emigrate to Boston or New York, Jackson was stymied. After a short apprenticeship with

4.

"View of Otter Creek From Ball Mountain, Vermont, 1861," NPS

a local portraitist, he was "soon forced to turn to the humbler work of coloring photographs for a more dependable income." In 1858, he became a piecework retoucher with C. C. Schoonmaker, "Troy's leading photographer," at about four dollars a week.[12]

Jackson's first formal employment brought a drastic narrowing of artistic possibilities. The hours were long and included Saturdays and Sundays as a matter of course, because those were the days when outlying customers came to town to shop and to attend church. In addition, the chance of contact with other artists or works of art shrank to almost nothing. Without any reason to seek out the work of others, and without clients to goad him, Jackson's visual education became limited to the stereotyped interior portraits that constituted the stock of Schoonmaker and virtually every other American studio photographer during that time.

Jackson's own tasks were rather deadly. During this era, the carte de visite replaced the daguerreotype's alchemical, one-of-a-kind beauty with a more utilitarian visual product. Quickly made, small enough to mail, and cheap enough to buy in quantity, these paper-print portraits were mass-produced in studios like Schoonmaker's, where division of labor and specialization promised a consistent product at a price that made the images as common as calling cards. For those who worked in such studios, however, this innovation guaranteed the sort of atomized, isolated work place least conducive to artistic growth. "My part in Schoonmaker's work," recalled Jackson, "was sharpening and improving certain details of his prints with India ink and 'warming them up' with water colors. . . . I was never an 'operator' (that is, a camera man) during those first years." Instead, he worked in a room apart from others, last or near last in a long chain of procedures that began with the receptionist, continued through the cameraman, the negative processor, the printer, and the finisher, who glued the image onto a cardboard mount or placed it inside a small glassed frame.[13]

Within two years, Jackson's passionate devotion to art had become an avocation, and he had adapted himself to what seemed an inevitable life. He had taken a new position in nearby Rutland, Vermont, where Frank Mowrey paid him six dollars a week for "quite a lot of brush-and-pencil work." His new position included oil-painted enlargements and the making of exotic backdrops, but otherwise the work was similar. Better paid than most men of his age and class, Jackson spent his money on clothes, supplies for his continuing hobby of sketching, "buggy rides with a sweetheart along the beautiful mountain roads," and such fashionable extravagances as a reading of the bumps on his skull by the celebrated phrenologist Orson Squire Fowler, from whom he learned that he had "a noble head throughout . . . love of the beautiful and perfect . . . a fine imagination" and talents that ran "towards the purely literary and philosophical."[14]

Then in 1862, after steadily increasing patriotic rhetoric swept through New England, Jackson heeded the call. A social club of which he was a member volunteered as a unit; by September, Jackson was on his way to join the Civil War.

For Jackson, the war was a period of freedom rather than restriction, of excitement rather than danger. Jackson soon was joined by his younger brother, Ed. Wartime service brought him into contact with men from throughout the Union, reintroduced him to railroads, cities, steamships, Washington City, and the exotic environment of the South. At the same time, army service meant a life occupied primarily with drill and preparation for battles that never came.

In his off hours, he amused himself by sketching and even painting scenes of camp life and casual portraits of his friends and fellow soldiers. Report of his talent to his commanding officer gained him some work drawing maps and sketches of fortifications, and relieved him of "fatigue duty" for a period. Jackson's Civil War views were not, for the most part, the studies of social relations and social spaces that characterized those of his contemporary Winslow Homer. Rather, Jackson defined his experience topographically. His most conventionally successful sketches, such as that of "Centerville, Va., June 15th, 1863" (illustration 5) described the drab physical details of army life with an accuracy that surely pleased Jackson's commanding officer. The images of soldiers themselves were relatively stiff vernacular portraits—even when they were attempts to be more casual studies of the idle life of waiting that was the experience of Company K.[15]

In mid-July of 1863, after only a year of service, Jackson and his fellow volunteers with Company K were mustered out and on their way home. Back in Troy, Jackson and his brother Ed, who had served with him in the Vermont Regiment, were treated royally. But within a week or so Jackson was back in Rutland with Mowrey, now specializing in oil portraits of General Grant, George Custer, and President Lincoln. He resumed his sketching and painting of surrounding landscapes, his "Sunday amusements," and began actively courting a young girl named Caddie Eastman. By the end of 1864, Jackson had made a change; he had taken employment as a retoucher with A. F. Styles's Vermont Gallery of Art, the principal gallery in Burlington. There he was paid twenty-five dollars per week—nearly double his salary of the previous year.

5.
"Centerville, Va., June 15th, 1863." NPS

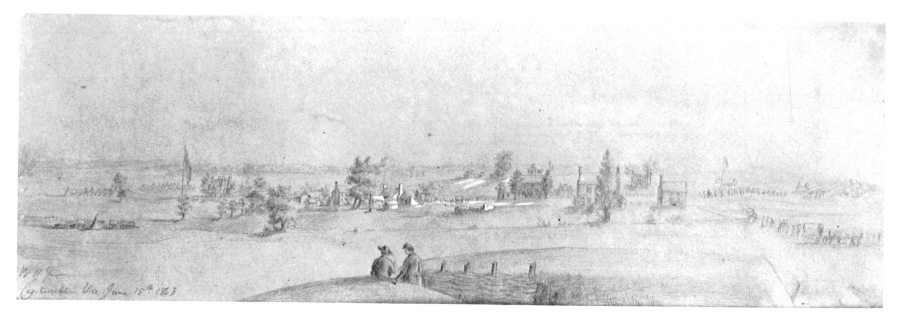

The move to Styles's establishment was a significant step upward in status—the gallery was in a university town and nationally known for its portraiture and its pictures of local scenery and university life. As Jackson sketched it in 1864 (illustration 6), the Vermont Gallery of Art was a typical example of the cultivated photograph studios as they had appeared in mid-sized American towns since the daguerreian era. Jackson's illustration, probably made to be reproduced in woodcut as the back of a Styles card mount or as an advertising image in local newspapers, presented it as a model of American democratic gentility, a place where well-dressed patrons acted the part of leisured aristocrats in plush surroundings. The pretensions to upward mobility no doubt attracted Jackson as much as the increased salary. He was successfully courting the stepdaughter of one of Rutland's prominent merchants; he had joined a secret society and was known as a dandy and young blade; he had taken up buggy racing.[16]

Once settled in Burlington, Jackson found he had the leisure to take up other diversions of the upwardly mobile nineteenth-century youth: the flute, physical culture, and membership in a literary society. There, he reported, "the young ladies and gentlemen . . . who comprised it were very serious in wishing to improve their minds. Few of us had enjoyed the advantages of a higher education, and I can think of no better way for the group to have set about remedying the condition." The group read Shakespeare, Dickens, Emerson, Holmes, Thoreau, and "Bancroft, the historian," as well as the American nature poets—Whittier, Longfellow, and Bryant.[17]

From the works of these authors, Jackson immersed himself in the moral sphere of American Romanticism—a movement far different from its European or English counterpart. Essentially democratic, directed to a wide readership, and convinced of its ability to reach that audience through the application of sentiment and the manipulation of common imagery and symbolism, this American Romanticism of Whittier and Holmes as well as Thoreau and Emerson provided Jackson with information about the relationship between landscape, man, and God that would prove crucial to his later career as a landscape photographer and chronicler of American culture.

But the context in which Thoreau and Emerson appeared to Jackson significantly altered their meanings. As one small part of the program of a reading club of earnest clerks and Empire-tressed young ladies in a provincial town at the end of the Civil War, these essays never developed the ironic complexities and philosophical aspirations

6.
[Reception Area, A. F. Styles's Vermont Gallery of Art], 1864. NPS

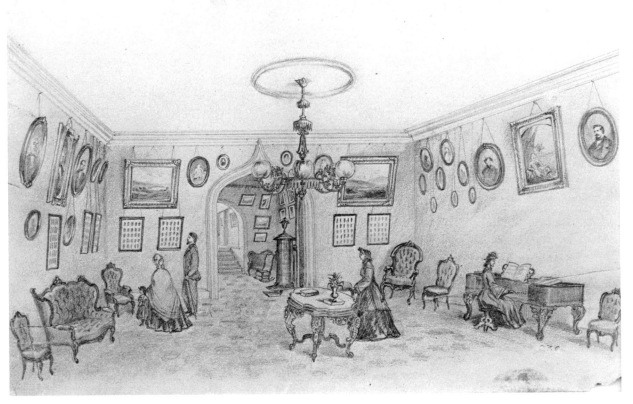

they have reacquired in the criticism of twentieth-century literary scholars. Instead, this context highlighted the American Romantic imagery of nature as a birthright of Americans and a means of reinventing Eden in an increasingly urbanized, bureaucratized, and socially stratified human environment. For a bank clerk or photographer's retoucher, Emerson's essay "Nature" became a primer in attitudes to be applied on a Sunday outing to picnic and look at the October foliage.

In his autobiography, Jackson recalled another important cultivating influence of that period: the mass-circulation press. And, in fact, magazines like *Harper's Weekly, Frank Leslie's Illustrated Newspaper,* and *Godey's Lady's Book* began to take a major place in American cultural life during the years immediately following the Civil War. Purveyors of fiction, philosophy, news, and advertising, the weekly and monthly magazines took advantage of new printing technologies, inexpensive paper, and the availability of the U.S. mails as a distribution mechanism to reach tens of thousands of American households with their messages. Linking city to country, East to West, they offered an increasingly monolithic model of proper belief and behavior to their thousands of subscribers: they were powerful antidotes to the dissension and atomism of American culture during the years surrounding the Civil War.[18]

These national weeklies were influential forces in the growing American "culture of consumption"; Jackson himself remembered that "it was in *Harper's* advertising columns that one could keep abreast of those little significant facts that made life worth living." But equally important were the revolutions in visual imagery that *Leslie's* and, in response, *Harper's* initiated. Frank Leslie's innovative use of multiple engravers for single images, and his dedication to the idea of a journal in which visual materials were on an equal (and often superior) footing with text, revolutionized American magazines. In particular, *Leslie's* lavish visual documentation of the Civil War resulted in a whole new genre for the wide dissemination of important facts, attitudes, and beliefs. By the end of the Civil War, *Leslie's* editions were running to a half million copies and reaching some two and a half million American "readers," providing a vital new visual culture in which Americans shared the imagery of warfare, urbanization, and Western expansion in the form of elaborate, often double-page size, wood engravings increasingly advertised as "drawn from the photograph."[19]

The mass-circulation magazines rounded out Jackson's life as a young professional at the end of the Civil War; they provided him with a sense of connectedness to a larger world that, while exotic on the surface, still retained at base the same fixed laws of scientific causality, morality, and political and social behavior that he experienced in his own community. With their illusionistic visual descriptions of wild regions, their tales of disorder tamed, unhappy love transformed, and political disunity brought into harmony, these magazines offered both escape from and return to Burlington, Rutland, Troy; with the coherence of fairy tales or myths, they ordered and made comprehensible both the exotic wilderness outside and the familiar world of everyday life. "And the future, if unknown, could be plotted from given lines. I liked things as they were

in 1866," Jackson wrote some eighty years later.[20]

The stability, security, and conventionality of Jackson's life in April 1866 stand out in profound relief against the apparently trivial event that caused him to uproot himself, to leave Burlington and the region with nothing more than his week's pay, his clothes, and a gold watch. The event that caused him to head "for the great open spaces to start life anew" was a quarrel with his fiancée, the solidly middle-class Caddie Eastman. Yet Jackson conceded in his autobiographies and in his diaries at the time that he could have patched things up easily. In addition, his obsessive return to the event and his botched attempts to patch it by mail and through intermediaries while he moved farther and farther West, himself unable to understand why he was not returning, suggest that the quarrel with Caddie was simply the excuse for a break. The first extant journal entry, for the very day of his impulsive dash to New York on the first leg of a lifetime of escape, begins with this fragment: "go right on without meeting anyone that would be disposed to ask questions disagreeable to me. Arrived in NY late in pm." A day later, he recounted his chance meeting with Civil War comrade Ruel "Rock" Rounds; asked what he would do, Jackson replied, "haven't the least idea—anything to get away from the civilized world."[21]

The underlying image of a claustrophobic "civilization," incompletely felt but compulsively acted upon, is in sharp contrast to Jackson's recollections of the story for his autobiographies. In both of these later documents, his escape from New England appeared as an enigmatic event, rationalized by sentimental-

ity. But, in fact, Jackson's diaries describe a logical, if unacknowledged, set of reasons for his leaving, even as they communicate a profound ambivalence toward the world he left, the act of leaving, and the promised world ahead. Writing from Chicago six weeks later, Jackson declared, "I shall never return to that country, unless I can return quite rich or famous. As plain, ordinary Will Jackson, I shall remain out of the sight of all that knew me as the young man that was going to marry C.E." On June 6, he wrote:

I feel a sort of a melancholy, grim satisfaction in my step. I feel I am independent. Striking out into the world to make a fortune unaided and by my own act, friendless. Both could be mine by just accepting them. But I want them not. All I want is an all-absorbing, ceaseless occupation for mind and body. Adventurous service would suit me best. But I shall accept the very first thing that offers to carry me across the plain into the new El Dorado.[22]

Jackson's year-long hegira through the Great American Desert to the Eden of southern California and back was his rite of passage from Easterner to Westerner. Jackson was part of a flood of young, effectively unattached American men who, after the Civil War, found themselves discontented with the restrictions of local life, disturbed by the apparent limit to personal progress in the post–war era, hungry for a reaffirmation of their fathers' world of dangerous possibility, and prey to a blizzard of propaganda concerning the American West and its opportunities for wealth, excitement, and freedom.

Just how prevalent this experience must have seemed during the later 1860s can be gleaned from the process by which Jackson's

escape from New England became a semiorganized expedition of men heading West to make their fortunes. The day after arriving in New York, Jackson met his army friend Rock among the crowd of young men who lounged around the Battery in New York: "R said he had a friend that was going with a silver mining co.—expenses paid & c." A search for Rock's friend Harry King took them to no fewer than five Montana mining company headquarters in New York. There they were part of a throng of men looking for sponsorship to the mines; none, needless to say, was forthcoming. They lost King but gained another comrade, Billy Crowl, with whom they resolved to reach the gold and silver regions.[23]

These were three malcontents headed for the mines: a professional stonemason, "footloose" and "flat broke"; a citified store clerk who "had led a wild life"; and Jackson. Their urge toward the West was the product of a dissatisfaction fed by the expanded horizons of wartime experience and by the common—almost universal—presence of gossip among Civil War soldiers about the opportunities of the West, especially as a mining frontier, and inflated by the glowing, imprecise accounts of the Western experience found in the popular press and the new national magazines. But to read Jackson's diary is to sense the crowds of others seemingly identical to these—young men who rode the "cars" from Chicago to Council Bluffs; who filled the Missouri boat upriver to Nebraska City, ogling the Mormon women on board and gossiping about polygamy; who beat our these three for a berth with a Mr. Myers on a wagon train bound with supplies for Montana; who hired on, along with

Jackson, Rock Rounds, and Billy Crowl, in response to an ad in the St. Joseph, Missouri, *Herald* for "100 teamsters for the Plains."[24]

Jackson left for the West "to make a fortune unaided and by my own act, friendless"—as he wrote in his diary on what was to have been his wedding day. That statement articulates beautifully the prevalent myth about Westward emigration that was in place in Jackson's time. But in fact none of those premises came true: Jackson never made his fortune and was never the radical individual he wished to be—neither in total control of his life nor "unaided" or "friendless." Instead, Jackson entered the loose community of the West in New York and followed it out to its geographical limit and back.

Jackson's experience began with a social contract and continued so at each step of the trip. The young rowdies on the boat to Nebraska City made an agreement with the captain that freed them from having to crowd in with the Mormons "if we will only keep quiet & not go into the cabin." And at the terminus, Jackson and his comrades bartered their way into Western society in the symbolic language of that time and place: "We all exchanged our tall hats for soft ones." It was an act that completed their self-conscious stripping of Eastern-ness and re-dress in the new codes of the West, which had begun in Detroit a month before, when Jackson recounted the process by which they sold each item of their Eastern uniform—vests, coats, shirts, and collars—to pay their way.

Once hired on as "bullwhacker" on an ox-train carrying supplies to the mining camps, Jackson's reeducation from tender-

foot to Westerner began in earnest. The labor itself was the first rude shock. Jackson, who had spent most of his working life seated at a stool with a retouching brush, now found himself wrestling wild Texas bulls into ox-harnesses—an infuriating process even for the experienced. Working hours were from well before dawn until late at night—sometimes after midnight. Deprivation of all "civilized" privileges was a shock. The men would find themselves "coated with [dust] to a uniform grayness, more like clay images than human beings." Food was the universal, unrelieved meal of the overlander: bacon, "bread" (a soda bread made of water, flour, and baking soda and baked over the fire or in makeshift ovens), and coffee so strong that Jackson reported to his parents having "lurid dreams almost every night, and invariably . . . related to my team of bulls." Jackson and his companions found themselves so sore they were ill, so tired they were feverish, walking zombies shouting out hoarse commands to their cattle as they plodded across a seemingly endless, flat, unmodified prairie.[25]

Jackson's letters and diary entries described the process by which these groups of young males rediscovered participatory democracy on a day-by-day basis. Writing to his parents from "Great Salt Lake City" on October 30, Jackson presented an engrossing account of the negotiations that comprised social life in that westward community. Of the first days, Jackson wrote:

As soon as we arrive at a halting place . . . we proceed . . . to get breakfast. When we had no regular cook that was usually a matter of a good deal of discussion. Who was to get wood and who was to get water? Who was to mix the bread, who was to brown the coffee? & this thing and that thing.

But by the time the train passed Julesburg and crossed the South Platte, community work was unconsciously shouldered, bunks and blankets shared automatically, adversity divided among all.[26]

The low pay, long hours, and miserable circumstances had a powerful effect, welding a social solidarity among the self-proclaimed individualists of the team. The loss of six men to the Union Pacific tie-cutting crews at Cottonwood Springs, Nebraska, cemented their unity: "There is a good deal of talk of striking for $50 per month soon," wrote Jackson on July 21. Apparently the threat was enough; by July 25, their trail boss had raised wages. But the conflict between solidarity and individuality was never fully resolved, in Jackson's eyes. The day before, Jackson complained that "one great source of trouble has been the laziness and independence of the boys, making it almost impossible at times to get them to do anything at all." And while the continued loss of men at each jumping-off point offered the potential for an organized confrontation with the trail bosses, in fact individuals could be hired on at the same junctions, or individual contracts made with employees to take on other wagons at limited increases in pay. The overall effect was a loose compromise between cooperation and competition, collectivity and radical individualism that Jackson saw again and again in the social landscape of the West during that trip.[27]

As the weeks passed, Jackson's horizons of perception widened considerably. In particular, he began to notice the social worlds through which he was passing and to describe the interactions between his group, fellow emigrants, settlers, Indians, and eventually—as the team approached Salt Lake City—the Mormons. Simultaneously, he began to comment on the natural landscape. These two phenomena were apparently intertwined. Jackson's first description of the settlements on either side of the trail began with a revealingly dour comment: "Deserted and ruined ranches are more numerous than inhabited ones. The country looks desolate enough anyway. The low mud huts called ranches were about once in six or eight miles so far, and their only redeeming feature is their wells.[28]

Four days later, the company reached the Platte River Crossing at Julesburg, in Colorado. For the past month his company had been following one of the variants of the famous Oregon–California Trail that ran from St. Joseph, Missouri, to Fort Kearny, Nebraska, followed the Platte River to Julesburg, passed Chimney Rock and Scott's Bluff to enter Wyoming Territory at Fort Laramie, then cut through South Pass, Fort Bridger, Salt Lake City, and on to California. But to this point Jackson had failed to notice the flat, unrelieved prairie, the unobstructed intersection of earth and infinite sky, the strange phenomenon of an overcrowded national highway splitting the region in half. At Julesburg, for the first time, Jackson awakened to the drama and strangeness of his surroundings.

At Platte River Crossing, the company had its first rest in weeks, as Ed and the other bosses sought new employees, supplies, and repairs to the wagons, and the wagons themselves waited their turn to cross. Jackson's

attempts to categorize his experiences in diary and sketches were significant, dividing the landscape into four parts—the "city" of Julesburg, the temporary town of émigrés (including his own company) awaiting the chance to cross, the Indians also camped nearby, and the unoccupied topography itself—Jackson presented them as discontinuous, atomized elements. Julesburg was "a small place of 8 or 10 houses, but the best I have seen since leaving the Missouri—real frame houses, two storied and shingled." The crossing and its settlement were "a very pandemonium" but also a place of cooperation and shared experiences. The Indians were "a band of Sioux . . . paddling along very nearly in a state of nature. The banks upon either side were covered with wagons & groups of drivers collected together to see the little Indians paddle in the water & chatter with the older ones." Nature itself was a hostile set of energies—the unruly, quicksandy river bisecting a realm of natural forces so powerful that "an Eastern person has hardly an idea of a thunder storm. The force and fury is difficult to describe."[29]

Jackson's response to his environment was an aesthetic one: at the end of his diary entry concerning the Platte River Crossing, he noted, "the scene was one to be remembered and I must represent it pictorially." Apparently he sketched the scene on the spot, commencing again that practice begun in his childhood. Two days later, the company passed Chimney Rock, famed landmark on the Oregon-California Trail. Jackson noted, "Made several sketches. Made a drawing of Ed again, and commenced a water color of the Rock for him." The sketch

(illustration 7) was perhaps the earliest of Jackson's purely topographic studies of unoccupied land, and his attention to the geological stratigraphy as well as his attempts to depict as accurately as possible the scale of the naked landscape (he had written in his diary, "distances are very deceptive, particularly so in the case of this rock") combined to make this work signally different from his sketchwork of the past. It was not simply that this small drawing included no people or signs of them—though it is hard to find an earlier sketch by him in which no traces of man are depicted. Rather it is that the picture is devoid of pictorial conventions as well. Without rules from Chapman's *American Drawing Book* or other sources to guide him, Jackson was forced back on the limner's yearning for topographic accuracy as a means of conveying the effect of awesome space and the sense of powerful forces at work in an uncompleted Creation.[30]

The same naked encounter with infinitude, and the infinitely strange, hangs over most of Jackson's visual responses to the regions west of Julesburg. In fact, one may see in many of his drawings a strange split: the foreground and middle areas are occupied by human activity portrayed in the stilted, easternized style of his Vermont studies; these seem all the more false against the vast sweeping spaces behind and around them. Later versions of the "Platte River Crossing" painting still retain vestiges of this dualism, which can be seen at its most extreme in his view of the trail and telegraph lines passing into the deep space of South Pass approaching the Sweetwater River (illustration 8). In this view, Jackson apparently never had time to go through the painful process of translating the realm of human activity from rough stick-figure cartoon into the stilted scenes to be found in his more complete pictures of the period. As a result, the sketch gains a chilling force from its combination of visual economy and the ludicrous powerlessness of its human figures.[31]

Jackson's few drawings from this point reveal the extreme disparity between his voice and his eye. Faced with this oppressive new landscape, Jackson the diarist fell silent or lapsed into platitude: a thunder shower "was worthy of the pencil of Rembrandt"; "we encamped in a very pleasant place" where there was a "big, pretty cottonwood." But the sketches themselves belie the implication that Jackson's response to these landmarks was callow or blasé. His view of the Wind River Mountains made at camp on the Little Sandy (at what the diaries called "a pleasant spot"—illustration 9) portrays a land where our eyes strain to grasp what we ourselves can never touch, to estimate inestimable distances.

Meanwhile Jackson's experiences took on greater and greater immediacy. At Sweetwater Station he and his comrades managed to read a newspaper, and reported that "it seemed a real luxury." His assessment of the Western ranchers, however, was inflexible: "These Ranchmen are the most rascally set of humanity in existence. They live and make all their money by thieving. One of them made approaches to me for sugar [from Jackson's wagon]." The next day's entry began tersely: "Oxen still dying." At Devil's Gateway near the Sweetwater in Wyoming, just west of the famed Independence Rock, a se-

7. (*opposite, above*) *[Chimney Rock], July 31, 1866.* NPS

8. (*opposite, below*) *[View of the South Pass Approaching the Sweetwater River], 1866. This drawing was apparently drawn over by Jackson, probably in the 1930s, to improve its reproducibility.* NPS

9. *"Wind River Mountains from the Little Sandy," September 2, 1866.* NPS

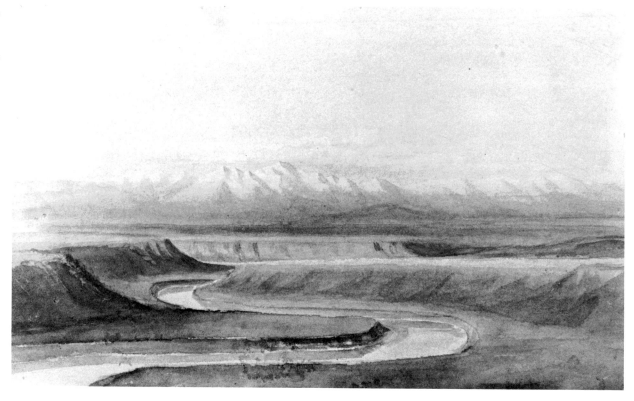

vere thunderstorm killed a driver for a rival company. Daily the weather grew colder, as the Wyoming summer ended and the wagons drove higher into the mountains.[32]

Early in September, Jackson's settled plan to emigrate to the Montana mines dissipated; instead, he decided to leave the train at Salt Lake City and find an alternate route to San Francisco, where he hoped his earnings would be sufficient to provide boat passage back to the East. But again his impulsiveness and independence effectively guaranteed he could not succeed. Meeting with Ed Owens, the trail boss, he found himself entirely out-bargained, losing his "outfit" of clothes, hat, whip, and the like that had been bought on credit, and receiving no wages at all for his two months' work. Rather than buying a ticket on the stage to San Francisco, Jackson took a job with a hay contractor "for $15 for a couple of weeks at haying & then he would take us into the city." From Salt Lake City, presumably, Jackson and his fellow deserters would be able to find further employment on supply wagons to the San Francisco region. Even this plan proved overly optimistic; the hay contractor failed to pay them and refused to drive them in, and they were forced to take a bullwhacking job at one dollar a day for the privilege of driving wagons down from Fort Bridger to Salt Lake City.[33]

Reaching the famed Echo and Weber Canyons, Jackson reported that they failed to live up to the sublimity they had been reported to have in popular travel, tourist, and newspaper accounts. "Am much disappointed in the cañon," he wrote; "my expectations ran altogether too high." By the end of the next day, however, he had passed through half of Echo; immersion in it replaced his conventional standards with a new appreciation, which, nonetheless, he continued to word in conventionalized terms, describing the landscape as "scenery" and choosing the usual stock adjectives, "wild" and "picturesque." The next day, as the wagon trains exited, his experience of the danger inherent in sublimity was more deeply personal: passing through "a very rough road all full of rocks, with barely room for the wagon to pass," Jackson saw a wagon ahead of him overturn, crashing down into the creek below.[34]

Four days later it began to snow. Jackson's boots had long since given out; for footwear he had a pair of moccasins he had acquired from his haying contractor. By evening his frostbite was so severe he could not stand for three days. Arriving in Salt Lake City, Jackson found that the trail boss planned to dock him for his days laid up with frostbite.[35]

There was little lower Jackson could go—he had less than twenty dollars, of which fifteen went to rent a room for a month; no photographer was able or willing to hire him on; and his desire for the mining regions was entirely dissipated. His self-diagnosis was a bleakly accurate picture of the émigré who had failed in his quest for freedom, wealth, and liberation from the East:

Felt blue, terribly blue all the evening, in fact for two or three days have been rather despondent— & no wonder. Just let me take a look at myself and see what I am like. 6 months roughing it on the plains has darkened me down considerably. My face looks rough from the hair that has taken it to itself at last to grow. My chin whiskers and moustache are somewhat thin but still look very well. My hands are black & it sometimes seems as if I never should get them presentable again. My apparel however caps the climax. My clothes in the first place are surprisingly dirty and very very ragged. My pants all but a continuous series of rents. I pull on another pair, very ragged also, but in different places, so between the two I manage to hide my nakedness. Coat has faded very much and holds itself together most perseveringly. My boots are heel-less, squashed down & run down & my hat beats all, in fact it is the greatest hat you ever saw, the most vivid imagination would fail to assign it any shape and it is about as easy to keep on my head on a windy day as a newspaper. Taken as a whole, you have a very seedy individual.

Three days later, Jackson had swallowed his pride. "Posted my letter home, asked for $100, and to have my clothes sent me," he wrote in his diary. "To me it is humiliating in the extreme to be compelled to ask for money to return, but I think it best I should."[36]

In a second letter, Jackson included an extraordinary description of the arrival at Salt Lake City. After the cold, the mud "a foot or two deep," the frostbite and exhaustion, his description of the City and its surroundings sounded like that of a supplicant entering paradise:

Salt Lake City is situated upon a gentle slope at the foot of the mountains while the valley itself stretches off for miles to the south and west—all being circled by magnificent snow-capped peaks. We can get just a glimpse of the lake itself with its mountain islands. The city at a little distance looks like a garden. Almost every house without any exception being surrounded by peach trees.

For Jackson, as for so many others, escape from the barren Plains took on the mythic character of entrance into the Garden at the end of a quest.[37]

While he waited for a reply to his letters—mail each way might, with luck, make the trip in two weeks—Jackson took a job on a Mormon farm. By the end of October the work was done but the Mormon farmer Birch, impressed with Jackson's book learning (Birch was not able to read or write, nor were any of the members of his family) and with Jackson's drawings, invited him to remain. For the next month, Jackson sketched or painted almost daily.[38]

This period of relative leisure was vital. Offering him a chance to reflect on his headlong immersion into the westering experience, it also enabled him to turn his attention to the visual qualities of his experiences and his surroundings. On November 17, he commented in his diary on the mountains that reared behind Birch's farm.

Over the next days, he made a number of drawings of these mountains (illustration 10). Taken as a group, they differ markedly from both the quick sketches and the conventionalized drawings Jackson made dur-

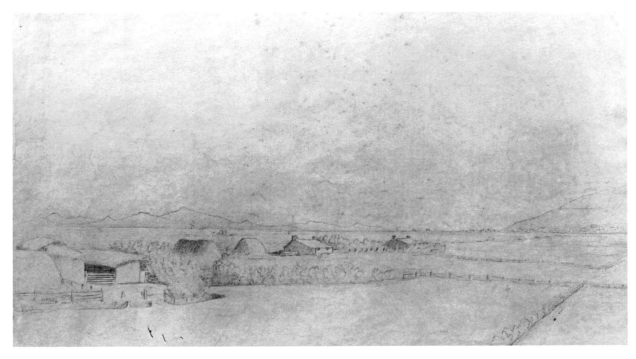

11.
[Birch Homestead],
1866. NPS

ing the journey itself; they are attempts to understand the intersection, the interaction, between human and natural spheres, rather than unthinkingly yoking topography and convention in unlikely combination. The resulting pictures (like his view of the Birch homestead, illustration 11) have lost some of that hard-staring accuracy in their rendering of mountains and range—the environment looks a bit more picturesque, a bit more like "scenery"—but the more important change lies in the sense we get of a symbiotic relation between man and nature in which the sublimity of the mountains is not diminished, but neither is the orderly comfort of the human sphere overwhelmed.[39]

The yearning for a return to the East pervaded Jackson's being for the rest of his sojourn. Just after arriving at the Birches', he had written "But O! how often I do sigh for the comfort & refinements of home life. This is not living at all." Once his money had arrived (on December 7), Jackson increasingly turned his eyes Eastward, planning his return, writing a carefully copied letter to Caddie that proposed a re-engagement, considering his parents' urging that he write a series of "Great West" articles for the *Troy Times* and send his drawings on to *Harper's Weekly*. Yet, paradoxically, he continued to plan an alternative, Western future, centered on a trip "through the mining region south . . . this fall." On December 19, he mailed his sketches back East; on De-

cember 23, Jackson and his friend Bill Halleck, who had traveled with him since leaving Ed Owens's train, booked passage for Los Angeles.[40]

This trip transformed Jackson's Western status in a fundamental way. After months of initiation into the fraternity of frontiersman, Jackson was an outsider again. And the change in status was mutually defined—now even as Jackson became a tenderfoot, a piece of "supercargo," so also he began to treat the surrounding landscape and society with derision.

The most noticeable change was in his attitude toward the Mormons. Jackson had traveled with them, lived in their sacred city, worked for them, eaten at their tables, discussed religion with them, and read to them. He had drawn their portraits and portrayed their lands. Again and again, Jackson had commented on his discovery that Mormons were humans, their society familiar to him. Yet suddenly they became enemies. A few days out, Jackson reported that he and others in the train "counted up [the] available Gentile [non-Mormon] and Mormon forces on the train, & the chances should trouble occur. 'Twas thought advisable to keep steady at all events until we are out of their settlements, or we might not come to time some fine morning." The next night he continued, "Those of us that staid about the fire had a good deal to say about Mormon vengeance, retribution, Destroying Angels, etc. etc." Though Jackson tended to remain in camp, some of his fellows made evening trips into the towns, on which they reported back in unflattering terms, even as their own behavior, it appears, was boorish—they walked out on religious services, laughed at

an old man in a public meeting, and were generally bad guests. And Jackson's own reports of these events in his diary were judgmental, even contemptuous.[41]

Jackson's attitude was emphatically that of the traveler, the bored tourist. "Time passed slowly and tediously. Poker for the apples played a good deal"—and cribbage, and euchre, and "the mysteries of Monte." Jackson and his fellow passengers stayed in the wagons, lolling about and gambling, or struck off from the train to look over nearby towns or points of interest. At night, they tended to drink, sometimes heavily, and often abused the bullwhackers. All the problems that Jackson had himself experienced on the trail now became objects of scornful notice or a good laugh.[42]

And the appearance of Indians evoked the extremes of condescension and contempt. On January 11, near the border of Utah, Arizona, and Nevada, the train ran into its first Indians. "Passed quite a party of Pi-Utes out hunting rabbits. [They] ran them down in the snow and killed them with sticks," reported Jackson. Six days later, he reported "quite a number of Indians about camp. If possible, they are poorer and more miserable looking than those we met at the Muddy." Their condition aroused not sympathy but abuse. "Bob had to drive them away from the fires," Jackson wrote, and then, "had a good deal of sport with them." A few days later, "all the Indians in the neighborhood crowded in & we amused ourselves with them a good deal." Primitives, these Indians received the treatment Mark Twain had described Southern small-towners giving dogs—petty cruelty and practical jokes that aroused much amusement.[43]

The usual nineteenth-century white stereotypes for nonwhites pervaded Jackson's encounters. Jackson divided Indians into two categories: the strong, independent, or sophisticated Indians were dangerous potential belligerents; the rest were primitive, dirty, uncivilized, and thus lazy and insufficiently respectful of private property and the corporal, mental, and moral superiority of the whites. In the process of confrontations with them, Jackson learned the lessons about the proper etiquette in dealing with Indians.[44]

On January 28, the train came out of the high desert above San Bernardino, California. It was, he said, "very pleasant and balmy, in fact, delightful. The fields were green & many plants in blossom. At a gulch where we stopped to water, mining was going on a mile or so to one side of the road. Had a great desire to go up & see things." Gold by the side of the road, eternally perfect weather, orderly rows of cultivated fields, a winery: this was Eden realized, so "splendid" that Jackson "lay on the grass & rolled around in pure enjoyment." The next day, "musical birds made the air melodious & everything seemed in calm pleasant repose." Once again, as he had in his description of Salt Lake City, Jackson organized his vision of the settled West in terms derived from the myth of the Garden.[45]

Two days later they were in Los Angeles. Before the first day was out, Jackson was restless to leave—to go up to San Francisco, then to "Clear Creek diggings," where he again planned to become a miner, earn his fortune, and return to the East in triumph. Without money, he and two fellow passengers began to walk. One of them lasted two

days; Jackson held out for three. At a stage station twenty miles out, Jackson arranged to become a hired hand at a dollar a day plus board. The Ward family, who ran the station, were "plain farmers, people from N.Y.," and they provided Jackson with an illusion of home. Two days later he wrote that "sometimes when I allow myself to wander back to the scenes and associations of one year ago it seems as if I should go crazy with impatience." Still he was committed to "my purpose of getting back east with plenty of money."[46]

Jackson stayed with the Wards for over a month. Had the old man needed more help, he might have remained indefinitely; he made no overtures to leave, and all mention of the gold fields disappeared from his diary. But on March 28, he and Nels put the last cactus in the large fence that they had been constructing, and he "made arrangements to go down with Ned" to Los Angeles. Receiving his wages—$33.50—he was gone by afternoon. Down in Los Angeles, he seemed unable to decide what to do; despite his short cash and his often-professed desire to save for a return to the East, he put up at a hotel, guaranteeing that his stash would last little more than a week or so. Meeting up with Ed Webb, the trail boss on the wagon train he'd taken from Salt Lake City, he heard that one of the fellow travelers was planning an entrepreneurial venture herding wild horses back to the East, where they could be sold for a huge profit.[47]

Without capital to invest, the best Jackson could find was a job, grudgingly given, with a team headed by a man named Sam McGannigan. Apparently sensing Jackson's eagerness, McGannigan never produced a con-

tract or even agreed to pay more than board. The group, consisting of the trail boss, Jackson, Jackson's sometime friend Jim, another herder named John, and some one hundred and fifty horses, left for the East on May 2, 1867, little more than a year after Jackson had departed from Burlington. Soon after, they were joined by another outfit, run by Jim Keller, consisting of two "hands" and including Keller's wife, who rode in the wagon.[48]

Disappointment, dissension, and unhappiness plagued the outfit during the three months it took them to drive their horses to Julesburg, terminus of the Union Pacific Railroad. The entire trip was a lesson in erasing the bonds Jackson had made with the West. Community and collective assistance were almost nonexistent. Instead, there was an uneasy, suspicious neutrality—between the outfit and the settlers and Indians along the trails, among the various outfits that teamed up and separated over the route, between McGannigan and his workers, and among the workers themselves. Because of the intense heat, they drove the horses through the night, but desert conditions made the herd skittish, and it required constant attention during the day. Exhausted by heat, lack of sleep, and frantic physical activity, Jackson and his fellows pushed on through the region between Los Angeles and Salt Lake City. For Jackson, the novelty of the West offered no relief—he had traveled this exact route just a few months before, as a passenger. What picturesqueness there had appeared to be from a wagon in January dissipated in the August dust. Now the landscape reinforced the stereotype of the Great American Desert, and the Mormon and Southern California Edens faded into a disenchanted world of sand-destroyed, abandoned ranches and failed farms.

Western society, as well, disappointed and betrayed him. Outside Salt Lake City, the outfit passed near the Birch homestead, where Jackson had spent more than two months and where he had been revered for his drawing talent and his ability to read. He borrowed a horse and went calling, but the family didn't recognize him. Reminded, they offered him strawberries, but he left quickly.

Within the outfit was a deeper betrayal of frontier society. As early as mid-April, Jackson reported:

Scandal, big. Sam has been going it rather steep with Jim's wife. She seems to be a young simple thing & Sam has completely ruined her. Sam has not taken the least precaution to conceal his maneuvers & the matter is familiar to all & completely disgusts us with both parties. Jim can't but hear of it soon & judging from his disposition & character there'll be a big row.[49]

Suddenly, Jackson and his fellows were in the midst of a conflict of Western values: on one side was the traditional reticence to inform on fellows and the deep respect of individuality; on the other, a revulsion at the violation of social mores particularly vital in a society composed almost entirely of males, and one wherein the traditional protections against sexual infidelity—community values, stabilized self-identity, family roots—were nonexistent. In addition, the conflict took on overtones of worker–employer relations, as McGannigan insisted that his hands stand guard over the wagon to prevent Jim from catching the couple, or that they signal the campsite whenever Jim left the horses to return. And, finally, the entire imbroglio in-creased tensions between the loosely allied outfits. The episode quickly colored Jackson's view of the entire frontier experience; his diary began to intermingle reports on the humiliations of standing guard for McGannigan with complaints about the roughness of the trail and the landscape itself. At one point, immediately after reporting the "scandal still big—Sam slept with Mrs. K all last night and took no pains to conceal it" Jackson burst out that he was "perfectly disgusted" with the immediate area, the "most disagreeable place I was ever in." When the affair was finally discovered some weeks later, the two outfits separated hostilely, and Jackson rather forlornly noted that night that "camp seems very quiet and lonely now." Shortly thereafter, reports of an organization of settlers who made a profession of preying on emigrant and merchant trains and stealing their stock did little to restore Jackson's enthusiasm for the West.[50]

The end of the trail back to the East was marked not by new settlements or increased permanent population but by the evidence of the Union Pacific Railroad, which had pushed its way past Julesburg and met the outfit in the Black Hills. From that point eastward, the men encountered each stage of the railroad—from the "new ranches where they were getting out ties" to the point where "the track was measured off, 300 yds." to the "frequent batches of men at work grading the road" and finally to the rail terminus itself, about a day's drive out from Julesburg, where Jackson let out "a whoop for very joy, it looked so good and natural." At the now-thriving "hell-on-wheels" of Julesburg, the outfits arranged for railway cars to take the stock to Omaha for sale; now came

the difficult process of separating the horses from each outfit. Jackson spent no time enjoying the city itself, which he reported "will probably all disappear with the progress of the R.R. All the buildings are mere board shanties put up in a day, 4/5ths of all are either gambling, drinking or dancing halls. More gambling, drunkenness & fighting going on than in any place I was ever in." Soon after, Jackson reported that McGannigan had taken up with another woman, this time the daughter of a fellow traveler—a "little chit of a girl." And when the band arrived in Omaha and Jackson found Sam unwilling to pay him more than "a suit of clothes" for three months' work, his rage with the entire experience condensed and overflowed.[51]

Even as his disgust with Western life peaked, his pleasure at the sights of "civilization" increased. August 1, on the train eastward, Jackson reported that "as we neared the Missouri a great deal of the Platte bottom was taken up & large thrifty fields of corn waved over many an acre." Suddenly he was in the role of Western booster, extolling the possibilities of settlement ("appears to be millions of acres of splendid land") and urging that the wilderness and the frontier be quickly converted to orderly, exploitable yeoman farms. He himself, however, arrived in Omaha determined to replicate his Eastern personality at the jumping-off place for the West. Bargaining twenty dollars out of McGannigan, Jackson "invested it at once in a suit of clothes . . . [and] a shave," interviewed with E. L. Eaton and Edric Eaton Hamilton, the owners of Omaha's two largest photographic studios, and within a day was at work for the latter as retoucher and painter at the same salary he had received when he left Burlington a year before. Surrounded by the vast potentials of the blank prairie and the railroad city, Jackson settled down in Hamilton's studio, "putting pictures up to paint, etc."[52]

For nearly a year, Jackson had lived on that line between wilderness and civilization that historian Frederick Jackson Turner was later to mythologize as the frontier. Unlike Turner's frontier, however, Jackson's had not lain in a vertical line west of the steadily encroaching forces of Eastern settlement. Instead, it was an amorphous strip comprised partly of temporary settlements, partly of permanent farms, towns, and even cities, all of which floated in a sea of unmapped, unaltered landscape like buoys held together by the lines of trails and wagon roads, and now the Union Pacific.

Jackson himself had matched the tenuousness of this frontier with a personal and psychological tenuousness. Vacillating between his Eastern longing for orderly, predictable, social relations and his sometimes rebellious, sometimes haphazard and casual acceptance of Western values, he seemed the perfect marginal man for the marginality of this actual frontier. Jackson's return to the Western border city of Omaha served to satisfy, at least temporarily, both his tendencies. Giving his allegiance to the business of photography, abandoning "the accursed camp" for "the Douglas House" and "a room of my own," Jackson exulted: "I cannot begin to tell how good my new life begins to feel to me. I just laugh aloud to myself in pure enjoyment."[53]

But for Jackson, settlement was never possible—at least not for long. Four days after reporting his joy at leaving the "tedious" world of the frontier, with its "contemptible rascal[s]," "perfect scoundrel[s]," and flexible social mores, Jackson reported in his diary that "my new mode of living & change of diet don't agree with me, & keeps me half sick all the while," and complained at his long work hours, because "Hamilton keeps open rooms." He ended his diary, appropriately, with a table of distances, a point-by-point record of miles traveled and settlements visited along the Great American Desert between Los Angeles and Lehi, Utah. Settled, he was unsettled.[54]

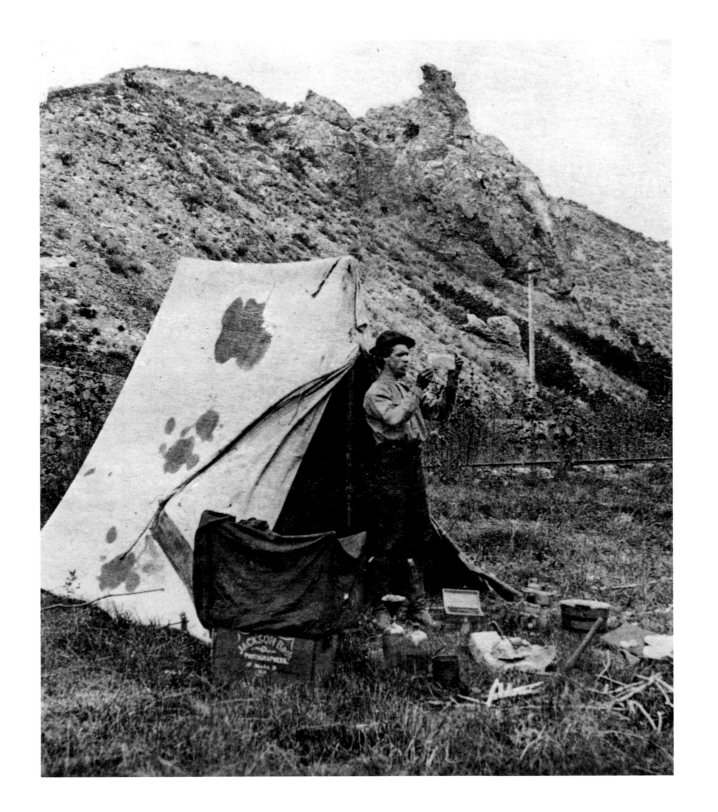

Learning Landscapes, 1868-1869
Chapter Two

I sought my subjects from the house-tops,
and finally from the hill-tops and about the
surrounding country; the taste strengthening
as my successes became greater in proportion
to the failures.
—WILLIAM HENRY JACKSON,
 "Field Work"[1]

Jackson's decision to settle at Omaha was fortunate. Located at the jumping-off point to the West, its back to the prairie and its face to the Missouri River and, beyond that, the East, Omaha was the quintessential frontier city of the 1860s. It was the last outpost before the wilderness: "the Missouri river was the recognized frontier line," wrote Western booster George Crofutt, in one of the earliest guidebooks to the West. "There all travelers for the great unknown, towards the setting sun, congregated; it was there they bid good-bye to friends, or mailed their parting lines, many times with fearful misgivings for the future."[2]

Omaha in 1867 was among the largest, most settled, and stable of the urban centers that dotted the Great Plains, servicing the surrounding farming, mining, or ranch lands and surviving off the needs and supplies of the transcontinental transportation line between the Missouri River and the Pacific Ocean. With a population over 12,000 it was the central metropolis in a state, recently elevated from territory, with a population of nearly 120,000. Dirt streets and vacant lots in the downtown area suggested the booming atmosphere of the previous decade; brick and stone "fireproof" buildings, horsecar tracks, and the number of hotels, some of them imposing structures, signaled a new era of substantiality. Large and rapidly growing, it was an island of urban possibilities in a sea of largely unsettled prairie.[3]

For a photographer, Omaha was an ideal location. Its place at the terminus of the uncompleted Union Pacific Railroad meant that a tremendous number of transient workers passed through on their way to or from the construction areas. With ready money, relatives and friends elsewhere, and a desire to reaffirm a substantial self-image, the railroad workers gravitated to the photographer's studio. In addition, Omaha provided the sort of clientele found in most mid-sized American cities of the time—middle-class businessmen, tradespeople, salesmen or "drummers" using the city as a base of operations, and farmers in from the outlying areas to shop.

There were also the tourists. Though few in 1867—largely upper-class, leisured, and cultivated—still they were a portent of what was to come. They marked a deep curiosity, even hunger, to understand, to *see* the great West that had begun to engage a growing

12. (*opposite*)
[William Henry Jackson with Field Equipment, Echo Cañon, Utah],
1869. NA

number of Americans. Here were markets, invisible but potent, for a mass-produced imagery of the West.

Jackson's own recent experience helped him to appreciate this. Infected with the Western booster optimism, discontented with mere employment for wages, he began to dream of an economic empire in the Jackson name, and to treat the dream as reality.

Within a matter of weeks, his glowing letters to his family brought out his younger brother Ed, colleague of the War; in addition, he managed to convince his father to stake the two in his plan to buy Edric Hamilton's business and strike out on his own. Early in 1868, Jackson Brothers, Photographers, was founded in Hamilton's old studio at the southeast corner of Douglas and Fif-

teenth streets. In addition, the Jacksons soon after bought out Hamilton's competitor E. L. Eaton as well, thereby creating what was almost certainly Omaha's largest and most sophisticated photographic establishment.[4]

The new business began with William as retoucher, Ed as business manager and sometime portrait assistant, and a friend of Ed's, Ira Johnson, as principal photographer; a third Jackson, Fred, soon appeared on the rolls as general assistant. But as William Henry later recalled, "the indoor work and the details of getting our new business under way soon began to get irksome," and he took up outdoor work—"viewing, as it was called then."[5]

Landscapes, in the elevated, artistic sense of the term, simply did not apply to the vast majority of the outdoor photographs Jackson (and a hundred photographers like him all along the frontier line) included under the larger category of "viewing." In fact, he later described the typical demands of his local audience:

Straight portrait jobs; group pictures of lodges, church societies, and political clubs; and outdoor shots that gratified civic pride. There were many commissions to photograph shop fronts and, occasionally, interiors. Now and then, too, somebody would order pictures of his new house; or of his big barn, and along with it the livestock.[6]

Purchase of the Hamilton and Eaton studios provided Jackson with a large stock of negatives; many were mundane, but within the lot there was a selection of studies of the local scenic curiosities, views that catered to the Eastern penchant for legendary Western extravagances of nature, especially anthropomorphic rock formations. These ap-

13.
"Ter-ra-re-caw-wah. Petabowerat [Pawnee]." Stereograph, probably by E. L. Eaton, ca. 1867.

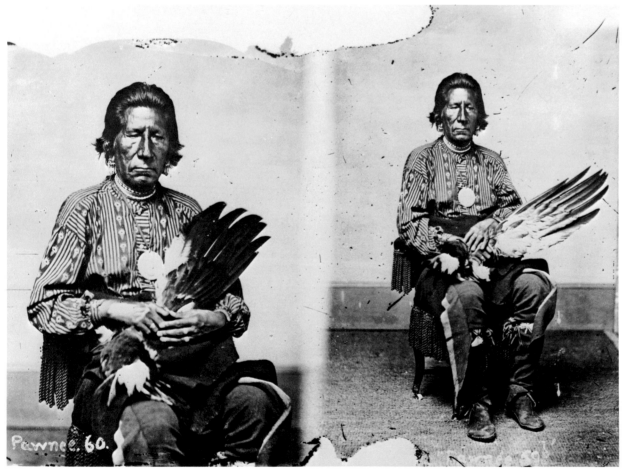

parently constituted the basis for Jackson's own move into a more ambitiously conceived landscape photography.[7]

Views, however, were not the principal stock of subjects Jackson purchased with the Hamilton and Eaton studios. Far more important were the tremendous number of Indian studies, in both carte de visite and stereograph form. Acquiring, altering, and marketing these portraits under his name, Jackson set a pattern that would continue for the rest of his career as a photographer. But Jackson's reauthorship of these views was, for his time, a common and natural part of the photographer's multiple roles as provider of visual images to a large, and growing, information-hungry culture. And in a larger sense, the Indian views provided one portion of a larger vision of the West that began, hesitantly at first, to form in the files of Jackson Brothers—a Western photography that not only reflected the prevailing norms of the Eastern audience to which it was primarily directed but also argued for a shifting notion of the West and its meaning to America.

Eaton's Indian views formed the base for this aggregate; they were doubtless the most important asset in his studio—Hamilton's two locations had already provided Jackson Brothers with sufficient equipment and materials to run the business. In part because of his Council Bluffs location, Eaton had been able to amass a large number of studio portraits of local Indians, mainly from the Pawnee, Otoe, and Omaha tribes whose reservations were nearby. These primitive portraits were, for the most part, rigidly stereotypical; the photographer seated his subject or subjects in a chair in a bare

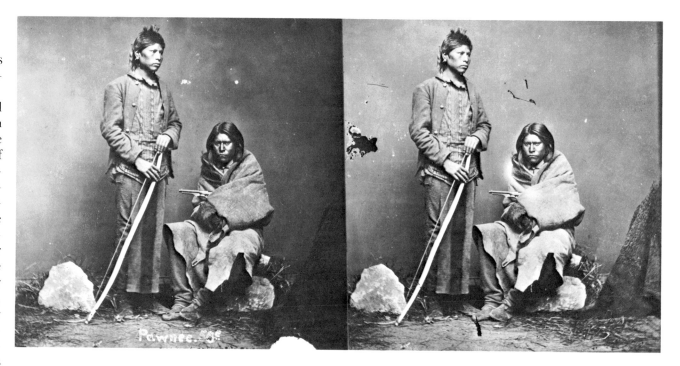

room with a jute rug on its floor and, using a dual-lens, split-back camera to divide the wet-collodion glass plate negative into two potential images, made successive views—either at different distances or with different poses (illustration 13). The result was a small, 3-by-4-inch image that could be and often was retouched, frequently in the common arched-top or oval styles. Once copied to a separate glass sheet, it could be mass-printed to provide small mementos of the ornate, even decorative savagery of the wild residents of the West.[8]

When the Jackson brothers took over these studios, they continued to produce their selection of the negatives on their own cardboard mounts. In addition, they began to make their own negatives, apparently adding a number of elaborations to the rudi-

mentary techniques of their predecessors. Jackson also began to construct stage sets appropriate to the prevalent Eastern myths of the Indian that he had carried west with him. In some, addition of straw, boulders, tree branches, and eventually a painted backdrop traced the process by which Jackson steadily transformed one part of the studio into a mock natural setting (illustration 14).[9]

In all these forms, Jackson Brothers photographs entered a broad national pool of Indian imagery, competing with many types of visual images, ranging from chromolithographs to photographs and sold in outlets ranging from stereo emporia like New York's Appleton's to railroad ticket agents and conductors running brisk side businesses in Indian pictures. And Jackson Brothers stereos and cartes

14.
[Unidentified Indian pair], 1867 or 1868.
NAA

of Indians corresponded closely to those made by a healthy populace of Western photographers—itinerants and reputable, established firms alike.

By the summer of 1868, Jackson began to move his viewing farther and farther from the studio in order to add outdoor scenes of Indians in their habitats. He had a wagon converted into a traveling darkroom and studio; in this way he was able to carry all the chemicals and equipment necessary for photography out into the Pawnee and Omaha Indian reservations, where he spent part of the summer making studies of Indian life.[10]

Jackson's decision to venture out onto these new "concentrated" reservations may be seen as evidence of his ambitions to garner a national reputation. In 1868, two aspects of the region dominated Eastern interest. One was the rapid progress of the Union Pacific Railroad—a subject Jackson would tackle successfully the following year. The other, closely related, was the transformation in Indian relations that was occurring all along the horizontal frontier line comprising the older wagon trails and the new railroad line. In the areas where the Union Pacific was laying track—west of Omaha and east of Salt Lake City—the nomadic tribes of Sioux and Crow families saw the railroad as an inevitable exterminator of Indian life. By splitting the buffalo herds, slaughtering millions of buffalo for food and entertainment, blocking access between hunting and wintering grounds for the tribes, and declaring in waybills and placards the imminent coming of a new, grid-planned, agricultural, fenced West, the Union Pacific threatened all aspects of nomadic Indian culture. Indian guerrilla wars, begun in 1866 to counter the government's construction of a fortified supply line (named the "Powder River Road"), now transferred to the railroad. The effect was to greatly increase military presence in that region of the West, while in the East a new outcry for Indian extermination arose.[11]

By 1868, however, a new policy was in place. The April 1868 treaty with the Sioux heralded an era in which the Indians would be neutralized, moved to distant reservations, and isolated from white settlement areas. The April treaty reassured Easterners that the Indian would no longer be a threat. Interest in the now-benign native once again swelled.[12]

Jackson's decision to photograph the Omaha, Pawnee, and other tribes in their actual locales was thus good business. In addition, it was made possible by the fact that the tribes and areas he was depicting were, for the most part, peaceful—though few Easterners had the information to discriminate between "good" Omaha and "bad" Sioux. So Jackson could safely work in these areas while still capitalizing on his viewers' undiscriminating enthusiasm for information about those natives of the Grest West. Properly photographed and distributed to the East, these older preserves could serve as visual indicators of the new Indian civilizations that would, supposedly, replace older states of so-called savagery. With all these advantages at hand, Jackson began the process of building a major archive of Indian images.

Photographing outdoors in 1868 was a complicated project requiring painstaking work. Jackson was using the then-universal wet-collodion process that required the photographer, working in complete darkness, to transform a sheet of glass and a collection of bottled chemicals into a light-sensitized plate. Once prepared, the plate had to be exposed to light while still tacky, or the light-sensitivity was eradicated. On humid days, one might have twenty minutes or more; on Nebraska summer days, the plates could dry in less than ten minutes, including the exposure, which routinely ran between one-half second and twenty minutes depending on amount of light and choice of lens opening. Once the exposure was made, almost always with the lens cap used as shutter, the plate had to be immediately developed, or the latent image would disappear as the collodion surface hardened. Plates were developed, fixed, washed, dried over an alcohol lamp, and then varnished to protect the image—all within minutes of the exposure.[13]

Choice of camera was also important; enlargements were rare, difficult, and expensive, so the size of the final print was dictated by the size of the negative, and thus of the camera. In addition, there was the question of stereographs. By the mid-sixties, the viewing of double-image photocards using a binocular magnifying viewer (a stereoscope) was a hugely popular American parlor pleasure. These cards provided the ultimate in nineteenth-century illusionism and verisimilitude; properly made, they could provide a seamless sense of three-dimensionality, and because the viewer used magnifying lenses, the small cards gave the illusion of a full-scale confrontation with the subject of the image. Desiring to produce both stereographs and effective full-size prints, Jackson experimented with a number of cameras that summer of 1868, including always a stereo-convertible camera,

which could make 3½-by-4-inch pairs as well as a 4-by-7-inch single image, but trying out 5-by-8 and 6½-by-8½-inch-negative cameras as well.[14]

Given Jackson's relative inexperience with the process—he had been working with it for only a few months—his forays out into the Indian reservations were adventurous from a technical standpoint; moreover, they included destinations as distant as 100 miles from Omaha (by rail on the Union Pacific). But Jackson's difficulties were more directly a matter of his chosen subject. Once on an Indian site, Jackson had to con-

tend with the natives' understandable reluctance to become objects of interest for white tourists. Photographers were considered "bad medicine" (in Jackson's parlance) by the Indians, and their intuitions were in some ways correct—the photographer was front man for a larger invasion that would, in a certain sense, steal the spirit of the Indian nations and their lands. Overcoming the Indian hostility to photography required bribes of more than photographs: clothes, knives, tobacco, and money were the usual media of exchange.

Jackson's photographs of that season fall

rather clearly into broad categories. The most rudimentary were stereographs of locations and Indians, usually with the two elements roughly conjoined. To some extent these caricatured his more sophisticated pictures, which presented a strict, uninflected description of the scenery itself. Jackson's view of a set of Pawnee earthen lodges (illustration 15) revealed the topography of the country and the arrangement of the lodges in relation to each other and to the site, even including a small portion of what appears to be Jackson's photographic wagon in the middle ground.[15]

15.
[Pawnee Earthen Lodges], 1868. NAA

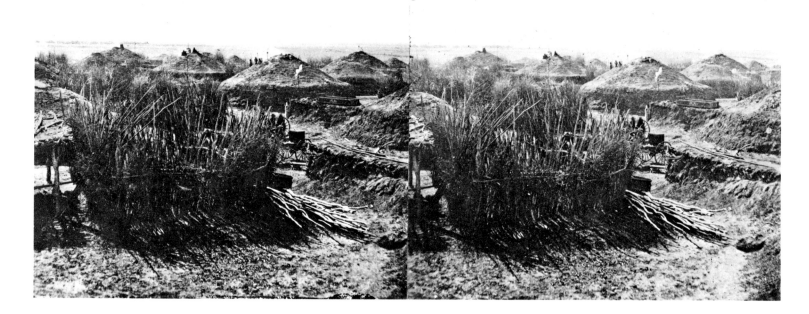

16.

"The [Omaha Indian] Village. Near View, Showing Lodges," 1868.

NAA

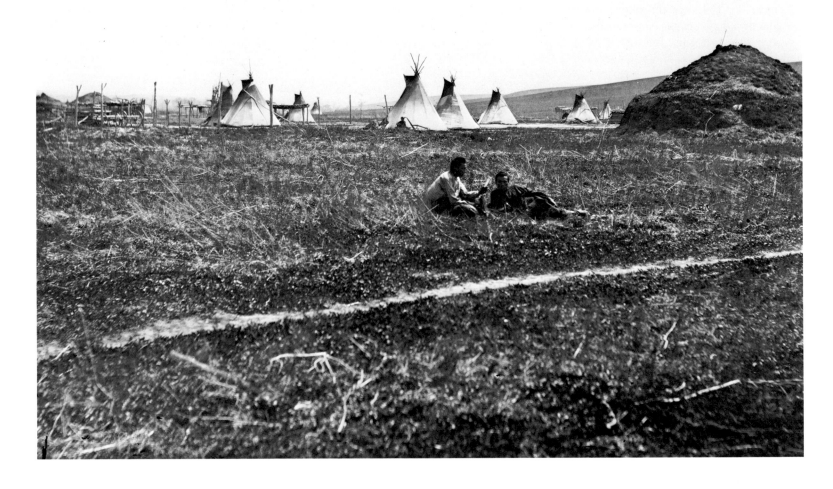

But even as early as the summer of 1868, Jackson was doing more than providing descriptive material; he was, it seems, reflecting back the preconceptions, myths, and desires of the Eastern audience that projected, onto the vast *tabula rasa* of the West, a set of completed landscapes—populated or awaiting population, ordered or awaiting order. In this context, Jackson's photographic wagon might not be seen as coincidentally located in the midst of the primitive earth dwellings of the Pawnees. Nor were the two figures in front of "The [Omaha Indian] Village" (illustration 16) accidentally assuming the poses of the middle-class witnesses of landscape so prevalent in the paintings of the era and found in Jackson's own Vermont sketches of five to ten years before. Rather, these touches served to modify the West by imposing on it the conventions of an Eastern vision—that of Jackson and his audience.[16]

Jackson's distillation of attitudes toward the Indian was largely hidden in these understated, topographic views. But most of his work, even this early, took more overt measure of the popular myth of the Indian. His view of "Gi-He-Ga's Lodge [Omaha Tribe]" (illustration 17), with its inclusion of an Indian squaw in the center and a teepee frame in the background, presented the Omaha as noble wanderers of the earth. Other views featured tomahawks, Indian blankets, papooses, and other accoutrements of the proper Indian.[17]

But the most direct adaptation of Eastern attitudes came in his portraits of individuals and pairs (illustrations 18, 19, 20). Here Jackson's distance from the stiffly unsuggestive poses of the studio portraits by Eaton and others is evident. In making these, Jack-

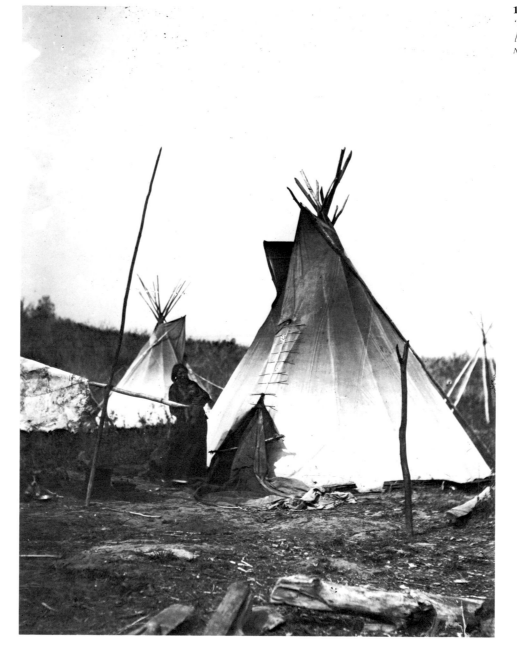

17.
"Gi-He-Ga's Lodge [Omaha Tribe]," 1868.
NAA

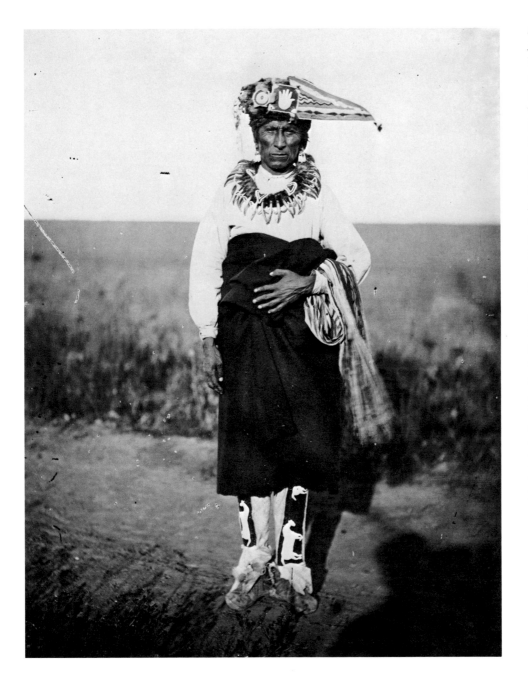

son had the counsel of the Omaha Indian Agency director Dr. Edward Painter, agent of President Grant's new "Quaker policy" in Indian affairs and a dedicated believer in Indian uplift and moral training. Painter lived with his family on the Reservation, where he served not only as doctor and administrator but also as teacher and mentor, mediating in disputes between tribal factions, and directing the tribe toward scientific farming techniques that would make them proper American yeomen. Though he had arrived only months before Jackson came to photograph, he had already begun dividing the reservation into homesteads and training his charges in the dual tenets of the Quaker plan: civilization and Christianization.[18]

Jackson's study of Omaha tribesmen appears on the surface to be strictly documentary in nature—that is, direct, uninflected, and descriptive. Yet the images, while perhaps successful *because* of their transparency, seem loaded with details that carried the popular attitudes of the East. The three we have seen all presented their subjects in poses that were atypical for tribal life on an everyday basis but popular with white Americans—the Omaha Chief Gi-He-Ga wore ceremonial garb, "Betsy" was presented on a horse with rifle, and "Standing Hawk and Squaw" were depicted gazing soulfully off to the future while their pony stands patiently. This last photograph seems, to twentieth-century eyes, too much, too extreme a caricature of the white man's Indian—the addition of tomahawk, ceremonial rattle, and other props exaggerates the already powerful set of sentimental cues.

In these and other picturesque portraits of Indian men and women from this pe-

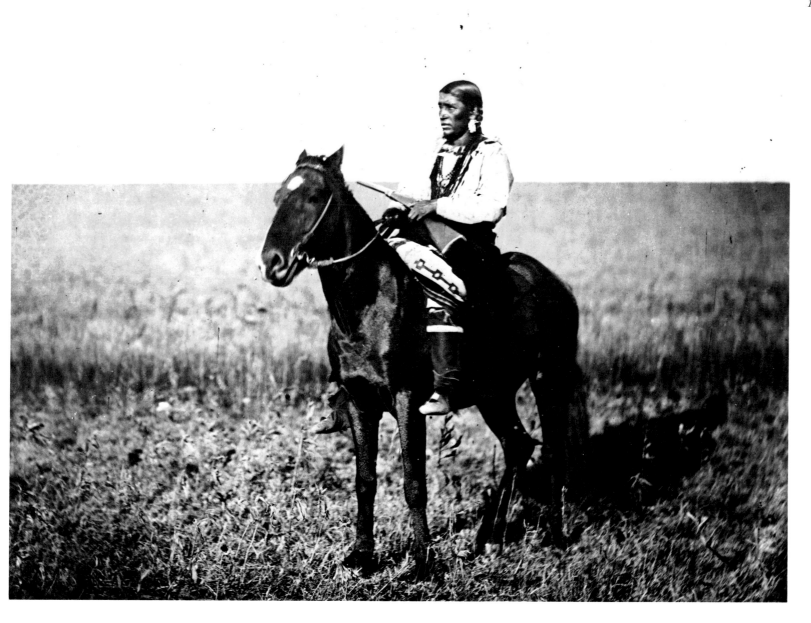

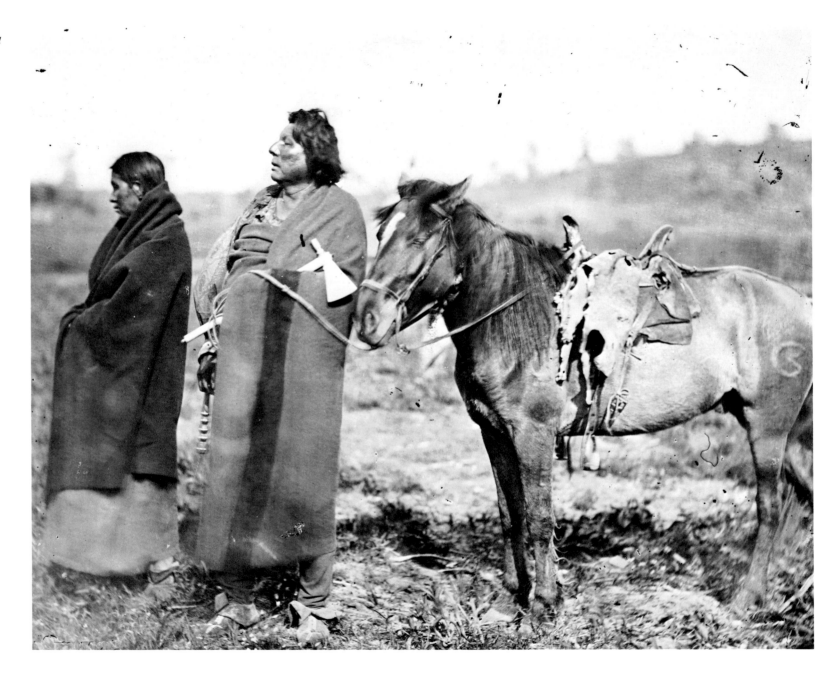

riod, Jackson did more than simply reproduce popular visual images of the Indian, drawn from chromolithographs, magazine illustrations, and other sources. He also applied peculiarly photographic techniques to emphasize and underscore the central message. In these views, we have a detailed condensation of the Indian as seen by whites. The figures are stopped, fixed—even paralyzed at the moment of photographing. All action is leached out of these people; even though in two of these three some activity seems to be suggested, the poses themselves leave the figures frozen like statues. Jackson has framed each figure so that the Indians are converted to specimens by their centrality in the frame and by the photograph's severely limited plane of focus, which strips the space behind them of particularity and leaves the figures plastered against the background like butterflies pinned into a specimen box. And the raking, contrasty light of all three serves to accentuate the sculptural quality of the figures, particularly the planes of their faces.

Although all of these characteristics might be explained away as artifacts of the cumbersome process of photography in 1868— insensitive plates, rudimentary lenses, an inexperienced photographer—in fact none of the effects need to have occurred. Instead, the group of photographs from the Omaha Reservation, taken together, reveals the wide range of alternatives Jackson applied, including direction of light, angle of camera, distance from subject, and depth of field. Not necessarily conscious of his ends, nonetheless Jackson was purposeful in his use of the medium to present these effects. And the influence on Jackson of a powerful, intelligent, experienced, and ideologically rehearsed individual like Dr. Painter cannot be discounted; from the photographs still extant, it seems that Painter guided Jackson around from subject to subject and must have acted as translator in the negotiations necessary to gain certain pictures.[19]

The result of Jackson's photographic techniques is to reveal the Indians as if they are presenting themselves, posing rather than being posed. They appear to have willingly cooperated with the photographer in their own remaking from actuality to impotent, nostalgic myth. Nowhere is this more evident than in the portrait of Gi-He-Ga, in which Jackson actually aimed the camera downward to place the chief in the exact center of the frame, thereby choosing to include his own shadow along the ground. The effect of this is to shrink the chief and set the viewer in a visually superior position. The Omaha chief seems to direct his weathered hand to the viewer as a specimen. The relentless line of the horizon behind him crucifies him; he is bestowed upon the viewer, to be examined, commented upon, *appreciated*.

It is impossible to document the extent to which these Indians willingly acceded to the poses in which they are shown, but that is unimportant here. What is crucial is the result, for it was the photograph that viewers saw, not the photography. And in this and other images of the Omaha from 1868, the final photograph eradicates the suggestion of external circumstances—ranging from bribes, to the threats or requests of a powerful administrator like Dr. Painter, to the simple process of exhaustion over years of conflict between Indian and photographer over the rights of the individual to be photographed or to refuse. The framing edge simply excises these tentacles of connection between the moment and the scene on the one hand and the vast world of historical actuality on the other. Inevitably, inherently an instrument of mythmaking, the camera under these conditions gave all power to the maker and none to the subject.

These photographs thus did more than simply reflect popular attitudes toward the Indian. In addition they displayed the Indians not as individuals but as types, types of a past civilization rather than a present one. As do all photographs, but in a more potent way, these present their subjects as history rather than presence. All three images, but that of "Betsy" especially, suggest a visual nostalgia for the Indian that is only possible after that civilization had lost its power to endanger or oppose—a nostalgia for the Indian that would reach its extreme in the photographs of Edward Curtis. Allegedly describing the actual condition, the reality, of the Indian, Jackson's photographs urged upon their viewers a myth of Indian picturesqueness, wisdom, spirituality, naturalness—all subsumed into the greater reality of the Indian's extinction as anything but parlor object for white, Eastern civilization.

Jackson's Pawnee and Omaha trips presented in hesitant first form an ideology of the American Indian that he would hone and develop over the next decade, presenting it in its most persuasive and ultimately influential form in the government-funded *Descriptive Catalogue of Photographs of American Indians by W. H. Jackson, Photographer of the Survey* of 1877. As he was to argue in the written introduction to and the selec-

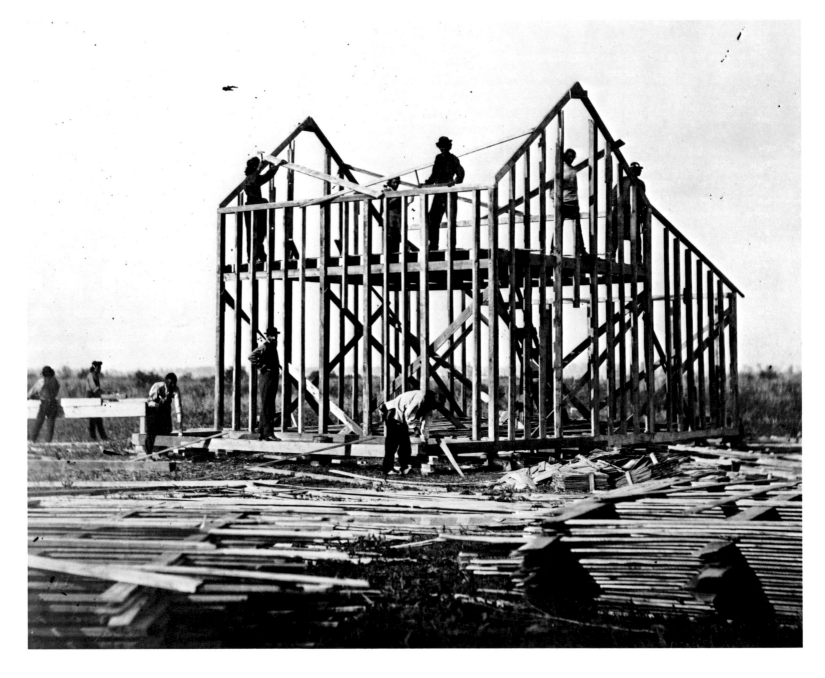

tion of photographs for the *Catalogue,* and as he was already suggesting in 1868, the Indian could be best comprehended by placing the individual, the tribe, the entire race in a moral hierarchy whose most important criterion concerned adjustment to white concepts of proper or civilized behavior. In 1868, Jackson had just begun to suggest this hierarchy by photographing the "good" Indians in their two guises: as nostalgic remnants of a now-lost natural civilization, and as industrious, willing adapters to their new role as yeoman–farmers tilling the soil in tightly demarcated homesteads, learning white values by experience—with private property, with work, with cooperation, with family and religion. This constellation of themes is evident in a view of "Indian Carpenters Building Houses for the Tribe" (illustration 21) that Jackson made during his trip to the Omaha Reservation. Here the central ideology of "enlightened" American Indian policy during the era appears in compacted visual form. Under the watchful eye of Dr. Painter, the Indians are learning a white man's craft; at the same time, they are being steeped in so much more—cooperation, the importance of work, the possibilities of another life-style. And they are constructing a literal alternative to the temporary teepee or the primitive earthen hut: the American farm. As the caption suggests, this is but one moment in a process by which the Omaha tribe is settled on a reservation, the land is parceled into separate lots for individual families, and these familes are then converted to individual yeomanry.[20]

Jackson's Indian studies of 1868 thus contained, in early form, central tenets of the nineteenth-century white mythology about the American Indian. In particular, they focused on two types of "good" Indian: the noble natural man, now rendered impotent and relegated to the world of nostalgia and yearning, and the pragmatic assimilator of white values, eager to learn the ways of the white man and apply them to the taming and civilizing of the American West. In addition, Jackson presented a picture of white–Indian relations that countered the prevalent mythology of the Indian as hostile ambusher of wagon trains with one better suited to the boosting of the West. In this scenario, enlightened white men—Quaker administrators under President Grant's new Indian policy, like Dr. Painter, his family and colleagues, and in another way Jackson himself—presided over a process of benign assimilation by which the Indian accepted, celebrated, and aided in the conquering of the West and its conversion from wilderness to pastoral Eden. All these themes were given greater power by their presentation in photographs, for in this medium the viewer controlled the process of interaction with the subject, holding all power to see, understand, and benefit from the relationship. After all, even the stereo, taken from the magnifier, was only a small piece of cardboard and sensitized paper. The viewer, aided by the sympathetic photographer, retained all rights in the intersection of Indian life and white curiousity. Jackson's pictures thus not only reflected prevalent attitudes; they amplified and modified them, particularly in their adherence to the growing position of Indian assimilationism and "civilization." Jackson's photographs were destined for success: as ingenious propaganda for an evolving Indian policy and, more important,

as part of a larger vision of the American West that could not sustain or include the actuality of Indian life.

Five elements composed the Western landscape of Eastern myth: space, land, nature, man, and civilization. In this order, each overlaid the last: space was infinitude, blankness, the source of the sublime; land was entrance, division of space, a plane of potential occupation; nature occupied land with the potential materials for human entrance; man entered as primitive (in which case he was, perhaps, more appropriately part of nature), as observer, as explorer, as aesthete, as transformer, orderer, tamer, gardener; civilization, the product of his intervention, was his empire, wherein all the previous elements were reorganized into their divinely ordained positions as his servants, he (perhaps) servant to divine order.[21]

These elements had constituted the mythic West at least since Thomas Jefferson wrote his celebrated letter of instructions to the Lewis and Clark Expedition of 1804. Repeated in a tremendous variety of cultural artifacts, these terms, and the equation that linked them, had developed a power that overcame the changes in meaning and relationship that occurred during the years before the end of the Civil War. From Jefferson through William Gilpin, the notion of an American continent defined by space, land, and nature and awaiting the transforming hand of man remained central to the mythology of the West and to its presentation in politics, literature, painting, and photography.[22]

In 1869 this nineteenth-century mythology of the American Western landscape lay

at a critical juncture—geographical, temporal, and cultural. In May of that year, the transcontinental railroad was completed. The implications were myriad. The railroad, representative of civilization, bisected Western space, beginning the process of gridding, demarcating, in a way no trail had previously succeeded in doing. The construction of this transcontinental link truly reordered the West, but the implications of this new organization had yet to be fully explored, presented in imaginative form, or widely disseminated.

In 1868, Jackson had begun his own examination of the interaction among the elements constituting the mythic West. But without a larger structure to order and make sense of them, his views of Omaha and of the Indians of Nebraska remained merely isolated pictures, souvenirs. The addition of the railway, however, introduced an entirely new subject, a West that might now be understood as a fruit split down the center, ripe and awaiting consumption. The transformation of the Western landscape required a redefinition of the terms of Western myth. Though he did not understand it in these terms, this was to become Jackson's vocation.[23]

Jackson had made some views of the railroad in a haphazard fashion in 1868. These excursions introduced the photographer to influential people on the railroad itself, particularly the engineers and heads of construction crews, men who would make possible the expedition of 1869. And the trips also provided transportation to Indian lands far to the west of Omaha, where Jackson could make his views. But no successful railroad pictures resulted from these early trips.[24]

The tour of 1869 served as Jackson's apprenticeship in landscape photography and marked him as a mature photographer and a force in the making and marketing of the American West. This enlargement from local to national arena and from reflector to transformer of national values, begun in the summer of 1868, was the result of important changes in Jackson's own life as well. The Jackson Brothers studio was now firmly established in Omaha, giving him far greater freedom to move about and providing an outlet for views that might result from his expeditions. And the spring of 1869 also marked the beginning of Jackson's first marriage, to Mollie Greer, whom he had met when she was visiting relatives in Omaha a few months earlier. His courtship of Mollie reflected another change in Jackson, from the sentimental Eastern lover to the businesslike Western contractor of partnership. Just how far this shift reached can be seen in his behavior with his new bride; after a six-day honeymoon trip to St. Louis by steamboat, Jackson promptly packed his new wife off to Ohio to live with her parents while he returned to Omaha to prepare for his trip.[25]

A major influence on his plans to travel was the presence of a new photographic assistant. About the first of the year, Jackson Brothers hired Arundel C. Hull, a St. Paul, Minnesota–born photographer who had spent the years from 1866 to 1868 photographing the territories of Colorado, Wyoming, and Utah, alternating with portrait work in Fremont, Nebraska, and in Omaha. Hull's arrival was a piece of luck; Edward Jackson was a bookkeeper who had great difficulty with the portrait work, and Ed's friend Ira Johnson was equally inept. Hull's experiences photographing throughout the West, and his knowledge of the techniques of the photographic "drummer" in getting local business, were to prove invaluable, both in the planning and the execution of the trip.[26]

This expedition was far grander in scope than any of Jackson's previous photographic endeavors. From his experiences of the previous summer, he worked up a new and far more extensive list of equipment and material. In addition, he determined to take Hull along as assistant. Together the two devised a new traveling outfit that would be both complete and portable. Jackson reported the process of outfitting in an essay published in 1875, conveniently omitting any mention of Hull's presence—an excision typical of photographers working with assistants during the era:

Made calculations for three months' work, and to make 10 × 8 and stereos, putting in about two hundred plates of the latter size and one hundred of the former, with all the accompaniments of the usual wet-plate process, taking along besides the paper, cards, etc, necessary to finishing up work in the field. In the light of my later experience, that outfit was a very unwieldy, bungling affair. One large stout chest was prepared, into which was stored all reserve stock, glass, cards, chemicals and everything necessary, and when filled it weighed a ton, more or less; making it an object of much vindictive profanity on the part of baggage-men and porters. . . . My dark-tent was an original contrivance, consisting of a box about

12 × 24 inches square and fifteen deep; the lid when opened out formed a shallow sink, with a hose to carry away the waste water.[27]

Aware from previous experience of the rich potential for customers in the railway crews themselves, Jackson and Hull planned to get on-the-spot commissions for portraits and studies of track crews at work, which they could sell in multiple prints to the workers themselves and thereby gain both money and the support of the train crews. This was particularly important because the photographers needed to be able to cadge rides on the track-laying engines, the handcars, and the through trains in order to move from one viewing area to another; tickets for such trips would have been prohibitively expensive. Their plan guaranteed transportation and short-term cash to support the production of stereos and whole-plate (8-by-10) pictures that might sell back East and to the tourists that were already flocking out along the railroad. Local views would thus subsidize national views.[28]

The trip began on June 22, with Hull, Jackson, and their boxes on the train to Cheyenne, Wyoming. Wary of running out of materials, Jackson and Hull had painstakingly packed every imaginable need. The list, written on the inside back cover of Jackson's diary, graphically points up the complexities of wet-plate work:

2 pr. stereo lenses
8 × 10 camera and plateholders, with stops and
 diaphragms
stereoscopic [camera and materials]
Dry plate box . . .
tripods

8 × 10, & 2-4 × 8 [for stereos] plateboxes
scales and weights [for measuring chemicals]
hydrometer—diamond
litmus paper—varnish
nitric acid [for making light-sensitive silver bath]
acetic acid [for stop bath]
pyro.[gallic] acid [for developer]
carb.[olic] soda
chloride [of] gold [for toning and preserving
 prints]
silver nit.[rate] [for silver bath]
ink and brushes [for retouching, titling, etc.]
paste brush and cup starch [for mounting prints]
printing frames and clips [for contact printing]
filtering paper [to filter precipitates from baths]
graduate and funnels
card stock and paper [for mounting]
evaporating dish [for mixing chemicals]
toning, silvering, and washing trays
tack hammer and tacks [for all emergencies]
iron [?] hypo, alcohol, ether [for collodion bath]
alcohol lamp [for drying negatives]
wax
shears, pins
ammonia
sulphur——[?], cyanide pot[assium, for toning]
collodion, chemicals
ferroplates, envelopes, & mattes
rotten stone, ——[?] [for polishing glass plates]
business cards
field glasses [for searching out vantage points]
pyro. & acetic acid
dusting brush
cotton flannel
shellac, iodine
towels, yellow calico
symph [?]
rubber blankets—focusing cloth[29]

The list seems endless—indeed, Jackson and Hull cursed their thoroughness every time they had to move their boxes by hand, which occurred far more often than they had calculated—but the cache was insufficient. Twice Jackson had to order materials from the nearest town and wait for them to come in. And the list differed very little from that required by virtually all landscape photographers working in wet-collodion. Where Jackson and Hull diverged was in their decision to carry not only the equipment for making negatives, but all the added requirements for printing—a necessity in order for them to finance the trip as they planned.

Arriving in Cheyenne the morning of June 23, Jackson and Hull had their first stroke of luck; they met up with an acquaintance of Jackson's, John Sumner, who had settled in Cheyenne and opened up a store. The upper floor of his building was empty, available for the photographers to take over. By that afternoon, they were making "exposures about town, taking Sumner's house with himself and wife in buggy, his store, &c." After supper, Jackson and Hull "went down town and visited one or two of the gambling rooms, and watched a game of faro awhile."[30]

Cheyenne in 1869 was one of the surviving "hells on wheels"—traveling towns that had followed the railroad construction, living off its money. Now, although the railroad was technically completed, vast stretches of road had to be regraded, track relaid, and temporary bridges replaced by permanent ones, or the government subsidies to the railroad would be lost. As a result, life in Cheyenne was nearly as busy as it had been the previous year, and the tenor of the town had changed little—it was still composed primarily of saloons, gambling halls, and houses of prostitution. The sec-

ond day there, Jackson "heard that some of the demi-monde [at Madame Cleveland's establishment] wanted some large pictures of their homes":

Hull and I thought we would go around to see if we couldn't get a job out of them. Talked it up awhile but they seemed indifferent. I called for a bottle of wine and soon after they began to take considerable interest in having a picture taken. Had another bottle and then they were hot and heavy for some large pictures to frame and began to count up how many they should want.

Returning from Madame Cleveland's, an unseasonal rain ended, and the two men "got out the box and made 3 or 4 negatives to show the inundation, getting some very good effects." Hull and Jackson were hard at work.[31]

Their short stay in Cheyenne netted them quite a bit of money—they took in sixty dollars in the first three days. And it was there that Jackson encountered Survey head Ferdinand Vandeveer Hayden, in a bizarre coincidence. Delivering the finished prints to Madame Cleveland's, the photographer "was much surprised to see Dr. Hayden come in with some military friends. He acted like a cat in a strange garret." Jackson's surprise was natural. He had met the eminent American geologist, scientist, and booster of the West sometime earlier that year in Omaha—Hayden had been there for his Nebraska Survey. Even a casual acquaintanceship with the high-strung, imperious, and rigidly correct Hayden would have dispelled any expectation to see him frequenting a brothel in a railroad hell (although his death of complications from syphilis many years later suggests another side to the doctor). At any rate, Jackson reported no conversation with Hayden, then or in the few days before the two photographers left for points West.[32]

The sojourn in Cheyenne set the tone for the rest of the season. Leaving there, the two photographers traveled to Wasatch, Utah, then took a train through Echo and Weber canyons, past Deseret and Corinne to Promontory Point, where they made the obligatory photographs of the joining of the Union and Central Pacific Railroads. Then began the slow trek back along the line to make their views—first to Corinne, then Uinta, both small towns Jackson remembered from his bullwhacking days, transformed by the railroad construction into tent cities. Uinta served as the base for trips to the famous scenic regions of Weber and Echo canyons and Devil's Gate. Weeks spent moving as little as a few hundred feet a day netted them hundreds of stereographic and whole-plate negatives.[33]

By the end of August, the two men were exhausted. They had photographed all the relevant scenery, and Jackson was growing increasingly worried about the state of the business back in Omaha. Waiting for news from Omaha, Jackson decided to return to Wasatch, then was persuaded by friends to make a fishing expedition up the Bear River. Late in September he abandoned the trip and returned, perhaps without Hull, to Omaha. The first season had ended.[34]

As an economic venture, the 1869 trip was mixed. No records exist suggesting how much money Jackson sent to Omaha; certainly Ed's handling of the studio in his brother's absence was disastrous; Jackson reported it in his diaries and his later autobiographies. Still, the summer was a success.

From the standpoint of a young capitalist, Jackson left for Cheyenne with a pragmatic program in mind: to earn short-term income creating memorabilia for residents of the region and workers on the railroad and to produce at the same time a catalogue of stereographic and whole-plate views of the route that would pay dividends over a longer term through sales to tourists along the railway. In both areas, he learned a great deal.

In short-term sales, Jackson had a gifted teacher in his assistant, Arundel C. Hull, who had traveled the West for years earning his living in this way. Jackson commented admiringly on Hull's talent for befriending other photographers, for rustling up supplies and lodging, and for finding, generating, and following up on potential customers. Even as early as Cheyenne, Jackson reported that he left the canvassing and delivery to Hull, while he did the darkroom work and made all but a very few of the negatives.[35]

By no means were all of these views made one per customer. Sometimes, as in the case of the studies of track crews, one picture might sell over a hundred copies. In other cases, one customer might order a number of different negatives made. This was the case with a man named McLelland of Cheyenne, to whom the team sold six dozen views, and another named John M. Laughlin, who apparently ordered a large number of prints to be sent out from Omaha. In addition, Jackson managed to sell a second set of negatives of the scenery in Echo and Weber canyons to a photographer named Ross.[36]

Nearly all of the negatives made on commission were created, printed from, and then destroyed. On July 9, Jackson wrote that he'd spent the day "cleaning plates, fixing up

chemicals and a general arranging," and later in the season, he reported "cleaning plates right along"; this process of housekeeping allowed the photographers to carry a minimum of glass, by allocating a limited number of plates to commissioned views, which could then be regularly stripped of their emulsion, polished, and then reused. A few, however, survived because they were marketable as souvenirs of the railroad building. Two of these photographs give some idea of the work that resulted from the process of making views to a client's specification. Jackson's view of "West Bank of Green River" (illustration 22) shows a road crew at work reducing a slope to prevent later rockslides; sixteen workers, including the boss, are visible, and Jackson reported that most of them bought pictures—so many, in fact, that the two photographers were forced to go back and reprint to satisfy the demand.[37]

This view described the work being done; "38. Devil's Gate Bridge [August 12, 1869]" (illustration 23) catered more directly to the pride of the workers. Here a work train has been stopped and the bridge builders have arranged themselves along its length in a variety of poses ranging from stiff frontality to the sort of relaxed, lounging postures common in contemporary cartes de visite. Jackson complained in his diary that "the bridge looked well but there was still a good deal of the old temporary bridge left that spoiled the effect"; he had been forced to choose between excluding the river (thus dwarfing the achievement of the builders by vastly increasing the amount of canyon wall that loomed above the bridge) and leaving the wreckage in, which diminished the sense of a clean intersection between nature, man, and technology. As an immediate money-maker, however, the photograph was a great success: Jackson and Hull sold somewhere between 120 and 150 prints to the bridge builders from the negatives made during their two-day stint.[38]

These pictures satisfied the desires of their purchasers, but they also resonated with larger meanings. Most noticeably, the people in these views are typically dwarfed by the terrain. They have become indicators of the vast scale of the Western sublime, but it is more than that. The enthusiasm with which the roadworkers greeted these views suggests that they satisfied a general taste, a desire to see the relationship between man, railroad, and natural environment portrayed in a certain way. In this case, what we see is a vast, ancient, hostile region surmounted, reordered by man, yet not diminished by the process. Jackson went to a good deal of effort to emphasize not simply the harshness, the inhospitability of this land, but also its significance as a repository of age, power, meaning. Again and again in 1869 we can see him including the geological stratifications exposed by the railroad's blasting; thus we see the land as a region of titled planes, arrested upthrusts, imminent rockslides. In addition, Jackson quickly developed the visual habit of directing his camera along the diagonal of the roadway. This resulted in a number of important visual effects. First, it enabled the viewer to trace the railroad's passage onward, often seemingly to infinity. In addition, the camera angle resulted in an asymmetrical composition whereby, in the canyons, a looming rock face dominated one side of the picture, hovering above the railroad tracks below. Finally, the diagonal view included a stretch of sky, which in Jackson's case meant a blank white force graphically emphasized by the subsequent opaquing out of any flaws in that area of the negative. The end product was a powerful symbol of infinite Western space, set off diagonally against the dark rock face of the canyon, with the railroad in between.[39]

These and nearly all the rest of Jackson's pictures during this exploratory stage of his career, before the settled years as a propagandist for the U.S. Geological Survey began in the mid-seventies, represent explorations of and variations on an accepted body of ideology about the West, and the place of landscape within it, that Jackson shared with a number of other Western photographers and artists and with the great majority of his viewers. Hence Jackson's photographs may be seen as parts of a complex, intense, vocal, and deeply important debate about the meaning and future of the American West.

Until the end of the Civil War, two sets of ideas existed in America concerning nature in general and the West in particular—ideas concretized in literature, popular journalism, landscape painting, and popular illustration. But these two mind sets shared a single assumption: that the natural riches of America themselves represented the blessing of a divine Providence on the national experiment, from colonization to the current moment. The conflict lay in what lessons were there for man to learn, what destiny was to be transacted—for virtually all Americans who addressed themselves to the issue, even half-consciously, agreed that nature was full of lessons for the American experiment, and

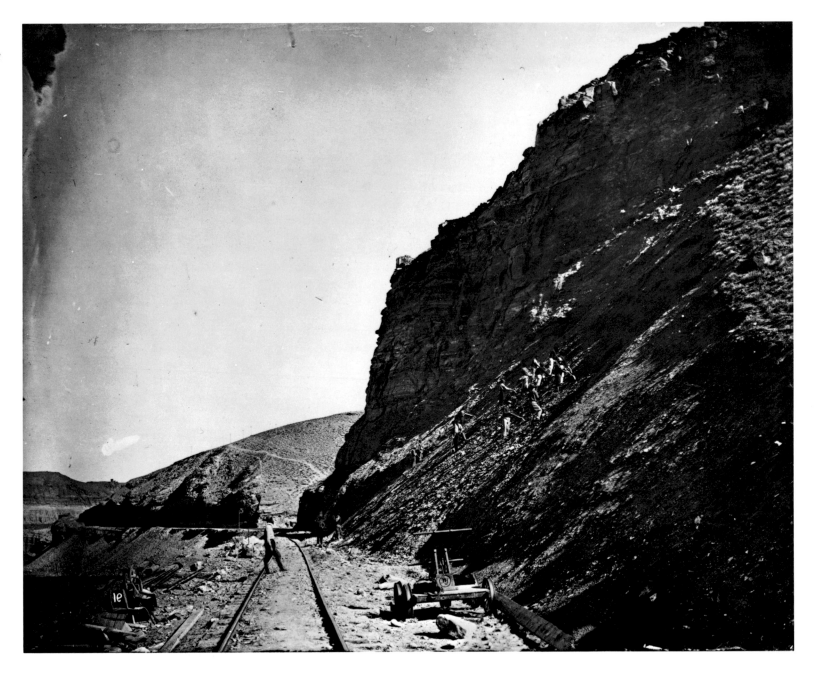

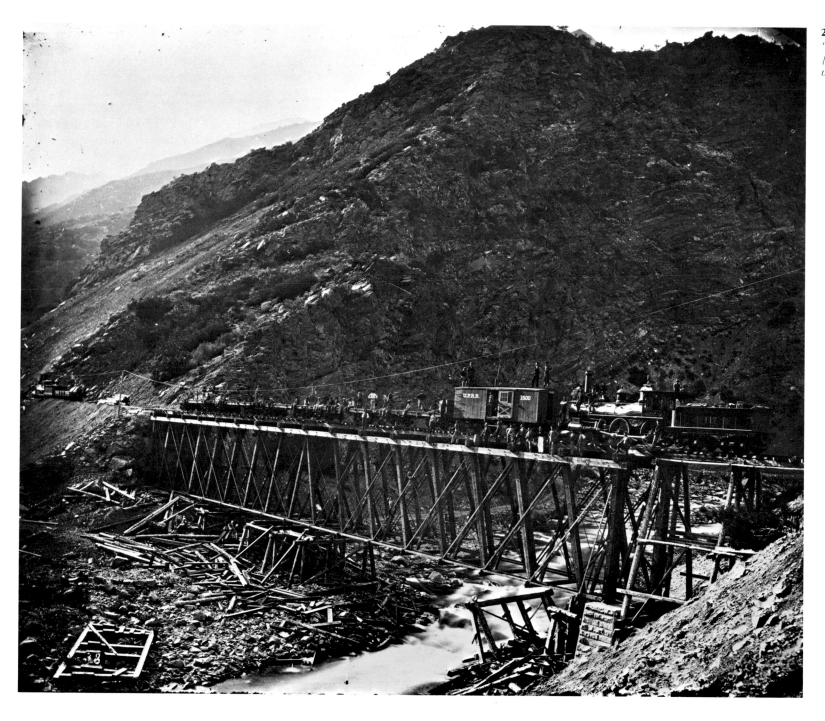

that a Providential destiny awaited transaction.

Within this unanimity lay an uneasy coexistence of conflicting attitudes. One, a variation on the aesthetic category known as "the Sublime," presented nature as omnipotent perfection, a sign of God's presence in the world. To order, alter, "tame," or exploit nature was to violate that Presence, and to guarantee its disappearance. This attitude motivated the host of antiexploitation voices, particularly among the artistic and literary elite, during the first half of the nineteenth century. Ranging from jeremiads to gently voiced statements of regret at the inevitable, these calls for the preservation of wilderness conflicted strongly with a second attitude, which corresponded to the aesthetic category of the Beautiful. In this second case, nature was seen as closest to perfection when ordered and rationalized by man. Here the model of Greek pastoral poetry, mutated through the European neoclassical strain of painting and into American art, as well as a host of American bucolic epics now discredited or forgotten, presented a forceful apologia, with its images of randy, unpleasant nature shepherded, smoothed, and given grace by the patient tending hand of man. This latter myth, while it was often invoked in the name of American expansion, could and did serve to separate wanton expansionism from proper development. Between these two lay a third position, the picturesque, which called for a compromise—a nature of tended irregularity, designed primarily for aesthetic consumption. Picturesque nature was never wild or hostile, but neither was it leached of its presence, its sense of otherness.[40]

As the steam river traffic and railroads of the fifties began to alter the face of the Mississippi Valley and transform regions farther east, the myth of nature's benevolent symbiosis with human development became the dominant strain, manifested in paintings like George Inness's "Lackawanna Valley" and a wide variety of popular prints, oratorical discourses on American destiny, and the like. At the same time, the expansion of American dreams farther and farther west, and active planning for the transcontinental railroad, began to alter a second set of myths—those about the West.

Previously the region, described in reports, diaries, newspaper accounts, and travel guides as well as the more "imaginative" forms of poetry, fiction, painting, and booster propaganda, had appeared in one of two guises: as American Eden or as the Great American Desert. Both images, of course, had their history as far back as the earliest settlers' reports and before. But more substantial forms of this myth had appeared, both to describe areas of the Ohio Valley and to characterize regions along the West Coast, notably Oregon and California settlements. The discovery of Yosemite fueled the myth even more, providing a virtual objective correlative for the biblical Eden, at the end of the American continent, hidden from all but the blessed.[41]

But Yosemite lies just west of one of the most hostile and uninhabitable regions of the American continent. Traveling west, one experienced Eden only after reaffirming that other American landscape myth: that of the Great American Desert. This image, recounted endlessly in travelers' exposés, emigration guides, newspaper accounts, and popular literature and art, presented the Great Basin as a vast, uninhabitable wasteland, a divine barrier to American development. This was, in large part, a response to visual conditions, particularly the alienness of the flat, largely treeless expanses that Jackson had himself encountered and sketched during his first sojourn. Americans used to conceiving of an ideal environment of treed, hilly, brook-lined valleys surmounted by gentle mountains found it initially difficult or impossible to imagine the Great Basin's flat infinity converted to some more hospitable—that is, recognizable—form. This phenomenon coincided with the fact that most visitors were simply passing through on their way to Oregon or California; for them the region became part of a mythic landscape of pilgrimage, hegira—the stony Hell through which one passed to Salvation. If the West was to become a part of an American mythology of bounty and redemption, American conceptions of the region would have to be transformed, through a change in the categories by which the landscape was assessed and described.[42]

The image of the Great American Desert, capable though it was of portraying vast sections of the trans-Mississippi West, did not remain a dominant one after the Civil War. As early as 1866, a Currier and Ives lithograph of "The Rocky Mountains. Emigrants Crossing the Plains" by Frances Flora Palmer described the Great Basin as a purely Edenic locale. This popular print was but one of a tremendous number of visual, literary, journalistic, and political expressions of a new ideology that neutralized the hostility and alienness of the Great Basin by suggesting

the West was part of a process, an advance from savagery and desert status to Edenic civilization that would occur as Americans entered the region, settled there, exploited its natural resources, and made the West over in their desired image.[43]

This process of transformation became a central theme in the literature of the West immediately after the Civil War. In the extensive, heavily illustrated book-length representations of the region, such as Albert D. Richardson's *Beyond the Mississippi: From the Great River to the Great Ocean* of 1867, or Samuel Bowles's *Our New West: Records of Travel Between the Mississippi River and the Pacific Ocean* published in 1869, a new formulation appeared, emphasizing the power of simple American occupation of the region to transform it from desert to garden. This reached its most stridently propagandistic level in the numerous assertions that "rain followed the plow." In 1869, science backed propaganda; Ferdinand Vandeveer Hayden and his U.S. Geological and Geographical Survey published the report of agriculturalist Cyrus Thomas, who declared that "the Americans bring rain with them . . . as the population increases, the amount of moisture will increase. . . . This is the plan which nature herself has pointed out." Thomas's assertion was one of many linking the covenantal relationship between God and America to the exploitation and transformation of nature, and more specifically to the settling of the West. That Thomas's attempt to substantiate a long-standing belief was drawn in part from data, admittedly "hastily tossed together" by the real estate and town site agent of the Central Pacific Railroad, attests to the ways in which the eco-

nomic development of the West had already begun to influence, even direct, the nature of its myths.[44]

With manpower and capital freed after the war to focus on the completion of a transcontinental railroad, an entirely new sort of Western economics had, by 1869, begun to appear. The effect of new capital and labor was to transform the Western landscape from potential to product, from aesthetic category to economic region. In this respect, the West merely participated in the nationwide evolution from agrarianism to a complex economic system that included large-scale industrialization, urbanization, and the development of sophisticated transportation systems linking regions and making possible geographically distant markets for raw and finished goods. These not only required a major expansion in American culture but altered older segments as well. Thus the farming sector, at one time close to the Jeffersonian ideal of self-sufficient subsistence farming, now entered the marketplace economy as a producer of goods for sale and a consumer of goods in return.

In the trans-Mississippi West, this change rendered the region at odds with its mythology. Whereas it had historically existed as sign and as potential, now it became exploitable commodity. Rather than simply developing into a region of 160-acre homesteads, as politicians and public figures declared it should, it became as well a ground for corporate development aimed at extracting natural resources, transforming those raw goods into finished products, and transporting them from one region to another. Timber and mining, necessarily, required

large-scale, capital-intensive companies to provide efficient exploitation; even Mark Twain commented in *Roughing It* that the future of mining lay not with individual entrepreneurs but with companies that could pour the money into machines and materials for sophisticated extraction. Farming, too, took on a new, efficient, industrial aspect in the post–Civil War West, as tracts of thousands of acres were assembled, then farmed on contract or by employees of large companies, using the sophisticated techniques of dry farming or the capital-intensive forms of irrigation that characterized not only Utah (where the Mormon Church served as a massive corporation) but California and other regions as well. Transportation links within the region and between the West and the coasts drew the area into the developing chains of communication between source and consumer.[45]

In this process of transformation, the railroad was both necessity and paradigm. Without the rail links that closed up the great distances characterizing the West, provided a means of moving crops and goods between Western sources and Eastern markets, and brought back necessary products from Eastern factories, the West could not have developed with the rapidity or in the form that it did. At the same time, the railroad was itself a powerful force bringing the forces of modernization to the region. Its construction flooded the region with thousands of men, most of whom typified the new Eastern immigrant industrial worker rather than the eager yeoman of myth. And it introduced as well the sophisticated factory systems of industrialism. Omaha, once purely an agricultural center, became the locus for

warehouses, filled with the materials for roadbuilding and factories built to service or manufacture everything from locomotives to switchhouses. And the process of building resulted in the concurrent importation of Eastern industrial "sins," typified by the hells on wheels of the moving construction towns. In these, too, the concept of human life and sexuality as goods, capable of exchange, subservient to money, came to the once-privileged West.[46]

Upon completion, the railroad continued to serve as a model for the new West, even as it contributed greatly to the creation of the economic culture that made this development possible. As a result of congressional action to support construction, the Union Pacific, Central Pacific, Kansas Pacific, Chicago and Northwestern, and several other railways came to constitute the largest Western landholders outside the government. And because their lands were contiguous to the railroad and hence most convenient for the transportation of crops and goods, these were prime lands. Corporate sale of these tracts continued the concentration of lands among a few, for the costs of single plots discouraged individual homesteaders, and the lack of restriction on sales of land encouraged the purchase of large areas for efficient cash-crop farming.

The railroads contributed to the overall visual arrangement of the region in a number of ways. Of course the railroad itself served as the basis for an entire visual reorientation of the West, providing scale, defining a linear orderliness to be strived for, and breaking up the area into segments. The sale of land in rectangular plots at right angles to the tracks accelerated this effect, as did the gridlike arrangement of the planned towns and cities the railroad surveyors laid out.[47]

These towns formed another aspect of the railroad's transformation of the region. Railroad towns fell into three rough types: established towns swamped by the population and the demands of the railroad and its employees; "instant cities" and towns ranging from the hells on wheels to more sedate entities; and the planned communities that the railroad surveyed, mapped, advertised, and developed. When successful, these provided capital for the corporation and ensured the orientation of the West, in developed form, around the railroad.[48]

Once finished, the railroad continued to support and even import industrial economies in the region. From the grain elevators of farm-supply towns to the birth of factories exploiting transportation, materials, and natural resources in the region, the new West was a phenomenon far different from the myth of a vast Western potential that had held sway less than a decade before. As a part of the national economic chain, it provided raw materials for Eastern factories even as it provided consumers for the products of those factories; it was a colony of the East. At the same time, it was a complete economic region, containing most of the elements of the modern industrial–capitalist matrix and rapidly expanding its capabilities in all areas.

This metamorphosis of the West required a corresponding new, or at least modified mythology to bring the older conceptions of the region into harmony with the new economic realities that were dictating the future.

In this, photography proved the most successful medium, surpassing not only painting and popular prints but the literary media of fiction, essay, and journalism alike. The preeminence of photography resulted from a number of factors. The first was simply physical: photographs, particularly stereographs, were small, inexpensive, easily consumed objects that could exist in large numbers in any parlor—and did, in virtually all. The physical aspect of the photograph coincided with the particular appropriateness of its consumption. As stereos or as single photographs, these objects offered a controllable yet thrilling experience whereby the viewer was transported away from the increasingly dense, elaborate environment of the Victorian parlor and into the open space of the West, at the same time that the subject of the photograph was reduced, converted to commodity, and brought safely into the controllable reaches of the home.[49]

In this respect, photography exemplified the extreme of a phenomenon occurring concurrently with the incorporation of the West: the transformation of art and literature into a new state, as the possessions of buyers rather than as pure vessels of meaning. This was the Victorian conception of *information as goods*. And by 1869, the medium was well able to exploit this new marketing of visual information; the photographic publishing industry had already adapted itself to the new conditions of a modernized America.[50]

But photography was appropriate to the selling of the American West most of all because of its reputation. Unlike other arts, the photograph was believed to be the prod-

uct of direct interaction between nature and technology, without the intervening, distorting hand of the artist. Photographers were called operators; they were believed to be facilitators rather than creators of this scientific–spiritual phenomenon. Hence all but the most elaborately manipulated photographs were pressed out of the realm of art, but they gained in return a reputation for verisimilitude that more than compensated for the loss.

In fact, however, the photographer had at least as many techniques for controlling the resulting image, for *making* a picture, as did the painter of the day. Something as simple as choice of lens could make the space described by the camera seem shallow and compressed or swoopingly deep. Time of day, combined with exposure duration, could produce skies rich in cloud effects, blankly white, or so heavily solarized that the mottled grey result had to be blanked out with a retoucher's brush. Choosing to set the camera up above the scene opened it invitingly—a technique that became a trademark of Carleton E. Watkins, California's brilliant master of landscape, and a contemporary and competitor of Jackson's. Changes in the angle of light on a canyon wall could make that canyon seem shallow and blankly harsh, melodramatically deep, or nearly anything between, as government Survey photographer Timothy H. O'Sullivan demonstrated in an extraordinary series of views of the Green River, made sequentially within a period of some six or so hours. Aiming the camera up or down or tilting it side to side (as photographer Rick Dingus has demonstrated was O'Sullivan's strategy)

could give the viewer a sense of awe or of superiority or could make a rock face appear to be tearing itself out of the earth, or a formation seem about to collapse on the viewer. Matters as simple and seemingly innocent as whether to shoot straight on or along a diagonal formed the pragmatic stock-in-trade of the outdoor photographer of the post–Civil War era. With such a repertoire, the best photographers—men like Watkins, Eadweard Muybridge, and Charles Leander Weed of California, O'Sullivan, William Bell, "Jack" Hillers (and soon Jackson) of the U.S. government exploration surveys, and A. J. Russell, Charles R. Savage, and Alfred A. Hart (propagandists for the transcontinental railways)—converted a region of raw topography, hasty settlement, and ill-planned development into a theatre where American viewers East and West—and Europeans as well—witnessed evocations of the fabled, potent myths of the Romantic landscape.[51]

But the reputation of the medium for scientific accuracy (a reputation that attracted Hayden to Jackson's photographs in 1870 and that the scientist trumpeted more than once in the published Survey reports of the next decade) cloaked the fictive, dramatic power of photography in a rhetoric of truth that held sway almost universally among those same viewers. A "good" Western photographer measured his success not in terms of his ability to connect actuality to myth, but the other way around. Successful pictures affected their viewers by a dual process. On the one hand, they presented an illusion of seamless accuracy. To produce bathetic or melodramatic views (as, for example, Muybridge did of Yosemite in the

1870s) meant risking the loss of an audience's respect for the picture. But the photographer had, still, to make pictures that were *about* much more than rocks, water, trees, grass, and sky. The pictures had to contain the signifiers of the parent culture's concomitant ideas and myths. In fact, one finds in nineteenth-century American landscape photography that even those who most signally failed at this delicate job of understanding the landscape as a dramatic stage still found their pictures judged and criticized in those terms. This was the case, for example, with some of A. J. Russell's more prosaic views; made to describe specific aspects of site topography for the Union Pacific Railroad, they were chosen by U.S. Geological Survey scientist-director Ferdinand Vandeveer Hayden for his 1868 *Sun Pictures of Rocky Mountain Scenery,* and ended up carrying back to Eastern viewers the weight of Hayden's prophetic visions.[52]

Photographers like Jackson, Russell, O'Sullivan, Watkins, and the rest did not, however, conceive of their work in grandiose terms, nor did they execute it with the sort of plodding, systematic consciousness that characterized the makers of bad epic poems or novels about American destiny and the West during this period. Partly because of the technological nature of their medium, partly because of its reputation for bald, understated factuality (a reputation most of these photographers simultaneously accepted and ignored, to judge by the fragments of documentary evidence that have come down to us), partly because of the universality, depth, and "naturalness" of the myths they embedded in their work,

and partly because of the ways they learned to convert myth to visual image, men like Jackson operated at a level simultaneously unconscious and purposive. Jackson, for example, learned the process from sources as far back in his history as Chapman's *American Drawing Book;* he understood the conventions of landscape well enough by adolescence to use them competently in his sketches and drawings of his Vermont surroundings.

Without fanfare Jackson and his fellow photographers of that time and place continued the Romantic landscape tradition, carrying it into the new medium and the new region, imbuing it at the same time with the near-universal debates, images, ideas, beliefs, and desires concerning the old ideal of American land and the new locus of the West. Like his audiences Eastern, Western, and European, Jackson was learning—and relearning—landscape, even as he moved steadily toward a central role in the making and marketing of its myths.

By the middle of the 1869 trip, Jackson received dramatic evidence that he was front man for an audience hungry for satisfactory images of the West. Leaving Cheyenne on June 29, Jackson had reported that he "had a talk about pictures with the train boy. Sold him the remainder of my Indians [pictures brought along as samples]. Said he should want a thousand stereos of scenery about Weber Cañon the first thing [to sell as souvenirs to tourists on the line]. Slept in our seats at night." Like many of the new transcontinental railway workers, Jackson's train boy had discovered that travelers between the coasts, unlikely as they were to actually stop between oceans except to eat or stretch, wanted souvenirs of their travel—edifying samples of the Western life, substitutes for experiences they might desire but could not have.[53]

Apparently this contract set Jackson to thinking; sometime shortly thereafter he must have sent word to his brother urging him to negotiate with Eastern distributors, or else he sent letters himself. On August 23, Hull fell ill, and Jackson went to town to get medicine. There he "found at the P.O. a letter from Ed enclosing one from a NY man who wants 10,000 of our UP views. Ed's letter rather meager and unsatisfactory—needs a little talking to." The New York man was Edward Anthony, head of the largest photographic equipment and supply house in the country, editor of *Anthony's Journal,* and the most important, prolific, and widely distributed publisher of stereos and views in America. The contract, which resulted in nationwide distribution of Jackson's views, instantly elevated him to a place among the elite of Western photographers—with Union Pacific photographer A. J. Russell, Central Pacific photographer A. A. Hart, and California photographers Carleton E. Watkins and Eadweard Muybridge—putting his pictures and his name on the mounts of an Anthony series of "Views along the Line of the Union Pacific Railroad."[54]

The 1869 trip taught Jackson the business of landscape photography at all levels, from day-to-day commissions to large-scale production. It instructed him, as well, in the proper use of assistants—to sell, to assist, even to make views, usually under supervision. But the most important lesson lay with understanding his own place in the chain of production, distribution, and consumption that characterized the rapidly rising industry of information of which the photograph was an important and rising new part.

These lessons, however, were incomplete in themselves. More vital was Jackson's attempt to learn how to manipulate and exploit the range of possibilities inherent in the business of photography and the business of information in the post–Civil War American West. By expanding the popular conception of how landscape photographs could and should look, by enlarging the range of meanings the genre could embrace, Jackson simultaneously elevated his own status.[55]

The diaries are full of evidence detailing Jackson's process of translating previous artistic experience, a sophisticated understanding of the mythology of the West, and a keen sense of observation into successful pictures. His references to the "good effects" of light off rain-soaked streets on his first day in Cheyenne were followed by near-daily references to the qualities that constituted a successful picture. Dealing with light itself was the first and most difficult problem. Photographing the prostitutes of Madame Cleveland's, Jackson commented that the "weather was just hazy enough to soften the light down for an out-door group." A week in Corinne was spent dealing with a generally hostile environment: the dust, which would "fly with any gust of wind; the light, [which] was hazy and yellowish and combined with the heat, was very detrimental to successful photography. . . . Got a few good negatives mainly in the morning but

as the day advanced it was impossible to secure intensity."[56]

Mastering light meant simply getting enough of it, then observing its qualities, its capacities to alter the significance of the subject. And choice of subject—deciding what was important, then deciding on a vantage point correct to the reality of the object—provided a second problem for empirical solution. Traveling on the train to Promontory, Jackson wrote that "the scenery of Echo and Weber appeared magnificent and will keep me continually perplexed when I come to select views." And Jackson detailed at one point an exhausting, day-long climb up the face of one of these canyons in order to study the nature and variety of angles from which canyon walls, floor, and top could be viewed.[57]

Jackson learned these possibilities not only from experience but from studying the work of two acknowledged masters of the Western view, Salt Lake City photographer Charles Roscoe Savage and the "official" photographer of the Union Pacific, Andrew Joseph Russell. Both of them taught not only what was significant along the route but provided vital lessons as well in composition and visual arrangement of the elements to make a conventionally satisfactory picture.[58]

Jackson learned from Savage by frequenting the business of Savage and Ottinger in Salt Lake City, ordering mounting board and chemicals from them, looking at their views, and in at least one case buying or trading for a negative—of the stonemasons quarrying granite for the construction of the Mormon Tabernacle at Salt Lake City. In his diaries, he reported that he had met with Savage,

"who had some very fine landscape work to his credit, and had a few minutes interesting conversation with him."[59]

With Russell, the process of learning was more evident and more sophisticated. That Jackson had seen Russell's work before leaving Omaha is clear from two pictures he made shortly after the trip began. The first, "Wind Mills and Shops at North Platte" (illustration 24) is a near-ringer for Russell's 1868 view of "The Wind Mill at Laramie" (illustration 25). The same applies to Jackson's picture of "Green River Bridge and Butte" made in July—it apes a view Russell made during the winter of 1868, "Temporary and Permanent Bridges & Citadel Rock, Green River [Wyoming]." In both cases Jackson drew cues as to subject matter, but failed to understand the larger reasons Russell's pictures were so good. In the first pair, one immediately recognizes the message of Russell's picture: the huge windmill represents the "technological sublime"—a man-made object of monumental proportions, designed for the heroic task of taming nature and converting it to human uses. But Jackson's version fails to communicate this, largely because he set the camera too far back from the subject—he placed the windmill in the exact center of the frame, but by including all the railroad cars and buildings, and by filling the foreground with wasted space, he reduced it to one more object among a group of objects. This was even more evidently the case with the study of Citadel Rock on the Green River, where Jackson chose the same subject but apparently lacked the technical expertise or the courage to match Russell's tour de force.[60]

But both of these photograph pairs show more than simply incomplete devotion to Russell's example. They show Jackson's attempt to set the human subject of his pictures within as vast a scale as possible, even if it meant sacrificing visual impact. Russell's two pictures flagrantly celebrated human domination over hostile natural scenery; Jackson's diminished the human presence within the frame to present a correspondingly diminished relationship within the open space of the West. This reflected his own experiences as a bullwhacker and mirrored many of the pictures he'd drawn during 1867, wherein his painterly training encouraged him to devote large amounts of the picture frame to sky and ground. Probably through his earlier contact with work of popular luminist painters of his time, Jackson had recorded a landscape of grand scope and near-infinite space, presided over by vast stretches of sky. Now he was apparently attempting to translate that technique from painting to photography—without particular success, in these cases.[61]

From Savage and Russell, from his own memory of pictures seen in Omaha and before, from his training as a painter of landscapes, Jackson developed multiple sets of stylistic conventions, each applicable to a different conception of the intersection between man and nature in the West. The first presented a set of specimens—rock formations, primarily—treated with the frontality and central composition that had characterized his Indian views of a year or so earlier. Often these subjects were chosen for their reputations and given perfunctory attention. Jackson accorded a more sophisticated treat-

31.
"120. Study Among the
Great Rocks That Have
Fallen from the Cliffs
of Echo Cañon," 1869.
USGS

parlor; and because the stereo effect itself tended to mask the message in its spectacular visual thrill. Thus Jackson's three views entitled "Study Among the Great Rocks That Have Fallen from the Cliffs of Echo Cañon" (illustration 31) are all compelling indicators of how Jackson managed to declare simultaneously the preeminence of man over nature while presenting nature as omnipotent, sublime. In two of the three views, thin strips of the railroad appear, threatened by looming cliffs or unbalanced boulders above. These stereos thus began by thrilling the Victorian parlor viewer with an image of old-style sublimity, in which the scale and hostility of nature threatens the products of man. But this effect was quickly neutralized in two ways. First, the stereo effect enabled the viewer to rearrange the scene so that it became clear that the threatening forces of nature were far from the railroad. Thus the rational mind could declare its dominance over the emotional; after the first view, the spectator was in complete control, making a willful decision to suspend rationality and be thrilled again by the trick of optical illusion. In addition, the view—even when first seen—was not in fact threatening to the parlor viewer; Jackson had carefully chosen his vantage points so that the point of view is located far away from the scene of potential disaster.

To this extent, Jackson's pictures only

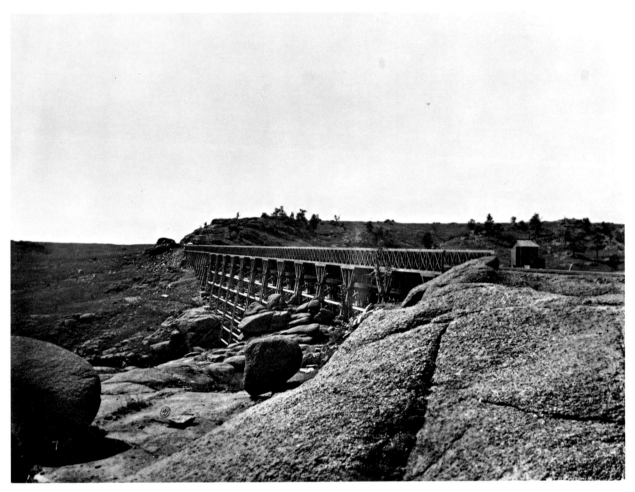

32.
*"7. Dale Creek Bridge
[West Cheyenne],"*
1869. USGS

Man himself appears rarely in these 1869 views; instead, he is replaced by his products. But another twist on the older mythology of the Western landscape occurred in views Jackson made that transferred sublimity from nature to technology. In "Dale Creek Bridge" (illustration 32), the man-made object imposes a graceful order on the scene, with its repeated patterns and its fastidious horizontal members; it counters the seemingly random arrangement of the boulders in the foreground and the uneven foliage on the far wall of the canyon. In views of blasted-out rock cuts, too (illustration 33), Jackson created images whose powerful verticals, harsh contrasts of light and dark, and rough textures corresponded closely with the requirements for the sublime view as practiced by European and American landscape painters and as filtered into popular consciousness through essays, engravings, and popular illustrations. But here the cuts were products of an absent human technology: dynamite and excavators made this cut.

In these images, Jackson retreated from the bold presentation of the technological sublime advocated by Russell. Instead, nature remained a mysterious, brooding force, worthy of attention and respect. This differed markedly from the most extreme stereographs he made, such as his famous view of Skull Rock (also a remake of a Russell photograph) where a minuscule human blithely waved victoriously from his conquering position above the anthropomorphic rock. For Jackson, the new West remained at least visually tied to the old.

One final element was needed to complete Jackson's visual creation of the new West: human occupation. With this theme

reaffirmed the image of an eviscerated nature whose postures amuse the viewer. But Jackson was careful to include another vital element in these stereos, one that reaffirmed the potency of the Western environment. Through his choice of camera angles, light sources, and times of day, Jackson introduced the angular stratifications of the rock faces along Echo. These, the principal scenic attractions of the canyon, indicated to Jackson and his viewers the tremendous power embedded in the environment. But by photographing far enough back, Jackson again succeeded in locating this power in an entirely different temporal realm—in geological time, where cataclysmic events could occur but still not threaten man or his productions.[64]

we see Jackson's most complete divergence from a purely propagandistic boosting of the West, especially as it had been presented in Russell's photographs. Rather than fixed and permanent, human settlements appeared in Jackson's views as tentative occupations. His view of Wasatch, Utah (illustration 34), made relatively early in the season, went beyond the simple description of temporariness inherent to the subject. It was an attempt at putting a panorama on a single 8-by-10 plate; as a result, almost all the pictorial rectangle was given over to blank white sky and rela-tively featureless prairie grass, with the city inserted between. Here Jackson tried to give a sense of the loneliness of the settlement, its insignificance in the scope of the region, its inability either to meld with the environ-ment or to declare its independence.

Stereo views of Corinne, Utah, suggest how deeply Jackson was interested in de-veloping a record of this first, hesitant stage of development in the West. Though his di-ary records that he took many views of busi-nesses, houses, and buildings in the towns along his route, he stripped most of them for reuse. Those he kept form a peculiar lot. They include views of tent towns with pretentious wooden facades, studies of rail-road buildings, and even a photograph of the Corinne *Daily Reporter* office. News-papers were vital signs for a town—with one, a collection of tents became a po-tential metropolis, and the act of record-ing such an institution and sending it back East made it a sign both of the civility of the West and its frontier status. His "Street View in Corinne" (illustration 35) seems witty today; the inclusion of such an odd

36.
"37. Devil's Gate Bridge
[Echo Cañon]," 1869.
USGS

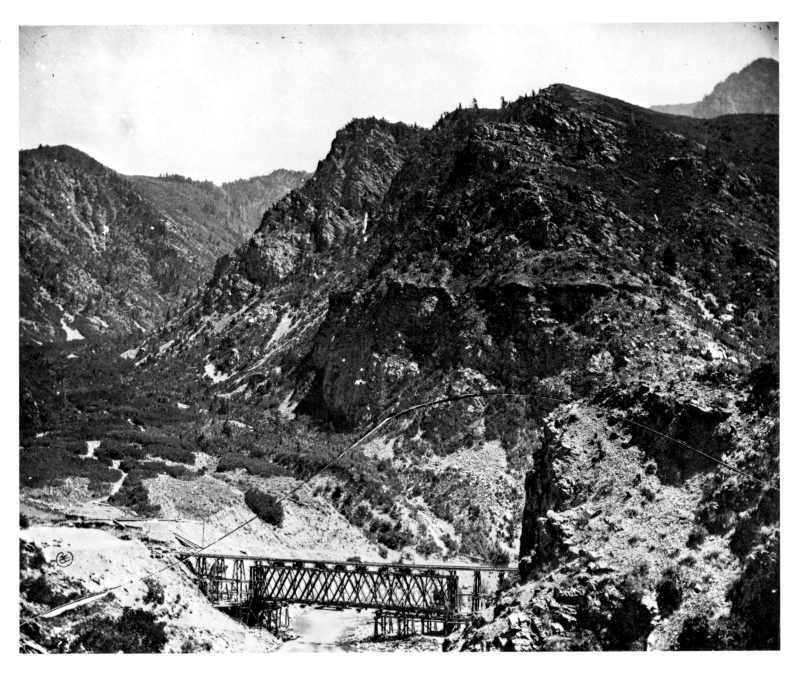

assortment of establishments—watchmaker, hardware store, livery, and, of all things, a painter—suggests the haphazard development process. But Jackson was apparently also interested in describing the flamboyant signs that had somehow made their way West: a huge wooden gun on a post, a large painted watch, an odd selection of pots and pans to announce a tinsmith. Here we see Jackson presenting frontier society as composed not only of tenuous occupation but of transported bits of the mother culture—signs like these, after all, were difficult to carry and probably impossible to construct in Corinne, but they reappeared in the region as part of the visual language shared by miners and bullwhackers, railroad trackmen and Mormon farmers. These are views that attest to Jackson's sense that the photographer was not only booster and guidebook maker but historian as well.

Jackson returned to Omaha in 1869 with an odd assortment of pictures. Viewed from more than a century's distance, they seem at first to reveal an underlying inconsistency, an uncertainty toward the subject of the West, an uncertainty toward the Western landscape style. But this seeming arbitrariness may, on close examination, simply represent an attempt to describe the West at a frontier moment between wilderness and civilization, and at the same time to present both of those ideals sympathetically. Hence in his superb view of "Devil's Gate Bridge [Echo Cañon]" (illustration 36), the harsh topography of the region, its vaster scale and alien temporal realm, and the bridge itself—with its precise order, its marvelous engineering, its practicality, and its great beauty—are both celebrated, both presented as heroic. Here, as in

so many of Jackson's views from that season, man has succeeded in claiming a place for himself within this awesome environment. But this stake affords the American little of the heroic; rather, it makes possible a true appreciation of the monumentality and omnipotence of nature even as it clarifies the alien scale on which the dynamics of that environment worked themselves out.

This position—a harmonious balance between development and sublimity, the first stage in a process by which both nature and man could be tamed and civilized through the other's influence—represented the best of Jackson's first year as a landscape photographer. That it could be adapted to the tourist's stance of temporary awe, symbolic claim, and permanent irresponsibility, was implicit in the ease with which Jackson could also make views like "Pulpit Rock, Echo" with "Ben and the Keeper of the Hash House as accessory ornaments" or "Castle Rock," with a group of women "who went along with the crowd, thinking it a great lark

to be included in some of the pictures." These views upset the delicate balance of Jackson's new West, turning awe to appropriation (to paraphrase historian Richard Masteller), human presence into human domination. But the best of Jackson's photography suggested otherwise. This, surely, was the lesson of the Jackson Brothers' 1869 trademark and advertisement (illustration 37), with its strange conjunction of Indians, high mountains, railroad, neoclassical ornament, and gothic type. Converted to wood engraving from a drawing by Jackson, the logo served as a full-page announcement in the Omaha *City Directory* for the following year and appeared on the back of the firm's mounts for the short period before Jackson returned to the heroic regions with Hayden and the U.S. Geological Survey. Here the new West became part of a sublime arcadian dream, wherein a healthy symbiosis developed among Western man, his technology, and a natural environment gratefully transformed, without diminution, into scenery.

37.
The Jackson Brothers' 1869 trademark, which appeared on the backs of certain of their stereo cards, was also used as their advertisement in the Omaha City Directory for 1869. This wood engraving was probably made from a painting or drawing by William Henry Jackson.
PC

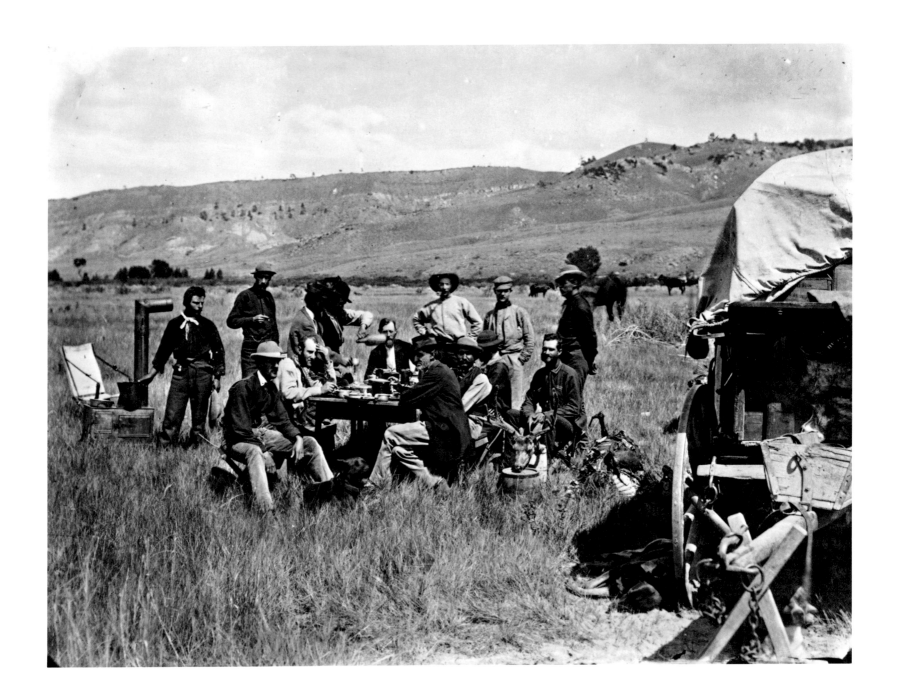

The lamented Greeley must have had photography in his mind, when he uttered that famous piece of advice—"Young men, go West!"
—"Stereoscopic Views of the West,"
 in *The Philadelphia Photographer,* 1873[1]

Jackson returned to Omaha in the fall to find the business a shambles. His brother Ed had proven an incompetent administrator, and it took months to patch up relations with customers, reorganize the establishment, and put it back on a paying basis. Apparently this included paring down the size of the work force: brother Fred, operator Ira Johnson, and even Arundel Hull seem to have left at this time. Jackson also had to reorganize his domestic arrangements. Mollie came back from a summerlong sojourn with her parents, and the two set up housekeeping. His marriage solved a major business problem for Jackson; Mollie provided him with a trustworthy associate in whose hands he could safely leave matters during his absences.

By the spring of 1870, Jackson was already suffering from his chronic restlessness.

In part this may have had to do with his success in placing his views with Anthony; now he was in a position to exploit his new reputation. But what should serve as his next project? There is strong evidence that Jackson had worked out some plans for a more extended photographic tour of the West. This one, however, would have to cut loose from the overexposed regions of the Union Pacific, ranging out beyond the frontier line and into the wilderness. Clearly A. J. Russell's proposal of the previous summer offered access to a region visible, yet inaccessible, to the tourists who would first appear in significant numbers in the summer of 1870. By summer, however, no plans had materialized from the other photographer.

Then, in July of 1870, Jackson received a visitor at his studio: Dr. Ferdinand Vandeveer Hayden, director of the U.S. Geological Survey of the Territories. Though it was now nearly too late for Jackson himself to make a full-scale excursion on his own, Hayden's Survey was just leaving—typically, it had only received its appropriation from Congress in the last days of the session, and hence had been waiting in a state of near-preparation for some time. Hayden was in Omaha on his way to the base camp outside Cheyenne; he had stopped in partly to renew acquaintance, partly to see the results of Jackson's work from the previous year.[2]

The Sioux had named Hayden "the Man Who Picks Up Stones Running" in an attempt to describe his frenetic energy and his manic, anxious behavior, which they had witnessed during his earliest specimen-gathering expeditions in the early sixties. Scientific training at Oberlin College had led him on to a series of military–scientific

38. (*opposite*) *"A group of all of the members of the Survey, made while in the camp at Red Buttes,"* 1870. USGS

surveys in the Upper Missouri area, where he was responsible for exploration of the Laramie coal beds. Working without firearms and often alone, Hayden was once left by hostile Indians who thought him insane because he was carrying only a bag of rocks. A Civil War surgeon, Hayden then became Professor of Geology at the University of Pennsylvania, an appointment he held during the first years of his Survey work. By 1862, when Hayden's "On the Geology and Natural History of the Upper Missouri" was published in the *Transactions of the American Philosophical Society,* he wrote that he had set a mission for himself: to bring into being and perhaps supervise a government-sponsored geological survey that would "lay before the public such full, accurate, and reliable information . . . as will bring from the older states the capital, skill, and enterprise necessary to develop the great natural resources of the country." Hayden's first Survey, in 1867, was funded by leftover monies appropriated originally to the Nebraska Territorial Legislature, and its mission was to explore the geology of Nebraska and discover and report on the mineral possibilities of the new state. As a supplement to his letters of instruction, Hayden was asked to present "graphic illustrations" of striking and beautiful landscapes for inclusion in the annual reports of the General Land Office, which was official sponsor of the Survey.[3]

The founding and funding of the U.S. Geological Survey under Hayden in the decade between 1868 and 1878 came as a result of more than just one man's assiduous work and commitment to an ideal. Hayden's Survey was only one of a number of such postwar expeditionary forces designated by Congress or by the U.S. Army to bring back information on the West. In each case, the notion of what constituted vital and necessary information differed. But behind all of them lay a nationwide concern with coming to some understanding of the vast region now made available by the opening of the transcontinental railroad.

Because of its geological emphasis, Hayden's Survey became the focus of particular interest on the part of American industrialists and their endeavors. The development of new ironworking technologies, including Bessemer and open-hearth steel processes, had all occurred between 1867 and 1870. Andrew Carnegie opened his first iron mill in 1868. Copper, lead, and other mineral industries as well were just entering the first stages of their development bonanza in the years directly after the Civil War.[4]

All these events indicated a nationwide trend toward increasing industrialization and demanded a concomitant knowledge of the availability of raw materials. Mineral deposits in general, and coal deposits especially, obsessed Eastern industrialists, many of whom had tasted or witnessed the demands and rewards of large-scale industrial activity in the building of the transcontinental railroad, and understood from that lesson that the speed and lucrativeness of American industrialization would depend in large part upon the availability of cheap raw materials. For them, the West became a place of exploitable natural resources, and Hayden's Survey must have seemed custom-fitted to answer their questions.

For Hayden, however, this formed only one aspect of the larger process he had long envisioned, in which the West would give up not just minerals but history and scientific secrets as well, and in return be transformed into an ideal site for the marriage of man and nature.

Hayden always understood that his role lay between serious, accurate science and boosterism. In some cases boosterism surpassed fiction. His independent survey of the San Luis Park region of Colorado for the English land-speculator and entrepreneur William Blackmore resulted in a glowing report that "sheep will yield an annual income of 90%; cattle 50 to 60%." The results made Hayden Blackmore's friend for life. In return for Hayden's optimistic assessment, the landowner gave Hayden $10,000 in stock in his land project; more important, he provided the Survey with a huge collection of Indian photographs and proved an influential champion of the government survey throughout the decade.[5]

These transactions seem, to modern eyes, felonious. But for their time, they merely document Hayden's deep commitment to the development of the West, his belief in its resources and possibilities, and his extraordinary, even blind, faith that entrepreneurs, settlers, newspaper publishers, scientists, photographers—all the elements forming the mixed population of Westerners—were honest, committed individuals whose actions would bring a great era to the region.

By 1870, Hayden's style had established him as one of the preeminent scientific authorities on the trans-Mississippi West. As Hayden's reputation grew, so did that of the Survey, and appropriations increased accordingly. From the $5,000 that launched the Nebraska Survey, the 1869 Congress had raised the stipend to $10,000; in 1870 it was to be

$20,000. Hayden's ambitions grew with each appropriation. In 1870 he planned to follow the general path of the Union Pacific Railroad west to Utah, sweeping both out and back in such a way that the entire Wyoming Territory would receive close attention, as well as portions of Colorado and Utah. The Survey would not, in fact map the region at all—no topographer was budgeted. Rather it would survey in the larger sense. It would look over the region, examining its natural and geological history and detailing the potential areas for development. It would be a typical Hayden Survey, aimed at providing the sort of information about the West most desired by Easterners, whether wealthy capitalists or potential homesteaders.[6]

In the spring of 1870, Hayden was looking for a photographer to take with him on the Survey. Already he had hired an artist and would soon sponsor another. By the time the Survey was to leave Cheyenne, Wyoming, nearly a sixth of the force was to be visual artists. Still, this apparent imbalance was not simply a matter of Hayden's whimsy. Secretary of the Interior Columbus Delano's formal letter of instructions had, that year, specifically enjoined Hayden to produce photographs or their equivalent: "You will be required to secure as full material as possible for the illustration of your final report, such as sketches, photographs, &c." In fact, the Secretary's letter made no direct mention of the Survey's "exploration" as a topographic one. Rather Hayden was to observe, collect, report, and illustrate the West.[7]

Standing in Jackson's studio, looking at the prints from 1869, Hayden's desire to have this photographer with him doubtless grew in part out of a mental comparison with the pictures he had just chosen (from A. J. Russell's railroad views) for his upcoming book, *Sun Pictures of Rocky Mountain Scenery.* *Sun Pictures* was Hayden's popularization of his first Survey reports; in addition, it served as a model for the public and nonscientific side of his subsequent publications, including the much larger annual reports of the seventies. As his introduction stated, *Sun Pictures* formed the first part of Hayden's larger attempt "to present to the world some of the remarkable scenery of the Rocky Mountain region, through the medium of photography, as the nearest approach to a truthful delineation of nature."[8]

To twentieth-century eyes, *Sun Pictures* seems a remarkable document. Covering the area from Omaha to Salt Lake City, Hayden had drawn a picture of "The Great West" within a vast teleological scheme that began with the earliest geological history, then continued through the present transformations of the West into human habitation.[9]

The year 1870 was but a moment's pause in what Hayden called "the beautiful plan of the physical growth of our continent." For Hayden, geology's purpose was man's destiny—"the multitude of rivers that wind like arteries through the country . . . excavate the avenues for our railroads." At this moment in the history of the Great West, nature awaited man's ordering and civilizing hand; the perfect end of landscape would be a complete symbiosis of nature and man. In arable regions, it would be "villages and farm houses [that] meet the eye on every side, fields of wheat and corn of unusual luxuriance [that] wave in the breeze, and . . . broad meadows . . . covered with a thick growth of coarse grass, so high as oftentimes

to conceal the horse and his rider." In the wastelands of the Great American Desert, irrigation would transform desert to garden, or mining would draw a different richness from the earth. Where mountains or climate made settlement impossible, the region existed to "attract the attention of the traveler, and . . . reveal to him some of the grandest, as well as the most beautiful forms of scenery in the world." In this scheme, all rivers were scenic, waterbearing, or navigable; "Indian lands" were designated as "sections [that] . . . to the agriculturist . . . [have] comparatively little attraction." In short, Hayden was presenting a master plan for the settling of the West, in a rhetoric approaching that of religious revelation.[10]

With *Sun Pictures,* Hayden created a poetics of geology and one of landscape as well, and the intersection between these two tasks was a vital part of his vision of the West. Sight, the activity of looking, became both precedent and substitute for other forms of acquisition—and after all, Hayden had chosen to marry his text to a selection of thirty photographs of the region. Thus the tourist role had, for Hayden, at least two meanings. In one case, tourism was a precedent for settlement and exploitation. This was the role Hayden reserved for himself in the text, and it would be the position he and Jackson would secure and advertise for the Survey over the next eight years. Here seeing became a powerful and complex act, including observation, intuition, ratiocination, and deduction. The observer, preferably scientifically trained, drew from sight the conclusions that would lead to a later, more active form of integration between man and nature.

In this type of vision, photography—

properly practiced—was both a record and a potential alternative to physical proximity. Hence for Hayden, the photographs chosen from Russell's wide selection were of value not simply for their beauty or for the beauty of what they showed but, more important, because they revealed such evidence as geological stratigraphy, riverbed composition, and geography. Hayden praised Russell's work for its clarity of observation, but how much better would be photographs made with this sort of observation as their *a priori* goal!

Observation was one type of sight, one way in which the tourist was a valuable role model. Appreciation pure and simple was the second. Here the eye, and the photograph, *substituted* for exploitation— appreciation replaced farming, mining, or lumbering as an independent form of landscape use. And Hayden's own descriptions mirrored the procedure, he invited the reader "to travel . . . wandering aside here and there, to cull a flower or examine an Indian village." Geology was but one part of this process of Romantic engagement with the landscape:

We shall also delay now and then, to study the rocks and unearth their fossil contents; and in many a locality we shall find the poet's utterance no fiction, that there are "sermons in stones" etc. Scenes more wonderful than any related in the far-famed Arabian Nights' Entertainments have been performed on these apparently lifeless, monotonous plains.[11]

Hayden presented the West within a context that formed the next phase of Western development after the tenuous occupation implicit in Jackson's 1869 views. Now the tourist tamed, humanized, and gave purpose to the landscape by the act of looking alone. Nature provided "'sermons in stones' etc."; to read her was to actualize her. This was the purpose of untamed mountains or vast deserts—to teach lessons about the infinite, about the grand plan of God for man and nature, about the smallness of man in the face of that grandeur: all the concepts inherent in the eighteenth-century philosopher Edmund Burke's description of the Sublime as an aesthetic category. Without this form of visual tourism, however, whole passages of Nature would otherwise have been found useless—an impossibility in Hayden's Romantic understanding of things.

Hayden's cosmology teetered between two apparently contradictory propositions. One, which historian William H. Goetzmann has called "pragmatist," stressed the West as a place whose existence necessitated the guiding hand of man. Nature was resource, potential, raw material for human civilization. The other, however, accepted the cosmic scope of nineteenth-century scientific theories, and thereby saw man's place as minuscule. Both propositions were inherent to the Romantic position, and Hayden's peculiar translation of scientific neutrality into cosmic fatalism at the end of *Sun Pictures* reveals that he wholeheartedly envisioned the West from an anthropocentric system of belief.[12]

But Hayden's inconsistency lay precisely in the contradiction between the older Sublime mythology and the new concept of the West as commodity that Jackson had succeeded in resolving with his 1869 pictures. The photographer's resolution was a fitting one for the geologist Hayden; it preserved the West as a place of awe and power by relegating that power to the eonic time span of geology, giving to man the exploitable transience of the present. This, surely, was the resolution Hayden strove unsuccessfully for in his astonishing final meditation to *Sun Pictures*—a passage that began by describing the meaninglessness of an earth without man's presence to give it meaning, and ended with a "lesson":

that life is infinitely short, and human achievement utterly insignificant. Let us hope that this future ["evolved"] man, purer in morals and clearer in intellect than we, may find as much to admire in the records of this first epoch of the reign of man, as we do in those of the reign of mammals.

Geologist and photographer: the two were matched.[13]

And the fit concerned not only Jackson's ideological resolutions. On the other side, Hayden's cosmology stressed sight as the primary, even sole, point of contact between the philosophical consciousness of the observer and the incomplete potentiality of nature. And for him, as for most of his generation, photographs had a privileged place; they resided between the object of observation and the act of observing itself, hence between nature and man. In such a place, they drew qualities from both. They were scientific evidence and scientific conclusion at the same time. They were the perfect models of scientific description—they selected, edited, ordered, and even judged their subject. The camera, under the properly trained intelligence, became a means of making sense of the world. This was the context for understanding his phrase that photography was "the nearest approach to

a truthful delineation of nature"—not in the older sense in which the photographer simply operated the truthful camera, but in a new, more sophisticated way, whereby the photographer became a passionate, thinking observer, dominated by scientific curiosity. The resulting photographs were, however, incomplete in themselves, demanding the analytic intelligence of the viewer. Nonetheless they contained the elements for analysis, already stripped of disorder and inviting the final processes that would turn data into information.

Hayden wanted a photographer, and Jackson's work was impressive. In later versions of the story, the photographer recounted Hayden's impressed response to the clear delineation of geology and to the overall quality of the pictures. Whatever was said, Hayden made Jackson an offer: a position as the equivalent of correspondent on the Survey—Hayden would pay his outfitting expenses and travel to and from the Survey, and provide all necessities while Jackson was with the Survey, but could offer no salary. Jackson would have to decide immediately, for the Survey was scheduled to leave Cheyenne in a week. Then and there, Jackson decided to leave his wife, his business, and his new home to enter Hayden's service.

Jackson's deal with Hayden was far better than it seems at first glance. All expenses were paid, with the exception of travel to and from Cheyenne, and Jackson's studio could get along without him for a few summer and fall months. In compensation, however, Jackson received much. First, as unpaid correspondent, he was permitted to retain any negatives he made. This meant that he could not charge the Survey, but other gov-

ernment offices, and the public, would have to pay what he demanded for prints from his negatives. At the same time, the imprimatur of the Survey was his to use as he wished. This meant, at least, inclusion of the Survey stamp and Hayden's name on every mount for every stereo or whole-plate image produced. And the mere fact of his being chosen could be used to improve his reputation and increase sales. Finally, however, the Survey offered him protected transportation, with gifted and friendly colleagues, into some of the most important regions of the West.

With just days to prepare, Jackson quickly assessed his position. Unhappy with the unwieldy nature of his kit from the previous year, he telegraphed east for new equipment, including a 5-by-8 camera, a new set of stereo lenses, and some traveling boxes from the American Optical Company. Putting his business in order required placing Mollie at its head, then completing the work that only he could do. While he waited for final authorization from Hayden, this became more and more difficult—he wrote in his diary that he was too excited by the prospects to complete a painting that was promised. Then on July 28, he wrote that "I received a letter from Dr. H. bidding me to come in at once." On July 31, Jackson took the train for Cheyenne.[14]

The photographer's introduction to Survey life provided a combination of high purpose, casual planning, and male camaraderie that was to characterize his experiences for eight more years. Arriving in Cheyenne, he found the Survey camped out of town by Camp Carling, an army depot. With a complete photographic outfit and no one there to meet him, Jackson had to send a mes-

senger for help. Reaching camp, he found that "the Dr. was down at Denver, but met Stevenson and through him was soon acquainted with the whole party . . . and found them jolly good fellows." The group consisted of a small core of "professional" members, including Hayden and Jackson. There at Camp Carling were James Stevenson, the geologist's executive officer and Hayden's organized, dependable right-hand man; Cyrus Thomas, Hayden's "agriculturalist," who also served as botanist, anthropologist, and Indian scholar; and John H. Beaman, the staff meteorologist, who would serve as Jackson's assistant through most of the trip; in addition there were a zoologist and a naturalist.[15]

Hayden returned to the camp two days later, bringing with him the two artists who would travel with the Survey that season. Henry W. Elliott, a twenty-four-year-old ex-secretary to Professor Joseph Henry of the Smithsonian and a one-year veteran of the Survey, was the official artist, paid to make sectional studies of geological formations, studies of the overall terrain, and sketches of points of particular interest, all for the *Annual Report*. The other man was Sanford R. Gifford. Gifford was a guest of the Survey, a noted and successful Eastern painter who had come west on the newly completed railroad, along with fellow landscape painters Worthington Whittredge and John Kensett. All three painters had left the East in search of new sources for the picturesque; they had come to capitalize on the current fever of interest in the West and the recent easy access to its scenery offered by the Union Pacific. Whittredge ended up traveling with the Pope expedition through Colorado and

New Mexico, while Gifford succeeded in persuading Hayden that he should be allowed along with the Survey. Elliott would have some friendly interaction with Jackson; Gifford would prove profoundly influential to the photographer's work.[16]

"Once Hayden arrived, camp went from doldrums to activity," Jackson reported in his diary. While the members of the Survey party each completed their separate preparations, the eight teamsters and cooks commandeered the necessary horses, saddles, bridles, ambulance wagons, provisions, and necessities from the army. Meanwhile Hayden arranged a contract with Jackson, which the photographer wrote up and signed, dating it August 1, his first day in camp.[17]

While primarily concerned with the mechanics of the arrangement, their agreement had a certain devotional quality to its phrasing. And this sense of application to a mystical elite, a scientific priesthood, was emphasized throughout the signed statement. Agreeing "to perform the duties of that position with fidelity to the objects of the Survey" was within the limits of normal contracts; the stipulation that Jackson "cooperate with . . . F. V. Hayden in every way possible for the advancement of Geological and Geographical Science" was a pure Haydenism, a reflection of the extent to which the professor could persuade his neophytes to the holiness of the task ahead.[18]

On August 7 the Survey moved out "in the midst of a cold sleety rain that was very disagreeable," Jackson reported that night in his diary. The next day, the surveying party broke up; Jackson went with Hayden's group, which included Gifford and Beaman. The Survey passed westward to Laramie, then north through what is now Medicine Bow National Forest to Fort Fetterman, west past Red Butte (near what is now Casper, Wyoming), to the mining towns of Atlantic City and South Pass City, then down to Green River, to Fort Bridger and the region around Blacks Fork River, near the Utah border. At Fort Bridger on September 15, Jackson reported he "saw Mr. Gifford and [Cyrus] Thomas off for Salt Lake this AM; am very sorry to lose Mr. G." The trip back, begun with an excursion into the Uintah Mountains and then a month of work in the region between Green River and the Utah border, ended as the party returned along the line of the Union Pacific to Cheyenne, arriving on the first of November. There the Survey team disbanded for the season.[19]

All along this route, Jackson worked the scenery, usually with Gifford at his side, often making specific views at the request of Hayden, who took a deep personal interest in guaranteeing that the photographs lived up to his standards. Jackson, Gifford,

39.
"109. Bad-Lands on Blacks Fork," 1870. ANS

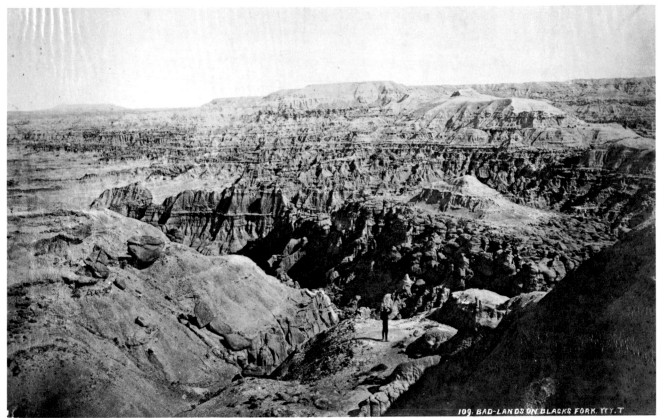

109. BAD-LANDS ON BLACKS FORK. W.Y.T.

Beaman, and sometimes Elliott or Hayden would range into the wilderness in search of views, sometimes taking off for a day, sometimes on more extended side trips. At times with Gifford's advice and Beaman's help, but more often on his own initiative, Jackson made views—"of the rocks bordering the Chugwater" (August 9); "in the mist and rain" (August 11); "of camp" (August 12 and at nearly every stopping point). On September 11, "near Church Buttes . . . me, Gifford, Beaman and one or two others took an ambulance and spent nearly the whole day in photographing the remarkable 'bad lands' of this vicinity. Secured quite a number of very fine pictures" (illustration 39). After Gifford left, the pattern continued. By the end of the season, Jackson had made nearly 150 whole-plate views, of which more than 110 ended up in the Survey catalogue, and as many or more stereo views—over 350 in all.[20]

The pictures that resulted were signally different from those of the previous year. From the rigorously descriptive and ideological work of 1869, now a far more artistic quality had entered—that is, the pictures drew far more on painterly conventions, undoubtedly due to the influence of Gifford. Writing in the introduction to the year's *Annual Report* and evidently paraphrasing his own daybooks, Hayden had commented that "during the day Mr. Jackson, with the assistance of the fine artistic taste of Mr. Gifford, secured some most beautiful photographic views which will prove of great value to the artist as well as the geologist." The interaction showed.[21]

Three stylistic elements entered the pictures to make this alteration. First, the an-

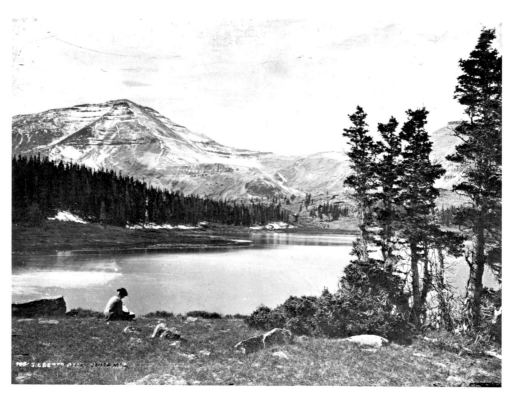

gle of view tended to change significantly. In part because of the longer, thinner rectangle of the 5-by-8 camera, the pictures have less sky and earth and hence seem closer to the ideal of artistic balance as it appeared in American landscape painting of the era—the orthochromatic plates of the era could not easily record cloud effects, so to have relegated as much space to sky as did contemporary painters would have drastically altered the meaning of the pictures. Closely allied to this change in viewpoint is the division of the picture into the traditional tripartite realms of foreground, middle ground, and background. Finally, Jackson completely al-

tered his use of human figures in the pictures; rather than primarily conveying scale, they began to serve as dramatic actors in a theatrical setting. All of these elements are visible in "128. Gilbert's Peak, Uinta Mountains" (illustration 40). Here the composition is artfully balanced, with the foreground evergreens compensated by the dark mass of trees to the left and the stark mountains behind it. All three elements—trees, woods, and mountains—serve as arrows pointing to the deep space at the center of the picture, where the lake ends. The division of the picture's illusionary space, too, settles the whole with its horizontal emphasis. And the

"139. The Flaming Gorge, A View On Green River . . . ," 1870. USGS

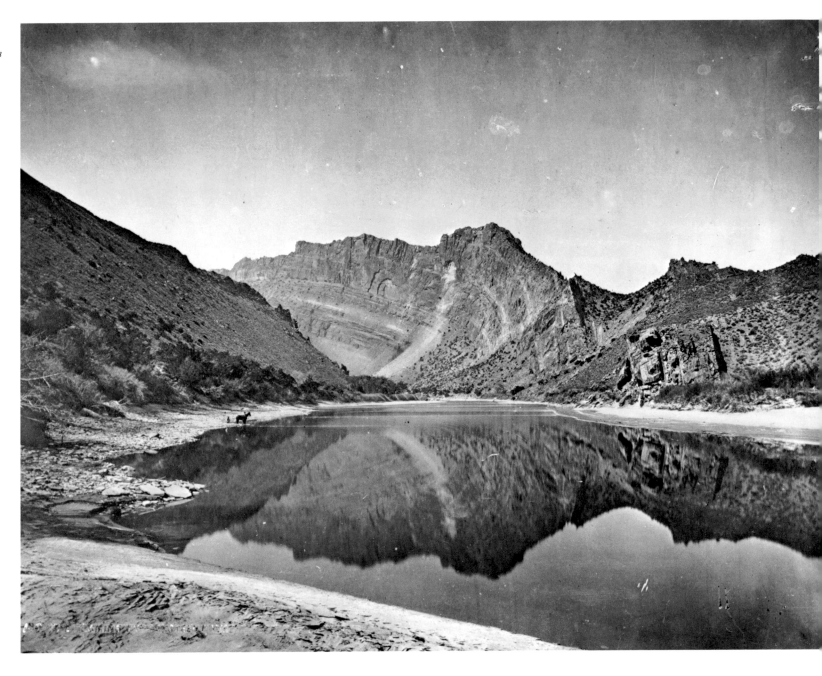

presence of Elliott sketching at the water's edge serves a number of important functions. Elliott substitutes for the viewer, instructing in the proper way to respond; he emphasizes the meditative quality of the entire image. He serves as a provider of scale, but in fact his value is deceptive—he confuses more than clarifies, in this respect. His function is picturesque, not factual.

More important than these stylistic matters, however, is the change in meaning they implied. Elliott's inclusion in the photograph signals the presence of man in this pristine environment; he signifies the Survey and its respectful investigations. This dualism—an altering of nature's power from the geological to the aesthetic, combined with an altering of man's presence from triumphant to investigatory—represents a real transformation in Jackson's point of view, and not simply the acquisition of a more painterly style. In "The Flaming Gorge, A View On Green River" (illustration 41) and "Green River at Brown's Hole" (illustration 42), the reflections in the water, artifacts of extremely long exposure times, serve to mute the geological forces implicit in the stratigraphy. And the patently artful inclusion of men and horses at the edge in the first instructs the viewer to enter the picture in a meditative state.

The result is meant to be a shift in consciousness on the viewer's part; pristine, powerful nature, entered at a hushed moment, was to provide a correspondent stilling of the rushed, modern mind and an extension of the soul into the space afforded by nature through the picture. This is, not coincidentally, a central justification of the so-called luminist painters operating in the East at roughly this time, and characterized by its historians as a new form of the Sublime, as an internal state. Gifford was a part of this movement, which attempted to shift American landscape painting from its involvement with the picturesque into a new, more direct, and more spiritual mode. Gifford's touch, and his eloquence as a thinker about nature and art, almost certainly influenced Jackson, taming the roughness of his earlier images, offering a sophisticated new language of Eastern landscape conventions, and at the same time supporting

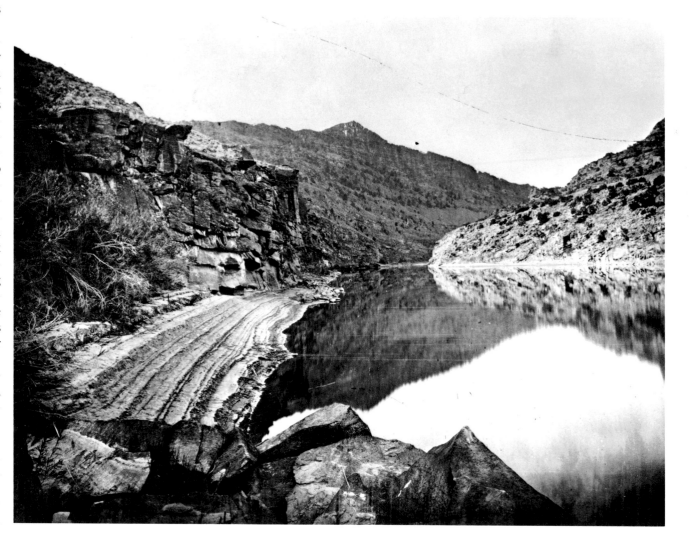

42.
"141. Green River at Brown's Hole," 1870.
USGS

the photographer in his ambitiousness and in the already powerful techniques he had developed to let the strange new Western landscape speak its "sermons in stone." In this, Jackson and his pictures taught Gifford something valuable as well.[22]

The extent of Gifford's influence in the making of these views cannot be overemphasized; at the same time, however, these pictures worked because they satisfied Hayden's desires, too. Views of waterfalls were not simply descriptions of picturesque features of the West; they were also evidence of such scientific and geological phenomena as erosion. And they signaled the presence of water in the West, water that itself im-

plied the feasibility of settlement. Jackson's "View of the Coal Bearing Cliffs Near Point of Rocks" was a signifier not only of sublimity and science but of economic potential as well.[23]

Science and sublimity, the expansion of knowledge and the enlargement of the spirit: these were the values Jackson worked out in the earliest views of the 1870 survey. As in 1869, meaning supplanted style; the pictures became witnesses of men themselves witnessing and surveying, looking out upon the unknown lands of the Great West (illustrations 43, 44). Men stand alone or in groups, contemplating the vast, primeval world that engulfs them. Looking out upon

the plains from near the head of Horse Creek, it seems suddenly logical why Hayden did not take a topographer with him; Jackson has communicated the sense that the land is infinite, and its function is to enable man to witness the Infinite. Yet this does not preclude the transformation of landscape into human habitation, as we see from the view of "Laramie River and Valley, Looking Northeast" (see illustration 44). Here Jackson succeeded in applying Gifford's lessons about the tripartite division of pictorial space to create a superb thematic statement. The foreground—harsh, sterile, even threatening—is occupied by human figures whose gazes lead us deep into space, past the man who rests contemplatively, to a land of harmonious beauty, where horses drink and bountiful grasses promise superb farmland. Above and beyond this region lies the sublime space of the West, stretched above the land like a benediction.[24]

Now Jackson was faced again with seemingly contradictory views of the West that required realignment into harmony. How could the landscape signify infinitude and still be reclaimable as human habitation? Here, as in 1869, Jackson found the answer in the introduction of temporality. But whereas time in the earlier work served to *separate* geological sublimity from human occupation, now it provided a continuum wherein the unknown became known, the trackless waste was mapped, untamed nature was tamed and humanized. In the photographs of 1870, we see the process as one about to occur; the Survey is composed of advance men for civilization. They are witnesses of the past and harbingers of the future.

43.
"49. Looking Out Upon the Plains . . . ," 1870.
USGS

"53. Laramie River and Valley, Looking Northeast," 1870. USGS

45.
*"64. Cottonwood on
the La Bonta [Creek],"
1870.* USGS

46. (*opposite*)
*"107. Camps of the 10th
and 11th of September,
Near Church Buttes,"
1870.* USGS

The scientific presence legitimized more than just the inevitable impingement of man in this region. It also gave new ways for the Eastern viewer to possess and appreciate the West. "Cottonwood on the La Bonta [Creek]" (illustration 45) is a superb example of the nineteenth-century obsession with scientific specimens—except here the photograph serves as an alternative means of bringing back samples. The inclusion of a blasted tree in front of the living cottonwood, and the tree trunk in center foreground, came directly from the stylistic repertoire of Eastern landscape painting but, in the context of scientific specimen gathering, imbued it with new significance. Now the combination of dead and living trees serves to give the scientific mind a cue to philosophical meditation of the sort we have seen in Hayden's writing, or found in that of the heroic Baron von Humboldt or Hayden's contemporary and competitor, the California Survey director, Clarence King.[25]

This is part of a broader message that came from the 1870 Survey photographs, particularly those that directly include the scientists of the Survey as witnesses, spectators, and subjects. In these, the notion of observers awestruck at having rediscovered Eden is simultaneously undercut by a redefinition of Edenic nature, in which it is amenable to man, awaiting man, the servant of man. In many views, Jackson presents man as a privileged witness, tiny but not threatened, utterly respectful. Properly deferential, man finds himself a welcomed guest, as Jackson's view of the "Camps of the 10th and 11th of September, Near Church Buttes" announces (illustration 46).

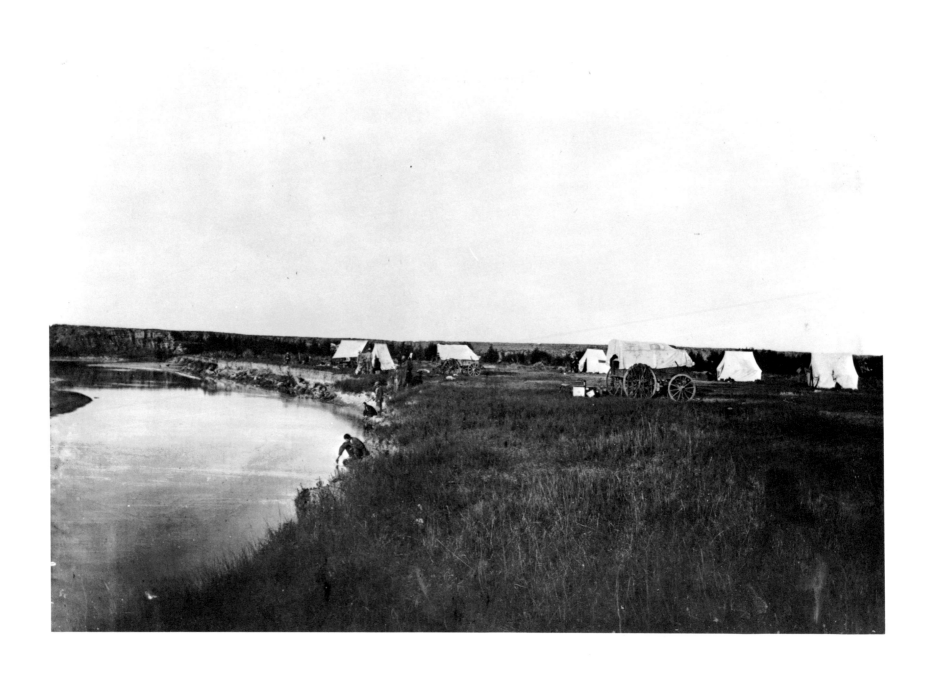

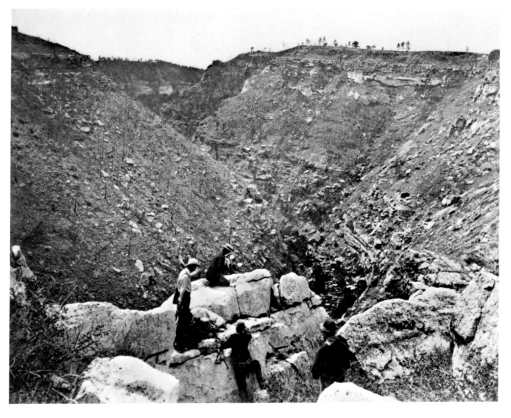

As the season continued, Jackson developed a number of secondary themes. One of the most important concerned the heroism of the Survey itself. Clearly this was a crucial bit of rhetoric; not only did it satisfy Hayden's ego (and Jackson's as well), but it served to bring home the vitality of the mission to Easterners and to Congress in particular. After all, a primary function of these pictures would be as gifts to influential politicians, and Hayden made a point of instructing Jackson to set the Survey in proper roles. To satisfy his employer, Jackson made views that melded the rhetoric of his 1869 railroad views with a more direct sort of heroic posturing on the part of Survey scientists. Often these photographic views have what, to modern eyes, seems a charming artificiality, as with "Box Elder Cañon South of Glenrock [Geologists at Work]" (illustration 47), for which Jackson evidently posed his figures. In most, a powerfully mythic quality results partly from Jackson's sophisticated visual techniques, partly from the scale of the West, which inevitably dwarfs the Survey men and their equipment (illustration 48). In this second view, however, more was intended, for the scene is located at a legendary point on the Oregon Trail, where emigrants left the North Platte River and began instead to follow the Sweetwater. Hence the picture condenses two generations of Westering heroes: the settlers of previous decades, and the scientists of the Survey.

In most of these views, Jackson worked hard to combine the ingredients necessary to his message. In views like "East from Independence Rock" (illustration 49), Jackson sought out vantage points that would include the harsh rock faces in the foreground, an opening to the valley below, a broad sweep to the deep space in the background, and posed figures to both represent the Survey and instruct the viewer in the proper response to such a scene. All this meant arduously climbing up from the campsites below, persuading Survey members to make the hike and pose, carrying equipment and setting it up, then transporting everything down again after sensitizing the plate, exposing it, and developing it in the portable tent–darkroom that went everywhere with the photographer.

But these views were not simply advertisements for the Survey. Nor were they calculated propaganda for Western exploitation. Here it is important to separate the process of intentional encoding of ideas and themes from a cynical process of ideologizing. For Jackson and his Survey compatriots, these images were attempts to communicate the Western environment as they experienced it. That they saw it as both vast, awesome sublimity and as raw material for American greatness was a result of their programming, the process whereby their culture

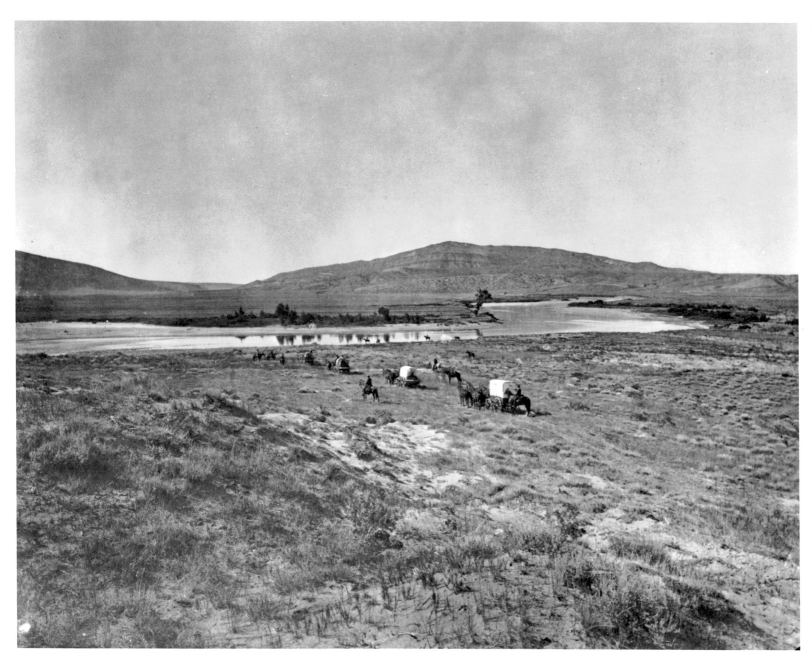

49.
*"East from
Independence Rock,"
1870.* USGS

instructed them in the range of meanings they could apply to landscape, to man, to the West. Jackson, Hayden, Gifford, and the others were all Eastern children, raised in the atmosphere of Romantic nature worship and American democratic acquisitiveness combined. The successful reception of these pictures, and the reports, magazine articles, engravings, and other products that resulted from the Survey, indicated how closely the ideals of these men corresponded to the beliefs of their surrounding culture. More than mere reflectors of American cultural values, the Survey explorers were also, deliberately, point men for that culture, instructed to examine the West to discover ways in which it could be brought into concordance with Eastern beliefs and values. This, in the end, was the heroic aspect of the Survey—its position between unknown potential and cultural need, and its capacity to bring the two together.[26]

One of Jackson's most marvelous photographs, his "View On the Sweetwater" (illustration 50), suggests how this process might work. Here Jackson drew upon a number of central American beliefs and applied them to the Western experience. Unlike most of his 1870 views, this photograph devotes much more than half its space to blank sky and the unrelieved grasses of the foreground. The line separating sky from prairie is straight as a ruler. Little of the picturesque exists to ease the confrontation between the viewer and the scene. What is portrayed, however, is deeply resonant to nineteenth-century American values. By the river's edge are nestled the Survey's tents; as in other views, they seem to substitute for the future settlement—they are eerie variants on the yeoman farmer's dwelling. But even more compelling is the lone human figure carefully silhouetted against the blank white of the Sweetwater, rendered featureless by long exposure. The figure poses, not turned away from us as are the observers in most of these 1870 views, but rather facing us. Behind the valley is a diagonal range of mountains, beginning with the Twin Peaks (now called Split Mountain). It is an image which reasserts the American equation of individual man, hesitant community, and overarching, omnipotent nature into one divinely ordained

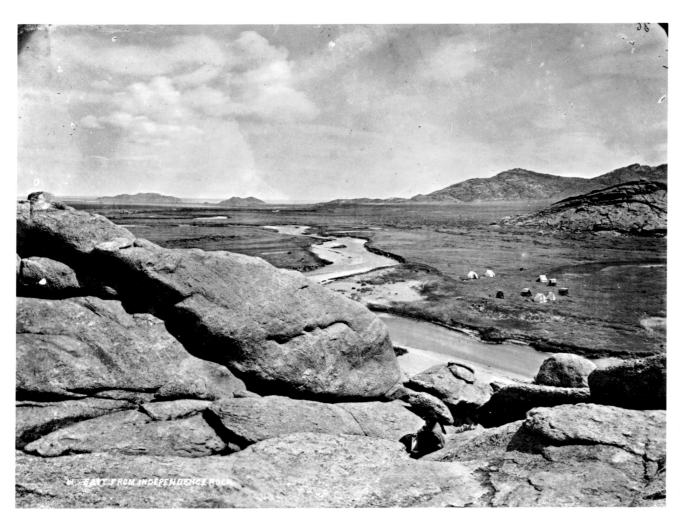

EAST FROM INDEPENDENCE ROCK

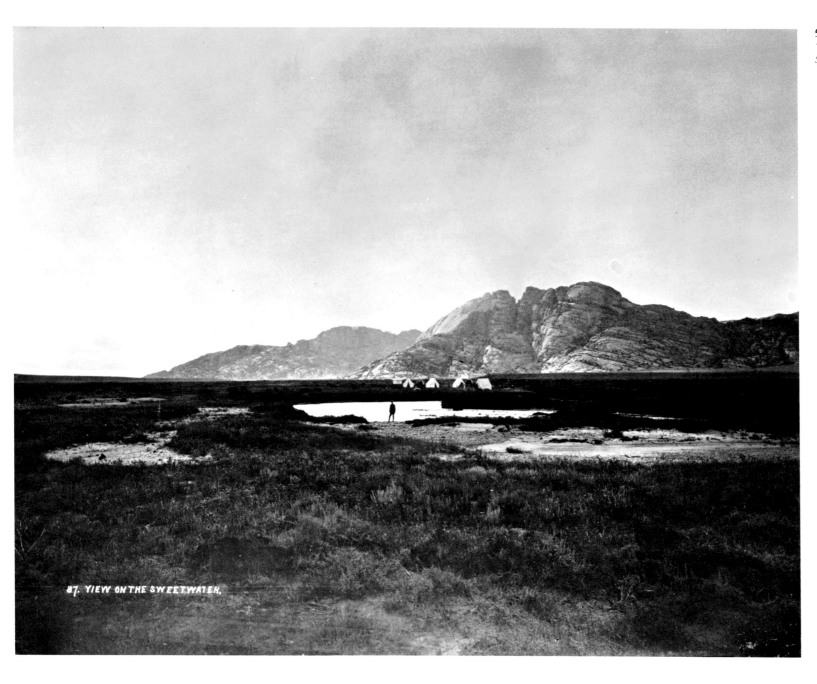

87. VIEW ON THE SWEETWATER.

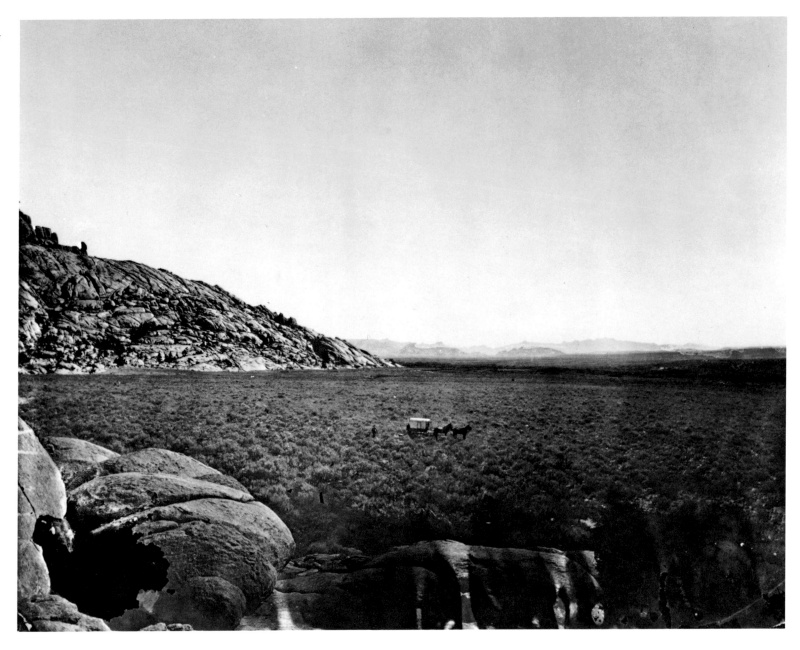

nation. Yet there is something deeply, deliberately disturbing about the lone figure's confrontation of the viewer, for rather than permitting us to remain disembodied and privileged, it draws scene and viewer together—it places us within that world, our gaze locked with another's. This sense is heightened by the deep focus of the picture, and the resulting way that the foreground grass finally disappears under the viewer's feet. It is an image, then, that does more than simply reinvent the American Eden; it demands of its nineteenth-century parlor viewer an active, participatory response, a confirmation.

The presence of man in Jackson's 1870 views takes on a hierarchical quality, as if the photographer intended to include all aspects of human settlement that could be retained within his ideological system. The Survey as front man for civilization represented one level (illustration 51). The historical presence of man represented another, signified in these views by icons of the past American emigrant history of the region, as in his view of "Independence Rock," a view that received three paragraphs of explanation in Jackson's *Descriptive Catalogue of Photographs*—one historical, one geological, and one topographical.[27]

Settlements in the West received a newly elevated treatment now that Jackson was with the Survey. Gone this year were the more prosaic, and descriptive, views of streets, temporary housing, false-facade storefronts. In their place were two extraordinary studies of frontier mining towns: "South Pass City" (illustration 52) and "Atlantic City, South Pass" (illustration 53).

These views represented far more sophisticated extensions of his 1869 attempt with Wasatch, Utah (see illustration 34). Assisted by the variegated terrain of the Wyoming region, Jackson had often sought vantage points requiring hours of riding; the results were views that set towns as jewels in the extraordinary sweep of wilderness surrounding them. Now Jackson used the distant view not to produce a panorama but rather to fill the surrounding space with rocks, sky, hills, and prairie valleys. In addition, the photographer used light to pop the city from its darkened surroundings; in the view of South Pass City, the sunlight glistens miraculously off two strips of fencing in the middle ground and limns the facades of the buildings in the far background. In "Atlantic City," the timing is even more precise: the sun has set in the foreground, and Jackson has photographed in the few minutes before the city, too, disappears in darkness. Between the camera and the city, the trunks and branches of whitened, blasted trees gleam against the dark sage and grass.

How much these views served as celebrations of human settlement, and how precisely Jackson manipulated his medium to communicate the message, should be evident. The view of South Pass City, especially, sought to place the town within that broader context of symbiosis between man and nature. Here Jackson has moved a step further in his vision of Western development; whereas the Survey presaged habitation, here the city represents it. For that reason the tenuousness of the town's presence, the power of nature expressed as geology, is important to recognize—it suggests

Jackson's desire to find some more honorable precedent for Western development than simple domination, a theme that almost overwhelms the stereo views of this year (illustration 54), with their recurrent images of scenic wonders, Survey members almost invariably standing, often waving, at the tops. In these larger town views, Jackson seems to have wished for something more—something perhaps unattainable: a balanced ecology of the West that might benefit both elements of the equation without stripping either of power. Eventually, Jackson would lose that fantasy and accede to the inevitability of a different transformation of the West.

Jackson, Hayden, and the rest of the Survey completed their work sometime in late November or December. After the party split up at Fort Sanders near Cheyenne, Jackson and Stevenson went down to Denver and the Manitou Springs region of Colorado, then headed directly for Washington by train carrying the completed negatives and the photographic equipment. In Washington, Jackson found himself offered the position of official photographer to the Survey, at a year-round salary, with offices and darkroom in Washington. Although it meant leaving his Omaha studio in the hands of Mollie and abandoning the notion of an even slightly settled domestic life, Jackson accepted the job.

In Washington, all energies now turned feverishly to the task of publishing and promoting the activities of the Survey. For Hayden, to conduct research without making the results immediately accessible was to render

54.

"282. Pyramid Rock, Near the La Bonta," 1870. USGS

the work valueless, not least because credit for scientific discoveries went to the first to publish, and not necessarily the first to discover. In the past, he had hurried *Preliminary Reports* out as quickly as they could be written and printed and had published material, and urged his colleagues to publish, in other journals, both scientific and popular. This year the rush was even greater, for Hayden's superior, Secretary of the Interior Columbus Delano, had included in his letter of instruction the order that Hayden "prepare a preliminary report of your labors, which will be ready for publication by January 1, 1871."[28]

So while Jackson and Stevenson continued their work, Hayden sped to Washington to complete the report, and those colleagues whose papers he planned to publish strove frantically to keep up with his demands. By the time Jackson had returned to Omaha, and then headed for Washington, D.C., however, it was far too late for his photographs to serve as sources for the engravings that would illustrate the *Preliminary Report.* Instead, Hayden had to be satisfied with a set of primitive wood engravings that combined Elliott's scientific sketches, with their precise, even exaggerated, delineations of geological strata, with some anonymous

engraver's rough approximations of picturesque details (illustration 55).

Despite this setback, Hayden set Jackson to work printing up the negatives from the last two years. Already the Survey head had worked out a number of uses for the prints. He had apparently contacted at least one publisher of stereographs, to arrange publication of a set of views entitled "Camp Scenes with the U.S. Geological Survey," and the negotiations had gone well enough to require that Jackson begin printing in January of 1871. In addition, he was sending out copies of views as quickly as Jackson could print them, to such "friends of the Survey" as the representatives of the Union and Central Pacific, the Denver and Rio Grande Railroad, and other business interests in the West. In one case, railroad agent Robert H. Lamborn wrote back to Hayden ordering "1,000 copies of at least *one* of the pictures you had taken along the route of our road, if I can get them at cost." Lamborn wanted the pictures to mount in prospectus books advertising the railroad—and he wanted them immediately. Presumably loose prints went to members of Congress as well, in an attempt to gain influence at appropriation time.[29]

Meanwhile, a more permanent means of disseminating the Survey's photographs had to be found. Here Jackson's own contacts bore fruit. Not only did he approach Anthony and Company, resulting in an eventual arrangement for publication of some two hundred negatives, but he also discovered an Omaha colleague named J. F. Jarvis, now Washington's largest manufacturer of stereographs. Jarvis eventually served as publisher for the majority of Survey views for the length of Jackson's tenure.[30]

With its primitive wood engravings and reports from agronomist Thomas, paleobotanist Leo Lesquereux, and others, Hayden's *Preliminary Report* appeared sometime in January of 1871. The report set the type for Hayden's publications over the next decade; it was a manifesto for the West, aimed at the broadest possible audience, arguing for the settlement, exploitation, and recreation of the region. Hayden described his goals for the *Preliminary Report* best in a later version:

The wisdom of the policy of publishing for the people the immediate results of my surveys, in the form of annual reports, even though somewhat crude, has received emphatic sanction by the great demand for them in past years and the general satisfaction they have given. I have, therefore, made them the receptacle of a mass of observations on the local geology of the routes which I cannot introduce into a more elaborate final report. The attempt, also, to give to these annual reports a somewhat popular as well as scientific cast has met with the cordial approval of the students of geology and natural history all over the country. I trust, therefore, that they may be continued from year to year.

And Hayden was right. Combined with the photographs and, in later years, chromolithographs drawn from pictures by Jackson and the Survey artists, the Survey's reports were among the most successful works of popular science in nineteenth-century America. As the new congressional appropriation of $40,000 (twice the previous year's) revealed, Hayden's policy of ambitious, rapid, and complete dissemination was a success, and Jackson was a crucial linchpin to the Survey's mission. Describer of scientific phenomena, reflector of Eastern myths and values, transformer of those beliefs to the new realities of the economic West, disseminator of information both descriptive and evaluative, Jackson had successfully constructed a role as witness and expediter of the transformation of the American West.[31]

By the time the Survey Report went into circulation in the spring of 1871, Jackson was firmly entrenched in the Survey family, a relatively well-paid staff member, a vital element in Hayden's carefully conceived plan for making his organization the central scientific and documentary force in the exploration, settlement, and exploitation of the American West.

Jackson's first year with the Survey was, at the time and in retrospect, a significant success. Despite his haste in entering Hayden's service, despite his total lack of education in scientific matters—geology and geography especially—despite Hayden's own confused demands and the conflicting desires of his two artist compatriots, Gifford and Elliott, Jackson succeeded in producing a body of work that presented a consistent and persuasive vision of the West.

Probably the single most powerful element contributing to his success was his development of a photographic aesthetic that reconciled the many conflicting notions of the medium in the mid-nineteenth century. Jackson's 1870 pictures succeeded as popular illustration, as scientific evidence, as art, as propaganda, as sensuous description, as cultural link, and as collector and disseminator of information.

Jackson's collection was a remarkably complete set of studies of the Western landscape, an elaborate survey of the range of interactions between man and the Western land, from *terra incognita* to urban settlement. If most of his pictures emphasized the relationship between man the explorer and an awesome yet neutral terrain, that was to be expected, given the already-established Eastern vision of the explorer as a heroic figure, a front man for the willed destiny of American civilization. That it also satisfied Hayden's desires for a celebration of the Survey was simply the specification of the larger myth.

With the 1870 Survey, Jackson had succeeded in making himself a central figure in the development as well as the dissemination of the developing dominant ideology of the American West. His greatest success, however, lay not with his invention but his consolidation of levels of significance for the region, as commodity and as myth. Brilliantly, he had assembled, collated, and then actualized the wide range of ideas

Fig. 1.

Chalk Bluffs, Cretaceous No. 1, near Blackbird Hill, Nebraska.

55.
"Chalk Bluffs . . . ,"
from Hayden,
Preliminary Report . . .
1870. PC

about the area at and beyond the frontier. Because he encapsulated his synthesis in the form of photographs, the conjunctions lost their forced quality, their internal contradictions, their incongruence with other geological, geographical, climatological, cultural, and economic realities of the West. Instead they came to seem part of one vast transcendental chord, a triad in which nature, the explorer, and the waiting spectator all conjoined to suggest a coming, grand harmony.

Jackson was assisted in this to some extent by the felicitous inclusion of Gifford on the Survey. Gifford reminded Jackson of the visual language of Eastern landscape ideals and offered him the newly appropriate vision of the luminist; with Gifford's influence, Jackson was able to expand vastly the accessibility of his pictures to cultivated Eastern viewers. At the same time, Gifford brought West with him the new ideology of American landscape painting, wherein the pristine land increasingly existed as raw material to exploit in the production of the finished product—the artwork. A view like "Castellated Rocks on the Chugwater," with its image of the painter at work (illustration 56) revealed the same process of expressing the West as a commodity as did the view, obviously demanded by Hayden, of coal-bearing hills near Laramie. Gifford taught Jackson the concordance between visual and economic possession and exploitation of the land.

Equally important was Hayden's presence, both actual and tactical. Hayden's instructions to Jackson reinforced the scientific qualities of the photographs, preventing them from losing their rhetorical force as truth, even as they gained accessibility as

art. And Hayden's choice of route was brilliant. As the team moved West along the old Oregon–California trail, the pictures became works of history, reminders of the heroic taming of the West already legendary in 1870. But equally important, the Westward trail gave legitimacy to the entire project, because it framed it within a region and along a set of landmarks familiar to a huge number of literate, middle-class Americans and satisfied a general hunger for information about that fabled strip of land connecting East and West. Finally, however, the return route reinforced Hayden's commitment to the exploitation of the West and his belief in the good faith of the powerful forces already committed to that exploitation. By choosing to follow the line of the Union Pacific, Hayden guaranteed that his list of uses to which the region would be set would have a sympathetic and grateful ear among the most influential American businessmen and politicians. And the entire season's explorations virtually ensured generous rewards to the railroad, which would sell or exploit what lands it held and service those it did not. But Hayden's choice was practical from another standpoint as well. Because the railroad was already built, and the land already in the process of transformation, Hayden could be sure that his investigations would rapidly bear practical fruit.[32]

Yet in 1870, Jackson made few pictures of the railroad. Already, it seems, he was conscious of the work he did for Hayden as constituting a complete archive, and the railroad pictures from 1869 had fully explored this subject. Rather than continuing his tendency to simplify the relationship between man and land by setting technology as the

final weapon, Jackson retreated into a position that used the mannered poses and civilized signs of the Survey figures in the landscape to present the West as a region already acceded to the inevitability of civilization.

This phenomenon manifested itself in Jackson's more general appropriation, adaptation, and application of the artistic conventions of the landscape art of his time. The tripartite division of artistically treated landscape—beautiful, picturesque, and sublime—had come to correspond not only with states of nature but with states of perception and consumption, in the increasingly popular visual treatments of American landscape, from the large canvases of the painter Frederick Edwin Church to the marketing triumphs of the chromolithography firm of Currier and Ives. Beautiful landscapes not only signified an orderly, fruitful realm where nature gave up her bounty to man in a literal sense; they also reminded the viewer of an internally "natural" state of harmony, rest. The picturesque, with its "pleasing irregularity of form" represented an intersection of wilderness and human perception, wherein nature existed to provide visual lessons for man. The sublime, that realm of omnipotent, absolute nature unsullied by man, had become something increasingly close to an amusement park thrill, terrifying to a point, but never really threatening. This quality of the sublime as parlor trick had been the element of Jackson's 1869 work he had drawn most directly from A. J. Russell; it reappeared in the stereos of 1870.

But Jackson continued to evolve away from that overly simplistic construction of the sublime in 1870. Now his 5-by-8 views in

particular applied lessons from Gifford and Elliott in introducing Survey members into the scenes. However, Jackson transformed the convention of the silenced onlooker, primarily by applying it without altering the boldly detailed and persuasive verisimilitude of the photograph. The result, especially when Hayden, Gifford, and Elliott were posing, was an exceedingly persuasive description of respectful men in a true and truly awesome surrounding.

Still, we must remember (as Jackson continually reminded his viewers) that these were members of the government Survey, advance men for an inevitably encroaching civilization. Jackson's spectators pointed to the sublime to remind Eastern viewers of what sublimity was, and to remind them of its passing. And this provides an important subclause to Jackson's assertion of the power behind nature. In 1869 he had devised a temporal separation between the powers of nature and man that enabled both to retain potency and to be celebrated, but he did not set their powers at war with each other. Now, in the security of the Survey community, with Hayden's oracular convictions about the taming of the West ringing in his ears, and (most important) with another year to work out the destiny of the West, Jackson changed his position considerably. Now the photographs took on an elegiacal quality, reminiscent of the communication of regret and passing that pervaded many of the Eastern painters of the time. Even as the expedition surveyed the empty, pristine land, its members' respectful silence began to resemble graveside etiquette.

This sense of the transience of nature's power was not always there in Jackson's pho-

tographs, for Jackson's body of work did not constitute a carefully constructed, internally consistent ideology. Rather it was the result of an individual's adaptation to, and adaptation of, his culture's understandings. Witness "109. Bad-Lands on Blacks Fork" (see illustration 39). Here Jackson's spectator is present not only to replace us on the scene

but also to drive home the utter desolation, the hostility of the locale. Nonetheless, this vision of an unoccupiable West represents the exception in the season's work.

Much the same tempering and reorienting occurred with his analogues to the aesthetic categories of the beautiful and the picturesque. For Jackson, adopting these cat-

56.
"Castellated Rocks on the Chugwater," 1870. The artist is Sanford Robinson Gifford. USGS

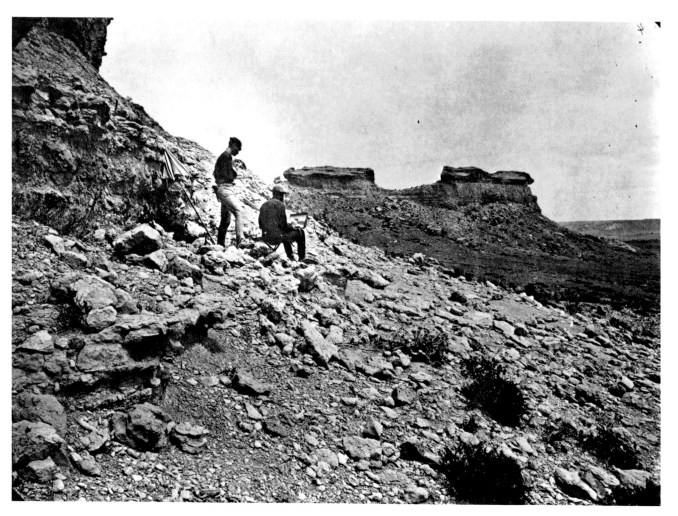

egories implied two possibilities, both divergent from the prevailing aesthetic of landscape painting.

The first involved simply reforging these painterly modes in the harsher and more persuasive medium of photography, making them analogues for seeing, feeling, and acting upon the land. The second possibility lay with seeing these elements as implying *potential* relationships of nature to man in the specific region Jackson had chosen to photograph. Hence a view like "153. Pleas-

ant Park," with its image of two men lounging in the grassy valley surrounded by rock faces and piney woods, appeared in the *Descriptive Catalogue* described as "a small picturesque valley." It was picturesque not by its form—in that case it would have been beautiful, since it was defined by peace and order rather than irregularity—but by its actual and potential relation to man; it was the object of aesthetic contemplation.

This vision of the West as simultaneously actuality and potential was the core of Jack-

son's aesthetic in 1870. The photographs that resulted served both as works of visual pleasure and as propaganda for the coming transformation of the West. But Jackson's pictures had as well to satisfy Hayden's desire for images that would serve as evidence, proof—scientific documents and compendia of data, even as they were material exhibits of the possibility for economic exploitation of the region. These elements Jackson wove in as intrinsic parts of his visual treatment of the scenery. "134. Beavers' Work" (illustration 57) was an extraordinary description of the stages of clearing trees. It was also a delicate and very lovely formal arrangement even as it suggested a concept of nature as a collection of warring species dependent on destruction for their own survival. A Survey member dipping his cup in a river near the "Camps of the 10th and 11th of September, Near Church Buttes [107]" (see illustration 46) signaled the presence of potable water even as the rest of the picture emphasized the vastness of the surroundings and the heroics of the Survey.

All this gave a peculiar irony to Jackson's studies of pristine landscape. As the Survey figures increasingly edged into the rectangle of the photograph, they correspondingly represented the process by which this empty land would be transformed. So it is not surprising that the elegiacal quality that appears in the earliest photographs of this year, thanks to the influence of Gifford, became less prominent as the season went along, to be replaced by studies of interaction between man and the land.

The last image Jackson photographed that season is the most disturbing in its implications for the future—of Jackson and

the West. It is a whole-plate made at Fort Sanders, the last rendezvous near Cheyenne before the Survey broke up for the season. Entitled "A Collection of Buffalo, Elk, Deer, Mountain-Sheep, and Wolf Skulls and Bones Near Fort Sanders" (illustration 58), it is less a photograph than a trophy. Someone—Jackson, perhaps, or perhaps some representative of the Army Corps at Fort Sanders—had constructed an elaborate pyramid of bones. The picture that resulted is thus both a testimonial to the variegated species of animal in the West and an image of death. What is most disturbing, however, is the ambiguity of the picture. Is this a description of the Darwinian hostilities of nature, hostilities that will end when man has come to the West—or is it a premonitory image of the hand of man on the landscape?

58.
"161. A Collection of Buffalo, Elk, Deer, Mountain-Sheep, and Wolf Skulls and Bones Near Fort Sanders," 1870. USGS

Though they inherited without questioning their parents' belief in the superiority of America over all other nations, [the generation that came into power in 1876] had a belief of their own that the country belonged to them by right of conquest as well as by right of inheritance: it was theirs to do with as they pleased. Unlike their fathers they saw themselves not merely as inhabitants but as owners, and with an owner's instinct they sought to find out the value of the patrimony.

—JOHN BRINKERHOFF JACKSON,
American Space . . . , 1972[1]

The spring of 1871 was a heartening one for Hayden and his Survey. Though late, the appropriation bill that passed Congress provided an unparalleled appropriation of more than $40,000. That spring also saw the bureaucratization of the Hayden Survey, with the addition of offices, darkrooms, specimen rooms, full-time staff, and the other attributes of a small managerial establishment. Requests for copies of the *Reports* grew significantly; Hayden began developing a small publishing empire to disseminate individual photographs, portfolios, articles, and books—all of which brought the Survey imprint into the public sphere.[2]

For Jackson, the winter had been hectic, and the spring was equally so, with demands from Hayden for prints, an entirely new studio and darkroom arrangement to set up and maintain, as well as the more general pressures of resettling. By the end of the spring, Jackson had immersed himself in the all-male company of scientists, explorers, plainsmen, government appointees, and manual laborers who worked for and around the Survey, while Mollie remained in Omaha to run the studio. He had become, comfortably, one of the permanent members of the Survey, joining Hayden, Stevenson, and Elliott. And by early June, he and his fellow veterans were in a state of "tremendous enthusiasm" as they left for Denver and another season of reconnaissance.[3]

The reason was clear enough: Hayden had managed to finesse a number of other exploration parties in order to preside over the first official government and scientific study of the fabled Yellowstone region. Hayden's decision to capitalize on the Washburn–Doane–Langford 1870 explorations of the Yellowstone region, and thereby exploit the subsequent burst of publicity and interest in the region, was a brilliant tactical move. That Langford's public lectures and his *Scribner's* articles were imprecise, even sensationalist, and that the 1870 party had done little true scientific work certainly provided some measure of motivation. But equally important was the guarantee of a rich appropriation from Congress and significantly increased public attention that such a destination promised.

The Yellowstone region, with its sublime canyon and its wild geological wonders, had been the stuff of legend since the 1830s, as the reports of fur trappers and mountain men worked their way along the complex channels of gossip from West to East. Each expedition and each report since 1859 had served to further excite interest even as each

59. (*opposite*) *"Hydraulic Mining, Summit of Hoosier Pass, 40 Miles West of Denver," 1871.* NAA

95

contributed to the developing public vision of Yellowstone. The last party, the Gustavus Doane–Nathaniel P. Langford-Henry Washburn expedition of 1870, did the actual naming of most of the geological phenomena, perhaps contributing the most to this vision by choosing hellish images as their sources and by repeating the Indian description of the place as a locale unfinished by God. And the experience of expedition member Truman Everts, who was separated from the party and believed lost until he turned up after a month of near starvation and desperate circumstances, only emphasized the sense in which this last unknown region came to represent the paradigm of wilderness. Yet at the same time, Everts's own potboiler account of his adventure for *Scribner's Monthly* contained the seeds of a new definition of useful wilderness—as a fictionalized land whose thrills were always safe thrills and whose sublimity never truly suggested the puny limitedness of humankind. He ended his tale with the assertion that "the time is not far distant when the wonders of the Yellowstone will be made accessible to all lovers of sublimity, grandeur, and novelty in natural scenery, and its majestic waters become the abode of civilization and refinement." And N. P. Langford, writing in his *Diary of the Washburn Expedition to the Yellowstone and Firehole Rivers in the Year 1870,* argued that the Yellowstone region

possesses adaptabilities for the highest display of artificial culture, amid the greatest wonders of Nature that the world affords, and is beautified by the grandeur of the most extensive mountain scenery, and not many years can elapse before the march of civil improvement will reclaim this

delightful solitude, and garnish it with all the attractions of cultivated taste and refinement.[4]

For Hayden, Jackson, and the others, the desire to witness this region where geological sublimity outdid artistic sublimity was natural. But it was a desire that bore witness to a national interest in the region as a place of sequestered scenery, a region designed by God for the visual pleasures of tourism. Langford's call for "artificial culture" was an indication; his conclusion to his series of articles for *Scribner's* was unabashed: "By means of the Northern Pacific Railroad, which will doubtless be completed within the next three years, the traveler will be able to make the trip . . . and thousands of tourists will be attracted . . . in order to behold with their own eyes the wonders here described."[5]

Hayden had timed his exploration perfectly: Langford's and Evert's articles had excited public opinion, but no extensive study had as yet been made. And, more important, no photographs or factual visual illustrations had been presented to give a proper picture of the scene. Finally, the Yellowstone was a perfectly Haydenesque geological subject, a spectacular example of geology as scenery. It would be Hayden's task to popularize Yellowstone, to convert it from legendary to scenic landscape. With that mandate in mind, Jackson, Stevenson, Elliott, and the rest of the Survey moved up from Denver to Ogden, Utah, prepared themselves, and awaited their mentor.

When Hayden met the party in early June, he brought with him news of additions to the Survey, concessions to his "employers." These were "half a dozen youths,

sons or protégés of men prominent in the official or political life of Washington," in Jackson's words—sons of senators, representatives, and delegates from the territories as well as other well-connected lobbyists and legislative figures. The most prominent proved to be Chester M. Dawes, son of Massachusetts Senator Henry L. Dawes, who would eventually serve as a principal spokesman for the bill designating Yellowstone a national park.[6]

Hayden's party was also soon to be graced with a second batch of supercargo sent out by influential Easterners, though neither Hayden nor the rest of his party yet suspected as much. He was Thomas Moran, landscape painter.

This was the year that Jackson and Moran would forge their friendship, and together produce the first mature artistic analysis and presentation of the Yellowstone region. Moran, who had drawn a series of illustrations for Langford's article, "The Wonders of the Yellowstone," published in *Scribner's* in 1871, was eager to experience the region firsthand. His illustrations of Langford's reminiscence had been derived from fairly inept drawings by two members of Langford's 1870 expedition. Moran's woodcuts were heavily Europeanized versions of the Sublime (illustration 60); apparently the reports he depended on to flesh out the available sketches suggested to him that something more profound might be discovered in the actual landscape.

Moran, perhaps more than any other painter of his time, represented the perfect amalgam of scientific realism and Turneresque Romanticism. And like Gifford, Kensett, and Whittredge before him, Moran

must have sensed that little time was left to see true wilderness in the United States. Accordingly, he used one of his paintings as collateral for a loan from *Scribner's* and arranged for General Alured Bayard Nettleton, financier Jay Cooke's office manger for the Northern Pacific Railroad, to get him a berth with the Hayden Survey. Nettleton wrote Hayden on June 7, 1871:

Mr. Moran is an artist (landscape painter) of much genius, who goes out under the patronage of Messr's. Scribner and Co., Publishers, NY, and our own Mr. Cooke on whom . . . you will confer a great favor by receiving Mr. Moran. . . . [I assure you that] Mr. Moran will be a very desirable addition to your expedition, and that he will be almost no trouble, and it will be a great accommodation to both our house [Jay Cooke and Co.] and the [Northern Pacific Rail] road.[7]

Eastern capitalists would be an increasing influence in the affairs of the Survey and of the Yellowstone story in particular as the supporters of the railroad moved to boost general interest in the West, particularly its potential as a tourist area. This letter, however, did little good; Hayden was racing around the country and never received it. But Moran went West anyway and was able to persuade Hayden to take him on.[8]

By the time Moran arrived, the Survey had already made a major portion of its season's exploration. Leaving Ogden, Utah, on June 1, it had traversed the shore of the Great Salt Lake to Willard City, then moved into the Wasatch Range and Cache Valley, and up to the Snake River Basin at Fort Hall. After a two-day rest, the party followed the stage road to Virginia Junction, then took an old road down the Stinking Water to Virginia City. The explorers then moved east to the

Madison River and headed downriver to Fort Ellis, at the top of the Gallatin Valley. Hayden reported in his "Letter to the Secretary" a year later that "A narrow belt was thus surveyed, connecting the Pacific Railroad with the Yellowstone Basin, our principal field of operation." That it was also a strip in which the Northern Pacific Railroad was vitally interested is not surprising.[9]

This early portion of the year was critical for Jackson. It not only produced an entire body of work but eventually served as well to provide ballast, resistance, to the persuasive aesthetic of the painter Moran. And from the beginning, Jackson worked at a level almost impossible to imagine from the photographs of the previous years. On one plane, the pictures simply drew upon and extended his discoveries of the year before—and in this respect, experience printing those earlier photographs, and a winter's season to meditate over them, must have had some effect. Yet these new photographs were also noticeably different than their predecessors. The themes remained the same; it was the mannered visual conventions acquired from Gifford that disappeared or were submerged into the work, replaced on the surface by an understated directness that effaced the photographer yet energized the pictures. "Camp Near the Head of Cache Valley, Utah" (illustration 61), for example, applied the same mathematics of meaning as the previous season's best work: infinite nature, the Survey as representative of current civilization and prefiguration of civilization to come. But now the terms had changed. The angle of view—downward, in 1870, to fill the frame with information when confronted with such flat, endless topography—is this time di-

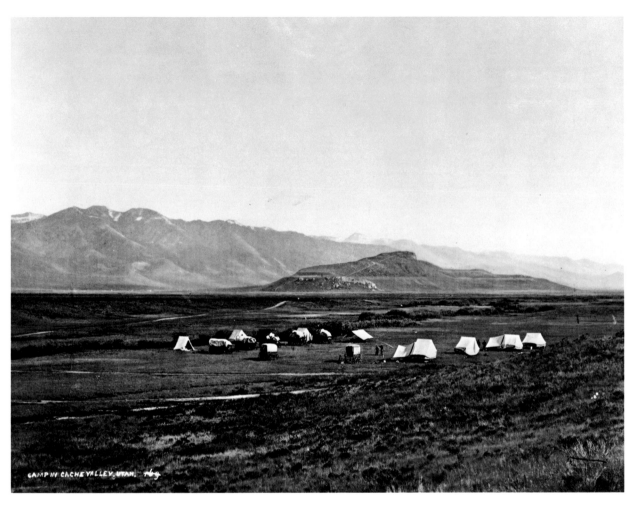

61.
"Camp in Cache Valley, Utah," 1871. USGS

thirteen or so buildings that constituted the town of Fort Hall. This time, blank sky occupies nearly half the frame.[10]

The immediacy of this transformed view is instantly evident. In "186. Camp on the Stinking Water" (illustration 63), we see directly, without the need for nudging or pointing. In addition, we see from a greater distance in all three of these views—and in most of Jackson's photographs for 1871. The result is the loss of the ostensible subject of the picture in the increasing immensity of space (as is the case with "Camp on the Stinking Water") or in the wealth of engrossing alternatives, as would happen with the views of Yellowstone—or the firmer, more believable placement of these emblems of human settlement in the verisimilitude of their surroundings.

Part of what made these alterations possible was a change in equipment that Jackson made before leaving on the 1871 expedition. Rather than using the 5-by-8 "half-plate" camera of his 1869 and 1870 pictures, he bought new 6½-by-9 and 8-by-10 cameras. Instead of outfitting both cameras with new lenses, however, Jackson apparently chose to use the lenses from his older 5-by-8 camera on the smaller outfit. The result was a significant change in angle of view and in the way the camera saw space. From the same vantage point, much more appeared on the ground glass of the camera, objects were pushed back, and context was crowded in. More profoundly, space grew deeper, more dramatically recessive. And finally, the lens appeared to "fold" the space—to be looking both down and straight out at the same time. The result was a set of views in which

rect. The foothills and the mountains behind them serve as a barrier; the camera stares across the tough prairie grass, the settled order of the Survey's camp, following the stripe of the road, on to the blank expanse of white sky that fills fully a third of the frame. "177. Fort Hall, Idaho" (illustration 62), made a few days later, is even more striking. Choosing to shoot shortly before sunset, Jackson made the most of the raking, punctilious light, which describes every single strawlike blade of prairie grass—including the shadow of Jackson and his camera and tripod silhouetted in the right corner—on its way to the

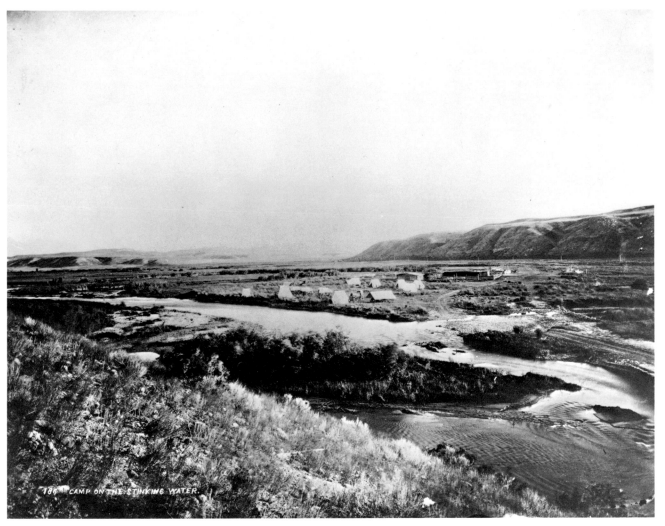

63.
"186. Camp on the Stinking Water," 1871.
USGS

curred because the wider angle lens presented the earth as an inviting bed onto which the viewer was invited, rather than a wall at which the viewer looked.

Another phenomenon also made these pictures more compelling invitations to enter, occupy, and transform. For at Virginia City, Jackson made his first views describing the actual exploitation of the West, in the form of a series showing the process of hydraulic strip mining. Here the new visual style and the new subject matter meshed perfectly. With their carefully opaqued skies and the incisory line of horizon high in the frame, the photographs presented the intersection of natural and man-made wastelands (illustration 64).

With Jackson at the height of his powers, Moran on board as artist, and the rest of the party in a fever of excitement, the Survey left Virginia City late in June for the Yellowstone region. Previously, Hayden had arranged with Captain Barlow of the Army Corps of Engineers for the Corps' small expedition to accompany the Survey; the resulting Barlow–Heap expedition traveled under the same army support as the Geological Survey. Accompanying them was a Chicago photographer, Thomas J. Hine. In addition, the company picked up another photographer, J. Crissman of Bozeman, Montana, whom Jackson remembered well from 1869, when Crissman had graciously lent Jackson and Hull his darkroom in Corinne, Utah.[12]

The first marvel of Yellowstone was Mammoth Hot Springs, reached after the party set up base camp and began their explorations of this supposedly untouched region of *terra incognita*. But despite Jackson's later claim that they were the first white men to see

the sublimity of silence and infinite space replaced the more conventionalized perspective of the work of the previous year; the viewer participated directly in the act of meditation, without stock spectator figures to instruct and, simultaneously, obstruct.[11]

These views repeated, in a new style, the message of 1870: the West was there, awesome yet unthreatening, awaiting consumption. Now, however, the assimilation of the image grew more difficult, demanding more of the viewer than simply the conventional glance of spectator at artwork in a gallery or an Academy salon. Yet, paradoxically, these were also views that invited the expropriation of the land itself. Formally, this oc-

these springs, Hayden reported that the Survey arrived to find a group of invalids taking the waters!

In truth, the end of the wilderness was evident even here; *three* groups of "outsiders" had already entered Yellowstone, though Hayden only noted the one that would best support his construction of the area as a near-miraculous work of nature to the visual, spiritual, and physical benefit of man. Even this group, the invalids, appeared in edited form in Hayden's report; in reality they had created a rough sort of settlement they called "Chestnutville," and it was on the way to becoming "McQuirk's Medicinal Springs," one of the squatters' claims that were to serve as trouble spots when the debate over the conversion of Yellowstone to a national park began in 1872. And one of the "invalids" was A. Bart Henderson, who was there to begin construction of a toll road into the region. The second party was composed entirely of entrepreneurs—two Bozeman, Montana, men who had laid claim to the Soda Springs area. And the third group was an amateur exploring team, a precursor of the Victorian and Edwardian tourist–explorer cadres. This one included a U.S. Mining Commissioner, an Indiana businessman traveling "for his health," a reporter and author, and A. F. Thrasher, a Virginia City photographer there to publicize the natural wonders.[13]

Hayden's party, too, treated the privilege of exploration as an excuse to behave like tourists. Hayden later wrote for *Scribner's* that "the whole party were filled with enthusiasm to catch a glimpse of the wonderful visions of which we had heard so much." Passing through the lower canyon, the water gave

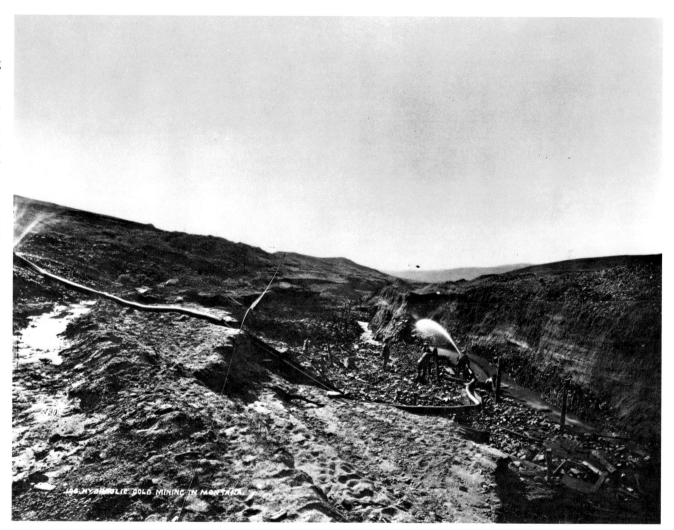

a most picturesque view to the eye as we looked from our lofty heights. Not the least attractive feature, and one that amounted to a wonder, was the abundance of fine trout which the river afforded. There seemed to be no limit to them, and hundreds of pounds' weight of the speckled beauties were caught by the different members of our party. But we cannot linger here, although the scenery is very attractive.

Jackson's view of the "Valley of the Yellowstone, Looking South from the First Cañon" (illustration 65) conveys the sense of exuberant discovery that Hayden's account recalled. Down from the viewer's high vantage point the valley is spread, open, inviting, full of delectable visual pleasures.[14]

As the party moved inward, however, Jack-

64.
*"190. Hydraulic Gold Mining in Montana,"
1871.* USGS

65.
*"200. Valley of the
Yellowstone, Looking
South from the First
Cañon," 1871.* USGS

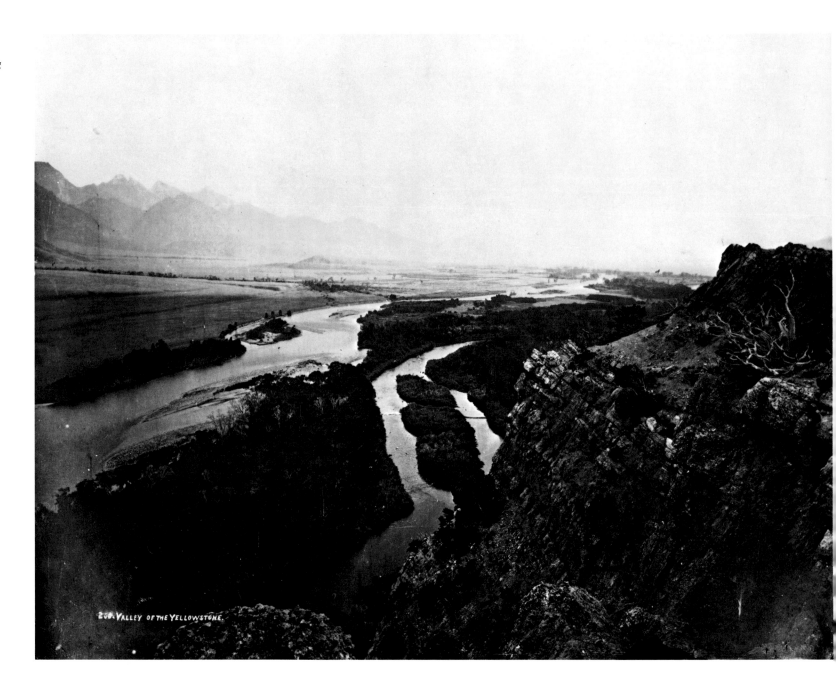

200. VALLEY OF THE YELLOWSTONE.

son's views began to change. Confronting the actuality of Yellowstone, its alienness, its geological freakishness, and its utter isolation, Jackson's views began to look more like records of an incomplete Creation. His photograph of "Tower Falls" (illustration 66) had required great pains to make. Because the ravine was too dangerous to take the darkbox down, Jackson had set up the camera at the bottom, then climbed up and back with collodion plates covered with wet blotting paper to keep them sensitive, a process that required four round trips and a half-day's work. The best of the resulting photographs rewarded him by presenting a terrifying aspect: the barren rock walls stare down; the viewer feels stifled, diminished, judged. This is the other sublime—not of space and silence, but of claustrophobia, noise, hostile alienation.[15]

In part this change in attitude must be accounted for by the influence of the painter Moran, whose painting style had some of the qualities Jackson applied at Yellowstone. In fact, the two men developed a collaborative relationship that was to continue for more than twenty years, with Moran assisting Jackson in the choosing of "points of view," and Jackson providing Moran with powerful finished products that could serve as "sketches" for Moran's paintings. Moran himself reported in his diary for the expedition that, at Yellowstone Lake, he had "sketched but little but worked hard with the photographer selecting points to be taken etc." When the two arrived at the Upper Fire Hole Basin in Yellowstone, Moran again reported: "Went to the Geysers. Helped Jackson during the day and returned by myself to camp." But the photographic evidence, particularly the

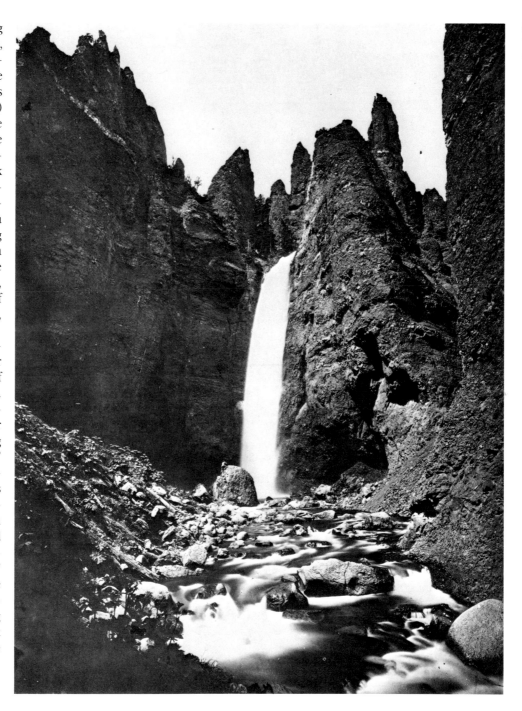

66.
"233. Tower Falls, 115 Feet," 1871. USGS

103

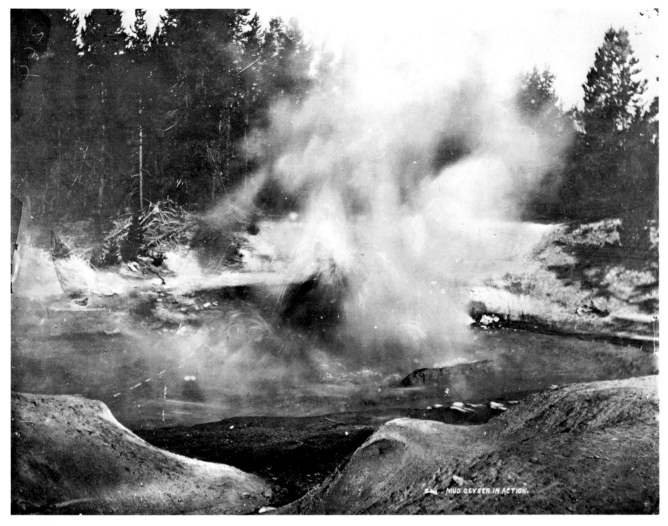

MUD GEYSER IN ACTION.

67.
"264. Mud Geyser in Action," 1871. USGS

68. (*opposite*)
"295. Crater of the Castle Geyser," 1871. USGS

assurance of the views made before Moran joined the party that year, suggests that the two men had a relationship marked by interaction rather than subjugation, and that the work of both benefited as a result.[16]

The geological and environmental surprises of Yellowstone existed in microcosm as well as macrocosm, and the geysers, mudholes, and other phenomena provided far more difficult problems for the photographer than did the scenery, in which he was more experienced. Exposure times made it impossible to produce large-plate views that captured the geyser effects—a problem that Jackson solved later by retouching the negatives, scratching in pyrotechnics, or painting on clouds and expulsions with the opaquing paint normally used on skies (illustration

67). That Hayden demanded views of these geyser effects is certain; the result was a series of photographs that, to modern eyes, look blatantly falsified, but to Jackson's contemporaries probably satisfied better than accurate views.[17]

The Survey members rarely appeared in Jackson's photographs of 1871; as we have seen, the photographer chose instead to bring viewer and subject together directly, without pictorial intermediaries. But one of Jackson's views of the geysers did include a human figure. It is "Crater of the Castle Geyser" (illustration 68), a photograph so central to the ideals of Jackson, Hayden, and their generation that it appeared and reappeared in various pictorial forms dozens of times, including a number of variants by Jackson himself, a painting and a chromolithograph by Moran, and various scientific and popular texts about Yellowstone and the West. Within the body of Jackson's Survey work, it is an odd picture; within the collection of rather understated, descriptive views that characterized the majority of 1871 Yellowstone images, it is seemingly out of place. Yet in its way it encapsulated a number of the central premises of the Survey, particularly concerning the interlocking structures of nineteenth-century science, philosophy, and art.

As a work of scientific description, this photograph seems all wrong. First, the spatial and scalar ambiguity of the picture seem to deliberately confuse rather than clarify. The space of the scene seems alternately shallow and infinite. And the crater of the Castle Geyser itself cannot be measured. Indeed, an inexperienced viewer might easily study the picture carefully without ever feel-

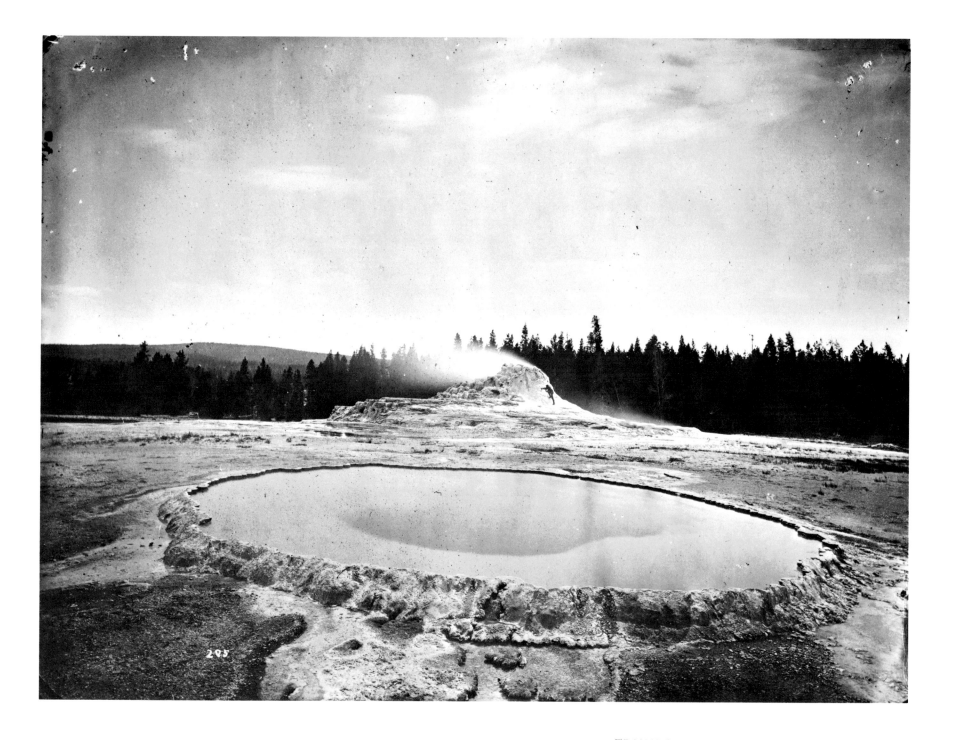

ing certain of what its true subject was—a quiet pool of water in a near-perfect circular form, the obviously steaming geyser mouth in the background, or the human drama that upstages it. All of these qualities violate the rules that classified mid-nineteenth-century photography as a scientific tool, rules that insisted on clarity of description, particularly of scale and space, in return for which the photograph was invested with particular power as fact-gathering agent.[18]

In truth, one can only conclude that the picture's purpose has nothing to do with scientific description or accuracy. Rather it reflects another tradition of landscape photography during this era, exemplified by Jackson's contemporary Eadweard Muybridge. Muybridge's theatrical and extremely popular views of California's Yosemite adapted nature to make the picture, rather than attempting to reproduce the subject by an attentive apprenticeship to the medium and its descriptive possibilities. Muybridge's boast that he had cut down giant trees in order to gain access to the best points of view and avoid distracting formal elements is an indication of the way that this aesthetic of the spectacular treated nature as raw material for the photograph and, finally, the viewer's response.[19]

With Jackson's photograph as well, scientific description is subverted to two other motives: art and propaganda. As an artistic object meant to delight the viewer it is an excellent work. As propaganda, too, it is remarkably successful. Here the Survey geologist is presented heroically risking his life to gain the scientific evidence necessary to understanding the workings of nature at its most unexpected and strange. Yet it is not

danger but adventure that the picture conveys; though the gesture is one of bravery, the stillness of the near pool, the tilted flag of steam coming from the far geyser, and the strip of dark trees behind all suggest that no vengeful explosion will occur. Thus the picture, failing as scientific description, succeeds as metaphysics; it provides its viewers with a lesson in the power and graciousness of nature. And because it is a photograph, the view draws its message out on a number of planes ranging from specific to general: it celebrates the individual geologist (probably Hayden himself), the Survey, the scientist as figure, and man himself.

Finally, though, we must see that Jackson made the picture by stitching together two parts: the foreground, in which the viewer stands directly next to one geyser pool, and the background, in which the geologist climbs atop another. Jackson thus yokes together two seemingly dissimilar experiences—the geologist's actual participation in the exploration and its dangers, and the viewer's passive, surrogate participation by viewing. The result is to reorient both phenomena; the geologist becomes himself a tourist, chipping off a bit of the scene to take home and examine at leisure, even as the viewer becomes an adventurer, testing his or her courage at the edge of a beguiling danger. Yet in both cases, nature appears as an unthreatening producer of visual and theatrical effects.[20]

This photograph and its implications represent an extreme in the work of 1871; still, it was a minority position that would grow steadily throughout Jackson's Survey career and would emerge triumphant as the aesthetic of appropriation during the commer-

cial years of a later decade. For the time, however, such images would remain countered by other views, like his study of "Yellowstone Lake, Looking South from Where the River Leaves It" (illustration 69), in which the pure pleasure of once again encountering the wonders of *terra incognita* stilled all other voices, and the picture became once again a respectful witness.

Jackson, Hayden, and the rest of the Survey returned to the East early in October of 1871, in a state of mixed exhaustion and preparatory frenzy. Hayden had made a calculated gamble in choosing to explore Yellowstone; the national attention focused on the region by Langford's and Everts' articles had been exploited by congressional forces, nursed, magnified, and elevated in tone. The appropriation to Hayden became a potent political act, a symbol of congressional involvement in the West, dedication to its potential, and power over its administration. By September of 1871, the *New York Times,* which had earlier reported noncommittally on a lecture by Langford, now declared its allegiance to Hayden's explorations:

Hitherto the reports that have reached us, have been mainly those of popular as distinguished from scientific observers. Those now to be furnished, on the other hand, we have a right to anticipate will be trustworthy, exact, and comprehensive, and will thus supply much needed information as one of the most wonderful tracts of the American continent.

In late October, the *Times* reiterated its position:

the official narrative of the Hayden expedition must be deemed needful before we can alto-

gether accept stories of wonder hardly short of fairy tales in the astounding phenomena they describe. . . . Professor Hayden's official report, which, we hope, will not be long delayed, will enable us to arrive at conclusions more positive.

Hayden, now *Professor* Hayden, had become the "official," the "scientific" source—had become, in other words, the voice of the government, with its implications of accuracy, reputation, and weight.[21]

The Professor had borrowed heavily on the prestige of Yellowstone; payment was due. This necessitated a sophisticated report, with high-quality engravings and, perhaps, accompanying photographs. But return to Washington brought an equally pressing summons: Jay Cooke's Northern Pacific representative A. B. Nettleton, having already contacted Moran and a number of Western political figures, now wished Hayden to make a recommendation in his report that "Congress pass a bill reserving the Great Geyser Basin as a public park forever—just as it has reserved that far inferior wonder the Yosemite Valley and big trees." Meanwhile, *Scribner's Monthly* was waiting for an article. An editor had written Hayden in early September, asking for an essay "to accompany the illustrations" of Moran. On November 13, the editor wrote again, that "I think the Department [of the Interior] will look upon such articles as a part of the good work it is doing in exploring the far away and peculiar regions of the country." By this time Hayden had already agreed—the rest of the letter urged him to consider other articles on "the Badlands of Dakotah and the wonderful unknown parts of the West."[22]

Hayden was later to claim credit for the designation of Yellowstone as a national park. But the official records of the government, letters to and from the principals, and the debate itself as recorded in the *House and Senate Reports* together describe a set of circumstances different from the common legend that Jackson's photographs, presented in bound portfolios to a number of influential senators and congressmen, single-handedly turned the tide for passage of the bill. The setting aside of Yellowstone resulted not from heroic individualism but rather from the continuing *entente cordiale* among three "interests" with widely different reasons for their desire to see the area a national park: banking and railroad corporations hoping to use the park to generate tourism in the region; government representatives who had explored the area and wished to see its wonders preserved; and a loose amalgam of more local Western interests who saw the potential park as a booster item for the region.[23]

Probably the most influential force came from two American capitalist entities par excellence—Jay Cooke's banking firm and the Northern Pacific Railroad. Cooke, engaged since 1869 in the attempt to raise some $100 million for the Northern Pacific, had effectively taken control of the railroad and was searching for any means possible to expedite his increasingly difficult marketing task. Thus it was Cooke who instructed the governor of Minnesota to call N. P. Langford back from Helena, Montana, to meet with the Northern Pacific representatives. How completely the Cooke strategy was unified and orchestrated is unknown; still, the firm's assembly of forces seems in retrospect brilliant. By mid-November, J. W. Sexton, one of the Cooke directors, had begun to marshall

propaganda, in the form of copies of Langford's *Scribner's* article, to present to members of Congress. Langford's influence was soon buttressed by that of the Northern Pacific's long-time friend, F. V. Hayden, who personally argued the case, along with Langford and Wyoming Territorial Representative William Horace Clagett, to every member of Congress over that winter.[24]

But Hayden's most impressive contribution, apparently, lay with the fact that, as Langford recalled, he "brought with him a large number of specimens from different parts of the Park, which were on exhibition in one of the rooms of the Capitol or in the Smithsonian Institution (one or the other), while Congress was in session." And those specimens included Jackson's photographs, one set of which went back to J. G. Smith, president of the Northern Pacific, in mid-January.[25]

The role of Jackson's photographs was straightforward: along with Hayden's other specimens, they acted to support the spectacular accounts of eyewitnesses in the popular presses and served as proof that these accounts were not wild Western hyperbole but descriptions of fact. Indeed, that was the function they played in the congressional debate as well. Senator Samuel Pomeroy of Kansas directed the debate in the first reading, and his argument in favor of the bill straightforwardly presented the photographs as part of the larger body of incontrovertible evidence that the region was worthy of denomination.[26]

In addition to the exhibition, Hayden also had Jackson print a number of the Yellowstone photographs for distribution. How many, however, is unknown; at least one

senator wrote Hayden later in the spring thanking him for a set, which he reported having "examined with great interest." But the fabled "bound albums," "portfolios," and "publications" of pictures that Jackson, his son, and most historians of Yellowstone have claimed carried such weight in the final vote apparently never existed as anything but individual productions, although the titles *Yellowstone's Scenic Wonders* and *Views of the Yellowstone* have persisted to plague photographic historians since. It seems likely that Jackson printed and had mounted on USGS imprints a number of the best views, which Hayden then distributed (in more or less elaborate packaging depending on the recipient), while he, Langford, and Clagett lobbied for passage of the bill. These served, then, as documentary evidence to weight Langford's published account, 400 copies of which were printed and distributed to members of Congress.[27]

The successful selling of Yellowstone as a national park has been presented for more than a century as a triumph over odds. Yet in fact the bill passed easily; the only trouble seemed to be getting sufficient numbers of congressmen to the floor, a difficulty that prevented its passage around the Christmas recess and postponed a final vote until January. But the passage has behind it a different drama from a conflict between dreamers and nay-sayers. Rather, the debate and the behind-the-scenes negotiating focused on proving to certain congressional recalcitrants that the boosters of the national park were in fact advocates of Western development, rather than nature lovers with a nostalgia for virgin land. The success of Hayden, Langford, and Clagett lay in their convincing

Congress that the national park idea was in total agreement with a vision of the West as a developed, fully exploited region.[28]

This seeming sleight of hand derived quite neatly from Hayden's vision, presented most completely in the introduction to *Sun Pictures*. Hayden's notion of a West of multiple uses, in which each region had its god-given purpose for man and should be so developed by man, was inherently applicable to the Yellowstone debate. One would, for example, have expected Hayden to have been mortified by the presence of invalids at the pristine park. In fact, he was delighted—it proved, as he later wrote in his article for *Scribner's*, "the sanitary effects of the springs." By the time Hayden's *Preliminary Report* appeared, this had been expanded considerably. Hayden reported that "around these springs are gathered, at this time, a number of invalids, with cutaneous disease, and they were most emphatic in their favorable expressions in regard to the sanitary effects. The most remarkable effect seems to be on persons afflicted with syphilitic diseases of long standing." Hayden's delight at these usurpers reflected his desire for proofs of the infinite usefulness of the West, a conception that was reinforced by his allies in the Yellowstone Park movement. Under their eyes, Yellowstone became presented as a specimen of the sublime that was, finally, useless for any other purpose—as Hayden pointed out again and again in his *Scribner's* article and in his *Report.*[29]

Hayden's concern for the passage of the park act had many levels. Primarily, he saw Yellowstone as a place where the government might order and regulate the wilder-

ness to make it more amenable to man. Thus his concern, and that of his allies, over the squatters already prepared to exploit the region lay not with their motives but with the haphazard, incomplete development that would result from their unregulated style of entrepreneurism. Far better was a plan whereby the government, the Northern Pacific, and the Cooke banking establishment could all have a hand in the progressive development of the region into a tourist haven, the better to benefit those Americans who wished to witness its wonders. And in fact this became the case, as Langford's annual reports, published in the *Congressional Globe* at annual appropriation time, indicated; the government supervised access and development in an orchestrated arrangement with the powerful forces of Eastern capital and business.

Implicit in Hayden's concept of Yellowstone as a specimen of virgin land and sublime spectacle was the premise that its preservation assumed and forgave the transformation of all the other Western lands. When Congress finally voted, it was only after the principal proponents of the bill had assured their colleagues of two facts: first, that the region was without exploitable resources other than tourism; and second, that its designation would result in increased traffic to the region, which would bring Eastern capital and transportation, guaranteeing economic development of the surrounding area.[30]

Jackson's photographs intersected perfectly with this vision of the West. In presenting Yellowstone as a fairyland bounded on one side by high cliffs (see illustration 65) and on the other by a lake that edged on in-

finite space (see illustration 69), Jackson had already constructed the walls separating this corner from the rest of the West. By presenting its wonders in a fashion alternately spectacular and understated, Jackson succeeded in suggesting its entertainment value without appearing to be spinning tall tales. Jackson's few images of the Survey itself in the region here reinforced the authority of the report; they suggested the heroic seriousness of the scientist, or they revealed the men in poses that presaged the genteel Victorian pleasures the area would offer in the future—fishing, strolling, or boating.

The designation of Yellowstone as a national park on March 1, 1872, was only part of Hayden's purpose in lobbying. The second lay with vindicating his role as the premier government scientist. Hayden's prominence on Capitol Hill and his published reports, first for *Scribner's* and then in the form of the *Preliminary Report,* served him well in this regard. By the end of the spring, Congress had passed a new appropriation, dependent upon Hayden's return to Yellowstone for a more complete and final survey, of $75,000. In addition, Congress designated $10,000 more for the specific purpose of endowing engravings for the illustrations of the Survey's publications. Now even Congress had ratified the power of the visual.

Jackson's photographs, of course, contributed to and benefited from Hayden's success in this area. For while they were not the prime forces behind the designation of Yellowstone as a national park, their more general power remained and grew even as their emphasis changed. The year 1871 represented perhaps the last time when Jackson's photographs would serve as proof, transportable evidence, of the wonders of the West. While vast portions of the region would remain unexplored for another decade or more, still Yellowstone represented the last outpost of truly surprising, legendary material—with the exception of a few scattered phenomena that Hayden and Jackson would ferret out over the next three years. On the whole, even the wonders of the Rocky Mountain fastnesses and the legendary Grand Canyon of the Colorado would prove only to be larger and more spectacular examples of phenomena whose outlines had already been discovered and transmitted back to the centers of American culture. Instead, Jackson and Hayden would find other uses for the photographs—as themselves the end-products of Survey expeditions, returned as if not specimens but valuable materials, visual gold or silver; or far more mundanely, as mere scientific aids, made to enable mapmakers to calculate angles of view, estimate distances, and discover relationships between elements, in the grid-

70.
"496. Hydraulic Mining in Alder Gulch, Near Virginia City, Montana Territory," 1872. The eccentric skyline here is the result of imperfect retouching. USGS

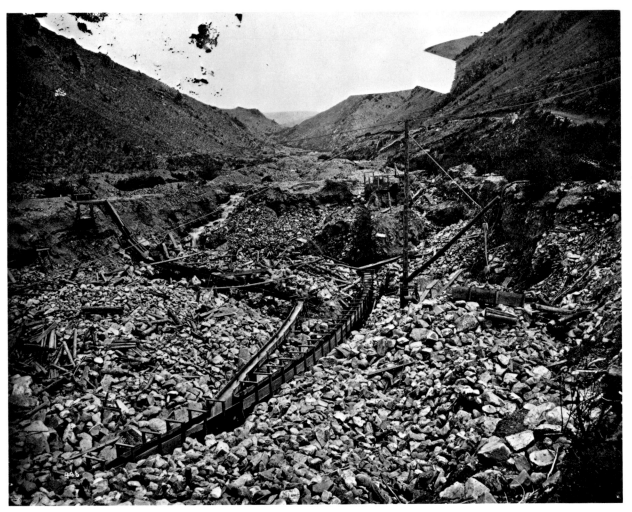

ding, reorganizing, and transforming of the West.

Hayden and Jackson returned to the field in 1872 with a huge new appropriation and fully established reputations as the greatest figures in their professions in the West. But the currents of Western exploration and development had begun to change; subtly, at first, then more forcefully, the ebullient sense of discovery that had characterized their first years together muted to a more professional, less adventurous style.

The itinerary for 1872 was itself evidence: rather than seeking out new wonders, the Survey was returning to Yellowstone to re-explore the region, supposedly on a more leisurely and scientific basis, while a party directed by Stevenson began the process of topographical mapping that Hayden had avoided for so many years.[31]

Jackson's pictures, too, became improvements upon his established positions rather than new discoveries. His view of "Hydraulic Mining in Alder Gulch, Near Virginia City, Montana Territory" (illustration 70) is superb; it is also a straightforward restatement of the theme that characterized the previous year's work in the same region: a desolate landscape already raped by nature and hence available to man. His view of "Old Faithful in Eruption" (illustration 71) subtly shifted the balance toward the tourist from the earlier view of the "Crater of the Castle Geyser" (see illustration 68)—but only subtly. A view of the Teton Range (illustration 72) is a visual triumph, but thematically it simply draws together the sense of entrance to an enchanted realm that the first picture of Yellowstone had conveyed, with the spec-

tacular visual effects Jackson had toyed with in 1870, possibly borrowing his techniques from the much-published Muybridge's hyperbolic 1867 Yosemite series.

The 1873 season, spent in the Colorado Rockies, displayed the first disturbing hints of encroaching boundaries in the ostensible infinitude of the West. Both Jackson and Hayden noted in their reports, essays, and diaries a disconcerting phenomenon: it was becoming increasingly difficult for the Survey to travel through its regions unhindered by the products of development. Now Jackson moved along the demarcation between civilization and wilderness, but this frontier line, rather than following some direct path, meandered about, disappearing and reappearing. Instead of a manly adventure in sublime wilderness, the Survey became a difficult and delicate exercise in small escapes from the prevailing landscape of development:

Three anecdotes from Jackson's diary present the picture.

Tuesday [May] 27th. Broke camp very early—all packed & on the road by 6 A.M. Followed up the right branch of St. Vrain & then struck over towards Little Thompson. Took a side road that promised to lead up into the range about where I thought a fine view of the peak [Long's] might be obtained. Soon came to an ugly termination of our trail & were compelled to camp at 9:30 in a little park high up in the hills. Before dinner prospected about and determined to take a light pack and push ahead up to the top of the range. Started at half past 2 and took a due west course. A mile or two out we came into the same road again that we had started out on in the morning. Appeared to be well traveled and opened out into beautiful little parks. Soon we came upon another road coming in from the south & apparently over

a very [easy?] Pass. Came to the conclusion this must be the main Estes Park road.[32]

May 29, 1873. Delayed a little in the morning by the straying of three mules, but got off by 6 A.M. Pushed on up the cañon, at 9 arrived at the Divide bet.[ween] Big and Little Thompson & obtained a glimpse of Estes Park & it was beautiful. Went down into it and camped by the river side, passing by a two story neat looking log cabin & in one of the windows spied two female faces—one quite young and good looking. Were very much surprised as we supposed ourselves

71.
"440. Old Faithful in Eruption," 1872. USGS

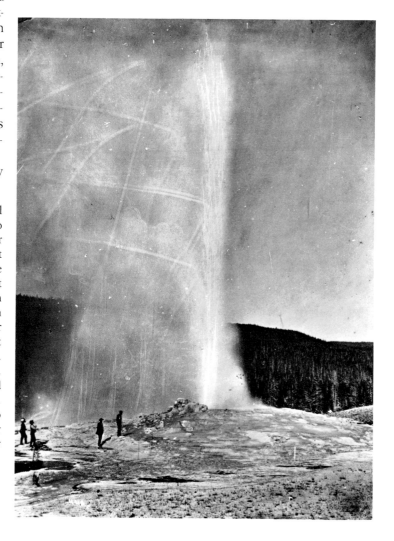

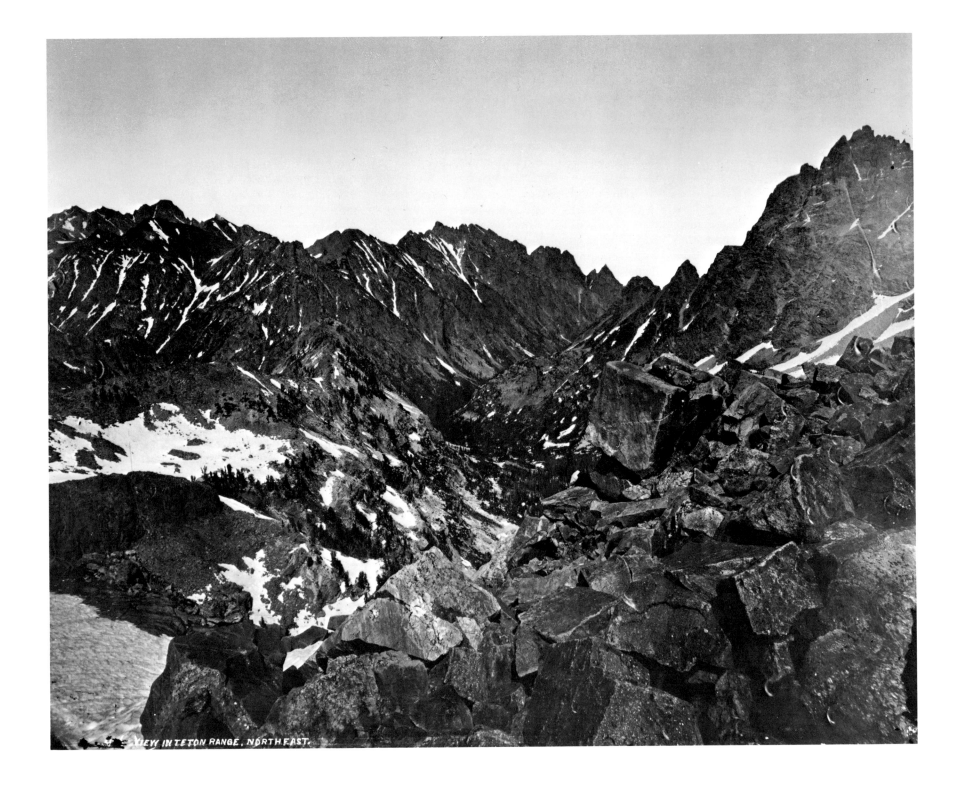

VIEW IN TETON RANGE, NORTH EAST.

outside all such civilization. After dinner went to work at once, & by evening had secured 7 good negatives. After supper went up and called on the occupants of the above two story house & spent a very pleasant evening in conversation with them. Are here just for their health.[33]

June 7: Worked until noon about Castle Rock & got a number of good negatives. Pleasure party came along while I was at work & for photoing them on the bridge left three bottles of claret with us. Packed up and went on thro town over on to Bear Creek; had a glorious dinner. John does tip-top for us & every once in a while serves up unexpected delicacies.[34]

By 1873 this region constituted the fabled frontier. Historian Frederick Jackson Turner in 1893 called it the line between civilization and wilderness—or between settlement and wilderness—but now civilization became a strange combination of tourists, invalids, cunning landholders demanding exorbitant rents for stock-forage, farmers irate over damage to their young wheat fields, nights of good food, and even resident breweries. As Jackson moved through Colorado seeking vantage points from which to make his panoramas, nearly every day brought incidents like these.

Stitching in and out between Turner's two states, Jackson developed a new state of mind, replacing awe and excitement with a professional's self-assurance and a bureaucrat's conditional commitment to the task. Often Hayden became an object of annoyance or amusement:

Rained during the night and did not get up until 8 and did not pack up for the road until 11. About 3 miles out met Bob White with a message from the Dr. to hurry as the "Golden Opportu-

nities" were passing & c.—his usual impatience. From top of [the Continental] Divide descended a very long, steep, wooded hill. Found some quite picturesque little falls that we should have photographed if we had time.

The point is clear: Hayden's push had forced Jackson to forego the very thing the geologist was rushing to get. But another message is hidden here—Jackson noted the "picturesque little falls" as items for photographing, not as evidence of grandeur or messages from nature.[35]

In part these changes resulted from a major alteration of venue that began in 1873 and continued until 1878, the Survey's last year. Eighteen-seventy-three began a five-year period when the Hayden Survey work was limited to the Colorado region, from the "Four Corners" section in the south through the Rockies. The result was, necessarily, that Jackson found himself increasingly moving through an older, more settled region of the West. But more important was the process of development occurring even as the survey did its topographical and exploratory work; railroads were built, towns laid out and peopled, whole areas flourished at an accelerated pace. Arriving at Silverton in 1874, Jackson wrote in his diary that "as we enter the town we find that it consists of about a dozen new homes—half of them still in course of construction, and town lots staked off over pretty much the whole valley." By 1878, the picture would be wildly different.[36]

For Jackson, the mountains became a sort of vertical frontier, substituting for the horizontal spaces of earlier years. Most of Jackson's views during the last five years of the Survey were studies of mountains; his most

spectacular discovery, the fabled Mount of the Holy Cross, was just one of them. Jackson's tour de force became the panorama, a long view composed of anywhere from two to six plates. Photographers had been making those multiple-plate images virtually since the invention of the medium, but Jackson added important innovations. First, most of his panoramas were designed so that at least half of the views could be sold as satisfactory, even dramatic single-plate images. This was necessary because the panorama already did double service. As a work of rhetoric, it produced a dramatic effect of omnipotence and omniscience on the part of the viewer, who stood at the height of some stony ridge, master of all surrounding land—but without the effort of mountain climbing (illustration 73). At the same time, its individual plates offered Hayden added scientific insurance by providing backup information in case the topographers' sketches or measurements were faulty.[37]

Alongside these, Jackson began as well to make increasingly picturesque views, and to experiment with larger and larger cameras in doing so. In these views, Jackson returned to the more mannered aesthetic of Gifford and the 1870 Survey; in "Great Morainal Valley of the Arkansas River" (illustration 74), he perched himself or an assistant on the cliff at the far right corner, beneath the artistically obligatory blasted tree. Just how formulaic a view this image was can be seen by looking at its twin, "Mt. Harvard and the Valley of the Arkansas" (illustration 75), where an almost identical blasted tree appears in virtually the same point on the negative. Both of these photographs succeeded spectacularly as pictures by interweaving three ele-

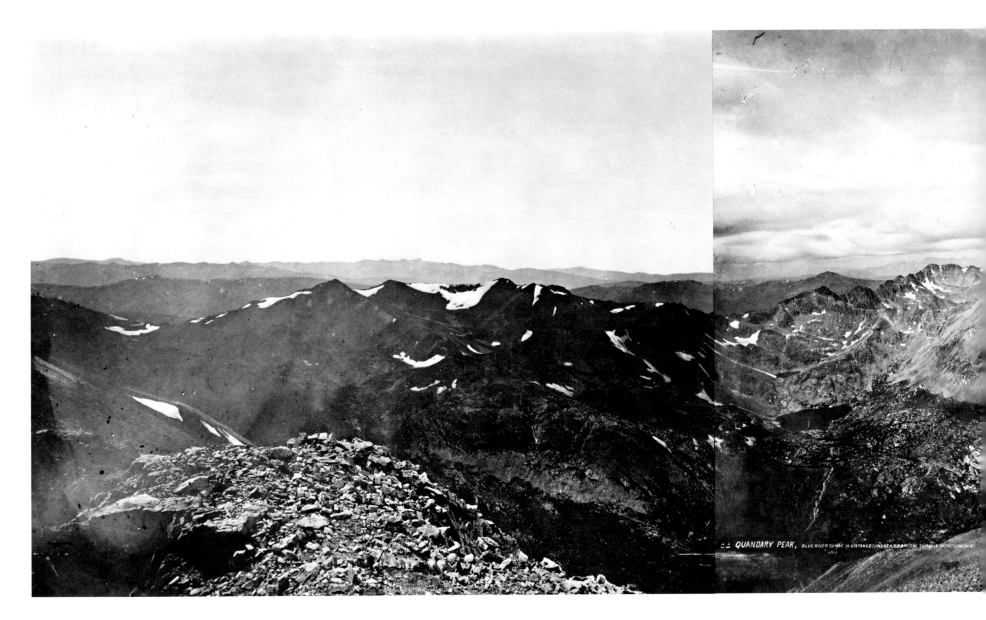

QUANDARY PEAK, BLUE RIVER RANGE IN DISTANCE—NORTH FROM THE SUMMIT OF MT. LINCOLN

73.
*"Quandary Peak, Blue
River Range in Distance.
North from the Summit
of Mt. Lincoln," 1873.
3-plate panorama using
11 by 14 negatives.* USGS

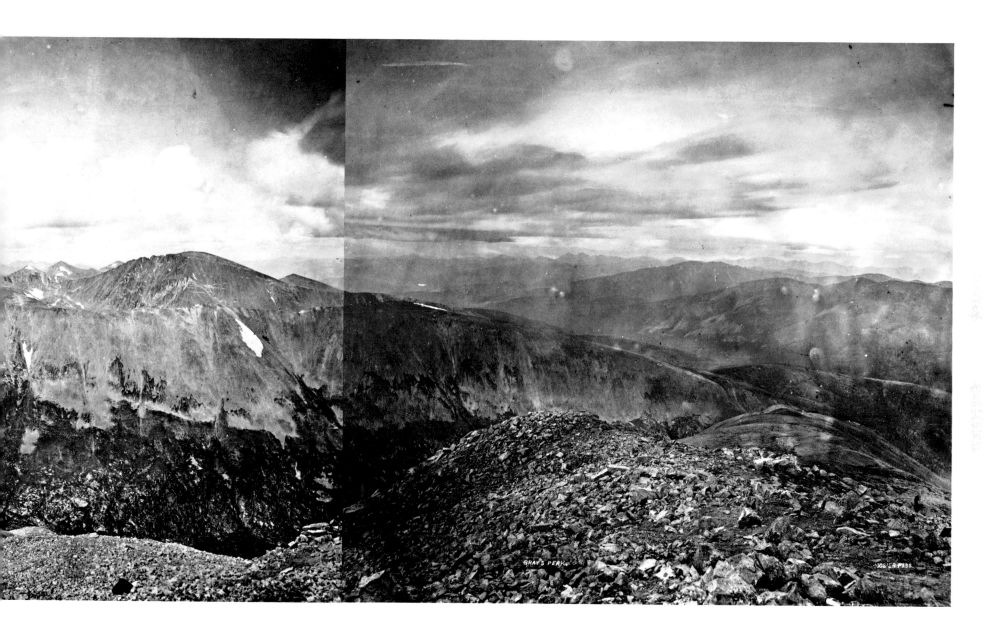

GRAY'S PEAK.

HOOSIER PASS

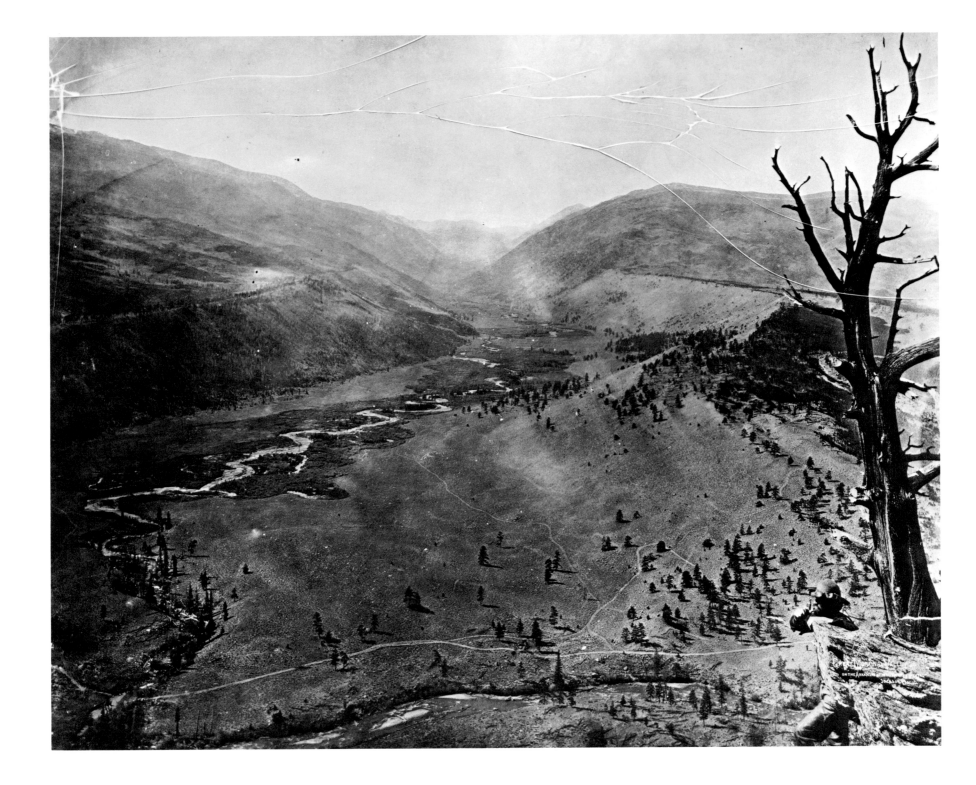

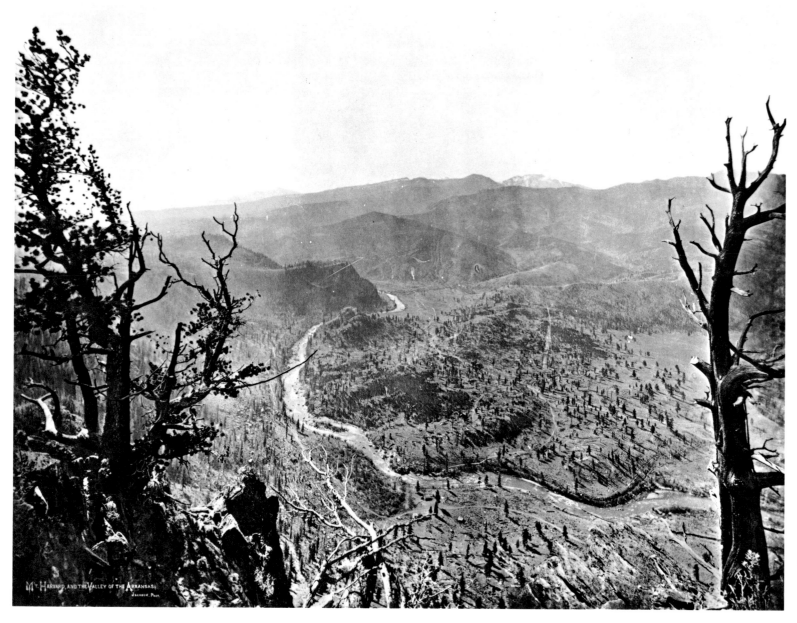

"Mt. Harvard and the Valley of the Arkansas"
JACKSON, PHOT.

74. (*opposite*)
*"Great Morainal Valley
of the Arkansas River,"
1875.* USGS

75.
*"Mt. Harvard and the
Valley of the Arkansas,"
1875.* USGS

ments of the landscape-viewing experience: the safety of convention, the thrill of vantage point, and the delectability of the landscape below, which seems to lay itself out like a courtesan in a rococo painting.

These two types of mountain view—panorama and picturesque study—signified two very different qualities in Jackson's response to the enclosure of the West. In both cases, Jackson sought out points of view that would neutralize, even deny the process of development. In the panoramas, Jackson attempted to use camera wizardry to resuscitate the sense of infinitude native to the views of 1870—and these panoramas were monstrously difficult to make successfully, requiring the photographer to match edges to give a sense of completeness and illusion. In the mammoth-plate views, however, the amplified, theatricalized scene substituted for what was lost. These views (made first in 20-by-24, later in 11-by-14 "Imperial plate" formats) became, increasingly, photographs about "the beautiful," scenes about scenery, composed as if viewed from a train window—but the subjects chosen were inaccessible (at least for now) to the tourist.

Both these types of view, however, were made to be part of a larger series—a series designated by the often-revised *Descriptive Catalogue of Photographs,* which Jackson and Hayden produced to market their views. Here the pictures that presented a supposedly undeveloped West were offered for sale side by side with views of hydraulic mining, townscapes, and the like. Buyers had their choice of Wests to collect: the "new West" of development, or the "old West" of untouched sublimity.

By the mid-seventies, Jackson was at the height of his powers. After nearly a decade, he had succeeded in drawing together the widely divergent elements of his aesthetic training, from Chapman's *American Drawing Book* to the sparse descriptiveness of his colleague and competitor Timothy H. O'Sullivan, and including a wide variety of contemporary landscape photographers, of the West and a heritage of Western photography stretching back to the invention of the medium. Jackson also drew heavily from other artistic media, from the lessons and paintings of Gifford and Moran to the topographical drawings of fellow Survey artists Elliott and now William Henry Holmes. But simultaneously he had lost some part of the sense of mission that had motivated his westering from 1867 to 1871; as the future, developed West became actualized in the present, the drive that had led him in his search for meaning in the West became less and less urgent.

To some extent this must have been a consequence of the photographer's complete assimilation into the world of the government employee—and, particularly, Hayden's employee. Although he had become a formal member of the Survey in the winter of 1870–1871, he had retained his studio in Omaha, leaving Mollie to run the place while he divided his time between Washington, Omaha, and the Survey expeditions. It was not until the late fall of 1871 that he decided to sell the business, a determination influenced in large part by Mollie's pregnancy. Then, in February of 1872, Mollie died in childbirth at his parents' house, while Jackson was in Washington on Hayden's orders,

printing the photographs of Yellowstone for the congressional exhibit.[38]

Just how deeply this event affected Jackson we cannot guess. His relationship with Mollie was an enigmatic one, especially to twentieth-century eyes, marked by long absences on both their parts and by a dearth of personal correspondence. While there was deep affection between them, it was not the sort of swooning sentimentality that had characterized his attachment to Caddie Eastman. Rather Mollie had become a central part of Jackson's life by her acceptance of the necessities of his chosen occupation and by her willingness to share the complex multiple demands of the Western marriage—a bond that may seem to us closer to a business partnership than to the sentimental Victorian ideals of the East, in which mock obeisance on the part of the husband required real and absolute submission on the part of the wife. When Jackson remarried, in October of 1873, it would be to a woman who offered qualities of strength and independence similar to Mollie's. She was Emilie Painter, daughter of Dr. Edward Painter, Indian Agent for the Omaha tribe, and the subject and mentor for many of Jackson's earliest Indian views. This marriage, however, would cleave more closely to the Eastern model, with Emilie largely isolated from Jackson's business and professional life, and left to carve out her "sphere" within the limits of family, home, and "proper" womanly socializing.[39]

The result of this end to things in 1872 seems to have been to cement more firmly Jackson's allegiance to Hayden and to diminish the dissenting voices from within that had served to balance and enrich his pho-

tographs, preventing them from becoming simply propaganda or illustration. The quality of Jackson's pictures would continue to be superb; but the spirit of exploration and synthesis that had characterized those first two years with the Survey would not return.

In its place Jackson began another campaign: to expand his control over the dissemination of Western views, not by stifling other visions but by acquiring them. His aim became, in true American Romantic fashion, to create for the Survey a complete, exhaustive collection of views that covered every aspect of the West as he understood and believed in it.

Jackson had begun this process as early as 1869, when he had, in a fashion common to photographers of the time, used his assistant Hull to make views that he could not, whether because of time or because both stereo and whole-plate views were required. In these cases, the negatives went into the Jackson Brothers' file, landscape equivalents of the pictures the firm had acquired from Eaton and Hamilton. This practice of using an assistant or assistants to make views, often under supervision, would continue throughout Jackson's career. The pictures that resulted often have maddened photographic historians because of their apparent similarity to Jackson's own work. But it would be surprising were this not the case; Jackson trained his assistants, directed them, and chose the negatives that satisfied him for inclusion in his body of work, and it is unlikely that he would have kept photographs that lay outside his vision.

A similar mechanism operated with views that Jackson purchased from other photog-

raphers and then distributed under his own name; these included photographs by Utah photographer Charles Roscoe Savage, probably bought as early as 1869. That year Jackson gave as well as took, for he sold a set of negatives to the photographer Ross while on the same Union Pacific expedition. This was part of the rights of sale for most photographers during the period; ownership of a purchased view was complete and included reproduction and authorship rights. This same marketplace convention covered a series of twelve photographs Jackson purchased from Crissman on the 1871 Yellowstone tour, which Crissman possibly even made using Jackson's own camera.[40]

These processes would continue throughout Jackson's career, representing not an attempt to monopolize production (as characterized Hayden's attitude toward exploration of the West) but rather a more Humboldtean Romantic desire to hold the widest, most complete assemblage of views possible—as Jackson's willingness to credit Crissman, and to note the many sources of the Indian photographs published under the Survey aegis, indicates.[41]

But in the matter of dissemination, Jackson and Hayden were in a collaborative conspiracy: both attempted to widen their influence to its maximum, using the views on the one hand, and the powerful managerial bureaucracy of the Survey on the other. To do so, they devised a sophisticated set of interlocking products, using a wide variety of media to promote their vision of the West and guarantee their influence.

The first and most authoritative medium was the scientific report or monograph. Hay-

den's preliminary and final *Reports* formed two examples of this genre; the *Bulletin,* in which Hayden allowed his fellow scientists to discuss aspects relevant to the Survey or its results, was another. But Hayden did not simply use the scientific report form—he modified it. The 1871 version is characteristic in this respect, not only because its subject was so important and hence its distribution so wide, but also because Hayden's need to prove the value of the appropriation necessitated a masterful job.[42]

Other historians have noted how dissatisfying Hayden's first Yellowstone report was and have pointed to the negative responses in the scientific community. But this represented only a minor aspect of the work itself. Hayden used the *Report* to present his vision of the West, in terms extraordinarily similar to those in his text for *Sun Pictures.* Once again, the West became a place where "the Creator" had provided for all forms of efficient human use, from mining, farming, and timbering to boat rides and parklike scenery. Yellowstone itself was, however, the set piece this year; whereas previous Surveys had focused on geological exploitation or agricultural potential, Yellowstone represented the tourist realm supreme, providing the perfect Victorian combination of visual spectacle, scientific education, and moral lesson. Here again, visual materials, and Jackson's photographs especially, became integral parts of the process of discovery and presentation, and the audience widened from a narrowly scientific one to the widest possible segment of American culture.

The 1871 *Report* was not exceptional. Where it lacked, in fact, was in the so-

76.

"Camp of the United States Geological Survey, On Shore of Lake," from Hayden's Sixth Annual Report . . . 1872.

CAMP OF UNITED STATES GEOLOGICAL SURVEY, ON SHORE OF LAKE.

phistication of its visual material; 1872 was the first year that a separate appropriation would make possible sophisticated wood engravings and lithographs by Bierstadt's Photo-Plate Printing Company, the Sinclair Company, Louis Prang, and Julius Bien, four of the finest engraving firms in America. But Hayden was already planning an enlarged publication program for visual materials even as the 1871 *Report* was being distributed; in early February, Edward Bierstadt wrote announcing that proofs were ready for lithographic reproductions from "three negatives received from Mr. Jackson," and offering to print them "at the rate of about 500 per day."[43]

Bierstadt's offer begins to suggest the popularity of the Hayden Survey material. This corresponded to Hayden's wishes that the Survey act as agent for an entire process by which a new democratic science was made available to all through the most accessible methods possible. In 1877, producing one of his periodic defenses of the Survey for the Secretary of the Interior, Hayden wrote, "The Survey has . . . perfected the means of spreading among the people a vast amount of information of the most practical and economic as well as strict scientific value, while the publications of a technical character compare favorably with those of the learned bodies of any country." And the scattered publication data suggest that these books, large and loaded with scientific in-

formation, were relatively good sellers—the 1874 *Report,* originally slated for 600 copies, was sold out and went to a second run of 1,500.[44]

Hayden's notion of a multiple-purpose publishing house that could define the "most practical and economic" future of the West even while announcing heady scientific discoveries offered multiple benefits to the culture he served and to the Survey. The *Reports* and *Bulletins* by their sheer volume and physical weight helped to ensure continued congressional support; so did the letters from scientists like Othniel C. Marsh of Yale and the equally famous James Dwight Dana, letters that returned the favor of publication or access to specimens by extolling the virtues of Hayden's editorial empire.[45]

But the published materials had honorable purposes; one of the most important, in Hayden's eyes and in the eyes of many others, was the rapid dissemination of information. While Hayden believed that the Survey thereby better served its public mandate, spreading news about mining or agricultural opportunities to the widest audience in the shortest time, still the almost instantaneous publication had another, perhaps unexpected effect: the resulting documents contributed to a general increase in the pace of Western change, both as commodity and as ideal. Whereas older ideas about the West had evolved over a great deal of time, allowing for a general percolation throughout the culture through a set of influence chains—including academic journals, congressional debates, election speeches, newspaper reports, and word of mouth—Hayden's new ideas, theories,

and recommendations reached the public in an authoritative, relatively finished form often only months after the observations that had inspired these conclusions. Some scientists rightly complained that such haste resulted in incomplete analysis, but perhaps a greater effect came in the more popular "practical and economic" areas. There, theories and observations came in a package; the result was to limit and direct the process of free debate and participation that had theretofore characterized the generation and transformation of myths about the West.

Jackson's photographs played an increasingly central role in all of Hayden's publications, including the *Reports*. Whereas in 1869 illustrations were drawn from primitive wood engravings, in 1870, a more accurate, photographic style had supplanted those earlier renderings, perhaps because the draftsmen worked from Jackson's photographs or were familiar with them. By 1872, however, the engravings themselves were being derived by tracing from the photographs (illustrations 76, 77), resulting in an illustration style that brought the scenic views into closer correspondence with the extraordinarily sophisticated scientific illustrations that appeared in both the *Reports* and the *Bulletins* (illustration 78). For a period, however, many of the Survey illustrations combined the heavily fictionalized Romantic painterly style with the graphic and scientific style (illustration 79). This represented not simply a transition of technique but a more complex transition of philosophy. Hayden's affection for the more grandiose and stylized images side by side with the drier work reflected his generation's

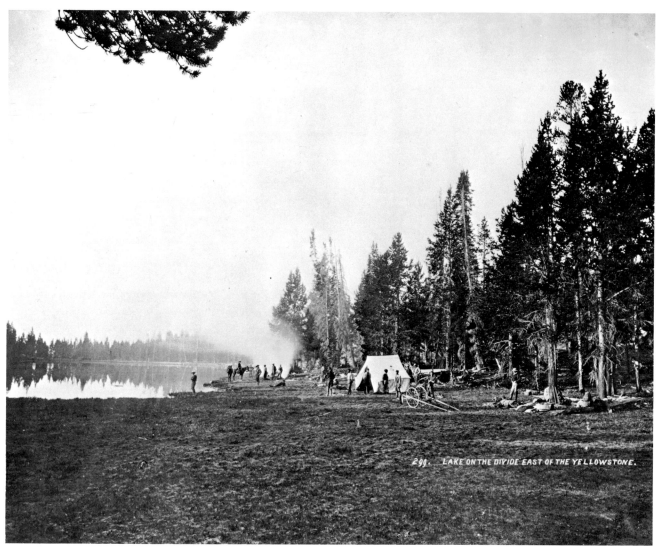

intersection of art and science in a common goal: the investigation and presentation of the mysteries of nature. And as Hayden's own writing indicated, he was nothing if not the yearning, incomplete Romantic, unable to determine whether the source of perception came from without or within, whether the true subject of study was the personal response or the external cue.

The reports were only one of many avenues by which Jackson's photographs reached American and worldwide audiences.

77.
"299. Lake on the Divide East of the Yellowstone," 1871. USGS

great beauty of the prismatic colors depends much on the sunlight, but about the middle of the day, when the bright rays descend nearly verti-

cally, and a slight breeze just makes a ripple on the surface, the colors exceed comparison; when the surface is calm there is one vast chaos of colors, dancing, as it were, like the colors of a kaleidoscope. As seen through this marvelous play of colors, the decorations on the sides of the basin are lighted up with a wild, weird beauty, which wafts one at once into the land of enchantment; all the brilliant feats of fairies and genii in the Arabian Nights' Entertainments are forgotten in the actual presence of such marvelous beauty; life becomes a privilege and a blessing after

Fig. 54.

FUNGIFORM SILICA.

one has seen and thoroughly felt these incomparable types of nature's cunning skill. There is another geyser, which has a chimney 3 feet high and 5 feet in diameter at the base, with an orifice 2½ feet at the top, lined with the spongiform silica inside, and on the outside adorned with bead and shell work. There is a form of shell crystallization that reminds one of the artificial shell-work made with small thin oyster-shells; the form of the chimney is like an old-fashioned bee-hive. High up in the hills there is one lone spring 20 by 30 feet, with considerable flow, forming with the sediment a high mound 250 yards in diameter; it is constantly boiling up in the center about 2 feet; it has the prettily scalloped rim, and is 250 feet above the river. The group just described is a most remarkable one, and I call attention to it on the chart in which the Bee-Hive and Giantess are located.

Fig. 55.

SPONGIFORM CF CAULIFLOWER SILICA.

We will now pass to the opposite side of the river for a moment, and examine the Castle and its surroundings. Upon the mound on which the Castle is located, there is one of the most beautiful of the calm springs, of which Mr. Jackson secured an excellent photograph; it does not boil at all, but the surface is kept in a constant vibration; the spring has a rim nearly circular, 25 by 30 feet; is somewhat funnel-shaped, passing down to a depth of 60 feet in water that has an almost unnatural clearness to a small aperture, which leads under the shell to an unknown depth; the rim slopes down on the other side all around about 12 inches, 1 to 3 inches thick, most elegantly scalloped, the under sides in leaves like a toad-stool; the inner lining of the basin is a marvel of delicate tracery of pure

Hayden's experience with *Sun Pictures* in 1870 had given him a sense of the power that the photographic book might have, and he eagerly participated in the production of booklike albums that offered the interleaving of text and photograph, the control over sequencing, and the narrative implications of the book form, combined with the greater visual and rhetorical impact of the large photograph mounted on the more grandiose imprinted stock of the album. Jackson's and Hayden's first successful endeavor in this area was a portfolio entitled *Photographs of the Yellowstone National Park and Views in Montana and Wyoming Territories,* released in 1873. It was a thirty-nine-leaf album containing thirty-seven mounted 11-by-14 prints with facing pages containing printed captions and, often, short explanatory essays ranging from a few sentences to two paragraphs, the majority of them apparently written by Jackson and Hayden.[46]

This portfolio signified the extreme of the popular, touristic side to the Hayden Survey years. Jackson and Hayden had chosen the most picturesque of views, including some with the modified arched top that was the popular mode of presentation for landscape paintings and artistic photographs at the time. The size of the prints, as well, dictated that they were the most artful of Jackson's views, and gave them the greatest possible impact. The comments, too, were tremendously revealing. The caption of plate 12, "Crater of the Grotto Geyser," reads:

This is a first-class geyser, and operates with great and long-continued power. It would be very unsafe to remain long in its vicinity did it not give ample warning. The peculiar shape of its crater permits it to hurl the columns of hot water in every direction. The crater is about twenty feet in diameter and six feet high composed entirely of silica. The ornamentation is beautiful and the variety of colors, red, yellow, and green, very attractive.

Here virtually every aspect of the Victorian rethinking of nature extolled by Hayden and Jackson is evident: the obsession with power, the notion of a self-regulated, timely, and hence safe expulsion of energy, the combination of scientific information with aesthetic judgment, and perhaps most important, the vision of the natural universe as a collection of phenomena to be organized hierarchically and then rated.[47]

The development of a commercially feasible, high-quality reproduction process known as the Albertype in the early 1870s offered an entirely new possibility for the mass-reproduction of Survey photographs. The production of original prints from negatives, and the attendant process of mounting each print, now was replaced by a far faster and also more permanent printing technique. Apparently Hayden and Jackson experimented with the idea of using the process to mass-produce popular portfolios as early as 1872, even to the extent of hiring the Bierstadt firm, holders of the Albertype rights, to produce a sample from three Jackson negatives. Then in 1873, Jackson and Hayden went so far as to commission the production of a portfolio from twenty of Jackson's 11-by-14 negatives. The project was canceled, however, when the Bierstadt's factory burned and Jackson's negatives, the Albertype plates, and all but 200 prints were destroyed. These 200, however, Hayden had bound with two double-column pages of text, mounted and bound in an extremely

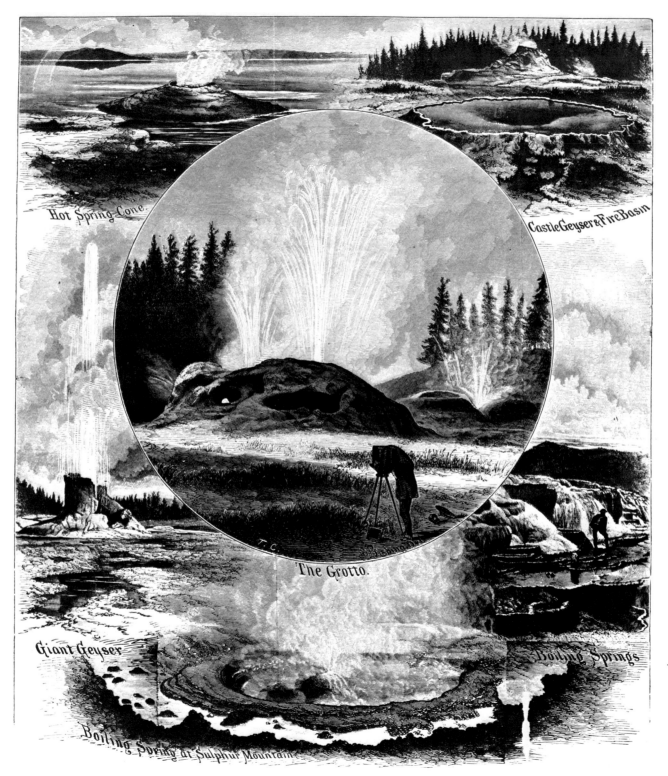

Hot Spring Cone.

Castle Geyser & Fire Basin

The Grotto.

Giant Geyser

Boiling Springs

Boiling Spring at Sulphur Mountain

78. (*opposite*)
Scientific illustrations from Hayden's Sixth Annual Report . . . 1872.

79.
Thomas Moran, "Yellowstone Geysers," 1871. The central image is entirely Moran's; the others are all derived to some degree from Jackson's photographs. Wood engraving from Hayden's Report.

123

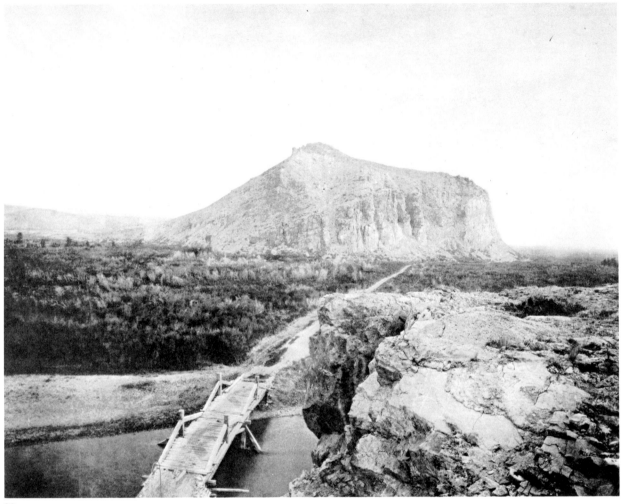

80.
"Point of Rocks. Beaver Head Forks," from the Bierstadt-Albertype portfolio. NAA

81. (*opposite*)
"White Mountain Hot Springs. Group of Upper Basins." Albertype portfolio print. NAA

luxurious 15-by-20-inch folio, and presumably distributed to "friends of the Survey." The project was resuscitated a few years later, and a much larger portfolio was produced, with more than twenty-five plates providing an exquisite overview of the more picturesque side of Jackson's work with the Survey (illustrations 80, 81).[48]

Portfolios represented an awkward transition between the reproduction technologies.

The Albertype was an innovative process not yet inserted into the mass-dissemination machinery necessary to unlock its capabilities. Photography itself was the opposite: labor-intensive and outmoded, but with a sophisticated distribution mechanism already in place. Jackson's photographs were published in a number of forms; by far the most popular was the stereograph. As we have seen, the stereograph was the visual

medium par excellence of American democracy during this era. With millions of views distributed, with stereo viewers in virtually every parlor in the nation, with national distribution houses producing finished cards by mass-production techniques and marketing them through outlets that ranged from stereo view emporia in large cities to bookstores and haberdasheries in small towns and subscription schemes for rural areas, as well as direct distribution through railway, steamship, and other transportation lines, the stereograph was a ubiquitous part of American culture. To guarantee successful distribution of his work, Jackson engaged in a number of marketing deals. One involved Anthony and Company, at the time the largest distributor of stereo views; through this contract Anthony eventually released 700 Jackson negatives, but on mounts of the Hayden Survey—mounts that prominently included not only Jackson's name but that of Ferdinand Vandeveer Hayden. The irregular publication by Anthony, however, was soon replaced by a longer-term arrangement with another sophisticated stereograph manufacturer and distributor, J. F. Jarvis, one of the largest stereo producers in America during the seventies and a specialist in the distribution of government photographs. And even later Anthony and Company again produced a further set of views, this time in its "Rocky Mountain Series." While it is impossible to estimate the numbers of Jackson stereos produced and distributed during the Survey years, their prevalence even today suggests they were among the most popular landscape stereos in America, a necessary part of virtually every stereo collection.[49]

Stereos themselves represented only

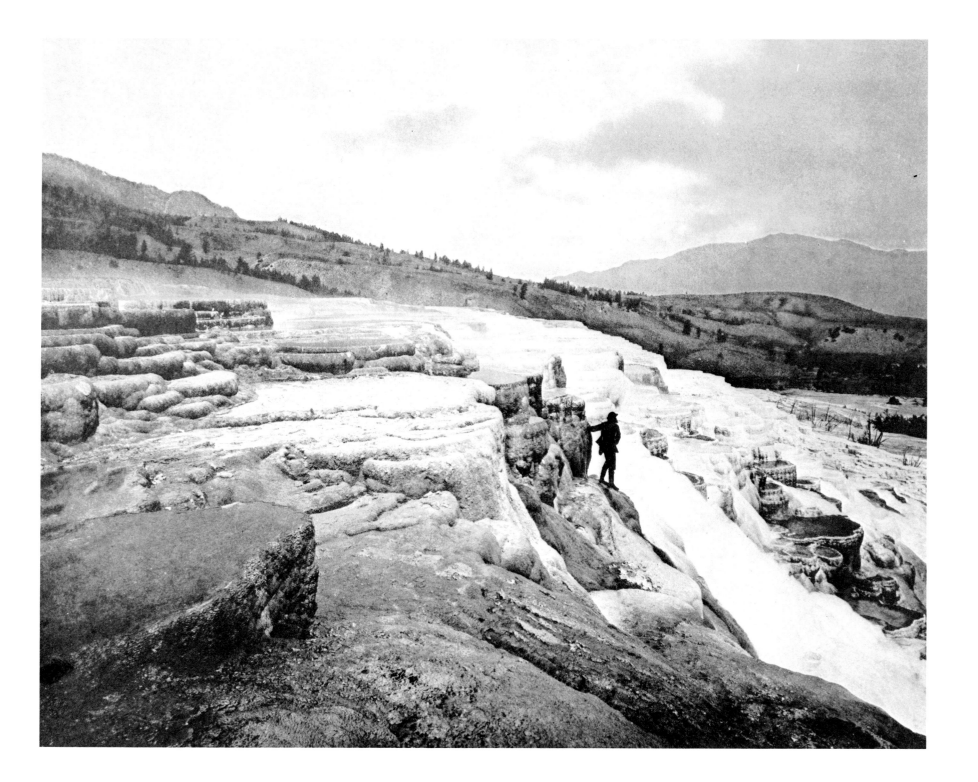

one part—though perhaps numerically the largest—of Jackson's distribution of images. As photographic curator Weston Naef has noted, the seventies were the era for serious collection of the landscape photograph, and Jackson made considerable use of this market. Probably his most ingenious innovation involved the joint publication, with Hayden, of a series of *Catalogues* to the Survey photographs. These evolved into something more than simple pamphlets; the 1875 version, for example, was eighty-one pages long and illustrated with wood engravings from the Survey reports. Such a publishing venture benefited both Jackson and Hayden: Jackson because every print purchased increased his reputation, and Hayden because the catalogue and each print advertised the Survey, even as it proved the value of his populist approach to scientific investigation. The 1875 catalogue, which listed and described over 2,000 stereos and whole-plate images, contained no information about costs of prints, leaving it to interested readers to address inquiries directly to the Survey.

This they did in great numbers. Though the Survey archives contain only letters addressed directly to Hayden, even these provide a bewildering array of responses from a cross-section of American figures. Perhaps most interesting is the number of influential literary, artistic, and political figures from America and abroad who wrote requesting prints or acknowledging receipt. Jackson's *Catalogue* was one of the most requested documents published by the Survey; a copy of "The Grotto Geyser" made it to Tasmania; images went to the National Gallery of Victoria, Australia; the Asiatic Society of Bengal, India; and many other foreign institu-

tions interested in maintaining up-to-date information on America. Elizabeth Bierstadt, of the American painter's family, wrote in late 1871, asking if Jackson could sell her a set of Yellowstone views—probably for the use of the painter. The head of the British Legation to Washington called the Yellowstone views "charming"; an editor for *Scribner's Monthly* wrote that "our Mr. Scribner wants to know the price of two sets of photographic views for his own use." The Royal Geographic Society of London catalogued views of "Gray's Peak from Argentine Pass," "The Upper Twin Lakes, Colorado," "View Near the Head of the Lake Fork of Gunnison River," and "Uncompagre Mountain" in April of 1876.[50]

This last order most likely resulted from preparations for another important public presentation of Jackson's views: the Survey exhibit at the 1876 Centennial Exposition in Philadelphia. This fair featured a large space designated for Survey work; Hayden decided to devote it almost entirely to visual materials, including specimens, Indian artifacts, sculptural models, and a huge exhibition of Jackson's photographs. For this he assigned Jackson to make all preparations, oversee the exhibition, and serve as a sort of walking specimen of Western science—a role he would repeat in the 1920s and 1930s. The result was a miniaturized, civilized microcosm of the West—as Hayden and Jackson had come to define and present it—so successfully wedded to its Victorian mandate that it won Jackson the large bronze medal of the Centennial.[51]

Jackson began work on the exhibit in the winter of 1875–1876. Partly because of Jackson's discovery and photographing of a collection of Indian cliff-house ruins near

Mesa Verde in 1874 and 1875, Hayden apparently decided to divide the exhibit into three parts, one to comprise scientific specimens and evidence of the practical use of Survey scientific discoveries, another devoted to extolling the beauties of the West through Jackson's photographs, and a third concerned entirely with Indian archaeology and ethnography. Jackson, Survey artist William Henry Holmes, and a group of assistants spent some six months constructing a three-dimensional scale model of the Mesa Verde ruins—something visitors to most modern science museums would recognize as a diorama. Jackson's version was apparently among the first of these, and the photographer later reported with some chagrin that it "attracted more attention than the many photographs and all the rocks and relics of Dr. Hayden's career.[52]

The decision to use these sculptural models rather than the photographs and reports alone, and the response to their exhibition, suggests a change both in Jackson's own attitude toward his photographs and in the more general public sensibility. For these clay models, derived from the actual photographs, represented substitute realities replacing the photograph in the role of privileged conveyer of fact. And this competition for effect showed itself as well in the pictures Jackson chose to exhibit: grandiose landscapes, many from mammoth-plate negatives, these became especially theatrical through Jackson's decision to convert them to even larger glass transparencies, which glowed with a rich emanation of light—no longer replicas of experience but jewels in themselves, products rather than references.[53]

This shift in the function of the photograph was reflected in Hayden's conception of the exhibit as well. In his application for further monies to fund the display, he emphasized the ability of the photograph to provide "pictorial representations . . . in an exceedingly attractive form." The effect, he declared would be to provide a "general graphic representation" of the work of the Survey, in such a way that it would please and engross viewers who would never take the time to glance at the scientific reports that constituted the Survey's normal mode of dissemination.[54]

Jackson's exhibit vied with those of other government explorers, including the 40th and 100th Parallel Surveys with the work of both Timothy O'Sullivan and William Bell, and Powell Survey photographs by Jack Hillers. In the estimation of the photographic press, however, Jackson's work far surpassed its competition. That summer and fall, Jackson received a number of laudatory reports in *Anthony's* and *The Philadelphia Photographer*. The most direct comparison of Jackson's work with that of other Western photographers came in a review of Centennial Exposition photographs by George Washington Wilson, editor and publisher of *The Philadelphia Photographer*:

The grandest examples of Government photography . . . consist of a large number of transparencies by William H. Jackson. . . . Mr. Jackson has displayed no less skill in the production of these immense plates containing the positives than he did in that of the splendid negatives from which they were made. . . . An examination of these pictures will convey an idea of the magnificent scenery there is in our own country. In another part of the building Indian education is illustrated by a large collection of photographs, which will be found interesting to examine.[55]

Wilson's casual mention of a second exhibit belied the elaborateness of Jackson's collection of archaeological artifacts, scale models, and photographs. In fact, Hayden and Jackson had decided to focus their attention on Indian life and history in the exhibit to reflect an important shift in Survey interest that had taken place after 1874. The Centennial Exposition exhibit focused on Indians for a number of reasons, some immediate to Jackson's own work, some relevant to the Survey, and some generalized to the culture. Jackson's discoveries of the Mancos Canyon ruins in 1874 (he narrowly missed stumbling upon the far richer Mesa Verde find) and his return to the region in 1875 had resulted not only in major archaeological discoveries, articles in Hayden's *Reports* and *Bulletins,* and a notable collection of photographs, but had more generally revived Jackson's stock with the Survey and his own interest in Hayden's mandate. The photographs that resulted, many of which appeared in the Centennial exhibit, reflected a new element in Jackson's presentation of the American Indian; they introduced a historical past of greatness from which the modern Indian had tragically descended (illustration 82). In the heroic past, these Indians had lived in a graceful symbiosis with a powerful and demanding nature, submitting themselves to its will. Jackson's report on the ruin declared that, "perched away in a crevice like a swallow or bat's nest, it was a marvel and a puzzle," suggesting by his use of animal similes and a diminutive verb that these Indians had miniaturized their lives in order to

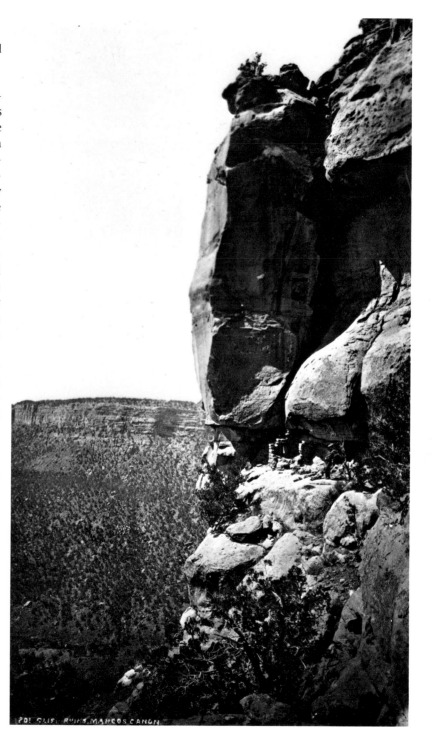

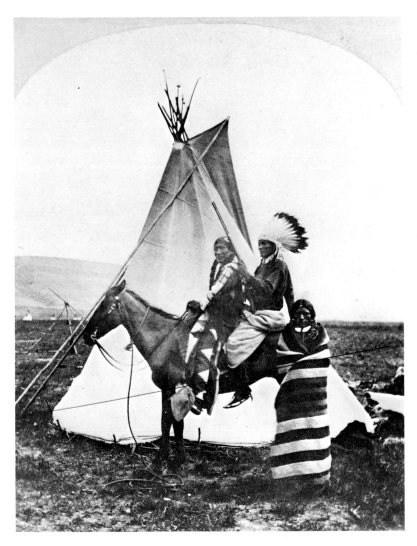

83.
[Unidentified Tribe, probably Utes from the Los Piños Agency], 1874. *Half of stereo pair.* CSHS

which itself seems about to collapse from its sheer height above the canyon, whose opposite wall stares back at the camera.

The posing of the figure served also to reintroduce the heroic stature of the Survey explorers, emphasizing a casual quality of claim over these ruins. This was reinforced in the exhibit by the inclusion of a collection of specimens removed from these dwellings. But in combining cultural and racial supremacy with "lost city" romance, Jackson reflected broader cultural imperatives concerning the Indian, ideas Hayden retained in his own decision to direct the Survey toward Indian subjects. In part an attempt to stake a new claim for the Survey in the wake of complaints about topographical and geological inaccuracy, Hayden's encouragement of Jackson's explorations reflected as well a new era of quasi-scientific Indian study and another upsurge in popular interest in the Indian during the mid-seventies. This wave of attention had been brought on by a number of phenomena. Perhaps most important was the generalized effect of the new Western tourism, which brought the experience of the West to a new state of intimacy. These tourists returned home to share their experiences of mock Indian raids on their trains or hotels, their visits to reservations or simply their glimpses of Indians from the windows of their Pullman cars; all of these stories increased popular awareness and piqued curiosity. In addition, the mid-seventies saw an upsurge in reports, often wildly exaggerated, of Indian depredations on new settlers. These were often the effects of revolts by tribes seeking to escape the reservations, rejecting corrupt tribal leaders, or attempting to return to hunting

reach right relation with their environment. Indeed, in the photographs, Jackson posed Survey figures in ways that would emphasize how small these houses were. In his best view, he chose a vertical format and shot diagonally across the scene so that the ruins would nearly disappear in the tall cliff,

or spirit grounds they believed still theirs by treaty, only to find them settled or desecrated. Less common but more terrifying were the reports of experiences with bands of Indian thugs who, like their white counterparts, roamed the West robbing and murdering. Enlivened political debate about the fate of the Indian, and renewed international interest in the Indian as an exotic curiosity, also contributed to the new vogue in Indian lore. But perhaps most interesting of all was the appearance of a new Indian policy, presaged by Jackson in his 1868–1869 views, which emphasized feeding reservation Indians as a "temporary measure" while applying moral uplift and education programs to encourage their assimilation into American yeomanry.[56]

All these phenomena affected Hayden's decision to emphasize Indian matters, in the exhibit at the Centennial and in the middle years of the Survey. But they also affected Jackson's response, that is, the mass of new data that was assembled under his direction during the mid-seventies. Jackson's own photographs, of course, represented one crucial area; stereo views of Indians were among the most popular photographs offered by the Survey. Here Jackson broke little new ground after generating his astute combination of assimilationism and nostalgia back in 1868 and 1869. New images were more dramatically ideological; Jackson usually stripped them of all but the most essential signifiers of the legend of the noble but now irrelevant Indian brave and his nomadic life on the infinite reaches of a mythic West (illustration 83).[57]

Jackson's encounters with Indians during the Survey years retained that quality of con-

descension and brutal stereotyping that had characterized his diary entries during his first trip West in 1867. Probably the most telling event in this respect was his visit to the Los Piños Agency of the Ute tribe in 1874. There he, his friend Ernest Ingersoll, and other members of Jackson's division of the Survey had hoped to photograph Chief Ouray, his wife, and a large selection of braves, and to put on film the "colorful" event whereby the Indian Agency dispersed a few cattle, which the Indians hunted as if they were buffalo. After killing all and feasting for days, their month's supplies exhausted, the Indians would then settle in to starve until the next disbursement. But while Ouray could be bribed into posing, the other members of the tribe grew more and more resistant and hostile, actively intervening on horseback at times to prevent Jackson from making views. The trip ended with little success: only a few views for Hayden's anticipated archive (illustration 84).[58]

Jackson's disappointment over the recalcitrance of the Utes hardened over the next years into an absolutism that divided Indians into good and bad and defined the Indians by their response to white presence and white desires. But Jackson was largely unaffected by Indian troubles; a few incidents with Indian bands who stampeded his stock in hopes of being rewarded for bringing it back or simply absconding with some of the mules represented about the worst he encountered, with one exception when he was forced to flee a hostile band in 1874. Most of his contacts came with Pueblo Indians on whose lands many of the archaeological discoveries were located. These Indians Jackson found picturesque, docile, even

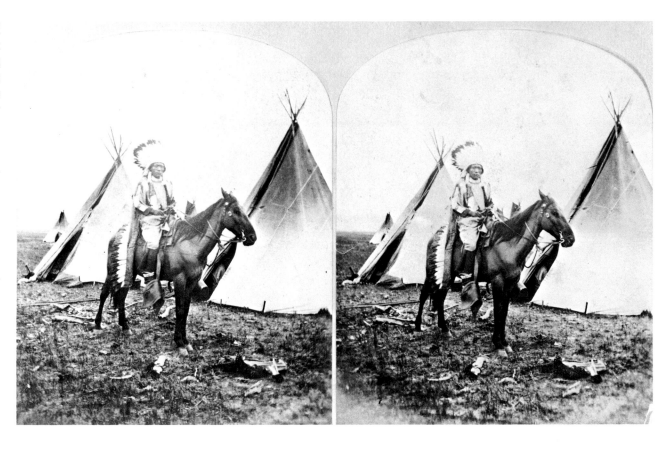

84.
*[Ute, Los Piños Agency],
probably 1874.* CSHS

attractive—for they corresponded almost exactly to the ideal of the assimilated Indian, living in villages, tilling the soil, participating in something that, to his eyes, approached democracy. As they would for others over the next fifty years, these Southwest Indians came to represent for Jackson the vindication of Indian policy, for they proved that it was possible for the Indians to be a peaceable agrarian tribe that nonetheless retained its attractive ceremonies and rituals and was willing to allow Westerners to witness them.[59]

Probably the most successful of Jackson's Indian works was the exhaustive, 124-page *Descriptive Catalogue of Photographs of North American Indians,* published in 1877. The result of years of effort on Jackson's part, the catalogue not only contained lists of over a thousand Indian negatives drawn from Blackmore's collection, from Jackson's own contributions, and from the photographs of all government agencies, but—more important—explained most images with what Hayden called "the informa-

tion which the Survey has acquired respecting the subjects of the pictures." The result, Hayden noted, "is believed to represent an acceptable contribution to anthropological literature." To complete the catalogue, Jackson reported, he had read extensively in the "standard works on the subject"; the captions were a marvelous blending of Jackson's ideology with the popular attitudes toward the Indian and the mass of quasi-scientific data ranging from phrenology to religious speculation that served as "anthropological literature."[60]

Jackson's captions—many of them closer to short essays—detailed a population composed of "bad Indians" like "Skellegunney" of the Coyotero, who "is looked upon as being a hard case," or "Auguste" of the Pembina, who "has the reputation of being a miserable, worthless Indian, unwilling to work, and adhering with great tenacity to the heathenish customs of his tribe"; and "good" Indians like "Qui-wi-zhen-shish Bad Boy," who "was a fine speaker and a man of much influence . . . farmed very successfully and raised considerable corn," or "Eskiminzin" of the Pinal, who "is now taking the lead in living a civilized life, having taken up a farm on the San Carlos River." But even while Jackson presented these assessments as Hayden's anthropological "information," his narrative was informed by an overall theme elucidated in the introduction to his companion *Descriptive Catalogue* of Survey photographs. The pictures, he noted,

are mostly studies of . . . habits and costumes, taken in their own villages and among their own mountains, showing their every-day life. They are fast passing away or conforming to the habits of civilization, and there will be no more faithful record of the past than these photographs. To their future historian they will prove invaluable.

Jackson's imagery thus could safely excoriate the bad Indian, admitting his existence, because these figures were relegated to history, killed off or converted to the new Indian policy of reservation, transformation, and assimilation. And page after page extolled the virtues of this policy, detailing the triumphs over recalcitrant hostiles, the religious conversions, the family farms, the tribal disappearances into the body of white settlement. And in this respect, it fit neatly with the archaeological work, where Indian civilizations could be safely resuscitated under the guise of history, an unreclaimable past.[61]

Here too, then, Jackson played out his role as a clarifier and condenser, and even a formulator, of meaningful contact points between the American West and the broader streams of American culture that were engaged in assimilating and transforming that region and all it implied. Like so many of his photographs of the Western landscape, Jackson's written descriptions of Indians contained beneath their alleged factuality a complex set of assumptions and ideas about the subject being described. And just as no single Indian existed alone to Jackson or his audience, but instead represented larger elements to be contended with (tribes, tribal groups, Indians as a race), so also Jackson's descriptions of particular Western spaces had been made and were understood as synecdochic. Like the steadily enlarging ring of circles that surrounds the spot in the water where one has thrown a rock, Jackson's pictures invoked meanings which themselves signaled ever larger implications. In this he was the child of his age, a Romantic turned Victorian, and his works served his large public audience by offering their allusiveness within a programmed, limited set of interpretive possibilites.[62]

From *Report* to photograph to exhibit to *Catalogue,* Jackson's work had aggressively entered the public information sphere. Sometimes as science, sometimes as art, it had become, as he and Hayden had hoped, an authoritative text on the West, presented in whatever guise seemed most persuasive to the particular audience the team desired to touch. But the very success of the Survey materials resulted in an unexpected phenomenon: loss of control.

This was an inevitable effect of the concurrent rise of Jackson's reputation along with a vast new information industry that included such giants as the telegraph and railroad companies but affected equally the publishing industry and the increasingly sophisticated photographic distribution businesses. The effects on Jackson ranged from small-scale annoyances to phenomena that were the result of culturewide changes. But all were more or less directly related to the revolution in the information industry that resulted in streamlined mechanisms for converting raw materials like Jackson's negatives into marketable products, distributing those products to the widest possible audience, and generating further demand for information. Even such minor problems as the appearance of pirated Survey views produced from copy negatives was, to some extent, dependent on a managerial revolution that made such theft economically feasible by

lowering costs of production and providing a demand for authentic goods that could be as easily satisfied by copies.[63]

A second phenomenon involved the use of the photographs as the basis for illustrations and paintings. How often this was the case we simply cannot know; scattered letters, such as that of Elizabeth Bierstadt to Hayden requesting prints, combined with the visual evidence in everything from newspaper illustration to painting, suggests it was extensive. The most celebrated of these transformations were made by Moran, who used Jackson's photographs as the sketches for a number of paintings, including his "Grand Cañon of the Yellowstone" and "Mount of the Holy Cross." But under Moran's hand, the photographs were not *used* so much as they were ingested. When he consulted a number of them as the sources for a series of paintings converted to chromolithographs and published in 1876 by Louis Prang, the resulting images bore no relation to the photographs except for correspondences of vantage point and angle of view, and even those were often subtly shifted to heighten drama. Instead, Moran overlaid the photographs with a painterly swirl of color, investing the scene with a vivid emotionalism whose thematic source was unclear (whether from nature or the painter's imagination) but whose artistic source is unmistakable—the English painter J. M. W. Turner. Thus Jackson repaid Moran for the painter's help in the field but lost nothing in the trade.[64]

The appropriation of Jackson's views for use as book illustrations was a different order of phenomenon. In some cases, use amounted to theft—as in F. D. Carpenter's *The Wonders of Geyser Land,* the story of the author's Yellowstone vacation and his experiences as a captive of the Nez Percé Indians that was given authority by the use of crude engravings derived from a number of Jackson's Yellowstone views. But the pilferage was a minor issue compared to the change in meaning that accompanied such jarring changes in context. Even as Jackson's pictures elevated Carpenter's narrative, so also their presence in such a work reduced their own authority, their associations with government scientific endeavor, with dispassion and investigation, while the inexpert wood engravings threatened the verisimilitude of the photographic medium from which they were derived. This occurred equally with works where the use was probably granted by Hayden or Jackson, as in Lord Dunraven's *The Great Divide: Travels in the Upper Yellowstone in the Summer of 1874,* or even Ernest Ingersoll's *Knocking 'Round the Rockies,* his reminiscence of life on the Survey. In these cases the free use of the pictures again dislodged them from their previous place as products of government exploration; more importantly, the surrounding context for understanding the photographs became the property of the author or his publisher—in Dunraven's case, they became souvenirs of tourism; in Ingersoll's, illustrations to "amusing" anecdotes. Perhaps the most extreme version of this was the liberal sprinkling of Jackson views in George A. Crofutt's popular series of tourist guidebooks to the West. Crofutt had written to Hayden in 1872 asking to use one of Jackson's views, and Hayden apparently approved, as he did most such requests, assuming they would provide publicity for the Survey and increased interest in the West. In this case, the result was comic: Crofutt reported in one edition that the wood engravings were derived from photographs "made by Prof. Hayden, the great explorer of the West."[65]

But all these were relatively unimportant compared with the largest processes wresting control of the images from Jackson and Hayden. The most notable of these was, quite simply, the number of images with which the Survey photographs had increasingly to compete as the decade waned. With the rise of Albertype, Woodburytype, gravure, and other photoreproduction techniques, combined with higher-speed, higher-output presses, cheaper publishing costs, and far more sophisticated distribution mechanisms, Americans found themselves inundated with images, many of them coming from Jackson's competition—Western photographers like Muybridge, Savage, and Watkins, whose pictures appeared under the imprint of San Francisco entrepreneur Isaiah W. Taber. The result was a steady erosion of exchange rate on the individual picture, especially when the images offered little that was new. Thus, even as Jackson's pictures increasingly entered the parlors and appeared on the walls of American homes, they did so as unremarked examples of landscape genre rather than manifestations of mystery and discovery.[66]

This process coincided with an even larger cultural phenomenon: the entire process of incorporation and industrialization that overtook the information industry during the seventies. Jackson's pictures soon had to compete not only against other stereos, cabinet photographs, and even wood engravings, but also against the pop-

ular publications that took their cue in part from the Survey's popularity and aggressively marketed the West to their readers. The result was not merely competition; it approached saturation. And at the same time, these publications increasingly devalued the entire Western experience, removing from the parlor viewing experience the all-important quality of escape into fantasy and replacing it with a simpler confirmation of prevailing attitudes. When, in July of 1877, *Frank Leslie's Illustrated Newspaper* began with great fanfare to publish its year-long series of anecdotal reports on the transcontinental railroad tour made by publisher Leslie, his wife, and their retinue, the West as region of veiled mystery was close to an end, and the West as collection of consumable tidbits had fully arrived.[67]

These phenomena increasingly separated Jackson from control over the potency and meaning of his pictures, even as that meaning was itself eroded. The photographer's diaries of his last years with the Survey reflect that sensibility in unconscious descriptions of his alternating states of professional boredom shading into incompetence, and more and more elaborate attempts to recapture some portion of past significance. The 1877 Survey year Jackson spent in the field exploring ruins of the Southwest Indians; for convenience, he chose to use a new "dry-tissue" process of negative, which he did not bother to test; it turned out to be faulty and cost him the entire season's work. Against that can be set his increasing use of more cumbersome cameras in order to bring back larger and more striking images, and his reports of devastatingly hard work to climb above the ele-

vations of encroachment, back to the regions of past purity and exaltation.[68]

But what happened over the last years was the creation of pictures the opposite of those Jackson apparently wished to reclaim; rather than Romantic recementings of art and science, of internal response with external reality, the pictures seem to have become, more and more, *images* rather than windows, substitutes for the experience of nature rather than records of that experience.

Probably the most illuminating and complex example of this lies not with a series of views but with one view reconstructed again and again, not just over the Survey years, but over Jackson's entire history: the Mount of the Holy Cross. In 1873, Jackson spent a great deal of the season searching out the fabled region, hidden deep within the Rockies, where, as Longfellow wrote in 1879:

There is a mountain in the distant west
 That, sun-defying, in its deep ravines
 Displays a cross of snow upon its side.

Jackson's connection to the popular mythology of the West and to contemporary religious sentiment resulted in a series of photographs that united the two. "156. Mountain of the Holy Cross" (illustration 85) quickly became the Survey's most famous picture, and a fixture on the walls of American homes, rectories, and even chapels for decades thereafter. But of equal importance is the way that Jackson transformed the image over time. As it originally stood, the picture portrayed a stony wall without sign of life, an irregular cross carved into its face. Jackson's initial improvement was minimal; besides opaquing the sky, he regularized

the cross by retouching one arm. The second alteration, however, was more drastic; it was the addition of the stream and waterfall to the picture. Whereas the improvement of the cross had been done in the name of truth and its communication—the ideal role of the mid–nineteenth-century photograph—the straightforward creation of a scenic prop (a matter of "moving" Holy Cross Creek into the picture from its place some distance below) removed the photograph into the category of fabrication. And the end of this fabrication now lay not with improving the photograph's accuracy but with bringing it into closer alignment with painterly conventions, particularly those of the picturesque.[69]

Jackson's other modifications corresponded to these two types of truthfulness and artfulness. In the category of clarification fall the changes that further "improved" the cross itself, altered the shape of a glacial ice patch to the right of the mountain (turning it into a "snow angel"), and introduced a few other more minor acts of visual housekeeping. Recopying the negative onto an oval format made it more clearly picturesque. After Jackson left the Survey, his improvements grew more drastic; he recopied the image so that it floated as a borderless oval surrounded by white, added clouds by compositing two negatives, further enlarged the cross, and made other minor and major improvements.[70]

These transformations were all attempts to convert the photograph into something it had not previously been in order to compete more adequately with the mass-market images and written works on the West that

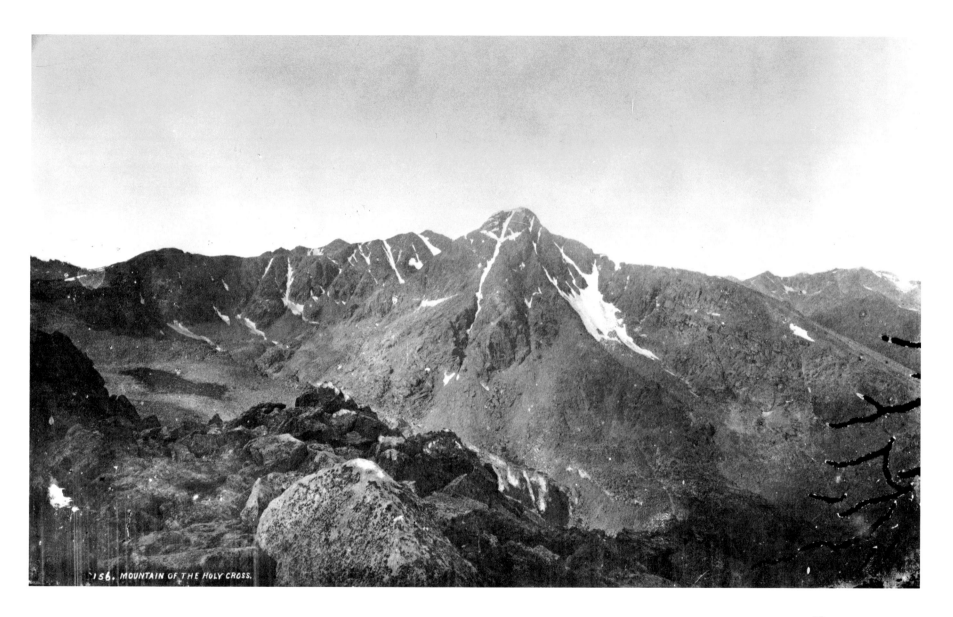

156. MOUNTAIN OF THE HOLY CROSS.

85.
*"156. Mountain of the
Holy Cross," 1873.* USGS

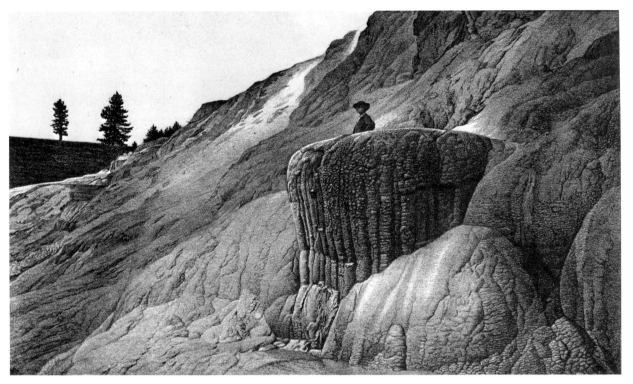

86.
"The Pulpit, Mammoth Hot Springs," probably 1878. Lithograph from Hayden's Twelfth Annual Report . . . 1878.

vied for public attention. The first type of alteration made the picture's message less ambiguous, more easily ingested by an audience increasingly inundated with images; the second simply brought the photograph more completely into line with the stylistic imperatives of the mass imagery with which it competed in the Victorian parlor. In either case, however, Jackson's acts altered the project on which he had embarked in 1869. Whereas the first photographs of the Mount demanded contemplation, the last did not; all complexity had been stripped from the scene, even as the act of doing so altered the photograph's power as fact, its reputation for

truth. This new type of photography, public in its direction—dependent for its meanings on the invocation and manipulation of the imagery of popular culture, devoted to a directness reminiscent of propaganda—went against Hayden's own declarations that the photograph served not simply to afford "the pleasure which lovers of the beautiful and picturesque may derive" but was meant to "secure truthfulness."[71]

With these transformations in the photographs of the Mount, Jackson had passed beyond his mentor, recognized his role to be that of propagandist, and mastered the tools to fit the task. The first photographs

of the Mount of the Holy Cross were clear in their description but demanding in their requirement of emotional and intellectual commitment on the part of the viewer. This was in tune with the requirements of the sublime: that the viewer discover the masked realities of internal and external spirit through personal interaction with the subject. The last views of the Mount turned this early formulation on its head; no longer descriptively clear, they were thematically transparent—they trumpeted their messages to all who might glance at them.

The Survey ended in 1878. A battle over appropriations among the various competing exploration teams, simmering since 1874, erupted into head-to-head conflicts among King, Powell, and Hayden; Hayden publicly stated that he would use his political contacts to eradicate Powell, but he discovered his support was insufficient. Having served his Western constituency so well that he was now unnecessary, Hayden found his scientific failings, as well as his arrogance, his acquisitiveness, and his hostility to other explorers, had caught up with him. The result was a humiliating battle that resulted in the consolidation of the various Western surveys into one organization, headed not by Hayden but by Clarence King, who would remain only a year before resigning, to be replaced by Powell.[72]

By the last season of 1878, Hayden may have known how desperate the circumstances were; in an act that was part retreat and part nostalgia, he gathered Stevenson, Jackson, and the rest of his team to return to Yellowstone. While the Wyoming itinerary was motivated to some degree by

a need to get accurate topographic information about the region, the inclusion of Yellowstone was a different matter. It was to be Hayden's chance, with a large appropriation ($75,000) and a sophisticated team, to prove that he could conduct an important scientific inquiry that drew together all the sciences and united them with the practical matters of topography and the aesthetic matters of photography and art.[73]

The result was disturbing for all concerned; except for a few sentences, Jackson never reported on the days in Yellowstone. The reason is clear—returning to the region late in the season, they found it not an escape from civilization, but an escape into civilization: accommodations had been built on the site and tourists were ensconced, riding the trails, staring at the fountains, taking the waters, bathing in the pools.

This was not a new phenomenon. In 1874, Interior Secretary Delano wrote the president, reporting that "the park has been visited during the past summer by many persons, and . . . has been despoiled by them of great quantities of its mineral deposits and other curiosities" and requesting "the protection of this great natural wonder from the vandalism of curiosity-hunters."[74]

Jackson's Yellowstone photographs of 1878 were themselves extraordinary. Some were of the regulation 11-by-14 "Imperial plate" dimension, but they were not the most interesting—they simply enlarged the phenomena of past trips and presaged the even more touristic views the photographer would make in the next decade and a half. Rather it was the collection of small, 5-by-8 views that seem now so arresting, so premonitory. As photographs or as extraordinar-

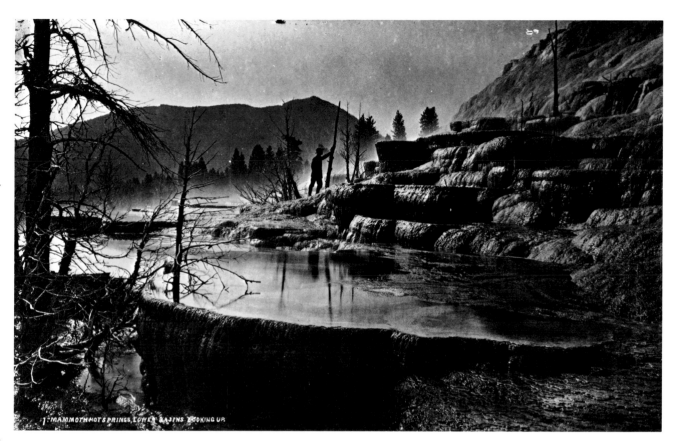

1. "MAMMOTH HOT SPRINGS, LOWER BASINS, LOOKING UP.

87.
"Mammoth Hot Springs, Lower Basins, Looking Up," 1878. USGS

ily detailed lithographic reproductions for the *Report* (illustration 86), they featured Survey figures leaning against, looking into, or standing behind the powerful geological specimens of Yellowstone. These figures seem more than merely contemplative; they seem exhausted, bowed down by some responsibility or weight. Compare the rather dashing explorer's pose of the figures in the earlier view of "White Mountain Hot Springs" (see illustration 81) with that of Jackson's spectator in "Mammoth Hot Springs, Lower Basins, Looking Up" (illustration 87) of this season. Gone is the ebul-

lient superiority of 1869, the grand scientific superiority of 1871. And the images of geological and natural phenomena themselves have changed. No longer distant, they fill the frame, often yawning below us, often with frightening, nightmarish dimensions. Survey figures, too, seem about to be swallowed up by these potent forces.

Unsettling as they are, these Yellowstone images intersect with the other photographs Jackson made that season, particularly the mammoth-plate images of mountain scenery (illustrations 88, 89, 90, 91). The result is a composite that seems to undo the ide-

ology of domination with a warning of its effects. But it is too late. In the large photographs of the high country, the elegiacal sense is uppermost, even in views where no human figures are visible. Jackson here has reinvested power in the landscape, in the stony lakesides and the harsh implications of a cluster of vertical tree trunks, most of them dead. In views where Jackson posed his fellow Survey members, the landscape seems to offer none of the excitement of 1870 or the solace of other years. Here nature is reinvested with power, with dignity, and with great beauty—a beauty that passes beyond visual and pictorial convention. But that power is not available to man, as commodity or as revelation. Instead, the landscape has become silent; it has retreated from man and will not return.

89.
*"Near View of Great
Fountain, Lower Fire
Hole Basin," 1878.
Lithograph from
Hayden's* Twelfth
Annual Report . . . 1878.

90.
"1252. Fremont's Peak,
Wyoming," 1878. USGS

91.
*"1251. Wind River
Peak [Wyoming
Territory]," 1878.* USGS

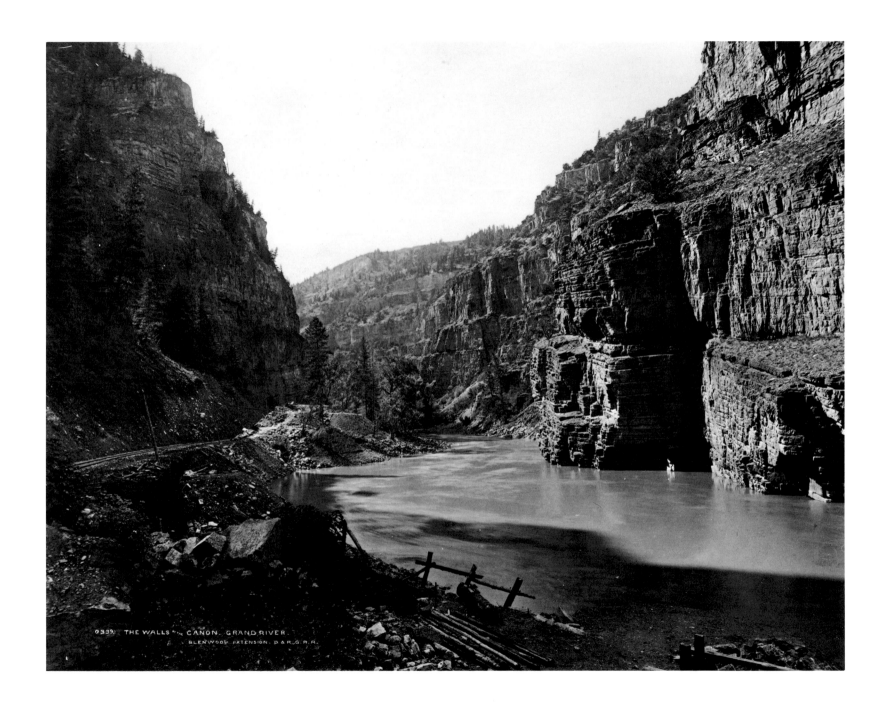

0339 THE WALLS OF THE CANON. GRAND RIVER.
GLENWOOD EXTENSION. D. & R. G. R. R.

The Commercial Traveler, 1879–1894
Chapter Five

Most of all, it was a matter of money.
—WILLIAM HENRY JACKSON,
Time Exposure[1]

I n the spring of 1879, Jackson and his colleague James Stevenson made their last trip together as members of the U.S. Geological Survey; it was to New York, to meet with railroad magnate Jay Gould. Stevenson was going to help arrange for the photographer's transition from the world of government scientific work to that of commerce.[2]

Jackson was lucky to have Stevenson as his interceder. As Hayden's right-hand man, Stevenson had dealt closely with the many "interests" that had involved themselves in the Survey—or had found themselves involved, through Hayden's enthusiasm. He had been a friend of Commodore Vanderbilt and was apparently well acquainted with Gould through the shadowy network of personal connections that characterized the world of American financial magnates during this transition period. In addition, Gould's

intimate relationship with the development of the Denver Pacific and the Denver & Rio Grande railroads had necessarily involved his empire with that of Hayden, as had his connections with the Missouri Pacific, Texas & Pacific, and a number of other lines, and his earlier dealings with the Union Pacific, beginning in 1874.[3]

Stevenson brought Jackson to the financier's office at an opportune moment. For Gould had just been vindicated in a stunning court upset that freed "his" Union Pacific Railroad from paying huge back profits on the original construction to the government; within nine months, Gould would force the Union Pacific to merge with his Kansas Pacific and the Denver Pacific as well. Already he was examining an empire based in Denver and was in need of proper publicity to attract passengers.[4]

Jackson later reported that the meeting, while intimidating, went admirably. Gould remembered Jackson's 1869 Union Pacific views and praised them; he also promised to smooth Jackson's way by contacting "a number of railroad officials in Denver." Jackson's commercial career had just been guaranteed.[5]

Leaving the Survey in 1879 was a forced decision; Jackson had toyed with reentering commercial life for some time previously, and the congressionally mandated reorganization that deposed Hayden and made Jackson unnecessary only cemented his resolution to do so. In part the reasons were financial; he was, as he inadvertently confessed in his autobiography many years later, a glorified government "department clerk." Skilled in his craft, he might have compared himself well with the topographers of the

92. (*opposite*)
"339. The Walls of the Cañon. Grand River. Glenwood Extension, D.&R.G. R.R.," ca. 1887.
CSHS

141

Survey, though his role as a publicist for the government, and his fame as a landscape artist belied this status.[6]

Yet as a photographer, and one "who had reached the front rank in his field," in Jackson's opinion, he earned very little. The reason lay with the great difference between Jackson's secure, yearly, salaried position with the government, wherein all expenses were paid and all equipment provided, and the risky demands of the commercial entrepreneur in the 1870s. The typical successful photographer of that period, in order to make a decent living, had to run a small business; he produced negatives, printed, mounted, and published stereo and card views, and contracted with national distribution houses, and to do all this was responsible for a work force ranging from three or four to fifteen or more, including camera operators, bookkeepers, clerks, assistants, printers, mounters, retouchers, and colorists. The photographer was thus a middle-level entrepreneur. In a good year the rewards could be great; major houses with which Jackson was to compare himself in the eighties—like that of Isaiah W. Taber of San Francisco—could put the owner–operator in the front rank of social figures for his city or region. Bad times, however, came with regularity.[7]

These were the realities of photographic entrepreneurship, which were exacerbated in landscape work. For while portraits offered a steady guaranteed income, successful marketing of landscapes depended on the photographer's location in a suitable region and his ability to reach an extensive tourist population. Jackson chose Denver.[8]

Approaching the railroads was only one part of the process by which Jackson scouted the possibilities of his region, then constructed a business to fit. Of course a principal reason for his choice of Denver was familiarity. Jackson had been in and out of the city for nearly a decade; the Survey had set up a field office there. Jackson knew city and region well enough to bank on their future; his affiliation with geologists over the past years made him privy to information about the mineral deposits in the mountains, and Denver was clearly on the verge of becoming a major financial center. The past decade's growth had been tremendous; in 1870 Denver's population was less than 5,000, but by 1880 it had jumped to more than 35,000. Statehood for Colorado in 1876 marked a new era of settlement, and by 1879 the *Rocky Mountain News* estimated that a hundred settlers arrived in the city every day. Denver was a major rail terminus; thousands of passengers and many millions of pounds of freight arrived there each year, and far more passed through. In 1879, the city had two telephone systems, and by 1884 it had an opera house. Denver was definitely up-and-coming. And to match its booming economic environment, Denver had successfully placed itself on the map as one of the principal health spas in the country, offering the cold, low-oxygen atmosphere and maximum of sunlight doctors were then prescribing as the best treatment for tuberculosis. The new Pullman palace cars made the city a terminus for invalids and a jumping-off place for middle- and upper-class tourists headed for California, or for the wonders of the inner Rockies. These were all potential clients, connoisseurs of landscape.[9]

Jackson knew Denver and, equally important, he knew its surrounding scenery intimately. The Survey's sojourns in Colorado meant that he was familiar with the roads and routes, the locations of hidden points of interest, and the proprietors of better-known spas, hotels, and tourist spots. He was freed of the problems of reconnaissance and could quickly build up a stock of negatives to supplement those he took with him as copy negatives from the Survey files. And this available stock underscored his national reputation as a photographer of Colorado scenery, which he reaffirmed by visiting the offices of the major photographic journals before leaving for Denver, and reacquainting himself with noted citizens after his arrival.[10]

Finally, Jackson himself had a set of established connections in Denver and the region. As a Survey member, he had become a noted friend of Western boosterism, and his periodic trips through Denver were duly noted in the newspapers. His feats of photographic exploration were also well publicized. The expedition to the Mount of the Holy Cross in 1873, for example, had included a correspondent for the *Rocky Mountain News:* its editor and publisher, William Byers. Byers's friendship was a valuable asset; in addition to his ownership of the *News*, he was also well known throughout the region as a devoted voice of regional development. Jackson was to trade considerably on Byers's name during the commercial years. But Byers was by no means the photographer's most visible or important friend in Colorado. Most important was the photographer's connection through his second wife, Emilie Painter Jackson: her uncle William Gilpin, Colorado's first governor and most famous booster and still a figure of repute in

Denver and the state—and Gilpin became a frequent visitor to the Jackson household.[11]

All these factors, taken together, provided the photographer with a wide net of influence. Yet each of these assets bore their costs as well. They provided obligations that would have to be fulfilled—socially, financially, politically, and artistically. And they also conspired to limit the photographer's vision, his sense of possibilities for a visual analysis and presentation of Colorado. Jackson's reputation as a spokesman for the West had helped to gain this wealth of connections, but it also meant that Colorado would necessarily become the center of his vision of the West, would become example and allegory. Even familiarity with scenes and routes limited as much as it opened. In Jackson's consciousness, Colorado was already demarcated into tidy regions, gridded into areas of scenery and blank spots. Discovery, the prime force behind his work in 1869 and the early seventies, would simply not be a powerful factor again. He had learned, and come to accept as natural, a particular understanding of the West, Colorado, Denver and, equally, had become proficient in manipulating a set of conduits for information, employment, and social relations. These beliefs and habits would remain virtually unchanged during his twenty-year sojourn in the region.

This placed Jackson in a paradoxical position in the culture of Gilded-Age American business, yet one that must have been commonplace during the eighties and even the decades before and after. Jackson's business during that period was the classic entrepreneurial enterprise of the owner–operator, wherein a single individual with a skill, training, and willingness to shoulder the responsibility founded a business that centered on that marketable skill, supported usually by family members and, below the management level, employees. Yet this structure, which should have made possible maximum innovation and independence on Jackson's part, offered little of the sort. Instead, he was to find himself hemmed in by requirements that curtailed his freedom far more severely than had been the case when he was a relatively low-level figure in the bureaucracy of the government. Paradoxically, government service had offered him freedom, but free enterprise restricted him. Primarily, as we shall see, these restrictions came from his clientele, particularly the managers of the railroads themselves, who demanded—and got—a certain specific set of celebratory formulae, then turned over the repetitive results to the far larger, less controlled, and more heterogeneous population of actual image consumers—tourists, recipients of postcards and gift "remembrances," visitors to and residents of the West, and the larger pool of interested spectators to the phenomenon of Western development.[12]

But to say that Jackson was moving from freedom into restriction is far too simplistic. Rather, it appears that the transition was between one set of restrictions and another. In both cases however, organized, managerial structures intervened between the photographer and his audience, instructing Jackson in the nature and meaning of the pictures he was to make, diverting the finished products to the proper audiences, and directing viewers to a proper interpretation, through context, caption, and other publication and distribution mechanisms.

The first summer in Denver served as a transition between Survey and commerce. Jackson left his wife and children in Washington City and took Frank Smart, his photographic assistant from previous years, out West. After contracting for his first studio, at 413 Larimer Street, Jackson made a stop at the offices of the *Rocky Mountain News,* where he was rewarded with a laudatory squib. Then Jackson and Smart embarked on a Survey-like photographic excursion through Clear Creek Canyon and up into the mining regions surrounding the booming silver town of Leadville.[13]

Returning to Denver in the fall, Jackson set up his business. In structure, it resembled most such establishments staffed by the hundreds—perhaps thousands—of would-be photographic capitalists who flooded the market during those years, usually lasting only a matter of months or, at best, a few years, before passing on. Jackson's studio combined portraiture with landscape and commission work, and offered stereos, card photographs, cabinet views, whole-plate landscapes, and Jackson's trademark mammoth-plate landscape views. In addition to Smart, Jackson hired a portraitist named Hosier and took on another employee as printer—he probably also mounted and finished the views. Jackson himself, presumably, combined camera work, retouching and coloring, and salesmanship. In the spring of 1880, feeling fairly secure, Jackson sent for Emilie and the children, and they moved into rooms at 488 Champa, near the studio.[14]

Jackson's business took off in 1881, when he succeeded in enticing Albert E. Rinehart, Denver's most prominent portrait photogra-

pher, into setting up a partnership with the Jackson firm. The arrangement was ideal: Rinehart and Jackson shared offices, operators, printers, finishers, and the other mechanical aspects of an eighties photographic studio but for the most part retained their separate identities. This guaranteed a measure of economic stability, added the high reputation of Rinehart's name, and at the same time freed Jackson to focus entirely on landscape work.[15]

Jackson's decision to consolidate with Rinehart was probably the result of his first stroke of great luck: a major commission from the Denver and Rio Grade (D&RG) Railroad. Sometime in 1880, Jackson had produced a set of views of Royal Gorge, one of the prime scenic spots along the D&RG line; in January, the *Rocky Mountain News* reported that these views were now being prepared for the treasurer of "the scenic line of America"—the motto of the D&RG. Then in 1881, the photographer succeeded in arranging for a grandiose tour of the West on the D&RG lines with his two old Survey friends, Ernest Ingersoll and Thomas Moran.[16]

Just exactly how the entire arrangement was made is unclear, but by the time the party left Denver on the tour, its results were fully spoken for. Ingersoll had been commissioned by *Harper's* to produce a report on the San Juan mining region, and Moran had agreed to illustrate the article. The painter had also been hired by the D&RG to produce a set of railroad illustrations, scheduled to appear in the *Colorado Tourist,* a booster publication of the Gould-interest railroads, published in Denver by the *News.* And Jack-

son had been hired to provide a set of photographs for the railway, many of which would serve as the basis for illustrations by Moran and John "Apple Jack" Karst, Moran's engraver, himself responsible for a number of the illustrations as well.[17]

The 1881 D&RG trip set Jackson's railroad career in motion; it affirmed his affiliation with Ingersoll and Moran and, through them, his reconnection with the booster forces of the railways, and it introduced him to his principal commercial specialty, the production of spectacular railroad views on commission from the Western railroad interests. The trip was the first of a series of commissions along the Denver and Rio Grande that would continue through the nineties, every time the railroad opened another segment of its seemingly endless spurs into the mining and tourist regions of the Rockies. And in many ways it was typical of the railroad tours over lines throughout the nation during the next twelve years.

The party itself apparently included not only the three men but Ingersoll's wife, a manservant, and a number of Denver artists, who signed on for portions of the trip. At Santa Fe, New Mexico, in late June, for example, the party included Denver's "lady" landscape painter, Mrs. Chain, and her husband, the proprietor of a bookstore and, shortly thereafter, a partner in the Jackson business. Besides these two, another landscapist, a Mr. Young, and a Mrs. Howland shared the adventure of this portion of the trip, which encompassed Taos and Espanola as well.[18]

The D&RG's provision of a private train to carry its publicists, the manservant Amos, and their guests was essential to the jour-

ney. Though the rolling stock was comparatively unimaginative—Jackson would later travel in railroad presidents' private trains and would, for a time, have his own customized darkroom/parlor car—still it served the vital function of making the railroad technology a servant of these model tourists, leaving them at liberty to halt for expeditions, fishing excursions, or simply to ingest "the wonderful blue of a Colorado sky" or the anthropomorphic gardens of rock, witnesses "of the gods, surely— . . . the gods of the Norse Walhalla in some of their strange outbursts of wild rage or uncouth playfulness . . . weird and grotesque, but solemn and awful at the same time," in Ingersoll's words.[19]

Ingersoll's writing, Moran's and Karst's illustrations, and Jackson's photographs all melded into a successful expression of the Gilded-Age tourist mind set, a mind set essential to the future of Jackson's work and to the development of the West over the next decades. Ingersoll's preface to *Crest of the Continent* condensed it perfectly. The journey, he reported, "was wild and rough in many respects. Re-arranging the trip, luxuries might be added, and certain inconveniences avoided; but I doubt whether, in so doing, we should greatly increase the pleasure or the profit." Intertwined with the concern for the symbiotic qualities of "pleasure and profit" (and Ingersoll's use of a financial term to describe an intellectual benefit was significant and typical) was the necessity that the proper tourist excursion toe the delicate line between luxury and austerity. "Roughing it, within reasonable grounds, is the marrow of this sort of recreation." And the ben-

efits to the individual were clear: a renewal of physical health through contact with the clear-aired antidote to dirty, crowded, polluted urban environments, and the "sound and serene" sleep that evaded the neurasthenic and the hysteric while at home—that is, measured respite from modern civilization, with its "unnerving" qualities. Ingersoll urged his trip on all readers: in the "grand and alluring mountains . . ." could be found "everlasting refuges from weariness, anxiety, and strife!"[20]

Jackson's photographs, Moran's drawings, and Karst's engravings had their place in Ingersoll's tourist ecology. Their function was to make the tourist's liberation last beyond the narrow confines of the trip itself—they were "food for subsequent thought and reflection." Ingersoll's book, too, was meant as a souvenir, even as it was in fact commissioned to persuade readers to follow the author's lead. This dual function was to characterize Jackson's photographs, as well, throughout the eighties and nineties—they were commissioned by the railroads to persuade viewers to make these very excursions, but they were bought by tourists to recompense them for the end of their liberty by providing fantasies of escape back into the freedom of the West-as-tour—they were remembrances.

These two marketplace functions, however, contradicted a third, growing role that the photographs of the tourist West would provide, especially (as we shall see) in the twentieth century—and that is as *substitute* for the experience of freedom, for the tour itself. Had the railroad publicists who commissioned Jackson's work understood that the pictures could and eventually would replace the experience, they would no doubt have protested the photographer's style and fired him. But the primary concern, on the railroad end, lay with publicizing the very possibility of a tourist route; the railroads themselves were built primarily to service mining areas rather than to provide recreation. And at least through the eighties, these photographs, and the engravings, chromolithographs, written accounts, and other media that accompanied them, served to introduce a vision of the West as recreation to a large and lucrative Eastern marketplace. As the railroad served the urban–industrial matrix with raw materials—coal, iron ore, precious metals—so also it would serve by providing an escape from the human consequences of urbanization and industrialization, an escape first geographic and actual and later fantasized and fictive.

This new, visited West differed peculiarly from mythic Wests of the past. The shift in focus from the land to the self was primary; tourists wished not to submerge their egos in contemplation of the infinite—they wished to rediscover themselves in a region distant from work and social obligation. Ingersoll's writing expressed this easily. His essays and descriptions focused time and again on the Western experience as an internal one, a process of moving from anxiety to equilibrium, through a distinctive operation by which the stillness of the environment lent stillness to the internal landscape. The function of the land now lay in its capacity to heal the alienated, disembodied individual and recreate the possibility of healthy "civilized" society.[21]

But the Western tourist experience, intended perhaps as respite from civilization, depended as well on the system of judgments that defined that civilization—in fact, was perhaps necessary as a means by which Gilded-Age Americans could return to belief in the rules of civilization. Pervading Ingersoll's account is an obsessive penchant for judgment typical of Gilded-Age American travel writing. First to be assessed was nature; Ingersoll's obligation to the D&RG produced a breezy optimism about nearly all spaces, but beneath each description lay an implicit concern with organizing nature into a hierarchy whose criteria subsumed economics, morality, and aesthetics.[22]

This reached its extreme with Indian settlements. At the pueblos, Ingersoll indulged in an orgy of cataloging; after careful weighing, *these* Indians were found valuable, even necessary to Western civilization, for two reasons: they reaffirmed the older model of Western agrarian virtue, and they provided a nostalgic image of another, now-lost Eden to counter Euro-American civilization. "It is a phase of humanity and conduct rapidly passing away," wrote Ingersoll, "melting under the steady sun of modern progress."[23]

This Indian paradise provided a nostalgic counterpoint to Eastern urban values, a revivifying human spectacle to match the natural spectacle of Western scenery:

We were never weary of wandering about these Indian towns, and watching the people at their work and sunny-tempered play. They are the happiest men and women on the continent. Well sheltered, well fed, well companioned, peaceful, guileless,—what else do they wish? Not theirs to know carking care, and the fluctuating markets

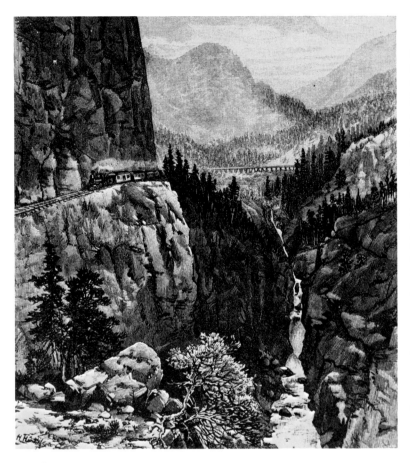

93.
"Cañon of the Rio de Las Animas," wood engraving reproduced in Ingersoll's Crest of the Continent, *1885.*

94. (*opposite*) *"Cañon of the Rio Las Animas,"* probably 1882. CSHS

which imperil hard-earned gains; nor to suffer the hurt unsatisfied ambition feels, or know the terrors of a crime-haunted or doubt-stricken conscience. The broad, bright sunshine of their latitude suffuses their whole lives and dispositions, turning their rock-bounded lowlands into a Vale of Tempe.[24]

Two justifications for the Indians were implicit in this account. The first, clearly, lay with their conformity to the American yeoman myth of the democratic farmer in the West. Ingersoll saw in them also that quality that lay more deeply in the ideology of the picturesque—the sense in which the distanced relationship between subject and viewer resulted in lessons learned. These Indians educated the tourist in the very qualities sought in the Western sojourn itself—peacefulness, guilelessness, freedom. Thus they served a dual function in this way: on the one hand they represented the longed-for escape from civilization; on the other they reminded the tourist of the superior position of the civilized man, concerned with the deeply important issues of "markets" and "ambitions." And it was not coincidental that Ingersoll devoted the next chapter to an account of the firing of the servant, Amos; it was a reminder of the responsibilities of the civilized over the lesser beings.[25]

The visual materials Jackson provided supported, and often even generated, the words (illustrations 93, 94). Remember that the pictures preceded all written text. In fact, Ingersoll evidently depended heavily on Jackson's photographs to remind himself of scenes and events, even to the point of organizing much of the book around selected illustrations.

Ingersoll learned from Jackson's pictures; the photographs encapsulated conceptions of the West as vacation that Ingersoll only dimly perceived in his text. In Jackson's views, the land became a playground for the tourist, and the railroad a servant. Trains stopped obediently so that one might dip a bit of cold mountain water for a drink (illustration 95). Or wildlife provided multiple pleasures: one could watch it from the windows, hunt it while at a rest stop (or while moving, as the numerous contemporary stories of passengers shooting at game from the rear observation decks of trains suggest),

have it cooked as a novelty item by the chef, use the bones as trophy to portray the new "steed," as in Jackson's views of D&RG engines festooned with antlers (see illustration 94), then take the remnants home as memento.

As Ingersoll implied that the tourist's responsibility was to judge the landscape, so the photographer judged, praised, and even *landscaped* the scenery by choice of vantage points, judiciously delegating the portions of the route that deserved attention and then explaining precisely what form of attention they deserved. Thereby the pictures became not only artifacts of taste but instructions in taste, in how the tourist might and should see the scenery. This depended on a particular sort of lie, for few tourists might find themselves seated on a flatcar where they could gain the perfect panoramic view, have total control over their gaze and what it acquired (illustration 96). Jackson's photographs thus presented an illusory sort of relationship between tourist and environment, one that was particularly close to the promise Ingersoll offered in his preface, of freedom from care, escape from civilization. For Jackson's views offered the tourist, potential tourist, or simple yearner after freedom a fantasized world wherein civilization—manifested as trains, schedules, hotels, and the like—suddenly became the servant of the tourist, not the force to be served or the cause of what Ingersoll had called "weariness, anxiety and strife."

Jackson's railroad tourist views offered something else as well—a vision of harmonious relations among nature, technology, and the individual tourist, contained within the frame and communicated by com-

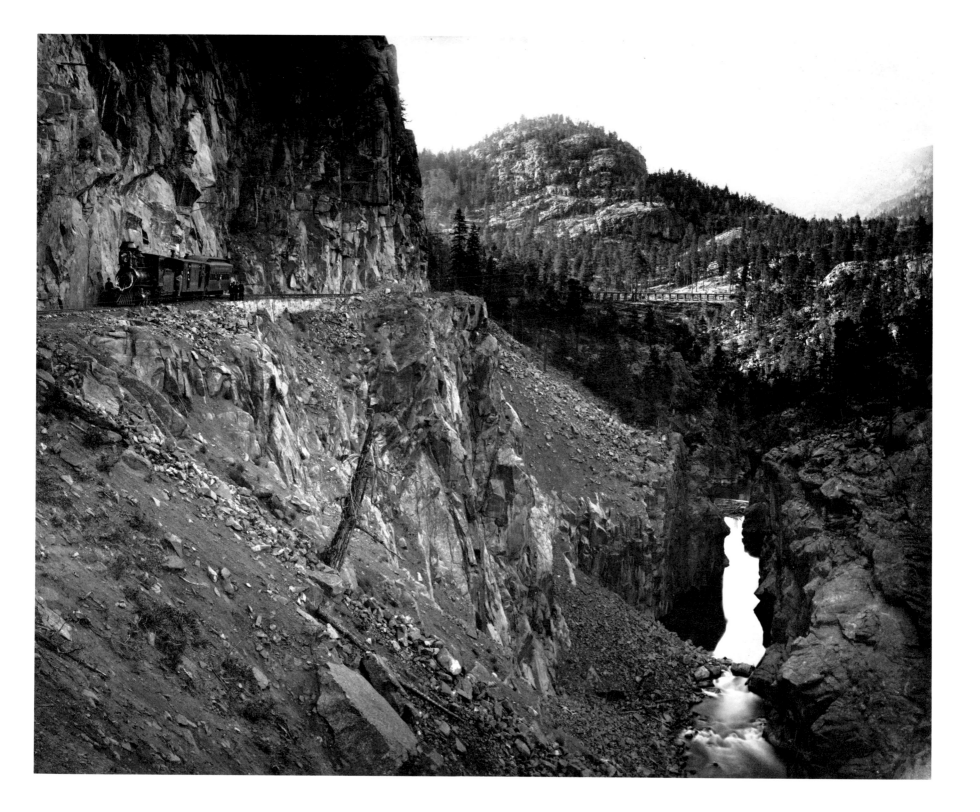

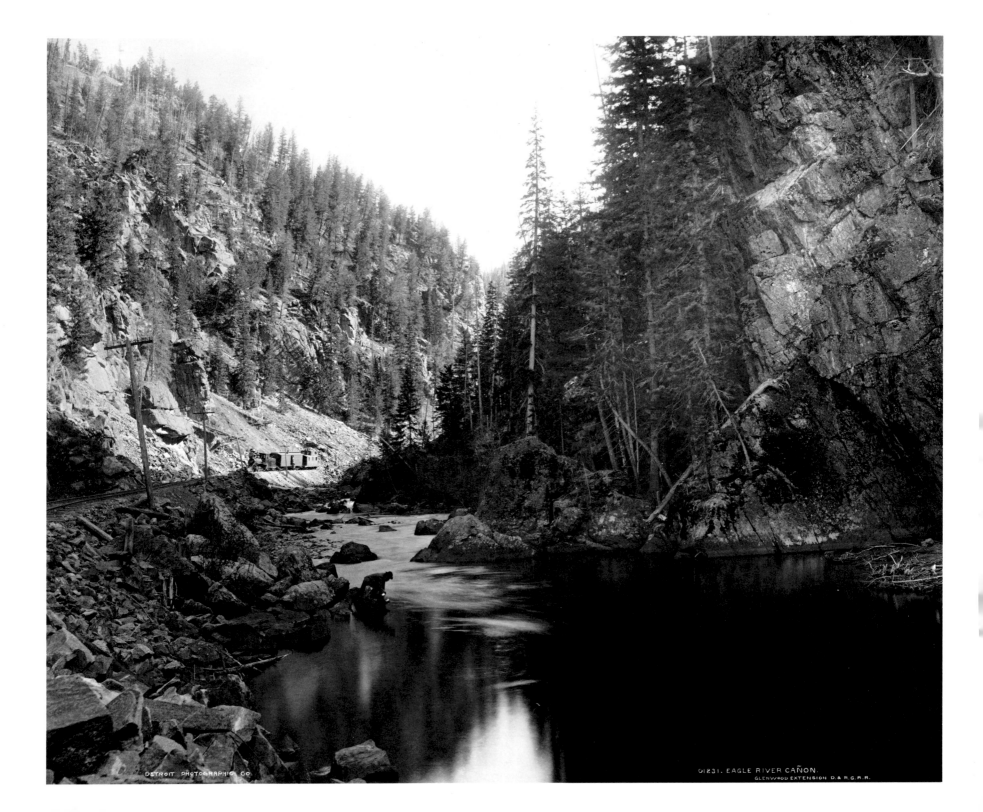

DETROIT PHOTOGRAPHIC CO. 01231. EAGLE RIVER CAÑON.
GLENWOOD EXTENSION D. & R. G. R. R.

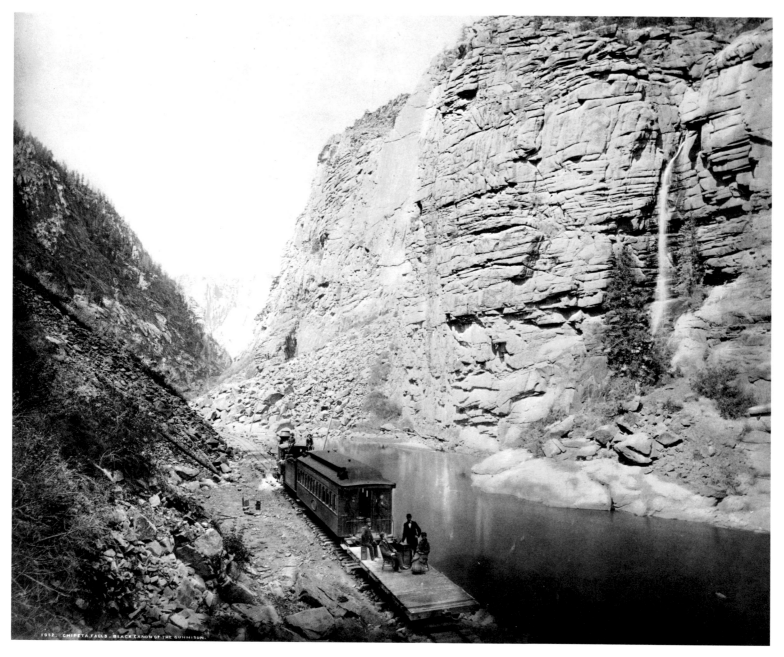

1052. CHIPETA FALLS - BLACK CANON OF THE GUNNISON.

95. (*opposite*)
*"1231. Eagle River
Cañon. Glenwood
Extension, D.&R.G. R.R.,"
ca. 1887–88.* CSHS

96.
"1052. Chipeta [sic]
*Falls. Black Cañon of
the Gunnison,"* 1883.
CSHS

position. In this respect, Jackson's commercial photography differs from work of the Survey that celebrated another sort of symbiosis. Here, the pictures are *made* rather than *taken*. His views of "Chipeta [sic] Falls, Black Cañon of the Gunnison" (see illustration 96) and "Cañon of the Rio Las Animas" (see illustration 94) are exemplary in this respect. In both cases, picturesque natural phenomena—waterfalls—are balanced against the signs of man, at either end of the composition. In fact, the Rio Las Animas view, made in the late summer of 1882, illustrates how delicately Jackson worked out the physics of such a balancing act. That day, the photographer made at least three mammoth-plate views. Of the first two, one was a vertical, the other a horizontal; the vertical (almost certainly the first) was made from a point nearer the train. The third view used the same camera position as the earlier horizontal, but with a telling change. Now Jackson moved his "special" train—a short train, engine and caboose with flatcar behind—and replaced it with a normal passenger train. The alteration was significant for ideological and formal reasons. With the longer train, the viewer was presented something approaching an illusion of naturalness, for Jackson's stubby special looked glaringly unusual to anyone even remotely familiar with railway travel. Equally important, however, the longer train provided noticeably more visual weight to counter the force of the waterfall, which gleams out of the darkness on the right side. In all three cases, however, the significant detail of the antlered engine was retained—which meant that Jackson had to prevail upon the crew of his special to remove their trademark trophies from the engine, place them on the cowcatcher of the passenger engine for the duration of the photograph, then reattach them afterward.[26]

One more aspect of these D&RG railroad views deserves mention: the redefinition of space that occurs. In all or most of these the photographer masterfully organized the space within the four edges, transforming space into shape, flattening it, making it a decorative rectangle on an interior wall rather than the exhilarating window that tended to characterize Jackson's Survey pictures and, of course, particularly the stereographs. The photographer's work in *making* this occur can be seen in many ways. In the views in the Canyon of the Rio Las Animas, it is evident in Jackson's decision to photograph the canyon when the light exploded off the background but left the foreground areas in near darkness, hence pushing both foreground and background into a spatially indeterminate region. In the photograph made in Black Canyon, the camera's angle, closing off the view of the receding railroad tracks just beyond the front of the train engine, contributes, as does, again, the choice of time of day and light. The result in each case is to make a *picturesque* image—a picture rather than a view. While this was a subtle shift in Jackson's work, it was an important one. Now the infinite space of the West became increasingly closed, limited; in its place the photographer offered the consoling, engrossing shallow space of the picture.[27]

The 1881 trip was a grand tour, indeed, through Colorado and down as far as the pueblos of New Mexico along the D&RG and other Gould-controlled lines. The photographer tasted the pleasures of the leisurely tour, an experience that would define the best of his railroad views for another decade. And the pictures he made that year, and in successive years, both for Ingersoll's *Crest of the Continent* and for other purposes, presented that new conception of the region wherein the phrase "the opening of the West" achieved new meaning. The land, stripped of any power but the power to please or displease, has become a pleasure ground. In these and the vast majority of Jackson's pictures from 1881 until the World's Columbian Exposition of 1893, all traces of awe, even respect, have disappeared from the faces of his surrogate figures—the men and women who "stand in" for the viewer in the illusionistic world of the photograph. This is particularly important considering the role Jackson had learned to make those figures play under the tutelage of painter Sanford Robinson Gifford in 1870; then, they had taught the viewer how to respond, they defined the landscape-as-seen by their reaction. Now, a decade and more later, the inattentive basking of the three figures in "Green Lake" and the stylized poses of the tourists in "Black Cañon of the Gunnison" demoted the sublimity of the landscape to picturesqueness, invited viewers to deny its potency as had their representatives—the posed figures and the photographer himself.

By the time Ingersoll's book appeared in print in 1885 (and it was popular enough to go through at least four edi-

tions before 1890), Jackson had developed a new visual ecology for the commercial West—that is, a vision of interlocking, interdependent relations among the various elements, natural and human, now resident in the region. In the railroad photographs, it went without saying that the rails and trains surmounted the landscape, perched upon it in poses of triumph that were the technological equivalent of the most didactic views of 1869—views like "Skull Rock." Railroad views like the celebrated photograph of the "Cañon of the Rio Las Animas" made from below, showing the railroad high up in the rock face, were perhaps the least important part of Jackson's gilded-age Western ecology. Rather, these rail views set the stage for a broader presentation wherein nature, now fully stripped of power, became the environment of the tourist. Train technology, too, became the servant of man, more a pet than a power.[28]

Tourists came to Colorado to see the fabulously productive silver mines, and Jackson made pictures of these sites. But after 1883, these were almost entirely tourist views as well. The mines appeared as picturesque hillside villages, or as openings like troll caves in the steep canyon walls. Periodically other images, of smelters or even the mine interiors, appeared in books with the W. H. Jackson & Co. imprint or credit line. But these apparently formed a different category of the company's work—they were made on specific commission and were used only for their original purpose, rather than reappearing as prints or in other guises—or they were pirated from other photographic firms for single use in a publication by the

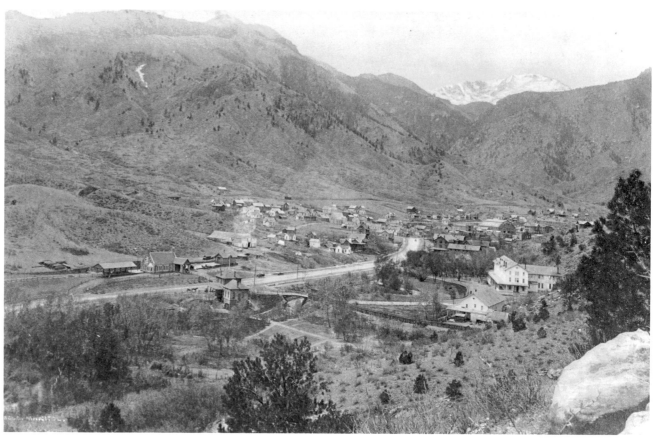

97.
"3009. Manitou, Colorado," ca. 1881–89.
CSHS

Jackson firm, as was the case with a "View of the Globe Smelting and Refining Company's Works" that appeared in one booster book. Illusion here was crucial; tourists came West to escape the slag heaps and pollution of the Eastern industrial region, and Jackson's patrons and clients were anything but interested in seeing such destruction replicated in images of the West.[29]

Similarly, cities posed a peculiar problem for Jackson, as they did for all Western boosters of the eighties in particular. On the one hand, the region had made

its reputation as a place untouched by such traces of civilization. Yet not only was the West dotted with towns and cities, but visitors were eager for the luxuries only urban settings could provide: high-quality accommodations, food and drink, places to shop and be entertained. Jackson provided a substantial number of city views of every city in Colorado, and of many others throughout the West. Some of these, like his study of the resort town of Manitou, Colorado (illustration 97), reversed the urban parks movement's *rus in urbe* to locate

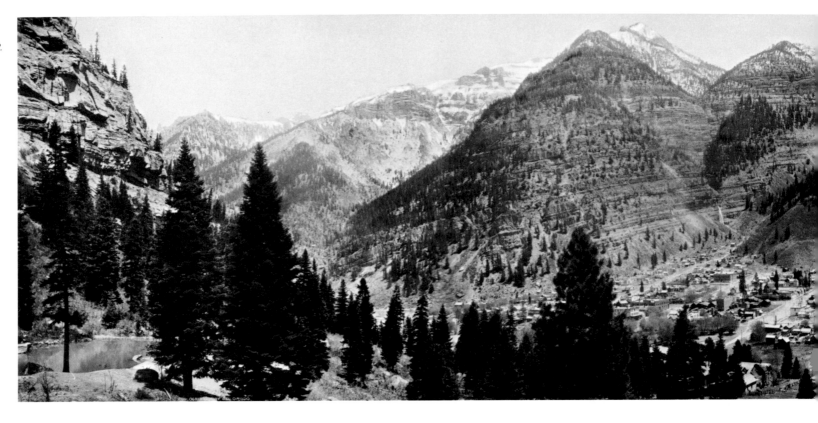

the town, jewellike, in a spectacular natural setting. Views like this, and like his wonderful panorama of Ouray made around 1889 (illustration 98), drew directly on his Survey images of Western mining towns like South Pass City and Atlantic City (see illustrations 52, 53). But they represented only one extreme of a spectrum. In the middle lay views like his panorama of "Baker's Park, Silverton, and Sultan Mountain" made around 1883, where two men stand at one side pointing to the outskirts and seemingly

arguing the next stage of city development. Views like this combined the myth of the Edenic Western society with a healthy dose of prodevelopment boosterism, in particular inviting the viewer to think of investment in townsites. These photographs straightforwardly supplanted the city-view lithographs of a generation before, which were used to promote investment in Western towns.[30]

At the other end of the continuum lay the images of large-scale urbanization in the West, particularly, in Jackson's case, Denver.

Unlike other Western commercial photographers such as Eadweard Muybridge and Carleton E. Watkins of San Francisco or Charles R. Savage of Salt Lake City, Jackson did not have the built-in picturesqueness of his city's site or its oddities of social history to attract viewers and mask other, less desirable qualities. This meant constructing an urban vision, rather than simply borrowing it. In addition, Denver was a booster town supreme during the eighties and early nineties; Jackson's social circle apparently in-

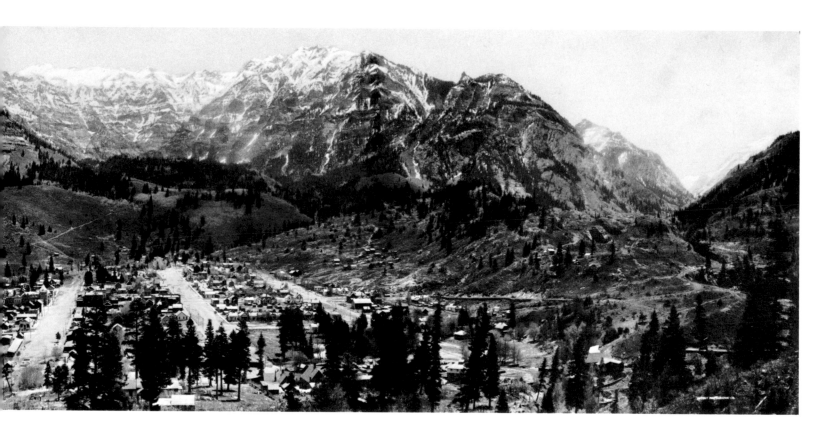

cluded the sort of developers and boosters who had the most to gain from a celebratory image of the city. But to produce it, Jackson had to combine the apparently conflicting ideas of the city as gateway to the vertical wilderness of the Colorado mountains, as civilized competitor to older Eastern centers, and as commercial and industrial power. He was to solve these in a number of ways during his years in Denver: through panoramas that used the high vantage point of a school or railway station tower to organize the city into an orderly environment; through selective studies of major monuments like the Brown Palace Hotel or the Tabor Opera House, often made by assistants, for example, Louis Charles McClure, Jackson's architectural photographer during the nineties; and through carefully edited sets of sequential views, published as accordion-style folding books, as albums, and eventually as reproduced books like *The City of Denver,* published in 1891 (illustrations 99, 100). The result was to present a variety of images of the city which, composited together, produced an image of an ideal urban locale—within reach of Eden, but itself bustling, orderly, and civilized.[31]

Having created a new West that was under the authority of civilized man, Jackson had to deal again with the Indian. This was an easy thing to do; he simply presented the Indian as an object of nostalgia, closer to a statue than a human being. Jackson & Company's view of "Buckskin Charlie, Sub-Chief, the Utes" (illustration 101) was the most ex-

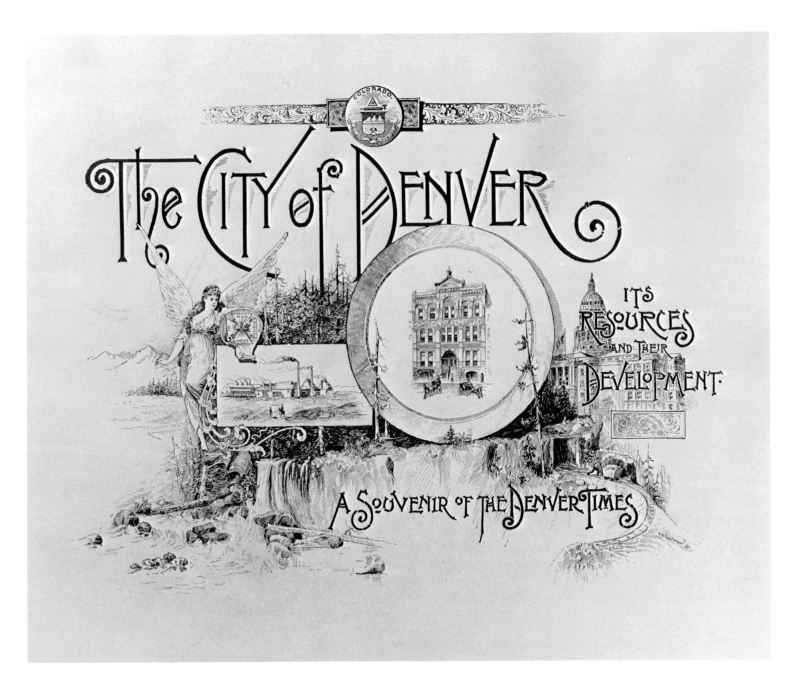

J. T. CORNFORTH

PHOTO BY THE W. H. JACKSON P. & P. CO.

ELITCH'S GARDENS, DENVER

T. S. CLAYTON

County, Illinois, on September 3, 1847, a son of Nathan L. and Minerva O. Eaton. He attended the district school of his native place and the Normal University, and subsequently came to El Paso County, Colorado, and, with A. A. McGovney, formed the El Paso County Abstract Company at Colorado Springs On April 13, 1876, he was married to Miss May S. Whipple at that city; from 1876 until 1879, was county assessor of El Paso County; was county clerk and recorder of that county from October, 1879, until January, 1890, and on January 14, 1891, was elected to his present position for a term of two years. Mr. Eaton is a member of the Masonic Order, and has attained the 32d degree.

JOHN M. HENDERSON, Auditor of State, was born at Titusville, Pennsylvania, on February 27th, 1858, a son of William M. and Mary B. (Hoskins) Henderson. He attended the high school at Titusville, and, in 1874, engaged in business, and since

that date has devoted his attention principally to the live stock and banking interests. On May 14, 1890, he was married to Miss Clara B. Shedd, at Sterling, Colorado, and is a member of the lodge, chapter, council and commandery of the Masonic order. He was a delegate from Colorado to the Republican National Convention at Chicago, in June, 1888, and was elected to his present position in November, 1890.

JAMES P. MAXWELL, State Engineer, was born in Walworth County, Wisconsin, on June 20, 1839, a son of James A. and Susan V. Maxwell. After attending Lawrence University, at Appleton, Wisconsin, he commenced business life, in 1861, in this State, and from 1863 until 1870 was in the lumber trade; from 1870 was engaged in the civil and mining engineering profession, being U. S. Deputy Mineralogical and Land Surveyor from 1876. In 1872-74 he was a member of the Colorado

PHOTO BY THE W. H. JACKSON P. & P. CO.

GARFIELD BEACH, GREAT SALT LAKE

ON THE LINE OF THE UNION PACIFIC RAILWAY.

PHOTO BY THE W. H. JACKSON P. & P. CO.

ANTELOPE ISLAND, GREAT SALT LAKE

ON THE LINE OF THE UNION PACIFIC RAILWAY

101.
William G. Chamberlain or assistant, "Buckskin Charlie, Sub-Chief, the Utes," n.d. CSHS

treme; he was the model for every movie Indian retainer of the mid-twentieth century, with his piercing eyes, honest look, elaborate costume, and single feather in his hair. This picture, like most Indian views appearing during the commercial years, wasn't even a product of the Jackson studio; it was acquired for the firm from another local photographer, after which it underwent a series of transformations, emerging around 1900 as a gaudy approximation of a chromolithograph.[32]

This phenomenon of mixed authorship increasingly characterized the output of the firm of W. H. Jackson & Company, and its later incarnation, the William H. Jackson Photograph and Publishing Company. By the mid-eighties, Jackson's constructed West was so logical as to have become "natural"—it lay at the center of the landscape aesthetic of the period before the World's Columbian Exposition of 1893. As a result, it could be, and was, pirated, borrowed, or even freely given into the larger pool of Western photography, which meant that Jackson could increasingly find samples of his work in the files of other photographers, and could do the same in return. But this was merely a sidelight of the firm's achievement in marketing the Jackson image of the West. In part such success resulted from the congeniality of this ideology to the principal interest groups of the West. Not coincidentally, these made up Jackson's clients and his audience: railroads, local boosters, Eastern industrial interests with investments in the regions, tourists, and finally, the broad general audience for landscape photographs throughout the nation and, beyond it, the globe. The success with which Jackson's pictures spoke for Western interests in fact resulted directly from the relation of client and audience to photographer during these years. Indeed, Jackson's importance as a cultural figure and his financial success during these years depended on his capacity to bring together the desires of his large and powerful clients—the railroads, the "interests"—with the longings of a far wider audience of viewers. Jackson converted good publicity into a visual form that seemed precisely right, natural—a part of the landscape.

His success grew also from his capacity to acquire and adapt already accepted visual styles and thematic messages about the nature of landscape from a wide variety of broad-based sources. During the Survey years Jackson had depended upon his own "taste" (which was really a set of cultural rules about constructing the landscape), influenced by his direct acquaintances and friends—Hayden, Gifford, Moran, Stevenson, Eliot, and the scientists with whom he lived in close contact while working. Behind their aesthetic ideals lay an entire tradition of Eastern landscape painting, a genre almost universally admired by intellectuals and scientists alike, to judge from such magazines as the *American Journal of Science and Arts*. Now his status as commercial photographer required that he broaden his readings and reconnect himself with the main currents of his culture in order to properly reflect its desires in his work.

This he did through a variety of means. Moran's influence was probably greater during these years than it had been during the Survey, for the painter was now himself a successful artist, in the very terms most respected both by Jackson and by mainstream American culture—he was well paid and in demand, and his work was seen by a wide audience. Moran's masterful presentation of a mass-market picturesque, evident in his illustrations as early as the publication of *Picturesque America* in 1874, now applied directly to Jackson's needs. But

Moran was only one source. Popular journals were full of such landscape illustrations, and Jackson contributed to, and learned from, many—from views of the Capitol Building in Washington to illustrations of popular southern California resort hotels.[33]

The popular landscape aesthetics of the period had, by this time, a direct conduit to commercial photography of Jackson's type, in the form of essays in the professional journals. These magazines—*Anthony's Bulletin, The Philadelphia Photographer, The Photographic World,* and the like—published landscape photographs throughout the era, first as actual photographic prints tipped into the bindings, then in the form of a wide variety of reproduction technologies that vied for approval during the eighties and nineties. These provided visual models from which not only Jackson but many other photographers worked. In addition, these journals published articles throughout the eighties and nineties urging readers to pay attention to the problems of landscape composition and providing detailed lessons, with illustrations, in the construction of a "proper" landscape view.[34]

The result was to generate a more homogeneous landscape genre in photography, within which Jackson's task became to fit the added requirements of his region, clientele, and audience. This was not particularly difficult for him. As a friend of editor George Washington Wilson of *The Philadelphia Photographer* and *The Photographic World,* Jackson had easy access to the views and articles—especially those in which he was set up as a model and example to Wilson's readers. More important, the prevailing picturesque aesthetic of the period was already a commercial aesthetic, already dedicated to adjusting its audience to the changing reality of landscape, to the control of the land by forces of "progress" and its exploitation, reorganization, and accessibility as a pleasure ground for tourists and visitors. Jackson's gift lay first with assimilating these sources, then with investing them with his particular brand of spectacular visual sense, a quality that made the best work from the Jackson studio immediately recognizable, eminently marketable, and, by the end of the decade, nearly ubiquitous.

In the mid-eighties, Jackson's success forced a major reorganization of the business. In 1884, Jackson and Rinehart separated, a move that represented Jackson's liberation into pure landscape work. Jackson set up a new partnership, with the bookselling firm of Chain and Hardy. This arrangement signaled Jackson's change in thinking from photography to publishing, from studio to corporation, concretized by the name of the new firm: the W. H. Jackson Photograph and Publishing Company. Production and dissemination now became the focus of the firm, and Jackson began an aggressive campaign to change the business from top to bottom. In 1885, Jackson brought in his brother Fred to work with the company; in 1886, his brother-in-law Orrin Painter also entered the firm. But these were only two of a large number of assistants who joined the Jackson Company, as Jackson himself moved increasingly into a dual position as senior photographer and director. This meant that Jackson turned over the making of most 8-by-10 and smaller images to assistants, leaving for himself the mammoth-plate views that constituted the company's most visible and spectacular product.[35]

The output of the Jackson firm was now reorganized to match the systematic business practices of managed corporations that formed the new wave of business innovation in the eighties; Jackson's legal incorporation in 1884 indicated his new devotion to modern business practices. As far as can currently be determined, the new system involved a number of tiers. Commissioned pictures were usually made by assistants, with the results monitored by Jackson to guarantee that they conformed to the Jackson style and were up to the photographer's standards. Often these views were remakes of older photographs Jackson had himself produced earlier in his career—railroad views updated to reflect new rolling stock or other alterations in the route, for example. In these cases, the assistant had a Jackson view to examine for clues to the proper way of working. When clients were particularly influential, or when mammoth-plate (18-by-22-inch) views were ordered, Jackson himself usually made the photographs. Railroad trips, it appears, remained Jackson's domain; they served as vacations as well as jobs, and Jackson often took friends, and sometimes family, along. But increasingly Jackson traveled with an assistant, who not only prepared the plates and handled the equipment but made the necessary smaller views.[36]

Assistants alone provided one part of the output of the company. Because of the popularity of views, Jackson made a policy of providing examples of well-known views in every popular negative size, from 5-by-8 through 11-by-14 to 18-by-22. In many cases this involved not reshooting the scene

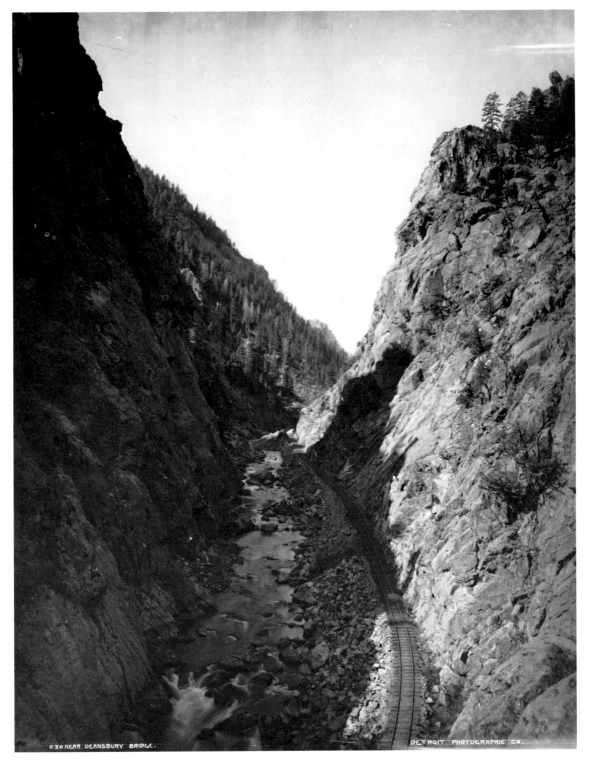

030 NEAR DEANSBURY BRIDGE. DETROIT PHOTOGRAPHIC CO.

but rather making reduction copies of Jackson's own mammoth-plate views; though this meant that portions of the image would disappear from a 5-by-8 view, it also meant that the company could "enlarge" portions of negatives if it wished. Combined with reshot views by assistants, the result was an amazing duplication of views in various sizes, such as those of the "Platte River Cañon Near Deansburg" (illustrations 102, 103, 104).[37]

Photographs purchased from other photographers and then published under the Jackson name formed a third source of views. This was the case, for example, with some of George Mellen's work, which arrived in the Jackson studio before the photographer himself went to work for Jackson between 1889 and 1890—possibly after the failure of a supposed joint venture between Jackson and Mellen in Colorado Springs during the eighties. This was even more common with the Indian views, which were, by the late eighties, so stylized and stereotypical that it required little or no effort to find images that fit acceptably with the Jackson style. Otherwise, purchases were limited to certain specific functions—especially to producing published booster books with reproductions of photographs. Hence a "Street Scene, Colorado Springs, Showing the Antlers Hotel and Pike's Peak in the Distance" was originally made by the Colorado Springs photographer Stevens, then acquired by Louis Charles McClure, who added a building by retouching before the final negative went to Jackson to be published in *Gems of Colorado Scenery* in the early nineties.[38]

McClure's retouching represented another way in which, in the eighties and

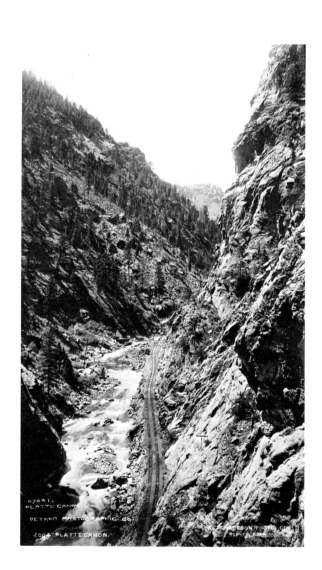

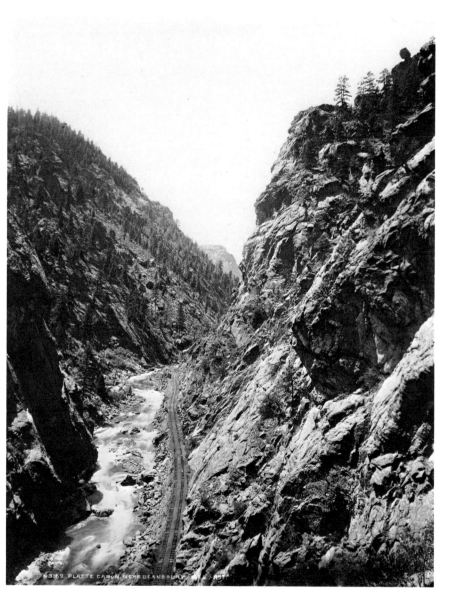

102. (*opposite*)
"*030. Near Deansbury*
[*sic*] *Bridge,*" *11-by-14*
version, ca. 1881–92.
CSHS

103. (*left*)
"*Platte Cañon, Near*
Deansburg," *5-by-8*
version, probably 1881–
83. CSHS

104. (*right*)
"*3169. Platte Cañon,*
Near Deansbury [*sic*]*,*"
8-by-10 version, ca.
1881–92. CSHS

THE COMMERCIAL TRAVELER 159

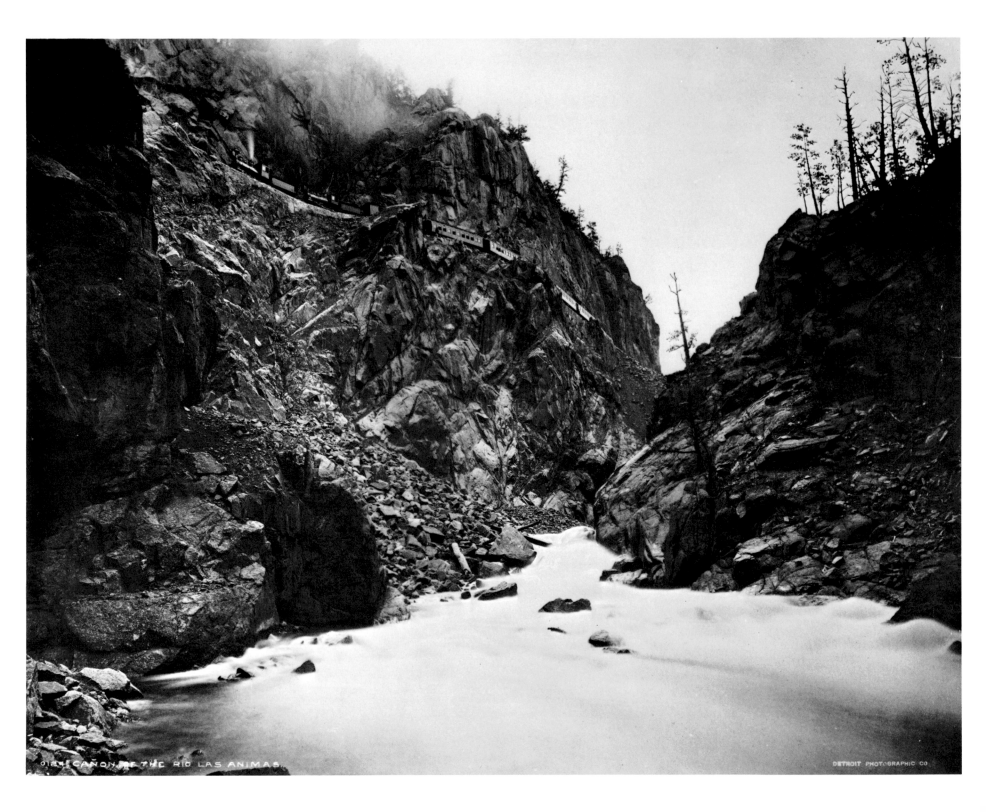

CAÑON OF THE RIO LAS ANIMAS. DETROIT PHOTOGRAPHIC CO

nineties, Jackson's final photographic images became dislocated from their original immediacy. Jackson's famous view of the "Cañon of the Rio Las Animas" (illustration 105) grew increasingly elaborate as the years passed; more and more smoke appeared, and the trains came to look like cartoons as the photographer returned and retouched.

In many cases, retouching was a necessity in adapting the finished print to the reproduction techniques of the period, particularly the rough, ill-made halftones that became increasingly popular during the late eighties and acquired a virtual monopoly by the mid-nineties. The advent of sophisticated reproduction processes in the eighties, primarily gravure and halftone, pressed on Jackson's economic territory, requiring that he adapt to their presence and find a place for himself. At first, this was a relatively simple process for him. He had been involved in photograph publication since the late sixties—the stereos he sold to Anthony & Company in 1869 were published views, albeit by a process less adapted to mass-production techniques, and the Survey years had acquainted him with the Albertype process and with book and periodical publishing as well. In addition, his relationship with clients as a commercial photographer had prepared him for the complex relationships between producer and image that characterized the world of publication. The commercial years saw Jackson adapting to each new wave of mass-market reproduction technology. An awareness of the power of mass-publication had led him to a partnership with Chain and Hardy in 1884 and impelled him into relationships with the *Rocky Mountain News,* the *Denver Times,* and other publishers. In addition, he had photographs published in *Wilson's Photographic Magazine* in 1889—as well as a lengthy "biography" in the same issue—and again in 1893.

Jackson's reasons for entering the publication area were canny, from a business standpoint. Faced with competition from other processes able to satisfy his marketplace more cheaply and in greater quantity than he could, he sought, and succeeded in creating, a vertically integrated monopoly on Rocky Mountain views, while competing with other firms on a nationwide basis for scenic views of other areas and retaining a place as a producer of views for other publication houses in the areas of architecture and city views. When he provided the images for halftoning in *The City of Denver* in 1891, the fact that his name appeared on images like Moran's chromolithograph of the Mount of the Holy Cross painting simply reflected his new role as a conduit and an archive for images. Like the early picture agencies of a decade or so later, Jackson provided views to order, made and acquired views he hoped would sell, and served as a national source for landscape images of all sorts, to which everyone, from publishers of textbooks and educational materials, to individuals looking for inspirational images for their parlor walls, could turn for a product.

Jackson's most direct connections in publishing lay with Frank S. Thayer, a celebrated Denver entrepreneur. The combination of Jackson, Thayer, and the Chain and Hardy firm made the perfect vertical integration for the Denver and Colorado marketplace, with Jackson providing the views, Thayer the publishing expertise, and Chain and Hardy the binding, finish work, and distribution channels. A typical work from this team was *Gems of Colorado Scenery,* first published around 1890. Without text, this work combined photographs from the Jackson archives (including portraits transparently the product of the Rinehart studio) with drawings from George Berger, a local Denver artist, to produce a large, well-reproduced tourist remembrance.[39]

Gems of Colorado Scenery was, in many respects, similar to the urban booster books of the same era; Jackson edited and sequenced the pictures to provide an unremittingly optimistic view of his subject. Beginning with a "Street Scene in Denver" (illustration 106) which, typically, showed a wide street lined with substantial, fashionable brick and stone houses, and even a liveried coach in the center of the frame, the book included views of the "State Capitol Building, Denver, Colo.," a page of "Types of Colorado Beauty" (portraits of local women), as well as views of mountain scenery. The combination of drawings and photographs indicated the virtues of modernization even as the drawings also generated a myth of the Western past as a place of romantic figures and wild events—hence a sketch of a miner's pack train to match the view of the Pike's Peak cog railway, and a drawing of a stage holdup below a view of the Manitou and Pike's Peak Railway complete with rifleman posed as if to guard the train. Images of landscape focused on locales accessible by rail, scenes of railroad feats (as with a version of Jackson's spectacular view of "The 'Loop,' near Georgetown, Colorado," illustration 107), or scenes that were pointedly designed to ap-

105. (*opposite*) *"1077. Cañon of the Rio Las Animas," in a late reincarnation as a Detroit Photographic Company 11-by-14.* CSHS

Street Scene in Denver.

106.
"Street Scene in Denver," from Gems of Colorado Scenery, *ca. 1890.*

107. (*opposite*)
"The 'Loop' Near Georgetown, Colorado—U.P.R.R.," *with added illustration by George Berger, from* Gems of Colorado Scenery.

peal to the tourist impulse, such as the photograph of "Trout Lake on the Denver and Rio Grande Southern R.R." And of course, a version of the "Mount of the Holy Cross" was included. Indians, cowboys, coyotes, and burros—all the *rarae aves* of the region, in other words—received their own page (illustration 108). A perfect remembrance or promise of a tourist's journey, it served its buyers by providing a complete fantasy of escape from complexity into simplicity, from

urban chaos to natural order, from the protective closed parlor to the protected open spaces of the West.

Books like *Gems of Colorado Scenery* almost always had a purpose in mind—they were meant to serve as general souvenirs, as remembrances of specific regions (as was the case with *Grand Cañon of the Colorado,* published by the Santa Fe Railroad), or as booster books and prospectuses for potential investors. This last was doubtless the case

with *Perry Park, Colorado.* Perhaps the most bizarre of Jackson's publishing ventures, it combined his photographs of the region with poems by one of Denver's "women poets" (illustration 109)—it was evidently meant to accompany a more direct prospectus concerning the availability of vacation lots.[40]

Jackson's publishing ventures had the effect of keeping the photographer's name prominent even as they testified to his own steadily diminishing independence. Most of the books had sponsors who demanded specific qualities from the finished product, even as they retained control over such production matters as paper stock, reproduction type, layout, and possibly even sequencing and editing. Other decisions had to be made in concert with the publishing partners—Chain and Hardy, Thayer, and the like. Thus each book bearing Jackson's name increased his celebrity but decreased his power, as his position in the landscape marketing business became more and more hemmed in each year. This corresponded to a broader phenomenon in Jackson's life during the late eighties—a process by which the intersections among personal, family, business, and artistic lives became confused as the values that underlay each area slipped over their boundaries. Nowhere was this more evident than in his family relations.[41]

The years after Emilie and the children arrived in Denver show the sort of steady upward mobility that exemplified American success in the Gilded Age, manifested in the addresses, and the architectural pretensions, of their various houses. As Jackson's studio spaces grew successively larger

The "Loop," near Georgetown, Colorado—U. P. R. R.

108.

A page from Gems of Colorado Scenery.

The "Burro," or Rocky Mountain Canary.

Cowboy.
Rocky Mountain Coyotes.

Indian Chief, Colorow.

109.

*"The Vale of Cashmere,"
a page from* Perry Park,
Colorado, *1890.*

THE VALE OF CASHMERE

Who has not heard of
The Vale of Cashmere,
With its roses the brightest
that earth ever gave,
Its temples and grottos, and
fountains as clear
As the love-lighted eyes
that hang
over their waves"

"When the
Spirit of
fragrance
is up with the day,
From his haram
of night-flowers
Is stealing away,
And the wind, full of wantonness
Woos like a lover
The young aspen-trees
Till they tremble all over"

CASTLE RIDGE.

and more luxurious, so did the family residences. Renting rooms first at 488 Champa, then nearby at 406 Stout, and then above the studio at 18th and Wazee, the family finally moved in late 1882 or 1883 into a substantial brick duplex, where they acquired a maid, whom Jackson also proudly included in the photograph he made of his wife and children (illustration 110).[42]

Eighteen-eighty-three was a particularly good year for the Jackson family. Their new house bespoke a momentous jump in status, and they had entered Denver society. On February 7, the *Rocky Mountain News* reported the presence of Mrs. W. H. Jackson, in a "black satin and velvet costume," at a reception at the Governor's Mansion. Mrs. Jackson joined the Flower Club, and Jackson himself was reported in the *News* as "the renowned landscape photographer." As part of the booster community of Denver, Jackson could count among his friends a wide range of socially important figures, including publishers, politicians, businessmen, and various railroad managers and executives.[43]

By 1886, Jackson's success was sufficiently assured that he ordered construction to begin on a house at 1430 Clarkson, on fashionable Capitol Hill. The photograph Jackson made of its unoccupied parlor, looking into the dining room, suggested a happy transition into upper-middle-class substantiality (illustration 111). Two other photographs made at the same time, however, are unsettling. They show Jackson's youngest daughter Hallie, now about eight years of age, slumped dispiritedly in two different chairs, one in the living room, the other in what appears to be a second parlor (illustrations 112, 113). Why Jackson would have included

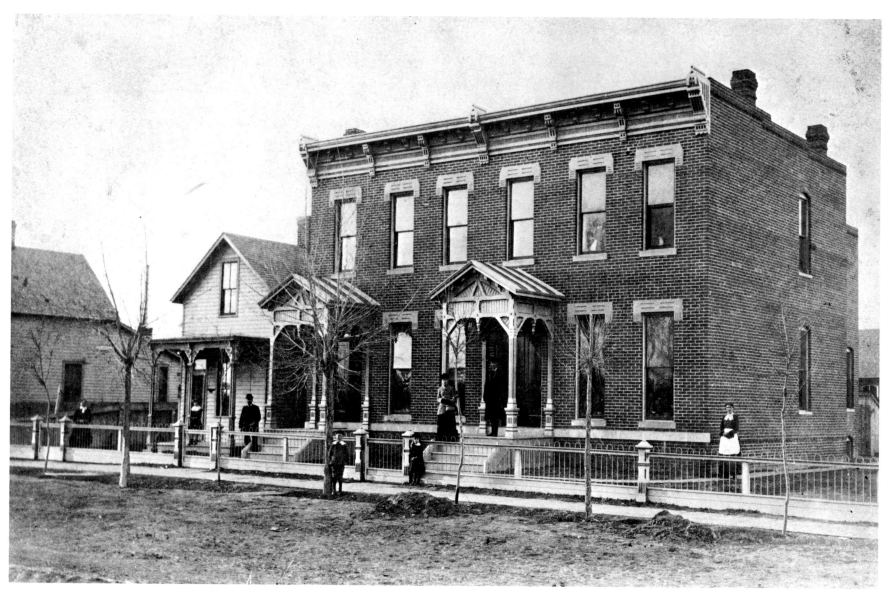

110.
*[Jackson's home on
23rd St. in Denver],
1882–83.* CSHS

her, so palpably unhappy in both cases, remains a mystery. Yet equally notable is the way Jackson directed the camera. In both cases, Hallie is a small, seemingly unimportant part of pictures whose focus is clearly on the wealth of goods—furniture, drapery, rugs, bric-a-brac—that overwhelms the sad little girl.

One might dismiss these pictures as anomalies in the Jackson family life, insignificant or at least inadvertent in their implications, were it not for the severity with which they go against the prevailing genres of late-nineteenth-century portraiture, especially portraiture in personal settings. Most such views, Jackson knew from experience, either presented the subject in a formulaic studio pose—seated formally, or standing at a fireplace or other such prop—or allowed the person to present or even act out a fanta-

sized persona, a type popular since the rise of the carte de visite and undergoing a resurgence at this time in the world of amateur photography. The photographs of Hallie reside out of the range of correct images, particularly of young girls. One must ask how Jackson could have allowed himself to make these pictures.[44]

The photographs are, perhaps, an indication of conflicts within the family structure, clues to which are embedded in Jackson's own autobiography. There he wrote of life during the commercial years:

If it wasn't always as satisfactory for my wife as it was for me, Emilie fully understood and agreed that it was, under the circumstances, the best one possible for all of us. It gave us the income to live well and to entertain our friends. It gave us the money to build a house of our own on Capitol Hill. It permitted us, without undue sacrifice, to

educate our children . . . and it gave us the leisure, now and then, to enjoy long holidays together. All in all, the Jacksons were a contented family.

Here the paragraph begins by separating Jackson's "satisfactory" life from those of his wife and children; the benefits that compensated for an unspoken failing—economic success, education, duty, intermittent leisure—are not emotional or even familial. The structure of the statement is a justification for an unadmitted insufficiency, ending with a qualifier ("all in all") that undercuts the final resolution.[45]

Part of that insufficiency must have been Jackson's status as an absent presence within the family. While he provided the material goods to compensate, he was himself gone for months at a time, on photographic excursions for his clients. Indeed, the passage preceding his apologia in *Time Exposure* concerns his liberty to travel, and the extent of his journeys:

In the summers I covered such sections as the Gaspé, the Yellowstone, Colorado, upper New York, and the White Mountains. After cold weather set in I found myself busy in Mexico or California or Louisiana or Florida. And since I enjoyed traveling even more, if possible, as I grew older, it was a thoroughly satisfactory life.

This was a different sort of absence and a different sort of travel from what the photographer had experienced while with the Survey. In those early years, the zeal and belief in a higher purpose expressed in Jackson's contract with Hayden had given meaning to the months of hard work, distance from loved ones, and economic sacrifice. Those qualities had leached out of Jackson's life, replaced by the more mundane desires of

prestige, comfort, security. And at some level Jackson may have understood this difference and yearned for the older set of beliefs.[46]

This desire may have motivated, in part, the photographer's apparent attempts to reenact the Survey years, by arranging trips with old Survey companions like Ingersoll and Moran. Jackson's "thoroughly satisfactory life" was almost entirely male-dominant and male-dominated. Time after time in his archives one finds images that recreated the masculine company of the Survey, as he had photographed it in 1870—photographs of groups at the base of Grand Canyon, on the trails of the Yellowstone, in the mountains themselves. Indeed, the proper Jackson shooting trip seemed to include the photographer, an assistant (Frank Smart for the first few years, then a string of others including, apparently, Fred Jackson and brother-in-law Orrin Painter), and at least one semiofficial guest—perhaps a writer, or a publicist for the railway.[47]

This was particularly noticeable given the makeup of the groups who modeled for so many of his views. These included men and women, and ranged in size from four or five (as in "Phantom Curve," illustration 114), all the way up to hundreds, as in Jackson's view of a wildflower-gathering excursion train (a popular "special" during the eighties), "1211. Colorado Midland Excursion Train, 11 Mile Cañon" (illustration 115). But these were views meant specifically to tempt tourists, and the reality was that tourists came in mixed groups and families to the railheads of Colorado.[48]

Jackson's other class of views seem more personal. Often they included him; they were closer to remembrances than com-

112.
[Interior of the Clarkson Street house, looking from the library], ca. 1890. CSHS

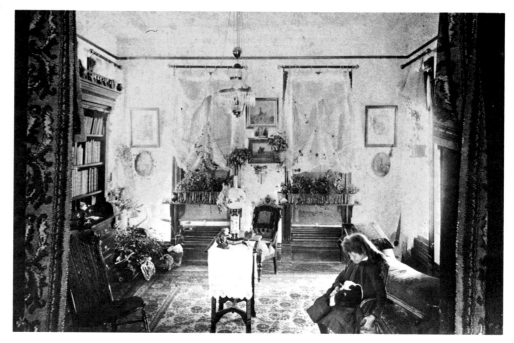

113.
[Drawing room, Clarkson Street house], ca. 1890. CSHS

114.
*"Phantom Curve," ca.
1881–92. CSHS*

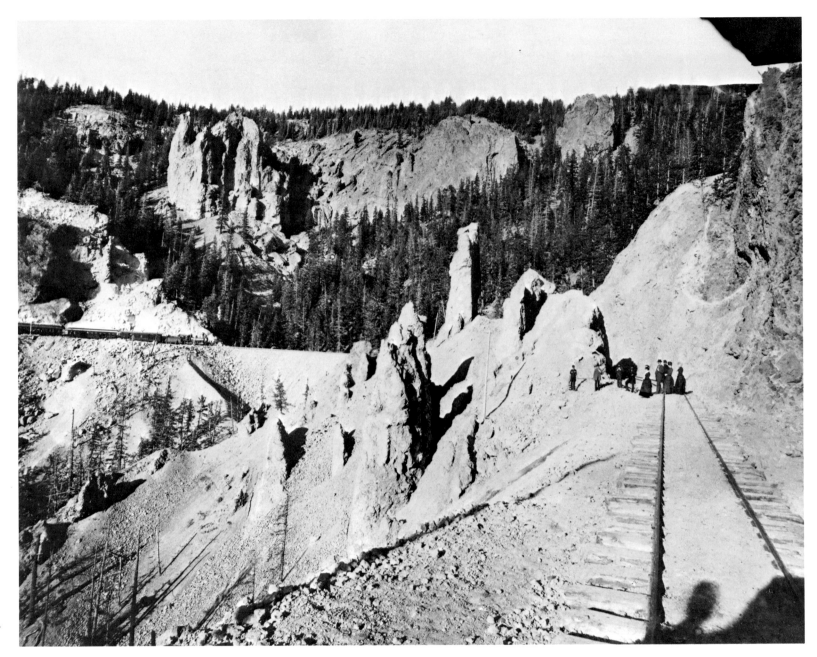

115. (*opposite*)
*"1211. Colorado
Midland Excursion
Train, 11 Mile Cañon,"
ca. 1881–92. CSHS*

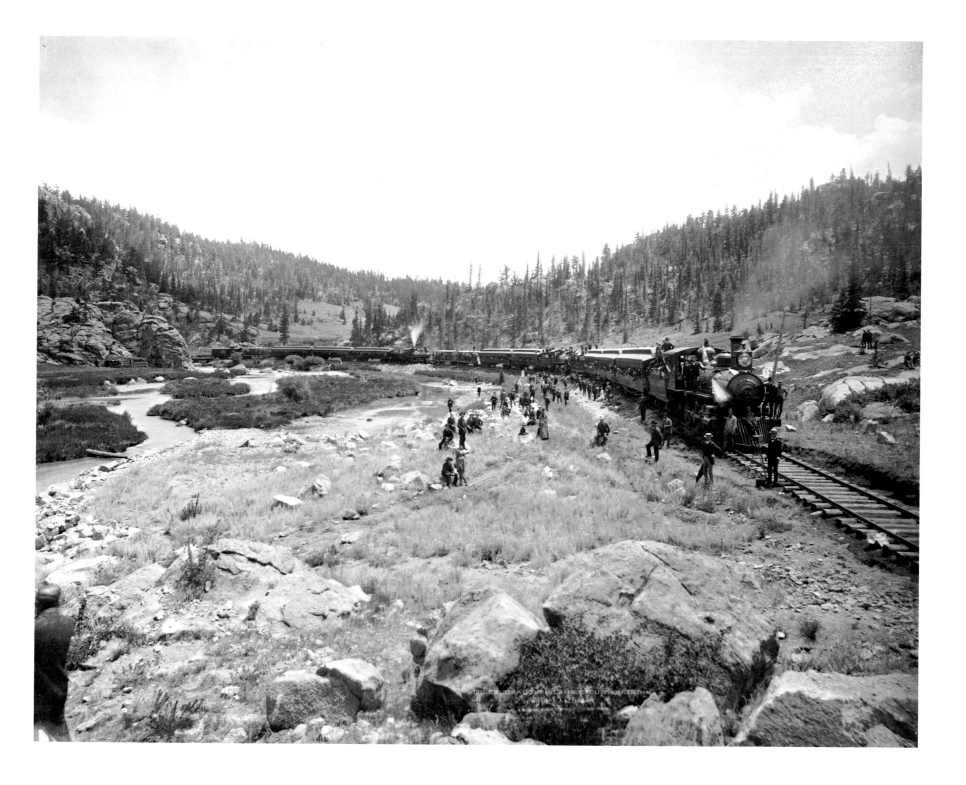

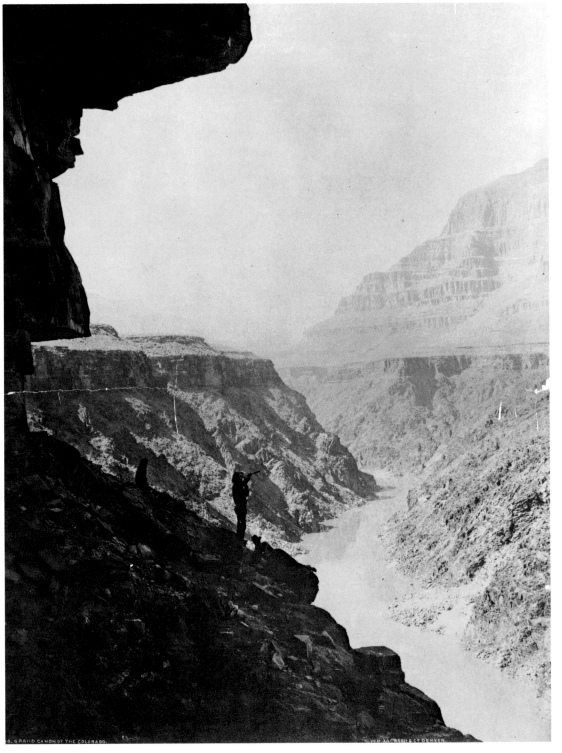

GRAND CANON OF THE COLORADO. W. H. JACKSON & C. DENVER.

mercial products, even though they offered an image of Western life that was singularly attractive to Victorian males. Whereas the mixed views emphasized the tameness and civility of the region, these photographs portrayed a rougher, more adventurous encounter with not nature but wilderness. These views emphasized the experiences of the explorer rather than the visitor, hearkening nostalgically to Jackson's Survey years, and offering a similar experience to small groups of properly prepared Victorian men of the eighties and nineties. Jackson's extraordinary view of the Grand Canyon of the Colorado, probably made in 1892, (illustration 116) is emblematic: two men stand upon a seemingly impossible trail and gaze out with the assured possessiveness of the explorer at a sunstruck landscape of sublimity. Often these photographs offered their viewers an experience of solitude and respite, often emphasizing the sport of fishing, almost always as a masculine and solitary occupation.

Jackson's work thus partook of the contradictory qualities of Victorian male and female roles. On the one hand, it emphasized the close, almost comradely relationship of husband and wife that Ingersoll had settled into in *Crest of the Continent* and celebrated the tightly knit nuclear family in similarly didactic images where civility in the family was enacted against a backdrop of suitably chastened nature. On the other, it celebrated a cult of male adventure, emphasizing near-tribal groupings (illustration 117, and see illustration 133) or solitude in a wilder arena. And Jackson's own family life seemed to mimic this dualism, with its periods when the photographer was at home,

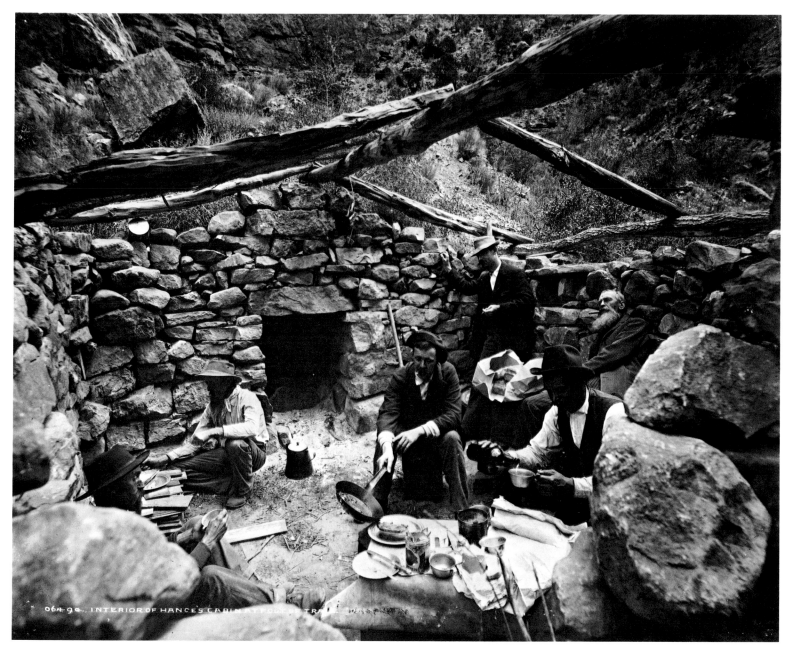

116. (*opposite*)
"1068. Grand Cañon of the Colorado," probably 1892. IMP-GEH

117.
"Interior of Hance's Cabin at Foot of Trail [Grand Cañon of the Colorado]," 1892. CSHS

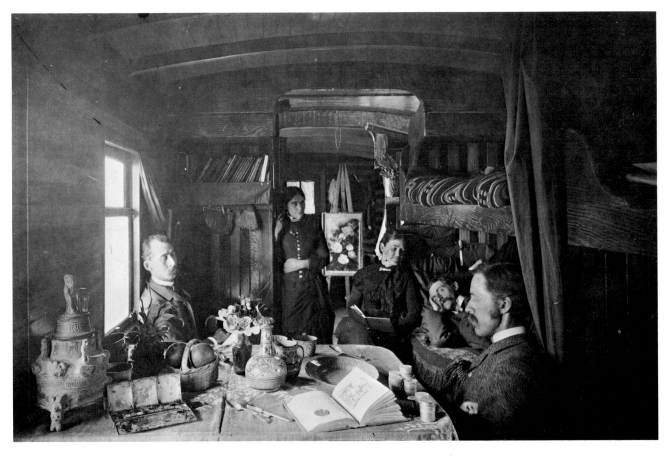

118.
Jackson (far right), *with his 1883 Mexican party, in their private car.* CSHS

Jackson was sensitive to what he saw as the prime failure of his family life—its inability to conform to what he termed a "businesslike method." It was a matter that returned in reminiscences and in letters to his wife. There he touched directly on a deeply problematic area in American Gilded-Age culture—a shift in ideals of social structure that included, indeed confused, the worlds of business and the family. But for him there seemed to be no way of resolving this dualism, and it would return to disturb him again and again throughout his life.

Perhaps another element of Jackson's life was intertwined within these confusions of role that he shared with his culture. For Jackson's quite evident unwillingness to see his medium, or his own occupation within it, as an artistic one corresponded with a culturewide movement to sequester the aesthetic impulse and offer it to woman as a substitute for freedom and potency. Historian Ann Douglas has written tellingly of the prison into which the "feminization" of American culture placed women, assuring them all the while that their bondage was a new sort of liberty. But there is also a male side of this; the "artistic" became, for middle-class American men, an occupation and an impulse that undermined their masculinity. Thus the decision to see the world in a "businesslike" way, dominating Jackson's economic and social lives and spilling over into his family life, may have had its connections as well to the day-to-day process by which he made pictures and, thereby, redefined American landscape as a contest to be won, a foe to be dominated, an object of beauty to be consumed.[50]

or when he took the entire family along on a railroad tour of the East, or even Mexico, sometimes even with friends—as was the case with a Mexican trip in 1883 or 1884 that included the J. A. Chain family (illustration 118). These phases of portraying the responsible parent and husband alternated with lengthy separations in which Jackson immersed himself in the company of men—a condition into which Jackson would later initiate his own son Clarence during a railroad trip on the Baltimore and Ohio Railroad in 1892 with B&O publicist Joseph Gladding Pangborn. Moreover, Jackson was not the only figure missing from the family circle—Clarence, and later the daughters too, went off to boarding school, one of the "benefits" of Jackson's income and success.[49]

Jackson's solution during the Denver years was, ultimately, to escape—into the wilderness (itself encroached), into the company of men, in a relationship that never quite matched the Survey experience of freedom, communality, and discovery. Jackson's trips ranged from brief excursions along the short-line railroads, to journeys of a month or more, of which the sojourns with Ingersoll in 1881 and with Moran in 1892 were apparently among the longest and most productive. As Jackson's short-line work became increasingly well known, he found himself called to travel farther and farther from Denver until, by the mid-eighties, his sphere of operations had expanded to include virtually all the scenic areas of America, including Mexico.[51]

In economic terms, these trips fulfilled two sets of obligations. Many were contracted by railroad companies that wished a set of views for their own use. At first, that use might have meant simply displaying them in stations (illustration 119) or offering them for sale as souvenirs along the line, but as halftone reproduction increasingly shouldered its way into the visual information marketplace, Jackson found his pictures used for railroad prospectuses, advertisements, and tourbooks. In any case, the problem remained the same: to produce a coherent set of pictures that advertised the sights along the railroad line and at the same time celebrated the presence of the railroad as a benevolent force in the landscape.

The other marketplace obligation lay with Jackson's own file of views—that is, with the necessity of maintaining as complete an archive as possible of American scenery,

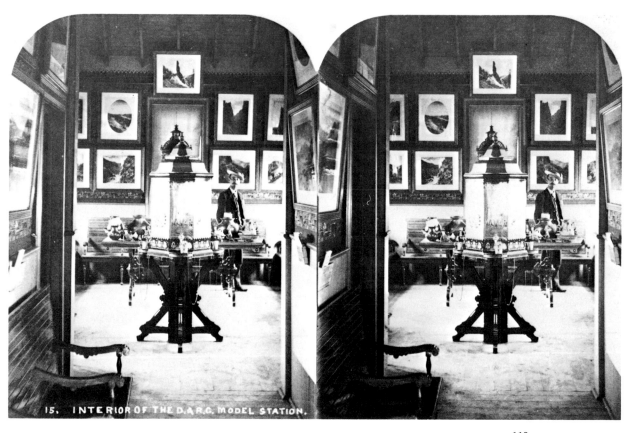

15. INTERIOR OF THE D.&R.G. MODEL STATION.

photographed in as close to the ideal Jackson style as could be done. This latter requirement motivated a number of Jackson's excursions during the late eighties and early nineties, and Jackson increasingly combined the making of views with the scouting of photographs by well-known local photographers. These he purchased, then copied to provide the Jackson company with negatives in a wide variety of formats. These trips took Jackson to virtually every Western scenic spot: to Yosemite, San Francisco, and Lake Tahoe in California, to Mesa Verde, Yellowstone, and other old Survey haunts. The overall result was to extend his tourist ecology to each new area.

But of greater import was the process by which the photographer expanded his vision to comprise both the East and the exotic Mexican scenery. Mexico was easiest; his client was the Mexican Central Railway, and the purpose for the pictures was essentially the same as if it had been the D&RG or the Atlantic and Pacific—to celebrate the

119.
"Interior of the D&RG Model Station." CSHS

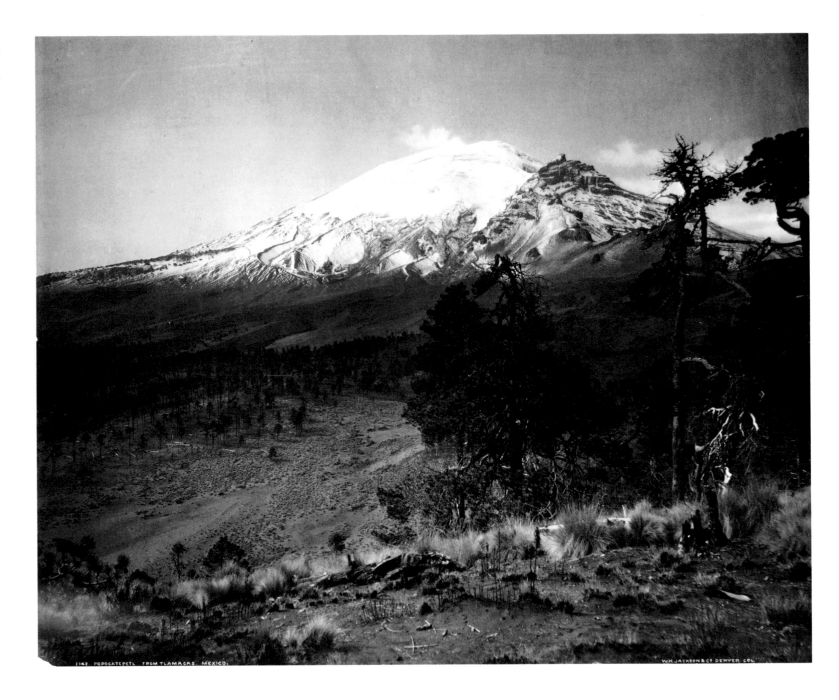

technologization of the wilderness and to advertise its availability to tourists. Jackson made at least three trips along the Mexican Central—in 1882, 1883, and 1891. The first trip occurred while the railroad was still in the final stages of completion; Jackson returned the next year to finish his catalogue, this time carrying a mammoth-plate camera, which he used again for his 1891 trip.[52]

Jackson's Mexican photographs, particularly the later mammoth-plate views, reveal the photographer's capacity to extend his commercial vision into regions other than the American West. In Mexico, the conditions were signally different; President Porfirio Diaz's dictatorship had rammed home a program of "modernization" that included building a new rail system and systematically transforming agricultural production to the more efficient hacienda system, which depended, however, on a labor force of peons—farmers forced off their lands and into contract-labor relations that approached slavery. Equally important, the capital necessary for this modernization program had come, to a great extent, from sources in the United States.

In Jackson's pictures, the result became an exercise in celebrating an American colonial power that would move to center stage in a few years with the photographer's work for the World's Transportation Commission. Jackson focused on a number of themes that were derived, in only slightly modified form, from the Colorado and Western views. The land became first of all a place of spectacular scenery—of exotic trees framing a desert of cacti yielding in the background to a wild volcanic mountain (illustration 120), of picturesque villages nestled in hillsides, of

equally picturesque peasants bowed down with their burdens. Jackson made a point of emphasizing the process of modernization, by depicting cities in transition, by portraying the haciendas, and of course by describing the railroads and their triumphant incursion into the stony deserts and wilderness of central Mexico (illustration 121).

Photographing the East required a different set of strategies. A number of these trips involved railroad commissions—for the New York Central, the Baltimore and Ohio, the Philadelphia and Reading Railroad, and others—but they also included commissions from resorts, hotels, and watering holes. For these clients, Jackson found a way to match his Western style but apply it to the very different scenic values of the East. Primarily,

121.
"Temasopa Cañon Above the Tunnels," probably 1891. LC

this involved the application of a smoother, more regular, restful, and stable aesthetic to the region. Now beauty replaced sublimity as the shading point of the picturesque (illustration 122), but the underlying message of the suitability of the region for tourism remained the same. Jackson's view of "Washington Bridge and Harlem River" (illustration 123), for example, portrayed the region as a place of leisured activity, gentlemanly sport, and perfect intersection between natural and technological beauty. His view of the Springfield cottages at Sykesville, Maryland (illustration 124), was probably part of a series he did for the B&O Railroad in 1892; it, too, followed a landscape style closer to that of Eastern painters and photographers. And the application of the mammoth-plate camera to these views served to elevate the less spectacular qualities of the scenery.[53]

Jackson's views of the East not only had to compete with the scenery and with his own more spectacular Western views, they also had competition from resident Eastern photographers. In Colorado, Jackson had the benefit of experience and reputation. In the East, he had to overcome the long heritage of scenic photography by men like Seneca R. Stoddard, George Barker, and others. To do so, Jackson applied some of his stock trademarks: he made mammoth-plate negatives and panoramas, like his long view of "Lost Channel, Thousand Islands, St. Lawrence River." Confronting the East's most fabulous scenic wonder, Niagara Falls, he made his series of views in winter to present the scene as a fairyland of whiteness (illustration 125).[54]

Urbanization in the West was a matter of quite different consequence from in the East. Whereas Western cities represented anoma-

123.
"1504. Washington Bridge and Harlem River," copyrighted 1890. LC

lies in the prevalent mythology of the region, cities were, in a sense, essential elements of the Eastern landscape. Jackson made a number of city views in the East, including mammoth-plate views of Hagerstown, Maryland (illustration 126), and Chattanooga, Tennessee, from Lookout Mountain (illustration 127). Both applied many of the same techniques Jackson had used in the West, but in this context their meaning must have changed considerably.

The capacity to adapt to the new realities of the East repaid him most of all with his work in Florida in 1887 and 1889. Jackson

124.
*"Springfield Cottages,
Sykesville [Maryland],"
1892. The helmeted
figure is Joseph
Gladding Pangborn of
the B&O Railroad.* LC

179. SPRINGFIELD COTTAGES, SYKESVILLE

126.
"Hagerstown, Maryland," probably 1892. LC

127. (*opposite*) *"Chattanooga from Lookout Mountain, Tennessee," probably 1892.* LC

had been hired to produce a set of views of the Ponce de Leon Hotel, a tourist haven for wintering Easterners. His views of the hotel were typical of the majority of his hotel photographs—they were persuasive, but unspectacular. Against that can be seen a series of views made of the swamp regions of Florida that reveal it as a place of mystery, a wilderness supreme, a place once again where nature presides and retains her power (illustrations 128, 129, 130).

These views transported to the East some of Jackson's long-dormant conception of landscape as a place of awe and respect. While men appear in all of these views, they are minuscule, and their tools have re-

verted from shiny modernity to ramshackle primitiveness. Battered boats peek out from around the bends of Rice Creek, the St. John's River, Sebastian Creek, Deep Creek, the Halifax, even the Ocklawaha, surrounded by regions of silence, enigma, timelessness. How could these pictures have fit within the Gilded-Age image of the relation of man to nature? They seem anything but confirmations of Spencerian doctrines. An answer seems to lie in the forces of decay that permeate the photographs, revealing themselves in the overhanging mosses, in the huge but dying trees, in the whitened tree trunks that protrude from the water. The overwhelming sense is of a nature both powerful and doomed. And the human figures suggest a further parallel. They are of two types: the native, who corresponds here, in his primitiveness and his adaptation to the conditions, to the Indian of the West; and the tourist, who is rarely visible but always implied by the presence of the camera. This is nature as museum piece, as specimen—as *park,* and these pictures correspond closely to the views of Yellowstone that Jackson would make in 1892. Nature is powerful, but its power will pass; until then, we must hurry to witness its spectacular qualities.

Jackson's Florida photographs in essence completed his Gilded-Age catalogue by providing a counter to the urban, industrial, and business views that the photographer also made in the East during his later trips. These latter views were essential to any compendium of the region, but to produce them, Jackson had to find ways to bowdlerize the scenes, to make them look like anything but the scathingly descriptive, harsh-lit

128.
"Deep Creek [Florida],"
probably 1887 or 1889.
LC

THE COMMERCIAL TRAVELER

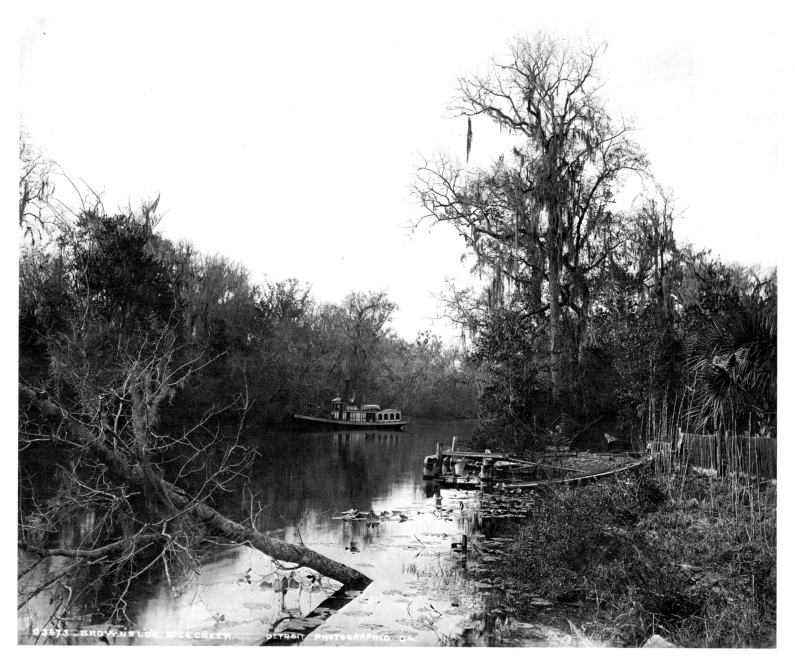

03573. BROWNSLDG. RICE CREEK. DETROIT PHOTOGRAPHIC CO.

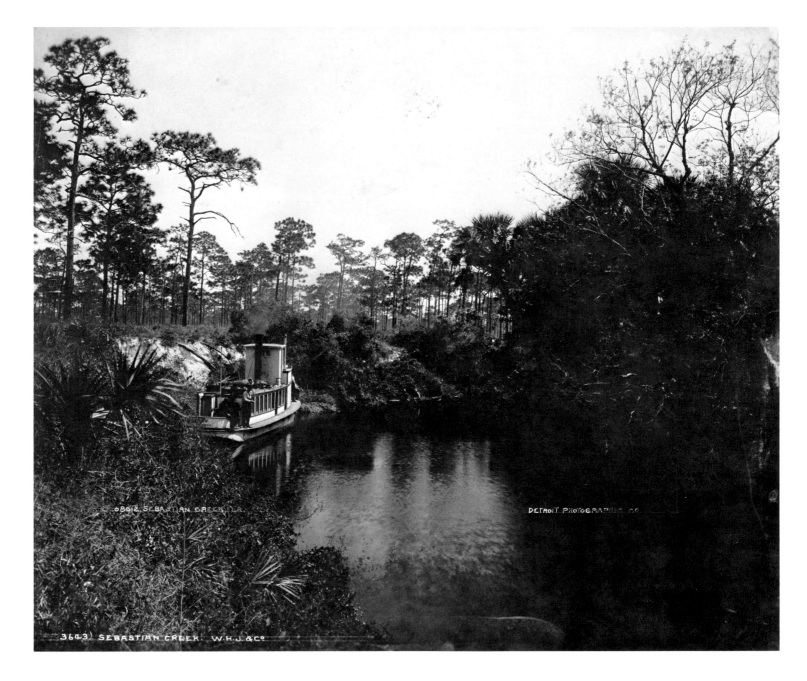

views his contemporary Jacob Riis was publicizing in New York at almost the same time. This accounts for his view of a "Cotton Gin at Dahomey [Mississippi]" (illustration 131), with its stalactites of cotton everywhere, softening the scene, naturalizing it, removing it from the context of work, of industrial exploitation, of wage-slavery into a context of organic richness that corresponds closely to the same quality in the Florida views. The two were necessary oppositions. One defined a region in which nature still reigned, to the end of describing the decline of that reign, while the other described a place where nature was transformed to goods, but in the process could soften and transform industry in return. Both, however, were preeminently "pictorial" views. Their logic was entirely visual and depended on that late-nineteenth-century habit of sight whereby what looked beautiful was deemed good—an aestheticism found more blatantly in the "high art" photography of wealthy amateurs in the circle of Alfred Stieglitz and in the paintings, by men like John Singer Sargent and even Whistler, that they imitated so assiduously.

Jackson's Eastern photographs completed his commercial years. What his earlier views of the eighties had prophesied came true by the nineties—the pictures had become adequate substitutes for a scenic America that was inexorably disappearing or being replaced. To make these replacements, however, Jackson had himself been forced to travel to farther and farther extremes—to Mexico, to the swamps of Florida, to pockets of wildness in the upper mountains of

Colorado. And this phenomenon marked, in its small way, the conflicts inherent in Jackson's commercial years, conflicts masked in the photographs by the seamlessness and sheer convincing transparency of the photographer's style.

But the final paradox lay in the subject of Jackson's photography itself. For Jackson's expansion of his visual empire to include the entire American continent coincided with a shrinkage of the very quality he sought

to celebrate. Now it was not nature, the deistic force that pervaded, animated, and gave meaning to the West of the Survey years. Rather, it was landscape itself that became his subject—an environment supposedly separate from human society but actually constructed by the projection of social and cultural needs onto a geographical entity, thereby ordering, signifying, and giving value to the result.

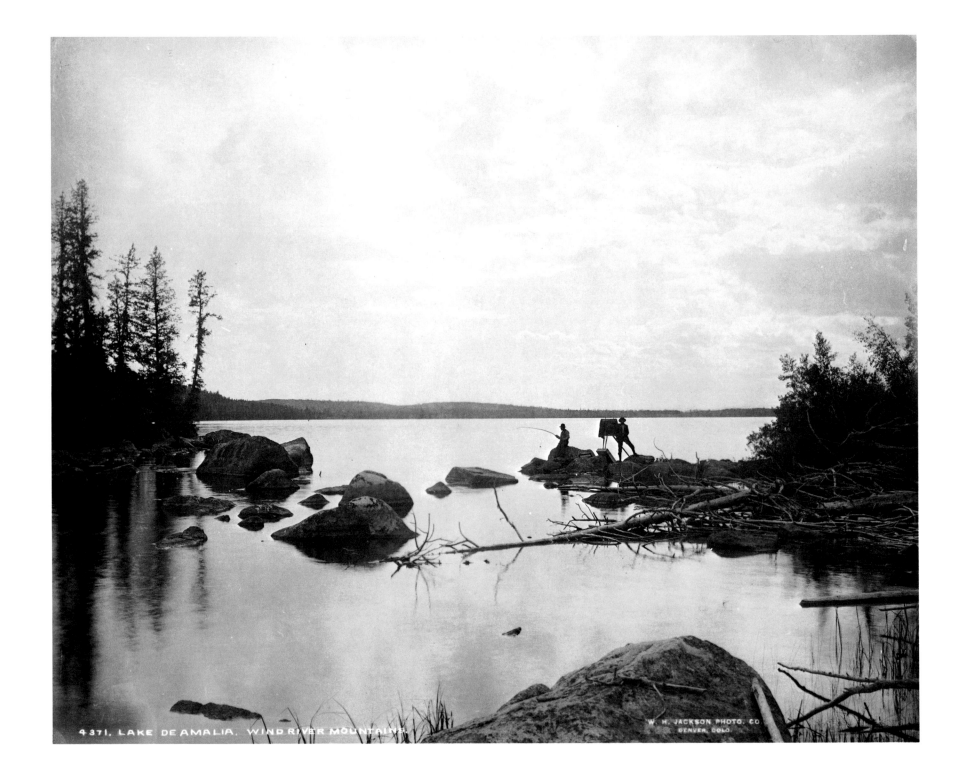

4371. LAKE DE AMALIA. WIND RIVER MOUNTAINS.

The Frontier Thesis, 1892-1894
Chapter Six

And now, four centuries from the discovery of America, at the end of a hundred years of life under the Constitution, the frontier has gone, and with its going has closed the first period of American history.
—FREDERICK JACKSON TURNER,
 "The Significance of the Frontier in American History," 1893[1]

In 1892, Jackson made his last great Western trip as an active photographer. Undertaken with his old Survey companion, painter Thomas Moran, it was a journey to reenact a past experience of freedom and rejuvenation. Yet the trip began with a trio of commissions to sell the West. One was to Moran, for a painting of the Grand Canyon: the Santa Fe Railroad had begun a new advertising program using scenic art, as well as a new public relations campaign that involved bringing famous artists to the Southwest, both as celebrities and in the hope they would produce work that could be used as advertising graphics. The second commission was to Jackson; he had contracted with the Santa Fe Railroad for a photographic book to be produced in time for distribution in 1893, doubtless as one part of the railway's promotions for the World's Columbian Ex-

position, scheduled to open in Chicago that year. The third included both men; it was from the state of Wyoming, to make a series of pictures of "the principal scenic features of the state" that would form the nucleus of its own exhibition at the Columbian Exposition. Jackson and his prospective new partner Walter Crosby formed the photographic team; Moran had been asked by Elwood Mead, the expedition's head, in hopes Moran would produce a painting which might also serve as part of the Wyoming exhibit.[2]

As Moran's letters East indicated, this trip was an attempt to revive the spirit of the Survey, but in a fashion more fitting to new times and new men. With the advantages of Gilded-Age transportation and the new accessibility brought on by the economic development of America's Western scenery, the two men and their small entourage would

tour the great scenic wonders of the West, rediscovering their beauty and gathering materials for another assault on the national taste for landscapes. But in attempting to bring this envisioned result to pass, the two encountered disturbing realities about themselves and the lands they had claimed as their subject.[3]

The first impediment lay in the sponsorship itself. By contracting beforehand with the Santa Fe Railroad and the state of Wyoming, the two men had locked themselves into a complex schedule made more constricting by the tour's status as part pleasure, part expedition, part employment. The size and mixed nature of the entourage made trouble as well; a number of other people—ranging from writers for the Santa Fe to Jackson's assistant, "Millett" (possibly a pseudonym), and his new business partner,

Crosby—all had to be taken into account. In addition, the itinerary itself was limited; though the two men managed to make a few excursions of their own, they were at the mercy of the Santa Fe route and their Wyoming sponsors' plans. Weighed down by these mundanities, the summer's expedition became not a leisured exploration of the geography of the area but rather a short interval between other business commitments, spent rushing from one visual monument to another.[4]

An additional impediment was the obsession of both men with exploiting the results of their artistic labors when they returned. The constant discussion of economic possibilities, including strategies for marketing as well as for producing work, significantly colored the overall tone of the expedition, as Jackson photographed at an almost frantic pace—Moran reported that the photographer made a hundred negatives of the Grand Canyon in just four days—and Moran spent much of the space in his letters home reporting on the number of sketches he had made, seeking some quantity sufficient to assure himself that "I have done well for this trip."[5]

Each portion of the tour detailed in a different fashion the changes that had engulfed the two artists and the region itself since the seventies. The trip through the Grand Canyon, while it reproduced the masculine companionship of the Survey, consisted only of a four-day jaunt down to the Colorado River and back up again, sandwiched between stints up above, during which the two artists rode around choosing their vantage points and making pictures to satisfy their own needs and the demands of

their clients. Even the pictures reflected a clear dissociation from the experience of the landscape. Jackson's photograph of Moran sketching on Bissell's Point, used as an illustration for the Santa Fe's booster book, was deceptively similar to his view of Gifford sketching at the Chugwater in 1870 (see illustration 56). But whereas in the earlier picture Jackson countered Gifford's mannered posing with the immediacy of the geological specimen the painter sketched, in this later version Moran's subject—and Jackson's—became the painterly swirls that resulted from flattening the deep space of the scene onto a pictorial surface. Here although the viewer, Jackson, and Moran were all at the edge of a supposedly awesome space, the camera's placement and the choice of lens both served to direct the eye across rather than down, thereby neutralizing the sense of danger and replacing it with a quality of visual texture.

Moran's comments about the trip reinforced this sense of distance between the men and the natural environment that had defined their careers and their identities. In a lengthy letter to his wife, for example, the painter never reported on the Grand Canyon itself, never mentioned its colors, its size, its grandeur—except once, to report that "the views on the way down are very magnificent." Instead the account is a mixture of professional comments ("the rapids were equal to the Whirlpool rapids at Niagara," which Moran had recently painted) and anthropocentric attention to the "homely" details of the trips. Jackson's photographs, too, revealed this aspect. At one point, Moran commented that "we let ourselves down with ropes and in the same way [descended]

six waterfalls. Jackson's photos will show you how we did it." And indeed they did—the photographer had set up his camera at the bottom to glorify the heroics of the small party, producing a series of pictures that were transparently fabricated (illustration 133).[6]

That these photographs were meant to communicate the rough-and-ready qualities of the men is, in retrospect, painfully ironic, for the true circumstances of the entire trip belied the impression of men engaging in a skilled encounter with wild nature. To get from place to place at the Grand Canyon, the railroad provided the party with a "special conveyance," and while at Yellowstone later, Moran reported that he and Jackson were traveling in a "Concord stage, four fine horses, and a driver to go where and when we please."[7]

How much had changed between 1871 and 1892 became clear when Jackson and Moran finally made contact with a landscape similar to that of the Survey years, in an ill-fated excursion to Devil's Tower. Meant as a sidelight to the trip through Wyoming that would culminate at Yellowstone, this event became that season's only true contact with an undomesticated West. Planning a quick tour, the two had rented a pair of horses and a wagon and set out with nothing but Jackson's photographic equipment, his silent and invisible assistant, Moran's "sketching outfit," their blankets, and "a rubber air pillow" Moran had bought in Denver on Jackson's recommendation. The horses were old and ill-matched, and travel was extremely slow. Their plan to buy food at ranches along the way brought them abruptly in touch with the new realities of the West; at their

first attempt, they discovered that the land was owned by an Eastern corporation and run by a dour, hostile superintendent, who nearly drove them off. A nearby "sodbuster" farm was equally inhospitable—it was virtually the last working noncorporate farm in a region dotted with abandoned homesteads. So the party set off toward the Tower, into a region of successively wilder and more unaccommodating topography. A hailstorm left them bogged in the thick clay of the primitive road, with night fallen. By next morning they knew they were utterly lost and began to retrace their steps. Eventually finding a kindly ranchowner, they broke their thirty-eight-hour fast (Moran had kept precise count) and went on to Devil's Tower.[8]

The excursion was certainly uncomfortable, a condition brought on by the two men's selective understanding of the conditions of the region, never more than sparsely settled, and now in a period of depopulation. On the one hand, their dependence on local residents for food, fodder, and lodging, appropriate for Colorado or Wyoming in the 1870s, when they were government surveyors and Jackson was a toughened Westerner himself, was amazingly naive given their current circumstances—tenderfeet in a hired wagon, lost in a region owned by Eastern capitalists and occupied either by hired men or by hard-pressed sod-house farmers. In fact, many of the "ranches" along their route had been abandoned by farmers unable to surmount the threats of agricultural depression, railway tariffs, and an inhospitable climate. At the same time, Jackson especially seemed to have forgotten all the lessons of his Survey years, leaving the two unprepared for the realities of Wyoming land and weather. Yet perhaps the most telling aspect of all was Moran's reaction; rather than seeing it as a sobering personal lesson about the perils of engaging hostile landscape with no protection beyond a tourist's sensibility, the painter chose to turn it into a magazine article wherein he presented the men as victims of an ungrateful environment.[9]

The trip back from Devil's Tower was a return to civilization. Reinstated in the safe companionship of the Wyoming excursion, with its politicians and servants, Jackson and Moran moved out into the Wyoming mountains under far tamer circumstances. For the next three weeks the group took a circuitous path through the spectacular Northern Rockies of Wyoming. Here Jackson's plans diverged from Moran's; the painter was impatient to push on to Yellowstone, the locale of past successes on his part, while Jackson was eager to photograph in the mountains. For Jackson's part, his instinct was correct. As he had learned during his last years with the Survey, the base of these mountains represented a vertical frontier above which lay the last remaining regions of a nature both magnificent and largely untouched. The Denver years had allowed him to witness and indeed assist in the exploitation of the Colorado Rockies; only here, where climate and inaccessibility made such incursions extremely difficult, could he find the remnants of a nearly erased American past. His pictures reflected the reappearance of an old vitality and force rarely found in the pictures of the Denver years. Using his mammoth-plate 18-by-22 camera, Jackson made a series of pictures of mountains, valleys and lakes. With no interruptions by telegraph poles, roads, houses, or mining detritus, Jackson

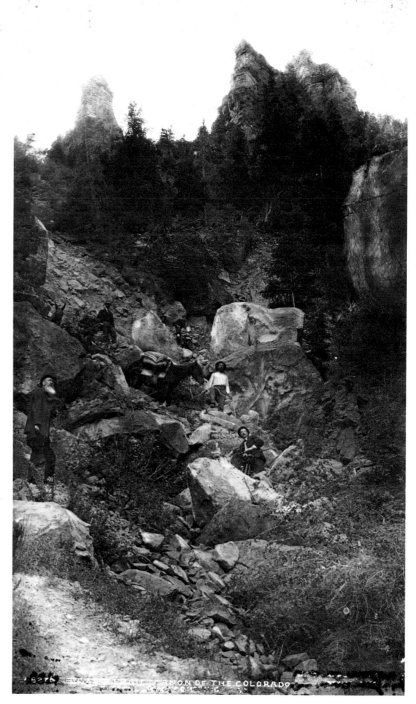

134.
"Lake de Amalia,
Wyoming." 1892. LC

LAKE DE AMALIA WY COPYRIGHTED 1892. W. H. JACKSON. PHOT. CO. DENVER.

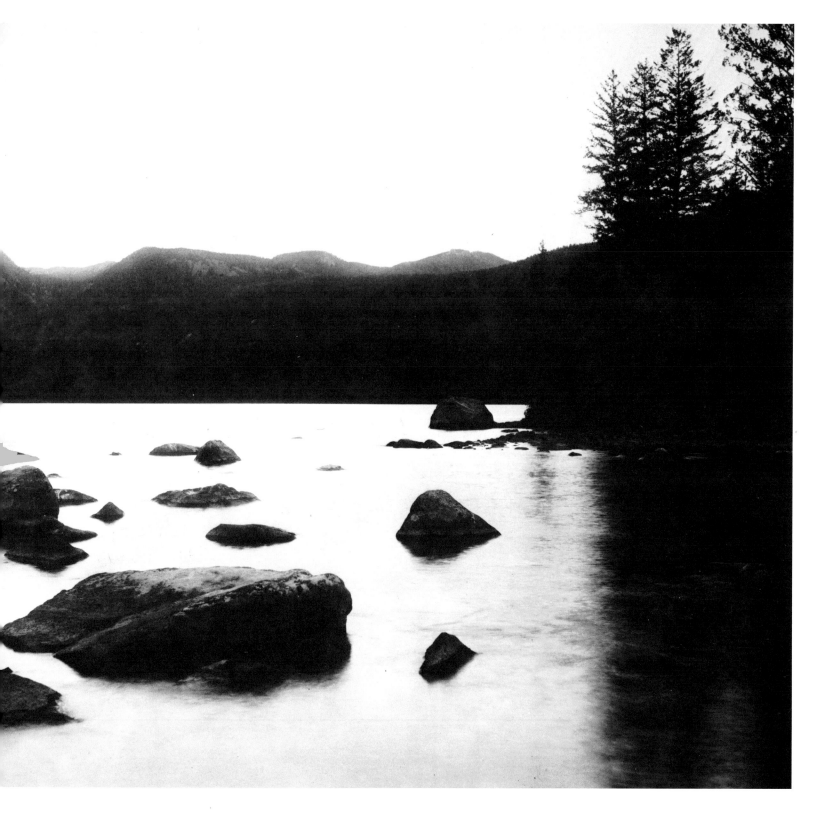

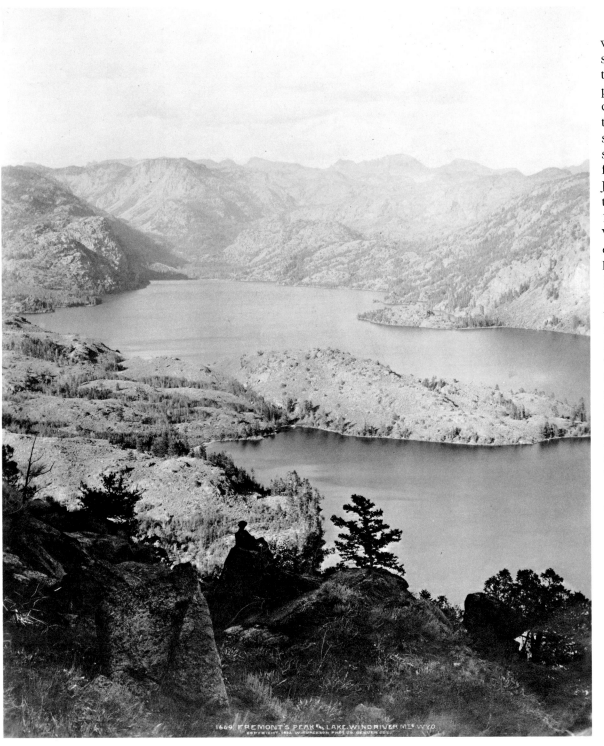

was free to make panoramas, and he did, some of them rivaling his panoramas with the Survey in its later years. An 8-by-10 view, probably by Walter Crosby, of Jackson at de Amalia Lake in the Wind River Mountains (see illustration 132) showed Jackson with his mammoth-plate camera on a stony outcropping, while Moran, inevitably, fished in the lake. The picture described Jackson in the process of making one of the best of his late panoramas, a two-plate 17-by-40 picture he titled "Lake de Amalia, Wyoming" (illustration 134). This and an equally powerful image—"1669. Fremont's Peak and Lake. Wind River Mts., Wyo." (illustration 135)—must be compared to the last photographs Jackson made with the Survey in 1878, particularly the views of Fremont's Peak and Wind River Peak (see illustrations 90, 91). Now Jackson's assurance with the large camera, acquired during the Survey but honed and extended during the commercial years, is signally evident. More importantly, however, nature's reappearance in these pictures provides not respite but solace. Stable and soothing, these photographs seem to portray a nature ready once again to welcome back her exiles.

Against this backdrop, Yellowstone represented an abrupt return to the realities of the Gilded-Age American landscape, although in fact the two men simply moved from one rather luxurious form of tourist experience to another, more accessible version. Moran was relieved; he wrote his wife that "I stayed at the Hotel in preference to camp as did Jackson and a couple of others. We have all had enough of camp life." Quickly the members of the group immersed themselves in their routines—Moran and Jack-

son rather frenetically rushing around in their rented conveyance, making sketches and photographs, fishing, and looking for proper vantage points. The painter reported pleasurably that "I have been made much of at all the places in the park as the great and only 'Moran' *the* painter of the Yellowstone and I am looked at curiously by all the people at the Hotels."[10]

Jackson's return was less triumphant. In the years since he had last photographed the scene, his place as the Yellowstone's photographer had been supplanted by the park's "official" photographer, F. Jay Haynes, whose studio did a booming business in views that ranged from uncannily accurate mock Jacksons to posed tourist views. Haynes had a great admiration for Jackson, and had learned more than style from the older man; within days after Moran arrived at Yellowstone, Haynes had made a deal to sell the painter's watercolors and oils of the park at his concession, and Moran reported he was hopeful of some substantial returns from the partnership. Meanwhile Jackson himself was apparently hard put to find a way of working that distanced him from Haynes on one hand and his own Survey photographs on the other. Such was the case with "Crater of Castle Geyser and Crested Springs" (illustration 136), which reproduced almost exactly his famous view of the geyser of almost two decades before. Working at the height of the tourist season, with clients' constraints in mind and limited time, Jackson was unable to find new vantage points and was reduced to returning to his old spots, most of which had become the standard stopping places on the tourist's survey of the park: Tower Falls, Yellowstone

Falls and the Canyon, Hell's Half-Acre, Old Faithful in eruption. About all he could do to make the pictures his own was to produce panoramas, which surely pleased his Wyoming clients, eager for graphically striking images that were nonetheless conventional at the core, for use in the Columbian Exposition exhibit.[11]

Returning to old haunts, however, could not mean making the same pictures. As Jackson himself was to report more poignantly some forty years later, the press of human habitation so close to the park's natural wonders had unduly stressed a number of the geysers and pools; tourists chipping off pieces of the rock walls, the stalac-

135. (*opposite*)
"1669. Fremont's Peak and Lake. Wind River Mts., Wyo.," 1892. LC

136.
"Crater of Castle Geyser and Crested Springs," 1892. LC

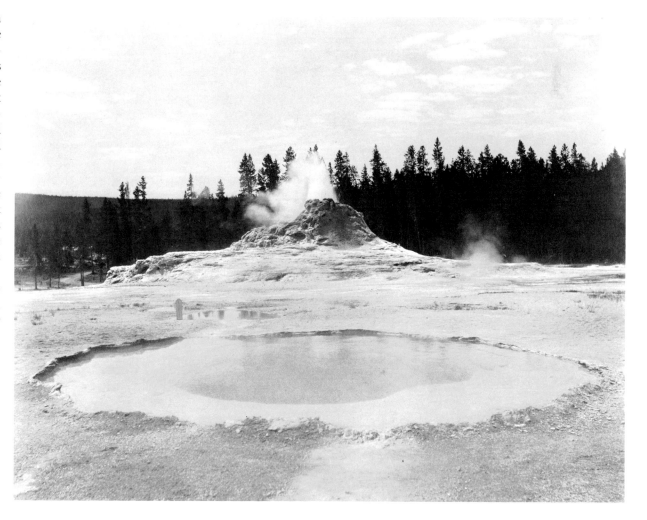

tites, and the frozen waterfalls had damaged some attractions enough that they could not easily be photographed. In addition, the natural environment itself had changed—Yellowstone was a volatile geologic region, creating new mud-pots and hot springs even as others disappeared or went dry. Moran commented at one point that "the Great Blue Geyser that I drew for Prang's work [in 1876] is about 10 times as large as when I saw it last and has become the greatest Geyser in the Basin."[12]

Now the difficulty lay with making pictures that portrayed the region as pristine or unoccupied. In the seventies, Jackson had pointedly included members of the Survey to advertise their presence and underscore the scientific authority of the images, but that was a different time, when Yellowstone was known as a wild, undiscovered region rather than a popular watering hole. In 1892, Jackson could not have controlled the region sufficiently to leave his images unoccupied by humans; more important, he could not even easily control human presence—tourists crowded forward, ignoring the master at work, eager to see, or even to photograph the scene for themselves with that faddish new toy, the Kodak. In any case, the photographer yielded; his pictures became once again part and parcel of his Denver commercial photographs—celebrations of the tourist experience, and the tourist presence, in the West. A two-plate panorama of the "Summit of Pools and Mammoth Hot Springs Hotel" (illustration 137) demoted nature to a source of hot baths and tonic waters. "Liberty Cap—Mammoth Hot Springs" again included the hotel in the background; "1102. Yellowstone River Above the Falls"

had a park ranger in it; "Yellowstone Lake" was more accurately a photograph of the excursion boat and landing, and the rows of rental canoes on the shore, than it was a study of the lake itself. Here was a natural environment that served as amusement park, a presage of the new wave of public entertainment spaces that would devolve from the Midway at the World's Columbian Exposition a year later.[13]

The result of two weeks in the park was a substantial body of mammoth-plate photographs, and a number of smaller pictures probably made by Jackson's new partner, Walter F. Crosby. Many of these would appear in the Wyoming exhibit at the Exposition; others would serve as the basis for a number of smaller pictures of the region by Moran, as well as one gigantic painting that combined Jackson's photographs and Moran's sketches in a work that once again reinforced Moran's place in American art. By the time Moran was settled in his Long Island studio at work on the painting, however, Jackson was back on the road—with publicist Joseph Gladding Pangborn of the Baltimore and Ohio, hard at work on a series for the railroad's own exhibit at the Exposition. Riding in luxury with Pangborn, "a go-getter without peer in his time," Jackson was listening to the advertising man unfold his schemes for a "gold braid and plumes" three-year trip around the world that would pay the photographer handsomely and extend his visual empire to the globe.[14]

Jackson's last great Western trip provided the final punctuation to an entire era. Though the two artists of wilderness had sought (and even found) remnants of the *terra incognita* of more than twenty

years before, their search itself parsed out a new meaning for the concepts of wilderness, settlement, and the frontier. In the region around Devil's Tower, they had witnessed the first effects of an economic reorganization of the West away from the older, revered model of the individual yeoman and his family conquering a hostile wilderness. In its place they had seen the corporation farm, with its "neatly painted frame dwelling house" containing hired men whose allegiance to their employer had pushed out the older ideal of comradeship and mutual assistance. And they had seen as well a landscape of devolution: "many ranches, all of logs, but in every instance deserted."[15]

Thus they had encountered two visions of the future West: an extreme of human manipulation of the landscape, and a reversion to wilderness as the old model of settlement failed. And then came Yellowstone. Once a region "unfinished by God," it had been completed by man—finished and now, increasingly, despoiled. With its new trails, its roads, hotels, restaurants, and concessions, it had become a constructed wilderness. Where the Survey had encountered its first sight of invalids taking the waters, now Jackson might find rows of tour wagons lined up bumper to bumper, each packed with its load of tourists, all awaiting the signal to begin another day of predetermined wilderness experiences.[16]

What the two men had *not* encountered was a West of promise, a West of psychological openness. Even where the land was unclaimed, the landscape was not; and they themselves contributed to this bounding. The end of their labors was, after all, a variety of products meant to advertise the West

at the World's Columbian Exposition the following year, thus bringing wild landscape under the protective wing of civilization. Their encounters corroborated the claims of historian Frederick Jackson Turner, who would deliver his famous "frontier thesis" address at the World's Columbian Exposition: like the superintendent of the 1890 census with his statistical enumeration, Jackson and Moran confirmed "the closing of a great historic movement."[17]

Jackson returned to Denver in the fall to complete the negotiations that had informally begun that summer with Walter Crosby on the Wyoming jaunt. Buoyed by an oddly swirling economy, the two men entered a new capital partnership, enabling Jackson to move from the Arapahoe Street studio, where the firm had settled with Chain and Hardy in 1887, to a new and even larger and more elaborate studio in the Industrial Building at 433 Colfax. The two-story space, at nearly double the rent, marked what Jackson no doubt saw as a new era; it offered a sumptuous place to exhibit and sell his ever-enlarging inventory of landscapes.[18]

But two sets of circumstances brought the Jackson firm from fame and prosperity to desperate circumstances in less than a year. The first was the general economic outlook. Europe had been in a stagnant recession since 1890, and by the end of 1892, a number of international and national factors were converging on the American economy, which moved full swing into a fevered boom, encouraging firms like Jackson's to expand. By the beginning of 1893, however, that boom had run out, and within months a full-scale panic was underway.[19]

Denver was hit hard. As a banking center, heavily dependent on mining, agriculture, and land speculation, the city economy felt the effects of each stage, from early panic and bank failure through business shrinkage and then the long-term effects of agricultural depression. Silver mining, source of much of the region's wealth, was devastated. Inevitably, Jackson's business suffered immediately and heavily. In the short term, his own speculative investments in land and building lots, and the firm's inevitable indebtedness as a result of expansion, struck first. More sustained and more terrifying were the effects on the company's marketplace. With railroads heavily hit, Jackson found his long-term commissions undercut.[20]

These events masked a more immediate crisis for the photographer. The William H. Jackson Company was essentially dependent on the disposable income of middle-class Americans, in their incarnation as tourists. They crowded his studio to buy mementoes of their vacations: mammoth-plate photographs to frame and hang in parlors at home in the East or, increasingly, the Midwest and Pacific Coast; fold-out souvenir books like Jackson's accordion-fold *The Cañons of Colorado,* published by Frank S. Thayer around this time; portfolios of prints; and sets of stereographs. Indirectly, tourists justified the substantial advertising budgets of railroads like the D&RG and the Santa Fe, formed the audience for booster books like Santa Fe publicity writer Charles A. Higgins' *Grand Cañon,* and hence warranted Jackson's railroad commissions. A severe depression made his photographs luxury items, and outmoded ones at that.[21]

Had Jackson's business suffered simply from these effects of the 1893 panic and the subsequent depression, he would have been in deep trouble. But the photographer had been deliberately overextended for a period of years before this, in a desperate, even daring, gambit to keep ahead of trends that were in the process of rendering the individual entrepreneur–photographer obsolete. Jackson's sudden crisis came on top of a collision of trends in the information industry. For a period of nearly two decades, the entire arena of publishing and disseminating information in American culture had been undergoing tremendous changes, and many of these focused on the creation, reproduction, and distribution of visual materials.

The single most significant phenomenon of this evolution was the development of sophisticated new mechanisms of mass-reproduction. While mechanical reproduction techniques had been available since the seventies (and Jackson had used some of them for Survey publications), inexpensive, fast halftone reproduction did not become a major factor until the first years of the 1890s. At that point, it became feasible for magazines to run halftones of photographs nearly as cheaply and easily as wood engravings.[22]

Removed from contention as mass-market visual documents, photographs became, increasingly, "originals" rather than multiples referring to an external truth; their fabled truth value, their so-called documentary value, decreased as their artistic and exhibition value increased. For photography in general, this shift represented the beginning of a new stage in the rhetoric of the medium. But for the most part individual photographers did not adapt easily. Few commercial photographers of the ear-

"Summit of Pools and Mammoth Hot Springs Hotel," 1892. LC

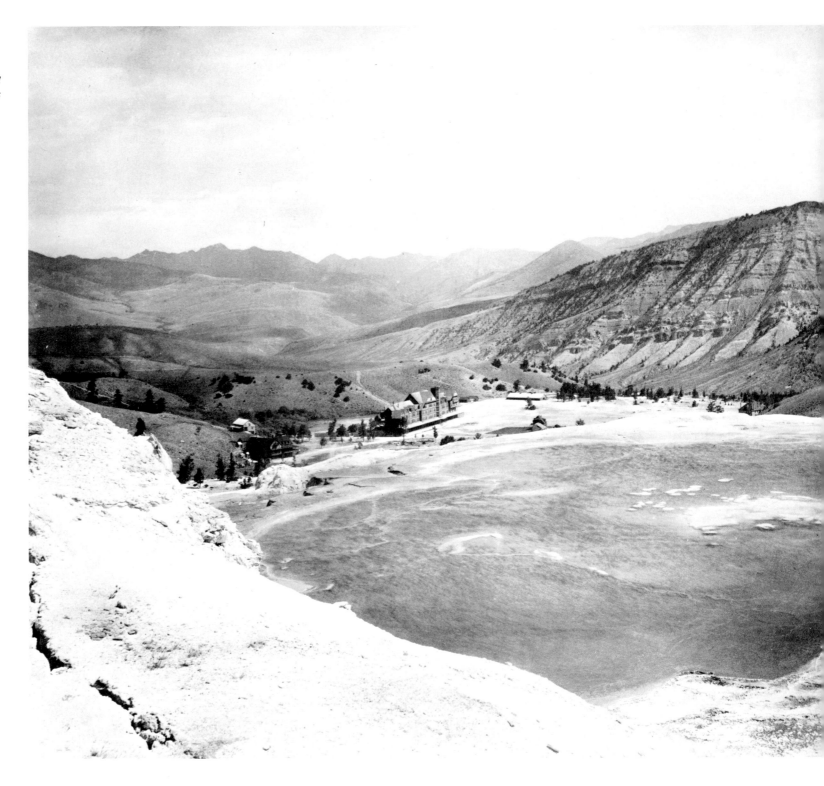

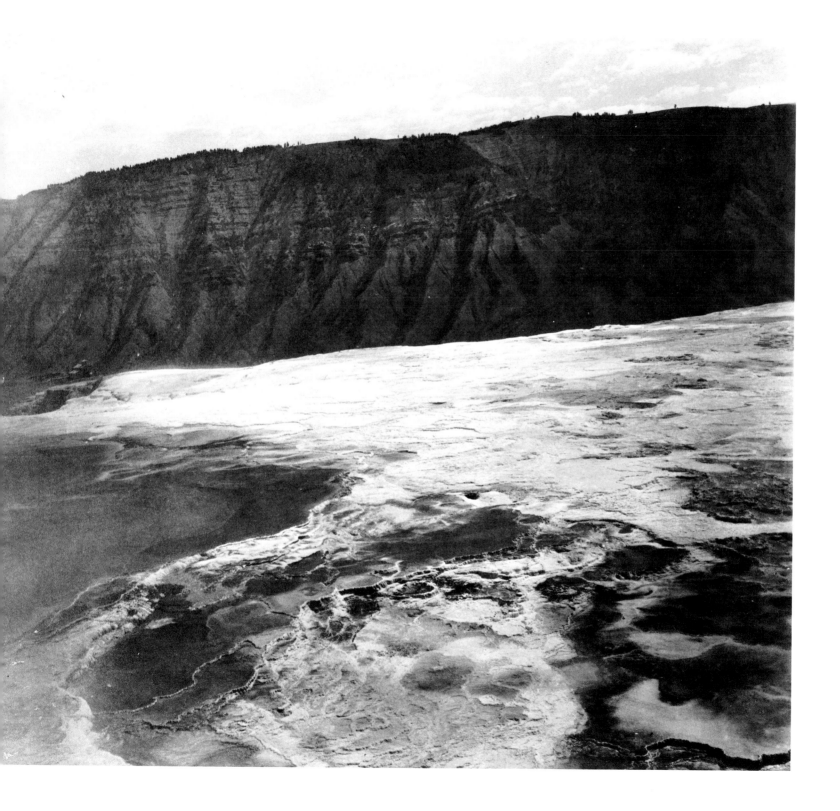

lier information era were able to shift over to the new aestheticized mode; many found themselves devalued and their work relegated to the background, while others simply moved into the appropriate niche of the new mass-reproduction processes, becoming producers of negatives for reproduction and distribution as gravures or halftones in books and magazines.

Reproduction technology was not the only area of transformation, however. The development of dry-plate negative materials in the eighties and the subsequent introduction of flexible-film processes in the early nineties, made the production of images itself far easier. This combined with new enlarging and printing technologies to make professional photography technically easy for the first time since the invention of the medium a half-century before. The result was a glut in negatives that corresponded with the glut in reproduced and distributed images.

These forces pressed the commercial photographer further and further from the center of contemporary American culture. Economically, these new conditions conspired to decrease market share even as the market was increasingly booming; in status, they moved the photographer from a central and respected place in the professional and business world down to the level of clerk; artistically, they altered the rules of "good" photography, increasingly separating aesthetic and economic values. For someone like Jackson, whose entire career as a commercial photographer had been predicated upon his ability to unite the realms of visual pleasure and financial gain, the effect was potentially devastating.

But Jackson had been adapting to these conditions throughout the previous decade. His decision to enter a partnership with Chain and Hardy, his business connections with the publisher Thayer and with the *Rocky Mountain News*—all in all, his entire adventure in the world of publishing—must be seen as a highly successful experiment in adjustment to these new demands. Hence we can see even Jackson's ill-fated expansion with Crosby in 1892 as a reasonable next step in the process of converting his role from the making of views to the production of *pictures,* and their marketing in increasingly sophisticated packages—an adaptation that culminated with the symbolic change of the company name, sometime between 1892 and 1894, to the W. H. Jackson Photographic and Publishing Company. Still, Jackson's business acumen and capacity to adapt to changing conditions only masked the deeper, longer-term problem: the steady phasing out of the photographic entrepreneur as the quintessential figure in American photography and his replacement on the one hand by wage-earning members of larger conglomerates and on the other by gentleman amateurs seeking to redirect photography into the central streams of fine art printmaking.

Jackson's strategy had been daring: rather than capitulating to the new trends in vertical integration that threatened him, he had redefined his business, expanding it in such a way that it mocked, in smaller fashion, the huge conglomerates that surrounded him and in many cases served as his clients. But all of this had come at a price—the price of overextension. Like so many American businessmen of the eighties, Jackson had viewed

expansion as inevitable, even necessary, had drawn heavily on the company's assets to support his own life-style, and had behaved entirely without regard for the possibility of calamitous economic contraction. Now the contraction had come.

On a short-term basis, the problem became one of weathering the storm and awaiting the inevitable economic upturn. But the longer-term trends that threatened the photographic entrepreneur still loomed. Jackson had thus far been able to absorb the publishing innovations and put them to use. But the centralization of publishing that would occur after the mid-nineties, and in particular after the advent of the Levy halftone screen drastically cut photomechanical reproduction costs and moved photographs into newspapers and less-expensive magazines, was potentially devastating to a firm structured, as Jackson's was, around the production of images first and foremost.

A second, perhaps more dangerous, threat to Jackson came not from publishing but from the empowerment of the middle class on which he depended to provide an audience for his work. With the advent of the roll-film Kodak in 1888 ("You Press the Button, We Do The Rest" was George Eastman's inspired slogan), amateur photography became not simply an irritant or even a competitor but a phenomenon that threatened to render Jackson irrelevant.

In 1889, two reviews of Jackson's work were published; their statements proved prophetic. The first text came from the *American Amateur Photographer.* Founded in 1889, this journal was one of the first devoted exclusively to the concerns—technical, social, and aesthetic—of the ris-

ing new tide of photographers whose leisure time was devoted to elevating the medium. It included a review written by Alfred Stieglitz at the request of British amateur Peter Henry Emerson, of the Jubilee Exhibition in Berlin in 1889. Stieglitz's comment about Jackson's work was brutally terse: "Jackson, Denver, carried off the highest honors with his immense landscape pictures of the Colorado region. Germans are not accustomed to work of such size and naturally gazed at it with wonder."[23]

Stieglitz's comment was meant as a stinging rebuke, both to the Germans awarding the prize—whom he considered to have revealed their fossilized understanding of photography—and to Jackson. For the American landscape photographer represented nearly everything Stieglitz opposed in his still-youthful attempt to deflect the medium from its courses as commercial production and realist description and to redirect it into the world of art. For Stieglitz, and for the growing number of middle-and upper-class amateur photographers in Europe and America, photography-as-democratic-art was a false claim to make for the medium, and photography-as-description was a bankrupt aesthetic. In their place, these gentleman and lady amateurs were engaged in actively inventing new production systems emphasizing individual production, craftsmanship, and autographic purity—even to the extent of converting the mass-reproduction system of gravure into an elaborate, expensive, and precious handicraft. At the same time, they were seeking (though without the same success) an aesthetic of photography that could emphasize its individuality yet adhere to the prevailing artistic styles of turn-of-the-century art—particularly the newly orthodox styles of Impressionism and Symbolism. Landscape for them (and for Stieglitz particularly, as his photographs of this period reveal) was a genre best suited for producing homages to Dutch painting of centuries earlier, or (for others) a setting for the obscurely spiritual meditations of half-draped figures holding crystal balls.[24]

Yet Stieglitz's position was still half-formed, and his complaint against Jackson reflected both his own paradoxical aesthetic and his honest assessment of the older photographer's work. For one may speculate that Stieglitz recognized in Jackson's Berlin pictures not just a notion of photography that opposed his own but a more general lack of conviction and belief on Jackson's part—a sort of rote production that resulted in pictures that were mechanical in their effects. And certainly Stieglitz had no complaint against landscape per se; he was a devout acolyte of British photographic aesthete Peter Henry Emerson, whose photographs of life in rural England amalgamated close, descriptive observation of a land and its people with stylistic effects blatantly imitative of Impressionist painting.[25]

On the surface, Stieglitz's critique was accurate: it recorded Jackson's tremendous prestige as an American photographer and attributed that prestige to the combination of subject and scale—two elements Jackson himself had cultivated as his trademarks. But beneath, the review was rich in implications. First, it pointed out Jackson's strategy for maintaining his status as America's greatest landscape photographer even while beset by threats: the development of sophisticated techniques for increasing the scale of his photographs, both to enlarge a steadily shrinking subject—wilderness—and to maintain a technical edge on newly competing photographers, both amateurs and professionals. Second, Stieglitz's tone of irony, even disgust, marked the disturbance in photographic circles over matters of taste. The Germans, Stieglitz rightly implied, were adhering to older standards for judging photographs when they awarded the highest honors to Jackson; his allegiance as a leader of the new movement of "artistic" photography, however, was entirely to the aesthete's position, as the rest of his review made clear—he devoted his most lavish praise to Peter Henry Emerson's naturalistic principles: "Artists greatly admired Mr. Emerson's work. . . . *Photographers* didn't like it. Naturally!"[26]

Stieglitz's reviews signaled that Jackson's work would no longer win the sort of unanimous praise Jackson had come to expect; more important, it presaged the sort of shattering of the medium that would occur in the 1890s, as ease of creation and mass-reproduction combined to diversify American photography.

More immediate dangers were outlined in the second review, a laudatory puff in *Wilson's Photographic Magazine*. Primarily a paean to Jackson's mammoth-plate panoramic pictures of Yosemite and the Hotel del Monte, the essay purported to underscore Jackson's position in the professional elite of photography:

It cannot be doubted that the amateur is hurting the professional photographer, especially in landscape work, for the former now reproduce themselves many of those scenes which formerly they were obliged to purchase. Yet here is a man of

such skill as an artist, and such ability as a man of business, that he stands while others fall, well illustrating the saying, "the survival of the fittest."[27]

The author's choice of metaphor was disquietingly prophetic. For it applied the logic of Herbert Spencer's theories of social evolution to the photographic arena, suggesting its increasing impingement by the forces of incorporation and large-scale, vertically integrated information conglomerates. Jackson had survived thus far, author A. J. Treat suggested, by competing within the arena of corporate Spencerianism: by creating a business that controlled all aspects of image processing, from negative to book. In 1889, Treat was correct; but by 1893 a different picture had emerged—the tide was turning against Jackson and his type. The 1893 panic and the subsequent depression merely clarified the conditions that were forcing independent photographers out of the industry or down into lower-status roles in local production.[28]

Jackson was by no means the only photographer to note this constricting of opportunities. His old teacher and acquaintance from 1869, Utah photographer Charles Roscoe Savage, dolefully noted in his diary in 1894 a trend that came to photographers less adaptive than Jackson: "Not doing much viewing lately. . . . Nearly everybody is becoming a photographer. . . . Business is changing to developing and finishing views for amateurs. Most of the magazines now published are illustrated by photo engravings—the demand for views is gradually falling off."[29]

Jackson's problem was especially acute, for his subject was landscape and his audience the very middle-class leisured Americans who were increasingly drawn into the amateur photography scene. Already in the late eighties amateur photographers were appearing in the backgrounds and corners of Jackson's photographs; by the nineties, they would constitute a great deal more than a nuisance. The case at Yellowstone in 1892 was instructive. For even as these tourists shrank his subject matter, demanding smooth carriage roads, helpful guides, the right to stand, sit, and lie on the natural wonders, even to remove portions for themselves, they were also simultaneously appropriating his style and subject for themselves while beginning the process that would press the Jackson landscape photograph into anonymous irrelevance—"technically perfect, pictorially rotten," to quote Alfred Stieglitz's favorite critical comment.[30]

In the fall of 1893, with a business foundering, Jackson found himself like many other Americans that year—adrift, looking for something to sustain him, uncertain what had happened or what could be done. And like many others, Jackson gravitated to Chicago, a place that promised enlightenment, and the last island of prosperity in a nation awash in debt, unemployment, and crisis.[31]

An industrial center sinking into the depression, Chicago housed a second city, a City of Light, part dream, part utopia, part celebration of technological might: the World's Columbian Exposition. That summer and fall of 1893, more than 27 million Americans came to Chicago to see the fair; over the years of preparation and publicity, the Exposition had developed religious implications—it had become a means of purifying American purpose, returning to the "celestial city" of John Bunyan, the "city on a hill" of the Puritan Governor Winthrop. By general consensus, the fair was redemptive—it would rewrite American history to revive the mission, it would reunite Americans, reorienting the rising tides of diversity into a symphonic union. The rhetoric surrounding the entire event was utterly extraordinary.[32]

The aura of allegory pervaded the fair, as a number of writers, both of the period and since, have pointed out. At the same time, it was perhaps the vastest, most expensive, and most carefully managed work of cultural boosterism in American history, designed and operated as a walk-through manifesto of the preeminence of American culture and its future place at the center of world civilization. But the fair's planners had conceived and executed the huge extravaganza without predicting the rhetorical effect of the panic and depression. Hence the White City came to represent an escape into fantasy for a nation in deep crisis. But the fair's purpose had been to celebrate and declare the permanent value of precisely the terms of American progress that had been checked by the Panic: industrial might, economic centralism, an orderly, grand, and polite urbanism, technological innovation. Underlying these were larger principles: laissez-faire capitalism, the Spencerian doctrine of "survival of the fittest" in the economic and social spheres, the belief in an inevitable line of progress that had moved America from edge to center of the world's civilizations. And pervading all of these was a conception of human society that was essen-

tially stratified, compartmentalized, ordered, managed.[33]

The summer months before Jackson arrived saw the embodiment of these "ideals" in a series of congresses—convocations of scholars, interested laymen, and cultural figureheads organized around a series of provocative subjects. The photographer missed the Congress on Evolution, at which Herbert Spencer spoke; he also missed the Historical Congress where the Wisconsin historian Frederick Jackson Turner delivered his essay, "The Significance of the Frontier in American History," in which he announced the end of geographical freedom for Americans, the end of a "safety valve" for dissatisfied elements in the society. Defining the frontier as "the meeting point between savagery and civilization," Turner declared further that "the existence of an area of free land, its continuous recession, and the advance of American settlement westward, explain American development" by rejuvenating American democratic, individualistic, and communal values through a necessary process of "perennial rebirth." Turner's essay was fundamentally elegiacal; framed by its opening statement that the frontier was ended, it closed with a troubled reiteration: "The frontier has gone, and with its going has closed the first period in American history." Expressed throughout the essay was the historian's apprehension about the future of a nation deprived of its greatest attribute. But other historians and convocationists were less concerned. As Spencer's contribution implied, the close of one era was less important than the accelerating curve of American progress toward civilization: "The beginning of a new epoch, in

which the race is again to be tested," to quote James A. Skelton's presentation at the Congress on Evolution.[34]

Just what that new epoch would contain for America was, finally, the subject of the Exposition. Yet two messages were presented. One stressed the achievement of civilization. This was the subject of the architecture, for example, and of those educational exhibits that emphasized classification and ordering of the world's materials, from rocks to birds to human beings. Both the architecture and the taxonomic exhibits presented a moment at which the grandest elements of human history were contained in the "great white cloud" of the architecture, and all of nature yielded her secrets to the orderly mind of man. But a second message concerned the process of reaching this timeless moment. Here Spencer's doctrines of progress became inextricably united with a mechanistic, technological ideal of human activity. The giant steam engine and the Krupp long-range gun (declared by visitor Clarence Day to be "better than anything on the Midway") became the agents by which human destiny would be achieved. And the line of progress moved from "the wilderness" to "the city and the town," as orator Henry Watterson's dedication speech stated.[35]

The Krupp gun, the U.S. Naval Exhibit, and other presentations underscored a crucial adjunct to this postfrontier worldview: the widening of American vision to a global arena, and the concurrent transposition of American expansionism from the West to the world. The World's Columbian Commission had encouraged international exhibits and devoted prime space to the foreign pavilions. But more important than the

"legitimate" internationalism of the national exhibits was the peculiar makeup of the Midway Plaisance. The area itself was an innovation—originally planned as a "dignified and decorous" ethnological museum celebrating the diversity of the world's populations, it had quickly become what Clarence Day described as "a broad promenade lined with sideshows." There, as at the American ethnological exhibits, where representatives of so-called primitive tribes dressed in "typical" native costume presented *tableaux vivantes*, the diversity of the world's populations were subsumed into the intertwined ordering mechanisms of progress and entertainment. Frederick Douglass's complaint that "the Dahomians are here to exhibit the Negro as a repulsive savage" underscored this quality: American visitors could find in the Midway exquisite evidence of their superiority and could then act out their preferred status by their amusement at the antics of their inferiors. This was the sort of racism in which Jackson had participated while heading west in 1868 and had extolled in his Hayden Survey Indian *Catalogue*, now extended to a vast, national scale. Even the Ferris wheel embodied this new calculus, offering the mechanical means to omniscience as riders were swept high above the fair to see the entire extravaganza laid at their feet. Beyond all these manifestations lay a new phenomenon: American global imperialism.[36]

Jackson's own photographs appeared in at least two places—in the gigantic Transportation Exhibit (under the sponsorship of the B & O Railroad) and in the State Exhibit for Wyoming. The pictures were superb. Jackson's old Western colleague Charles Roscoe Savage of Utah recounted wistfully in his di-

ary that Jackson's photographs were "larger and better printed than mine, showing his superior facilities." Still, despite their expert treatment, they may have looked dated, even a bit out of place to viewers agog at the powerful message of civilized urbanity and global ambition exemplified by the Court of Honor. Though Jackson's Gilded-Age ecology fit beautifully within the logic of the Exposition, his photographs were perhaps unnecessary. They rehearsed what had *led* to the "new epoch," in Skelton's words, rather than participating in the utopian dreams that motivated the rest of the fair. Though they described a plausible intersection between the new civilization and the old nature, almost no one else was considering nature at all. The horticultural exhibit, for example, was a hothouse that stressed an imperial assemblage of exotic plant samples from around the world; the agricultural exhibits were chock-full of sample sheaves of wheat, rye, and other grains, divorced from any context of land use. An earnest student who learned agriculture from the fair would have imagined that bread came from a complex assembly line composed of various machines, from seeders to reapers to bakery ovens to slicers and baggers. The Agricultural Building itself, a typically neoclassical decor masking a railroad-shed structure, was filled with "mural decorations by celebrated painters depicting the spirit of agriculture," and the internal exhibits themselves resembled a dream city made of foodstuffs—giant towers of canned and bottled goods, eclectic minarets and gothic-revival flying buttresses of cheese, neoclassical "long glass columns" filled with soil, "a series of arches decorated

with wheat. . . ." The Iowa agricultural pavilion was an orientalist extravaganza; Pennsylvania's looked like a baroque-revival building. In this context, the sight of mountains, wooded hills, valleys, and streams, even if conquered by railroad lines and steam locomotives, was largely irrelevant.[37]

This was particularly the case considering the official photography of the Fair. The photographic image of the Exposition was almost entirely the work of a monopolistic concession held by New York architectural photographer Charles Dudley Arnold and his partner, Harlow N. Higinbotham, Jr. (son of the Exposition president, and an amateur less gifted than Jackson's financial partner Crosby). Arnold's background as a photographer for most of the prestigious East Coast architects had trained him well in the attributes necessary to celebrate the neoclassical style, the grand scale, and the geometric order of the fair, its buildings, and its spaces. His productions, often mammoth-plate platinum prints that surpassed Jackson's own photographs in scale and finish, were the exemplification of Eastern nicety and stylishness, and they presented the White City as just that—an urban center without reference to any surrounding rustic or undomesticated landscape. Against them, Jackson's images of Yellowstone and the Grand Canyon must have looked especially anachronistic.[38]

But Jackson was fully prepared to enter the "great White Cloud" of the fair and celebrate it, if he could. By the time he arrived after a summer of photographing in California and elsewhere in the West, his name had already been entered into an intense debate concerning the photography of the fair that

had raged almost since the opening of the Exposition. For the Photography Division's monopolistic practices, its high prices, the erratic quality of its smaller, souvenir-size images, its attempts to eliminate amateurs from the fairgrounds, and its "high-handed" attitude so mirrored the supposed public behavior of "the Trusts" that it aroused its own miniature storm of populist and progressivist protest. In August, an otherwise unknown figure named J. F. Ryder wrote to *Wilson's* passionately urging that "this dream of the architect's creation" be memorialized. "In justice to the wonderful enterprise which gave to the world this magnificent showing, the best possible photographic record should be made and preserved"; Arnold was simply not good enough. Instead, "such a man as W. H. Jackson, of Denver . . . should be permitted to face the White City with his largest camera, and give us some photography such as he alone can do. . . . What a regret and what a shame it would be to close the Exposition without having its memory marked by the best possible efforts of photography from the best skilled hands." Ryder's comments dovetailed with the objections in the amateur marketplace to Arnold's disdain for their presence, his allegiance to the tightly defined language of signs that characterized classical architectural photography—a language his architect–clients understood perfectly—and his intolerance for the new "pictorial" style. Stieglitz, by then returned to America and in the midst of his self-proclaimed messianic quest to reorient American photography through his role as editor of the *American Amateur Photographer,* would never

have recommended Jackson, but his lobbying efforts opposing Arnold and trumpeting the monopolistic habits of "commercial" photography succeeded in seriously discrediting the official photographer.[39]

By midfall, matters had come to a head within the administrative circles of the Exposition. When it became clear that Arnold was unwilling to present a final set of "official" negatives, Daniel Burnham, chief architect, director of construction, and then formally director of works, commissioned Jackson to produce a set of a hundred 11-by-14 negatives to be used as the source for the architect's planned *History* as well as the necessary portfolios. Burnham, apparently aided by Director-General Higinbotham himself, agreed to pay Jackson $1,000.[40]

Beneath the complex negotiations over contractual rights and responsibilities lay another set of issues. Arnold's refusal to produce a set of photographs without recompense or guarantee of copyright control represented a continuation of his longer-term attempt to combat the new forces of amateurism and mass-market publication with monopolistic agreements and exclusionary techniques almost identical to those of the railroad trusts of the same period. Indeed, Arnold was battling the same forces that threatened Jackson, and in many of the same ways. Jackson's undercutting of Arnold's position, however, formed only one part of a Byzantine scheme by which Jackson was able to capitalize on the fervor aroused by the Exposition, salvaging for a short time his own threatened career.

Jackson himself did not suffer financially by the complexities of the Exposition's politics. He was paid in full for his negatives from the first. And while Arnold had balked at giving over control over his negatives, Jackson solved the problem in another way. He reported in *Time Exposure:*

It was not those prints alone which kept the W. H. Jackson Photograph and Printing Co. out of the red in 1893: when I returned home I sold a duplicate set of negatives to Harry Tammen, proprietor of a curio shop, for another $1,000, thus netting nearly $2,000 out of a ten days' job. Tammen, who later . . . [became] the partner of Frederick G. Bonfils on the *Denver Post,* made considerably more than that from the profits of *The White City,* as the collection of pictures was labeled when published; but I was perfectly satisfied with my share.[41]

Jackson's reference to Tammen's success underscores the extraordinary marketing effort Tammen made on behalf of the portfolio. Using the pages of his folio-sized journal, *The Great Divide,* Tammen made *The White City Artfolio* the subject of an advertising blitz. Announcing that "100 Rich Men Each Subscribed and Paid $1,000" for the photographs themselves, Tammen then offered them to his readers at twenty cents per each installment of four photographs, or a total subscribed cost of four dollars. This was patent nonsense—Tammen stated that the original portfolio had cost $1,000 per set, when in fact the commission paid only a total of $1,000 for the negatives. Tammen's hard-sell continued; subscribers had to sign a bogus coupon when ordering the pictures, stating that "I agree to show them and *The Great Divide* to at least one friend and neighbor as soon as I receive them, and tell about your wonderful offer."[42]

Tammen's description of Jackson's work was inflated, even by booster standards.

William H. Jackson, the Greatest Scenic Photographer in the World, was called to the World's Fair to photograph it. Eighty pictures were selected from all that were taken, and . . . you will stand aghast with wonder and amazement when you see them. OUR GUARANTEE—We positively guarantee these White City Artfolios to be a superb work of art, and stake our reputation that they are of extraordinary value.[43]

The rhetoric continued in every issue of *The Great Divide* through September. Tammen reproduced the most popular images, noting that the 8-by-10 images were a "Quarter [the] size of Photograph[s] in the $1,000 Book and in the White City Artfolio"; he offered an "Artfolio Holder made to hold the twenty sets . . . only $1.25 Express paid"; he recommended it as a "befitting gift" for "your wife, mother, sister or sweetheart." As each issue passed, he warned of the imminent end of the series, reminded subscribers of their good fortune, and exhorted new readers to take back sets before they were all sold out.

Jackson produced somewhere around a hundred 11-by-14 negatives of the fair for Burnham. In subject, these were designed for comprehensiveness; Jackson must have settled with Burnham to make exterior and interior studies of each of the main buildings, plus a set of more panoramic photographs, encompassing the Court of Honor and the Grand Court, for example. Then the photographer rounded out his collection with a series of details that offers a telling hint to his own compulsions. Some involved improvements on his old techniques—as,

for example, a "Bird's Eye View of the Midway" made from the top of the Ferris wheel. Others were more evocative. He photographed a "Statue of Cowboy" and a "Statue of Indian Scout"; he also chose the statues of "Plenty" and "Industry."[44]

Overall, the pictures presented a revealing set of themes concerning the Exposition, some of them predictable mirrors of the common knowledge of 1893, but others more personal to Jackson. Clearly, the set was designed to prove the photographer to be more than a mere landscapist. Technically superb, the individual photographs reveal Jackson's ability to adopt, adapt, or ignore the Eastern style at will. More importantly, however, they retain an odd dualism—between a sense of "the Fair Beautiful," as one advertisement phrased it, and a more ambiguous image of the Exposition.

The peculiar stamp Jackson put on his study of the fair lay primarily in his approach to the entire project. Rather than attempting to produce a body of work to satisfy his client, he instead seems to have approached the White City as if his responsibility were to describe rather than praise it. Perhaps he got this strange notion from Burnham, but it seems doubtful. Certainly, however, the work is signally different from that of the official photographer Arnold in both approach and in details.

Stylistically, Jackson stressed disjunction and surprise over transparency in his portfolio. Pushed, perhaps, by the competition with a consummate architectural photographer like Arnold, Jackson most often rejected the easy solutions and chose instead unexpected ways of showing his subject. His an-gles of view were rarely as direct as Arnold's. Rather he often chose to shoot across the diagonal, breaking the classical orderliness of the buildings and portraying the Fair more as a viewer might see it. His points of view were, in fact, almost always logical and clear. As a result, the viewer stands in a specific place, rather than remaining outside the picture, looking through the window or at a framed image. Both of these qualities are evident in his picture of "40. Transportation Building from Wooded Isle" (illustration 138). Here Louis Sullivan's famed "Golden Door" fades into the broader context of the building, its companion, the setting, the sidewalks, and even the figures of spectators. Details undercut the "general effect"—railings, half-dead shrubs, a scrap of newspaper, a placard advertising a concert. The scale of the building, seen from an observer's-eye view, seems almost absurd, its facade unrelieved, the scale of the entire fair not just inhuman but almost inhumane. No viewer of the picture would wonder why so many of the figures seem to be hurrying—the sense of great distances to be covered is self-evident.

Whereas Arnold had rigorously exercised his power to excise, control, and order the fair into a unified image, Jackson took to parts with interest and affection. His study of the Fisheries Building, for example, included a healthy portion of a stylistically inharmonious building next to it. And in photograph after photograph, his choice of more human viewpoints results in the spectator casting about in the scene for smaller details—and finding them. Jackson tended to instruct two or three people to stand still for the camera, and they relate to the scene and the viewer in ways that are uncannily similar to certain of his Survey models during the seventies. Rather than staring at the sublime object, they look back at the viewer, demanding recognition, relation. In this way, they undercut the omnipotence that Arnold had sought so carefully in his official photographs; they engage the viewer as an active presence and invite a critical turn of mind.[45]

Where Jackson did choose the straight angle and the complete view, his pictures look even more odd. By shooting across water in case after case, Jackson produced images that sandwiched the building between rather blank stretches of sky and water. Dreaminess pervades many of the images, but it is of a different order than the utopian quality author Frances Hodgson Burnett meant when her characters described the Fair as a "dream . . . come true." Rather it is more like a fantasy, like Kubla Khan's "stately pleasure dome" of Xanadu in Coleridge's poem. In many pictures, this quality is accentuated by Jackson's division of the frame into two horizontal stripes—the lower, in shadow, contains people, sidewalks, wagons, horses, and trash; the upper is occupied by the gigantic buildings, their white facades sunstruck to the point where they actually fade into the white of the photographic paper.

Witness the "South Colonnade" (illustration 139). Across the bottom strip of pavement, the viewer can see runaway newspapers lodged against the balustrades. The lower section of the photograph is full of dirt, horse manure, and trash—the evidences of human occupation and the inevitable decay of urban spaces. Perhaps a quarter-mile away, wagons stand in front of the building to the left; one contains a large, rolltop desk

138.
*"40. Transportation
Building from Wooded
Isle [World's Columbian
Exposition, Chicago],"*
1893. CHS, ICHi-17129

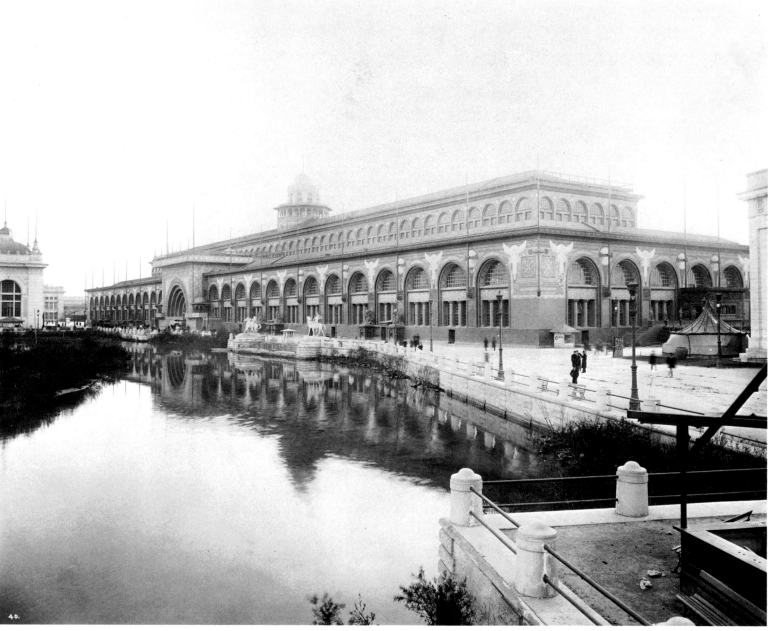

40.

139.
*"22. South Colonnade,
World's Columbian
Exposition," 1893.* CHS,
ICHi-17132

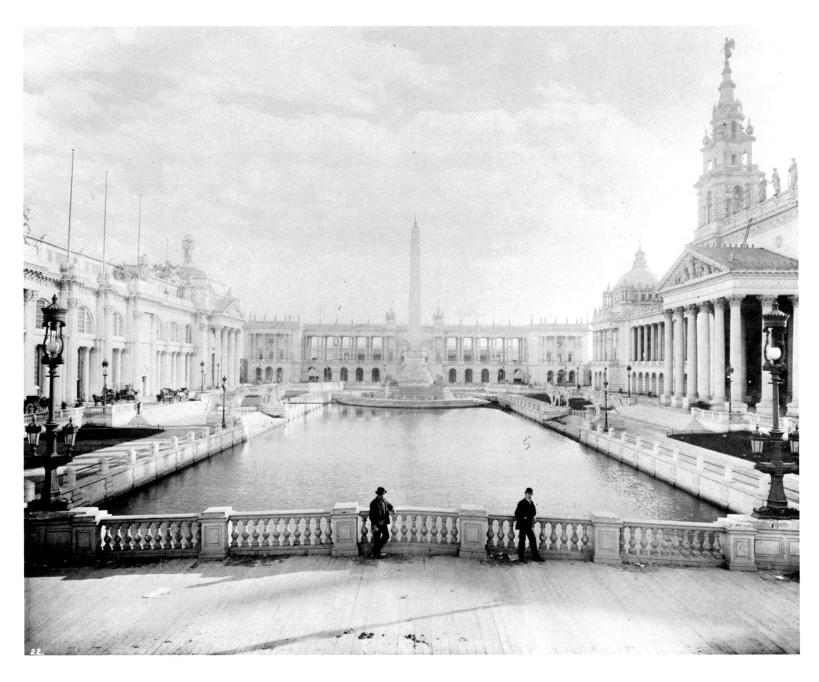

THE FRONTIER THESIS

that has apparently been removed from the hall. Another appears to hold wrought-iron ornament, also culled from the interior. Two men stand in front of the Basin, leaning on the railing, looking at us. Dressed for fall weather, they are less than formal. The entire picture is packed with the traces of entropy. In another study, of the interior of the Women's Building, we are in the balcony, looking down; a few administrators stand here and there, removing the exhibits and piling them untidily on the display cases. In a picture of the Choral Building, and again in the photograph of Sullivan's Transportation Building, one can see a placard announcing the "final concerts" on the "Great Organ." And in an extraordinary study of the Administration Building, Jackson even posed a cart and driver at the still center of the once-bustling plaza (illustration 140).

An elegiacal sense pervades Jackson's pictures, but the lost object is not simply the fair. It must be the entire fantasy of power, domination, order, and civilization that the Exposition trumpeted as its province. The dream has ended, and Jackson photographed the moment just after the end, a time of reminiscence, reoccupation, and repossession of the space, the buildings, and their contents, of return to human scale and human priorities.

This overall effect came about through a number of phenomena that intersected in the pictures. First, Jackson's mandate to photograph came during the first few days after the fair had ended. The space was mostly empty, and the scale changed. In addition, spectators were absent; in their place were workers, whose familiarity with the Exposition had inevitably suppressed the sort of awed, respectful quality that seemed to pervade virtually every visitor. Because the fair had closed, cleaning crews stopped their vigilant policing of the grounds, and trash entered the scene. And the wide colonnades and sidewalks, intended only for humans, now became streets for the wagons and conveyances of workers dismantling the White City.

All of these elements account, in part, for the overall sense that pervades Jackson's pictures. But they do not deny the quality that these pictures communicate; nor should they suggest that Jackson was not himself in control of that quality and responsible for it. In pictures of Denver it is evident that Jackson had assistants clean the streets and public areas before making the photograph, just as—with landscape views during the same years—he sawed off branches that disrupted the organization of a "proper" view. And for a picture of the Cliff House in San Francisco, made probably in 1892, Jackson eradicated whole segments of the scene after the fact, retouching in new details to replace them. And Jackson's railroad views of the previous decade reveal how deft the photographer was at bowdlerizing a scene. Yet here the opposite is true. Jackson had seen Arnold's work; he knew how to make the fair a "heavenly city," yet he chose to make it an earthly one.[46]

No record exists of Burnham's response to the portfolio. But a small detail in the minutes of the Executive Committee speaks volumes. There, the Secretary noted the final resolution of the conflict over pictures to be given to foreign dignitaries, "the arrangement being that the Department of Photography should furnish the photographs called for, the same to be charged to the World's Columbian Exposition . . . and also providing that the so-called 'Jackson negatives' which had been in the possession of Mr. Burnham be turned over to the Department named." So Jackson's pictures did not make up the final portfolio, nor were they to end up as the body of illustrations for Burnham's cherished *History*. Burnham rid himself of the negatives; they were "turned over" to Arnold, where they sank from view. None of Jackson's pictures appeared in the final book; instead, it was illustrated with examples from Arnold's Department of Photography.[47]

Jackson thus lost control, even authorship of his "official" pictures, and they disappeared from the archives of the World's Columbian Museum. Jackson's duplicate negatives surfaced instead, heavily retouched, in two populist versions, where the disturbing disjunctions with popular taste were diminished through alterations made between Jackson's finished prints and the final halftones, the form of their public presentation. Though they bore his name with fanfare, these popular images barely resembled Jackson's pictures. Whole elements were excised by the retoucher—the wagons, with their ladders, desks, and pillaged ornament; band shells; concession tents; and the like. In their place, painted in flags now flew, fictional spectators appeared to gaze at the vast monuments, imaginary gondolas again plied the waters. The show was reprised, and Jackson's ambiguous portrait was erased.

The resulting portfolios were a great success. One of these was Tammen's; the other, *Jackson's Famous Pictures of the World's Fair,* was part of an uplift periodical called

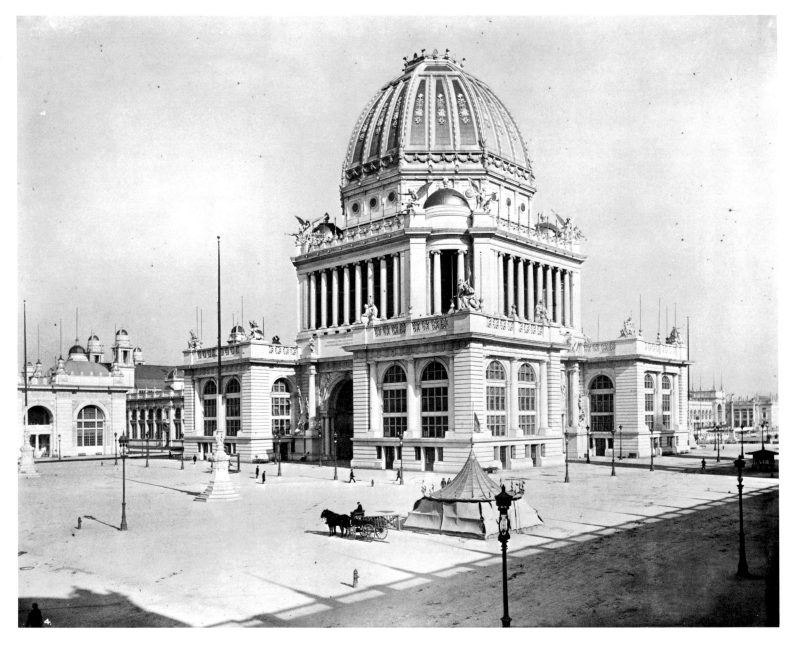

THE FRONTIER THESIS

the *Educational Fine Arts Series.* Their clienteles were similar—both tapped the vast middle-class audience who had seen or wished to see the fair and believed the messianic rhetoric that surrounded the entire event. In a July advertisement, Tammen quoted the praises of Mrs. Potter Palmer and Selim Peabody, Chief of the Exposition's Liberal Arts Department, but he also included a lengthy quote from a Professor David Swing:

The White City Art Company remembers that the people have always been educated in part through pictures. The White City itself reached a few millions by the seeing of the eye, but to the vast majority of minds it must go only in pictures. . . . Our presses and artists should make the views of the World's Fair as abundant as autumn leaves.

This, then, was to become Jackson's direction as "a new epoch" began—a new role of personal anonymity but an even greater pervasiveness for his images. For these 14-by-17 halftone reproductions, with their mock embossing, gold leaf, and massive retouching, overwhelmed Arnold's souvenir images and swept the market, defining the nation's visual memory of the fair for generations after its doors closed.[48]

J ackson's adventure in the marketing of civilization was, on the surface, a great success. He had entered the good graces of one of America's greatest architects, had stolen a commission from an established Eastern architectual photographer, had managed a marketing coup that salvaged his business, and had put his name on one of the most successful publishing ventures to come out of the World's Columbian Exposition. Yet at each point disquieting conditions had attached themselves. His sojourn at the Exposition had for the most part been one of enforced leisure, not vacation or edification. His pictures were never used for the *History;* in fact, Arnold's pictures replaced Jackson's, and the offical photographer received Jackson's negatives as well. And the *White City Artfolio,* and its sister, *Jackson's Famous Pictures of the World's Fair,* removed Jackson from his controlling role as a vertically integrated disseminator of images, demoting him to a far less powerful role as maker of images altered, edited, printed, and distributed by others.

In retrospect, we see that Jackson's pictures of the fair conveyed far more of the gritty actuality of the White City than did Arnold's. Jackson had undercut the authority of his employers, had diverged from their beliefs. While few casual viewers would have noticed the difference between his vision and theirs, Burnham, it appears, perceived the heretical elements, and excised them from the official history. And when the reproductions appeared, what survived the retoucher was dissipated in the haze of the halftone screen.[49]

Meanwhile, an equivalent process was occurring to Jackson's original subject, Western landscape. For while Tammen was advertising the *Artfolio* to readers of *The Great Divide,* he was also marketing another side of Jackson. In January of 1894, he began publishing a "series of trips," which he titled "Wonder Places," composed of pictures, fully 9-by-11 or larger, each with a short essay beneath. These extolled the virtues of thirty-nine Western scenes, including the Mount of the Holy Cross, Yellowstone, and a selection of "Gorges, and the Rocky Mountains in Picturesque Forms," as an announcement of the set described it.[50]

As the months passed, and entry piled upon entry, the peculiar purpose of the series—and in fact of the journal itself—became clear. The *Great Divide* was a resuscitation of the Western booster book; Jackson's entries were updated versions of the lithographic city views that had been used to attract settlers to the West two decades and more ago. Advertising nature rather than culture, the *Great Divide* sought to attract new residents to the region, even as it catered to tourists by offering them a combination of Western lore, imagery, and mementoes. Adjacent to one ad for *Wonder Places,* the publisher offered "Tammen's Juvenile Rocky Mountain Cabinet" (which contained a variety of Colorado ores), at only eighty-five cents express paid. Tammen was shrewd. The product for children was also an interesting lesson for parents in the mineral and mining potentials of the region, and, in much the same way, the essays accompanying Jackson's pictures were targeted toward two markets—as tour guides for new visitors, and as souvenirs to remind home-bound tourists of their vacations.[51]

By the time Tammen had run six sets of "Wonder Places," the success of the *White City Artfolio* had persuaded him to offer the second project as an "edition *de luxe* . . . daintily bound in white leatherette or elegantly bound in silk . . ." for $1.50 or $2.00 depending on the version. In this form, Jackson's pictures were transformed

into confections and lost their older function as signifiers for a potency resident in the landscape.[52]

Wonder Places held equally important implications for Jackson's career. These two portfolios in many ways represent complementary documents; seen together, they show the extent of Jackson's attempt to bridge the gap between his old original-photograph entrepreneurship of the eighties, and the realities of conglomerate publishing and halftone reproduction. *Wonder Places* was, Tammen trumpeted, "a selection of perfect photographs from a collection of 30,000 negatives of the world famous W. H. Jackson." While the portfolio might have offered undeniable advertising for the original photographs, in fact no mention of Jackson's business address, or the availability of mammoth-plate versions of these photographs, appeared in the book. Probably the only direct noncash benefit *Wonder Places* offered Jackson himself was as a market test for the possibility of nationally distributing and mass-reproducing photographs from his collection via large-scale, heavily advertised media with a national client base.[53]

But more realistically, the selling of *Wonder Places* suggests Jackson's desperation; he was gutting his entire collection for one mass-produced book, abandoning the concept of photographic entrepreneurship in one gesture. Jackson had built his collection with the assumption of a multiple-outlet marketing system. The photographs were "sold" once when commissioned by railroads, landowners, developers, resorts, hotels, and even towns and cities. Once made, they could then be sold again and again,

serving as their own advertisement for the Jackson establishment.

Jackson's marketing strategy could not be transported into the halftone era unaltered, because it depended upon a particular mythos surrounding the photographic image itself. Halftone reproduction, particularly the grey, muddy type that appeared in many of the newspapers and magazines during the early nineties, operated on an entirely different principle. Halftone-reproduced photographs were already turning their graphic drawbacks into communicative successes; the photographs became simpler, bolder, far more dependent on text and caption than they were previously, equally dependent on preexistent stereotypes and simplified rhetorical devices. Even today, these photographs reproduce almost equally well as photocopies; at the time, they were meant to translate without damage to wood engraving, should it be necessary to employ the older process. Bold and simplified compositional devices and contrasty, low-detail imagery replaced the subtleties of tone that had become the hallmark of the truly meaningful photograph of the previous era. But Jackson's own photographs had been made to be seen as extremely long scale, gold-toned, contact-printed images, wherein the process of long study rewarded the viewer with greater and greater immersion in the scene itself until, with the mammoth-plate views especially, one felt oneself inserted into the landscape.

Wonder Places signified Jackson's capitulation to the halftone world and his abandonment of the studio ideal that had sustained his commercial years. It also announced

a closing of possibilities in the role of the Western landscape photographer. In the context of Tammen's inflated rhetoric, his marketing of the photographs as souvenirs alongside pasteboard rock-collection boxes and "Pozzoni's Complexion Powder" not only diminished Jackson and his photographs but signaled a correspondent devaluation of the Western landscape itself. This was a step beyond Jackson's own selling of the West as tourist attraction to a more complete stripping of power and meaning from the landscape. It ended a long trend, presaged in the later Survey era and enacted in the commercial years. Even at their most extreme, Jackson's railroad photographs had always depended upon the viewer's belief that the scenery "came up to" the depiction. Jackson had applied his transformational powers to shifting the meaning of that scenery, making it accessible, soothing, and rewarding to the exhausted spirit of the weary mental worker. Still, the commercial years had seen a slow leaching of that sensibility, as the picture came to seem less and less a window and more and more an object unto itself—first a substitute and then a casual experience of its own, deserving a glance but little more. The commodification of the landscape and the landscape photograph at the same time had proceeded from the stereo card to the framed mammoth-plate picture or mounted card photograph to the published book and, finally, to the complete replacement of the photograph itself with a "daintily bound" souvenir.

But *Wonder Places* was not a success. Unlike the *White City Artfolio,* its sales were apparently unimpressive; perhaps because

Jackson's landscapes were never designed for the sort of glancing appreciation appropriate to the halftone, or perhaps for the very reason Jackson himself was failing—a glut in the market for landscapes. By the end of 1894, Tammen's entire *Great Divide* empire had been sold to a Chicago publisher and reincarnated as a small anecdotal magazine of only marginally Western emphasis. Turner's statement that "the frontier has gone, and with its going has closed the first period of American history" now combined with the millennial gloss put on it by fellow Columbian Congress speakers who envisioned a new era of national prosperity and mission; now it suggested a civilization set loose from the bipolarity that had defined it. In the "new epoch" of post-Columbian America, more than the old model of the photographic entrepreneur was threatened by the repercussions of 1893. Now the West itself seemed marginalized, stripped of its power as an alternative to the East, to urbane civilization. With the West denied to him, with the White City disappeared, with the "grey city" of urban dystopia as an emblem of American civilization, Jackson turned to the globe.

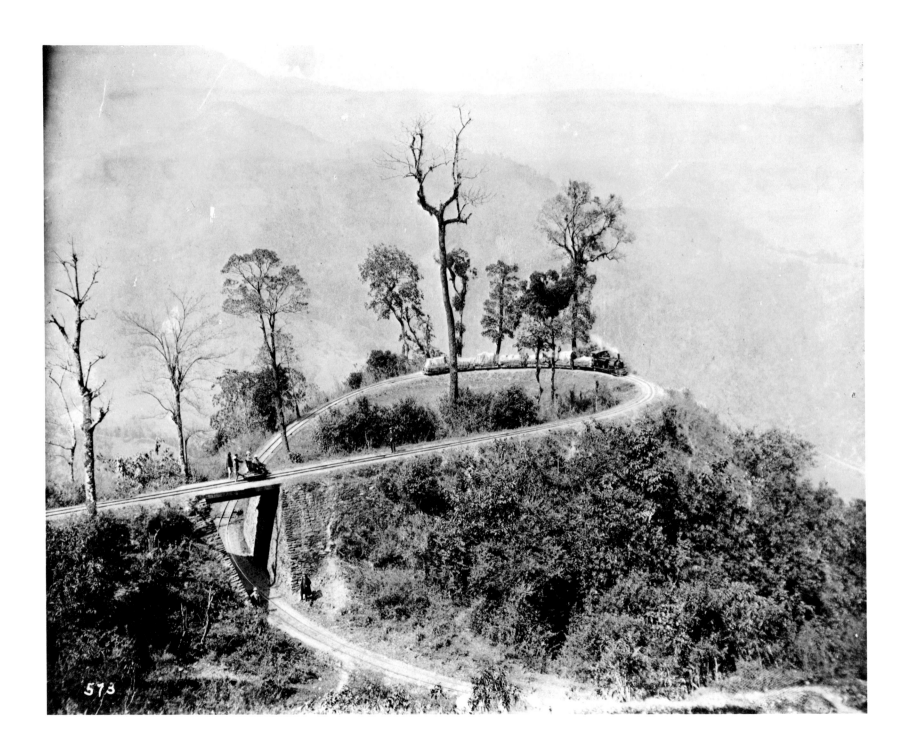

573

One of the most serious problems of modern civilization is that of which two factors are the rapid pace of life and the limitations of human endurance. A man who would keep up the race must go with all his might and never stop; otherwise, he is sure to lag behind, and be regarded . . . as a failure.
—"This Modern Civilization,"
Harper's Weekly, 1896

William Henry Jackson returned to Denver from Chicago in the fall of 1893 to a business threatened by bankruptcy. His quick sale of the Exposition negatives to Tammen offered only a stop-gap solution, but Jackson was hopeful about the longer-term prognosis. At the close of the fair his old B&O Railroad employer, publicist "Major" Joseph Gladding Pangborn, had approached him to announce that a round-the-world trip the two had discussed in 1892 was to become a reality.[1]

Pangborn's trip was one block in a pyramid of schemes the hyperbolic, silver-tongued publicist persuaded Marshall Field to fund as part of the Field Columbian Museum. Pangborn had carved out an entire fiefdom within the multimillion-dollar Field Museum, as head of the "Museum of the World's Railways." And he had persuaded Field to contribute $25,000 to a "study of foreign railroads" that rapidly expanded into a more elaborate goodwill, fact-finding, and exhibit-gathering trip, under the auspices of the World's Transportation Commission, that would supposedly make Field's museum a worldwide name. This money would serve as "seed corn" (in Jackson's words) from which a magnificent tour could be arranged. By the time of departure, the sum approached $100,000, with contributions from a stellar list of American merchant princes: George Pullman, Joseph Leiter, George Westinghouse, Cornelius Vanderbilt, Jr., and even Andrew Carnegie, according to Jackson. And Pangborn's plans matched the generosity of his patrons. Devoted to ostentation, Pangborn organized the retinue accordingly: in addition to the Major, his secretary, Jackson, a professional railroad engineer, an artist, a naval and a military attaché, and a general servant, Pangborn planned to add other, unspecified "experts" and assistants.[2]

Pangborn's success underscored the new emphasis in American capitalist circles on expansion into international trade as a solution to the problems of economic slowdown and constricted markets at home. The reduction in tariffs, marking a new era of free trade, recent attention to naval might and economic spheres of influence, and a more sinister rise in jingoistic rhetoric in Congress and in business circles as well all marked this new stress on an international economic policy. Pangborn's project neatly addressed these preoccupations by offering two quite different commodities, equally necessary for

141. (*opposite*)
"573. The Choonbatty Loop on the East Bengal Railway in the Himalayas," 1895. LC

American businesses to enact their global ambitions: information about nations, cultures, and markets; and a lobbying presence to advertise American goods.[3]

While Jackson had been doubtful about Pangborn's original scheme, now he grasped at the Major's effusive promises, especially when they seemed to be confirmed by a number of newspaper stories, one of which even mentioned "W. H. Jackson, the great Denver photographer" as a member of the party. And Pangborn offered a salary of $5,000 per year, which would support Jackson's family during the three-year trip; Jackson's own costs would be fully defrayed by the Commission. Before leaving Chicago for Denver, Jackson agreed to the arrangement.[4]

The photographer thus made a commitment requiring that he sacrifice his family life, turn his business over to lieutenants, and disappear from public prominence for a lengthy period. Leaving for a long time, Jackson believed, would almost certainly necessitate a complete change of career direction upon his return—probably requiring him to abandon Denver as his locus of work and, necessarily, to rebuild his reputation. In addition, he would have to leave his family for at least eighteen months, perhaps three years. This was a different sort of absence than those in the past. Jackson was fifty years old, Emilie in her forties. Their two daughters, Louise and Hallie, would have to be uprooted and sent East to schools. Son Clarence was a greater worry, however, for he had entered a troubled adolescence. He, more than his sisters, had relished the financial and social benefits of the Jackson family's Denver years, and he seemed unwilling

to alter his tastes to fit new realities. Now especially Clarence needed his father's presence, even as Jackson prepared to leave.

But there seem to be no alternative. With the Denver business failing, with his reputation in decline, with his profession threatened by the revolutions in photography and in mass-market reproduction, Jackson saw the trip as a godsend—a chance not only to recoup his career but to rediscover once again the spirit of adventurous exploration that had been his muse since taking up the camera nearly thirty years before.[5]

In the late fall of 1893 Jackson returned home to arrange some solution to the problems of the W. H. Jackson Photograph and Publishing Company that would ensure its continued existence at least during the time he would be gone. This turned out to be easier than it might have seemed. First, his leaving removed an economic burden from the Company by subtracting his salary. Second, the Company's entire business structure had moved increasingly toward the use of assistants and employees to make the photographs, with Jackson himself serving as overseer, visible symbol, and specialist for difficult or prestigious jobs. With a competent manager, Jackson believed, he could leave the business not simply surviving but in a position to improve its weakened state through the institution of modern managerial practices—something he himself had been unable to do during his reign. Jackson found his man in W. H. Rhoads, "a capable photographer from Philadelphia" and, more important, an efficient and experienced manager. Rhoads would oversee the production, collaborate with Crosby in man-

agement, and—where necessary—take photographs himself.[6]

As winter progressed to spring and then to summer, the Commission's departure continued to be delayed. More disturbing, it began to shrink, as first the naval and military aides, and then the servant, were excised, and a general secretary was eliminated in favor of Pangborn's long-time stenographer. Any fears Jackson may have had were confirmed when Pangborn wrote him in September that his salary had been eliminated from the budget, although his expenses would still be paid. Now the photographer was in a personal and professional bind. His business had been reorganized to eliminate him; he had himself publicized his leaving with much fanfare; his long-term plans for a new career as an Eastern professional depended on his connections with the Transportation Commission.[7]

He was able to resolve the problem of financing by approaching an irregular employer of his. Probably at Pangborn's suggestion, he contacted *Harper's Weekly,* then America's most successful weekly journal, to see if the magazine was interested in contracting for a steady stream of pictures under the dual letterheads of William Henry Jackson and the World's Transportation Commission. Negotiations with *Harper's* art editor Payne resulted in a package that included Jackson, Pangborn, and the graphic artist for the Commission, Edward Winchell. Jackson would provide the photographs complete with full accompanying information from which *Harper's* editors could make up a text column. Pangborn promised a less-regular series of separate articles, and

Winchell would submit periodic watercolor or pen-and-ink drawings of "picturesque" and "educational" materials concerning the Commission's trip, its mission, and the scenes it encountered. *Harper's* originally planned to run one article per week, with a page or more of illustrations, for which the Commission would be paid a total of $100 per page spread, $400 or more per month. Jackson would receive the lion's share—$250 to go directly to Emilie to pay for family expenses, the rest to go to the Commission account to defray such costs as film and shipping. Before the Commission left, *Harper's* would advance $1,000 to Emilie, to be offset by a shipment of negatives due in December, showing Egypt, Syria, and Turkey, the first three countries on the Commission's itinerary.[8]

Jackson thus became an employee of *Harper's Weekly;* more precisely, he became a freelance stringer whose contract, he would later find, guaranteed him money only if his editor was pleased with the work and found it timely and relevant to the magazine's purposes. Jackson was actually quite lucky. As he was later to discover, *Harper's* had a number of other sources for foreign views. Jackson's name counted for little in the mass-reproduction world of *Harper's,* where artists, photographers, and authors shrank or even disappeared entirely into the omnipotent, disembodied persona of "The Journal of Civilization," the magazine's motto. What Jackson offered *Harper's* was the guarantee of a regular shipment of views from a set foreign itinerary around which the magazine could plan its international articles.

Jackson's reputation was of lesser importance, but the name of the World's Transportation Commission, and the names *behind* the Commission, were exploitable. About a year later, educated in the ways of the weekly, Jackson wrote Emilie:

I don't imagine for one moment that the *Harper's* would advance me 500 per month on my own account apart from the *eclat* which surrounds the *Commission* . . . or even that they would take pictures from me to this extent. . . . I am standing alone and dependent, with hands and feet tied, powerless to do more than drift along with the party.[9]

By then Jackson understood that the contract bound him absolutely to the Commission, no matter what might happen along the way—bound him not legally, but financially. With no cash of his own and no expectation that *Harper's* would buy his pictures "even if I had the money to go ahead . . . with the assurance before me that they would be paid for," Jackson was utterly dependent on Pangborn in the immediate region, and on editor Payne at headquarters in New York.[10]

Jackson's experience would lead him to bitterly regret his naiveté, but in September, with the Commission about to leave, he was simply grateful for an arrangement that seemed to guarantee the security of his family and the continuation of the trip. Rushing to pack, to arrange with the Carbutt Company of Philadelphia for shipments of their new flexible nitrate films, working with Anthony's to get a new camera, and negotiating with his wife's family for housing in Baltimore while the Denver house was rented, Jackson neglected even to formalize the con-

tract or familiarize himself with its details. In a glow of optimism, he simply left matters to the good manners of *Harper's* and to his characteristic belief that things would work out better than he could imagine.[11]

While Jackson was relatively unimportant to *Harper's,* he was still "indispensable" to Pangborn and his Commission. Pangborn, a born public relations man, understood that Jackson would serve a number of functions on the trip and afterward. The Commission offered Jackson legitimacy; Jackson returned the favor by providing a stock of work that could be used to satisfy the Commission's backers, even if no other tangible results appeared. And the *Harper's* agreement guaranteed the publicity Pangborn craved for himself and needed for his Commission: at least a page of pictures every week, complete with a column topped by a special Commission logo designed to imitate the offical seals of government bodies (illustration 142).[12]

Pangborn's thorough knowledge of Jackson's work, and his previous experience in working with the photographer on a day-by-day basis, convinced him that Jackson had two vital attributes necessary for the trip: a capacity to glamorize and dignify his subjects and a willingness to bend to satisfy the demands of his clients. Both of these were qualities on which Pangborn would tax Jackson to the fullest over the next eighteen months.[13]

Not until the Commission arrived in London in late October of 1894 did Jackson face his own reasons for so eagerly embracing this long and questionable journey. While he had paid some lip service to the possible uses of his photographs in the construction

of some future Jackson company, he had not, apparently, bothered to determine whether he or *Harper's* held the rights to his negatives. And while he recognized the prestige implicit in the Commission, he also knew that it would require much work to turn that prestige to capital once he returned from the trip. No, the tangible rewards were not central.[14]

Jackson's global excursion, it seems, was an escape *from* responsibility, from the past, and into what he hoped might be an expiated self in a new, recreated future. In London, on October 28, he wrote Emilie a long and painfully honest letter. He began by confessing that the Commission was in some disarray: the personnel had been abruptly changed; Pangborn had apparently lost important letters of credit (or was unwilling to admit he had never received them); and the itinerary had been hastily rewritten—in a manner that was sure to infuriate *Harper's*. On more personal issues, he hoped the money the Jackson Company owed him would be enough "to place Louise at the school she would most desire to attend." He looked forward to the time when Emilie, too, could "shake the dust of that town from your feet" and get back East. And then comes an astonishing passage:

One reason why I was so anxious to go on this expedition at any cost whatever was to establish a new starting point in our career. To be able to draw a line separating our old way of getting along, and a new and more businesslike method. . . . The whole twenty one years of our married life—while it has been a happy one—has also been an improvident one. That we are not worse off and have not been entirely swamped before this has been due more to hard and indefatigable work than to good judgment.[15]

Jackson's combination of the rhetoric of the American West—of "a new starting point" and of drawing a line—with the economics of middle-class business and personal life was probably to be expected. But what seems at first inexplicable is the magnitude of the break Jackson felt was necessary to start upon this "new path." At the same stage in his life when his own father had dragged the young William from state to state in fruitless experiments in economic recovery, Jackson was now attempting the same application of geographical mobility in hopes of reenacting an economic mobility suddenly lost. A Westerner living in a closed frontier, he had turned to the globe.

With evident hesitation, Jackson confessed to Emilie just what his circumstances were. His new manager Rhoads's settlement of the business, detailed in a letter the photographer had received in London, had apparently revealed to Jackson that he could not hide certain facts from his wife—for the matters concerned not just reticence but dishonesty and even illegality and concerned her family. Just how bad the matter was, Jackson hesitated to confess. But in the reincorporations of the Jackson Company first

142.
"Official Seal" for the World's Transportation Commission, from Harper's Weekly.

AROUND THE WORLD

WITH THE OF THE

TRANSPORTATION FIELD COLUMBIAN

COMMISSION MUSEUM

SIAM AND PENANG.

with Chain and Hardy and then with Crosby, Jackson had failed to completely remove previous stockholders' claims. At the time of Crosby's entrance, the amount in question was $7,000—which Jackson apparently financed with money that was supposed to have paid off mortgages on building lots he had been empowered to purchase for Emilie's mother. Then he had depended on business receipts to pay the interest on these mortgages—a procedure that Rhoads was, for obvious reasons, unwilling to continue. Jackson had been caught in a seeming double embezzlement: first from his mother-in-law to support recapitalizations of his Company, and then from the Company itself, which had thus far paid the interest on personal property. And still there was the $7,000 to find, as well as the future interest.[16]

This was the worst face of an extremely ambiguous set of circumstances. In the longer perspective, Jackson simply found himself at the abrupt end of a long chain of events that in some respects typified the economic climate of the eighties and nineties for small capitalists such as he. Hoping to compete with larger and more-sophisticated businesses, the photographer had aggressively expanded his company, betting on paper profits from the expansion. As these had come, however, he had spent the sums in schemes that seemed guaranteed to succeed in the fevered boom atmosphere of mid-eighties Denver. He had used the profits to refinance his own business, expanding it further in response to the need for continued innovation to compete. At the same time, he had begun to speculate on land values—both personally and, even-

tually, with capital entrusted him by his mother-in-law. The tremendous expansion in population and prosperity of the city and region seemed to ensure not only the success of the Jackson Company but the rapid revaluation of land. In fact, Denver lots did increase in value tremendously during this era—until the panic of 1893 and the depression that followed. Then, like many other small-time speculators, Jackson found that his land could not be sold for its greatly inflated value or even for its purchase price in the boom years when he had bought it, and interest payments were still required. Apparently Rhoads was able to engineer an arrangement to pay the interest from company receipts; the principal was left until later. But Jackson's plan of escape had failed; rather than leaving his woes to start afresh, he was now even more dependent on the Commission, *Harper's*, and Rhoads for his livelihood.[17]

The result of this, oddly, was liberating as well as imprisoning—actually, it was liberating because of the way it imprisoned the photographer and altered his vision in subtle, complex, but discernible ways. The weeks in London, the boat to Tunis, and the first months of the expedition proper made clear to Jackson his own subservient status. But this abrupt downfall in prestige eventually converted him from a participant in the Commission into something approaching a critical observer of it. From that vantage point, he found himself released from inevitable participation in the imperialism of the tourist and free to seek some other way of understanding his experiences in foreign places. A servant himself, he would learn to

sympathize with the natives when they suffered under Pangborn's imperiousness, and to see—though to a lesser extent—the peculiarity in the economic and social relations between dominant and submissive nations in the imperialist game of the late nineteenth century. But this was not to occur for months.[18]

Meanwhile, Jackson was in the process of discovering the first unhappy truths about life on the Commission with Pangborn. He had planned to have nearly total freedom to work, building up a body of pictures that would include some "technical photography" as he called it—obligatory pictures of the Commission and of transportation "specimens"—but would consist primarily of a comprehensive study of the global landscape. The Commission was hardly off the boat before he began to be disabused of his expectations. The Commission staff now shrank to five: Pangborn, his stenographer Harry Stevenson, the obligatory "engineer" and transportation expert Clement Street, the artist Edward Winchell, and Jackson. The itinerary had also been divided into two stages. The first would take them through Egypt and thence eastward to Japan and China, then north to Siberia, then back on the still-uncompleted Trans-Siberian Railroad to Moscow and Europe; the second would include Europe, Africa, and finally South America.

In London, Pangborn treated his colleagues like house servants, and his overloaded itinerary of social obligations precluded any time for Jackson to photograph, let alone escape to other nearby regions for sightseeing or to scout sites for possible

143.

"Statue in Bas-Relief, Recently Exhumed from the Ruins [at Carthage] and Restored," 1895. LC

views. By the end of the first weeks, Jackson reported to his wife; "I have seen so much and been around so many places. . . . All impressions are somewhat confused from the great multiplicity of them that have been crowded upon me, and I have not had the leisure or the quiet necessary to collect my thoughts in proper shape."[19]

Most disturbing, Jackson discovered quickly that Pangborn could not be depended on to keep to his itinerary. In London the first and most dramatic change occurred, lopping off whole countries and rearranging the entire tour, in part because of undetailed changes in the Commission's financial status, partly to take advantage of offers from British government officials who guaranteed free passage on colonial transportation systems and paid nearly all costs while the Commission was in British colonies. But, Jackson later realized, the changes also reflected Pangborn's nearly deranged personality, his absolute refusal to take into account the needs of others, and his sybaritic devotion to personal pleasure.[20]

This first change of plans, combined with the wild haste of Pangborn's schedule and his insistence that Jackson serve as attendant at all social functions, undercut Jackson's entire rationale for making the tour and threatened the *Harper's* contract as well. Almost certainly, there was no chance of a great, complete set of pictures of the globe, and any time for photographing would have to be stolen from Pangborn or taken from him unawares, for the Major was adamantly opposed to Jackson's leaving the entourage for any reason. In addition, Jackson evidently lost the possibility of actually immersing himself in the environment sufficiently to make some sense of it.

London was a failure; the weather made pictures impossible during the few days Jackson could have slipped away from Pangborn. At Tunis, the first stop of the tour itself, Jackson immersed himself in picture taking, much of it under the eye of the Ma-jor. This first subject he approached with the widest possible net, hoping to satisfy all the competing interests. For Pangborn, he produced a set of pictures describing the variety of transportation types characteristic of the region. These images of water carriers on burros, the Bey's bodyguard on horseback, hand-drawn baggage carts, and "The Railway Train of the Italian Line between Tunis and the Site of Ancient Carthage Leaving Marsa," were stiffly conventionalized "specimen" photographs. They competed with views of the modernized railway stations and fortifications for the approval of *Harper's,* which had, after all, commissioned the series to "educate" its viewers in the progressive stages of transportation technology throughout the world. Other photographs stressed the picturesqueness of the region.[21]

A trip to Carthage also enabled Jackson to make a small series of more ambitious photographs—studies of the ruins themselves. These were celebrations of Roman grandeur, made by an American in his first contact with the reality to which so much lip service had been paid. For the statuary, columns, urns and other objects Jackson so respectfully depicted in his views (illustration 143) were the source of his artistic training, the models from which Chapman had derived those exercises in the *American Drawing Book* that had so profoundly influenced him forty years before. The photographer composed his view of a restored Roman bas-relief so that it floated against a rectangle of white wall, bounded on one side by elaborate columns, on the other by vases and other pottery awaiting the restorer's hand. The result was to suggest an

homage to past civilizations—an obeisance that would be converted by *Harper's* into a more strident ideology of colonialism in its first column, some three months later.[22]

From Carthage to Algiers to Morocco and Egypt, Jackson's work continued to include views made expressly for Pangborn or *Harper's*. But increasingly, these became integrated into a larger frame, which encapsulated the conventional wisdom of nineteenth-century imperialist and tourist sentiment. His view of the "Depot and Station Grounds of the Algerian Railway" (illustration 144) was a superb description for Pangborn of the bustle of a colonial railway station, complete with an inventory of the goods that daily were transported in and out. His study of "The Gorge at Constantine" (illustration 145) rivaled his views of the cliff dwellings of Colorado made with the Survey more than twenty years before. Here, however, the picture celebrated the triumph of man over an inhospitable landscape.

Jackson's response continued to be that of the awestruck tourist reacting in conventionalized ways to the correct subject matter of foreign places. Still, his work contained within it the visual vocabulary of Victorian imperialism. And at this point Jackson was in total agreement with its sentiments—writing Emilie at each stop, delineating the process of "improvement . . . vigorous, aggressive improvement," that the European colonization of North Africa had instituted.[23]

In Tunis, Jackson began in earnest a series of letters that, rarely completed, always regretted, were to have encapsulated for his homebound wife his impressions of the world. These letters, usually dry and factual in tone, alternated with far different messages—deeply personal notes, usually written in a markedly different script, filled with loneliness, homesickness, profound guilt, and anguish at the emotional and economic hardship his absence wrought on his family. These powerful messages marked the servant Jackson; the professorial tomes marked the tourist. In these, Jackson provided a commentary he hoped could eventually be rewritten into publishable form. As such, they mirrored his conception of what proper travel literature should be—they were Jackson's version of the Baedeker and Murray guides on which he depended to provide himself with proper information and correct responses.[24]

As the Commission moved onward, a similar process went to work on the photographs, though in this medium Jackson could more easily transcend the merely imitative and begin to forge his own position. This was particularly evident in the photographs that resulted from his confrontation with Egypt, that most obligatory stop in the late-nineteenth-century version of the Grand Tour. In subject matter utterly orthodox, the photographs are still supremely interesting, for Jackson succeeded in drawing upon and then expanding the approaches of a long list of photographers before him—men like Francis Frith, whose work was widely disseminated in America, and Maxime Du Camp, whose less popular views nevertheless had eventually percolated into public consciousness of the nature of ruins and of colonialized regions (illustrations 146, 147, 148, and 149).

The Egyptian views presented a region of conventionalized romance—of Pyramids and Sphinxes, deserts and oases, exotic natives and dominant tourists—employing a precisely correct and publicly accepted visual language but arranged in syntactically novel ways. No wonder Jackson wrote Emilie that the pictures were grand successes. He had worked hard to make them as they are. While the rest of the Commission remained on their mounts or rested below, the photographer hiked his way around each stop on their guided tours; he alone climbed a pyramid; he chose his native guides, posed them against the proper backdrops, and apparently instructed them in the direction of their gaze and the props they were to hold. This was less difficult than the photographer might have feared, because all the native boys who fought for a chance to "guide" the tourists spoke English, which they employed mainly to charm their clients into increasing the fee or sending presents back when they returned to the States. And the guides themselves already knew quite well the "proper" positions to take in order to satisfy the European eye—they were willing and experienced posers.[25]

Jackson's pleasure with these pictures seems to have resulted from the resurgence of older issues that had obsessed him during his Survey and Denver years. Most particular was the renewed confrontation with infinite space, which now intersected with a sense of the near-infinitude of time implicit in these scenes of ancient grandeur, decayed yet still magnificent. Once again, man seemed diminished in relation to the magnitude of sky, desert, or sea, and his shrunken scale lay in relation not only to

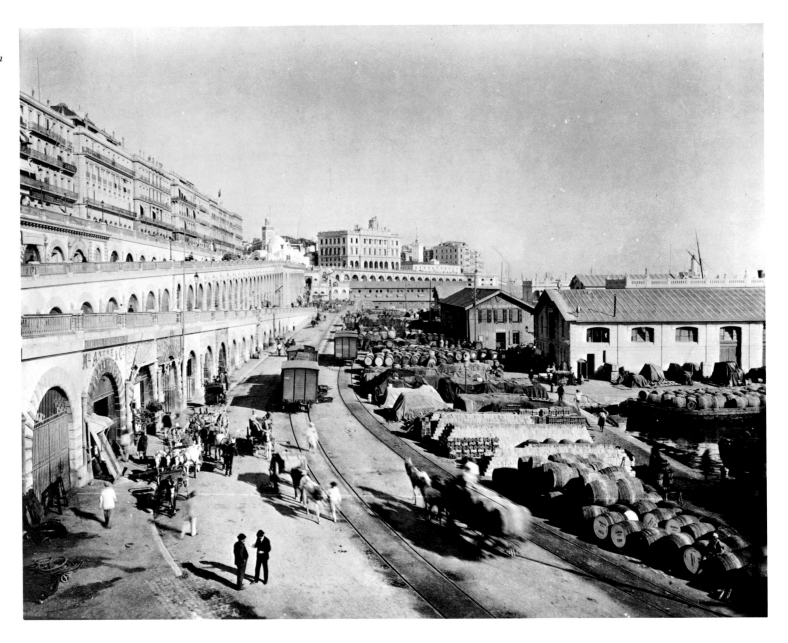

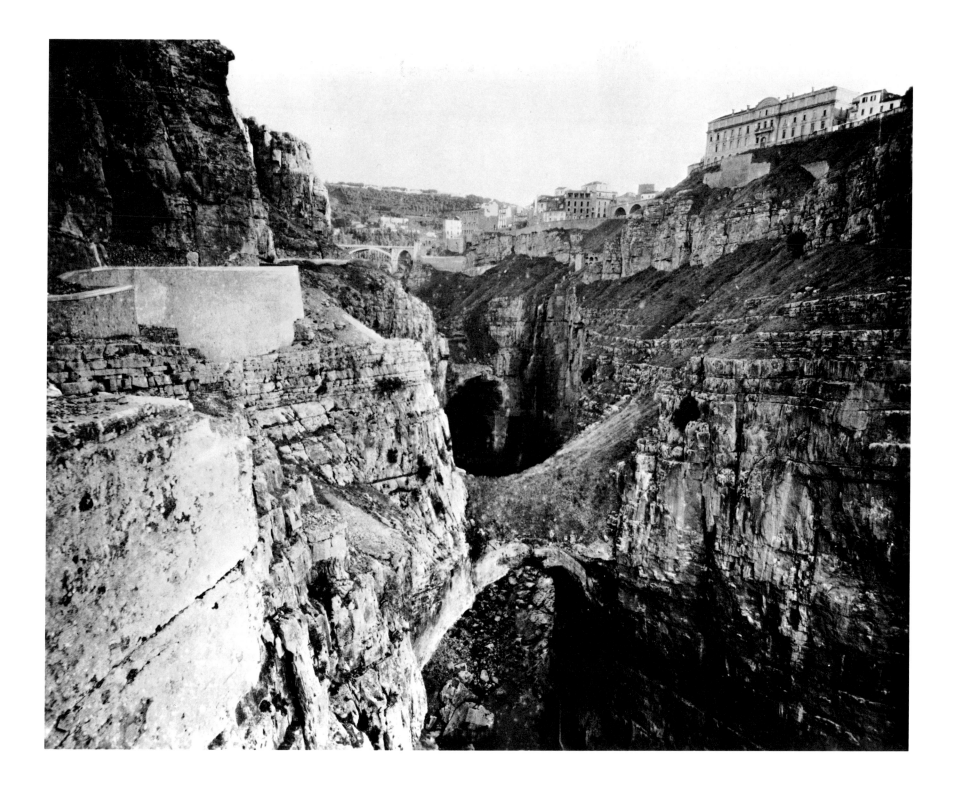

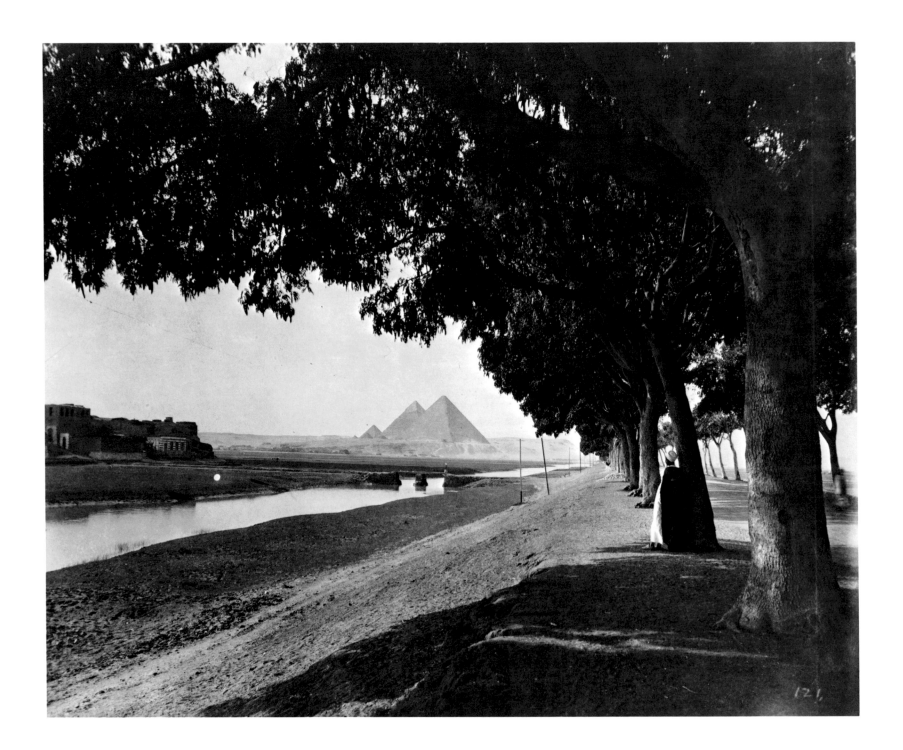

THE IMPERIAL FRONTIER 223

148.
*"115. "A Side View of
the Great Pyramid,"
1895.* LC

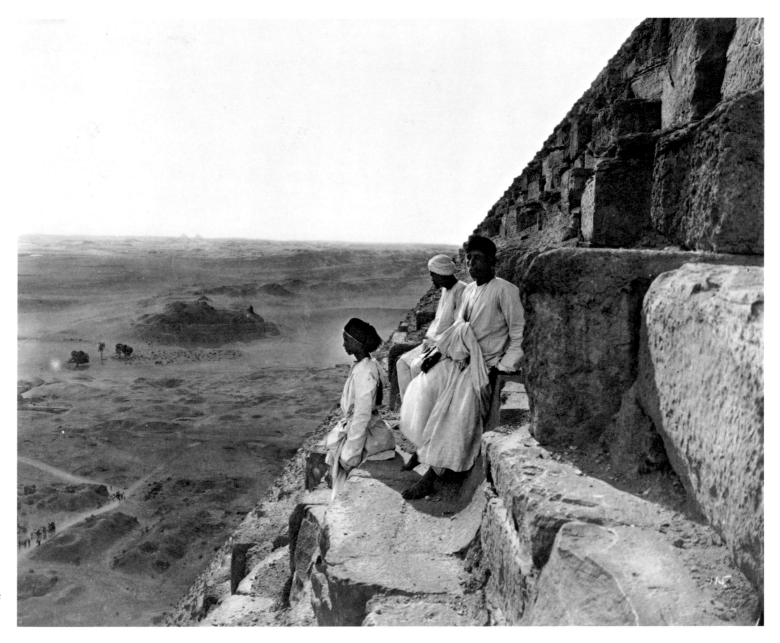

149. (*opposite*)
*"143. The Well of Moses
in the Sinai Desert,"
1895.* LC

the vast hostility of the desert but to Jackson's own stretched conception of time. In letter after letter, the photographer contrasted historical time with touristic time, the span that had built and populated each region against the haste of Pangborn and his Commission—and this obsession permeated his photographs, as well.[26]

The conflict between two conceptions of time reached its climax at the Suez Canal (renowned symbol of the success of imperialist modernization) before the Commission left Egypt for Ceylon. There Jackson photographed a native Arab dhow (illustration 150). Plastered against an infinite space, its mast and sail intersecting the horizon, the craft is, as Jackson noted in a letter, an object out of another time. Here he succeeded in encapsulating a hushed alternative to Pangborn's rowdy hurry—in the ripples of the water, in the scale of the boat and the men on it, in the eccentric composition of the image itself.[27]

"Haste is the order of the day and we rush from one thing to another almost before we know what we have seen," Jackson wrote of Egypt. The next day, Jackson wrote again, a personal letter:

Enough to say for short that I have realized a great disappointment in the conduct of our tour and the opportunities it affords me both for pictures and personal profit and pleasure. I cannot repeat all the *causes* leading up to this. . . . It was a serious question whether [to] force an issue and possibly return direct from here or to continue further on and then go home via Japan and San Francisco. . . . I am now committed to the trip as far as India anyway. I want to get just as much as I can out of the thing before the smash-up comes. All the rest of the party are united in the *same*

opinion and by hanging together I think we can accomplish more than by individual action. . . . *Say nothing* of this, so [none?] will get outside.

A number of causes had combined to bring Jackson to such a fatalistic position. Perhaps the most important concerned the increasing difficulty of making time to photograph, combined with a further change in the itinerary—a matter that altered the scope of the expedition but also threatened Jackson's revenues from *Harper's*. A week before, Jackson had written to Emilie of his fears:

In each interesting country we come to we are hurried through in order to make some other connection. When we get to an interesting city or other place we have barely time to get located and to know what we want to do when we are hurried off. . . . Now my fear is that the Harpers will "kick" on this showing of our work: I am afraid I cannot get the material that will be desireable from their point of view. And if they do protest, we shall be so far away and the news so long in reaching us that it may cause unpleasant complications.[28]

Here again Pangborn was impervious to the desires of his fellows. More discontent resulted when Pangborn announced that each member's daily expense money had been cut to seventy-five cents from the original amount of three dollars. All these factors forced Jackson to realize that his grand dreams for the trip were not to be fulfilled and that the problems he had humorously cited in his letters were in fact the symptoms of his role on the Commission and of the Commission's role as well.

While the individuals were able to patch over their disagreements (Jackson wrote from Calcutta that "the fact is that dissolution was so imminent that Pangborn got scared

and has mended his ways very much"), Jackson never recovered his sense of membership in the Commission. Two weeks after his outburst to Emilie, Jackson wrote bitterly that "I am doing nothing now but to make as many pictures as I can." Now the trip became contingent. From India, Jackson reiterated his position:

I am shaping things to get as much out of the Commission as I possibly can, with the view of being in a position to leave the party should it be advisable, with something to show for the time we have been away. So with this end in view I will stay by the party until we reach Japan.

His toleration of Pangborn's eccentricities hardened ineluctably into disdain, and he himself became more and more isolated. When *Harper's* inevitably wrote that his payments were suspended, at least temporarily, until the magazine received a sufficiency of pictures to justify continuing the column, Jackson wrote plaintively that "there is no one in the party in whom I have the sympathy or confidence that will be of any assistance to me."[29]

One clear benefit came from these conflicts. Whereas, Jackson had previously limited himself to making pictures that would satisfy either *Harper's* or Pangborn, he now began to devise a third set of photographs that might be of some longer-term use to him. His earlier dream of a cache of global pictures that would complete his lifetime's collection of negatives and sustain Emilie and himself in old age now returned, but in a modified form. Instead of hoping for commercial success, Jackson began to talk of, and make, more deeply personal pictures.[30]

With his new sense of purpose, Jackson

began to worry less that his work satisfy *Harper's*. By January, he had settled upon a system: he was making as many pictures as he could, sending them all on to the magazine, figuring that the sheer bulk would impress them and that the pictures they could not use would await him in New York. Meanwhile, he began to photograph what interested him more and more, and what he believed would interest *Harper's* less and less. And he also began to resist Pangborn's demands, rebelling outright in matters of etiquette, dress, and, eventually, photography. Finally, however, he and the Major reached an uneasy compromise: he would make "publicity" and "technical" photographs and in return would be given a measure of freedom. While this was a policy constantly breached by Pangborn, nonetheless it provided the basis for a serious campaign of photography, within the limits of the Commission.[31]

All of this affected his position in relation not only to Pangborn and the Commission but to the surroundings through which they moved as well. As America faded, in memory and in distance, and as the letters from home contained increasingly disturbing news of no money from *Harper's*, dour charity from Emilie's brother Will, problems with son Clarence, and continued slack times in Denver, Jackson found a role for himself as an observer rather than a participant. This represented a new position for him. Alienated from his clients, yet obligated to produce work for them in order to retain enough reputation even to return, the photographer increasingly disconnected himself from the "proper" European tourist's stance.[32]

This shift in attitude corresponded to an important change of geographical location. Late in December, the Commission began a six-month tour of British colonies from Ceylon eastward as the favored guests of the colonizing nation. Bombarded by a polite British form of propaganda, the Commission found itself essentially closed out from any alternative image of the regions through which it passed. For Pangborn, this was fine; he was deeply impressed with the British and went to absurd lengths to impress them. But for Jackson, the problem of identity became more acute. Desiring to separate himself from the Commission, deeply aware of the manipulations of the British in guiding the group through their colonies, he still had little alternative but to go along. Even the possibility of photographing outside the prevailing ideology was extremely difficult for a man whose visual vocabulary was constructed of many of the same conventions and beliefs that underlay the British imperialist position and its visual correlates. Over the next months, Jackson would find ways of expressing his discontent, both in letters and in pictures, but the expressions would, for the most part, be sporadic and incomplete.[33]

His change of heart had its first pictorial test in Ceylon, which the party reached the day after Christmas, 1894. There the Commission remained for nearly two weeks, royally treated by their English hosts and carefully directed around model examples of the success of imperial colonialism. Neither taken in by the British nor yet able to forge some personal alternative, Jackson struggled to produce a complete picture of the Ceylon colony. Notably, the results concerned the interaction of landscape, economics, and so-cial domination. And the sum of his pictures created a composite vision of the region that included not only the English, the natives, the land, and the climate but the effects of modernization and, even, the World's Transportation Commission.

Arriving at the island, Jackson's first reaction was shock at the landscape itself—at its lushness, at its combination of jungle, mountain, and reclaimed land. His second and equally powerful intuition lay with the conflict between the modernizing force of the British colonials and the ageless relationship worked out between the natives and their landscape. This sense of juxtaposition pervaded Jackson's work in Ceylon. It reached its most didactic in pictures like the one *Harper's* entitled (probably from Jackson's notes) "The Two Ways" (illustration 151). Here he composed the frame so as to set the ancient native cart road and the modern British railroad on parallel tracks. The railroad was elevated above the native track, something he exaggerated in the composition when he as easily could have minimized it by shooting from above or along the diagonal; in its smoothness, near-perfect construction, and evident newness, it was the victor over the rough ways of its counterpart. But Jackson gave the alternative its due. He posed native carts at the last curve, where they softened and humanized the roadway. And he aimed the camera so that, while the railroad was relegated to a rather harsh section of landscape, the native road had as its backdrop a lush, lovely valley.

The sense that these represented two ways of life symbolized in two transportation systems is tellingly confirmed in one of the last two pictures the photographer made

THE IMPERIAL FRONTIER

in Ceylon. This view, of "Natives Washing Clothes at Water's Edge" (illustration 152), set the picturesque native activities in the foreground against the long line of the train in the background. Here it was the train that Jackson posed; the natives continue their tasks unabashed by the "English" and his camera. This picture is important because it indicates the complex set of intersections that resulted in Jackson's continual confirmation of a duality between a settled symbiosis of native and landscape, and the new reality of colonial technological modernization. To satisfy the demands of his clients, Jackson was obligated to make such comparisons. Thus the client relationship pressed the photographer toward setting up a dualism. At the same time, Jackson himself was drawn to the more-settled ecosystem of the native relationship to the landscape, for it appealed not only to his own obsessions with land and its occupation but to his interest in the particularity of non-Western cultures— a matter that was bound up in his romanticism. In this, as in all of his views of Ceylon and those of India as well, natives appear in relaxed, natural poses, sympathetically portrayed going about their business, while the British presence most often is represented by its products—railroads, factories, fortresses, and military installations.[34]

Jackson extended his dualism to include the very different land uses in Ceylon, notably opposing the delicate beauty of terraced rice paddies against an entire visual essay on the tea-growing plantations and factories under British control. The rice paddies (illustration 153) presented the photographer with a favorite topic—the beauty of nature civilized and nurtured by human intervention. Jackson countered this image with an equivalent study of the Ardvenu tea plantation made from the mountain (illustration 154). The views are in many ways quite similar. Where they differ is in the obtrusiveness of human domination. The rice paddies have adapted to the contours of the land, and native housing is nestled almost invisibly in background groves of trees. At the Ardvenu plantation the crop rows march relentlessly across the topography, and the combination house and processing plant stands out against the background. Jackson made these views just six negatives and as little as one day apart; the first informed the second, justified its production, and anchored its meaning.

152.
"Natives Washing Clothes at Water's Edge [Colombo, Ceylon]," *1895.* LC

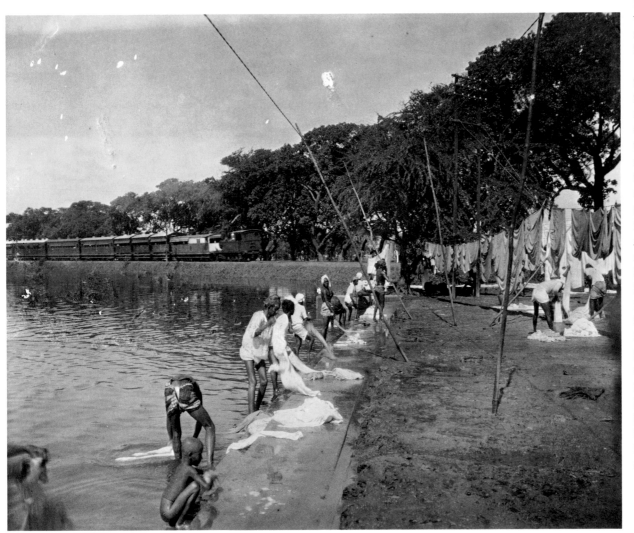

"208. Rice Paddies Near Banderawalla," 1895.
LC

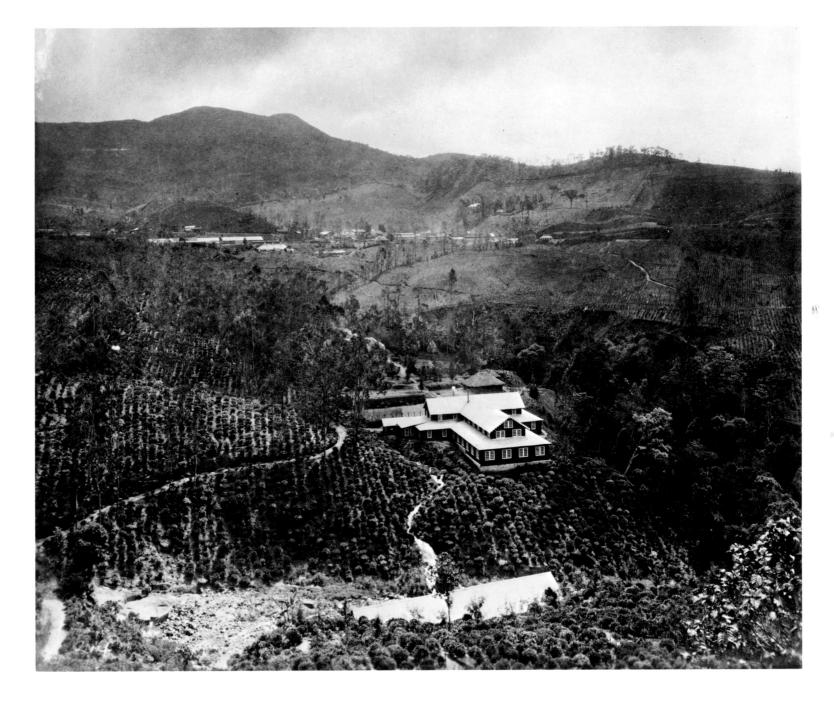

In pointing up how carefully Jackson delineated this dualism, we should not be confused into thinking that his allegiance lay simply or entirely with the native ecology against the colonialist philosophy of exploitation. For Jackson had spent a lifetime celebrating the exploitation of the American West and understood exploitation to be a necessary and inevitable part of the process of civilization. This did not change during his global adventures. Indeed, writing his wife of the Ceylon tea plantation, Jackson may have continued his gentle unmasking of the English colonials but was quick to remind her that their factories turned out clean, palatable tea—tea he sent back to her with directions that she package it up as gifts to his employees at the Denver picture factory.

What distinguished Jackson's Ceylon pictures and shifted them subtly away from the side of the British was his almost inevitable affection for the exotica of the native life. A view of a pair of natives with elephants at a riverside; a photograph at the Maria Watta tea factory where a pith-helmeted, white-suited overseer stiffly posed in the center while a native, dressed in typical garb, worked away in the right foreground; a study of tea-picking in which beautiful, dark-skinned native women stared sultrily at the camera: these revealed and magnified Jackson's romanticism toward the natives. But his affection lay not in the political but in the environmental sphere. His longing was for a hypothetical perfect mean in which civilized humanity and suitably tamed exotic surroundings interacted in an Edenic perfection (illustration 155).

155.
"267. A Bungalow by the Lake, Suburb of Colombo," 1895. LC

Leaving Ceylon and passing on to India, Jackson did not abandon his vision. Rather the new environment provided another aspect under which he could investigate the relationship. In India, however, his interest was directed almost entirely toward the historical relation between native and landscape—and equally important, toward the presence of an exotic, highly sophisticated, native cityscape that reflected an equally developed native civilization.[35]

Architecture and landscape justified the term *cityscape,* but an investigation of native culture posed a formidable set of problems. Jackson spoke none of the Indian dialects and was dependent on hired guides. In ad-

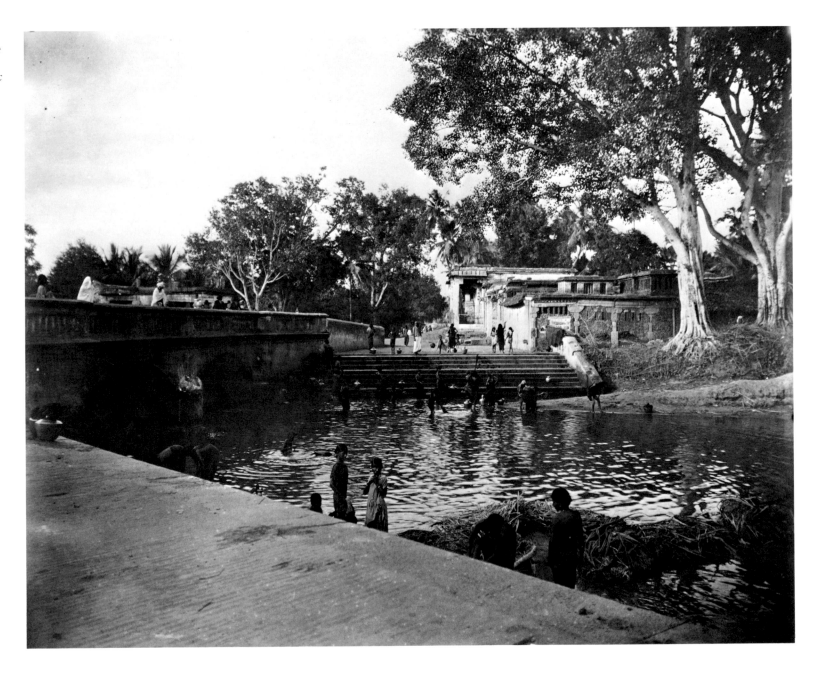

dition, Indians tended to be self-conscious if asked to pose or if too aware of the camera. As a result, Jackson made a number of street views that look stiff and stilted to twentieth-century eyes. And he himself commented on the difficulties in letters and diary entries. But he resolved the issue by working in a way more comfortable to his own habits and preoccupations—by describing the relationship between the natives and their environment, whether natural or cultural. Two views of bathing places—one a bathing tank at Trichinopoly (illustration 156), the other a holy well in Benares, presented the natives not as savages descended from the majestic civilizations of a lost past (as *Harper's Weekly* would argue) but as rightful owners of a realm in which time operated at a nearly infinite slowness compared to the European clock. The photograph of Trichinopoly's bathing tanks also condensed natural, architectural, and human beauty into an organic whole, centered on the barely visible hand gesture of a distant native woman, her dark profile set off against a sunstruck white wall. A picture that demanded large scale, fine printing, and patient examination to yield itself, this could never have succeeded in *Harper's* halftones, though the magazine did its best, reproducing it as a half-page image, the largest of any used during the tenure of the Commission articles.[36]

In India Jackson found himself and the Commission fully immersed in the world of imperialism, as guests and, increasingly, as privileged participants. At Hyderabad, the Commission was treated to a gold-braid tour of the city by

Mr. Gaye, the railroad representative of his Highness . . . upon elephants belonging to the Royal living. . . . We paraded the town to all the curious quarters for an hour or more, and attracted considerable attention. Afterwards, one of the native Mohammedan gentlemen who accompanied us took us all through his private residence, showing us how they lived and pretty much everything but their women. These, of course, no one sees in private except their masters.

Imperialists-for-a-day, the Commission members enjoyed themselves hugely, Jackson included. But his experience was spoiled somewhat by the task of photographing Pangborn on his elephant, after the Major refused to accept the group portrait of the Commission as sufficient. The city itself, Jackson wrote, was a steadily merging collection of three separate elements: "one—Hyderabad—the ancient capital, the next a suburb with many European residents . . . and the last almost entirely European with of course a very large native contingent, and also in the immediate neighborhood a cantonment of some 10,000 English troops." But this was observation, not critique.[37]

Between Bombay and Jammu, Jackson recounted an endless travel through the landscape of British imperialism: ever-repeating state dinners, railroad trips through "a place of but little interest—a flat treeless valley [for example], barracks for troops, and long lines of earthwork fortifications, and then, besides, the station buildings and the cantonment buildings. . . . All the troops here are natives—Sepoys, Ratans, Goorkas—but officered by English men." This combination of armed force, indentured natives, inhos-

pitable land, and exiled, ritualistic colonials increasingly reflected his own position concerning Pangborn and the Commission. At a state dinner in Bombay, Pangborn gave a great harangue to a man he thought to be Lord Harris, the governor, only to find he was mistaken, embarrassing the entire Commission but amusing them as well. By the time they left India, such incidents had become the norm rather than the exception, and Pangborn began to turn his abuse directly on his colleagues, particularly after embarrassing lapses of taste or decorum.[38]

As relations between Pangborn and the Commission grew more hostile, so did the landscape through which they rode. Near the divide between Harna and Quetta, Jackson photographed their fortified train next to a blockhouse that guarded the British station (illustration 157). At Kojack Pass, Jackson wrote coolly of the cause for such precautions—the British had recently built

a tunnel nearly three miles long [through] the actual frontier itself, but the British had violated their agreement with the Amir. . . . Once through it was quickly extended to the bottom of the valley beyond, and enough material at once brought in to carry the line right on to Kandahar, the capital of Baluchistan. The Amir was said to be much displeased.

At the Khyber Pass, Jackson again recorded the uneasy relationship between native and colonizer.[39]

In the atmosphere of increased tension, Jackson found his escape in pictures—pictures of a more Edenic native ecology, and, increasingly, pictures of space. The two images came together in some, like his

view of the junction of the Ganges and Brahmaputra rivers (illustration 158), or remained relentlessly separated, as in his study of "Coolies Transferring Bales of Jute from Boats at Saraghat" (illustration 159). In these two, Jackson presented the natives in alternative postures of escape and imprisonment. The first, an elegiac, romantic image of palm trees and fishermen, set the natives at the edge of land, gazing outward. In the second, it is the photographer and the viewer who are privileged to see the blank, infinite space, while the natives stare back at the camera or continue to carry their improbably large loads upon their heads, to no visible destination.

As it had since 1867, space still signified freedom to Jackson, but entering it became an unresolved problem. In his equivalent Survey views, one looked out at a vast space awaiting occupation, with the Survey explorers as point men and representatives. Here, however—half a globe, a quarter-century, and a vast gulf of personal and cultural change distant—the ease of entrance and redemption had been lost. In its place Jackson seemed to see, again and again, two visions. For the natives, he imagined a symbiotic relationship to the land and its spaces that was, increasingly, threatened by modernization and colonization. But the Westerners, whether colonials or Commission members, traveled at the edge of that vast space of freedom staring straight ahead, unaware of the lessons in their surroundings (illustration 160). This was the case in Ceylon views of the Commission on section cars. It was even more forcefully true of a view Jackson made just a short while before his image of the junction of the Ganges and Brahmaputra rivers. It is "The Choonbatty Loop on the East Bengal Railway in the Himalayas" (see illustration 141), a picture at turns amusing and disconcerting.

In this photograph, the Commission is split among one of its handcars (on which Pangborn and a British agent sit), the rail ahead of the car (where Stevenson—apparently—stands), and the base of the rock pilings, where Street and Winchell pose. Behind Pangborn on the car are two of the natives who have been delegated to push the Commission up and down the Himalayas. At the opposite end of the curve, on a collision course with the Commission's handcar, is "a veritable toy train" (in Jackson's words) car-

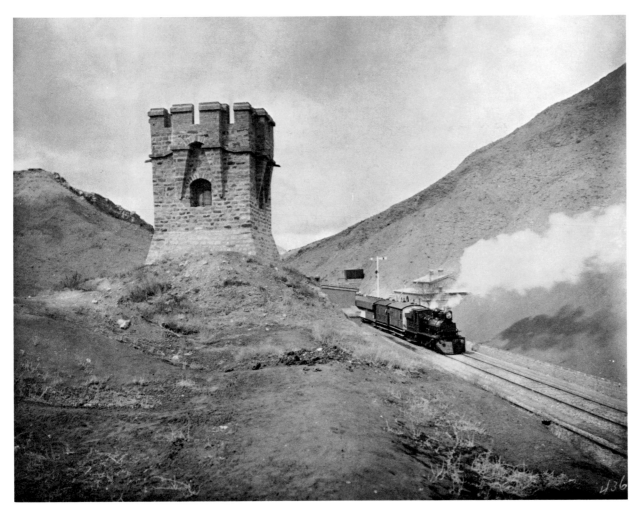

157.
"436. Kach Station and Blockhouse near the Divide between Harna and Quetta," 1895. LC

"579. Junction of the Ganges and Brahmapootra Rivers," 1895. LC

579

THE IMPERIAL FRONTIER

rying freight covered by tarpaulins on open flat cars. To make the picture, Jackson has hiked back about a quarter-mile through the brush to a vantage point behind and above the loop.

From the standpoint expected of pictures, much seems wrong. In the center of the loop stands an impossibly tall tree, its branches leafless and dead. Three other dead trees are behind the Commission car. Beyond the loop is a vast, wild, mountainous region, left mysterious because the haze of altitude and season has obscured it. The Americans pose themselves cockily, unaware of what the camera sees, seemingly uncomprehending of their own unimportance in the vastness surrounding them, a vastness that condenses space and time together.

Here, it seems, the dualism between native and colonialist relations to the land has been resolved. The natives who run the railroad train relax, barely visible, against their masters' tools of domination. The Commission's natives wait patiently for the command to resume their labors. But the Commission presents itself as victor, swaggers, and hence is deflated by the making of the picture.

So, also, the picture breaks the delicate separation Jackson had maintained up to this point, between the Commission and the imperialist landscape through which it rode. Now the railroad, the Commission, and the British representative all are conflated; so, perhaps, is Jackson himself—scaler of hills, wielder of mechanical object, servant, victim, and student of the mentality of imperialism.

T he Choonbatty Loop" is a suggestive picture, redolent with implication. Still it holds out one piece of predictable Jackson optimism: the landscape triumphs. Whether the picture is, finally, simply a publicity shot gone subtly wrong, or an attempt at a more-complex imagining of the relationships among different sorts of power—imperial, native, natural—all this is enacted against a hazy realm that is not a backdrop but, in the end, the subject of the picture itself, and the reason for all the rest.

None of this mattered to the editors of *Harper's Weekly,* who ran the picture, cropped into an odd asymmetry, as part of a mixed text-and-image layout (illustration 161), on October 12, 1895, seven months after Jackson made the picture. In the *Harper's* image, part of a dual spread on Kashmir and the Himalayan Railway, the reproduction was too poor to reveal the infinite, rich landscape behind the loop, and the harsh deadness of the central tree had also been diminished in significance. No reader could see all the figures, let alone guess their poses or facial expressions. And the picture competed with three other views: one of "A Passenger Train at Sookna," a view of a "Hindoo temple," and one of the Commission, Pangborn prominently separate, on the "State Elephants at Jimmoo." No longer text, the picture had become an illustration to text, one among many.[40]

This page spread offers a paradigm for the transformation and control of Jackson's photographs, the damming and diverting of their expanse of meanings into channels of value to *Harper's Weekly* and consistent with its larger "editorial philosophy." First, the picture was cropped. In this case, the excision was relatively minor; at other times, entirely new pictures were constructed from fragments of Jackson's views. This was the case with the photograph of a restored Roman bas-relief at Carthage (see illustration 143), where only the relief itself survived the editor's knife, and the picture was translated from a meditation to an illustration. Here, however, the cropping only served notice of the dispensability of the picture, its subservience to the block of text that seems to write itself across the hazy mountain background.

Of somewhat more import in this case was the presentation in *Harper's* of the picture with the particular set of other illustrations that formed the page. This was vital to the way viewers and readers might understand the individual image; visual context defined the parameters of interpretation. Here the other images presented a general aura of safe factuality. Each of the other three pictures fit neatly into standard photojournalistic genres of 1895—the "scenic," the "factual" or "technical," and the "human interest" categories. And because all three together rendered the Commission as a tame sight-seeing tour, this same overall impression was transferred to the fourth picture, diminishing its complexity and undercutting its other messages. Closely aligned to this is the phenomenon of *aestheticizing* that accompanied the arrangement of pictures into a layout. In this case, the page was constructed to set asymmetry against the boxiness of the magazine format and the photographs themselves. This encouraged the viewer to read the individual pictures as formal elements in an abstract design rather than as vessels of meaningful information.

This abstraction was reinforced by a third quality of the photojournalistic page spread of this era—the interaction between text and

image. Here the text that obtruded onto the image itself, and surrounded two of its sides, formed a "knowledgeable" essay, presumably by Pangborn, concerning the Himalayan Railway. Each statement served to direct the viewer in how to understand the accompanying illustration. Thus when Pangborn wrote, "The journey is perhaps the most wonderful in natural beauty in the world, and as a triumph of engineering it is certainly one of the most remarkable illustrations of what may yet be done in the application of railway transportation to mountaineering districts," the viewer learned to see the photograph as signifying "a triumph of engineering." This was further confirmed in the specific note on the loop: "Our view of the Choonbatty loop on the line may serve to give some idea of the devices of construction which have been resorted to in the execution of the formidable task of mountain climbing." Here the text utterly diminished the potential connotative field of the picture, leaving only a strictly delineated denotative message: the construction difficulties for the railroad were formidable. The only connotations derive from the written text: mechanistic technology has conquered even the Himalayas; colonialist England has deservedly transformed the land to new purposes. Just what those purposes were was spelled out a few lines later: "Two facts stand out with prominence in connection with the working of the line which may be said to prove the wide-reaching value of the experiment . . .; the first is that it has paid the company by yielding a dividend on cost . . . and the other, that . . . no accident has ever happened to a train." By organizing and dominating natural and native disorder, it says,

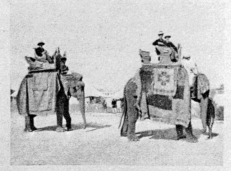

A PASSENGER TRAIN AT SOOKNA.

AROUND THE WORLD

WITH THE
TRANSPORTATION
COMMISSION

OF THE
FIELD COLUMBIAN
MUSEUM

KASHMIR.

OF all the protected Indian states there is none that is more romantic in its natural features, and few that are more interesting for other reasons, than the dominions of the Maharajah of Kashmir. For the most part the country consists of the first slopes of the giant chain of the Himalayan Mountains, with the valleys that mark the courses of the rivers that find their sources in the snow-clad ranges, including the head-waters of the Indus, the Chenab, the Jhelum, the Ravi, and the Sutlej, the five great rivers which water the great plain of upper India, and gave to the Punjab the name of the land of the five rivers. The scenery and climate of Kashmir cannot be surpassed in any part of the world. It is a land of hill and valley, of noble forests, and of rich alluvial flat lands, and behind

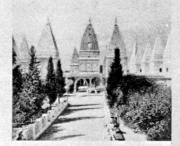

HINDOO TEMPLE AND TOMBS OF THE KINGS FROM INSIDE THE WALLS.

it all the range of the loftiest mountains in the world forms a background of silver wedges that seem to pierce the unchanging blue of the sky with their long line of serrated peaks.

Civilization, in the sense in which men of European race understand the term, is a thing of very recent introduction into the vales of Kashmir, and although the scenery may have lent itself readily to the purposes of poetry, the country itself lay too much out of the path of progress, as indeed it also did out of the highway of invasion, to partake in more than a very limited degree in the peculiar civilization which renders India unique in the records of the world. Until the country was subjected to the overshadowing influence of England it pursued as far as possible a policy of exclusion, and its people were a comparatively simple and pastoral race, having but few arts or manufactures of their own. During the last thirty years this has been greatly changed, and the introduction of railroads is working a complete alteration in the condition of the people. Unlike the natives of lower India, the people of the province are vigorous and robust, and, enjoying such a climate as they do, there would seem to be good reason to expect that they may yet become one of the most prosperous races in the empire.

There are no really great cities in Kashmir, and comparatively few of the great architectural monuments which, while they speak of a high development of art and of a kind of civilization, speak even more plainly of a state of oppression and tyranny which armed the rulers of the country with the power and wealth necessary for executing those vast works. Jummoo, the winter capital of the Maharajah, is situated on the river Tawi, a tributary of the Chenab, and contains some very interesting buildings, and among these the great temple with the tombs of the kings, as shown in our illustration, presents a general appearance quite unlike that of the ordinary architecture of Hindoo temples. The city, however, has little to recommend it except the beauty of its site, and as seen from the railway station, which is on the opposite side of the Tawi, the general effect of the town embowered in trees is very beautiful.

While Kashmir is by no means one of the most populous of the protected native states, and the country indeed is less densely peopled than most of the others, its position is one which has made it of such importance to the safety of British India that it should be friendly beyond the possibility of doubt. The great pass from Afghanistan into India is not, indeed, directly menaced by any possible disaffection of Kashmir, but passes from the Pamirs open through the Himalayan range into the principality at two different points. It is true that both are extremely difficult, and the approach to them on the side of the great Pamir plateau is one which hardly any army could face, yet in the defence of the Indian Empire it is evident that England has determined to leave nothing to chance. The cordial co-operation of the people of Kashmir would render any invasion from the Pamir plateau an impossibility and therefore the Indian government lays itself out to secure cordial feeling.

The recent visit of the Lieutenant-Governor of the Punjab, Sir Denis Fitzpatrick, to the Maharajah was one of those official events which in a country like India go far to cement the bonds of friendship, and to all appearance it seemed likely to be a success. We took a picture of the Lieutenant-Governor and the chief members of his staff, which shows them mounted on state elephants on the occasion of their visit, and we had a good opportunity of seeing Kashmir in high festivity at the time. There is much that is impressive in these ceremonial visits, and it is easy to see how greatly English power in India has been owing to the genius of her representatives in diplomacy. What the sword has gained these men have secured to a great extent by the power they have shown of accommodating themselves to the habits and customs of the people they have studied so long and apparently so successfully.

STATE ELEPHANTS AT JUMMOO.

THE HIMALAYAN RAILWAY.

One of the most interesting experiments in railway construction which even India can show is the railway to Darjeeling, on the slopes of the Himalayas. The problem which its projectors undertook to solve was how to construct a railway for purposes both of goods and passenger traffic which should rise to a perpendicular height of more than 7000 feet in a distance of about forty-five miles. The distance, indeed, as the crow flies, is only some sixteen miles to Darjeeling, but by winding out and in among the slopes an entire length of nearly fifty has been obtained, so as to diminish the grades. At first it was the fashion to call it a toy railway, and the company which obtained the government's guarantee to enable the capital to be raised was supposed to have owed their success to large influence rather than to a bona fide prospect of performing a work of real public utility. The results have shown that the government was better advised than its critics, for not only has the line been successfully carried out, but it has done wonders in the development of a valuable tea district, and has actually returned last year a revenue to the government treasury of India amounting to twenty thousand pounds sterling, or a hundred thousand dollars. The advantage to the treasury arises from the conditions of the concession, which, as in all cases of guarantee by the treasury of a minimum dividend, provides for the payment of one half the surplus into the treasury as government revenue. The methods by which difficulties which might well have seemed insurmountable were overcome form a

most instructive page in the history of railway construction. Our picture of a passenger train at Sookna shows the peculiar construction of the rolling-stock to adapt it to the new requirements of the situation. It will be noticed that the centre of gravity of engines and cars alike is placed as low as possible, giving a singularly dwarfed appearance to the whole arrangement. This was largely rendered necessary by the fact that the gauge of the line could only be made two feet, while curves not exceeding a sixty-foot radius are by no means exceptional. In spite of its narrow gauge and dwarf engines and cars, the line is in all respects a model of construction. The rails are substantial, weighing forty-five pounds to the yard, and everything else is in proportion. The difficulties of the undertaking can be estimated when it is remembered that the average grade for the whole distance of forty-five miles is about one in thirty-three, while there are many parts of the line at which a grade of one in twenty prevails.

The journey is perhaps the most wonderful in natural beauty in the world, and as a triumph of engineering it is certainly one of the most remarkable illustrations of what may yet be done in the application of railway transporta-

tion to mountainous districts. With such a gradient it is, of course, impossible that a high rate of speed can be attained with even a hope of safety. The speed actually in use at present on the line is ten miles an hour on the ascending, while that on the descending trip is limited to eight miles. Our view of the Choonbatty loop on the line may serve to give some idea of the devices of construction which have been resorted to in the execution of the formidable task of mountain-climbing. Two facts stand out with prominence in connection with the working of the line which may be said to prove the wide-reaching value of the experiment of the Darjeeling-Himalaya Railroad: the first is that it has paid the company by yielding a dividend on cost at the rate of 10 per cent. per annum, besides leaving a large government surplus; and the other, that since it was opened no accident has ever happened to a train, and not a single passenger has ever received an injury. It is almost certain that the system so successfully employed in this case will be employed in others of the hill districts of India, and the world's transport by means of railways may benefit almost indefinitely by the experience which will thus be gained.

THE CHOONBATTY LOOP.

Photograph by W. H. Jackson.

161.

Harper's Weekly *page layout, October 12, 1895.*

241

the British colonials have brought financial profit to themselves, increased development to the area, and reduced danger to the operators.

The argument was circular. Without the railway, there would have been no danger of trains being wrecked; without a British corporation to exploit the land and require a railroad, there would have been no balance sheet upon which the railroad might post a profit or loss. Hidden in the text was the assumption that colonialist domination was inevitable, necessary, and beneficial; from that, all else devolved. And since this assumption was at odds with Jackson's experience in the region (a central influence on his system of thinking when he made the photograph), the written essay reoriented the meaning of the picture from one sphere to another.[41]

One more element of the *Harper's* layout affected the photograph's final message to its late-nineteenth-century American audience—the hidden process of editing that resulted in this and only this set of pictures standing for the entire experience of Kashmir and the Himalayas. For we must remember that *Harper's Weekly* editor Payne selected these photographs together only after looking at a much larger selection of negatives Jackson had sent, along with accompanying texts, for potential publication. Payne and his fellow editors were able, in this as in so many cases, to choose from a vast range of possible stories to which the pictures might serve as illustrations.

All of these elements together gave *Harper's* editors the freedom to make Jackson's pictures convey nearly any message they wished, within the broad field of global politics, imperialism, and the questions inevitably raised by the Commission's itinerary. Jackson made his pictures with a broad understanding of what *Harper's* wanted: conventional images of global subjects, with the aggrandizement of modernization as a prime theme. Beyond that, he was "free" to do as he wished. But he was free precisely because the editors of *Harper's* could alter his images to fit their purposes—and they did.[42]

Jackson and *Harper's* diverged at the most basic of positions concerning the meaning of the photographer's own experience with the Commission. Central to Jackson's perception of the global landscape was his vision of a dualism between Western civilization and a native ecology that was age-old, delicately balanced, and about to be eradicated by the forces of modernization and colonialism. For reasons drawn directly from his own history, especially his vestigial Romanticism, reinforced by his own troubled position in the American economy, Jackson found himself inevitably drawn to this native ecology. Like so many others, he yearned for a return to a lost Eden, and he found traces of this mythic region nearly everywhere he looked. *Harper's Weekly* fit this polarization into a larger myth about the continuum of human progress, based on Spencerian notions of human social evolution, justified by a doctrine of inevitability, and shared by the principal powers of American culture at century's end—popular publications, elected officials, business leaders, even organized farmers. In fact, Jackson's pictures became part of a concerted campaign to reinvigorate the belief in a global American mission—a process that required the deletion or transformation of Jackson's expendable nostalgia and Romanticism.[43]

Harper's chose to run "Around the World With the World's Transportation Commission" at a delicate moment in the history of American internationalism. Before the mid-eighties, American military might had been minimal. With nothing to protect and no foreign expansionism to oversee, this was natural. But the last years of that decade saw a significant shift in American sentiment. Alfred T. Mahan's widely read defenses of navalism, first published at this time, took up the earlier call of Admiral Perry and the American Geographical Society, arguing the inevitability of American attention to the international sphere, both because of the nature of world politics and as a result of America's newly awakened economic self-interest. The commissioning of the *Maine* and the *Texas* in 1886, then the appearance in the nineties of the *Indiana,* the *Massachusetts,* and the *Oregon,* signaled the arrival of a modern American navy devoted to Mahan's theory of "mercantile imperialism"—a combination of overseas bases, an expansionist merchant marine, and a protective navy, all devoted to enlarging American markets abroad.[44]

The tremendous surge of European imperialist activity throughout the globe in the nineties had a mixed effect in America. While it fostered a conservative protectionism of the Americas, it brought as well new dreams for American producers—not just large manufacturing and industrial corporations, but farmers too. Stagnant economic times after the panic of 1893 increased this

sentiment, which was fanned as well by the rise of a significant and vocal group of American politicians derisively called "jingoes." These figures, many of them in Congress, seemed to call at every opportunity for war against European usurpers at the same time that they urged an increasingly aggressive imperialist foreign policy on the United States. While the noisiest of jingoes represented a near-fanatical minority, by the mid-nineties a significant population of influential Americans had come to believe in the necessity, and the inevitability, of American imperialism.

In the spectrum of American sentiment concerning this prospect, *Harper's Weekly* was relatively conservative. Opposing the jingoes, *Harper's* called it "folly" to enter into "the very storm-center of Old-World politics" by intervening in colonial disputes. For *Harper's*, the Monroe Doctrine represented the key to eventual economic domination of the hemisphere, and trade and economics represented the key to American engagement in the larger sphere of globalism.[45]

Yet *Harper's'* vocal opposition to adventurism masked its underlying acceptance of the "reality" of American membership in the league of imperialist nations. An essay entitled "The Cost of Empire" in May of 1896 consisted of a cleverly structured economic argument against unthinking expansionism, concluding that the defending of colonies cost Europe $433,000,000 a year. But the opening paragraph set the tone: "Are we now to witness the rise and establishment of empires? This would seem to be the logical progression of events." The twentieth century was the century of empires, said the au-

thor, as the nineteenth was the century of nationalities, and the eighteenth the era of "the Universal Brotherhood of Man." While America might control its expansion and determine its policies wisely, expansion was inevitable. And as the nineties progressed, the magazine had increasingly devoted its pages to studies of "situations"—international conflicts in which America might have an interest. By the end of 1895, there seemed no portion of the globe Americans might freely ignore.[46]

The sense that business interests, applied to the global sphere, would result in universal progress—a linchpin of imperialist sentiment—was also inherent to the ideology of *Harper's*. An 1895 article on Liberia was supposedly a sort of travelogue, but it ended on a different note:

Owing to the lack of push and energy, the fertile ground produced little . . . [but] during the past year, two white men from New York have made Liberia an experimental station. . . . If their investigations prove satisfactory, companies will be formed, roads built, beasts of burden introduced, and a commerce attempted. Until some such energetic push comes from without, Liberia will sleep on.

American business would generate the forces for modernization; modernization would awaken the primitive nation. The result was inevitable, the benefits to both parties so self-evident as to remain unspoken.[47]

Harper's was thus in a central position in the debate surrounding the new American expansionism. As a weekly journal centered in New York City, as a relatively conservative "journal of civilization" aimed at a middle-

and upper-class audience, it found itself immersed in foreign policy issues and in need of material to satisfy an audience increasingly focused on the globe as a sphere of imperialism and a place of potential American involvement, good or bad.

And the *Harper's* role was, finally, to minister to its audience, an audience already suffering the diseases of modernity and reeling under the added responsibility of potential and, increasingly, actual international commitments. A glance at the advertising that supported *Harper's* is revealing of its audience's predilections; typewriters, soap, painkillers, laxatives, pepsin gum and Pabst malt extract (both aids to digestion, the latter offering "perfect health, strength, and beauty") cold medications, eye drops, deafness cures, asthma cures, sticking plaster, shoes, upholstery, baking powder, fishing tackle, and bicycles constituted the products sold in that first Commission issue in February of 1895. To this troubled, neurasthenic, rest-seeking, health-seeking American populace, *Harper's* offered the solace of a predigested international position, one that promoted neither adventurism nor "cowardly" isolationism.[48]

Into this context, the Commission series appeared in late February of 1895. Filling three pages of a twenty-four-page issue, the combination of pictures and text was located in the second half of the magazine, at the head of the portion devoted to international news and articles. This first article incorporated two pages of illustrations, including a watercolor by Winchell of a horse-racing event in Tunis. The text, lengthier than most would be, included a segment devoted to

Tunis, the first stop from which Jackson had sent pictures. First, however, there was a detailed explanation of the Commission and the series itself:

A history of railway development means the history to a large extent of the material advancement of the past fifty years in the intercommunications of nations. It means the development of wealth, the free communication of thought, and that interchange of commodities without which any high degree of civilization cannot long continue among any race of men.

A department of the world's transportation, to be perfect, must represent the past as well as the present . . . it must be possible to see as far as possible how ideas have been developed and modified by the circumstances of climate and population in different parts of the world.[49]

These opening sentences began the series by compressing time and space, setting geographical and cultural difference on a scale of evolutionary progress. Seeking to delineate human progress in the form of transportation technology, the Commission would search for cultures at all stages, from most primitive to most modern (the quest would end in Europe), finding in them evidence of the causes of human evolution and explanations for its variable character.

In that first batch of work Jackson sent from Tunis, *Harper's* found a wealth of material upon which to base its conclusions:

There is no country where the process of building a new civilization upon an intermediate barbarism, itself founded upon the ruins of an ancient civilization, is so markedly apparent as it is along the African shore of the Mediterranean. Other countries are today emerging from bar-

barism and assuming the garb of nineteenth century civilization, as in the case of Japan, with greater or less success, but it is here chiefly that the relics of the older civilization come well into view beside the prevailing barbarism and the newly reclaimed recivilization. . . . In few places is this more evident than in the dominions which the Bey of Tunis professes to govern under the overshadowing influence of France to-day.

This message, of progress in which European imperialism enabled a recivilizing of ancient lands, was to be repeated again and again—in the first article, in succeeding essays, in the choice, cropping, and layout of the pictures, and in the location of each article in relation to others in the issue. The caption accompanying a view of a Tunisian guard on horseback told readers that the "primitive-looking warrior in our illustration . . . represents in a forlorn caricature the troops of Masinissa." Discussing the elaborate decorations in Moroccan architecture, the anonymous *Harper's* writer reminded readers that this was "an art which . . . does not greatly flourish, in Morocco"—due to "the absence of the wealth, which can only exist to any considerable extent in connection with commerce and ready communication between nations." An article on Egypt a week later began, "From the Algerian provinces of France, where the new civilization is in such visible contrast to the mediaeval barbarism overlying the older civilization of Rome and Phoenicia, the Commission proceeded . . . to Egypt."[50]

There too, of course, its American members encountered this same tripartite division: ancient civilization, "intermediate barbarism," and "recivilization" through Eu-

ropean colonialism. These "facts" made sense to nineteenth-century readers, because they were based upon a recent variation on an older model of progress, one that had influenced Jackson's pictorial sources, like Frith, Du Camp, and the American Greene. Many European Romantics of an earlier generation had viewed progress as part of an enclosed cycle that might bring England or France to the top now but would render all civilizations the prisoners and victims of time. The imperialism of the late nineteenth century redefined this concept of cyclical progress. Believing human social organization to be progressive and evolutionary, Europeans and Americans increasingly sought explanations for the failure of older civilizations. Often, they found their answers in the failings of the populace in familiar areas: morality, religiousness, and commitment to the work ethic. These conceptions simultaneously justified a doctrine of the inferiority of natives as they presented an uplifting, reeducating role for colonizing nations. Objects like trains, brought to the colonial frontier, became simultaneously mechanisms for domination, modes of economic exploitation, examples of racial superiority, and sources for native education.

This became the central message of "Around the World with the World's Transportation Commission," and it depended on the pictures to reinforce its textual message, just as it provided the instructions in how to interpret, to understand the pictures. The first article, on Tunis, ended with the equivalent of a photographic caption: "Our view of the Bay of Tunis [a two-plate panorama of virtually no ideological content whatso-

ever] . . . completes the picture of the dead past, and only a little less dead present, of civilization on the shore of Tunis." The connection of "view" and "picture," and their application to two quite different referents, is significant; thereby, *Harper's* tied the photograph to a complex ideological argument masquerading as "fact." So instructed, what *Harper's* viewer would not find in the photograph the evidences asserted to be there?[51]

This first layout, too, served to organize the reader's responses to the photograph. The inclusion of Winchell's illustration, with its fashionably painterly style, emphasized the factuality of the photographs. The choice of three of Jackson's "technical" photographs, and their placement in a row directly above the beginning of the essay, also served this purpose. And the cropping of all the images to eliminate extraneous materials—that is, materials that offered a more complex interpretive field—completed the process of limiting and directing the photograph to its subsidiary role as disengaged proof of the assertions found in the text.

These layouts both drew their meaning from and contributed to the broadest messages contained in each issue as a whole. Several elements combined to produce this interactive synergism: not only the structure of the magazine—unfailingly, reassuringly, fixed—but the editorial position, the style itself, and even the carefully controlled sequencing of articles. On May 9, 1896, after a six-week break in the series, *Harper's* ran "Siam and Penang." Directly preceding that Commission spread, on the adjoining pages, it ran two other articles—one was

Worthington Fort's "The Cost of Empire"; the other was a pictorial on the commissioning of the new American warship, the *U.S.S. Massachusetts* (illustration 162). On July 24, 1897, a similar combination appeared: this time it was a Commission article on Korea (recently the spoils of a three-way battle between the empires of Japan, China, and Russia, and the cause of China's dismemberment by the European imperialist community) that ran opposite another pictorial on the *Massachusetts*.[52]

Harper's Weekly had other full-page picture spreads on international topics; in fact, many of them now look identical to those of the World's Transportation Commission, reaffirming the power of cropping, layout, and editorial choice over the idiosyncrasies of photographer or even subject. A spread entitled "Along the Dalmation Coast" ran concurrently with a Commission article on Algiers; even a close analysis of the individual pictures leaves it difficult to determine that the images are not Jackson's. Not only message but style as well had been appropriated by the power of the journal. With all of this divested of him, Jackson himself became a sort of ghost, a byline that contributed to the homogeneous production constituting *Harper's* but without the power to explode the formulae that determined, ordered, and limited the meaning and effect of his pictures.[53]

The result of this, to our more omniscient view, was to create a strange sort of dualism. As public figure—the figure on which his career was based, on which it would seem his entire personality depended—Jackson had rather completely disappeared. At the same

time, as personal figure, as voice rather than image, Jackson had reappeared, or perhaps emerged clearly for the first time: vulnerable, desperately lonely, tender, and even erotic in his messages to his wife; bitter, humorous, and keenly observant as private diarist.[54]

By the time the Asian tour was done, however, this side of Jackson resubmerged. The reversion resulted in part from a change in the Commission's makeup. Rumored for months, Street's acrimonious departure in Japan represented a peak of discontent and anger, for his conflicts with Pangborn had been the most horrific—Pangborn had apparently been embezzling Street's salary while telling him the money was going to the engineer's wife, who was nearly starving in Germany. Street's departure put the period on Jackson's own debates about throwing up the trip and returning to the States, forcing him to accept his commitment to the remaining months.[55]

The fact that the Commission's journey was more than half done (no one believed in the fabled second leg), that one could count the remaining months rather than years in letters home, had an equal effect. Now Jackson began to think ahead to his reentry into the public arenas of American photography in general and Denver in particular. His personal letters began to focus on plans for the future: how to exploit the Commission pictures in his own business, and whether to return to Denver or move to the East. Unsettling messages from Crosby and Rhoads had some effect on this rumination; Jackson had written them of his contemplated return from Japan and his notion of traveling from California di-

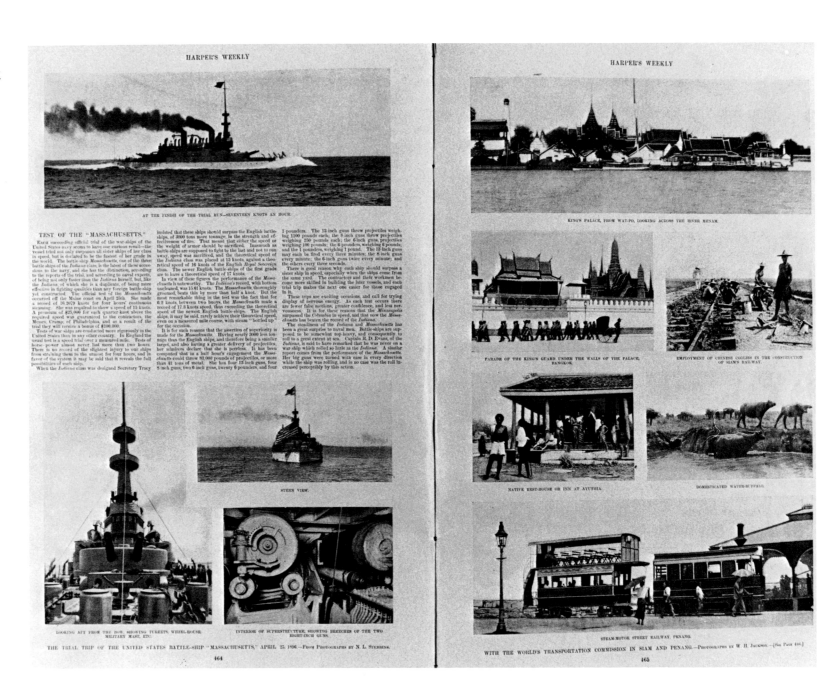

rectly to Denver to reassume the reins of the W. H. Jackson Photograph and Publishing Company. Earlier, Jackson reported that Rhoads had written that "it will not do for me to be too long away from the Denver business." By August, however, Jackson reported to Emilie that "Crosby and Rhoads both write that the business there cannot support both Rhoads and myself, and with the inference that R. is indispensible; they advise me to stay away as long as possible." But these dour pronouncements no longer plunged Jackson into depression, as they had for so many months. Instead, he schemed to gain employment with *Harper's* for a few months, organizing and copying the negatives, so he might scout out the possibilities on the East Coast and wait for better times out West. In all of this, the old Jackson—optimistic, unselfconscious, a man of business—resurfaced.[56]

Jackson's return to the public persona of W. H. Jackson, American landscape photographer, seems to have affected the photographs themselves. In New Zealand, Jackson made a tour of the Whakarewarewa Geysers, which he understood entirely from his previous Western experience (illustration 163): "At times I could hardly imagine that instead of the Yellowstone I was at almost exactly its antipodes . . . [though] none of it can begin to compare with the Yellowstone." Jackson's response to the natives became a reiteration of the racism of the Survey years and before. Now the Maori tribe took on the character of the Utes: "The majority of them are a shiftless, good-for-nothing but very amiable and good-natured people."[57]

Jackson's shift of allegiance from the physical landscape and its native peoples to the

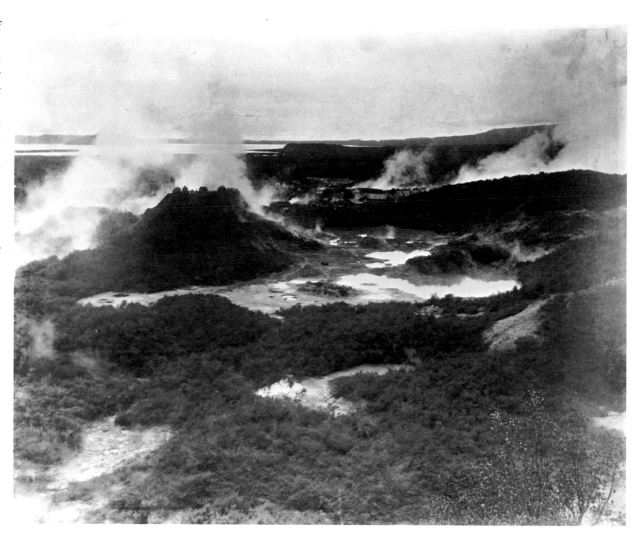

163.
"Whakarewarewa Geysers on the Waikete Geyser Crater at Hot Springs [New Zealand]," 1895. LC

abstract construct he had endorsed in America affected his behavior markedly:

None of the principal geysers were playing at the time of our visit, so we coaxed one to give us an eruption by throwing into its mouth a large quantity of soap. After filling the mouth of the crater with two or three pounds of common bar soap, a column of water shot up into the air nearly a hundred feet in height.

This understanding of the natural landscape as a product in service to the entertainment of the civilized was reflected in the pho-

"726. Bella, a Maori Guide, Sitting at Edge of . . . Geyser," 1895. LC

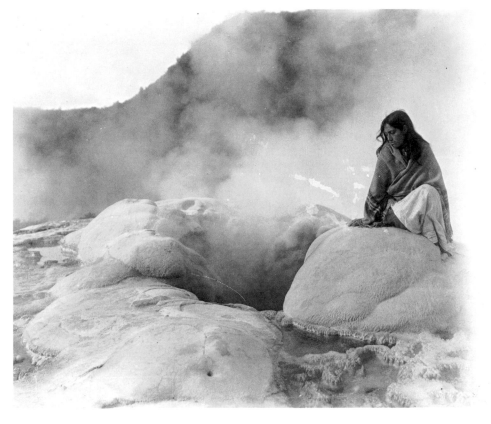

techniques from his two American competitors, the snapshot amateurs and the "artistes" of Stieglitz's crowd. A "Street View" in Hong Kong (illustration 165) had some of the inadvertence and surprise of the best amateur-made "snap-shots" of the era. His view of a railyard in New Zealand bore a strong resemblance to similar photographs by Stieglitz, in which the urban–industrial environment was salvaged by a sheath of impressionistic air and light effects.

Still, anomalies and disruptions of the public photography reappeared sporadically. Possibly the trip's last major work concerning the intersection between civilization and landscape occurred in China. There Jackson made a view of the Wu-Men gateway to Peking, the fortification wall in front of it, and the desolate plain that ran outside the city (illustration 166). Like the view of Choonbatty Loop, this was a photograph that could not possibly succeed as a halftone in *Harper's Weekly;* in this case the magazine didn't attempt to use it. Even with modern reproduction, it remains difficult to reclaim the elements of the photograph, precisely because it is a picture about vast scale, in which the details that delineate the massiveness of the gatehouse and wall, the expansiveness of space, and the insignificance of man are so small as to be nearly invisible. In particular the people, carts, and horses that shrink into the distance along the road, seemingly meant to stand for the individual citizen in this ageless and giant civilization, can only be seen by close scrutiny at an extremely short viewing distance. At the same time, however, the live ducks or cranes in the waterway below are indistinct enough

tographs, where both nature and native were forced into subservience to clichéd poses of picturesqueness. A view of "Bella," a Maori guide, seated at the edge of the geyser (illustration 164) exemplified this treatment. Jackson had commented in his letter to Emilie that the Maori were "always delegating the youngest and best looking women of the village" to guide Westerners. But his perceptiveness did not prevent him from exploiting Bella's youth and prettiness to make a picture any American would recognize im-

mediately as the stuff of which Hiawatha and countless other chromo myths had, long ago, been constructed.[58]

In fact, this picture, and others from New Zealand onward, marked Jackson's return to a photography of public and popular signs, a photography of communication to his old audience of interested middle-class viewers. In the process, however, Jackson experimented with adding new elements to his visual vocabulary; particularly, he attempted with some success to appropriate

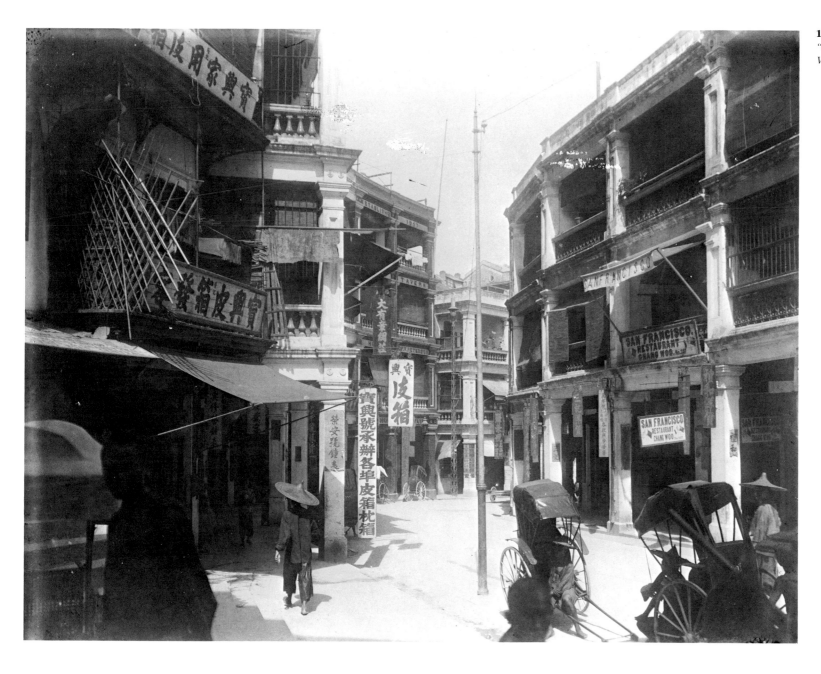

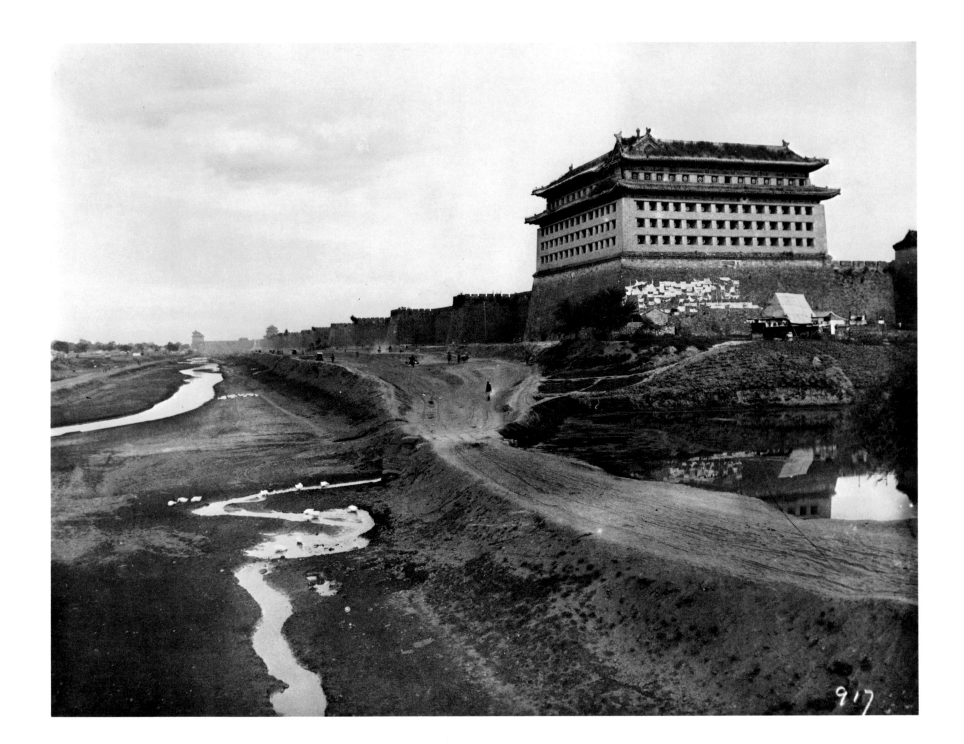

that it becomes nearly impossible to tell if they are boats in a river or pieces of flotsam in a drainage ditch. The result is a picture where certainty of distance is sacrificed in order to generate an even more powerful sense of scale—one that includes referents not only to space but to time and progress as well.

This was just one of a number of pictures Jackson made of the gateway. All of them suggest this same attempt to set two sorts of scale against each other. In street views of the areas just in front of and outside the gate, Jackson contrasted the contingent momentariness of human activity in the present against the monumental permanence of the gateway and all it symbolized. The panoramic view of the gate, however, was the most dramatic as a photograph, if the least successful as an object to be reproduced. Jackson's choice of the long diagonal and the elevated angle of view both worked to eliminate traces of the picturesque and the expected from the frame, elements that served important purposes in his other street views. Here even the gateway itself becomes an ambiguous object when viewed closely; its roofline is of the expected Chinese type, but its windows all seem to be filled with round objects that may be decorations, may be large gongs, or may even be the mouths of cannons. In front of the building is a strange temporary structure, and its existence substitutes for the activity of the street in signifying the present, even while avoiding the trap of picturesqueness.

This picture may well have been made with the lantern-slide audience of an illustrated lecture in mind; Jackson was contemplating that route as a method of capitalizing on the trip, and the larger image size of such projections may have promised him a solution to problems otherwise insurmountable in reproduction. In any case, this was one of the pictures most clearly made without *Harper's* in mind, most clearly a turning away from the arena of reproduction and back to the older conception of production. In fact virtually all the pictures in which space and scale returned as issues belong in a separate category from the photographs that preceded and even surrounded them. Whereas Jackson's pictures of natives, imperialists, and their cultures for the most part retained the specificity of their subjects, these seem to have dissolved that quality into a more diffuse and general meditation.

This dualism between specific, scenic, and informative views and more general or philosophical photographs is clearly evident in the last work Jackson did for the Commission, in Siberia and Russia. The factual views seem relentlessly factual—as if Jackson had excised all references to larger matters. Often they are blatantly travelogue photographs. Jackson made photographs like these by the dozens in Siberia and throughout Russia—and *Harper's* published them in a series of articles. They were, in fact, perfect material for the magazine's discussions of Russian modernization.

The same applied to a set of pictures Jackson made of the convict-labor camps for building the Trans-Siberian Railroad. These camps were notorious, and Jackson knew it; he recognized their newsworthiness and pressured his Siberian friend Schimkevich, an army officer, amateur photographer, and sometime anthropologist, into taking him twice to the camps. Jackson was impressed by their orderliness, lack of cruelty, and attention to the necessity of physically sustaining the workers. The photographs were apparently the first views of these camps made available to the West, but they were nonetheless relentlessly conventional as pictures. Jackson showed the convicts lined up in front of their quarters; he borrowed flash powder from Schimkevich to make a view of the interior of one of their dugout houses; and he photographed the crews at work. Indeed, he even made a few portraits of convicts. But all of these retained a careful flatness of effect, as if to emphasize their factualness.

Against these, we must counter another series of views made less than a week after the second convict camp trip. This set concerned a sort of obverse of the prison camps—a trip to an aboriginal village of the Goldi tribe, which was encountering its first real pressure from Western forces with the nearby construction of the Railroad. The trip was the result of an offer by Schimkevich, who had made a number of excursions to the village in the past, in his role as anthropologist.

The two men went by a horse sledge along the Amur River ice; the experience was similar to their earlier trip to the convict camp, where Jackson reported, "It was a . . . cold, hazy and smoky day. Forest and prairie fires all over the country made the air so thick we could see but a short distance." The Goldi village of Scepcheede was small:

Five or six mud houses thatched with straw, with a few scattered out-houses. . . . Schimkevich is preparing a work of some kind on these people and his purpose now in addition to doing some photographing was to get some detailed accounts

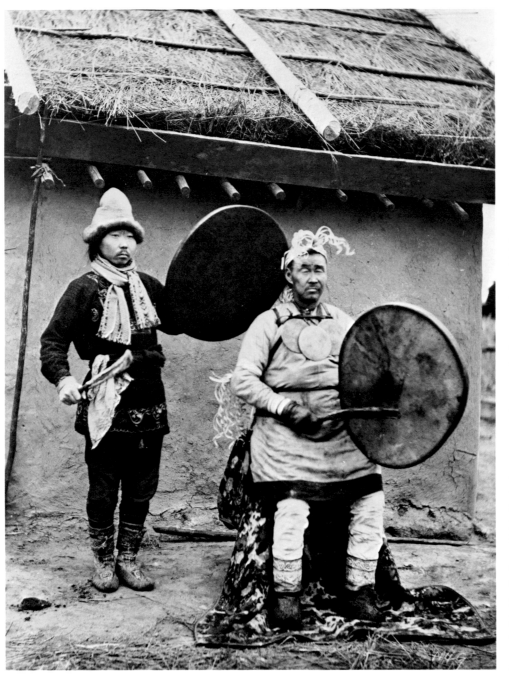

of their manners, customs, and legends. . . . They are the aborigines of this country as the Indian tribes are of America. I thought I could see a great resemblance between them and the Pueblo tribes of the Southwest in the States.[59]

Jackson's description is a curious one. On the surface, it seems primarily to describe the sort of imperialist ethnography that characterized much of the anthropological work of the late nineteenth century (illustrations 167, 168, 169, and 170). Schimkevich "plied the people . . . with a long string of interrogations"; the shamans were "a class of imposters"; the dance "was a ludicrous affair"; the two men returned "well pleased with our outing." And many of the pictures retain that sense of ethnographic style—they are "records" of "typical" acts, in which the individuals look evidently stiff and artificial (illustration 167). Others used a more distant vantage point to contain within the frame a number of disparate details of Goldi life—including housing, costume, and even diet (by the addition of frozen fish "casually" leaning against a fence). All are evidently meant to fit within the broad category of "evidence"—they are not quite those "technical" photographs of transportation Jackson had to do for the Commission, yet they are also not attempts to apply the photographer's American landscape style to this circumstance.

Still, these pictures contain one element that seems purposely included time and time again—the element of space, the surrounding envelope of the environment that powerfully redefines the Goldi existence. Again and again, Jackson posed his figures in order that the frame include the blank, flat prairie reaches of Siberia behind the

people (illustration 168). This was the case even when such a framing specifically confused the relationship between foreground and background, complicating the picture and harming its clarity for *Harper's* reproduction. In some cases, Jackson and Schimkevich even brought their subjects back out onto the banks of the Amur River or posed them on the ice itself; in neither case was this necessary for technical reasons or "correct" from anthropological standards, which would have dictated that the figures be located where their activities might take place. Hence a view of a "Goldi or Giliak Hunter on the Amur River" (illustration 169), and another of a "Goldi Shaman North of Khabarovsk" (illustration 170) may be seen as made in order to describe the relationship between the Goldi tribe and its peculiar surrounding environment. In each of these photographs, this conjoining has powerful effects. The first sets the everyday life of the Goldi—their hunting—against the backdrop (here presented literally as such) of climate and topography. The two most powerful signs of these are the wavelets in the ice, suggesting a brutal cold and nearly instantaneous freezing, and the placement of the horizon line almost exactly at the hunter's eye level. The relative separation of subject and photographer, the amount of sky included, even the careful control of focus effects all contribute further to this sense.

Many of these qualities appear as well in Jackson's view of the shaman. Here the artificiality of the placement is most evident; we know from Jackson's diaries and letters that the proper locale for the medicine man was in the settlement itself, where he could heal the sick and bring blessings on the tribe. Yet

here Jackson has set him by the river's edge and, as important, posed him off center in the frame, his long shadow reaching out to touch the border of land and ice. In addition, the pose enabled Jackson to include his own shadow prominently as a sort of balance to the eccentricity of the shaman's

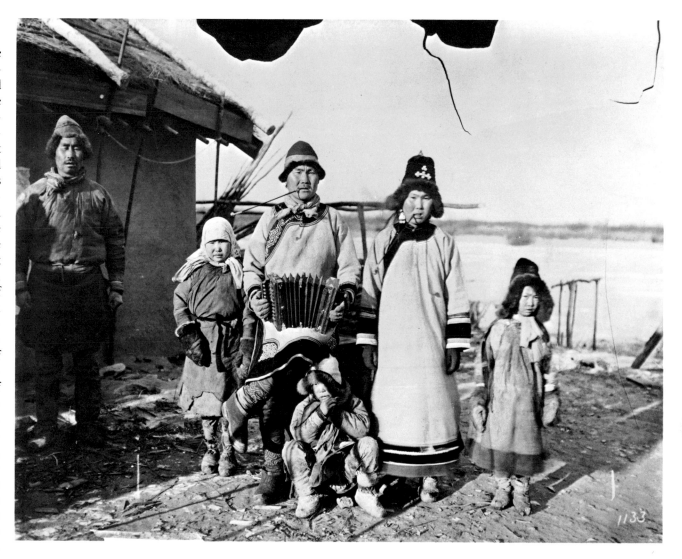

location in the frame. A deliberate, desired element of the picture, it returns us to one of Jackson's earliest Indian views, his study of the Omaha chief, Gi-He-Ga. The shadow in that view, and this one as well, offers two conflicting interpretations among a number of possible meanings: as a counter between

168.
"1133. Goldi Along the Amur River," 1896. LC

169.
"1140. Goldi or Giliak Hunter on the Amur River," 1896. LC

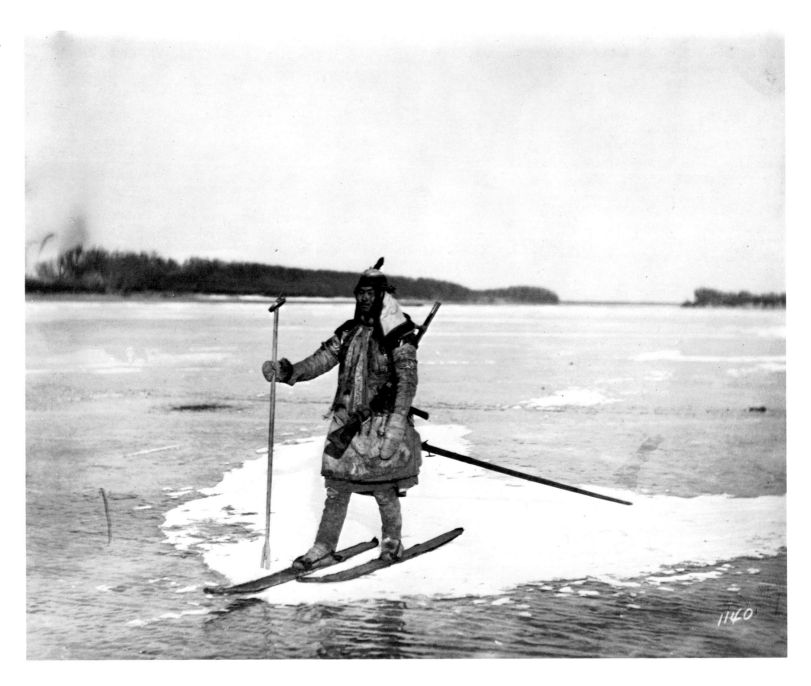

modernity and primitivism and as a suggestion of the unity between the modern shamanism of photography and the older shamanism of drum and headdress. Certainly these pictures—in fact, most of the views of the Goldi themselves—conflict rather powerfully with the flat, condescending imperialism of Jackson's letter. As such, they suggest the strange but tempting possibility of a sort of doubleness within Jackson, combining self-definition as a genial representative of Gilded-Age American attitudes on the one hand, and a more discursive, exploratory, even ironic consciousness on the other. These pictures of the Goldi tribe, then, might correspond to the dualism that ebbed and flowed throughout Jackson's time with the World's Transportation Commision: between a public persona—servant to the demands of his employers—and a more private explorer of world relationships that came to correspond in central ways to his own crises of self and profession. If this is the case, however, we might also think of Jackson's "employer" in the broadest possible sense, as comprising not simply the Commission and *Harper's* or, in earlier periods, the railroad companies and the Survey, but rather as encompassing the broader forces that stood behind those manifestations. For we have seen that one of Jackson's great talents in the past lay in making pictures with an eye beyond his immediate employer, an eye focused on the public. But to reach that public, we have also seen, meant negotiating at every turn with the intermediary institutions and to a greater or lesser extent relinquishing to those institutions an increasing measure of power over the meaning and purpose of the photographs.

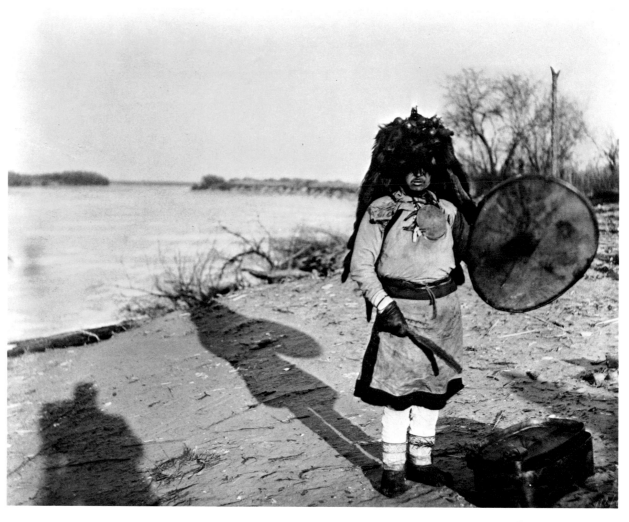

170.
"1144. Goldi Shaman North of Khabarovsk," 1896. LC

This was certainly the case with the World's Transportation Commission. For despite Jackson's on-again, off-again ruminations about creating a body of work that could stand independent from *Harper's* and Pangborn and that he himself could control, in the end the most direct and powerful expression of the photographer's encounter with the world would be found on the pages of *Harper's*. Indeed, the Commission trip might best be seen as another point in a steady encroachment of Jackson's power over the signification and the significance of his own photographs. From the Survey's

rather flexible regulations to the more sophisticated supervisions of the corporations who controlled the publication and marketing of his images to the editors at *Harper's Weekly,* Jackson had been fighting a long and losing battle.

Yet we should also remember that, in the scale of possible dissension over ideas about landscape and land use, about the meaning of the West, about American mission and the American destiny, and about the relationship between modernization and the global environment, Jackson's own beliefs were not wildly divergent from those of his "masters." His nostalgia for the native and that precolonial ecology was engendered by the colonial experience, which offered a means of comparison and also afforded a certain freedom to regret without accepting the consequences of such regret. Jackson's "Choonbatty Loop" may have found more power in the Himalayan landscape than in the "veritable toy train," but it was the train that made Jackson's pictures possible, that brought him home to his quarters for a tea laid out by native servants.

Jackson resisted the pace of modernization, its often wholesale dislocation or destruction of the past, its requirement that a division be kept in mind between "modern" and "native." And this resistance certainly generated and informed many of the Commission pictures we of a later era find most compelling. Yet we must also remember that this division, between modern and native, present and past, originated the personal, technical, and cultural terms that allowed the photographer to make the pictures he did. Perhaps, in describing the Goldi shaman, Jackson unwittingly described his own po-

sition. Like the shaman, Jackson wielded a power that depended on his audience's belief in him and his medium. And, like the shaman, Jackson had to believe in his centrality in order for the magic to work. For a moment, Jackson had allowed the mask to slip, but the effect was remediable; *Harper's* stepped in to correct the disruption. Now, once again, Jackson reimmersed himself in his Western shamanism, rejoined his "class of imposters."

Early in December of 1895, the polar winds reached Siberia, freezing river and tundra alike, converting the open reaches into a vast roadway upon which Jackson and the World's Transportation Commission rushed west, escaping the frontier, heading toward civilization. First by sledge, then by sleigh, then by the Trans-Siberian Railroad to Moscow, the Commission pressed homeward, with little pretense at investigation or attentiveness to the surroundings.

By the fifth day out it was thirty-five degrees below zero. The days, nearly two months of them, achieved a relative routine. Each morning Jackson checked the temperature; after breakfast he and his colleagues were treated to one of "the most amusing experiences of the trip . . . [the increasingly corpulent] P's tribulations in getting himself fixed. Whenever he got in his sledge he required two attendants." Then for the remainder of the day, and often well into the night, the party moved westward, past "the long lines of freight sledges" rushing in the opposite direction to provision Siberia for the rest of the winter and the spring, when transport would again be impossible. At Blagoveshchensk, Jackson reported that

they were "presented to the Governor, and spent a full two hours there; the showing of our big photographs being an important event." But Jackson's photographic ventures were largely perfunctory. With the combination of the intense cold and his own attention to matters farther west, he did the bare minimum he felt would satisfy *Harper's.*[60]

At Krasnoyarsk, past Irkutsk ("it is called 'the Paris of Siberia,'" Jackson ironically noted), the Commission reached the eastern terminus of the Trans-Siberian Railroad. It was January 26, 1896. Eleven days later, the party was en route to Moscow. Upon their arrival there on February 12, Pangborn announced what everyone had already long known: budget problems forced him to cancel the European and South American portions of the trip. The Commission would disband in Europe; he himself would be leaving them at St. Petersburg.[61]

In Berlin, with just days left before returning to the States, Jackson began to think rather frantically of "trinkets" but suffered the fate of so many American tourists abroad: "I see so much that I am bewildered . . . I do not want to buy things here that could be had just as cheaply . . . at home." Now the last moments before leaving were filled with anticipation. Everything would now be resolved, he told Emilie; there was nothing more to worry about. The Commission, its failure or success, the question of some future meaning to the changes of mind and heart that had occurred during those eighteen months, now even the ownership of the negatives themselves, were all matters that would solve themselves or could be more safely ignored. All would be well.[62]

Jackson's last letter ended with a re-

soundingly optimistic statement about his relationship with his employer: "Do not worry about the *Harper's* business. I will straighten them up at once." But Jackson discovered upon his arrival in New York that he had again misapprehended his relationship with the magazine. Returning under the assumption that he could resolve the contract disputes, regain control of the negatives for himself, and continue on the payroll while he organized and copied the negatives, Jackson was quickly reminded of the new relationship between photographer and public. Once again *Harper's* held all the cards. The magazine retained all publication rights, making the set virtually useless to the photographer.[63]

So Jackson's experiment in the global landscape resulted in an encyclopedic record of the late-nineteenth-century global tourist's path, but a record that was to have its exposure almost entirely at the hands—and in the edited pages—of *Harper's Weekly*. Jackson's pictures offered magazine readers a set of excursions that appeared within the context of the tourist's mode of engaging and consuming the world. Regardless of the photographer's desires, *Harper's* readers would continue to see Jackson's photographs as illustrations to increasingly strident discussions of imperialism and expansionism; the last views would appear in 1898, just a month before the battleship *Maine* was to explode in Cuba's Havana Harbor, putting the cap to three years of steadily increasing pressure for intervention and war. Indeed, some of the photographs would reappear, accompanying reports on global imperialist conflicts—notably concerning "Khyber Pass, Captured by the Re-volting Afridis," which would reuse the picture of the Commission at the foot of the pass reproduced some two years before. In virtually all their last incarnations, Jackson's pictures would serve as descriptions of a world defined by imperialist power relations and offering thinly veiled lessons for American interests.[64]

Even stripped of this specific context, Jackson's pictures reinforced the tourist's vision of the world, in which the distance between viewer and viewed was always comfortably maintained, always defined on a hierarchical scale that placed the tourist above both the native and the native environment. This was precisely the position from which Jackson struggled to liberate himself throughout the trip, with greater or lesser success. Hampered by the derivation of his entire visual vocabulary from an ideology that underlay and led to the imperialist position, himself a creature of that ideology and its ethics and morals, Jackson's greatest resistance lay in dividing his subject between the native ecology and the forces of colonial modernization. Into this separation, Jackson could introduce the elements of nostalgic Romanticism that Americans already recognized from similar contemporary treatments of the American Indian and of the privileged American landscape. This allegiance to the romanticized native culture and its landscape, however, carried with it the same implications as it had when applied to Native Americans and their environment—it suggested the inevitable extinction of this life and its replacement by another.[65]

On the pages of *Harper's*, imperialism and tourism became inextricably intertwined; in fact, tourism became, essentially, the visual form of imperialism. These were realities in which Jackson himself participated, with greater and lesser awareness, greater and lesser resistance, throughout the trip. *Harper's* merely removed ambiguity from the relationship, bringing the central concepts of progress, inevitability, and superiority to the fore.[66]

But the actuality of modernization was a more immediate issue for Jackson, for it existed in his experience as a collection of discrete facts—railway locomotives, forts, guns, billiard rooms, social events, and matters of etiquette. Bonded to this factual realm, Jackson's photographs remained open, free for interpretation, tolerant of ambiguity and unresolved tension, both ideological and formal. *Harper's* mission was to strip them of this ambiguous space in order to give to modernization an aura of inevitability, to place it within the realm of the "natural." *Harper's* thus succeeded in completing what Jackson himself had begun as early as 1869: the transfer of photography from the realm of the fact giver to that of controlled ideological tool.

This transfer applied not to the medium as such but rather to a particular strand of it. Yet this was the strand within which Jackson had worked since his immersion in photography more than a quarter-century before: the interstice between content and theme, between factual description and ideological presentation. Now this tradition had engendered and been subsumed by the technology and the industry of mass-reproduction illustration. As individual, entrepreneur, or author, Jackson would now take a place far from the center.

I fully believe that all these troubles, bad as they are, will result in the end in bringing our affairs to a climax from which we can work upwards better than we could from the dead level of our daily struggle to keep up appearances.
—JACKSON to Emilie,
 January 12, 1895[1]

During Jackson's global sojourn a series of his most famous American landscape photographs began a new life. "Royal Gorge," "The Grand Cañon of the Arkansas," "The Cañon of the Grand River," and others all began appearing—translated to steel engravings—in a new series of tourist guidebooks produced by the rapidly expanding Chicago map and tourbook publishing company, Rand McNally.

In one sense, the series only continued a smooth progression by which the Western landscape became translated into the Western "experience," packaged for tourists and offering that peculiar paradox, predictable adventure, that marked the successful "vacation." The Rand McNally engravings appeared in new, McNally-published versions of Higgins's Santa Fe guidebooks of a few years before, which were themselves cut-rate, nationalized versions of the more elaborate books and mementoes Jackson had produced in the eighties, both in his own name and for the Denver and Rio Grande and other railroads.[2]

Where the new series differed, however, was in the authorship claimed in each engraving. Jackson's productions of a decade before had featured his company's name; those in Higgins's first Santa Fe Railroad book had been without signature at all. This was the case with many other works of the era, including Moses King's 1891 production of *King's Handbook of the United States,* which had used engravings of a number of Jackson's photographs. McNally's series, however, reintroduced a signature in the lower right corner of the image: in mock script, it read "R. McNally." While this was not an entirely uncommon phenomenon with reproductions of this time, it dovetailed with a more direct eradication of Jackson from the authorship of the images: the title pages advertised the books' illustrators but failed to mention Jackson—even though he had produced by far the lion's share of the images.[3]

Over the next decades, Rand McNally continued to market a huge variety of texts using these Jackson-derived plates; it also sold the engravings to other publishers, where they retained their McNally "signature." Yet the McNally pictures were only part of this larger process by which Jackson's photographs from the Denver years reached further and further out into the national and international market, stripped of their authorship and reconstituted as the products of the corporations and publishers who had acquired them. We can find Jackson views,

171. (*opposite*) *Detroit Photo. Company, "011017. Los Angeles, Calif. Hallenbeck Home, Rose Trees," ca. 1905.* CSHS

often heavily retouched, appearing in guidebooks, brochures, and even railroad timetables as late as the 1930s. So *Harper's Weekly* was not the only place where Jackson's photographs developed a new life during the photographer's absence on his global adventure. While there were no lavish productions from the Denver firm in Jackson's absence, his images proliferated in a wide range of markets. But this very universality, combined with the anonymity of production, signaled the very different world to which the photographer returned in 1896.[4]

Jackson quickly learned of the gap between his optimistic forecasts in letters from Europe and the condition of things in New York, Denver, and the country. An extremely short visit to the offices of *Harper's* removed his fantasies about months of further employment by the magazine. And his return to Denver shortly thereafter brought the unpleasant realization that the W. H. Jackson Photograph and Publishing Company could not offer him any security in the short or the long term. By now heavily in debt not only to partners like Crosby and Rhoads but to other, more anonymous sources of capital, the Jackson firm continued to reel under the combined effects of the depression and the reproduction revolution exemplified by the events at Rand McNally. In addition, the disappearance of Jackson from the scene for such a period had meant the loss of valued old customers who wanted only the master to produce work for them. Even as early as August of 1895, Jackson had written Emilie, "The work is running down—or rather the negatives are, and from other sources I hear that the work turned out is very poor. Rhoads also has lost pretty much all our old line

of business—i.e. the hotels and railways." If the company was to survive even the next months, something would have to be done.[5]

Recognizing the condition of things, Jackson attempted to mount an offensive on two fronts. The first concerned regaining control of his landscape images and the genre itself; in addition to supervising the marketing of his work to the increasing number of glossy pictorial magazines, he arranged as quickly as possible for the production of a new set of photographs to replace those now dispersed through other publishers or devalued because of their saturated distribution through Tammen's *Great Divide, Wonder Places,* and other publications. Jackson was aware of the effect of the new 1891 copyright law covering photographs, and he wished to make certain that no more of his views ended up owned by others; a set of these new views went for copyright deposit by the end of 1896, comprising subjects from the most picturesque tourist regions immediately surrounding Denver.[6]

These new photographs display a certain difference from the majority of earlier views marketed by the Jackson Company. In subject matter, they are recognizably attempts to generate a body of marketable work that would quickly reclaim the reputation of the company. Jackson photographed the Ice Palace at Leadville, Colorado, a wintertime carnival feature; made a view of Salt Lake City; photographed Pike's Peak from a point near Colorado City; and produced studies of a number of features of the Garden of the Gods, in lower Colorado. These last seem most clearly to come from another sort of landscape consciousness than Jackson's before the World's Transportation

Commission Trip; in some, the features have been relegated to the background, and foreground details mar the quality of natural wondrousness one might expect—in one, a barbed-wire fence is even visible. When Jackson did reclaim his older style, it seems almost perfunctory. These views might regain some market share for the Jackson Company, but they could not reinsert the photographer in the center of the landscape-view business.[7]

Jackson's other strategy for recovery, a lecture tour entitled "100 Minutes in Strange Lands" was a straightforward financial failure. This second misadventure ended Jackson's long-held hopes that his global tour could revitalize his company, elevate his reputation, and net him a return to economic and social solvency. But another way offered itself concurrently: a graceful capitulation to the new order of things in commercial photography. This possibility appeared in the guise of an offer, tentative at first, that Jackson sell his negatives to a newly capitalized national view company committed to competing with such popular giants as Keystone and Underwood & Underwood.[8]

Jackson reports that he was first approached while in New York en route from London in March of 1896. At that time he met an old competitor and acquaintance from California, Edwin H. Husher. Husher had left California for Detroit a year or two before, setting up as a photographer and engaging in negotiations with local businessmen to create a major view-manufacturing business. Husher had wide experience in the production of photographs and apparently had gotten wind of a Swiss method of converting black-and-white photographs into color

images—images of such superior quality that they are today almost indistinguishable from actual color photographs. In 1896, Husher succeeded in gaining the support of a major Detroit figure, William A. Livingstone, Jr. Son of one of the Midwest's largest shipping, banking and publishing magnates, himself a wealthy scion of the Livingstone empire, William, Jr., was convinced of the potential in Husher's process and had taken under advisement Husher's suggestion that the new company speed its expansion by acquiring a large stock of negatives from many sources, the largest and most prestigious being the William Henry Jackson Photograph and Publishing Company.[9]

Matters reached a head in the fall of 1897. Livingstone had gone to Switzerland that summer to negotiate a contract for rights to the Photochrom process of color photolithography; upon returning, he traveled to Denver to meet with Jackson directly and make his offer. Perhaps he was aware of the Jackson Company's desperate circumstances; in any case, he was able to acquire what he needed at fire-sale rates. The Detroit Photographic Company received some twenty thousand negatives, and took as well a most valuable asset—Willian Henry Jackson himself, who agreed to join the firm as a partner at what he later termed "a comfortable salary."[10]

Though matters had been rushed, by 1898 Livingstone and Husher had successfully launched their new enterprise. Even before Jackson arrived, they had purchased a variety of negatives. Some were Husher's own—these included many views of California but also a considerable number of negatives depicting the Michigan and Great Lakes areas. Through Livingstone, the Company had acquired a large stock of views of shipping, ports, boats, and the transportation industry. And, finally, the company had committed itself to an aggressive marketing of fine-art reproductions, often hand-tinted—views that were popular not only in education but as tasteful and uplifting decorations for middle-class homes. This, in fact, was the original rationale for investigating the Photochrom (later called Aäc) process. Jackson moved to Detroit early in 1898.[11]

Simply adding Jackson's extant negatives to the Detroit Photographic Company files had a tremendous impact on the entire endeavor. Jackson's pictures were perfect for the firm. Because Jackson's primary business had been with, in his words, "the hotels and railways," he had a huge stock of views of the very places where there was the most demand for the Detroit Company's products. National parks, scenic wonders, tourist spots, resorts, fabulous American cities and towns, and Indian villages, all areas of demand, were instantly filled by the addition of Jackson's views. At the same time, the pictures themselves had a certain grandeur of treatment that elevated their subjects in status. Jackson's style was the dominant landscape photograph style by 1898, and his very preeminence in creating and maintaining this enduring visual dogma made the pictures themselves comfortably familiar, proper, and correct.

Yet the transfer of these photographs to the Detroit files changed their significance. As large-scale prints mass-marketed by the Detroit rather than the Denver firm, they achieved a greater public exposure—a matter that, we shall see, altered their meaning and influence considerably. But as postcards, they moved from their status as mementoes and substitutes for an encounter with grand American scenery, to a new position as simple *markers* of their purchaser's encounter, directed to a friend or relative.

This position was enforced by several ways in which they differed from other incarnations of Jackson's views. The first lay in the nature of their ownership. Because they were transferred from their purchaser to another, and then often thrown away after receipt, their capacity to alter the attitudes or beliefs of their recipients was signally diminished.

This change was related to the other differences: the often tremendous diminution in size from original to postcard, the cropping that occurred with the changing of format, and the effect of a message-bearing section, which competed with the image for attention and often provided texts that changed the meanings of the pictures themselves. This shift in size seems to have negated the capacity of the picture to substitute for the scene it represented. Unlike the stereographs of Jackson's Survey years, with which the viewer used magnifying glasses to gain an effect strikingly similar to actual presence on the scene itself, these small views made obsolete the traditional paths of entry invoked by landscape photographers for decades. At the same time, telling details—people placed in the scene to give a sense of scale to monumental natural objects or used to signal correct responses on the part of the viewer, to name just two examples—became largely irrelevant. The subtle tonal qualities and the overall rich-

ness of effect inherent in mammoth-plate contact prints were replaced in the reduction by a more contrasty, almost posterlike effect, with compositional elements exaggerated, even dominant, and the cropping from a 4-by-5-ratio image to a thinner rectangle did further violence to the photograph as originally conceived. This was a matter Jackson had confronted before, in approving 5-by-8 versions of his mammoth-plate views, but it had its effect nonetheless.[12]

Finally, the consequences of a text-bearing space should not be underestimated. These blanks competed with the view for precedence; the words a purchaser wrote there *became* the message, supplanting, countering, or in other respects altering the information-bearing power of the visual image on the other side. Even the typically minimal notes sent during these early years offered a text of human, personal presence that was far different from the sort of thematic messages Jackson's landscape views had sent out previously. This was even more the case with the earliest postcards put out by the Detroit Photographic Company because the space for written messages was located not on the back but on the front. The overall effect of these changes, then, seems to have been a significant decrease in the power of the photograph to carry meaning. Instead, it became a carrier of status, a reminder of the event of vacationing rather than its pleasures or lessons.[13]

Luckily for Jackson, however, his pictures did not simply disappear into the postcard files but instead anchored an equally important and lucrative production category for the new corporation. One of the first acts by the Detroit Photographic Company was to publish a *Catalogue of the W. H. Jackson Views (Formerly Denver, Colorado) Published by the Detroit Photographic Company* late in 1898 or early in 1899; this included everything from 5-by-8 to mammoth-plate sizes and marketed the new firm as a sort of national distributor for Jackson's work. The opening page made clear that the Detroit Photographic Company sought to benefit from Jackson's reputation in the landscape view field; it announced that he would supervise all future photography.[14]

The Jackson catalogue offers an engrossing glimpse into the workings of the Detroit Photographic Company, and more specifically into what its owners saw as valuable and relevant in Jackson's negatives. The Company had apparently chosen to market a huge number of Jackson's tourist views; the vast majority of photographs in the catalogue were studies of Niagara, the Rockies, Yellowstone, the Grand Canyon, and the like. In addition, separate categories extolled views along the major scenic lines of the West; views along the Eastern lines were, for the most part, broken up and catalogued by locale. Certain omissions were significant: only twenty-two Indian views appeared in the catalogue, and they were typically picturesque in treatment. Though the Company would later add a number of Indian images to its catalogue of Aäc color views and would serve as producer for another block of views of Southwestern Indians, these too would hew to the "noble Savage" line that had entered fashion when the native American became mythologized as "the vanishing race." This was the case with the Company's oddly compelling view of a Denver park statue (illustration 172).

Possibly the most telling element in the catalogue, however, is the price list. Here Jackson's pictures truly entered the world of mass culture. Whereas the larger pictures cost about the same amount as Jackson had charged for them in Denver ($1.50 unmounted for mammoth-plate views; up to $30 for a mounted, hand-colored 28-by-64 panorama), the small original prints sold for $1.25 per *dozen*. At that rate, even the poorest American could own a Jackson photograph—and the Detroit Photographic Company was banking on the probability that many Americans would take the opportunity. It was a calculation that would later serve the company well when it looked to price its new lines of postcards.[15]

The Detroit Photographic Company was intent on becoming one of the largest publishers of photographic views in the world, and that required expansion into a wide variety of markets. Sales to schools and other educational and social groups (including Sunday schools, for example) represented one area beyond the stock market of tourists and scenery enthusiasts toward whom Jackson had already directed his work, and the Detroit Photographic Company aggressively followed this lead. It began to specialize in photographs for businesses—for display cases, for kiosks, for placards, and for brochures and other advertising purposes. And increasingly the Detroit Photographic Company became a sort of early stock picture house for publishers of all sorts. When that famous model of Progressive investigation and publication, the *Pittsburgh Survey,* reached print, its opening panorama of the city was not by the reform photographer Lewis Hine or by his colleague Ralph R. Earle

but by the Detroit Photographic Company.[16]

Expansion into new markets, particularly those generated by the energetic American urban–industrial arena, with its municipalities, social service agencies, and giant corporations, required that the Detroit Photographic Company do more than simply rest on its substantial stock of negatives. To compete with other large houses, the Company had its Photochrom or Aäc photolithographic process to offer, but this required conversion of black-and-white negatives for color printing. And it needed a constant stock of new images from throughout the country in order to maintain its reputation as a complete source of photographic imagery for every purpose.

Both of these areas demanded immediate and comprehensive work on Jackson's part. Conversion of his negatives for color apparently occupied the first part of 1898. Because of the elaborateness of the process, each negative had to be converted to ten lithography stones before printing. The technical staff included not only printers but retouchers, color separation specialists, and plate preparers. In addition, the plates themselves had a very limited lifespan, as the pressure of the printing press and the abrasion of the paper itself quickly damaged the sensitive surface. This accounts for the premium price of Detroit Photographic Company postcards—ten for twenty-five cents, or two for five cents—later raised to five cents each.[17]

Jackson had little to do with the technical issues of the process—Livingstone and Husher had imported a printer named Albert V. Schuler from the Swiss factory, along with an "artist," a machinist, and two oper-

ators. But the photographer did have to supervise the hand-tinting of the master photograph, for it would determine the realism of every reproduction thereafter. Color versions of some of Jackson's most famous views suggest that the photographer was involved closely in the conversions, for which special prints were made from the original negatives—in some cases revealing portions of the original scene that had been cropped for over a decade.[18]

Once this process of conversion was at least started, Jackson moved toward his real occupation with the company: the gener-

172.
Detroit Photo. Company, "The Indian Statue, City Park, Denver, Colo.," copyrighted 1906. CSHS

ating of new views and the updating of older ones. This meant returning to the road; by the summer of 1898 the photographer headed West—first to Omaha, site of his first studio, to photograph the Trans-Mississippi Exposition, then to the Black Hills of Dakota. In addition, he traveled East, to Washington, D.C., to make views of the important public monuments—the White House, the Capitol, and so forth. And Jackson also managed to squeeze in a visit to Chautauqua Lake, New York, that summer, to develop a series of views of the resort that appeared as postcards, "cabinet prints," and more in the next catalogue.[19]

From 1898 until the end of 1903, Jackson's main responsibility lay with acquiring the negatives necessary to satisfy the almost incredible demand for views. By 1902, when the Detroit Photographic Company reached its peak of production, output had passed seven million photographs annually, ranging in size from 3¼-by-5½ postcards to mammoth-plate 17-by-21 prints and panoramas of up to 17-by-40 inches routinely, with some panoramas as large as 21-by-150. The company was producing "view" catalogues of nearly 350 pages, with separate catalogues for postcards, lantern-slide transparencies, "art subjects," "educational subjects . . . for use in Colleges, Academies and Schools," and Aäc color prints. To meet the demand, the factory had expanded to employ some forty artisans and a dozen salesmen or "commercial travelers"; in its catalogues, it advertised offices in New York, Los Angeles, London, and Zurich.[20]

Needless to say, Jackson himself could not possibly accommodate a demand of this magnitude—one historian has estimated that

the Company produced more than sixteen thousand different views between Jackson's arrival and the early twenties. Instead, he divided his time between periods in Detroit and road trips, during which he made as many views as possible and sought out sources for the rest. A trip he made in 1901 was typical. Leaving Detroit on September 26, he traveled to northern and southern California, Oregon, and Washington, returning in mid-November. His diary recorded fifty-one days spent rushing from locale to locale by train and buggy, struggling to satisfy an itinerary of photographic subjects up and down the Pacific Coast, fighting "hazy atmosphere . . . rain . . . [and] occasional banks of fog . . . so that no general work can be done," complaining that "there are also no good clouds." In the end, Jackson concluded, "there is much less accomplished in looking for special things that one feels one *must* get than in reaching out for anything that offers."[21]

Jackson was fifty-eight years old when he made that trip in 1901, with more than thirty years of photographic travel behind him; it is little wonder that his records of these last excursions conveyed little excitement, wonder, or even accomplishment in the act of photographing. Simple economics, too, dictated that Jackson increasingly spend his time on these road trips exploring the files of other photographers, whose work, Detroit Photographic Company records show, could be purchased for between two and three dollars per negative.[22]

That trip, Jackson remained relatively attentive to the making of photographs. His researches brought only two photographers into the Company fold, but both were to

provide a significant number of views to the company in later years. One was a man named Hassell, an assistant to the Tibbitts studio in San Francisco; Jackson hired him to make 4-by-5 "Kodak" hand-camera views of Chinatown groups, while he struggled with his 8-by-10 outfit. Apparently the cost of hiring assistant Hassell included all rights to the resulting pictures; Jackson made no note of payment to the man and counted the negatives among his successes for the trip.[23]

If Jackson's treatment of Hassell reflected the nineteenth-century concept of authorship and ownership, his dealings with the other photographer, Adam Clark Vroman, reflected a modern method of business dealings. On October 14, Jackson reported:

Went out to Pasadena at 11 AM; spent a little while with Wadsworth to get some ideas from him as to desirable subjects, and then to Vroman, who took me out to lunch with him and then for two hours afterwards looked over many of his negatives and prints to get an Indian Snake Dance subject. Think I can make a good one by combining two of his negatives.

Three days later, Jackson "spent the day until 5 pm looking over Vroman's negatives and in making some positives from them." On October 21, he "spent an hour or so with V. in his rooms looking over more of his negatives and made up a list of about 15 that I think we should have. Arranged for him to send on proofs by the time I get home." Vroman, a Southern California amateur turned professional, had an excellent collection of Pueblo Indian views; eventually the Detroit Photography Company would publish a large selection.[24]

The migration and fate of "Vroman's negatives" (as Jackson called them) indicates the

patterns of acquisition, retention, and distribution that characterized the huge mass of often anonymous views that the Detroit Photographic Company files comprised. Apparently Vroman sent along the proof prints, and negotiations were satisfactory, for Jackson arranged that year to have copy negatives of these views made in a wide variety of formats. These he and his assistant, "negative man" Vorheis, carefully wrote into the company's negative registers, where data was kept on original source, restrictions on use, damage to the negative, numbers of equivalent negatives in other sizes, and the like. These particular views would eventually constitute the core of one of the most substantial collections of Pueblo Indian views for the period, including Vroman's justly famous "Man with a Hoe."[25]

In the case of Vroman's work, there were no particular instructions to be recorded. In many other cases, however, restrictions might be substantial. The Boston photographer Thomas E. Marr, for example, designated that certain of his views could only be used in postcard format, doubtless to avoid competition with his own establishment. Often photographers retained copyright to the photograph or insisted that their identifying names and negative numbers be stripped from the image. Copyright itself was a sensitive issue throughout the Detroit Photographic Company's career. Jackson had been an early copyrighter of photographs after the first major change in copyright laws in 1891; when new copyright provisions were discussed in Congress, Livingstone was an ardent lobbyist, traveling to Washington to testify and organizing fellow publishers and photographers on behalf of legislation.[26]

Seeing photographs as end products of a mass-production environment, Livingstone and his company naturally defended the copyright process. But concern over control of rights to the pictures formed only one aspect of a larger process of change in the way the Company viewed the photograph. Nearly every act of the Company reinforced its commitment to that vision of photographs as goods more than as containers of meaning. The cropping and reducing that characterized the transfer of mammoth-plate views to postcards formed another manifestation, as we have seen. But this was only one function of an entire subsection of the Company devoted to adapting the images for market. Almost no enlarging was done, on the grounds that it was cumbersome and uneconomic, but it was equally impossible to demand that photographers working for the Company make views in multiple formats, as had sometimes been the case with the Jackson company. And purchased views usually arrived in the form of prints from which copy negatives had to be made. As a result, a vast warehouse of negatives of different sizes grew up in the back of the factory; for each size of image marketed, a copy transparency had to be made, then recopied onto a new copy negative. Sometimes this process occurred three, four, or even more times, as original negatives were broken, then replaced with copies of them made from older reduction copies, and so on.[27]

The Detroit Photographic Company's vision of the photographic negative as something closer to a stamping mold than a work of art can be seen in the process by which photographs were retouched and cropped to "modernize" the appearance of the product and reduce the number of negatives needing to be reshot every year or so. As years passed, buildings were retouched in (or out), skirts lengthened or shortened according to fashion, anomalous details judiciously excised with brush or scissors. As automobiles replaced carriages and horses, in particular, the Company's retouchers went to work, removing horsemen, trolleys, drays, and so forth from busy streets. And once automobiles became regular features of everyday life, it became necessary to delete the older models from some negatives, and to strip in newer ones at times.[28]

Nonetheless, many views had to be reshot every few years, and in some cases every year, in order to remain up to date. Particularly popular scenes, like Coney Island in New York, amply repaid the regular updating of negatives. In this case, sets were made not only by the New York firm of George Hall & Sons but by Jackson's own son Clarence, who had moved to Brooklyn after leaving the successor to his father's company in Denver. And it was this reshooting process that occupied Jackson during a good deal of his first years, as he strove to replace outdated views from the Jackson Company files with newer examples. In many cases, this involved removing photographs he himself had done and replacing them with work by others—as was the case with Yosemite and Yellowstone, both sites of Jackson's most famous work.[29]

As the Company reached its highest output, around 1904, this process of interchangeability increased considerably. Rushing to cover all possible demand, now with a large network of available photographers, the Company often commissioned or purchased sets of views of the same places from

different photographers at nearly the same time. In some cases, this enabled the firm to offer different views in postcard and larger sizes.[30]

The overall result of the Detroit Photographic Company's policies of expansion, coverage, and aggressive marketing was to generate a "style" that became a Detroit Company trademark, in which high production values accentuated uniformity of visual treatment. This was vital in a company that included among its photographers not only major national figures like Jackson, Husher, Marr, and Hall, but others like Lockport, Illinois, druggist H. H. Carter. And that stylistic continuity indicated the power of the Company over its individual photographer–employees. Using many of the techniques Jackson had brought with him from the Denver firm—careful choice of photographers, severe editing of incoming images, cropping, retouching, and the like—the Company produced a body of pictures significantly more homogeneous than the mass of images made by small-time producers of the same era. In the process of building a potent corporate identity, the Detroit Photographic Company eventually submerged the sorts of themes that Jackson had embedded in his earlier landscape work into a more general thesis: a celebration of modernity, of the modern nation, the modern cultural landscape.

One aspect of this expansion and redefinition of the commercial landscape photograph was the Company's policy, during this period, of producing postcards and other photographs on contract to specific major distributors or marketers, a policy formalized by the change of name from the Detroit Photographic Company to the Detroit Publishing Company. Probably the most famous and important case was that of Fred Harvey, the wizard concessioner for the Santa Fe Route, who in 1904 commissioned a large list of views that he sold through his restaurants, stores, and hotels in the Southwest. Between that year and the bankruptcy of the Detroit firm in 1924, over a thousand different images appeared as a result of the partnership. These views had a huge popularity, marketed as they were in one of the most aggressive arenas for the new tourists of the region; their result was almost certainly to shift American perception of the West yet again—but in directions that contrasted sharply with Jackson's earlier themes and ideals, even those at the end of the commercial years in Denver.[31]

At a time when the Southwest remained one of the few regions tourists still insisted they'd rather travel through at night than during the daytime, Harvey's decision to use the Detroit Photographic Company and the postcard medium as a means of generating a new and more positive image, was brilliant. Certainly it was far more successful than the Santa Fe's own earlier campaigns using Jackson's and Moran's talents.

Harvey's commissions—for which he provided many of the negatives—presented the Southwest as a place of romance rather than Romanticism. Focusing first on the most obvious points of tourist interest, the earlier sets "worked up" the Grand Canyon, revitalized the Indian as a creature of interest to visitors, and began to market a new Western sublime of the desert. All three of these stages represented divergences from earlier trends by Jackson and the Detroit Company. Harvey's Grand Canyon views differed from most by their step-by-step reconnaissance of a typical tourist's trip to and through that natural wonder. Harvey's sets resurrected the Indian first by focusing on the gentle exotica of the Pueblo tribes—by showing their "thrilling" snake dances and homing in on their everyday lives in ways similar to both the earlier Jackson views made with Ingersoll in the 1880s and the Vroman pictures Jackson had purchased for the Detroit Company in 1901. Where Harvey's postcard series differed was in its development of a myth of "cowboys and Indians." Harvey's set showed Kit Carson's house, Navajo medicine men, an "Apache War Party," Indians on horseback, Indians in ceremonial garb, Indians in all possible poses designed to suggest to the viewer the possibility of reenacting a mythological Western past without danger to self or property. And this presentation dovetailed with the campaign to present the dry Southwest as a place with an exciting past and a picturesque present. Views of the Grand Canyon vied with colored images of the "Painted Desert," the "Geological Formations near Gallup, New Mexico," the "Picturesque Village of Cordova, North of Santa Fe, New Mexico," and a "Bull Fight on the Plains."[32]

This new image of the West as a place of horseback romance and excitement supported Harvey's aggressive development of a tourist empire in the region. Not accidentally, this was also the moment when the Western novel reached its first real flowering at the hands of Zane Grey, who by 1920 had successfully moved the venue of the West from Wyoming, Montana, and the Dakotas (where Theodore Roosevelt and his friend, writer Owen Wister, had situated it) down

to the border between the United States and Mexico. And this period also coincided with a noticeable upturn in border skirmishes between the two countries and a concurrent rise in imperialist sentiment concerning Mexico, climaxing in 1915 with the American humiliation of the Mexican government concerning the Tampico incident, and the naval bombardment of Veracruz.[33]

In the manufacture of this new West, Jackson had little or no direct part. Instead, he was something closer to a functionary; his last two years as a photographer were spent in the East or Canada, and though he may have assisted in assembling the Harvey order, he made none of its views. Indeed, the entire campaign sprang from Fred Harvey's own mind; the Detroit Photographic Company was relegated to the level of mechanic, carrying out his orders and producing a product—a superior one, admittedly—to his specifications.

Jackson did, however, serve as a liaison with the earliest traces of this new campaign to celebrate the Southwest through mass-production photography. In 1902, sponsored by the Santa Fe line, Jackson toured the region in a special railroad car done up as a traveling showroom for Detroit Company views (illustration 173). This tour enabled Jackson to sell the Company's pictures along the route; it also allowed him to scout out photographers who could provide new views for his employer, and doubtless these photographers supplied many of the photographs that later served as raw material for Harvey's landscape marketing blitz.

Other pictures for various clients provided a similar involvement of the Company with alternative sources of distribution and

173.
Detroit Photo. Company, "Interior of Photographic Railroad Car," 1902. CSHS

specified requirements that were sometimes stringent, sometimes relatively flexible. The latter was the case with a number of trips Jackson made for different railroads in the East and Midwest. These railroads were interested in developing an otherwise rather moribund tourist industry along their lines and probably hired the Detroit Company in order to gain the services of Jackson, who remained justly famous in railroad circles for his views of Western and Eastern lines alike. The resulting photographs served doubly to enhance the market in those regions for the Detroit Photographic Company and

to cement a fruitful relationship between the Company and the railroad that was of benefit to both.[34]

To understand the aggregate effect of the Detroit Photographic, and later the Detroit Publishing Company on the American cultural landscape, we must look less at specific photographs and more closely examine the broad scheme of subject matter and classification. There we can find a sort of American self-image for the decades representing the peak of the Detroit Company's production; by catering wholesale to public demand, the Company finally reflected the tastes and desires of its public—a public, we should remember, that was purchasing upwards of seven million views a year from this firm alone.

Scenery represented probably the largest single category of images in the Detroit Company's collection throughout its twenty-six-year history. These pictures represented the landscape as *scene*—that is, hermetically sealed from the actuality of the viewer's experience—and also as *scenery,* in the sense of visual props within a stage setting. Scenery formed itself into many subcategories in the Detroit catalogue, but these still shared that overall combination of separation and stagedness. In traditional landscape subjects, this often occurred because the pictures were made from utterly conventional vantage points, as if deliberately to avoid breaking with the viewer's expectations. This was the case with Company-marketed views of Yosemite, for example (illustration 174), which were made from points marked off by C. L. Weed in the early 1860s and repeated by Watkins, Muybridge, and a number of other scenic photographers (including Jackson) to

such an extent that some locations were re-named as "Artist's Point" and the like.

This technique of conventionality was a mechanism the firm employed to diminish the tension potential in the landscape genre. Views along the Chicago and North Western Railway almost certainly made by Jackson show the power of the high-angle view to present landscape in its most pleasurable guise. His view "Down the Des Moines Valley, from C&NWRy. Viaduct" (illustration 175) left the viewer hovering, seemingly omniscient, above a scene of tactile pleasure; the photographer increased this sense by shooting at a time of day when the sunlight raked across the trees, riverbanks, and sand bars. When he moved down to earth, the photographer chose vantage points that emphasized restfulness, peace, and meditation, that presented the viewer with a predigested conception of nature's healing powers (illustration 176). This was no different in theme from Jackson views of the eighties that presented the tourist's notion of landscape-as-vacation—rather, it was a difference in intensity.[35]

With the sublime subject now relegated to the outskirts of the catalogue, the picturesque, too, moved to the side, and a new set of artistic conventions took its place—those of "the beautiful." How completely this set was derived from landscape painting can be seen in two views. One, entitled "General View, New Milford, Pa." (illustration 177), seems at first an inspired amalgam of Hudson River School landscape painting from the years when Jackson was himself an apprentice painter, combined with the endless string of derivations from French Barbizon School painting. The second, a "Birdseye View of Moccasin Bend, Look-

out Mountain [Tennessee]," reproduced any number of "ox-bow" river paintings—especially the most famous, that of Thomas Cole. In both cases, however, Jackson and the Company employed these antecedents not as references to art but as means of presenting the most comfortable expected sort of rendition of American scenery.[36]

Conversion of the photographic landscape from black-and-white to color had its own set of implications. Because the Aäc process was potentially so accurate, it moved the image even closer to its role as a simulacrum of the world. This meant that all the elements of surrogate ownership, of substitution, and of a supposed democratic availability to all, inherent in Jackson's earlier photographs, were now even more powerfully brought to the fore. Viewers on a hot summer's day in New York could all the

174. (*opposite*)
Detroit Photo. Company, "*013595. El Capitan, Yosemite,*" *probably 1904.* CSHS

175.
Detroit Photo. Company, "*013748. Down the Des Moines Valley from C&NW Ry. Viaduct,*" *copyrighted 1901.* CSHS

176.
*Detroit Photo. Company,
"04572. Des Moines
River Below Moingona
[Boyer Valley, Iowa],"
probably 1902.* CSHS

177. (*opposite*)
*Detroit Photo. Company,
"12226. [General View]
New Milford, Pa.," date
unknown.* LC

012226 NEW MILFORD, PA.

DETROIT PUBLISHING CO.

more easily escape to the cool mountains of Colorado, without the expense or inconvenience of the actual trip.

Many of the Detroit Company "scenics" reveal the powerful influence of domestic tourism, and the rising tourist industry, on the output of the company. The Company naturally retained and republished Jackson's own extensive collection of photographs of resorts and resort hotels and apparently required Jackson to update them regularly, judging from his photographic itineraries. Sites of organized tourist activity, increasingly popular after the turn of the century, also began to appear, often with the tour group prominently included in the scene (illustration 178). All these corresponded closely to Jackson's earlier commercial tourist views; there were changes of degree, but not of kind.[37]

A new sort of subcategory involved the American tourist monument. Jackson had made some desultory attempts at portraying such "shrines" during the Denver years, but these were for the most part local curiosities rather than national phenomena. With the Detroit Company, it became one of his prime tasks to create an archive of views of these national monuments. His trip in 1903 to the area around Washington, D.C., netted photographs of the Capitol, the White House, the Washington Monument, even the Library of Congress, as well as Mount Vernon, the James River, and Richmond, Virginia, where he went to make views of the Confederate Monument. All of these catered to the rising fashion to visit places whose existence was defined by the presence of secular shrines. Jackson's photographs provided the raw material for postcards and me-

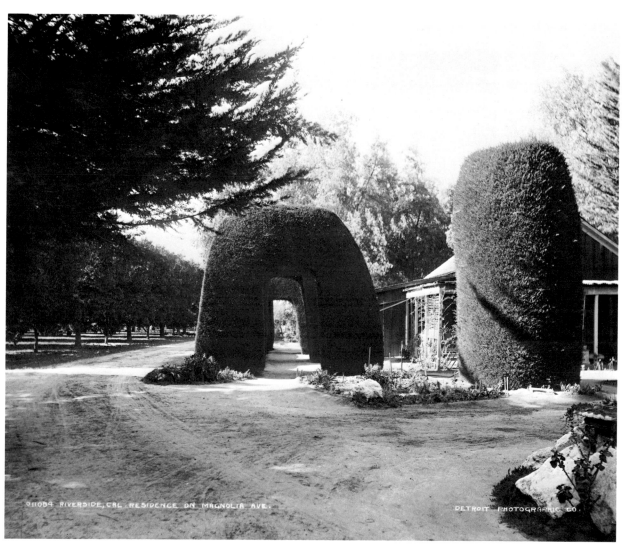

mentos both—and they were also the type of view that needed infrequent updating or reshooting.[38]

These photographs of scenery shade almost imperceptibly into two other categories of work—studies of the domesticated landscape and views of labor and industrial activity. In the first case, the Company presented a surprisingly comprehensive study of the southern California suburban landscape, and the pictures celebrated the intersection of idyllic suburban life and an overflowing cornucopia of natural delights. Detroit's view of a "Riverside, Cal. Residence on Magnolia Ave." (illustration 179) set the worker's cottage on one side, a stand of trees

179.
Detroit Photo. Company, "011084. Riverside, Cal. Residence on Magnolia Ave.," date unknown.
CSHS

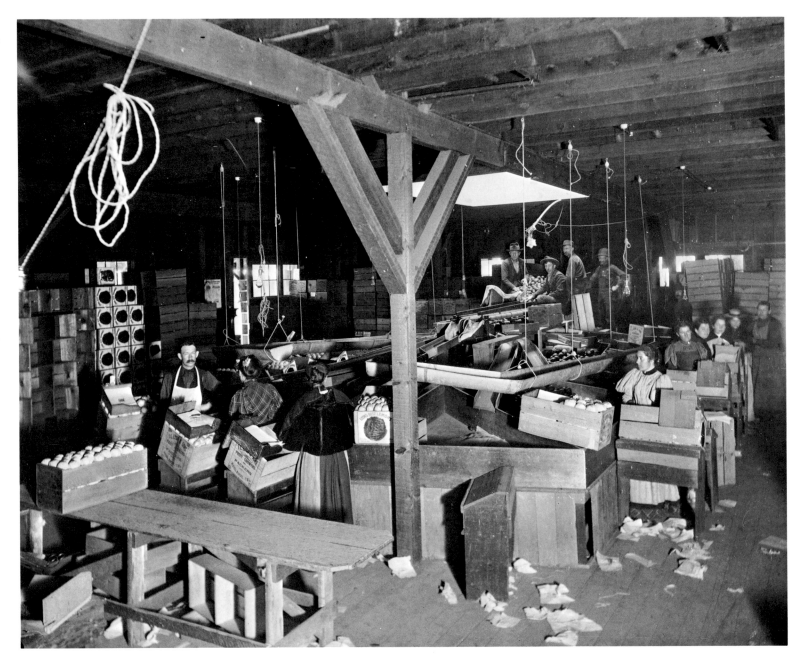

180.
Detroit Photo. Company, "011077. Redlands, Cal. Packing Oranges," copyrighted 1899. Like so many others, the original of this view had been broken and replaced with a near-duplicate. A number of minor differences exist, particularly in the lighting and posing of figures. CSHS

on the other, and between them a set of sculptural hedges—nature turned into a veritable gate of Eden. In this and many other views like it, the Detroit Company mapped a new sort of frontier: not between wilderness and settlement, but between urbanism and the rural setting, itself increasingly encroached on or transformed. An extensive series of views detailing the agricultural sector depicted the process by which fruits and vegetables were packed and shipped to the consumer (illustration 180). These views, often commissioned by the packing company or the railroad line, celebrated the industrialization of agriculture even as the Company expanded its views of industrialism and urbanization, treating both with an orderly, approving style.[39]

In fact, industrial and urban views with the Detroit imprint often fit more neatly as scenery than as anything else. These photographs ranged from images that depicted with uninflected matter-of-factness the gridding of the American landscape and its conversion to useful tasks (illustration 181), to magisterial panoramas and high-angle studies of industrial and shipping sites (illustration 182). The Detroit Company was a masterful collector and disseminator of the high-angle city view, a subgenre of the late-nineteenth-century urban photograph that offered its viewers an illusion of an orderly, rational, and successful modern urban environment. In Company views made after the turn of the century, the addition of crowds of people, still seen from above, had the odd effect of further isolating viewers from the scene, providing them with an aura of omnipotence while the subjects of the camera gaze were reduced to antlike insignificance.

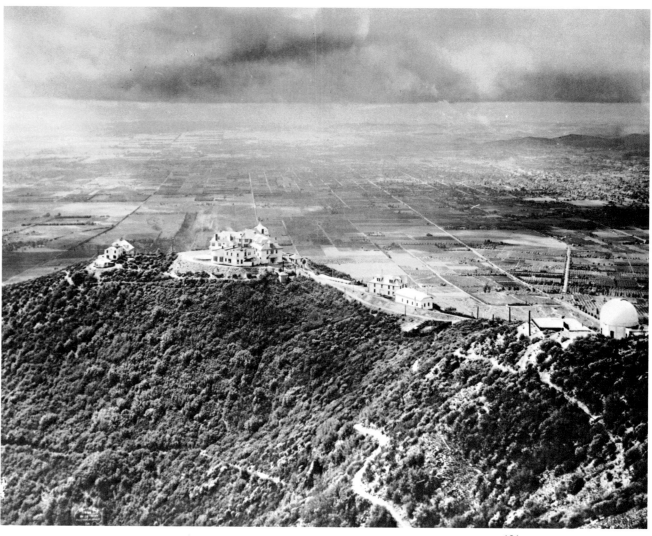

This sense of power was doubtless heartening to viewers of the American city during these years, when chaos seemed the law of the urban scene.

Other classes of view catered to other fears and desires surrounding the American city. The Detroit Company developed a small but emblematic set of photographs of immigrants, including views of Ellis Island and Battery Park made in 1905 (illustration 183). These offered a glimpse of the new polyglot urban environment to a geographically

181.
Detroit Photo. Company, "011049. The Valley from Echo Mountain, Cal," date unknown.
CSHS

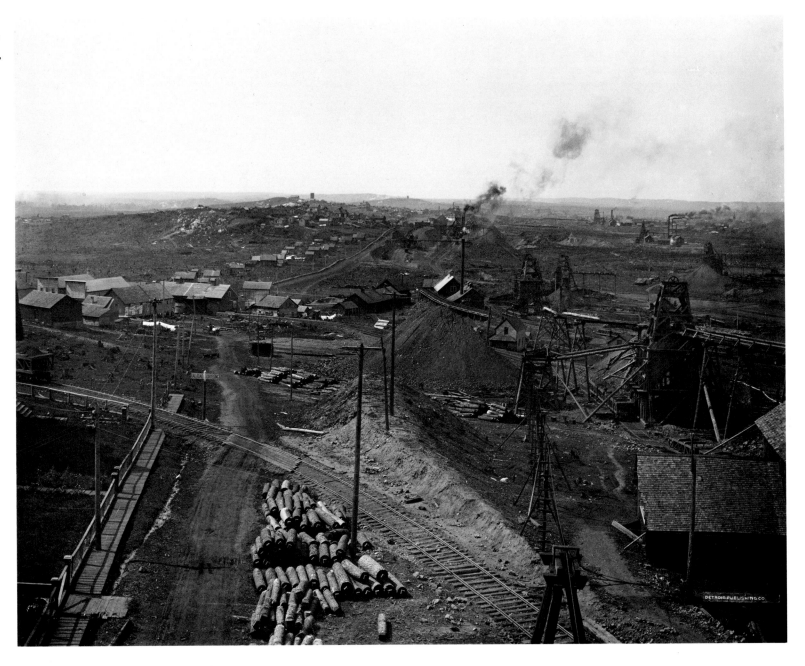

diverse but intensely curious audience of Americans, who provided the Detroit Company with a major market for such views and guaranteed their continued production throughout the history of the Company.

Closely allied to this was a relatively small series of street views in which the photographer and the viewer came down to eye level to witness some of the intimate realities of the modern city, from mountains of snow to dead horses in the gutter. But these photographs were the distinct minority, and their negative implications were countered by other street views that had as their subjects the urban voluntarism movements—Christmas street campaigns for the poor (illustration 184), "fresh-air fund" days, and the like—that took to the streets at the beginning of the twentieth century. And finally, many more views celebrated the picturesqueness of urban street life, particularly as practiced in New York. Jackson's son Clarence, for example, was just one of a number of photographers who provided views of the popular amusement park at Coney Island, photographed in the summer of 1901 (illustration 185). And Edwin Husher himself probably supplied the extensive series on park life in Detroit around 1898.[40]

All these urban street-life photographs exploited the capacity of new photographic technology to make "instantaneous" views with a sense of immediacy that had eluded earlier practitioners of the celebratory grand style of urban photography. But the output of the Detroit Company also differed radically from either the reform photographs or the amateur "snap-shots" of the same years. Almost nowhere in the Detroit files will one find the sort of unstable, dynamic composi-

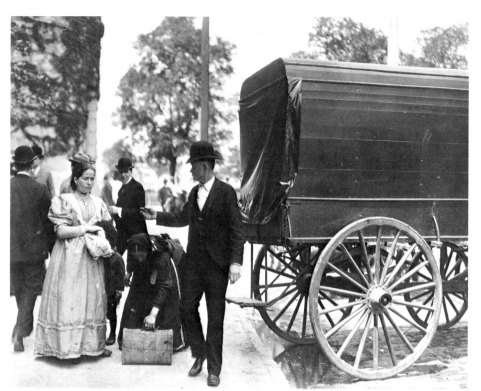

183.
Detroit Photo. Company, "13618. Immigrants at Battery Park, New York, N.Y.," 1905. LC

184.
Detroit Photo. Company, "9147. Santa Claus on Broadway," copyrighted 1903. LC

185.
Clarence S. Jackson, for Detroit Photo. Company, "09030. Coney Island Beach," probably 1903.
LC

INCORPORATED MAN

tional strategies that appear in the work of reformers like Jacob Riis or the happy-go-lucky spontaneity of the hand-camera enthusiasts who remained outside the amateur academies like Stieglitz's self-consciously noble and serious Photo-Secession.

In this unstable mix of new photographic possibilities, the Detroit Company charted a conservative course, containing the directness of the instantaneous street view within a stable, grand-style compositional framework. The result was a body of work that celebrated the city's liveliness but downplayed its volatility.

In this respect, the heritage of landscape photography formed a valuable basis for devising a strategy applicable to the modern city. These urban and industrial photographs presented an unabashedly positive image of modernization in America, an image that meshed perfectly with the Detroit Company photographs of a domesticated landscape of scenery. The amalgam of these views depicted an America of industrial power, middle-class leisure, and urban order. This new, constructed American landscape was bounded and demarcated into units according to use: parks, raw materials exploitation, urban growth. Agriculture now disappeared, divided into the realms of scenery and industrial manufacturing. The overall effect was to emphasize the unity of the American landscape, in which an interlocking ecology of *use* replaced older ecologies of potential, of beauty, and of myth. The American landscape as Jackson had previously presented it appeared now in the guise of vacationland. National parks competed with famous golf courses for a place in the updated Detroit Company catalogues.

This postcard American landscape coincided perfectly with the other views the Detroit Company marketed concurrently—the popular photographs of racial stereotypes (illustration 186), the views of American institutions of higher education, the almost endless series of reproductions of fine art objects, even the pictures of yachts. The composite was an unmatched celebration promising not simply a landscape of symbiosis among elements that were generally seen as antagonistic but an economy and a social and intellectual life of progress and harmony combined.

Marketed by the tens of millions over a twenty-six-year period, the Detroit Company's views inundated the American market; they formed a comprehensive American self-portrait during the years of American modernization. Ubiquitous, their influ-

186.
Detroit Photo. Company, "9012. "Bliss," copyrighted 1901. LC

ence lay precisely in their unobtrusiveness, their appearance of uninflected description even as they transmitted back a detailed and complexly edited portion of the American experience. The Company's America had little in common with the concurrent vision found in the newly invented genre of American reform photography beyond its presentation of a dynamic and multicored culture and its de facto commitment to photography as an instrument of mass information. Operating at the level of "the natural," the Detroit Company output reinforced a number of widely held notions about the nature of America. And in the process, it served a vital function as a counterweight to the overwhelming forces of change that drove even Progressives like Theodore Roosevelt to rant about anarchism and to escape to the safety of reconstructed rural or Western wilderness retreats. While much of America shrank in horror from the urban-industrial world, the Detroit Company succeeded in amalgamating it into an ecology that subsumed rural, urban, and even wilderness myths into a magisterial, progressive whole.

This role as a cultural unifier was made possible in part by the Detroit Photographic Company's placement at a delicate moment in American photography. Technical innovations of the eighties and nineties—flexible film, enlarging papers, small hand cameras, sophisticated "instantaneous" lenses, and more—had introduced a tremendous number of new practitioners to the area. Ranging from gentleman amateurs to casual snapshooters, reformers, and small-scale professionals, these new photographers had the dual effect of increasing photographic output tremendously while also engender-

ing a form of stylistic laissez-faire that opened up photographic style and introduced a wide variety of new subject matter. The effect of this revolution was to provide Americans with a far broader range of information about their fellow citizens, their physical geography, and the circumstances and landscapes of the globe.

But the effect of such an influx of new visual material was not necessarily positive. The information revolution that accompanied modernization and the move into the twentieth century also overwhelmed the individual citizen with huge amounts of data, ranging from a quantum increase in the number of faces an urban dweller might see on the street, to a rash of published statistics about population, to a wide variety of images of people of widely differing races and backgrounds. This disruptive overflow, however, could be monitored by cultural institutions that controlled its output, turning the raw chaos of data into information by packaging it with instructions concerning its significance, then ordering its dispersal. We have seen this process at work in *Harper's Weekly* during the nineties; the same mechanisms applied equally to many other areas where larger-scale institutions took leading roles in their media.

In photography, the danger of chaotic overflow was particularly severe precisely because of the wide divergence of new practitioners introducing information to the field. And the advent of new, more democratic disseminating mechanisms meant that the products of these new operators could reach a wide audience. The picture postcard— cheap, easily distributed, incredibly simple to make (Kodak even introduced a special

paper with postal markings on one side in 1902)—was an important contributor to this confusion of voices. Amateurs found it a simple matter to make postcards of their babies, their houses, snowstorms, floods, boats, churches, bridge clubs, and the like—and they did, in tremendous numbers. Their output swamped the nation by the end of the first decade of the twentieth century, making photography no longer a privileged medium of meaningful fact but rather an uncontrolled transmitter of data.

The Detroit Photographic Company served as one of the most notable checks to this flood of inchoate messages. With its combination of an experienced, internationally famous photographer as manager and a staff of superb marketers, production supervisors, jobbers, and salesmen, the Company was able to generate a competing stream of visual information in which a wide variety of subjects were treated but organized into categories of usefulness and meaning. In addition, the process of controlling visual style meant that the output of the Company, while embracing widely divergent aspects of the American cultural landscape, drew that divergence into some sort of unity, so that viewers received new messages packaged in familiar ways. And by combining this new information with a flood of older, conventional photographs, the Company offered an overall package that interwove conservative and innovative visual materials.

In this Jackson played a vital role, for he brought with him not only his huge stock of images but an experienced, assured visual intelligence that could be put to use organizing and unifying the stream of pictures that came into the Company every day.

First as a photographer, then as a procurer of photographers and views, then as an editor and marketer of the images, Jackson played a continuous and indispensable role in the corporation, and in its effect upon American culture. If his was not a controlling influence within the Company, still it was a pervasive one. For Jackson participated at most of the many levels whereby the Company gained control over its output and took responsibility for the final product. This control began with the choice of photographer and the assignment of subjects. It continued with the editing of the negatives, with their cropping (often extreme), and with the interrelated matters of enlargement or reduction, and retouching. Then came the decision to market the picture as an Aäc color print or as a black-and-white image, and the seemingly mundane but often profoundly influential question of captioning.

In all these ways, the Detroit Photographic Company, and Jackson himself, took responsibility for instigating the process of image making in the first place. Thereby many of Jackson's own values ended up stamped on the broad body of the Detroit Company catalogue—in particular his capacity to see a fruitful interaction between the forces of nature, corporate capitalism, and middle-class man. But Jackson's ideas of what seemed natural to photograph (or to consider worth purchasing as a photograph) a decade before had now changed—sometimes subtly, sometimes manifestly. Cities, parks, and suburban experiments in tamed nature now pressed wilderness out of the canon of acceptable photography, and "landscape photography" as a pure genre reached its end—an end pointedly documented as early as 1907, when "Photographer, Landscape" disappeared from the *Denver City Directory,* replaced by a new term with a wider purview but, finally, a narrower space for individual action: "Photographer, Commercial."[41]

By that time, however, William Henry Jackson himself had retired from the ranks of photographers. Accepting the inevitable with some grace, he moved over from his more freewheeling position as "supervisor" of negative production and became plant manager late in 1903, when Edwin Husher retired to an orange grove in California. In the world of the information corporation, Jackson's new position moved him out of a profession that had lost its place at the center of American cultural production, and into a more typical, if less directly potent, role: corporate manager. With Livingstone and the other directors, he mapped the future of the Company, chose its subjects and photographers, and directed the smooth flow of its mass-production output. As an individual, however, the shift in profession meant the end to a lifetime of apparent freedom, and its replacement by a life of regular hours, commuter travel, and a landscape of golf courses and vacation trips. These would occasionally result in a note in the Detroit negative registers recording a few negatives made of boating parties or fishing trips—the idle occupations of vacation hours, signifying little beyond the instinct for landscape that remained even after the reason for that instinct had disappeared.

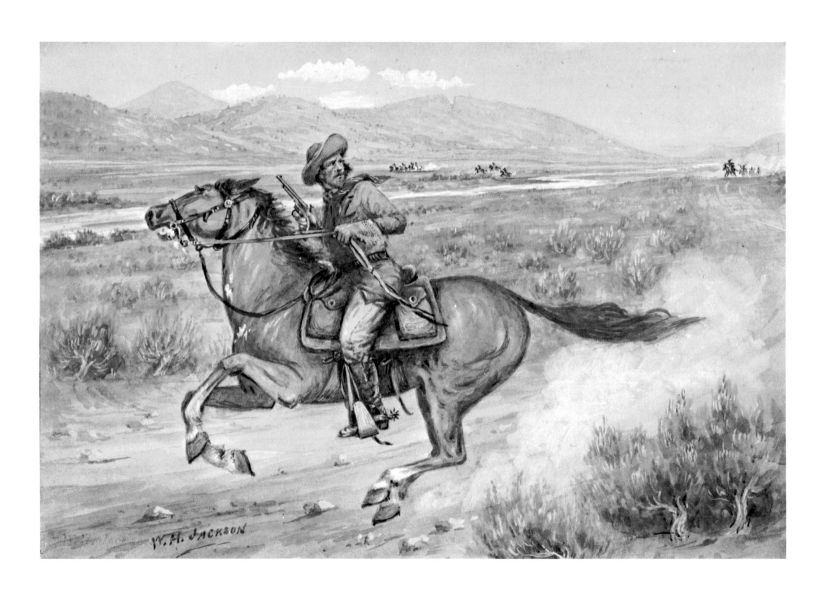

W.H. JACKSON

Each kind of them, each kind of man and
woman can have a description. There are many
kinds of them, each kind of them can have a
description.
—GERTRUDE STEIN,
The Making of Americans[1]

Late in June of 1924, William Henry Jackson received a letter from a Casper, Wyoming, oil executive, Robert Spurrier Ellison. Ellison had read Jackson's article in *Colorado* magazine telling of his experiences with the U.S. Geological Survey in the Mesa Verde cliff dwelling country. He was frankly surprised that Jackson, a pioneer of those golden days in the American West, was still alive. The letter was mostly fan mail; Ellison was an amateur historian, one of the growing ranks of those devoted caretakers whose energies founded numberless local historical societies and produced the reams of privately published monographs and books to fill their shelves. To Ellison's eyes, Jackson was that rarest of things, a genuine bit of history.[2]

Ellison ended his letter with a question. He had recently purchased "a wonderful folio of photographs put out by the government, I think, in 1870 . . . and on account of its covering the Teton, Jackson Hole and Yellowstone Park country, in particular, I esteem it most highly." Could Jackson identify this find?[3]

Jackson replied promptly: the folio was almost certainly one of those put out by the Survey during the seventies; given its contents, it could not have been produced before 1878. Jackson's reply was detailed, precise, and lengthy; Ellison was apparently delighted by the old man's clarity of mind and memory. But in the process of a further series of letters it became apparent that Ellison himself had little knowledge of his own portfolio—he had badly misstated the contents and had seemingly paid little attention to the images themselves.[4]

Nonetheless, Jackson was evidently flat-tered by Ellison's attention; it came at a difficult time and helped to redirect his energies from more fruitless channels. The Detroit Publishing Company had just gone bankrupt; after a wartime era of booming sales, principally of postcards for soldiers and sailors, the Company had finally succumbed to competition from the more sophisticated and less expensive reproduction technologies of the twentieth century. Jackson's own investment in the firm had disappeared, leaving him with a settlement for back wages and his Civil War pension.

The end of the Detroit Photographic Company punctuated a series of tragedies that had stripped Jackson of his identity. Emilie's death in 1918 had been a shocking blow; in Detroit their life had been more settled and satisfactory than at nearly any other time in their lives together. Now the old man was

187. (*opposite*)
*"Pony Express Rider,
Along the Sweetwater,"
ca. 1929–35.* NPS

283

alone, with nothing in particular to occupy him.

From the beginning, Ellison's letters offered solace and support at a time of self-doubt. Soon after the first exchange, Jackson resolved to leave Detroit for Washington, where he had been invited to live with his daughter, Hallie. With Ellison's enthusiasm as a buttress, he resolved to find a new identity for himself—as an antiquarian of the Old West.

Washington was the inevitable stopping place for such an occupation, then as now. All Jackson's negatives were there, housed at the U.S. Geological Survey; the Library of Congress provided a nearly infinite supply of history books in which to research; and Jackson's old friend and Survey comrade William Henry Holmes, for many years head of the Bureau of American Ethnology, was now director of the National Gallery of Art. Finally, Jackson had, for two years or so, been a member of the Cosmos Club, a center for American scientists and intellectuals that welcomed explorers of an earlier era. At first, the plan was almost entirely a private one; Jackson would, in his words: "get back to my painting . . . bring my journals up to date and do some writing." He envisioned a pleasant, relaxed retirement, combining reminiscences with old friends and compatriots, a return to the hobby of decades past, and perhaps some further publication on the order of his article on Mesa Verde for *Colorado,* the results of "research" in the echoing, dignified space of the Library of Congress reading room.[5]

By mid-1925, however, events had conspired against this quiet life. Already he had begun to find patrons for his paintings—late in 1924, he wrote to Ellison that "I have been doing some Indian subjects for a gentleman interested in ethnographic matters." And in March, Jackson was approached by Howard R. Driggs, a sometime teacher's college professor and writer of "as told to" reminiscences on subjects of American popular history. Already responsible for such "books for boys" as *Hidden Heroes of the Rockies, Jacko and the Dingo Boy,* and *Deadwood Gold,* Driggs was the editor of a "Pioneer Life Series" published by the World Book Company. He wanted Jackson for his next subject.[6]

Jackson found all of this somewhat disturbing. Already he sensed a disjunction between his public and his private histories. The pleasures of the retirement he had planned had included his immersion in a world of true veterans of the West—whether actual, at the Cosmos Club in Washington and the Explorers Club in New York, or documentary, in the form of the materials he was reading at the Library of Congress. This had enabled him to remain aloof from the rising tide of interest in the history of the West that had begun to form a significant portion of American popular culture—whether in written form or in the serial Westerns that ran in nearly every movie house in the country, to wild enthusiasm. Writing to Ellison, he confided his doubts about the new venture:

Stories of the early days of the west without a dozen or so encounters with hostile Indians, or some hair-raising shooting affair of some kind, are not likely to be considered a true reflex of the period. Now, you will have seen that in all my comings and goings through the troublesome '60s, I . . . never participat[ed] in a shooting adventure of any kind. Can a story of that time be made interesting for the general reader without that adjunct? Perhaps the W[orld] B[ook] Co. may not think so.[7]

Ellison, however, thought that adventure books should introduce some romance to foster a love of the past and its lessons. He had already encouraged Jackson in regard to the publication possibilities of his journals; now he wrote back, "I do not see any reason . . . why you should not draw on your imagination a little in writing a boy's book."[8]

Like many of the younger men who would cluster around Jackson during the next years, Ellison's primary interest lay in the history of the West as it might reflect forward on the present. Vice-president of an oil-drilling and refining company and an Indiana native transplanted to Wyoming, he had a stake in retaining the West-as-past in its pristine state; at the same time, he publicly lobbied for its development as an economic resource in the present and future. Driggs shared a variant of this attitude. His aim was to see that the lessons of the pioneer past—individualism, perseverance under adverse conditions, commitment to the work ethic and to democratic values—would be passed on to a new generation of young men who might not have access to the environment in which such character-building virtues had developed. Drigg's image of Jackson reflected this. He wrote in the preface to *The Pioneer Photographer* that Jackson was an "upstanding American" and declared, "Out of the reading of this volume will surely come . . . a deeper respect and appreciation for the heroes of times of peace, who are braving dangers every day in quiet ways to promote the welfare of our nation."[9]

Ellison, too, was urging a public persona on the old man. That summer, he arranged for Jackson to make a trip out West to inspect the portfolio, entertain friends old and new, and reacquaint himself with old haunts. The itinerary was an exhaustive one. Ellison marketed Jackson with expertise. Jackson arrived in Casper, Wyoming, by train, where an employee of Ellison's Midwest Oil Refining Company met him at the station and delivered him to the Company's Midwest Club. After a bath and breakfast, Jackson was driven to the Company office for introductions, then taken on "a long ride into the country." The next days included a trip to the Shoshone Reservation, an excursion to Jackson Lake, and then travel by car to Yellowstone National Park with a small retinue of Ellison's family and business associates. There Jackson reported that he "called on Superintendent Albright, and following a two hour interview all of us were photographed many times." The next day, he "devoted an hour to photographing [the] Tetons," no doubt to the charmed amusement of his colleagues. Then on July 2, he was guest at a "reception for old timers. . . . Was introduced to everybody as the pioneer of the region and Mr. A[lbright] had his photographer take a number of 'snaps' of us all singly and in combination." Jackson then went on to Denver, where "W——[?] called up [a Denver] *Post* reporter to photograph and interview me for [an] article." Two days later, there was an "interview with Hafen of [the] museum."[10]

The trip did not give Jackson unalloyed pleasure. He wrote in his diary of arriving at the Midwest Refining Company and finding himself in the awkward position of seeking his host among a group of people. Introducing himself to a retinue he assumed had been assembled to greet him, he wrote that he was "treated rather distantly and cold, and no remark made about my presence. . . . I became much puzzled and rather crestfallen." Expecting kindliness and respect, and promised much more than that, Jackson shrank into a corner until Ellison arrived. Then things were made right, but the image remains: an uncertain old man finding it difficult to understand both his own role and the responses of others.[11]

Though Jackson reported with relief that Ellison "reminded me at once of Rudyard Kipling," the executive was not above exploiting the photographer for his personal ends as well as those of his region and his company. After the Yellowstone sojourn, Ellison persuaded Jackson to return with him to Casper, where, at the Midwest Club, he had Jackson write out a set of "biographical notes," which Ellison planned to turn into one of his "monographs"—a short, privately published pamphlet of sorts, under the imprimatur of a local historical society, entitled *Jackson of the Yellowstone.* And he also asked the photographer to go over the Survey portfolio, signing the prints and writing captions or notes on the mounts.[12]

Ellison's motives for asking this of Jackson were probably mixed. As a historian, he must have hoped that the photographer's notes would provide an added measure of accuracy to his own picture of the past. As a matter of sentiment, Jackson's signature and notes offered a connection between the past and the present and brought the West of another time into the possession of the twentieth-century oilman. And as a capital-

ist, Ellison may have recognized that Jackson's notes would add immeasurably to the value of the portfolio.[13]

Jackson's response to this request was painfully telling. Sitting at a table in the Midwest Club, he wrote what he could concerning each image, sometimes just signing his initials, sometimes adding detailed notes. But some of the notes told more about the present than the past. Of the view of "Hot Spring and Castle Geyser" (see illustration 68), Jackson wrote: "This beautiful rim has been almost entirely destroyed, never to be entirely reformed, it is feared." On each of three other views of Yellowstone features, Jackson penciled, "Its glory has departed." On other pictures, he wrote "As they were—WHJ."[14]

This elegiacal sense, particularly coming so quickly after his triumphs at Yellowstone, suggests Jackson's discomfort with the West he was being asked to trumpet and even represent, and his sense of loss at a West now departed—more innocent, more spacious, sublime, and regenerative. Other hints of his uncertainty with the present—and, perhaps, his growing sense of his own mortality—surfaced in his dealings with Driggs concerning *The Pioneer Photographer*. It was at this time that Jackson began the process of reconstituting his own history. His first steps involved retyping his diaries into a condensed narrative form. The first redraft included many subtle substitutions of language to "Westernize" the narrative: in one short section of the 1874 diary, for example, "path" became "trail," and the phrase "on the road" was deleted entirely, to give the impression that Jackson and his team were enduring physical hardships to

arrive at their goals. Probably at this time Jackson erased the segment of his report on the first Yellowstone trip concerning the photographer Crissman, who had provided a number of the Yellowstone negatives later credited to Jackson. And the old man now found himself increasingly dependent upon Driggs—writing not to his own satisfaction but to the demands of his sometimes tyrannical coauthor. Jackson's diaries recount his meetings with Driggs and the nervous bouts they brought on.[15]

In his paintings, as well, Jackson found himself steadily encroaching on his own personality to feed his new persona. After losing most of his savings in a stock deal in the mid-twenties, Jackson was under increasing pressure to sell his paintings to the denizens of the new "old" West, men like Ellison and Driggs and the clients they brought. Ellison, for example, used Jackson's paintings as the illustrations to a number of his pamphlets; he was able to pay Jackson, and in return received not only the paintings but the added cachet that came with Jackson's name. Thus he included, in the introduction to *Independence Rock,* an irrelevant but rather lengthy history of Jackson's career, which served as a sort of de facto proof of the authenticity of the pamphlet itself. Driggs, too, acquired a number of Jackson's paintings to use for his own projects.[16]

These relationships began to have their effects on the paintings themselves. Having decided upon retirement to return to the medium, Jackson found himself uncertain as to what precisely he would do with it. His first attempts were replications of his early photographs—one of the "Shoshone Village," another of the "Pawnee Village." Con-currently, however, he began a reproduction of his earliest Western painting, "California Crossing, Platte River," made in 1867 after his return from the far West. This new version (now lost) was derived like its predecessor from sketches made on the spot. But whereas the first presented a sublime landscape with a crisp clarity that approached the hallucinatory, this second version cloaked the background in haze and indistinctness. In the foreground, too, the frieze of figures and incidents lost the sense of consuming interest in the anecdotal qualities surrounding the Westward emigration. In its place was a sort of enervated formality.[17]

Drawn deeper into the net of relationships with Ellison, Driggs, and their compatriots, Jackson found a ready market for his paintings, but paid a price for it. Between 1924 and 1928, Ellison made a point of introducing Jackson's name to a number of amateur historians, especially through his connections with the New York–based Explorers Club. These men were often interested in purchasing paintings and sketches of an antiquarian nature. Their first preference was for original drawings; Jackson lamented to Ellison that he had so few of those he'd made between 1866 and 1870. Next in value were "historical" reminiscences by veterans of the era, and Jackson qualified. The drawings and paintings he made of this type were often derived rather straightforwardly from his original photographs. Finally, there were the paintings and drawings of famous Western events, which had their value primarily because they were made by Jackson.[18]

Jackson's paintings thus moved toward a notion of historical precision defined not by himself but by others. Indeed, once this pattern started, the old man found himself increasingly hemmed in by Ellison's demands, as drawings and paintings passed back and forth many times while Ellison corrected Jackson's historical details, suggested revised compositions, urged additions and deletions, sent photographs to serve as sources, and generally took over the responsibility for making sure that the painter got his paintings right. As Jackson began to provide illustrations for Ellison's own historical "monographs," the amateur historian's concern for accuracy began to approach pettiness. Jackson redid the illustrations for *Independence Rock* (1930) and *Fort Bridger, Wyoming, A Brief History* (1931) a number of times before Ellison was satisfied with their "truthfulness."[19]

This trend reached its culmination in a painting Jackson made for Ellison in 1934. It was "a picture of the Red Butte Battle"—an Indian war scene, exactly the sort of thing that Jackson had confessed to Ellison long ago was furthest from his own experience. Jackson wrote to Ellison rather proudly of the result; he had, he felt, conceived a balance between size and detail that was unusual for his work but extremely satisfactory. Still, Jackson voiced his worries about a key issue of his painting:

There is hardly a limit to the detail that might be worked into such a picture. Perhaps I have put in too much. With the idea of telling the story of the engagement as far as possible, I have made a sort of bird's eye view of it. . . . I am sending the picture on to get your opinion of it. And also if it will be worth while undertaking a larger one.[20]

Jackson had hit on precisely the problem most troubling to his later paintings. His

original drawings had largely suppressed narrative and detail in order to communicate a sense of the space, the land, the atmosphere of the West as he himself was experiencing it. His earliest paintings from 1924 and 1925 sought to reproduce this sense, in part by working up from the original sketches, and in part by using his own photographs as sources. The antiquarian interests of his clients, however, had increasingly moved him to narrative subjects, or to introduce narrative elements to his otherwise atmospheric studies of the Western landscape. Occupation became an obsession—no one, it seems, was content with an empty or nearly empty topography, and his clients insisted that Jackson fill it with exciting incident, and accurate incident at that.

Ellison's response to the "Red Butte Battle" painting was of a piece with this trend. His recommendations virtually guaranteed a further cluttering of the painting. On January 29, 1935, Jackson responded to him:

I have conformed to your opinion as to the use of war bonnets in actual combat by those chiefs and other headmen entitled to wear them. I have distributed these around in a few prominent places, clothed some others in colorful leggins, and left the greater rank-and-file to the more common breech-clout and moccasins—all of which is in accordance with my first conception of the subject.

Ellison's interest lay, we can see, not simply with adding accuracy, but with adding *colorful* accuracy—war bonnets, "leggins," and the like. Jackson's additions satisfied his patron—Ellison bought the painting for $150.[21]

Jackson's migration from a landscape of memory to one of modern popular myth was hastened by his involvement with one of the first major marketing organizations for the West as popular history: the Oregon Trail Memorial Association. Founded by Ezra Meeker, another veteran of the "true" nineteenth-century West, it was an extension of Meeker's rather bald ambitions to capitalize on his history and his longevity. By the time he founded the Association in 1926, Meeker had already executed such stunts as retracing the Oregon Trail with a team of oxen; he had conceived that it was the nation's responsibility to "rediscover" and memorialize the Western trail with a series of stone monuments and had set about assiduously raising funds for the project. With the founding of the Association, Meeker was able to create an air of permanence and disinterest that allowed Congress to pass a bill authorizing the minting of 6 million fifty-cent Oregon Trail Memorial coins, to be sold at twice their face value, with the profits to be applied to the marking of the Trail and the creation of a series of other, increasingly vague memorials, including the preservation of written accounts and memorabilia as well as the commissioning of movies, paintings, and photographs. Driggs later described the shadowy purpose of the Association as devoted "not alone to saving our wealth of pioneer traditions, but also to putting them to work for America . . . to helping promote the all-American cause." Driggs had become something approaching Meeker's heir-apparent, and after Meeker's death in 1928, he became president of the Oregon Trail Memorial Association. In 1929, Jackson reported he "called on Driggs who intimated employment by OTMA." Later that year, after the successful publication of *The Pio-*

neer Photographer, Driggs appointed Jackson "research secretary" of the Association, and Jackson moved to New York.[22]

Jackson's tasks with the Association were mixed; essentially, he became the organization's resident pioneer, replacing Meeker at the job. This meant a number of interlocking tasks. Probably the closest thing to his actual title was his responsibility for researching various minor historical points—a matter that took up a minimum of his time. Of far greater importance to the organization's continued health were the Association-funded summer excursions he made for publicity purposes: to historical society meetings, Western history conventions, festivals, holiday events, and the like, throughout the West. There he was trotted out, sometimes to give a slide talk, more often to say a few words or even simply stand on the podium or wave from the open car in some parade celebrating "Independence Rock Memorial Days" or the like. Often he made these trips under the eye of Driggs. In 1929, a trip took them to Yellowstone for the dedication of a plaque at the park, to Emigrant Pass, and then to Casper, Wyoming, where he spoke at a historical society meeting, then to Fort Hall for a similar encounter. Out West in 1932, Jackson was driven around by his old Yellowstone rival Haynes, who took him to an appearance in a Wyoming town where Jackson "lined up with eight or ten others on the grandstand" to be witnessed and applauded by the citizens of the new West. In 1934, he and Driggs met in Salt Lake City, where they dedicated a bronze plaque commemorating some unnamed Western event; both men spoke at the ceremony. Then Jackson went on to Den-

ver, where he participated in the Fourth of July parade and gave an Independence Day speech, before going on to ceremonial occasions in Cheyenne, Wyoming, Idaho Springs, and then at Berthoud Pass, site of one of his most famous photographs (see illustration 192). In 1937, Jackson wrote a postcard from Cheyenne, Wyoming, reporting he had been "touring about the Black Hills, including visit to the haunts of Wild Bill and 'Calamity Jane.' Celebrated at Fort Laramie yesterday." At Cheyenne, he was scheduled to "meet a delegation of our Oregon Trail Ass'n and accompany them to Salt Lake City for some sort of a convention"—just which, among the blur of similar occasions, Jackson could not recall.[23]

Between the teens and the thirties, the twentieth-century tourist experience made a further transition that reflected the general cultural shift from individualism to shared social experience. That decade saw a return to more collective vacation experiences, and it was on these that Jackson found an important place. By the thirties, the Association was sponsoring "trail drives"; members and friends would travel in caravans along the routes closest to the old Oregon Trail, in a sort of organized camping excursion that culminated at the Association's annual convention. Jackson's presence on these drives lent authenticity; apparently he was part of the nightly entertainment, a mixture of guide, historian, storyteller, and totemic symbol of connection between the past and the present.[24]

Jackson's summer road trips with the Oregon Trail Memorial Association mirrored the latest phenomenon in American touristing—the auto tour, whereby couples, families,

even organizations spent their summer vacations "gypsying." These trips brought an increasing number of middle- and upper-class Americans into direct contact with the topography of the West, but they also organized and defined the experience in specific ways. First, there was the distance between the imagined past and the prosaic present; "gypsies" made their search for "authenticity" and were often disappointed. But the Association's drives were designed to alleviate this where possible by providing colorful and authentic commentary by veteran Westerners and devout historians. Thus vacationing excursionists received what they came for—Western romance, a sense of escape from the urban present, immersion in "Nature's vernal call," leading to a rebirth of "more primitive and stronger currents of being," as a 1924 article in *Motor Camper and Tourist* magazine called it, and even a sense of reconnection with the legendary past.[25]

More important, however, the Association's trail drives generated a sense among participants that the Western region was something more than topography. This, in turn, reflected the strange sort of dualism inherent to the tourist phenomenon as a whole: a distance between the tourist, who experienced the West as a shadow-place of symbols and memories, and the resident, who experienced it as a place in which to live—a topography, a climate, a collection of people—before it was a history. But this disjunction was oddly less and less evident in the West of the twentieth century, as residents, too, came to see their region as a place where a "heritage" dictated aspects of everyday life. In this transition, as well, Jackson was a participant, for his speeches,

parades, and the like were often supported and sponsored by Westerners themselves. In addition, many of Jackson's friends in the West were devoutly committed to its myths and assiduous in their missionary activities on its behalf. Men like George Gilchrist and Fred Mazzulla of Colorado, Driggs and Hafen of Utah, and Ellison of Wyoming were busy founding and supporting institutions to bring a heritage consciousness to Western residents—and Jackson offered them a ready symbol and a potential ally.

But these motives were only part of the reason for Jackson's summer work in the West. The general shift in consciousness toward the West manifested itself specifically in steadily increasing attendance and support of events and institutions. For the Oregon Trail Memorial Association, this translated directly into matters of survival. Jackson's rounds of public appearances were vital to the continued health of the Association. He was a commodity not only for public events, where he might bring new members to the Association and new support from the broader populace, but for other sorts of fund raising as well. Private donors, charmed by Jackson's affable presence and impressed by Driggs's academic credentials (which he and others were quick to parade to suit their purposes), would help the Association through a number of financial crises over the next years.[26]

In addition to his role as a presence in the Association, Jackson also was expected to produce some of the "memorials" to the Oregon Trail, in order to justify the spending of congressionally monitored funds on his salary. He reported later that "in those years I turned out hundreds of water-color sketches

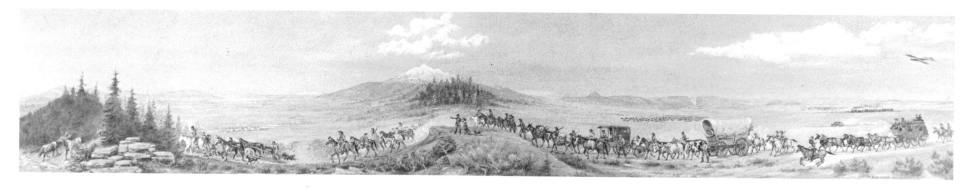

188.
"Westward America,"
ca. 1929–35. NPS

and at least a score of sizable oil paintings" for the Association as well as the continuing stream of private patrons. They primarily concerned incidents along the Oregon Trail, especially during its heyday—the two decades *before* Jackson traveled it in 1866 and 1867.[27]

These paintings were essentially recountings of the clichés of Western romance and history, and Jackson rendered the scenes themselves in the most bald of visual stereotypes. The majority were views showing the Oregon Trail at various famous spots, crowded with pioneers, all of them busily engaged in historically verified activities. But to viewers of an age less steeped in the romantic popular culture of the West, the paintings have the quality of old museum dioramas. Too many supposedly typical events are packed side by side, too many examples of different transportation types, pioneer types, age groups, costumes, and the like crowd the compositions (illustration 188). Their subject matter, however, serves as an excellent catalogue of American popular conceptions of the West during the thirties. Indian battles, Indian powwows, Indian ambushes, buffalo hunts by whites, by Indians, and by fur trappers, and Pony Express stations and riders are interspersed with repeated views of long lines of covered wagons winding through the Western landscape. Their episodic quality seems drawn wholeheartedly from popular fiction and movie serials. A painting of a Pony Express rider (see illustration 187) shows him riding flat out, gun drawn, pursued by at least three separate bands of Indians. A view of a "Sod House" portrays the idyllic perfection of the American yeoman myth.[28]

While in these paintings of the thirties the foreground anecdotes became sketchily painted cartoons, the background landscapes often retained potent remnants of Jackson's history. Jackson seems to have divided the spaces of the paintings in two when making them, folding the front half downward slightly to give more space and readability to the mass of anecdotal materials, and leaving the distant spaces sublime and monumental. Often this occurred because his deep-space landscapes came directly from his earliest sketches or his Survey photographs. This was the case with a painting of the Oregon Trail subtitled "Along the Sweetwater Near Split Rock," which Jackson finished on July 8, 1930 (illustration 189). While the foreground would shame the producers of *Westward Ho! The Wagons,* the background behind the stage station is drawn directly from Jackson's photographic "View on the Sweetwater," made for the Survey in 1870 (see illustration 50).[29]

The views whose backgrounds he took from his earliest sketches are even more eerie. Here it is as if two different eras coexist within the same frame. In his "View of the Chimney Rock Region from Courthouse Rock to Scott's Bluff, Western Nebraska," the background is derived almost entirely from a sketch Jackson made on the spot on July 31, 1866. In fact, this and a few others look disturbingly as if the painter had worked directly over the original drawings; the Western landscape exists as a pentimento to the harsher caricatures of the emigrants.[30]

The backgrounds make sense from the standpoint of 1866, the foreground narratives from that of 1930. Jackson was apprehensive that Driggs and his other acquaintances and friends of that era would not approve these

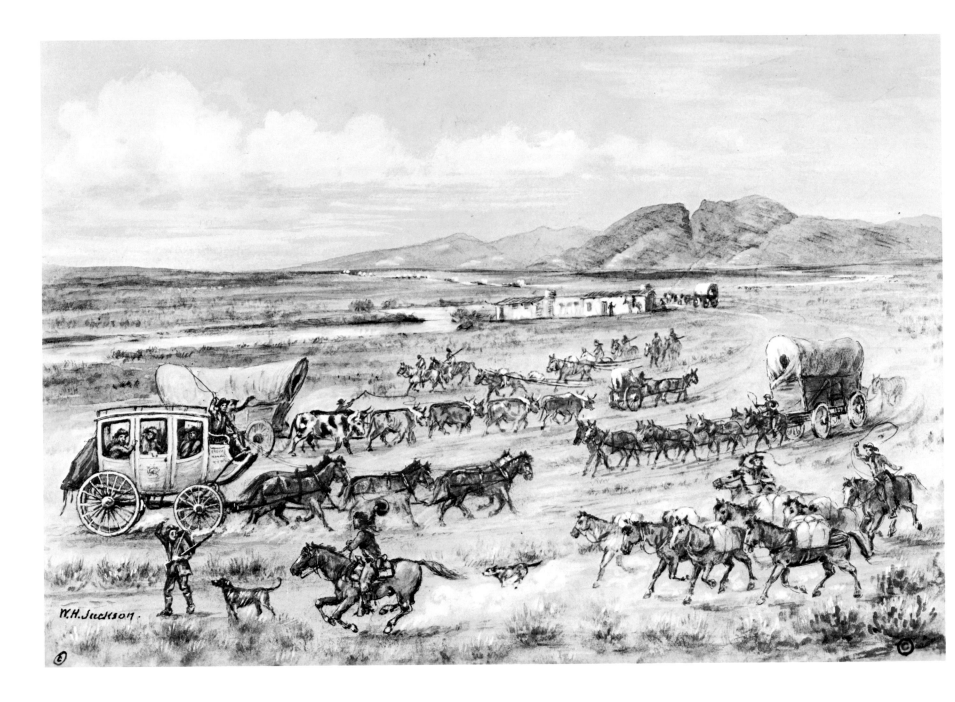

W.H. Jackson.

paintings; in one diary entry he described the pains he went to to make sure they were liked: "Freshened up the drawings a little more and took them with me to the [Association] office. The binding I put around the borders helped their appearance greatly."[31]

Jackson understood that his livelihood depended on his patrons, and in the case of the Oregon Trail Memorial Association, that meant fitting his work to the unexamined but powerful demands of a large popular audience, as he had in other eras of his career. Jackson's paintings were of value to the Association not simply to alleviate embarrassing inquiries by congressional investigators or to provide appropriate wall decoration for office walls or even to give an old man, once an important figure in the taming of the West, something to occupy his time. They were meant to be publicized, published, and used to further the Association's purposes, and Driggs and others worked with Jackson to make sure this happened. As early as 1929, Jackson reported he was "working part time on drawings and collected pictures to illustrate pamphlets." In 1930, many of his Oregon Trail paintings appeared "illustrating a new edition of [the famous Western historian Francis] Parkman's *Oregon [Trail]*." The edition was lavish—"Some of them are in color and are very well reproduced . . . [and] exceedingly well done. . . . The reputation as an illustrator of the *Oregon Trail* should be of some benefit in getting other work of the kind." Made into slides, his paintings went the rounds of the lecture circuit with Driggs, who reported they received "a fine appreciation from the audiences." And throughout the period Driggs and others schemed to produce first a book of the paintings,

and then a new combination of autobiography, journal entries, and paintings to supplant *The Pioneer Photographer*. Both these plans reached fruition, though not until the end of the Depression. *Time Exposure*, Jackson's autobiography, appeared in 1940, and Driggs published *Westward America, With Reproductions of Forty Water Color Paintings by William H. Jackson* in 1942 under the imprint of his organization, just previously renamed the American Pioneer Trails Association.[32]

What seems at first most surprising about all this is how rarely Jackson's original photographs appeared as part of the generation of his new image as a pioneer of the American West. But the paintings were made for a twentieth-century audience, the photographs for a nineteenth-century one. Like the photographs before them, the new paintings were generated out of a consensus between Jackson and his patrons, and both producer and client had their eyes directed toward appealing to the large pool of Americans interested in the West. As it had in the past, this meant that the objects that resulted communicated their meanings in a visual language appropriate to that audience. And in the case of these Depression-era works, it implied that the most successful pictures would satisfy a conservative, even nostalgic desire for an era more prosperous, more optimistic, and more open-ended than the present. Jackson's paintings of this period celebrated an American past—or, more precisely, an American dream—in which individuals were able, by their pluck and perseverance, moral rectitude, and religious belief, to wrest economic and personal satisfaction from the landscape. Like the fan-

tasies that attracted so many Americans to the movies during this decade, Jackson's paintings offered an escape that was also a reaffirmation of faith in American values ("the all-American cause," Driggs had called it), and a declaration that such values might still afford the individual some hope of success.[33]

The year 1935 saw the amalgamation of a number of Jackson's roles as new representative of the Old West. He reported to Ellison that he'd been the recipient of "frequent calls to show my slides and talk about the old days of the Hayden Survey"; in addition, he'd been working on a painting as a gift to the oil executive, now living in Tulsa, Oklahoma, where he was president of Standard Oil of Indiana's crude oil purchasing and pipeline divisions. It was a study of Custer's last stand. Jackson's annual summer excursion to the West culminated in what was probably the ultimate of his parade and speech appearances. The seventy-fifth anniversary of the Pony Express called forth a national celebration, and Jackson carried a message by airplane to Franklin Delano Roosevelt, from three hundred Boy Scouts who had ridden relay over the old route. At the White House, he presented a "commemorative gold medal" to the President.[34]

This government-sponsored pseudoevent signified a larger phenomenon into which Jackson, probably unwittingly, stepped: the acquisition of the Old West by the New Deal. Much of Roosevelt's program included natural resource and land-use involvement by the government, from the Civilian Conservation Corps (CCC) to the Farm Security Administration. Many of these programs represented a new policy of government in-

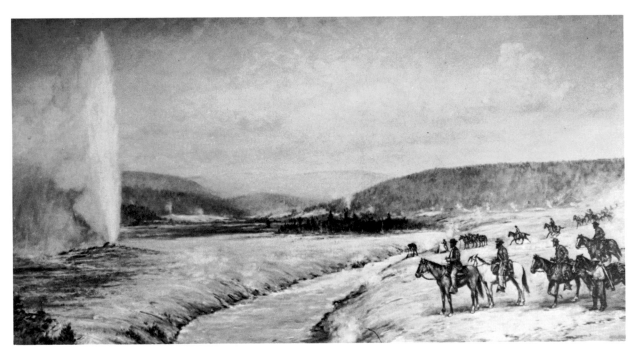

190.

"First Official Exploration of the Yellowstone, Wyoming Region," 1936. ID

volvement in the American landscape, in which the government became the active intervener and also the judge of what should properly be done to preserve and protect both the nation's natural resources and its general welfare. This policy went squarely against many, if not most, of the elements of the older Western myth—individualism and laissez-faire, and more generally, the entire notion that a benevolent deity had foreordained the best possible outcome for American involvement with nature in the West.[35]

To support this change in policy, the Roosevelt administration had engaged in a number of propaganda campaigns, ranging from publicity squibs in newspapers to the more general policy of directing Works Progress Administration (WPA) artists, Farm Security Administration photographers, and the like to promote the policy of wise, government-supervised land management. Thus it was natural that Jackson, visiting the Interior Department on the day after his appointment with Roosevelt, was approached by the director of the National Parks Service and asked if he would join the artists sponsored by the WPA. The Director had a specific project in mind: he wished Jackson to produce a set of four large paintings, one to commemorate each of the great Surveys of the seventies, to be hung in the planned Museum of the new Interior Department Building.[36]

The Museum (largely untouched even as late as the 1970s) was a classic example of New Deal documentary-as-propaganda. Its dioramas advertised each of the ways in which the government's active intervention in the arena of natural-resources management had served to better the nation, even as it reassuringly celebrated America's wealth. Jackson's murals would hang with two by another WPA artist, Wilfred Swancourt Bronson, entitled "Beginning of Irrigation" and "Modern Construction Provides for Irrigation and Water Conservation."[37]

Jackson's murals in essence completed the full circle of the photographer's involvement with the government in the marketing of the American West. His paintings presented the Surveys as emissaries of a benevolent government that had sent out its representatives in the name of the people. In their final context at the Interior Department Museum, they presented the first stage—exploration—in a complete process by which the government presided over the discovery and classification of the national resources and then determined their best use, regulating and watching over the exploitation of nature to guarantee that the best interests of the nation as a whole were being met. Jackson's stiff, stilted compositions, designed to enable guides or visitors to identify each member of each party, presented a near caricature of visual propaganda.

Jackson reported that he had spent much time researching the various Surveys, seeking the right details and the proper ceremonial moment to depict. The mural of the Hayden Survey (illustration 190) is especially suggestive. As he did with the other three, Jackson chose a moment not of historical richness but of popular memory—that

is, he showed his viewers what they already knew about each party. Wheeler's Survey was shown camped in front of the Zuñi Pueblo; Powell's was portrayed at the entrance to the Grand Canyon; and King's was shown in front of a misty mountain range, the foreground tents rigidly lined up, American flags flying on each side of the painting. Hayden's, naturally enough, depicted the party in the act of witnessing the first public eruption of Old Faithful at Yellowstone; Jackson even portrayed himself photographing the event.[38]

Two disruptions in the Hayden painting are rich with implication. The first concerns a deliberate historical falsehood; Jackson included N. P. Langford in the scene, although he was not present on that Survey, because of his importance to the founding of the Park and its development. This represented an overt violation on Jackson's part of his code of historical accuracy, a code that had been hammered home to him by Ellison, Driggs, and the rest. Jackson evidently did it because he understood the purpose of the mural was not to describe a truth about the Survey but rather to celebrate the Survey as a predecessor to the current government policies. Hence Langford, legendary representative of a government intervening to protect and preserve the environment, became a crucial figure—he was possibly the only man in that mural outside Jackson himself whose name visitors might recognize.

The second disruption is a broader one: these new government policies of management and intervention went against the ideology Hayden had himself promoted during the Survey years. Hayden's image of the government's function was as expediter of laissez-faire development; the Survey was to discover valuable, potentially exploitable natural resources and promote them to private individuals and corporations. Once this process was begun, the government was to stand aside rather than intervene. In fact, the New Deal policies derived rather straightforwardly from the arguments of Hayden's archrival, Major Powell, concerning the necessity of resource management. But when this painting is set with the other three in the context of the Interior Department Museum, what comes forth is a message of measured, ceremonial impingement on the wilderness, respectfully witnessing, investigating, documenting, and protecting. Hayden and Powell thus appear in the murals to be brothers in spirit; both tread lightly on a landscape of natural wonders, both prepare it for its preservation.

Jackson's successful completion of the commission cemented a relationship between the old man and the New Deal that would continue throughout the thirties. Jackson's commission with the WPA was extended, and he produced another six oil paintings and more than forty watercolors of National Park subjects to be distributed to the individual parks, where many can still be found, above the information desks or next to the entrances to the theatres. When the Interior Department hung the murals in Washington, it sponsored a special reception in the artist's honor—an unusual activity for WPA artists, to say the least. And in 1940, the Department arranged for an exhibition of Jackson's Survey photographs. Now Jackson's photographs had a new context in which they might be once again relevant: as witnesses to that early phase of government-sponsored exploration and management of nature in the West. Presented under the sponsorship of the Interior Department, in the same building where his murals hung amid dioramas and admonitory placards, Jackson's photographs had been successfully resuscitated. Torn from their old history, they were true to a new history of the West.[39]

Government sponsorship moved Jackson firmly to the front ranks of publicly recognized and revered historical figures. Projects that had languished for years, now finally became sought-after items, in particular his long-planned book of watercolors and his new autobiography. The former marked his place as a dean of American "Western artists"—a category that remains a specific and extremely influential (if underanalyzed) segment of the American art market. And his elevation pleased Jackson mightily, signaling the satisfaction of a rediscovered dream: to be respected as an American artist and painter.[40]

Jackson's response to the planned publication of his book of paintings reflects his successful adaptation to his new role as a sort of benign living figurehead for the rising tide of Western nostalgia and interest. The autobiography—while it, too, fed on and fed this phenomenon—made Jackson uncomfortable. Jackson had been approached around 1938 by the respected publisher G. P. Putnam's Sons, which was interested in producing a full-length autobiography under Jackson's name, with a large number of his drawings as incidental illustrations, and a few of his photographs as well. But Putnam's was not interested in Jackson's writing—it wanted his life, to be molded

and made literate by a ghost writer. Evidently troubled, Jackson wrote to Ellison concerning the plan, and Ellison wrote back supporting the idea and suggesting a specific writer for the project. By that time, however, Putnam's had already chosen their own writer, a figure rather spectrally known only as "Brown." Jackson's life was fine material, an editor wrote, but it would have to be "dramatized."[41]

Jackson spent the next year working with "Brown" on the text of what eventually became *Time Exposure*. The finished product was a strange amalgam of fact, romance, anecdote, shaded truth, and sheer fiction. The alterations to Jackson's history were of a piece with the entire rewriting of his life that had occurred in the twentieth century. Jackson's early life developed a log-cabin-and-firewood wholesomeness to it, with its farmhouses and kitchen stoves. Jackson's years with the Survey were heavily bowdlerized; his commercial years were stripped of nearly every trace of financial insecurity, personal strain, or doubt. A relentlessly cheerful book, *Time Exposure* ended with Jackson's dietary prescription for long life and his suggestions of alcoholic moderation; a final paragraph, probably tacked on while the book was in galleys, noted the old man's survival through other wars than the one just begun.[42]

Probably the single most significant change in Jackson's career as it was redefined in *Time Exposure* concerned the relation between the individual and his surroundings. Examining the old man's history in the mid-twentieth century, Putnam's ghost writer unabashedly heroized and, more important, individualized Jackson, separating him from his context and from the nets of influence and circumstances and introducing him as an artist of the twentieth-century type. Eradicated were Jackson's complex relations with the marketplace of his time, his interactions with other photographers, and the collective nature of his commercial studio, with its assistants, its traded and purchased negatives, and its managerial emphasis. In their place was the ideal mid-twentieth-century American artist: a photographer who was able to be artist and capitalist alike, sacrificing nothing in either arena.

Jackson himself was ambivalent about the result of his collaboration with "Brown," and the text shows this tug of wills in subtle ways. In places, Jackson managed to maintain his inherent generosity and readiness to credit others; when it did appear, it jarred slightly with the overall tone of the text. And whereas Jackson wished to remain "attentive to the landscape," in his words, his coauthor evidently was more interested in personality. The result left Jackson writing to Ellison alternately proud and embarrassed: he reported the successful sellout of the first edition and the publication of a second, as well as the Navy's order of 150 copies to go in ships' libraries. But he invited Ellison's *really candid* opinion." "You know how it was," Jackson confessed, "I furnished the background of facts but not entirely the words or spirit with which they are presented."[43]

Jackson's hesitancy over *Time Exposure* reflected a larger doubt that came with the role of public figure. Pleased at the honors ("I have been one of the fortunate," reads the last line of *Time Exposure*), Jackson was also aware of the loss of control over his own history, even his own persona, that came with that. Jackson had become a celebrity, furnishing "the background of facts but not entirely the words or spirit with which they are presented." Caretaker of Western myths, he was becoming lost in their latest incarnations.[44]

This diffidence reappeared in another fashion in one of Jackson's last public acts: while in Washington for a preliminary viewing of the 1940 exhibition of his Survey photographs, he was approached to become the subject of a "sound-reel recording," a managed oral history for the Interior Department's continuing series of public presentations, part citizen education, part self-promotion. Jackson agreed, spending most of a day in a government studio, recounting the history of the American landscape.[45]

We may end with this image, illustrated by a typical government-issue publicity photograph (illustration 191), sent out to accompany a press release, no doubt. Jackson is in Washington for the interview; the interviewer asks him a series of questions, most of them well-intentioned, ignorant, and ultimately inane. "Mr. Jackson, how would you compare the U.S. to the foreign countries you visited?" "Mr. Jackson, what were the grasses like on the prairie?" This Interior Department representative of the New Deal has a fixed notion of the West he is attempting to reclaim from this "old-timer." He is attempting to correct popular misconceptions about America; he thinks what he is doing is that new vogue, "documentary." But the image he tries to counter is that of the movie serials of the period, derived from Zane Grey's novels, themselves derived from Owen Wister's West—on and on, in a seemingly end-

less series of distorted reflections of reflections reaching back even to Jackson's actual history and beyond.[46]

The interviewer hopes somehow to use this living remnant of history to achieve a *true* image of the nineteenth-century American West. But the questions he asks are completely wrong for the old man who is his subject. His interest in Indians reminds us of Jackson's rather plaintive report to Ellison on the pressure to romanticize his history, and Ellison's reply: "I do not see any reason . . . why you should not draw on your imagination a little." The interviewer continues, with his rich radio voice and interested tone, attempting to extract picturesque homilies from this living legend, this pioneer of the Old West.

Against his deep baritone, the tape is full of Jackson's high, breathy, rapid speech. His responses interrupt and eventually silence the questioner, as the old man struggles to implant his history on the limited immortality of a rotating metal wire in a recording machine. But the story that high-pitched rapid monotone recounts is closer to a recitative than a reminiscence. It is the condensation of all the speeches and autobiographical statements Jackson had made in the past two decades, down to the stock phrases—about the one fabled brush with Indians in 1874, about the length of time it took to make a wet-plate image. Jackson's voice warbles faster and faster; eventually we, and the interviewer, find we cannot precisely understand it. We are left in a space between other spaces—between Jackson's own history, as he lived it, and his life as he had come to understand it in 1940, and finally our own constructions of meaning and respect we wish to find in his story. Momentarily disconcerted, we wait for order to reassert itself, while Jackson's own voice fades from comprehension, still constructing a landscape of sorts, arranging and rearranging incidents across the topography.

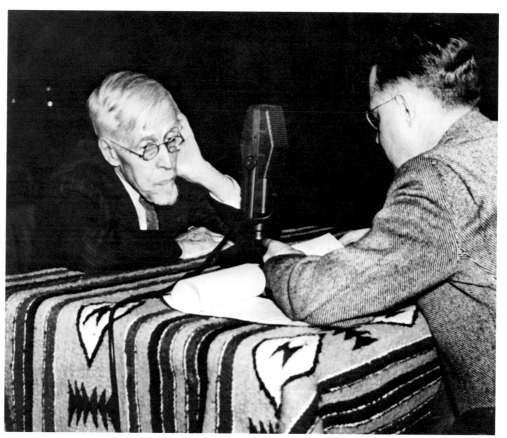

191.
A publicity shot of Jackson being interviewed at the Interior Department, probably 1940. ID

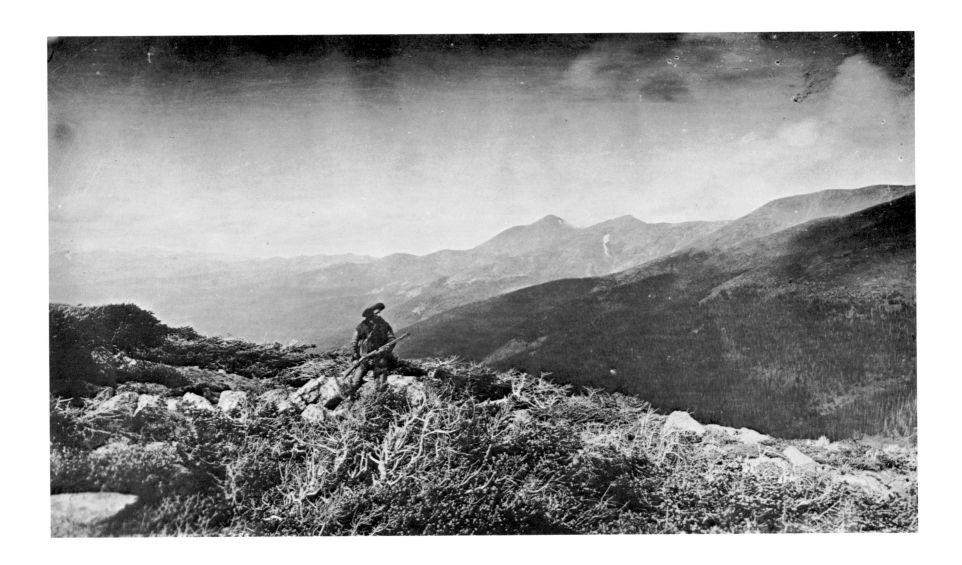

Any one can begin again. . . .
—GERTRUDE STEIN,
 The Making of Americans[1]

William Henry Jackson died on June 30, 1942, of injuries sustained in a fall at his hotel in New York. His death did not particularly slow his production. Over the next decades, Jackson's name continued to appear on books, articles, illustrations, sound recordings, novelizations, newsreels, educational materials, and the like, as well as a host of reproductions of his photographs and paintings. In addition, his influence lay heavily on the steadily increasing number of images of the American West produced in the fifties and later, nearly all of them indebted to his legacy, whether consciously or unconsciously—from Technicolor Viewmaster stereos of Yellowstone to Ansel Adams's Wagnerian variations on the nineteenth-century American landscape photograph. And with the discovery of photography as an "artistic" medium in the sixties and seventies, Jackson's pictures reappeared at the forefront of interest in nineteenth-century landscape photography. Thus the photographer continued as a powerful spokesman for the centrality of landscape to American culture; his continued revitalization signals the power of the myths he generated, transformed, and tended throughout his life.[2]

To say that Jackson participated in the transformation of the American West from vast potential to bounded, exploited actuality and thence back to myth again would be to limit him too much and pretend too clear a distinction between myth and historical reality. But we may begin with that. His return to prominence in the twentieth century, I think, resulted from a new need to reconsolidate this modernized America with its older myths, for the older landscape to reappear in an adaptation to the modern, as nostalgia. At the same time, Jackson's resuscitation signaled a vacuum in modern American culture requiring the reemergence of individualism as at least a symbol, if not an actuality. From the mid-twenties until his death in 1942, Jackson played out both these roles—as a symbol of the American West and its redemptive possibilities and as a vestigial reminder of a concurrent American individualism that had supposedly opened and "tamed" the West. The living Jackson and the mythic Jackson steadily diverged, however; by the forties, the old man was in danger of disappearing into his own image, as his nineteenth-century landscapes of memory and experience disappeared under

192. (*opposite*)
"North From Berthoud Pass," 1874. NA

297

the impastoed paintings of the new myths, myths reclaiming the West once again as a place of escape—but now an escape into fantasy rather than possibility.

This correlation of the West and escape had existed since Jackson's earliest experiences: of his father's futile attempts at different careers and different regions, and of his own exodus, in 1866, from the shrinking promises of the East. But in this, too, the West changed its meanings, from its offer of permanent physical escape to its presentation in Jackson's railroad pictures as a vacation ground affording release from the work place and the East and finally to its use as a fantasy, a substitute for lost freedom. The most striking example of this is not, in fact, one of Jackson's pictures at all. It is Ansel Adams's wildly popular photograph "Aspens," printed nearly life-size and mounted as a room divider: the photographic successor to nature, offering to stand in place of windows, doors, even the imagination, in the modern home or office. This substitute sublime of the twentieth century reminds us of the deeply rooted desire of Americans for some myth of unsullied nature, something purer and more gracious than the products of man. It was a desire Jackson's friends and patrons of the twentieth century understood well, and their pressure to reconstruct the old man into a symbol of that regenerative landscape speaks of both the power of the myth and the power of the man.[3]

Jackson was never a hero, for his work and his personae were too central to the dominant strains of American culture to allow him the sort of outsider status that seems inherent to the nineteenth- and twentieth-century elitist notions of the hero. Nor was he the heroic "embodiment of an era" that the popular documentaries of the thirties were so fond of discovering—for even at its most monolithic, his culture was too loosely conceived, too dependent on negotiated relationships among smaller groups, for any single individual to successfully embody such a whole. But he was deeply involved in the generation, the celebration, and the transformation of a central myth of American culture, and he was one of those most directly responsible for adapting it to new cultural conditions in order that it remain central to the culture. When that myth was a magnetic one, drawing individuals out from the core to the boundaries, from conservatism to activism, from East to West, Jackson was its voice and eye, and he was also a representative of the men and women who believed the myth, acted on it, and thereby continued to make it real. And when it became, eventually, a nostalgic myth, connecting new cultural conditions to older roots, Jackson became, for a brief time, a celebrity of sorts, his name even more than his productions the symbol for a great past that the present and future must live up to. Jackson reached this extreme of individual fame at that point in the twentieth century when, paradoxically, Jackson the individual disappeared into a new myth of authenticity that insisted on the effacement of his historical and personal self so that a legendary self could take its place.[4]

This moment corresponded with the last major transformation of the American landscape over which Jackson would preside as a living man—the final stage of that bounding of wilderness, freedom, and potential that had begun in the 1850s and in the midst of which Jackson had worked. During the last two decades of his life, the photographer-turned-painter-turned-celebrity became the pet of a new brand of Westerner—or perhaps we should say of a new brand of Americans attempting to reclaim the West for their own. Ellison, Meeker, Driggs, Durlacher, and the rest used Jackson to confirm what was necessary to their own positions. Their West, as we have seen, comprised an imaginary realm of the privileged past and an exploitable, eradicable West of the present. It was, in many ways, the logical extreme of Hayden's vision, but its variations were significant. Hayden could never have dreamed of the destruction inherent in twentieth-century technology, nor could he have imagined the effect an American population in the hundreds of millions would have on the seemingly endless, infinitely adaptable and available American West.

Jackson's appropriators can not be villains, however, for that would imply too simple a human universe. But they—along with the last heir to the living Jackson, the interventionist government of the New Deal—presaged a new and more chilling future for the American landscape, when not only its principle but its mythology could be actively exploited as a part of the propaganda of a free-market capitalism and a benevolent social–democratic governmentalism alike. Thus Jackson's life shaded, at its end, into yet another conception of the American landscape, wherein its importance as a bankable cultural artifact expanded in seeming proportion to the shrinking physical spaces allotted to Americans themselves—when the "Marlboro man" seemed to be the only American privileged

to look into and across that vast, infinite space that Jackson had once entered and explored, struggling to make sense of its meanings and implications, and bringing his conclusions back to an eager audience.

Even as that space beyond the frontier faded from memory and the frontier became the province of propaganda, Americans themselves would turn their attention to new sorts of landscapes, landscapes of boundedness and accommodation—in the postwar suburbs and in the bureaucratized office spaces of urban corporate centers. Now these landscapes would be recorded, celebrated, and transformed not in photographs but in television and popular music, leisure parks, and other media and artifacts of the postwar era.

The frontier, the West, and the wider American landscape comprising the two would not die out as their physical and demographic counterparts shrank and perhaps disappeared. One need not join the bumper-to-bumper Winnebagos in the valley of Yosemite or fight for camping spaces at Yellowstone to appreciate this: a glance at the Westerns on paperback shelves of the local supermarket will reveal America's continued regeneration and reconstruction of a liberating, ennobling, and purifying landscape, a moral counterpart of freedom to set against the dark, immoral, imprisoning streets of the city.[5]

What has happened to the American landscape has been, then, not its end but its continued transformation, a process of which Turner's fabled argument about the presence of absolution at the edge of wilderness represents only one part. That William Henry Jackson should remain a central part of our conception of America, should continue to engage the interest of contemporary Americans and offer them at least the appearance of some counter to everyday life, attests to the capacity of our culture to adapt even in its moments of deepest self-doubt or most strident jingoism. Jackson was himself most important for his capacity to acquire, adapt, and regenerate the beliefs of his time and space, making them, at each jarring shift in context, still capable of affording continuity and hope to a culture more and more quickly spinning out its meanings.

Postwar America has retained its commitment to the American West and the larger American space, but that region now exists within a subtly yet significantly transformed cultural consciousness, altered by the recognition of our own potential eradication: this is the nuclear landscape, generating an unspoken sublime of far greater power and terror than the geological forces that had informed Jackson's earliest Survey pictures, or the forces of industrial capitalism that had transformed American space during the entirety of the photographer's ninety-nine-year lifetime. Like its nineteenth-century counterpart, it is a landscape we continually remember and forget precisely because it is so central to our time and space. In the face of that tremendous disruption, we have returned to our oldest myths with passion, even desperation, and have found in them possibilities not previously explored or exploited. Jackson's death did not put an end to the landscape he helped generate and regenerate over a century; that world of freedom and redemption remains still, awaiting us in our frontier metaphors, in our suburban homes, in our vacation plans, in the books we read and the tales we tell our children.

Notes

INTRODUCTION

1. Quoted in Lee Friedlander, *Factory Valleys* (New York, 1982), frontispiece.

2. This picture is reproduced as the frontispiece for William Henry Jackson, *Time Exposure: The Autobiography of William Henry Jackson* (New York, 1940).

3. Originally, this image was a stereo view (no. 515 in Jackson's original U.S.G.S. numbering scheme), from which 8-by-10 enlargement no. 423 (shown here) was copied. The original stereo was apparently damaged and replaced with a cropped copy negative—a common matter in the history of the Hayden Survey archive.

Readers will note throughout this book a selective use of gender pronouns. As Ann Douglas (among many other historians) has noted, a separate myth of American femininity coexisted with the male myth described here. See Ann Douglas, *The Feminization of American Culture* (New York, 1977).

4. Jackson's own articles and speeches during these years almost always included mention of the ease of photographing nowadays, and he delighted in charming his hosts during Westward trips by photographing with his Leica and—after 1935—Kodachrome film.

5. In fact, it appears that *Look* never did use the image; it was apparently one of the numberless "newsmaker" images that the magazine had prepared for an appropriate moment. Jackson's name does not appear in the index of the magazine between its founding in 1937 and his death in 1943.

6. J. B. Jackson's definition comes from a paper he presented to the International Conference on Architecture and Photography held in Ottawa, Canada, in October 1984; it is echoed in his essay on landscape, "The Word Itself," in *Discovering the Vernacular Landscape* (New Haven, 1984), esp. p. 7.

7. Here and elsewhere in the text, I hope to discriminate between an ideology and a myth by adhering in part to Clifford Geertz's definitions of the two in his essay, "Ideology as a Cultural System," in his *The Interpretation of Cultures* (New York, 1973).

8. Richard Rudisill discusses the ways Americans believed photographs should be understood in his enormously influential and important study, *Mirror Image: The Influence of the Daguerreotype on American Society* (Albuquerque, 1971); this is also, though more peripherally, discussed in Richard Masteller's important essay, "Western Views in Eastern Parlors," *Prospects 6* (New York, 1981), pp. 55–71. Oliver Wendell Holmes's articles in the *Atlantic Monthly* have become standard references on the subject of the "reading" of photography during its second generation; see his "The Stereoscope and the Stereograph," *Atlantic Monthly* 8 (1859), pp. 738–739; "Sun Painting and Sun Sculpture, with a Stereoscopic Trip Across the Atlantic," *Atlantic Monthly* 10 (1861), pp. 13–18; and "Doings of the Sunbeam," *Atlantic Monthly* 12 (1863), p. 1.

9. I am grateful to my colleague Victor Margolin for first suggesting to me, in a far different context, the analogy of negotiation as a means of understanding the dynamic relations between individuals and their cultures.

CHAPTER ONE

1. J. Hector St. John de Crèvecoeur, *Letters from an American Farmer* (New York, 1981), p. 9.

2. The materials for this biographical sketch are drawn from Jackson's two autobiographies. The first, written with Howard R. Driggs, *The Pioneer Photographer: Rocky Mountain Adventures with a Camera* (Yonkers-On-Hudson, N.Y., 1929), appears to be the more trustworthy in its details because of its earlier date and because it is in large part derived from sketchy materials Jackson produced c. 1920. The second, *Time Exposure: The Autobiography of William Henry Jackson* (New York, 1940) is more heavily embellished. The nature of these two autobiographies as themselves significant fictions is left to a later chapter.

3. The materials for this analysis of the Jacksonian man are primarily drawn from Marvin Meyers, *The Jacksonian Persuasion: Politics and Belief* (Stanford, Calif., 1960), pp. 5–32. Information about Jackson's family comes from his autobiographies; *The Pioneer Photographer* and *Time Exposure* disagree about the amount of time the Jacksons spent in Georgia; I have trusted the former. *Pioneer Photographer*, p. 1; *Time Exposure*, pp. 11–12.

4. *Time Exposure*, pp. 3–4, 16–17; *Pioneer Photographer*, p. 1.

5. Perhaps the most significant set of numbers in the U.S. census during these years concerned these dual migrations. The drain was at its worst after the Civil War: during the decade from 1870 to 1880, Maine, New Hampshire, Vermont, and New York all *lost* population, while Kansas, Colorado, and California all increased in population by from 10 to 50 percent. The steady stream of emigrants to Kansas, Missouri, and Iowa, the Oregon migration of the mid-1840s, and the California gold rush of 1849 and the following years all drew the vast majority of their numbers from native-born Americans leaving the settled regions of the East. New York State offers perhaps the most immediately relevant statistic: between 1860 and 1870, its native-born population increased by only 1,000—approximately .33 percent over a decade—and this number included immigration into the state as well as intrastate migration from the upstate farming areas to New York City. Plattsburg lost over 15 percent of its population between 1840 and 1850; Peru Township, where the Jacksons' farm was located, made a slight increase over that decade but lost ground between 1850 and 1860 and then made a precipitous decline of some 35 percent between 1860 and 1870—the decade during which the young William Henry Jackson himself abandoned upper New York State for the West. These statistics are drawn from the following sources: the original population census reports for 1840, 1850, 1860, 1870, and 1880; the *Compendium* volume of the census, published in 1880; and volume 1 of the two-volume *Historical Statistics of the United States: Colonial Times to 1970* (Washington, D.C., 1975). See also John D. Unruh, Jr., *The Plains Across the Overland Emigrants and the Trans-Mississippi West, 1840–1860* (Urbana, Ill., 1979), esp. pp. 84–85.

6. Writing in *Time Exposure* (pp. 18–19, 20–21) some eighty years later, Jackson recalled the force of Chapman's book:

No single thing in my life, before or since that day, has ever been so important to me. . . . From Chapman I first learned the mysteries of perspective, the rules of composition and design, the laws of color values, and how to model. I discovered the technique of delineating man's features—by copying and recopying the heads of Apollo and George Washington. I learned how to draw the human body in bone and muscle, and I found the way to give roots to my trees and how to bend them in the wind. And I learned how to economize, to eliminate, and to suggest, as well as to emphasize.

7. Here is Chapman on the necessity of an American art:

Of all people in the world, we stand most in need of knowledge in the Arts of Design, [so that] the cast off frippery of European garrets and workshops will no longer find place beside our home productions in the Fine and Industrial Arts. The vast resources of mind and matter with which a bountiful Providence has endowed our land will be brought forth to add to its greatness, and although we have no vast cathedrals or regal palaces to fill with pictures and statues, or adorn with works of ornamental art, we have a vast, an intelligent people to appeal to: who need only to be shown the truth, to know and maintain it.

John G. Chapman, *American Drawing Book* (New York, 1847), pp. 3, 4, 9–10.

8. Jackson, *Time Exposure*, p. 22. Unfortunately, none of Jackson's sketches, drawings, or paintings before 1860 appear to have survived.

9. Chapman, *American Drawing Book*, p. 170.

10. Jackson, *Time Exposure*, p. 24.

11. On American popular taste in art, and the connections between "high" and "popular" arts during the period, see the classic by James T. Flexner, *That Wilder Image: The Native School from Thomas Cole to Winslow Homer* (New York, 1970), esp. pp. 205–234, wherein the author points out that most American "high" artists of that era evolved from beginnings remarkably similar to Jackson's. That George Henry Durrie, the most famous artist for Currier and Ives, began doing window shades and screens, is recorded on pp. 212–213 of Flexner. See also Barbara Novak, *American Painting of the Nineteenth Century* (New York, 1969) and *Nature and Culture* (New York, 1980).

12. Jackson, *Pioneer Photographer*, pp. 3–4; Jackson, *Time Exposure*, pp. 25–26, 30–34. His teacher was probably James Hope, "a picturesque local artist . . . a Scotchman, who wore long hair and a plaid shawl," (*Pioneer Photographer*, p. 4).

13. My account of Jackson's career at this time conflicts with his own recollections when, at the age of eighty-six, he wrote his autobiography. Jackson's account is nostalgic in the usual way that autobiographical descriptions of childhood are; see Chapter Nine for more on this. What seems a more accurate set of descriptions of work in the daguerreotype and card-photograph studios of the era can be found in Richard Rudisill, *Mirror Image* (Albuquerque, 1971).

14. Jackson, *Pioneer Photographer,* p. 4; Jackson, *Time Exposure,* pp. 34–40.

15. It is difficult to tell just how much Jackson exaggerated his work as "staff artist" (*Time Exposure,* p. 59) for Colonel Blunt; in *Pioneer Photographer* (p. 5), the work is given far less emphasis.

16. Styles's Vermont Gallery of Art is mentioned in all three of William Culp Darrah's remarkable studies of popular photography in nineteenth-century America: *Stereo Views* (Gettysburg, Pa., 1964), p. 49; *The World of Stereographs* (Gettysburg, Pa., 1977), p. 211; and *Cartes de Visite in Nineteenth Century Photography* (Gettysburg, Pa., 1981), p. 215. Mowrey's Rutland studio appears in none. Jackson, *Time Exposure,* pp. 74–76.

17. Jackson, *Time Exposure,* pp. 80–81.

18. Frank Luther Mott, *A History of the American Magazine* (Cambridge, Mass., 1957); Richard Reinhardt, *The West on the Overland Train: Across-the-Continent Excursion with Leslie's Magazine in 1877 . . .* (Palo Alto, Calif., 1967), pp. 5–9; Mark Twain's celebrated story of the dumping of the mail to the Western territories, found in the first volume of *Roughing It* (New York, 1899), pp. 21, 22, 27, bears witness to the increased volume and the changed nature of the mails during this era.

19. Jackson, *Time Exposure,* p. 81; Reinhardt, *West on the Overland Train,* pp. 6–7.

20. Mott, *A History of the American Magazine;* Dorothy Schmidt, "Magazines," in M. Thomas Inge, *The Handbook of American Popular Culture* (Westport, Conn., 1981), vol. 3, pp. 137–162; Jackson, *Time Exposure,* p. 81.

21. Jackson's diaries began well before this point. A segment of his Civil War diaries remains extant, so do notebooks, sketchbooks, and diaries for some of the USGS expeditions, as well as both daybooks and journals from the years after he left the Detroit Publishing Company in the 1920s. It is safe to assume from some fragments Jackson recorded in *Pioneer Photographer* that he was a consistent diarist from the early 1860s. At some point, however, he made the decision to destroy a number of diaries; others were apparently lost. This diary entry follows some pages that have been torn from the diary. Jackson, *Diaries* (New York Public Library Manuscript Collection), vol. 1, April 15, 16, 1866; Jackson, *Time Exposure,* pp. 81, 84.

22. Jackson, *Diaries,* June 5, 6, 1866. Henceforth, unless otherwise noted, all information in this chapter is derived from the diaries, either as they appear in Jackson's "clean copies" or in their original form—the originals and copies are mixed between the Colorado Historical Society and the Manuscripts Collection of the New York Public Library. A good, though sometimes oddly transcribed, version of some of the diaries is Leroy R. Hafen and Ann W. Hafen, eds., *The Diaries of William Henry Jackson, Frontier Photographer* (Glendale, Calif., 1959).

23. Jackson, *Diaries,* April 16, June 12, 1866.

24. Jackson, *Diaries,* April 16, 1866; this phenomenon is detailed in most of the standard histories of the westward movement—see, for example, Frederick Merk, *History of the Westward Movement* (New York, 1978), pp. 412–418; Ray Billington, *Westward Expansion* (New York, 1967), pp. 617–634; see also Richard Bartlett's more general statements on "the Basic Mix" of Westward population, in "Basic Traits and New Ingredients," in *The New Country: A Social History of the American Frontier, 1776–1890* (New York, 1974), pp. 117–172.

25. Jackson, *Diaries,* July 2–December 18, 1866.

26. This letter is reprinted in *Pioneer Photographer,* pp. 18–39; see also *Diaries,* July 11, 1866.

27. *Diaries,* July 21, 25, 1866.

28. Ibid., July 21, 1866.

29. Ibid., July 25, 1866.

30. Ibid., July 25, August 1, 1866; Jackson's drawings are located at Scott's Bluff National Monument, Nebraska. Little documentation accompanied them on their journey through various Interior Department subdivisions to their current resting place.

31. The Gilcrease Institute's version of the "Platte River Crossing" appears to be the original, though this is not certain. The Nebraska Historical Society has a version made in the 1880s—it is this version that Jackson mentions in *Time Exposure.*

32. Jackson, *Diaries,* August 22–24, September 1, 3, 5, 1866; the notion of emigrant cooperation and communitarianism in the era immediately before the Civil War is carefully researched in John D. Unruh, *Plains Across,* esp. pp. 118–155. Jackson reported on the trip in a letter, now in the Western Americana Collection of Yale University Library, written to his mother October 30, 1866. It has been published along with a set of misdated sketches and paintings and a somewhat inaccurate introduction by Jackson's son Clarence in the *Denver Westerner's Brand Book* (Denver, 1954), pp. 5–16.

33. Jackson, *Diaries,* October 7–19, 1866.

34. Ibid., October 8, 9, 10, 1866.

35. Ibid., October 14, 15, 1866; Jackson, *Time Exposure,* p. 138.

36. Jackson, *Diaries,* October 23, 27, 1866; letter to his mother, October 30, 1866 (Western Americana Collection, Yale University Library).

37. Jackson, letter to his mother, October 30, 1866 (Western Americana Collection, Yale University Library). The matter of quest imagery Henry Nash Smith has traced as integral to the mythology of the West during the nineteenth century.

See his *Virgin Land: The American West as Symbol and Myth* (Cambridge, Mass., 1950).

38. Jackson, *Diaries,* November 19–26, December 1–19, 1866; Jackson's sketches for this period are at the Scott's Bluff National Monument.

39. Ibid., November 17, December 27, 1866.

40. Ibid., December 11, 12, 20, 23, 1866.

41. Ibid., December 29, 30, 1866; January 4, 5, 6, 1867.

42. Ibid., December 27, 1866–February 1, 1867 passim, esp. January 27, 1867, and December 27, 28, 29, 1866.

43. Ibid., January 11, 16, 17, 19, 1867; Jackson described this sort of "play" between Indians and traveling whites while still with Ed Owens's train, July 26, 1866.

44. Ibid., January 16, 1867; an incident with "Frenchy" of the Ed Owens wagon train is exemplary—his boast about his sexual desires for squaws, even Jackson saw, was motivated by "his scare when we met a few Ottos near Nebraska City." See also July 26, 1866.

45. Ibid., January 28, 29, 1867.

46. Ibid., February 14–18, 1867.

47. Ibid., March 27, 28, 29–31, 1867.

48. Ibid., April 27–May 2, 1867; Jackson, *Pioneer Photographer,* pp. 43–45.

49. Jackson, *Diaries,* April 15, 1867.

50. Ibid., April 15, 16, June 26, 27, July 8, 1867.

51. Ibid., July 22–31, August 4, 1867.

52. Ibid., August 1, 7, 8, 1867. Paula Fleming of the National Anthropological Archives of the Smithsonian Institution has supplied Hamilton's first and middle names.

53. Ibid., August 5–11, 1867.

54. Ibid., August 6–11, 1867, and end page.

CHAPTER TWO

1. William Henry Jackson, "Field Work," *The Philadelphia Photographer* 12 (1875), p. 91.

2. The first quotation is from the first edition of George Crofutt, *Crofutt's Transcontinental Tourist Guide* (Chicago, 1868); the second is from *Crofutt's Overland Tours* (Chicago, 1888), p. 10.

3. Information on Omaha may be found in two standard sources, James C. Olson's *History of Nebraska* (Lincoln, 1966) and George R. Leighton's *Five Cities: The Story of Their Youth and Old Age* (New York, London, 1939), pp. 140–236. The city directory for Omaha is a rich source; it was published every two years during this period. See also Gunther Barth, *Instant Cities* (New York, London, 1975); Charles Edgar Ames, *Pioneering the Union Pacific Railroad* (New York, 1969).

4. Jackson later recalled that Hamilton wanted "to get back to his fine farm near Sioux City, Iowa." In fact, the older man still owned his original studio in Sioux City; more probably, his entrepreneurial fantasies had not taken hold as quickly as he wished. See Jackson, *Time Exposure: The Autobiography of William Henry Jackson* (New York, 1940), pp. 171–172, though this report is rather exaggerated—more accurate fragments appear in Jackson's essay "Field Work," pp. 91–92, and in *The Pioneer Photographer: Rocky Mountain Adventures with a Camera* (Yonkers-on-Hudson, N.Y., 1929), pp. 56–57; see also the Omaha city directories between 1866 and 1874. Jackson reported that Hamilton had, as well as the Sioux City studio, two establishments in the Omaha area, the second "idle," probably in nearby Council Bluffs. Like Hamilton, Eaton had a primary studio elsewhere—in Council Bluffs—to which he retreated. He then returned to Omaha in 1872 to compete with Jackson Brothers' successors, Parker and Johnson; this placed him in the odd position of competing against himself, as Parker and Johnson were still selling old Eaton images of Pawnee and other Indian chiefs. See, for example, the National Anthropological Archives (NAA) negative no. 45, 247-R, which appeared first under an E. L. Eaton mount, then a Jackson Brothers mount, then a Parker and Johnson mount. William Culp Darrah has

traced Eaton, Hamilton, and Parker and Johnson, among a host of other nineteenth-century photographers, through collections of original cartes de visite and stereographs in *Cartes de Visite in Nineteenth Century Photography* (Gettysburg, Pa., 1981), and *The World of Stereographs* (Gettysburg, Pa., 1977).

5. Jackson, *Time Exposure,* p. 173. On the Jackson firm's staff, see the Omaha city directories for those years, as well as "Field Work," p. 91, *Diaries*—typescript introduction to 1867–1869 diary, and *Pioneer Photographer,* pp. 57–58.

6. Jackson, *Time Exposure,* p. 173.

7. Information on the views of Eaton and Hamilton and their acquisition and use by Jackson is found in the collections of photographs made by all three. I have examined those held by the Amon Carter Museum, the International Museum of Photography, the NAA, and the Colorado State Historical Society. Richard Rudisill has also mentioned this process of acquiring negatives in his research report on "A Problem in Attribution," *Research Report No. 1* (unpublished internal report for the Museum of New Mexico, Albuquerque, 1975), and in his more elaborate presentation for the American Studies Association National Convention that same year.

8. Authorship of these negatives, many now held by the NAA, has been established by an elaborate process of investigation, most recently on the part of the NAA researcher Paula Fleming. Fleming's work involved comparing the NAA negatives, prints, and copy images with mounted vintage prints held by the British Museum as part of its Blackmore Collection, an archive of materials held by the British peer and Colorado land baron Sir William Blackmore. Blackmore's own citations, however, reveal his confusion between the making and the marketing of a photograph. For a photograph of a "Pawnee Squaw with Papoose . . . ," for example, Blackmore wrote "Taken at Omaha, June 1867 by Jackson." Either the picture was made by Eaton or Hamilton and pro-

vided by Jackson or Blackmore's dating is wrong. In part to alleviate such problems, both Fleming and I have attempted to reconstruct a series of studio settings by looking for repeating decorations, light sources, wall types, and so on. It now appears that Jackson Brothers acquired images made in two Eaton studios and at least one Hamilton studio, and then continued to make Indian portraits in one of the Hamilton studios, albeit with significant variations, including the development of sets using boulders, twigs, tree stumps, and the like, and the use of painted backdrops, probably made by Jackson.

9. The originals of prints on Jackson mounts are located in the Blackmore Collection of the British Museum; copies are held in the NAA in Washington, D.C. In some of these Jackson Brothers views, a neoclassical architectural scene appears, perhaps suggestive of the linkage between Greek and American "children of Nature" but more likely the standard studio portrait backdrop, used because the Indian subjects insisted or simply because it was easiest. Paula Fleming of the NAA has deduced the addition of this painted backdrop—it can be seen on a number of Blackmore-acquired Jacksons.

10. Jackson, "Field Work," pp. 91–92; *Pioneer Photographer,* pp. 58–59—the wagon is reproduced on p. 59.

11. This history is well told in Ray Billington, *Westward Expansion: A History of the American Frontier* (New York, 1967), pp. 653–672; Richard A. Bartlett, *The New Country: A Social History of the American Frontier, 1776–1890* (New York, 1974), pp. 19–37; and Frederick Merk, *History of the Westward Movement* (New York, 1978), pp. 419–430. An excellent combination of historical overview and bibliographic review is Robert C. Carriker, "The American Indian from the Civil War to the Present," in Michael P. Malone and Rodman W. Paul, eds., *Historians and the American West* (Lincoln, Neb., 1983), pp. 177–208. More complex and controversial anal-

yses can be found in Robert F. Berkhofer, Jr., *The White Man's Indian* (New York, 1979), and Francis Paul Prucha, *The Great Father: The United States Government and the American Indians* (Lincoln, Neb., 1984). For information related to the Union Pacific Railroad's problems with Indians, see Ames, *Pioneering the Union Pacific,* pp. 123–344.

12. This policy remained in place only until those "distant" reservations themselves became objects of white desire, causing a new policy of "assimilation" and stripping of reservation lands to take place in the 1890s.

13. The method of controlling lens openings (*f/stops* in modern parlance) involved the introduction of a "Waterhouse stop" into a slot in the lens. This provided a primitive means of narrowing the aperture of the lens to increase sharpness and depth of field that also correspondingly decreased the amount of light hitting the light-sensitive plate. Information on photographic processes of the period is perhaps best found in Dr. John Towler's *The Silver Sunbeam* (New York, 1864). Towler, editor of *Humphrey's Journal of Photography,* produced a remarkably complete and immensely popular instruction book, which Jackson no doubt used as a reference when learning the process in 1867.

14. On stereoscopic photography, still the best information is found in William Culp Darrah, *Stereo Views: A History of Stereographs in America and Their Collection* (Gettysburg, Pa., 1964), and *The World of Stereographs.* A vital source on the cultural significance of the stereograph is Richard Masteller's "Western Views in Eastern Parlors," *Prospects* 6 (1981), pp. 55–71. Information on the cameras comes from the lists of images that appeared on the backs of Jackson mounts in 1868 and 1869; Blackmore noted on his copies that the outdoor Indian views in his collection were made in the summer of 1868.

15. Jackson's views of the Omaha tribe, discussed later, may have been made shortly before

he left with Hull in the summer of 1869 to photograph along the line of the Union Pacific. I am fairly certain, however, that they were made at the end of the summer of 1868, both because Jackson himself makes no reference to Indian trips except in 1868 and because it seems doubtful that he would have devoted quite so much attention to Emilie Painter (who appears in some of these views) just weeks after marrying another woman.

16. My analysis of Jackson's Indian photographs is indebted to the seminal study of the myth of the American Indian, Berkhofer, Jr., *The White Man's Indian.* I have also followed Berkhofer's lead in making a distinction between the "native American," a hypothetical historic entity, and the "Indian," a white myth. See his preface, pp. xxiii–xxvii.

17. Jackson, *Pioneer Photographer,* p. 60. "Gi-He-Ga's Lodge" was so appropriate to the popular image of the American Indian that it remained in active use by academics, the government, and the popular press into the twentieth century; it appeared under the guise of a contemporary photograph, as fig. 308, on p. 272 of the Bureau of American Ethnology's *13th Annual Report* in 1892.

18. Not only Edward Painter, but Grant's entire Quaker experiment is detailed in Clyde A. Milner, *With Good Intentions: Quaker Work among the Pawnees, Otos, and Omahas in the 1870s* (Lincoln, Neb., 1982), esp. pp. 160–163, 170–173. See also the photographs and descriptions provided in Clarence Jackson's discredited *Picture Maker of the Old West,* pp. 68–77. Painter's influence was personal as well as intellectual—in 1873, Jackson took Painter's daughter Emilie as his second wife, and pictures of her appear as early as 1868, including one particularly didactic view of the Painter family ministering to an Indian couple while two Indian women, dressed in servant's uniforms, look on. The negative of this view, reproduced in *Picture Maker of the Old*

West, p. 70, has since been lost. Another image of Emilie Painter appears in the USGS collection for 1869: "1. Missouri River Near Omaha Indian Agency."

19. See, particularly, the photographs reproduced in Clarence Jackson's *Picture Maker of the Old West,* in several of which Painter appears prominently.

20. In this context, see also "School Building on the Pawnee Reserve, on the Loupe Fork, Nebraska," Jackson catalogue no. 538. This and other images of the administration buildings, administrator dwellings, and schools all suggest the safe presence of a permanent white influence on the reservation. On the general topic of Painter's attempts (eventually only marginally successful) to transform the native American into an American yeoman, see Milner's *With Good Intentions.*

21. I have used the male pronoun in this passage; in this Eastern myth, woman was far more often relegated to the category of nature on one hand or spirit on the other than admitted to the role of explorer and gardener. On this, see Ann Douglas, *The Feminization of American Culture* (New York, 1977), esp. pp. 49–60. Douglas points out the significant variance between Eastern attitudes toward woman's role and those in the West, where women like Jackson's first wife, Mollie, routinely held positions of economic power.

22. See, for example, Donald Jackson, ed., *The Letters of the Lewis and Clark Expedition* (Urbana, Ill., 1962), which includes the text of Jefferson's message; the issue is admirably discussed in William H. Goetzmann, *Exploration and Empire: The Scientist and the Explorer in the Winning of the American West* (New York, 1966), esp. chap. 1. Just three contemporary descriptions of the West will give an idea of the prevalence of these themes: Abbé Em. Domenech (probable pseudonym), *Seven Years' Residence in the Great Deserts of North America* (London, 1860); William Gilpin's *The Central Gold Region: The Grain, Pastoral, and Gold Regions of North America* (Philadelphia, 1860); and Samuel Bowles,

Across the Continent: A Summer's Journey to the Rocky Mountains, the Mormons, and the Pacific States (Springfield, Mass., 1865). The presentation of these themes in visual form is discussed in Barbara Novak, *Nature and Culture: American Landscape and Painting, 1825–1875* (New York, 1980); the paradigmatic study of their literary manifestation is Henry Nash Smith's *Virgin Land: The American West as Symbol and Myth* (Cambridge, Mass., 1978).

23. Smith, *Virgin Land,* is still the most important source for understanding the West as cultural construction. Of particular importance are his chapters on what he calls "the new calculus" of Western energy that came with settlement of the Great Basin: see "The New Calculus," "The Agrarian Utopia," and especially "Garden and Desert." Alan Trachtenberg has written an important extension of Smith's work on the altered conception of the West as exploitable commodity, in the essay "The Westward Route" that constitutes chapter 1 of *The Incorporation of America: Culture and Society in the Gilded Age* (New York, 1980), pp. 11–37.

24. Jackson apparently had planned to make and issue a set of views along the Union Pacific in the summer of 1868; in fact, he reported in a 1922 typescript addendum to his diary that he "accompanied some of the . . . official expeditions and excursions [along the uncompleted rail line] for the purpose of making personal groups and details of track work." The attempt was a failure: "the work of this first year had little permanent value, but it gave me the experience I needed for carrying out the purpose I had in mind all the time of photographing everything of interest between Omaha and Salt Lake as soon as the road was complete." If he did indeed make technically successful views, he probably cleaned the glass plates of images once he had printed up the orders he received, saving the glass for reuse by destroying the negative. See the typescript addendum to *Diaries,* 1867–1869.

25. The indications of the Jackson firm's new

success are many. For the *Omaha City Directory,* Jackson was able to secure not only a credit-line for the wood-engraved portrait of the directory's publisher but also a squib in the opening section declaring that "the Jackson Brothers, corner of 15th and Douglas, are recognized as being the best photographers in the Western states." In addition, the firm invested in a display space that advertised "pictures enlarged to any size and Colored in Oil, Water Color or India Ink. Views of Omaha and Photographs of Indians" (*Omaha City Directory,* 1868, pp. 21, 58). That Jackson himself was responsible for these commercial touches is suggested not only by his career-long talent for self-advertisement but also by the troubles that the firm had while he was absent, reported and bemoaned by him in his diaries for 1869. By 1870 he had solved this problem, making his new bride, Mollie Greer, manager of the studio. On Mollie, see *Time Exposure,* pp. 175–176.

26. On Arundel C. Hull, see Nina Hull Miller, *Shutters West* (Denver, 1962). Hull apparently considered Johnson incompetent—see, for example, p. 140. An Indian view of his is reproduced in Darrah's *Cartes de Visite,* p. 70; however, it appears to be incorrectly dated.

27. Jackson and Hull were not present for the laying of the Golden Spike at Promontory Point, Utah, on May 10; Jackson stated in his autobiography that he was busy marrying Mollie Greer, but given the sort of planning that went into his trip, this can only be part of the reason. More than likely, Jackson understood that the event would be crowded with photographers, making the trip unnecessary and—given his plans to support the endeavor—economically unsound. As it was, the three established Western railway photographers—A. J. Russell and Charles R. Savage, both employees of the Union Pacific, and Alfred A. Hart, of the Central Pacific—were all present, and their views saturated the market. See Ames, *Pioneering the Union Pacific,* p. 339. On Hull, see Miller, *Shutters West;* Jackson's quote is from "Field Work," pp. 91–92.

28. Jackson, *Diaries,* June 22–July 4, 1869.

29. Ibid., 1869, inside back cover and two back pages.

30. Ibid., June 23, 24, 1869.

31. Ibid., June 24, 1869.

32. The entire incident is peculiar; only in the *Diaries* does Jackson mention this meeting. In *Pioneer Photographer,* he reports that "we had met . . . while he was making his Nebraska Survey" (p. 73). In *Time Exposure,* he reports that "in Wyoming during my summer along the line of the Union Pacific I had first met Dr. Hayden." Probably Jackson, aware of Hayden's secret disease (Hayden had long since died of locomotor ataxia), chose to bowdlerize his accounts rather than puncture the myth of Hayden the scientific giant. Weston Naef, who quotes from the diaries in *Era of Exploration* (Boston, 1975), makes no mention of Hayden's presence.

33. Jackson, *Diaries,* June–August, 1869.

34. Ibid., July–September, 1869. Information on Hull is spotty. While he disappears from Jackson's diaries and in *Pioneer Photographer* remains behind only long enough to pack up, Jackson wrote in the thirties or forties to Hull's daughter that her father may have remained behind photographing while he returned. See Miller, *Shutters West,* p. 16.

35. Jackson, *Diaries,* June–September, 1869. Though Jackson wrote in a letter to Hull's daughter that Hull had worked as photographer, the diaries show only a very few instances where Jackson relinquished the camera to Hull. Probably Hull made many of the stereoscopic views, under Jackson's direction, while Jackson made the larger-plate photographs of the same subject. At only one point in the diaries does Jackson actually mention Hull making views: on July 21, while Jackson climbed to the top of the canyon wall to scout views, "Hull made some 8 × 10s of the bridge and gateway and in the p.m. I made another of the bridge from a [higher? better?] standpoint." Evidence of Hull's dubious talents is found in Miller, *Shutter's West;* his most inter-esting pictures are his views of hanged criminals, a subject offering an immediate, if rather limited, market.

36. Jackson, *Diaries,* June 28, 1869; on Laughlin, see the inside rear cover of the 1869 diary, as well as scattered notes on samples made and delivered; on Ross, see entry for August 17.

37. Ibid., July–September, 1869.

38. Ibid., August 11, 12, 13, 1869.

39. Surprisingly little note has been made of the significance of these strips of white sky in the landscape photography of the American West. John Szarkowski, in a discussion of one of Timothy O'Sullivan's photographs in *Looking at Photographs* (New York, 1973), spoke of the graphic quality of the white sky but treated it in modernist terms unrelated to the culture of O'Sullivan's time. Others, some in response to Szarkowski, have retorted that the white sky was an inevitable artifact of the orthochromatic nature of wet-collodion negatives. Joel Snyder pointed out the incorrectness of this assertion in his *American Frontiers: The Photographs of Timothy H. O'Sullivan, 1867–1874* (Philadelphia, 1981). His suggestion that the sky was an ideological element in the pictures reinforces the already vast body of knowledge concerning the significance of skies in nineteenth-century American landscape painting.

40. A wide range of works describes and analyzes the entire phenomenon of the transliteration and Americanization of Romantic concerns with nature and landscape: see esp. Novak, *Nature and Culture;* Hans Huth, *Nature and the American: Three Centuries of Changing Attitudes* (Berkeley, Calif., 1957); and John Wilmerding, ed., *American Light: The Luminist Movement, 1850–1875* (Washington, D.C., 1980).

41. A huge body of scholarship details these phenomena in literature, art, and popular culture. The seminal work is Henry Nash Smith's *Virgin Land,* which traces these myths through a wide range of primary sources, from popular "dime" novels to letters, the writings of Emerson, news-paper accounts, and so on. Also vital are Perry Miller's *Errand into the Wilderness* (New York, 1964), Hans Huth's *Nature and the American,* and R. W. B. Lewis's *American Adam* (Chicago, 1958). Recent studies in the visual arts include Novak's eminent *Nature and Culture* and her earlier *American Painting of the Nineteenth Century* (New York, 1969). A number of painters wrote or painted on the subject; the letters and poems of Thomas Cole (copies located in the New-York Historical Society) are indispensable, as is his "Essay on American Scenery," published along with much else that is crucial in John McCoubrey, ed., *American Art, 1700–1960* (Englewood Cliffs, N.J., 1965). Of particular importance is an article on the subject of George Inness's "The Lackawanna Valley" in *The American Art Journal* 2, no. 2 (Fall 1970), pp. 36–57. An interesting study relating visual modes to literary production during the period is Donald A. Ringe, *The Pictorial Mode: Space and Time in the Art of Bryant, Irving and Cooper* (Lexington, Ky., 1971).

42. Traveling eastward from Yosemite, the modern tourist may reproduce the route of that other Survey photographer, Timothy H. O'Sullivan—descending from the grassy havens of Tuolumne Meadows to the eerie moonscape of Mono Lake.

43. Some of these expressions are recorded in Smith's *Virgin Land,* pp. 174–183. Currier and Ives made other, even more spectacular manifestations of the doctrine of manifest destiny, notably "Westward the Course of Empire Makes Its Way." In most, as in "The Rocky Mountains," Indians are presented surveying the scene, passively accepting their obsolescence.

44. Albert D. Richardson, *Beyond the Mississippi: From the Great River to the Great Ocean* (Hartford, Conn., 1867); Samuel Bowles, *Our New West: Records of Travel Between the Mississippi River and the Pacific Ocean* (New York, Chicago, 1869), some of whose illustrations, interestingly enough, were derived from photographs by Charles R. Savage; Cyrus Thomas, "Agricul-

ture in Colorado," in Hayden, *Third Annual Report of the U.S. Geological Survey of the Territories . . . 1869* (Washington, D.C., 1870), pp. 236–237. Concerning the Central Pacific's influence on the report, see "Letters Received" file of the *Records of the Hayden Survey,* NA, RG (Record Group), 57, reel 2, letter of November 16, 1871.

Realistically, the American image of the West had to remain optimistic and development dependent because so much was already at stake. Once the doctrine that democracy depended on free land was transported to the West, its corollary also emerged: the West *must* be amenable to settlement, or God's covenantal relationship with America would be annulled. For to look West and see a barren wasteland denied democracy her "safety valve," a term that was in currency concerning the West as early as 1839. A brilliant chapter in Rush Welter's *The Mind of America 1820–1860* (New York, 1975), entitled "The Frontier West as Image of American Society," details this argument; the equation of covenantalism, democracy, and free land, however, is mine. See Welter, pp. 298–328, esp. pp. 301, 316, 320, and 324. Welter's statement (p. 320) that "the West as Americans perceived it made room for their disparate hopes, while the resources it made available may have reconciled their conflicting visions of society" is one of many that stimulated this study.

45. On the "incorporation" of the West, see Alan Trachtenberg's important essay, The Westward Route," in *The Incorporation of America.* On the transformation of farming, see Frederick A. Shannon, *The Farmer's Last Frontier, 1860–1897* (New York, 1945); on farming, timbering, and mining, see the following sources: Ray Billington, *Westward Expansion,* esp. pp. 617–744; Richard A. Bartlett, *The New Country,* especially the section titled "Despoilment: The Rape of the New Country"; and Frederick Merk, *History of the Westward Movement,* esp. pp. 412–476.

46. On the railroad as capitalist transformer,

see scattered portions of Ames, *Pioneering the Union Pacific;* see also Billington, *Westward Expansion;* Merk, *History of the Westward Movement;* and Bartlett, *The New Country.*

47. Much of this is discussed in more sophisticated fashion in John Brinkerhoff Jackson's writings, especially his seminal work, *American Space* (New York, 1972).

48. On the planned towns, see Ames, *Pioneering the Union Pacific,* pp. 291–292.

49. A rich but incomplete discussion of some of these issues is found in Richard Masteller, "Western Views in Eastern Parlors: The Contribution of the Stereograph Photographer to the Conquest of the West," *Prospects 6* (New York, 1981), pp. 55–71. Masteller writes compellingly of the sense in which the stereograph offered its consumers a version of the subject they could control: "they represent awe followed by appropriation, enthusiasm degenerating into entertainment," he has written. This seems to me an overly judgmental assessment; in addition, it ignores the second half of the equation—that is, the role of escape offered by the experience, an escape that enlarges rather than diminishes the subject, making it the engenderer of fantasy and wish-fulfillment rather than the product of rationalism.

50. See Reese Jenkins, *Images and Enterprise: Technology and the American Photographic Industry* (Baltimore, 1975); William Culp Darrah, *Stereo Views, The Carte de Visite in America,* and *The World of Stereographs.* Probably the most interesting sources are several essays by Oliver Wendell Holmes—"The Stereoscope and Stereograph," *Atlantic Monthly 3* (June 1859), pp. 738–748; "Sun Painting and Sun Sculpture," *Atlantic Monthly 8* (May 1861), pp. 13–29; and "Doings of the Sunbeam," *Atlantic Monthly 12* (1863), pp. 1–15. Holmes's description of the Anthony view factory is a vital indicator of the incredible popularity of these images and the industrialization of the medium that it brought about.

51. I have written more extensively of the

capabilities of the wet-plate camera in *Silver Cities: The Photography of American Urbanization, 1839–1915* (Philadelphia, 1984); highly recommended are Joel Snyder and Neil Walsh Allen, "Photography, Vision and Representation," *Afterimage* (January 1976), pp. 8–13, and John Szarkowski, *The Photographer's Eye* (New York, 1964). Recently published is Naomi Rosenblum, *A World History of Photography* (New York, 1984), which has excellent sections devoted to technical matters. Rick Dingus has demonstrated some of the means Jackson's contemporary Timothy H. O'Sullivan used to manipulate and gain control over the photographic medium—including tilting the camera, altering angle of vision, over- and underexposing, and the like. See Dingus, *The Photographic Artifacts of Timothy H. O'Sullivan* (Albuquerque, 1984).

52. Hayden's most famous defense of photography as scientific tool appeared in the *Ninth Annual Report . . . 1875* (Washington, D.C., 1877), pp. 22–23. Ferdinand Vandeveer Hayden, *Sun Pictures of Rocky Mountain Scenery, with a Description of the Geographical and Geological Features, and Some Account of the Resources of the Great West; Containing Thirty Photographic Views Along the Line of the Pacific Railroad, From Omaha to Sacramento* (New York, 1870). This was Hayden's first booster book on the West, containing 150 pages of text and 30 photographs by A. J. Russell (though he was only mentioned in the introduction by Hayden). The photographs were originals, tipped into the text as frontispiece and at the rear as plates.

53. Jackson, *Diaries,* June 29, 1869.

54. Ibid., August 23, 1869; see also Darrah, *Stereo Views,* pp. 35–38, and *The World of Stereographs,* p. 98. Interestingly, Anthony's biographers do not mention this contract. See William Marder and Estelle Marder, *Anthony: The Man, The Company, the Cameras* (Amesbury, Mass., 1982).

55. Weston Naef's résumé of Jackson in *Era of Exploration* , surprisingly, misses the significance of the work done in 1869. Rather than noting its

divergences from the canon of Western photography, Naef downplays them, attributing those he does find to Jackson's inexperience in the field. This is partly the result of an unfortunate selection of views spanning Jackson's entire career, possibly the result of limitations in the collections Naef explored. Naef's description of Jackson in 1869 as a "journalist" is unfortunate indeed, as it projects a value-laden twentieth-century term onto a historical era for which it is irrelevant, even as it flattens the complex relationships between photographer and clients.

56. Jackson, *Diaries,* June 25, 26, 29, July 9, 1869.

57. Ibid., June 29, August 21, 1869.

58. The first two of Jackson's teachers were more mundane: Hull himself, whose lessons were apparently rudimentary, and his friend in Corinne, one J. Crissman (who reappeared at Yellowstone in 1871), who was running a studio there. Despite the potential loss of business, Crissman offered them the run of his gallery, and Jackson looked at his negatives and views during the time there. But in neither case is there particular evidence of the process of imitation and homage that is clearly visible in the instances of Savage and Russell.

59. Jackson, *Diaries,* July 9, 23–25, September 8–11, 1869. The picture of stonemasons appears, incorrectly attributed to Jackson, as the cover photograph for Beaumont Newhall and Diana Edkins, *William Henry Jackson* (Dobbs Ferry, N.Y., 1974). In 1975, Richard Rudisill reported on the error in a seminal paper delivered at the Fifth Biennial Convention of the American Studies Association.

60. Jackson, *Diaries,* June 29, 1869. Jackson actually made another version of the windmill photograph (J. no. 3) from closer up, but there the object became just one part of a mechanical landscape of train tracks, switches, and freight cars.

61. Jackson's experience with Russell was not limited to a preexpeditionary study of his pictures. On August 21, Jackson reported he "walked to town in evening and had quite a talk with Russell's printer and in looking over his negs. and pictures." Then in mid-September, while working in Wasatch, he reported that "Russell was up here and was about [?] here a good deal. Borrowed his evaporating dish and boiled down our old bath. . . . Found Russell a very companionable, sociable fellow and had some very pleasant times with him. Made a sort of half-arrangement with him to go up into the Uintahs next year." By this time, Jackson had retained most of his views of the summer, and Russell undoubtedly looked them over. That he would suggest a mutual trip into the mountains for the next season was not only a flattering suggestion of equality for Jackson but a testimony to the finished views themselves. See *Diaries,* August 21, September 19, 1869.

On luminist painting, see Novak, *Nature and Culture,* esp. pp. 34–44 and 78–100. On Savage, see his essay "A Photographic Tour of Nearly 9,000 Miles," *The Philadelphia Photographer* 7 (1867), pp. 287, 313. Some secondary information is found in Current and Current, *Photography and the Old West* (New York, 1978) and Robert Taft, *Photography and the American Scene* (New York, 1964), p. 491. On Russell, see his "On the Mountains with the Tripod and Camera," *Anthony's Photographic Bulletin* 1 (1870), p. 35; secondary information is found in Current and Current, pp. 130–136; in Weston Naef, *Era of Exploration;* pp. 201–218; and in Barry B. Combs, *Westward to Promontory: Building the Union Pacific across the Plains and Mountains* (Palo Alto, Calif., 1969).

62. Jackson, "Field Work," p. 91.

63. In fact, though William Cullen Bryant announced in the introduction that illustrations from photographs were not used, possibly the only ones that were came from Jackson; they were Moran's interpretations of Jackson's photographs, used in the section on "Our Great National Park" in volume 1. See William Cullen Bryant, *Picturesque America* (New York, 1874).

64. These images, too, owe much to A. J. Russell's "Hanging Rock, 1867."

CHAPTER THREE

1. "Stereoscopic Views of the West," *The Philadelphia Photographer* 10 (1873), p. 64.

2. This reconstruction is drafted from typescripts and notes by Jackson accompanying the diaries in the New York Public Library's manuscript collection and from his report of the meeting in *The Pioneer Photographer: Rocky Mountain Adventures with a Camera* (Yonkers-on-Hudson, N.Y., 1929), pp. 73–74.

3. Ferdinand Vandeveer Hayden, "On the Geology and Natural History of the Upper Missouri," *Transactions of the American Philosophical Society,* new series, 12 (1862), quoted in Richard A. Bartlett, *Great Surveys of the American West* (Norman, Okla., 1962), p. 8. His instructions are quoted in Bartlett, p. 11.

4. On this, see Mary C. Rabbitt, *Minerals, Lands, and Geology for the Common Defense and General Welfare,* 2 vols. (Washington, D.C., 1979), pp. 168–180.

5. Quoted in Bartlett, *Great Surveys,* p. 16. Hayden's findings were eventually published in William Blackmore, *Colorado: Its Resources, Parks, and Prospects as a New Field for Emigration* (London, 1869). A letter from Blackmore to Hayden detailing the status of Hayden's stock is located in Record Group (RG) 57 of the National Archives (NA), *Records of the U.S. Geological Survey,* "Letters Received," microfilm reel 16, frames 120–125.

6. Information on the budget of the Survey is found in the "Financial Records" section of NA RG 57, microfilm reel 21, frame 14.

7. In Hayden, *Preliminary Report of the United States Geological Survey of Wyoming and Portions of Contiguous Territories (Being a Second Annual Report of Progress* [1870 Survey]) (Washington, D.C., 1871), p. 3.

8. Ferdinand Vandeveer Hayden, *Sun Pictures of Rocky Mountain Scenery, with a Description of the Geographical and Geological Features, and Some Account of the Resources of the Great West;*

Containing Thirty Photographic Views Along the Line of the Pacific Railroad, From Omaha to Sacramento (New York, 1870), p. 1.

9. Here is Hayden on the subject:

Never in the history of our country has the term "The Great West" possessed so much significance as at the present time. Thirty years ago, Ohio, Indiana, and Illinois were called the far Western States, while but little was known of the vast regions beyond; now, farms and villages with sites of future cities are dotted over the plains and mountain slopes as they stretch westward toward the setting sun.

Ferdinand Vandeveer Hayden, *Sun Pictures*, p. 1.

10. Ibid., pp. 4, 5, 14.

11. Ibid., pp. 18–20.

12. William H. Goetzmann, *Exploration and Empire: The Scientist and the Explorer in the Opening of the American West* (New York, 1966).

13. Hayden, *Sun Pictures,* pp. 148–150.

14. Jackson, *Diaries,* July 23–July 28, 1870; see also Jackson, "Reminiscences of a Summer Jaunt," *The Photographic World* 1 (1871), pp. 72–74, for a singularly uninformative set of anecdotes whose primary purpose seems to have been to further establish Jackson's claim over the photography of the West.

15. Jackson, *Diaries,* July 31–August 3, 1870; Hayden, *Fourth [sic] Annual Report of the U.S.G.S. . . . 1870* (Washington, D.C., 1871); Bartlett, *Great Surveys,* pp. 11, 25.

16. Jackson, *Diaries,* August 1–7, 1870; Bartlett, *Great Surveys,* pp. 16–25, J. Gray Sweeney, "The Artist-Explorers of the American West, 1860–1880" (Bloomington, University of Indiana, doctoral dissertation, 1975; in Xerox University Microfilms, Ann Arbor, Mich., Dissertation no. 75-17,068), pp. 277–279.

17. This letter is located in NA RG 57-H, box 15A, "Hayden Survey Letters of Application 1872 [sic]–1879."

18. Ibid.

19. Jackson, *Diaries,* August 7–9, 1870, *Pioneer Photographer,* p. 80; Bartlett, *Great Surveys,* pp. 25–26; Hayden, *Fourth Annual Report,* pp. 35–38.

20. Jackson, *Diaries,* 1870, passim; Hayden, *Fourth Annual Report . . . 1870;* Edkins and Newhall, *William Henry Jackson* (Fort Worth, 1974), p. 137; Jackson, *Descriptive Catalogue of the Photographs of the United States Geological Survey of the Territories for the Years 1869 to 1875, Inclusive. Second Edition. W. H. Jackson, Photographer . . . Miscellaneous Publications—No. 5* (Washington, D.C., 1875), pp. 11–21.

21. Hayden, *Fourth Annual Report,* p. 37.

22. Gifford's trip with Hayden appears in a heavily romanticized, and fictionalized, form in Worthington Whittredge's "Autobiography," published in the *Brooklyn Museum Journal* (1942), pp. 45–62. Whittredge reported that Gifford "had done literally nothing in the way of work during a whole summer," an assertion proven false by the picture Jackson made of Gifford painting (see illustration 56).

23. This corresponded to Hayden's assertions in *Sun Pictures* that even the wastelands of the far West held potential value for the American nation.

24. Here the distinction between the picturesque style of painter Thomas Cole and the older so-called Hudson River School of painters, and the new style and content of the luminists, including Gifford, needs to be qualified. Like most of Gifford's paintings of this era, Jackson's photograph retains many of the qualities of the older picturesque mode; it is in the mutations away from this that a new position can be glimpsed.

25. See, for example, Clarence King's marvelous *Mountaineering in the Sierra Nevadas* (New York, 1871).

26. This is the thesis of William Goetzmann's magisterial *Exploration and Empire,* esp. p. 199.

27. Jackson, *Descriptive Catalogue,* p. 14.

28. The letter is included in the beginning of Hayden's *Preliminary Report* for that year.

29. On the projected "Camp Scenes," apparently never widely published, see letter from S. R. Gifford, Jan. 6, 1871, NA RG 57; on the print order, see letter from Robert H. Lamborn, D&RG, in NA RG 57, reel/2, frame 0187. Although much

has been made of the influence of Jackson's pictures on the Congress in the founding of Yellowstone National Park, most of it has turned out to be exaggerated retellings of Jackson's own hyperbolized reminiscence. But it seems clear that loose prints were rather lavishly distributed throughout the Survey years—see the many letters acknowledging receipt in NA RG 57.

30. On Jarvis, see William Culp Darrah, *The World of Stereographs* (Gettysburg, Pa., 1977), p. 74.

31. Hayden, *Preliminary Report . . . Wyoming . . . 1871* (Washington, D.C., 1872), pp. 8–9. On Survey appropriations, see NA RG 57, reel 21, frame 14.

32. Charles Edgar Ames, *Pioneering The Union Pacific Railroad* (New York, 1969), points out the significant relationship between congressional figures and members of the boards of directors of the Union and Central Pacific railroads.

CHAPTER FOUR

1. John Brinkerhoff Jackson, *American Space: The Centennial Years, 1865–1876* (New York, 1972), p. 19.

2. See National Archives (NA) Record Group (RG) 57, esp. microfilm reels 20 and 21, for information on the Survey's business dealings. Letters to Hayden from publishers are interspersed throughout the Record Group.

3. William Henry Jackson and Howard R. Driggs, *The Pioneer Photographer: Rocky Mountain Adventures with a Camera* (Yonkers-on-Hudson, N.Y., 1929), p. 100; William H. Goetzmann, *Exploration and Empire: The Scientist and Explorer in the Opening of the American West* (New York, 1966), pp. 502–504; Richard A. Bartlett, *Great Surveys of the American West* (Norman, Okla., 1962), pp. 38–41.

4. Goetzmann, *Exploration and Empire,* pp. 401–406; Truman C. Everts, "Thirty-seven Days of Peril," *Scribner's Monthly* 3, no. 1 (November 1871), pp. 1–17. Langford's statement is quoted

in the introduction to his *Diary of the Washburn Expedition to the Yellowstone and Firehole Rivers in the Year 1870* (St. Paul, Minn., 1905).

5. Nathaniel P. Langford, "The Wonders of the Yellowstone," *Scribner's Monthly* 1 (1871), pp. 1–17, 113–118, esp. pp. 10, 12, 118.

6. The connection with influential Washington figures was, in fact, even more powerful; Jackson reported in the *Descriptive Catalogue of the Photographs of the United States Geological Survey of the Territories for the Years 1869 to 1875, Inclusive. Second Edition. W. H. Jackson, Photographer . . . Miscellaneous Publications—No. 5* (Washington, D.C., 1875), p. 29, that the boat "Annie" used by the Survey to explore Yellowstone Lake was named "in compliment to Miss Anna Dawes, a daughter of the distinguished statesman whose generous sympathy and aid have done so much toward securing these results." See also Goetzmann, *Exploration and Empire,* p. 507. Hayden, *Preliminary Report . . . 1871,* p. 3; Jackson, *Pioneer Photographer,* pp. 100–101.

7. J. Gray Sweeney's very important dissertation is the source for much information on Moran as well as other figures. It represents one of the most important general works on the art-making of the American West during the period: "The Artist-Explorers of the American West, 1860–1880," (Bloomington, University of Indiana, doctoral dissertation, 1975), pp. 305–316. Nettleton's letter is in NA RG 57, reel 2. Studies of Moran are, surprisingly, rather sparse. Richard A. Bartlett's "From Imagination to Reality: Thomas Moran and the Yellowstone," *Prospects 3* (1977), pp. 111–124, is a rather cursory study of Moran's trip, leaning heavily on the painter's diary, now held at the library of the National Park Service in Yellowstone. Aubrey L. Haines's *The Yellowstone Story: A History of Our First National Park* (Yellowstone, Wyo., 1977) is a superb source generally and includes information on Moran's role with the Survey. Phyllis Braff's catalogue *Thomas Moran: A Search for the Scenic* (East Hampton, N.Y., 1980) provides an accurate chronology;

Thurman Wilkins's *Thomas Moran, Artist of the Mountains* (Norman, Okla., 1966) is the standard biography but contains a number of factual errors. Fritiof Fryxell has provided an excellent selection of edited letters from Moran to his wife in *Home-Thoughts From Afar* (East Hampton, N.Y., 1967).

8. Hayden had invited Gifford, but he could not come. See Gifford's letter of reply, NA RG 57, reel 2; Sweeney, *Artist-Explorers,* pp. 306–316.

9. Hayden, *Preliminary Report . . . 1871* (Washington, D.C., 1872), pp. 3–4.

10. Earl A. Powell has written convincingly of an American sublime sensibility that "found its roots in man's internal perception of time and space," in which "a contemplative view of nature thus displaced terror and majesty." See "Luminism and the American Sublime," in John Wilmerding, ed., *American Light: The Luminist Movement, 1850–1875* (New York, Washington, D.C., 1980).

11. The lens's "folding" of space is similar to the distortions of certain contemporary wide-angle lenses for hand cameras and bears a remarkable resemblance to the same phenomenon with a legendary view camera lens: the 8½-inch Goertz "Golden Dagor."

12. Thomas Hine's two-hundred-plus photographs of the Yellowstone were, with the mysterious exception of sixteen prints, tragically destroyed, along with virtually all of Barlow's notes and records, in the Chicago fire of October 8, 1871. As a result, Barlow was forced to purchase prints from Jackson, who had held all the negatives under his August 1, 1870, contract with Hayden. See Aubrey L. Haines, *Yellowstone National Park: Its Exploration and Establishment* (Washington, D.C., 1974), p. 178ff.; letter of Jackson to Hayden, August 1, 1870, NA RG 57 (not microfilmed). Of Crissman, virtually nothing is currently known. Most writers on the subject of the Yellowstone expedition have parroted Jackson's report in *Time Exposure: The Autobiography of William Henry Jackson* (New York, 1940), which

is based on a forged section of his diaries. Future research may well discover more of Crissman's work than is now known. The complete itinerary for the trip is detailed in Hayden, *Preliminary Report . . . 1871* (Washington, D.C., 1872), pp. 3–4.

13. Haines, *Yellowstone National Park,* pp. 104–106. It is an enigma that Haines's extraordinarily detailed and sophisticated books—both the title cited and the much more elaborate, two-volume *Yellowstone Story: A History of Our First National Park*—have not been consulted by scholars on Jackson and on the National Park Service, including Bartlett, in his later essay on Moran, cited above, and Howard Bossen, whose "A Tall Tale Retold: The Influence of the Photographs of William Henry Jackson on the Passage of the Yellowstone Park Act of 1872" appeared in *Studies in Visual Communication* 8, no. 1 (Winter 1982), pp. 98–109. In part it helps account for the many misconceptions concerning the founding of the park and Jackson's part in it. The photographer Thrasher's work has apparently disappeared; an "I. T. Thrasher" of Lewiston, Idaho, is listed by Darrah as working in the 1870s—see Darrah, *The World of Stereographs* (Gettysburg, Pa., 1977), p. 199.

14. Hayden, "The Wonders of the West—II: More About the Yellowstone," *Scribner's Monthly* 3 (February 1872), pp. 388–389.

15. Jackson reported on the making of the "Tower Falls" photograph in his diaries, in *Pioneer Photographer,* p. 112, and in *Time Exposure,* pp. 198–199.

16. Moran's diary is quoted in Sweeney, *Artist-Explorers,* pp. 324, 342.

17. On Jackson's retouching, see Weston Naef, *Era of Exploration* (Boston, 1975), p. 223.

18. Compare this picture to any one of a number by Jackson's contemporary, King and Wheeler Survey photographer Timothy H. O'Sullivan. His "Historic Spanish Record of the Conquest, South Side of Inscription Rock, New Mexico" (1873) is but one of many views where O'Sullivan fastidiously included rulers, human figures, even such

homely objects as tin cans and bottles to provide an accurate sense of the dimensions of the photograph's subject. Jackson's picture does use a human figure—but its presence so far in the background distorts and confuses the scale of the subject, the depth of the scene, and the relationship of spring to geyser.

19. One of Muybridge's boasts is detailed in the 1873 catalogue of his photographs issued by his publisher, Bradley and Rulofsen: *Catalogue, Photographic Views* (San Francisco, 1873), unpaginated.

20. An edifying comparison can be made between this view and Moran's, published in Prang's centennial portfolio in 1876. Able to situate his hypothetical viewer higher up from the scene than Jackson could locate the actual camera, Moran produced a view both more topographic and more theatrical. Jackson had to compensate for the failings of his medium with the inspired inclusion of the human figure.

21. *New York Times,* September 18, 1871, p. 4, October 23, 1871, p. 4, quoted in Bossen, "A Tall Tale Retold," p. 102.

22. NA RG 57, reel 3, letters from R. Watson Gilder on *Scribner's* letterhead.

23. This information, and much of the background on the subject, is derived from records of debate in the *Congressional Globe* for 1871–1872, from miscellaneous letters found in NA RG 57, from Hayden's own assertions in both the *Preliminary Reports* and the final *Reports,* and—most important—from Aubrey L. Haines's two works: *Yellowstone National Park* and *The Yellowstone Story.* See also House of Representatives Executive Document 147, *Yellowstone Park,* 43d Congress, 1st sess., in *House Executive Documents* 1610, pp. 1–8, in which Secretary of the Interior Delano's letter describes the bill's aim: "To preserve it as a public park or pleasuring ground for the benefit and enjoyment of the people"; the bill itself in its final form is found as House Report 26, *The Yellowstone Park,* 42d Congress, 1872, 2d sess., in *House Reports* 1528, pp. 1–2.

24. Haines, *Yellowstone National Park,* pp. 109–111; Langford, *Diary,* p. xxii; Haines, p. 114.

25. Langford, p. xxii; Haines, *Yellowstone National Park,* p. 115; Hayden Survey, letters received, NA RG 57.

26. Pomeroy's announcement stated, "There are several Senators whose attention has been called to this matter [of the pending bill], and there are photographs of the valley and the curiosities, which Senators can see. The only object of the bill is to take early possession of it by the United States and set it apart, so that it cannot be included in any claim or occupied by any settlers." *Congressional Globe,* 42d Congress, 2d sess., January 22, 1872.

27. NA RG 57, reel 2, February 14, 1872, letter from H. B. Anthony [? signature illegible]; Naef, *Era of Exploration,* p. 73, reports the first title but gives no citation or location; Beaumont Newhall and Diana Edkins, *William Henry Jackson* (Fort Worth, 1974), p. 152, gives the second, but although it reports precisely eighty-one prints in the volume and asserts that "this is the album which was presented to Congress as proof of the wonders of Yellowstone," there is no further reference to support the titles or the assertion. Indeed, no volumes with those titles appear in the *National Union Catalogue;* and although many Jackson authorities repeat the presence of such albums, I have never seen one that is, in fact, an original work and not a later compilation of pictures, often including views from 1872 and 1878. Carol Roark of the Amon Carter Museum reports that a portfolio with an 1871 date stamped on its cover was offered at one time to the museum, but it was not purchased. The most accurate source on the history of Yellowstone, Haines, never suggests the presence of such albums in the numbers implied by Newhall and the rest. See also Bossen, "A Tall Tale Retold," and Hiram Martin Chittenden, *The Yellowstone National Park* (Norman, Okla., 1964), esp. p. 82.

28. On this, some suggestions are found in Haines, but most come from Langford's *Diary,*

Hayden's writings, and the debate itself, recorded in the *Congressional Globe* for December 18, 1871; January 22–23, 30, February 27–29, March 5, 1872.

29. Hayden, *Preliminary Report . . . 1871* (1872), p. 65; see also Langford, "Wonders," p. 389 and passim. William H. Goetzmann has suggested that Hayden was reporting the effect of the springs on his own "long standing" syphilitic disease (conversation with the author, 1986).

30. See the various debates, recorded in the *Congressional Globe,* in note 28.

31. See Goetzmann, *Exploration and Empire,* pp. 511–512, on the disputed claim of Stevenson's mountaineering exploits in this year's trips.

32. Jackson, *Diaries,* May 27, 1873.

33. Ibid., May 29, 1873.

34. Ibid., June 7, 1873.

35. Ibid., August 5, 1873. Hayden, too, began to note by a sort of rote behavior the "charming water-falls . . . [and] scenes of great beauty." (Hayden, *Report . . . 1873* [Washington, D.C., 1874], p. 62).

36. Jackson, *Diaries,* August 29, 1874. Indeed, Jackson and his colleagues also witnessed the opposite, a sort of anticivilization process. The journalist/botanist Ernest Ingersoll, who accompanied the Survey in 1874 and became a lifelong friend of Jackson's, reported of the mining town of Empire that it had shrunk from a respectable population of 1,500 to nothing in a matter of months, so that "the school-house (newly built) did not even see the benches that were to be whittled by jack-knives of pupils who never came." Ernest Ingersoll, *Knocking 'Round the Rockies* (New York, 1882), p. 32.

37. On July 20, 1873, Jackson was working above the Twin Lakes in Colorado when he wrote that he "proceeded with my views and succeeded in getting a fine panoramic series. All the topographers were on the same point at their work." *Diaries,* August 20, 1873. Hayden reported in his introduction to the annual report of that year that "Mr. W. H. Jackson performed his duties in the

field with his usual success. His triumphs in the mountain regions of Colorado are already well known all over the country. The panoramic views of the mountain-peaks have been of great value to the topographer as well as the geologist, and have proved of much interest to the public generally." Hayden, *Annual Report . . . 1873,* p. 7.

38. Jackson, *Time Exposure,* p. 204.

39. On the general issue of the difference between the pioneer marriage and the rising cult of sentimental womanhood in the East after the Civil War, see Ann Douglas, *The Feminization of American Culture* (New York, 1977), esp. pp. 54–56; see also Nancy Cott, ed., *Root of Bitterness: Documents of the Social History of American Women* (New York, 1972).

40. William Culp Darrah has confirmed my assessment; in a letter to me written January 12, 1986, he stated that "this was an almost universal practice, to purchase negatives or prints from photographers presuming that purchase transferred all rights to use them without further credit. It took me almost ten years to appreciate fully this complicating factor in determining 'authorships' in great numbers of photographs." The many errors of authorship found in Newhall's and Edkins's *William Henry Jackson* (including the slipcase cover photograph, which is by Charles R. Savage) were often the result of confusion over this phenomenon of commercial photographic publishing in the nineteenth century. Richard Rudisill first brought the authorship question to light in a paper delivered before the Fifth Biennial Convention of the American Studies Association in 1975; it is also available as "A Problem in Attribution," *Research Report No. 1,* Santa Fe: Photo Collections, Museum of New Mexico, 1975. On Crissman, see Jackson, *Descriptive Catalogue,* pp. 44, 25–26.

Crissman's views offer perhaps the most telling indication of the changing ideas of authorship in the nineteenth and twentieth centuries. Crissman ended up uncredited in the 1871 catalogue of Jackson Survey views, but Jackson rather haphazardly corrected the oversight by the time his 1875 *Descriptive Catalogue* appeared—he noted Crissman as photographer in the captions for the 1872 Yellowstone views, referring the reader back to the earlier set. By the 1930s, however, standards had so changed that Jackson felt obligated to eradicate the portion of his typescript autobiography that mentioned Crissman's views, erasing the text and then gluing a substitute set of typed lines, concerning another subject, over the original. The typescript autobiography is in the Manuscripts Collection of the New York Public Library. That this is not a minor inadvertence is made clear by the fact that Jackson used multiple erasures to remove all but the very faintest traces of the underlying materials—a technique he never even approached anywhere else in any document of his. Just exactly which pictures are by Crissman has never been established; Nellie Carico of the U.S. Geological Survey has tentatively identified twelve, but they do not correspond with the numbers Jackson asserted—which are themselves incomplete.

41. On Hayden's attempts to monopolize production, see letters between Jackson and Hayden in NA RG 57, reel 3, letters received, J.

42. See Goetzmann, *Exploration and Empire,* pp. 508–511; Bartlett, *Great Surveys,* p. 59.

43. Letter, Edward Bierstadt to Hayden, February 3, 1872, in NA RG 57, reel 2.

44. Hayden, handwritten draft of letter to Secretary of the Interior, NA RG 57, reel 21; an equally valuable source is Hayden's published "Letter" in the *Ninth Annual Report . . . 1875* (Washington, D.C., 1877). Even this single statistic on printing runs is derived from data not on the reports but rather on the reproductions; in 1874, Hayden's inclusion of a set of maps of Snake River and the surrounding regions supplied those numbers—see NA RG 57, letters received, letter from [Sinclair?].

45. The extent of this symbiotic relationship is detailed in the "letters received" section of the USGS files, filed as NA RG 57. O. C. Marsh's allegiance turned out to be quixotic; in 1878, he was an opponent of Hayden for the directorship of the consolidated Survey.

46. Jackson, *Photographs of the Yellowstone National Park and Views in Montana and Wyoming Territories. Department of the Interior, U.S. Geological Survey of the Territories . . . W. H. Jackson, Photographer* (Washington, D.C., 1873). I have examined two copies of this portfolio, one located in the Rare Book Collection of the Library of Congress, the other in the Lilly Library at Indiana University. While the former is in its original leather binding, the latter is by far the more interesting. Sweeney, in *Artist-Explorers,* asserts that this was Jackson's private copy, but in fact it was the property of Robert S. Ellison, Standard Oil executive and sponsor of Jackson during the twenties and thirties. Ellison's relationship with Jackson is detailed in a later chapter; in typical fashion, he asked Jackson to autograph each photograph and every caption he'd written, and to provide written comments. These are an invaluable source of information on Jackson's own feelings about the past as they appeared in the twenties.

47. Jackson, *Photographs of the Yellowstone,* caption page to plate 12, Lilly Library copy signed by Jackson.

48. A number of the proofs of this portfolio are located in the National Anthropological Archives, where they apparently were deposited by Jackson's friend and Hayden Survey artist William Henry Holmes, later head of the Bureau of American Ethnography. There is a possibility that these are, in fact, the proofs of the lost 1873–1876 portfolio and that Hayden simply miscounted the number of views. The presence of cloud effects in a number of the negatives, however, suggests that at least some of the prints were made in 1878.

49. On the creation and distribution of stereos, see Oliver Wendell Holmes's superb series of articles describing his responses to sample stereos, his explanation of the meaning and value of the phenomenon, and his "tour" of a stereo view

factory: "The Stereoscope and Stereograph," *Atlantic Monthly* 3 (June 1859), pp. 738–748; "Sun Painting and Sun Sculpture," *Atlantic Monthly* 8 (May 1861), pp. 13–29; and "Doings of the Sunbeam," *Atlantic Monthly* 12 (1863), pp. 1–15. See also William Culp Darrah, *Stereo Views* (Gettysburg, Pa., 1964), and *The World of Stereographs* (Gettysburg, Pa., 1977), and Richard Masteller's vital essay, "Western Views in Eastern Parlors," in *Prospects* 6 (New York, 1981). On Jackson's contracts, see Darrah, *World of Stereographs*, pp. 93, 74, and William and Estelle Marder, *Anthony: The Man, the Company, the Cameras* (Amesbury, Mass., 1982), pp. 151–153.

50. Regrettably, the letters relating to photographs are scattered throughout the "letters received" section of NA RG 57, and are arranged alphabetically by author; only those directly addressed to Hayden were retained in this file. Some further information is found in the section of miscellaneous documents at the end of NA RG 57, reel 21, which includes drafts of letters Hayden wrote, speeches, fiscal calculations, and some financial records. In the alphabetical section are found the letters from the Royal Society of Tasmania; the National Gallery of Victoria, Australia; Count Marshall, Budapest, Hungary; Elizabeth Bierstadt; J. P. Harris-Gestrell; Watson Gilder[?] for *Scribner's;* and the Royal Photographic Society, London.

51. See Fritiof Fryxell, "William Henry Jackson: Photographer, Artist, Explorer," *American Annual of Photography* (1939), pp. 208–220, esp. p. 215. Fryxell had access to Jackson's diaries, notes, and reminiscences for this essay, which appears to be at least partly written by Jackson. Hayden reported on the Centennial Exposition presentation in his "Official Application for Increased Appropriation [for the Centennial Exposition]," in NA RG 57, reel 21.

52. These models remained on display at the American Museum of Natural History as late as 1940; see Jackson, *Time Exposure*, pp. 240–243;

see also Jackson's letters to Hayden, 1876, NA RG 57.

53. A number of reviews noted these transparencies, including two for Wilson's *The Philadelphia Photographer:* "Interesting American Scenery" and "Scattered Photography in the Great Exhibition," in *The Philadelphia Photographer* 13, pp. 120–123, 294–295.

54. See Hayden's "Official Application for Increased Appropriation [for exhibits at the Centennial Exposition]," in NA RG 57, reel 21.

55. Cf. "Return of Mr. W. H. Jackson" and "Photographs of Rocky Mountain Scenery and its Prehistoric Ruins" in *Anthony's Photographic Bulletin* (1876), pp. 31, 187; "Interesting American Scenery" and "Scattered Photography in the Great Exhibition" in *The Philadelphia Photographer* 13, pp. 120–123, 294–295.

56. Robert F. Berkhofer, Jr., *The White Man's Indian: Images of the American Indian from Columbus to the Present* (New York, 1976), pp. 166–175; Ray Allen Billington has an excellent synopsis of Indian events during the period in *Westward Expansion: A History of the American Frontier* (New York, 1967), pp. 653–672; Paul Prucha's definitive two-volume study of government policies toward the Indian, *The Great Father: The United States Government and the American Indians* (Lincoln, Neb., 1984), covers the seventies in chaps. 19–23, pp. 501–606, of vol. 1.

57. The popularity of these Indian views is evidenced not only by their relative commonness in collections but also by the fact that Jackson published the *Catalogue of Indian Views* at all.

58. Jackson, *Diaries,* August 18–20, 1874.

59. In addition to scattered reports in the *Diaries,* see Jackson's report on the ruins of Chaco Canyon, in Hayden, *Ninth Annual Report . . . 1875* (Washington, D.C., 1877), esp. pp. 428–432, where Jackson reports on the differences between the "good" Navaho, who are "devoted to husbandry" and the "bad" Utes who are "aggressive."

60. *Descriptive Catalogue of Photographs of*

North American Indians (Washington, D.C., 1877), pp. iii–iv, v.

61. Ibid., pp. 10, 22, 23, 24, 52, 62, 64, 71–72, and passim; *Descriptive Catalogue . . . Survey,* pp. 3–4.

62. Much of this speculation particularizes ideas found in Howard Becker's *Art Worlds* (Berkeley, 1982); I am grateful to musicologist Robert Morgan of the University of Chicago who, in a lecture on postmodern composition delivered at the University of Illinois, Chicago, in 1981, talked about the composer who declared his conservatory training to have been a waste on the grounds that he simply forgot the rules he'd been taught; Morgan pointed out that such disclaimers almost always meant only that the composer in question had so deeply assimilated those rules that he or she was now able to relegate them to the unconscious. This remark, similar to Becker's descriptions of his own experiences playing jazz in Chicago nightclubs while sleeping, directed my attention to the concept of an artist who could be purposive without being conscious.

63. Probably the most important books on the managerial revolution here discussed are Alfred D. Chandler, Jr., *The Visible Hand: The Managerial Revolution in American Business* (Cambridge, Mass., 1977), and Reese Jenkins, *Images and Enterprise: Technology and the American Photographic Industry, 1839–1925* (Baltimore, Md., 1975).

64. Ferdinand V. Hayden and Thomas Moran, *The Yellowstone National Park and the Mountain Regions of Portions of Idaho, Nevada, Colorado and Utah. Described by Professor F. V. Hayden . . . Illustrated by Chromolithographic Reproductions of Water-Color Sketches by Thomas Moran, Artist to the Expedition of 1871* (Boston, 1876).

65. F. D. Carpenter, *The Wonders of Geyser Land: A Trip to the Yellowstone National Park . . .* (Black Earth, Wis., 1878); Windham Thomas, Earl of Dunraven, *The Great Divide: Travels in the Upper Yellowstone in the Summer of 1874. With*

Illustrations by Valentine W. Bromley (London, 1876); Hayden bought Dunraven's book in 1876, paying five dollars for it—see NA RG 57; letter, George A. Crofutt to Hayden, February 16, 1872, NA RG 57, reel 2; Crofutt, *Crofutt's Trans-Continental Tourist's Guide* (New York, Chicago, published annually, 1868–1877); *Crofutt's New Overland Tourist and Pacific Coast Guide . . .* (Chicago, published annually, 1878–1887)—see Annexes 35, 36 for miscrediting; *Crofutt's Overland Tours. Consisting of Nearly Five Thousand Miles of Main Tours, and Three Thousand Miles of Side Tours . . .* (Chicago, 1888) also used Survey pictures, as well as later Jackson Company views. Probably the record was the appearance of Jackson Survey views in annual reports by the Bureau of American Ethnology as late as 1915.

66. Richard Masteller has brilliantly argued this point in his "Western Views in Eastern Parlors," *Prospects 6* (New York, 1981), pp. 55–71.

67. See *Frank Leslie's Illustrated Weekly* issues from July, 1877, through September, 1878; some of the reports have been excerpted in Richard Reinhardt, *The West on the Overland Train* (Palo Alto, Calif., 1967). During the seventies this practice was continued not only by Ingersoll, writing for The New York *Tribune, Harper's Magazine, Scribner's Monthly, St. Nicholas, Good Company, Forest and Stream, The Country, The Congregationalist, Spirit of the Times, The Hour,* and the *Army and Navy Journal,* but also by correspondents for the *New York Herald,* the *Philadelphia Inquirer,* the *New York Times,* and other newspapers and magazines, many of them accompanying Hayden's, Powell's, Wheeler's and other expeditionary teams in order to experience and then write about the West.

68. See, for example, Jackson, *Diaries,* June 30, 1875.

69. These conclusions are drawn from an examination of the negatives held by the National Archives and close study of a number of prints made during the seventies and held in various collections. My conclusions have been confirmed by Joel Snyder, who mentions the alteration of the cross in *American Frontiers.* I am speculating about the chronology for the early alterations; it seems likely that Jackson added the waterfall after seeing Moran's pictures, as the photographer would not have wished his friend's painting to be found overly "poetic." Moran himself described his work for George W. Sheldon's *American Painters* (New York, 1879): "The idealization of the scene consists in the combination and arrangement of various objects in it. At the same time, the combination is based upon the characteristics of the place. My purpose was to convey a true impression of the region."

70. Many of these examples can be found in the collections of the Colorado State Historical Society; others can be found in the Amon Carter Museum, Fort Worth, Texas, the International Museum of Photography at the George Eastman House, Rochester, the Library of Congress, and other public collections. Jackson also produced mock stereographs of the improved view.

71. Hayden, *Ninth Annual Report . . . 1875* (Washington, D.C., 1877), pp. 22–23.

72. This entire sordid battle can be found scattered in the letters of the Hayden Survey, NA RG 57, and especially in the miscellaneous papers found in reel 21; the congressional debates and the far more damning committee testimony is found in the *Congressional Globe,* with portions excerpted, apparently by Hayden's assistants, in RG 57. See also the more sympathetic account of Clifford M. Nelson, Mary C. Rabbitt, and Fritiof M. Fryxell, "Ferdinand Vandeveer Hayden: The U.S. Geological Survey Years, 1879–1886," *Proceedings of the American Philosophical Society* 125, no. 3 (June 1981), pp. 238–243. Nelson, Rabbitt, and Fryxell make a persuasive argument for Hayden's deep sense of mission and argue successfully that it surmounted any motives of self-aggrandizement on Hayden's part. Probably the most accurate source on the entire history of consolidation is Rabbitt's *Minerals, Lands, and Geology for the Common Defense and General Welfare ("Before 1879"),* vol. 1, pp. 263–288. Rabbitt includes many of the letters among the various principals; the image of Hayden abandoned by his scientific colleagues, many of whom he had counted among his friends and solicited for contributions to the Survey *Bulletin* and other reports, is very strong.

73. Just how much Hayden depended on that Yellowstone inquiry to salvage his reputation can be seen by looking at the *Report;* five years in the making, it was two volumes long and featured a tremendous amount of data, as well as a superb collection of lithographs—both scientific and derived from photographs—and even full-color chromolithographs derived from Moran's portfolio for Prang and Company of 1876.

74. Langford's first warning letter is included in Delano's "Letter From the Secretary of the Interior and Report of the Superintendent of the Yellowstone National Park for the Year 1872," Senate Executive Document 35, 42d Congress, 1873, Long 3d sess., *Senate Reports* 1545. See also Delano letter, in *Yellowstone Park,* 43d Congress, 1st sess., *House Executive Documents* 1610, p. 2.

CHAPTER FIVE

1. Jackson, *Time Exposure: The Autobiography of William Henry Jackson* (New York, 1940), p. 251.

2. Ibid., pp. 252–254, offers a probably inflated account of this meeting.

3. See Charles Edgar Ames, *Pioneering the Union Pacific Railroad* (New York, 1969), pp. 503–515; Jackson, *Time Exposure,* pp. 252–254.

4. Ames, *Pioneering the Union Pacific,* pp. 508–509.

5. Ibid.; Jackson, *Time Exposure,* p. 254. While Jackson refused to commit himself to the effect of Gould's letters, this may have been simple vanity. Jackson's pictures for these railroads were superb,

but it seems virtually impossible to overestimate Gould's influence during the early eighties.

6. Survey salaries were recorded in the USGS Hayden Survey materials, National Archives (NA) Record Group (RG) 57, reel 20; Jackson's comments are found in *Time Exposure,* pp. 251–252.

7. Little has been written about the business of photography during this period in America, in part because the almost universal practices of buying, selling, and trading images, and the equally common practice of using assistants and "camera operators" to make pictures that were published under the name of the business head, are all profoundly threatening to the burgeoning market in "authentic" nineteenth-century photographs, especially landscape photographs. In addition, these practices have created a complex aesthetic problem for which art history, the discipline most aggressively expanding into photography, is currently incapable of providing solutions. Hence the documents that record the history of such photographic businesses—like those of Watkins at the Bancroft Library of the University of California, Berkeley, the Taber firm, also at the Bancroft, and others—have been largely unconsulted, although Peter Palmquist's recent essay, *Carleton E. Watkins, Photographer of the American West* (Albuquerque, 1982), makes an important start, and the doctoral dissertation of Nanette Sexton, "Carleton E. Watkins: Pioneer California Photographer (1829–1916): A Study in the Evolution of Photographic Style During the First Decade of Wet Plate Photography" (Harvard University, 1982), goes even further. A significant source for general business practices is found in the photographic journals of the day, especially Anthony's *Bulletin,* Scovill's *Photographic Times,* and editor Wilson's *The Philadelphia Photographer.* See also Jenkins, *Images and Enterprise: Technology and the American Photographic Industry* (Baltimore, 1975), for information on the business surrounding the photography business.

8. Men like Watkins, Muybridge, and Taber located in San Francisco; Seneca R. Stoddard and Bierstadt in the resort areas of New York; others dotted the resorts and picturesque regions. Stoddard's photographs are held by the Library of Congress; he was the Eastern equivalent of Jackson during the eighties and nineties and was well published in the photographic magazines—as were Bierstadt and others.

9. All this information on Denver comes from Robert Perkin, *The First Hundred Years: An Informal History of Denver and the* Rocky Mountain News (Garden City, N.Y., 1959), pp. 345–380 and passim.

10. Jackson, *Time Exposure,* pp. 254–255; Jackson's visits to photographic journals resulted in a number of squibs, notably in the *Philadelphia Photographer.*

11. Jackson, *Time Exposure,* p. 220.

12. See Alfred Chandler, Jr., *The Visible Hand: The Managerial Revolution in American Business* (Cambridge, Mass., 1977), particularly part 1 and the opening chapters of part 2, for more detailed information on the changing structures of business management in nineteenth-century America.

13. *Rocky Mountain News,* July 4, 1879, p. 8, col. 1; Jackson, *Time Exposure,* pp. 254–257.

14. See "A New Photograph Gallery," *Rocky Mountain News,* November 2, 1879, p. 6, col. 3; Jackson's advertisement in the *Rocky Mountain News* for January 1, 1880, p. 24, col. 5; Jackson, *Time Exposure,* pp. 257–258; *Denver City Directory,* 1880.

15. Jackson, *Time Exposure,* p. 258; The arrangement between the two photographers included issue of some Jackson & Rinehart printed backs for cartes, but the two never advertised their consolidation in Denver directories, suggesting the formal association was quite brief. Instead, they shared the studio space on Larimer and, apparently, all other expenses and necessities; see the *Denver City Directory* for these years. Some mention of the arrangement is made in Fred Mazzulla's taped interview with Jackson's assistant Louis Charles McClure, held in the Denver Public Library Western History Collection. Rinehart appears nowhere in the standard histories of American photography but was a prominent portraitist not only in Denver but nationally, judging from mention of him in the photographic journals. In addition, his portraits were the standards for Denver businessmen during the eighties and nineties. They appeared in a tremendous number of booster books, annual reports, and the like; copies of many of these are located in the Western History Collection of the Denver Public Library.

16. *Rocky Mountain News,* January 9, 1881, p. 6, col. 2; see also Jackson, "Photographic Trips of Denver Period—1879–1898" (typescript held by the Amon Carter Museum, Fort Worth, Texas).

17. Edkins and Newhall's *William Henry Jackson* (Fort Worth, 1974) dates this trip as 1883 and does not mention that Moran was also a member of the tour. Jackson himself mentioned only in passing that 1881 was his first D&RG commission, in *Time Exposure,* p. 258. In addition, Ernest Ingersoll's *Crest of the Continent: A Summer's Ramble in the Rocky Mountains and Beyond* (Chicago, 1885) contains no dates, and many of the photographs from which the illustrations are derived were made by Jackson in 1883 and possibly 1884. Even more confusing, Ingersoll included a chapter, "Queen of the Cañons" on the D&RG route to Silverton—which wasn't opened all the way up to that town until 1882! But most of the report on the region in *Crest of the Continent* was simply an update of Ingersoll's "Silver San Juan," *Harper's New Monthly* 64 (1881), pp. 689–704, which Ingersoll must have written immediately upon returning from the area. Ingersoll also managed to squeeze a second article out of the trip: "A Colorado Cavern," *Century* new series 2 (July 1882), pp. 347–349. In addition, Moran's papers contain information about the trip; they are located at the Gilcrease Institute, Tulsa, Okla. Some material is contained in two works about Moran: Thurman Wilkins, *Thomas Moran: Artist of the Mountains* (Norman, Okla., 1966), pp. 144–158; and Carol Clark's *Thomas Moran: Watercolors of the American West* (Austin, Tex., 1980), p. 57.

18. An entry in the *Santa Fe Daily New Mexican* on Friday, June 24, 1881, p. 4, lists the Denver contingent but strangely makes no mention of Moran, Karst, or the Ingersolls. While this may simply be local chauvinism on the newspaper's part, it seems also possible that the Easterners had left the trip by this point, continuing it at some later point or simply depending on Jackson's photographs and reports for the information Ingersoll wrote up in his text. Another likely explanation is that the Eastern contingent had left the party at Taos or remained with the railway car at Espanola. The newspaper report states that the "special car . . . was in charge of Mr. W. H. Jackson . . . an artist of prominence." The report also lists the party as "numbering eight persons," which would be the correct number if the Ingersolls, Moran, and Karst were added to the Denverites; it also discusses a planned return "to the East," suggesting that at least some of the visitors were not from Denver.

19. Ingersoll, *Crest of the Continent,* pp. 46–47.

20. Ibid., pp. 5–6. On the nervous diseases of Victorian America, see John S. Haller and Robin M. Haller, *The Physician and Sexuality in Victorian America* (New York, 1974), esp. "The Nervous Century," pp. 2–43.

21. Ingersoll, *Crest of the Continent,* pp. 343–344.

22. Examples of Ingersoll's assessments abound; the valley of the Grand River and its flagship town, Grand Junction, were "uninviting and desolate looking on the extreme," and "an orderly jumble of brick buildings, frame buildings, log cabins, tents, and vacant spaces," respectively. The tourist found their existence justified, however, because though not picturesque they presaged a new era of irrigation farming and hence of national prosperity. Time and again in Ingersoll's text, the works of God had to be exhaustively tested, catalogued, and assessed—often through direct application of an economic model. Ingersoll, *Crest of the Continent,* pp. 297–299.

23. Ibid., p. 97.

24. Ibid., p. 105.

25. Ibid., pp. 111, 113–114.

26. The vertical, no. 1037, is reproduced in Edkins and Newhall, *William Henry Jackson,* p. 82. The horizontal with Jackson's "special" is reproduced in my *William Henry Jackson* (London, 1984), unpaginated. Jackson Thode, Terry Mangan, Russ Coltman, and Dell A. McCoy, the railroad experts responsible for *William Henry Jackson's Rocky Mountain Railroad Album* (Silverton, Colo., 1976) have not only dated the picture but identified the engines and the trains themselves. See captions to plates 44 and 45 in that book.

27. Rosalind Krauss has presented an obverse case in a discussion of the King Survey photographs of Timothy H. O'Sullivan, arguing persuasively that it is the twentieth century that has found the shallow "exhibition space" in O'Sullivan's work—that they were meant originally as views rather than pictures. Her application of Walter Benjamin's illuminating argument falls apart, however, when she attempts to apply it more indiscriminately to nineteenth-century American Western photography as a genre. The difference in intent and effect between the straightforwardly picturesque views of Carleton E. Watkins's earlier Yosemite series and O'Sullivan's powerful evocations of a blank, transcendental sublime, is so wide as to endanger such a generalization. In Jackson's case, I think, we can see a process of transformation occur between view and landscape precisely as the pictures move into service of an urban bourgeois consumer population. See Rosalind Krauss, "Photography's Discursive Spaces: Landscape/View," *Art Journal* (Winter 1982), pp. 311–319.

28. Significantly, though Jackson made hundreds of views of tourists, trainmen, and others casually posed on the engines of the various railroads he served in the eighties and nineties, nowhere in his files are there examples of the incredibly popular images of train wrecks—pictures that were a staple for other mountain photographers of the period. Oliver Jensen, for some

years the head of the Prints and Photographs Division of the Library of Congress, has written of the craze for railroad accident accounts, photographs, even county fair reenactments during the end of the nineteenth and early years of the twentieth century; see his *Railroads in America* (New York, 1975), esp. pp. 178–189. Colorado had its specialists in these images of horror—Eric Paddock of the Colorado State Historical Society has resurrected some of these professional disaster mavens.

29. These comments are based on my examination of the Jackson views held in the Colorado State Historical Society and the Denver Public Library. As two major collectors of Jackson's works, and the principal repositories for other collections of the photographs made west of the Mississippi, I have assumed they provide a representative sampling of the works produced and the frequency of their production. Smelter views, for example, appeared in a number of publications allegedly illustrated by Jackson photographs or by engravings taken from them, but the original photographs appear rarely if at all in the collections of negatives and prints. A view of the Globe Smelting Works appeared in *The City of Denver, Its Resources and Their Development* (Denver, 1891).

30. I have written more extensively about Jackson's city views in *Silver Cities: The Photography of American Urbanization, 1839–1915* (Philadelphia, 1984); an excellent source on lithographic city views and their history can be found in John Reps, *Cities on Stone* (Fort Worth, Tex., 1976).

31. *The City of Denver, Its Resources and their Development* (Denver, 1891). Jackson's city views, and their context in the urban photographic tradition, are explored more exhaustively in my *Silver Cities.*

32. On "Buckskin Charlie," see Donald English, "William Henry Jackson, Western Commercial Photographer," *Colorado History* (1983), nos. 1, 2, p. 68.

33. An early oddity of reproduction is a bird's-

eye study of "Our Nation's Capitol Viewed from the South . . . Drawn by Theo. R. Davis, from photographs by W. H. Jackson," reproduced in 1882 in *Harper's Weekly.*

34. Wilson's "Dixville Notch" appeared in the *Philadelphia Photographer* 18, no. 203 (November 1880), opp. p. 22; Lawrence's "A Bit of Old Ireland" in *Philadelphia Photographer* 18, no. 209 (May 1881), opp. p. 9. Essays on landscape include Xanthus Smith, "Composition, Part II—Landscape," *Philadelphia Photographer* 23, no. 268 (February 20, 1886), pp. 7, 98–101; Wilson's "Our Picture" and R. J. Chute's "Landscape Photography," both in the same issue of *Philadelphia Photographer,* citation lost, ca. 1883, pp. 137–140. It is interesting to note the difference between these articles and the earlier essays on "landscape photography" such as George Washington Wilson's "On Outdoor Photography," *Philadelphia Photographer* 6 (1868), pp. 66–68, which concerns itself entirely with technical and chemical matters.

35. The staffing of the Jackson firm is documented in individual entries in the *Denver City Directory.* Often these entries list specific jobs within the firm—retoucher, for example, or photographer.

36. My conclusions here are drawn from my examination of negatives, prints, sample books, and catalogues to the Jackson company, found in the Colorado State Historical Society, the Denver Public Library, the Library of Congress, the International Museum of Photography at George Eastman House, the Amon Carter Museum, the Bancroft Library, the Newberry Library, and the New York Public Library. Conclusions about assistants were derived in part from a search of the *Denver City Directory* for the relevant years, incompletely confirmed by a similar search conducted by Donald English in the early eighties. Identifying which pictures were "originals" and which were reductions or enlargement copy negatives involved examining the negatives for information, particularly for such traces as thumbtacks revealing the process of copying. Names and alternative numbers scratched in many of the smaller negatives appeared at one time to suggest the authorship of the views, but these may also simply only declare the authorship of the *negatives,* which may be copies. Donald E. English is currently working to more precisely delineate these distinctions, as is Carol Roark of the Amon Carter Museum. In addition, a cataloguing project at the Colorado Historical Society, overseen by Curator Eric Paddock, has unearthed a number of codes scratched into the negatives in the Society's possession. All three of these paths will probably bear fruit within the next few years. I am deeply grateful to all of these scholars for sharing their own researches on this issue with me, although I have, finally, agreed completely with none.

37. More commonly, the 11-by-14 represented a direct reduction of the original 18-by-22. Jackson apparently rarely or never used the camera of that particular size, relegating it to the studio as a copy camera. The source for these observations is found in comparisons of the tremendous number of Jackson prints at the Colorado State Historical Society and the Denver Public Library—both with each other and with the "original" negatives, held by the Society.

38. Carol Roark of the Amon Carter Museum has ferreted out a set of mammoth-plate views almost certainly taken by Mellen, made along the D&RG and Colorado Midland Railroad Lines. At least two of these ("2455. Silverton and Sultan Mountain," and "1417. The Old Roadmaster, Clear Creek Cañon") have both the Jackson and Mellen credit lines—though Mellen's ("Geo. Mellen Phot. Colo. Springs") has been nearly eradicated. This situation is similar to that of Jackson and Crissman detailed in Chapter Four. Katie McClintock of the Colorado State Historical Society has done the work concerning the strange history of the Antlers Hotel view, assisted by Curator Eric Paddock.

39. *Gems of Colorado Scenery* (Denver, n.d., probably 1890–1892). The title page actually delineates the distribution of this vertically integrated production house. Later versions of this work differed significantly, particularly after 1900, as Jackson's work was steadily replaced by the work of McClure and others.

40. C. A. Higgins, *Grand Cañon of the Colorado River* (Chicago, 1892). *Perry Park, Colorado* (Denver, 1890).

41. My conclusions here are drawn in part from the internal evidence of the many tourist books on which Jackson worked, which include *Albuquerque, New Mexico* (Albuquerque, n.d.); *Among the Rockies: Pictures of Magnificent Scenes in the Rocky Mountains* (Denver, n.d., ca. 1900); *The Cañons of Colorado* (Denver, n.d.); *The City of Denver, Its Resources and their Development* (Denver, 1891); *Colorado Springs, Colorado and Its Famous Scenic Environs* (Colorado Springs, 1892); *The Grand Cañon of the Colorado* (Chicago, 1892); *Gems of Colorado Scenery* (Denver, n.d.); *Perry Park, Colorado* (Denver, 1890); *Picturesque Colorado* (Denver, 1887); *The Story of the Ancient Missions and Churches of America* (Chicago, 1894); and *Wonder Places . . .* (Denver and Chicago, 1894). One of the most noticeable aspects of these is the wide range of production values applied to them; some include Albertypes or gravure images, some are made with cheap halftones, a few of the most elaborate (evidently souvenir "remembrances") use hand-ribboned bindings.

42. See the *Denver City Directories* for these years; see also the manuscript boxes at the Colorado State Historical Society, esp. boxes ff3, 22, and 29.

43. *Rocky Mountain News,* February 7, 1883, p. 8, col. 2; *Rocky Mountain News,* July 19, 1882, p. 8, col. 2.

44. Almost nothing has been written concerning the stylized formulae of American commercial portraiture during this period; I have de-

pended on my own experience examining a wide range of nineteenth-century family albums and the archives of a number of commercial studios during this period, some of which are located at the Chicago Historical Society, the International Museum of Photography at George Eastman House, the Gemsheim Collection, the Bancroft Library, and other major repositories. Michael Lesy has touched on this general subject in his suggestive works, including *Wisconsin Death Trip* (New York, 1973), and *Real Life: Louisville in the Twenties* (New York, 1976). The flaws in Lesy's analytic technique, especially as found in *Wisconsin Death Trip,* are too well known to be reargued here; but the reactions to the negative criticisms of Lesy's work have resulted in a general rejection of analysis of many of the types of pictures in which Lesy has specialized. At the same time, Lesy himself has significantly modified and honed his techniques, eschewing the sort of popularizations of social and psychological analysis of photographs that appeared in the seventies. I think there is a place for such analysis, but it requires techniques drawn from an understanding of the genres of photography from which the works have come as well as a studied awareness of the means by which photographs are made and the limitations and techniques of photographers at a specific moment in time. In this case, a further indication of the atypicality of the views is found by comparing them with Jackson family portraits made in the nineties in Detroit, where the family is shown relaxed and good-humored, enjoying themselves and the photographing. These photographs are held in the collection of miscellany related to Jackson in the Colorado State Historical Society.

A number of books explore the Victorian house and its significance. Replete with pictures is William Seale, *The Tasteful Interlude: American Interiors through the Camera's Eye, 1860–1917* (New York, 1985), a collection of photographic views of Victorian interiors. A broad study that explores the significance of the ideal Victorian home through interdisciplinary cultural analysis is Gwendolyn Wright's *Moralism and the Modern Home: Domestic Architecture and Cultural Conflict in Change* (Chicago, 1980).

45. This is one of the points in *Time Exposure* when it is clearly Jackson writing, and not the ghostwriter Brown (see Chapter Nine). It deserves careful analysis, not least because it so evidently does not need to be there in the autobiography at all—Jackson seems to be responding to some internal need to justify a family life that no reader of *Time Exposure* would ever notice was out of place. *Time Exposure,* pp. 259–260.

46. Ibid., p. 259.

47. Ibid., pp. 259–260.

48. See Terry Mangan, Russ Collman, and Dell A. McCoy, *William Henry Jackson's Rocky Mountain Railroad Album,* ed. Jackson Thode (Silverton, Colo., 1976), for information about the train and its history.

49. Jackson, *Time Exposure,* p. 261, recounts the trip with Clarence and Pangborn. An album of Mexican views held by the Library of Congress was Mrs. Chain's, and contains at least one Jackson view (J no. 2632), which shows the landscape painter herself. Jackson gave her the album in January of 1885.

It is worth noting that men of any number of other professions during this era also endured this combination of lengthy absences and periods of intimacy: sailors, railroad men, scientists, scholars, salesmen, and the like. In fact, my point here is not to single Jackson out but to suggest this particular quality of family life in nineteenth-century America.

50. Interestingly enough, that Mexican trip was not the only one on which Emilie Jackson accompanied her husband. The Amon Carter Museum has a typescript for what is apparently a projected photo-book with text by Emilie, entitled "Ten Days in Old Mexico." Probably this was a planned halftone-illustrated book publication of which was canceled by the 1893 panic. My thanks to Carol Roark of the Museum for bringing this text to my attention.

Ann Douglas's *The Feminization of American Culture* (New York, 1977) portrays the redefinition of gender roles in nineteenth-century America. Some of these issues are also discussed in John S. and Robin M. Haller, *The Physician and Sexuality in Victorian America* (New York, 1974). I am grateful to my editor Janet Francendese for suggesting to me that Jackson's rigid sequestering of family roles might also apply to the question of "artistic" photography.

51. Jackson, "Photographic Trips of Denver Period—1879–1898," p. 1; see also the *Catalogue of the W. H. Jackson Views (Formerly Denver, Colorado). Published by the Detroit Photographic Company* (Detroit, ca. 1898).

52. Jackson's Mexican photographs are held by the Library of Congress in the Detroit Photographic Company Collection of the Prints and Photographs Division. In addition, a number of individual pictures of Mexico by Jackson are held in the rare books collection at the University of Chicago. Jackson wrote very little about his trips; see *Time Exposure,* p. 259. His wife Emilie did compose a typescript for a never-published book entitled "Ten Days in Old Mexico," recounting a trip in 1892; the typescript and a carbon are held by the Amon Carter Museum. See also Judith Hancock de *[sic]* Sandoval, "Cien Años de Fotografía en Mexico (Norteamericanos, europeos y Japoneses)" (unreferenced Xerox held by Colorado State Historical Society), p. 109; and William C. Jones, "William Henry Jackson in Mexico," *American West* 14, no. 4 (1977), pp. 10–21. Jones persists in treating Jackson's photographs as "documentary"—that is, as pictures that "reveal" social consequences; in addition, he sees Jackson as an enlightened liberal recording the consequences of a society in change. Both positions seem to me naive—the first about the nature of photography, the second about Jack-

son's political and social allegiances during the period. See also Jackson, "Photographic Trips of Denver Period—1879–1898." A "Glimpse of Guanaroto, Mexico," published in *Harper's Weekly* on November 13, 1886, pp. 732–733, was reduced from a mammoth-plate view, a copy of which is held at the Amon Carter Museum.

53. On Jackson's Eastern views, a great deal of information is contained, though not in a particularly easy form to decode, in the Detroit Photographic Company's *Catalogue of the W. H. Jackson Views,* held by the Library of Congress in the Prints and Photographs Division (E169/J156/P&P). Recently the Library of Congress began examining its boxes of Detroit Photographic Company mammoth-plate views; these have turned out to contain many photographs made during the Denver years— including the views almost certainly made for the B&O and used as part of the World's Columbian Exposition exhibit by the railroad.

54. These views are mainly copyright deposits in the Library of Congress Prints and Photographs Division; they are located in uncatalogued boxes in the back rooms of the Division. Many have copyright stamps on them, enabling an estimate of the date of production—the stamp marked date of entry, often as much as a year before the registration of copyright.

CHAPTER SIX

1. Frederick Jackson Turner, "The Significance of the Frontier in American History," in *The Frontier in American History* (New York, 1947), p. 1.

2. See Jackson's letter to Fritiof Fryxell in Fryxell, ed., *Home-Thoughts from Afar: Letters of Thomas Moran to Mary Nimmo Moran* (East Hampton, N.Y., 1967), pp. 146–147; see also Thurman Wilkins, *Thomas Moran, Artist of the Mountains* (Norman, Okla., 1966), pp. 198–199. Wilkins's account is garbled; he had read Moran's business correspondence, but not the letters from

Moran to his wife that recounted Jackson's place as the prime figure on the excursions.

3. See Moran, *Home-Thoughts,* pp. 80–123.

4. Ibid., p. 89; see also the photographs in the copyright deposit boxes for Jackson at the Library of Congress. Moran reports Jackson's assistant as "Millet" in "A Journey to the Devil's Tower in Wyoming. (Artists' Adventures)," *Century Illustrated Monthly Magazine* 47, new series 25 (January 1894), p. 450. However, Millet appears as a more substantial Denver citizen, working to endow a municipal art museum, in the letters to Mary Nimmo Moran, *Home-Thoughts,* p. 101, so Moran may have confused the names. Jackson's pictures eventually appeared in a number of Santa Fe publications; see Chapter Seven.

5. Moran, *Home-Thoughts,* pp. 93, 97, 101, 148–149, and passim.

6. See Moran, *Home-Thoughts,* pp. 89–92. The pictures by Jackson served as source for a Moran painting, reproduced in Charles A. Higgins, *Grand Canon of the Colorado River, Arizona* (Chicago, 1897), p. 19.

7. Moran, *Home-Thoughts,* pp. 83, 89–105, 99, 101, 121.

8. Moran wrote what appears to be his only published essay on the subject, "A Journey to the Devil's Tower in Wyoming," pp. 450–455.

9. Ibid.

10. Moran, *Home-Thoughts,* p. 121.

11. On Haynes, see Freeman Tilden, *Following the Frontier with F. Jay Haynes* (New York, 1964), and the Montana Historical Society's catalogue, *F. Jay Haynes, Photographer* (Helena, 1981). Haynes himself published a number of halftone-reproduced tourist guides to the park, many of which are found at the Library of Congress. Moran detailed his delight with Haynes in a letter republished in *Home-Thoughts,* p. 121.

12. Jackson's notes on Ellison's copy of the Yellowstone portfolio, held by Indiana University's Lilly Library, are particularly edifying; see Chapter Nine for further comments on this. Haynes's photographs are further evidence of

the destructive potential of Gilded-Age tourists, who swarmed over the park in the late eighties and early nineties, as the illustrations to Tilden's *Following the Frontier* reveal. Moran, *Home-Thoughts,* p. 123. An illuminating description of tourism in Yellowstone just five years later is found in Frank B. King's essay, "In Nature's Laboratory: Driving and Fishing in Yellowstone Park," *Overland Monthly* (1897), pp. 594–603, which is illustrated with uncredited photographs, probably by Haynes.

13. Copies of these views are located in the Prints and Photographs Division of the Library of Congress.

14. See Moran, *Home-Thoughts,* pp. 117–123, 148–149; Jackson, "Photographic Trips of Denver Period—1879–1898" (typescript held by the Amon Carter Museum, Fort Worth), p. 1; *Time Exposure: The Autobiography of William Henry Jackson* (New York, 1940), pp. 260–262. That Crosby made the smaller views is strongly suggested by the Jackson views of Lake de Amalia that head this chapter.

15. See Moran, "A Journey to the Devil's Tower," pp. 451, 452.

16. Just how extensive the changes were is partially witnessed by the photographs of F. Jay Haynes during this period. See Haynes catalogue, *F. Jay Haynes, Photographer.* Haynes himself cashed in with a vengeance on the new Yellowstone; see Tilden, *Following the Frontier,* for the amazing story of the tour wagons.

17. Turner, "The Significance of the Frontier," p. 1. As all scholars will immediately recognize, I have chosen to ally myself with a particular group of interpreters of Turner, in that I consider his statements to be descriptions of a myth rather than historical analyses of empirical phenomena. On this, see especially Henry Nash Smith, *Virgin Land: The American West as Symbol and Myth* (Cambridge, Mass., 1950), pp. 250–260, and Wilbur Zelinsky, *The Cultural Geography of the United States* (Englewood Cliffs, N.J., 1973), pp. 3–36.

18. Jackson, *Time Exposure,* p. 262; see *Denver City Directory* entries for the Jackson firm for 1889–1893.

19. On the sequence of events leading to the 1893 panic and the subsequent depression, see Otto C. Lightner, *The History of Business Depressions* (New York, 1970), pp. 186–217; Rendigs Fels, *American Business Cycles, 1865–1897* (Chapel Hill, N.C., 1959), pp. 159–192; and Ross M. Robertson, *History of the American Economy* (New York, 1973).

20. On Denver in particular, and on the depression in general, see Ray Ginger, *Age of Excess: The United States from 1877 to 1914* (New York, 1975), pp. 163–190, esp. p. 166.

21. Just how much Jackson's products were luxury items can be inferred from the detailing of Jackson's *The Cañons of Colorado* (Denver, n.d., ca. 1892). Although the pictures themselves were mediocre halftones with heavy retouching, the cover was made of stuffed silver-white cloth, and the frontispiece used silvered relief lettering.

22. On the development of reproduction technologies, see William Ivins, *Prints and Visual Communication* (Cambridge, Mass., 1953); see also Robert Taft, *Photography and the American Scene* (New York, 1964), pp. 436–450.

23. Alfred Stieglitz, quoted in Peter Henry Emerson, "The Berlin Exhibition," *The American Amateur Photographer* 1, no. 5 (1889), pp. 202–204.

24. The best sources for understanding Stieglitz's developing vision of photography are found in the reviews and articles he wrote for various magazines while in Europe and his crusading work as a writer and editor for the *American Amateur Photographer.*

25. In fact, Emerson had recently awarded Stieglitz his first silver medal in a salon competition, and Stieglitz was writing his review at Emerson's behest—an example of the sort of tightly knit, mutually supportive environment built up by these early photographic aesthetes.

26. Stieglitz's comments are quoted in Emerson, "The Berlin Exhibition," pp. 202–203.

27. A. J. Treat, "A Celebrated Photographer and his Work," in *Wilson's Photographic Magazine* 26 (1889), p. 378.

28. Two essays on Darwin and Spencer illuminate the extent to which these theories, and their misprisions, dominated American middle-class circles: Morse Peckham's "Darwinism and Darwinisticism," and Richard Hofstadter's "The Vogue of Spencer," both anthologized in Philip Appleman, ed., *Darwin* (New York, 1978).

29. Charles Roscoe Savage, *Diaries* (n.d., ca. 1894), located in the Harry B. Lee Library, Brigham Young University, Provo, Utah.

30. This phenomenon can be seen acutely in the "Prize Photographic Contest" held by the *Overland Monthly* around this time. In 1898, for example, all the published entries except one were landscapes, and their subject and style were rigorously conventional. See "Prize Photographic Contest," *Overland Monthly* of November 1897 (pp. 553–559) and January 1898 (pages unavailable).

31. Jackson reports in *Time Exposure* that he arrived in the fall of 1893; he was there to photograph "Chicago Day" on October 9, but it is likely he arrived in September. See Jackson, "Photographic Trips of Denver Period—1879–1898."

32. Perhaps the most impressive condensation of these ideas is found in a book for children and adolescents, Frances Hodgson Burnett's, *Two Little Pilgrims' Progress* (New York, 1895).

33. The sources on the fair are almost numberless. The standard secondary texts on the subject are David Burg, *Chicago's White City* (Lexington, Ky., 1976), and R. Reid Badger, *The Great American Fair: The World's Columbian Exposition and American Culture* (Chicago, 1979). Two works that deal with the Exposition in a larger architectural and artistic context are John Reps, *The Making of Urban America: A History of City Planning in the United States* (Princeton, N.J., 1965), and Richard Guy Wilson, Dianne H. Pilgrim, and Richard N. Murray, *The American Renaissance, 1876–1917* (Brooklyn, N.Y., 1979). A more provocative discussion of the Exposition is Alan Trachtenberg's in *The Incorporation of America: Culture and Society in the Gilded Age* (New York, 1982). See also Alfred D. Chandler, *The Visible Hand: The Managerial Revolution in American Business* (Cambridge, Mass., 1977).

Most of the assertions that follow, however, are derived from the primary documents, ranging from manuscripts and fragmentary fiscal sheets found in the Manuscripts Collection of the Chicago Historical Society, and the visual materials, located in the Society's Graphics Department, to the extensive collection of guidebooks and memorabilia. Among the more common examples of this last category are: Hubert Howe Bancroft, *The Book of the Fair* (Chicago, 1894), one of the few actual guidebooks published during or after the fair, and hence more accurate concerning exhibits and events; Julian Ralph, *Harper's Chicago and the World's Fair* (New York, 1892, 1893); Benjamin Truman, *History of the World's Fair* (Philadelphia, 1893); J. W. Buel, *The Magic City* (St. Louis, 1894); and *Halligan's Illustrated World: A Portfolio of Photographic Views of the World's Columbian Exposition . . .* (Chicago, 1894). Vitally important are the speeches given at the dedication ceremonies by Henry Watterson and Chauncey M. Depew, both published in Truman, *History of the World's Fair,* pp. 115–136.

34. Turner, "Significance of the Frontier," pp. 1, 3, 38; James A. Skelton, "The Future Civilization," is quoted in Moses P. Handy, *The Official Directory of the World's Columbian Exposition* (Chicago, 1893), vol. 4, pp. 441–458.

35. Clarence Day, *Life With Father* (New York, 1935), p. 151; Watterson is quoted in Truman, *History of the World's Fair,* p. 121.

36. Douglass's comments are quoted in Trachtenberg, *The Incorporation of America,* p. 221.

37. Savage's comments are found in the September 20, 1893, entry in his *Diaries.* On the official photography of the fair, see the illustrations in the guidebooks and illustrated souvenirs

cited above, note 33. The quotes are from Truman, *History of the World's Fair,* pp. 265–280, esp. pp. 265, 269. I have excepted Wooded Isle because it seems so clearly a set piece designed to exemplify Olmsted's ideals of *rus in urbe* and so clearly out of place in the "great white cloud" of the rest of the setting. I have searched the plans, guidebooks, and official reports for visual or written references to nature but have found none. Of course the fair abounded with organic life, from the grassy plots in front of the state buildings to the livestock in pens at various locales. But these are not what the nineteenth century called Nature—and that is, I think, what is so striking about the omission. The one noticeable exception is the representation of organicism in the paintings shown at the Fine Arts Building and in national exhibitions interspersed throughout the fair. But these represent illuminating exceptions.

38. I have written more extensively on Arnold in *Silver Cities: The Photography of American Urbanization, 1839–1915* (Philadelphia, 1984), pp. 133–159.

39. J. F. Ryder, "Photography at the World's Fair," *Wilson's Photographic Magazine* (1893), pp. 422–423.

40. See *Minutes of the Board of Directors, World's Columbian Exposition, 1892–1905,* vol. 2, subvol. 44, pp. 691, 860, 889, 894, 923–924; *World's Columbian Exposition Executive Committee Minutes,* vol. 35, p. 985, see also entry for October 24, 1894 (unpaginated), and p. 1098; vol. 36, pp. 1064, 1066–1067; *Executive Committee Minutes* vol. 36, January 3, 1894, pp. 1066–1067.

41. Jackson, *Time Exposure,* p. 263.

42. *The Great Divide* (April 1894), p. 1 and (March 1894), p. 89. Tammen also tried to acquire the copyright to fifty-six pictures "*in my name* [his emphasis]," in a letter to the U.S. Copyright Office, then was forced to retract his request two weeks later, probably after Jackson found out what he had attempted. See letters, Frank S. Thayer to U.S. Copyright Office, January 22, 1894, and February 6, 1894, held by the Library

of Congress. I am grateful to Larry Viskochil of the Chicago Historical Society for bringing these letters to my attention.

43. "Dream of the White City. The Great Divide's Rich Offer," *The Great Divide* (March 1894), p. 89. Only one incomplete set of original prints exists—it is held in the Graphics Department of the Chicago Historical Society. That the Society, which receives hundreds of calls per year concerning Exposition images, had never been contacted concerning Jackson images attests to the strong possibility that the only sets made were used to produce the halftones for Tammen's artfolio. The set sent to the Library of Congress for copyright deposit has disappeared. However, if others were sent to foreign exhibitors, it is likely that sets are still located in obscure archives of a number of countries.

44. See the list of eighty artfolio views in *The Great Divide* (September 1894), p. 231.

45. With the similar Survey pictures, however, the intention of such posing seems to have been quite different—to aggrandize the Survey and legitimize its role in the landscape.

46. An indication of Jackson's power over the scene while photographing can be found in the view of the Midway from the top of the Ferris wheel. Here Jackson must have had the giant amusement started up again for his purposes, then arranged for it to stop at a certain point in order for him to make his exposure. Here and throughout the series, the long arm of Burnham doubtless enabled the photographer to control the scene to his wishes. Indications that Jackson had assistances clean the streets in front of his camera abound, not only in views of Denver, but in those of other major cities, where leaves, horse droppings, and trash are all magically absent from the negatives.

47. *Executive Committee Minutes* vol. 36, January 3, 1894, pp. 1066–1067.

48. *The Great Divide* (July 1894), opp. p. 161. The extraordinary pervasiveness of halftone copies of Jackson's views can be estimated by the

number of copies donated to the Chicago Historical Society, by a data base search of library holdings through OCLC and other library computer services, and by the still-low price of good copies.

49. The retouching of these photographs is a crucial issue here. All evidence points to Jackson's having made the views to stand as they were. He sold not prints but negatives to Burnham, but did not retouch those negatives—the only extant set of prints, held at the Chicago Historical Society, shows them to be pristine. This was highly unusual for Jackson—rarely if ever did he let works of this sort out in an incomplete form; rather, his system was to retouch immediately, so that there would be no chance of unidealized images being made from his negatives. The retouching that did occur, moreover, is of a radically different character from Jackson's typical painting and compositing techniques of this period. Instead, the retoucher, with amazing skill, removed huge portions of "distracting" details from the pictures—including band shells, tents, and the like—and added such elements as flags, gondolas, steam launches, and other popular sights at the now moribund fair.

50. *The Great Divide* (August 1894), inside front cover.

51. *The Great Divide* (August 1894), inside front cover; see "Williams Cañon, A Most Remarkable and Interesting Gorge," *The Great Divide* (April 1894) p. 107, or "Lake San Cristoval. A Beautiful Crystal Gem Set in a Granite Ring," p. 108.

52. See the advertisement on the inside front cover of *The Great Divide* (August 1894).

53. *The Great Divide* (July 1894), opp. p. 134.

CHAPTER SEVEN

1. Jackson, *Time Exposure: The Autobiography of William Henry Jackson* (New York, 1940), pp. 263–265.

2. Ibid., pp. 264–265; John T. Bramhall, "The

Field Columbian Museum," *Harper's Weekly* 38 (August 4, 1894), p. 738; "Joseph Gladding Pangborn," *National Cyclopedia of American Biography* 16 (New York, 1937), pp. 282–283.

3. Bramhall, "The Field Columbian Museum"; "Joseph Gladding Pangborn." Pangborn's own published works give an indication of his personality; see *The World's Railway, Historical, Descriptive, Illustrative* (New York, 1894 [1896]); *Sidelights Management World Systems Railways* [*sic*] (Baltimore, 1901); *The Cross or the Pound: Which? A Talk on the Modernization of Civilization in India with Application to the Hindo and Hinduism* (New York, 1900); and *Sidelights on Russia: A Series of Sketchy Glimpses of Life as It Is in the Great Muscovite Realm* (Baltimore, n.d.), all of which were published in some relation to the World's Transportation Commission trip. See also his earlier publicity writings for the B&O Railroad: *Deer Park, 3,000 Feet Above the Sea* (Chicago, 1884); *The Glades of the Alleghenies: Deer Park, Oakland* (Baltimore, 1884); and *Picturesque B&O* (Baltimore, n.d.). But most of the information about Pangborn on which one can depend with some degree of certainty comes from Jackson's own diaries and letters of the trip, during which he was extremely candid about Pangborn. These are now located in the Rare Books and Manuscripts Collection of the New York Public Library.

4. Jackson to Emilie, November 1, 1894 (London); the newspaper report is quoted in *Time Exposure*, p. 264, without citation.

5. Jackson reported his apprehensions and plans in a number of letters to his wife during the early part of the trip. See the letters for January 12, 1895; March 25, 1895; May 14, 1895; August 7, 1895; and August 25, 1895.

6. Much of this came to light during the trip; see Jackson to Emilie, October 28, 1894; January 12, 1895; February 20, 1895; and August 7, 1895.

7. Jackson, *Time Exposure*, p. 265; Jackson to Emilie, October 28, 1894.

8. Jackson to Emilie, January 7, 1895; April 5, 1895; May 14, 1895. Jackson's account of the business in *Time Exposure*, pp. 265–266, was a self-serving oversimplification.

9. Jackson to Emilie, May 14, 1895.

10. Ibid.

11. Jackson to Emilie, November 18, 1894; he writes "I have been doubtful and anxious . . . [because] all of the formalities attending the closing of the contract have not yet been closed." Yet he never pressed the journal for a contract, never even understood the agreement under which he was hired. That the situation was entirely due to his own willful naiveté is indicated in the series of letters he wrote as the trip progressed—see below.

12. Just how much Pangborn depended upon Jackson to keep the South Sea Bubble of publicity afloat is detailed in Jackson's letters and diaries. See, especially, Jackson to Emilie, March 23, 1895.

13. Pangborn's experience with Jackson included more than one stint photographing the B&O as well as the warm reference of Jackson's friend (and Pangborn's employee) Thomas Moran. See Chapter Five.

14. See Jackson to Emilie, October 28, 1894.

15. Ibid.

16. Ibid.

17. Ibid.; on Denver during this period, see Robert L. Perkin, *The First Hundred Years: An Informal History of Denver and the* Rocky Mountain News (Garden City, N.Y., 1959), pp. 380–426.

18. See Dennison Nash, "Tourism as a Form of Imperialism," in Valene L. Smith, ed., *Hosts and Guests: The Anthropology of Tourism* (Philadelphia, 1977).

19. Jackson to Emilie, October 12, 1894; October 21, 1894; October 15, 1894.

20. This growing perception of Jackson's is found interspersed through the letters and diaries in comments too numerous to cite. Pangborn was able to finagle a letter from Earl Ripon, the English Secretary of the Foreign Office, "commending him and his commission to all the governors of British dependencies and colonies, all on the word of our charge-de-affairs. Roosevelt says no American ever before received from the British government so sweeping and official an endorsement." (Jackson to Emilie, November 1, 1894).

21. The World's Transportation Commission negatives—what remains of them—are located in the Prints and Photographs Division of the Library of Congress, in its Detroit Photographic Company Collection. These negatives, some on glass, some on nitrate, and some transferred to hand-colored transparencies, had disappeared from sight after Jackson joined the Detroit Photographic Company in 1898. In 1981, Tom Beecher discovered the set of nitrate negatives in a storage area of the Library of Congress and, with Annette Melville and me, identified them as World's Transportation Commission images. With their assistance, and with the kind permission of then-director Oliver Jensen, who allowed me to go into the vaults and inspect the Detroit negative files case by case, I was able to identify a significant number of glass negatives that were interspersed in the Detroit collection. Since that time, George Hobart of the division, along with a number of other staff members, has been able to significantly increase the number of discovered images. These have since been placed on video disc as part of the division's pioneering laser disc project, making access to them, as well as to the entire Detroit Photographic Company Collection, a simple matter. The intentions of *Harper's* toward their share of the pictures were clearly delineated in the first Commission column, *Harper's Weekly*, February 23, 1895, pp. 180–182.

22. See "With the World's Transportation Commission in Tunis—Photographs by William H. Jackson" *Harper's Weekly*, February 23, 1895, pp. 180–182.

23. Jackson to Emilie, November 16, 1894.

24. See, for example, Jackson to Emilie, December 12, 1894; November 16, 1894.

25. Jackson to Emilie, December 19, 1894; December 13, 1894. Jackson's amused report on the native guides reveals that they knew quite

well what the European photographer needed of them, and charged accordingly.

26. See Jackson to Emilie, December 1, 1894; December 12, 1894; December 21, 1894. On the tourist experience, see especially John A. Jakle, *The Tourist: Travel in Twentieth-Century North America* (Lincoln, Neb., 1985); and Nelson H. H. Graburn, "Tourism: The Sacred Journey," and Nash, "Tourism as a Form of Imperialism," both in Smith, *Hosts and Guests;* revealing accounts can be found in Mark Twain's *Innocents Abroad* and his 1891 short story "Playing Courier," in Charles Neider, ed., *The Complete Short Stories of Mark Twain* (Garden City, N.Y., 1957), pp. 253–265.

27. Jackson to Emilie, December 12, 1894.

28. Jackson to Emilie, December 13, 1894; December 3, 1894.

29. Jackson to Emilie, December 30, 1894; February 20, 1895; January 19, 1895; January 7, 1895.

30. See Jackson to Emilie, January 19, 1894: "I am having good success with my pictures, and these in connection with the advertising given us by the Harpers cannot but result in some material benefit when we get through." This notion of "material benefit," however, appears only in this letter—all others thereafter discuss the pictures in terms of some more permanent body of work that is, implicitly, both economically valuable and important to the resurrection of Jackson's reputation.

31. Jackson to Emilie, December 13, 1894; December 30, 1894; January 7, 1895; January 17, 1895; February 20, 1895.

32. Jackson to Emilie, December 19, 1894; see also Nash, "Tourism as a Form of Imperialism."

33. See especially Jackson to Emilie, December 30, 1894; see also Jackson to Emilie, n.d., letter received March 7, 1895; in a letter sent March 21, 1895, Jackson wrote that "many times over we have blushed with shame" at Pangborn's behavior toward his British hosts.

34. Just how pervasive this sense of dualism is can be seen by examining the entire collection of Ceylon views, and indeed the complete collection of views in British colonies and protectorates, on the laser disc project at the Library of Congress.

35. See Jackson, *Time Exposure,* p. 279; the negatives of Agra are now lost—only the reproductions from *Harper's Weekly* remain to suggest what Jackson did with the subject.

36. See *Harper's Weekly,* July 27, 1895, p. 707.

37. Jackson to Emilie, January 1895 (descriptive letter concerning Hyderabad); see also Jackson, *Diaries,* January 16–18, 1895.

38. At Jammu, India, Jackson wrote to Emilie of other such incidents:

It is very amusing to see our chief—who of late has been growing a head entirely too big for his hat—get in to a crowd where everyone does not bow down to him as the great *President* of the American Commission. Some attention in the past has spoiled him, and because he was not treated as a special guest of honor at the banquet [with the Maharajah] he got very petulant and childish and almost got us all into a mess by deciding at the last moment not to attend the banquet. As it was, he made us all late by sitting in his room sulking until it was time to go. He is still sulking and making himself very disagreeable to all the gentlemen who have done so much to entertain us.

Jackson to Emilie, February 14, 1895; February 13, 1895; February [? Bombay dinner], 1895.

39. Jackson to Emilie, February 14, 1895.

40. "Kashmir," *Harper's Weekly,* October 12, 1895, p. 974.

41. "The Himalayan Railway," *Harper's Weekly,* October 12, 1895, p. 974.

42. Jackson to Emilie, July 19, 1895; August 6, 7, 1895; Jackson, *Diaries,* April 11, 1895. During the entire nineteen months of the trip, Jackson received no instructions from his editors, no letters, and no replies to his own letters. In fact, when the Commission seemed on the verge of collapse, Jackson wrote Payne demanding a cabled commitment to further publication but received no reply even to this attention-getting gambit. Only once did he see the results of his labors—and then only the first two issues—and his only comment was that Winchell was upset by the reduction of his watercolor in the first layout.

43. The discussion on the context surrounding reception of Jackson's pictures is based in part on the following: the famous work of Julius W. Pratt, especially *Expansionists of 1898* (Baltimore, 1938) and his essay "The Ideology of American Expansionism" in Avery O. Craven, ed., *Essays in Honor of William E. Dodd* (Chicago, 1935), pp. 335–353; Richard Hofstadter's essay, "Manifest Destiny and the Philippines," in Daniel Aaron, ed., *America in Crisis* (New York, 1952), pp. 173–178; Harold U. Faulkner, *Politics, Reform and Expansion* (New York, 1959); Frederick Merk, *Manifest Destiny and Mission in American History* (New York, 1963); and Walter LaFeber, *The New Empire: An Interpretation of American Expansion, 1860–1898* (Ithaca, N.Y., 1963).

44. On the heritage of American internationalism, see William H. Goetzmann, *New Lands, New Men: America and the Second Great Age of Discovery* (New York, 1986).

45. "Foreign Affairs in the Senate," *Harper's Weekly,* February 22, 1896, p. 170; see also "What War Would Mean," *Harper's Weekly,* April 4, 1896, p. 315; "Americanism and Jingoism," *Harper's Weekly,* March 30, 1895, p. 291.

46. Worthington C. Fort, "The Cost of Empire," *Harper's Weekly,* May 9, 1896, p. 466; The Situation in Korea," *Harper's Weekly,* May 25, 1895, p. 488; see also equivalent articles on the Japan/China war, May 11, 1895 (p. 432), the Nicaraguan crisis, May 18, 1895 (p. 456), and on Samoa (passim). During the period, *Harper's Weekly* ran a regular series of articles celebrating American naval might. These were divided into two broad types. The first were, simply, reports on the manuevers of current warships, the progress in building new ones, and the organization and preparedness of the new navy. The second set, more interestingly, concerned great naval battles of the past. These articles ran in almost every issue in 1895, continuing into 1896 and beyond. With their attention to strategy mixed with their

unabashed celebrations of American naval heroes, they seem clearly meant as inspirational reading.

47. "Liberia," *Harper's Weekly,* April 27, 1895.

48. See *Harper's Weekly,* February 23, 1895, for these ads. I have reorganized the list by category; otherwise, the list is complete.

49. "With the World's Transportation Commission in Tunis," *Harper's Weekly,* February 23, 1895, pp. 180–182. I think this must be Pangborn's prose.

50. Ibid.; "With the World's Transportation Commission in Morocco," *Harper's Weekly,* March 23, 1895, p. 278; "With the World's Transportation Commission in Egypt," *Harper's Weekly,* March 30, 1895, pp. 303–304.

51. "Tunis," *Harper's Weekly.*

52. *Harper's Weekly,* May 9, 1896, pp. 464–465; *Harper's Weekly,* July 24, 1897, pp. 728–729.

53. See "Along the Dalmatian Coast," *Harper's Weekly,* March 9, 1895, p. 245; "With the World's Transportation Commission in Algiers," *Harper's Weekly,* March 9, 1895, pp. 229, 234.

54. Jackson's erotic letter to Emilie is dated July 10, 1895; it is one of the tenderest and most diffident of his letters, too deeply personal to bear introduction here.

55. On Winchell, see esp. Jackson to Emilie, August 25, 1895. On Street, see letter March 23, 1895; see also *Diaries.*

56. Jackson to Emilie, April 6, 7, 1895; August 7, 1895.

57. Jackson to Emilie, June 23, 1895.

58. Ibid.

59. Jackson to Emilie, November 21, 1895.

60. Jackson to Emilie, December 25, 1895.

61. Jackson to Emilie, February 17, 1896.

62. Ibid.

63. Ibid. There is no known information on the disposition of the World's Transportation Commission negatives. My conclusions are drawn from Jackson's own hints in the letters to his wife, combined with the peculiar history of the negatives themselves. These went to the Jackson Company, and thence to the Detroit Photographic Company when Jackson joined the firm in 1898. But although the Detroit Company was in need of international views, none of these negatives entered the file. Instead, they languished in a "dead negative" area of the Company's collection. The lantern-slide views, however, were almost certainly those Jackson made for an ill-fated lecture series he reports in *Time Exposure,* p. 322. On Jackson's short sojourn in New York see *Time Exposure,* p. 319.

64. "The Troubles in India," *Harper's Weekly,* 1897, pp. 872–873; "The Dispute Over China," *Harper's Weekly,* 1898, pp. 28–29; "Across Korea on Horseback . . .," *Harper's Weekly,* 1898, pp. 59–61, was written by Jackson, but the strident context of surrounding articles significantly altered the tone—as did what appear to have been editorial changes by *Harper's.*

65. On this, see esp. Nash, "Tourism as a Form of Imperialism." On the contemporary nostalgic treatment of the Native American, the photographs of Edward Curtis are the most common and clear example; see Berkhofer, *The White Man's Indian* (New York, 1977), esp. pp. 71–112; see also Edward S. Curtis, *The North American Indian: Being a Series of Volumes Picturing and Describing the Indians of the United States, and Alaska,* vols 1–20 (Cambridge, Mass., 1907–1930), and two studies of Curtis: Barbara A. Davis, *Edward S. Curtis: The Life and Times of a Shadow Catcher* (San Francisco, 1985), and Edward S. Curtis, *Edward Sheriff Curtis: Visions of a Vanishing Race* (Boston, 1976).

66. See Nash, "Tourism as a Form of Imperialism"; Dean McCannell, *The Tourist: A New Theory of the Leisure Class* (New York, 1976).

CHAPTER EIGHT

1. Jackson to Emilie, January 12, 1895, located in Rare Books and Manuscripts Collection, New York Public Library.

2. The Rand McNally books include *New Guide to the Pacific Coast* (Chicago, 1894, 1895, 1897); *To California and Back* (Chicago, 1897), republished as *To California Over the Santa Fe Trail* (Chicago, 1903, 1904, 1905, 1907, 1909, 1910, 1911, 1914, 1915, 1917). Earl Pomeroy has chronicled the transformation of the West into an "experience" for tourists in his superb and apparently timeless study, *In Search of the Golden West: The Tourist in Western America* (New York, 1957).

3. See M. F. Sweetser and Moses King, *King's Handbook of the United States* (Buffalo, 1891), pp. 103, 104, 107, 108. King's selection included "Phantom Curve," complete with Jackson's shadow, still marking its way across the railbed. An earlier book using Jackson pictures, *A Souvenir of the Beautiful Rio Grande . . . The Scenic Line* (Denver, 1893), also had its plates marked with the engraver's name, but in the lower left rather than the lower right corner.

4. This was the case, for example, with a D&RG brochure and timetable produced in the thirties; it is located, with a host of other published materials using Jackson images, in the Manuscript Collection of the Colorado State Historical Society. An extensive collection of timetables, brochures, and the like related to Western railroading and using Jackson's pictures can be found in the Western History Collection of the Denver Public Library; finally, the Library of Congress has a huge repository of such published documents, often received as copyright deposits and filed under the name of the particular sponsoring company.

5. See Jackson, *Time Exposure: The Autobiography of William Henry Jackson* (New York, 1940), pp. 318–322; see also Jackson to Emilie, August 25, 1895.

6. Jackson's older pictures appeared, for example, in J. M. Goodwin's "The Snake River Country: A Wild Part of Idaho," *Overland Monthly* 31, 2d ser. (January 1898), pp. 3–13 and frontispiece. These pictures were taken from Jackson's 1892 trip with Moran and included a picture of the Natural Bridge at Shoshone, with Moran atop it. These pictures were credited to Jackson.

That some of the newly made pictures may

themselves not have been made by Jackson suggests how well the photographer understood that he could not alter the trends in visual communication and would have instead to compete in the new arena they would delineate. These copyright-deposit prints are in the Library of Congress Prints and Photographs Division. Some are located in lot 3749; others have been disbursed by region and are identifiable only by their deposit dates, usually marked on the backs of the prints.

7. Some of these views are 18-by-22 mammoth-plate size, and the rest are 11-by-14; however, this can no longer be considered a criterion for authorship by Jackson, as the company was so routinely making multiple-copy negatives in a variety of formats that it may well have been simply easier to include the smaller format in the copyright deposit, since it would not affect the actual process of copyright. Still, this line of argument simply increases the likelihood that the larger views were made by Jackson and deposited in their original negative size in order to speed the process of protection. Carol Roark of the Amon Carter Museum is convinced that the Oregon views from this set were made in 1890–92, and only copyrighted this late; this seems likely given Jackson's 1892 itinerary.

A second issue is at work, however, in the views of Garden of the Gods. Donald English has argued that the majority of views in the Jackson Company files of this area were made by George Mellen, citing the Mellen numbers on many of the smaller (5-by-8) negative plates. However, as I have argued earlier, this cannot alone be considered a criterion for ascertaining authorship, as Mellen explicitly etched his identifiers onto a number of reduction copies of earlier Jackson mammoth-plate and other views. Yet even if these were not made by Jackson (and English's case is a good one) their divergence from the company's style suggests a slackening in Jackson's previously quite rigorous control of output under his name.

8. Jackson's abortive lecture tour involved hand-colored lantern slide views drawn from the Commission trip; apparently he had been able to work out a limited agreement with *Harper's.* These slides are now held in the Prints and Photographs Division of the Library of Congress.

Information on the Detroit Photographic Company and the Photochrom Company is scattered. Two publications for postcard collectors provide a significant body of information, though some of it is confused in its dating or overdependent on anecdotal sources: Jeff R. Burdick, *The Handbook of Detroit Photographic Company Postcards: A Guide for Collectors* (Essington, Pa., 1955); and George Miller and Dorothy Miller, *Picture Postcards in the United States, 1893–1918* (New York, 1976). Some manuscript material can be found at the Colorado State Historical Society and the Prints and Photographs Division of the Library of Congress, repositories of the Detroit archives for the Western and Eastern United States respectively, and scattered materials are located at the Edison Institute of the Henry Ford Museum in Detroit, which was the original purchaser of the materials. Jackson's own reports in *Time Exposure* may be accurate but are often in conflict with other sources. Further information has been gleaned from the *Detroit City Directory,* the Detroit Company catalogues, and the negative registers held at the Colorado State Historical Society.

9. See Jackson, *Time Exposure,* pp. 321–323; Burdick, *Handbook,* pp. 3–5. The *Detroit City Directory* lists an E. H. Husher & Co., Photographers in 1895; the Detroit Photographic Company first appears there in the version published as 1898–1899, and the Photochrom Company appears first in the same edition, suggesting that the companies were simultaneously incorporated in 1897 or 1898. An earlier Detroit Photographic Company, managed by a stationer and bookseller named F. Kilroy, was apparently unrelated to this firm. The Company produced at least two styles of color: one was a high-quality attempt

to reproduce the original scene; the other was a rather garish imitation of nineteenth-century chromolithographs.

10. In its final form, the settlement between Detroit and the Jackson Company involved a number of interlocking parts. Livingstone offered a total of $30,000, $25,000 of it in stock in the newly formed Detroit Photographic Company. The cash apparently was the bare minimum necessary to cover what Jackson later called "floating indebtedness"—that is, money owed to people who would accept nothing but cash settlement. Jackson's partners Crosby and Rhoads were satisfied with an arrangement whereby they received the Denver firm's assets, the name of the company, a recently opened retail store, and a large selection of negatives of the most successful Jackson views. This last matter was simple enough to negotiate—the Jackson Company held so many versions of its most popular views that it was doubtless simply a savings of shipping fees to leave these repetitive glass plates in Denver. Jackson, *Time Exposure,* pp. 322–323; Burdick, *Handbook,* pp. 3–5. The tortuous history of the Denver Jackson company after 1897 is detailed in the *Denver City Directory* and in various brochures, advertisements, and the like that followed its transformation into the Jackson-Smith Company, then the Smith-Hassell Company, then, finally, the Hassell Company. During some of these years, Jackson's son Clarence served with the firm; Jackson's architectural photographer Louis Charles McClure remained with the firms through all these transformations. He reported that Rhoads "came to manage . . . Jackson-Hassell, and his son [Clarence Jackson] was in on it . . . I was with Rhoads until he quit. Then there was a fellow named Smith." See Fred Mazzulla and Herbert Davis, "Interview with Louis Charles McClure, 1956," tape copy in Denver Public Library Western History Collection. One of the most interesting pieces of evidence from this period of transition is an incomplete set of sample-books for the

successor company in Denver, now held in the Western History Collection of the Denver Public Library.

11. For some reason, Livingstone had determined to divide the corporation into two interlocking companies. The Photochrom Company apparently produced only colored pictures, especially postcards; the Detroit Photographic Company produced and sold every other size of photograph, up to and including multiple panoramas of mammoth-plate dimensions. But the companies shared the same factory and office spaces and in many cases the same staff, although there were differences in the formal arrangements of the companies' directors. Still, the two companies were in spirit nearly identical—both marketed memorable images of specific locales, both catered to tourists and visitors. And eventually even the institutional differences disappeared, as the Photochrom Company was absorbed into its larger partner. See the *Detroit City Directory* for information on the staffs of the companies and their addresses and directors; Paul Vanderbilt, *Guide to the Special Collections of Prints and Photographs in the Library of Congress* (Washington, D.C., 1955), pp. 47–48; Burdick, *Handbook,* pp. 4–5; Jackson, *Time Exposure,* pp. 322–325.

This list of general subject categories for the earliest output of the Company is derived from the catalogues of the Detroit Photographic Company, held in the Prints and Photographic Division of the Library of Congress, and from study of the entire Detroit Collection in the Division. When I began research for this project at the Library of Congress in 1977, few prints had been made from the Detroit Company negatives; I began by looking at the glass plates themselves. Recently a huge video disc project has enabled the Division to make available all the negatives, visible on laser disc screen as positives. I am deeply grateful to the staff of the Division for allowing me access to materials, for assisting me in my searches, and for sharing their own research with me. This is

particularly the case with Tom Beecher, George Hobart, and Annette Melville.

12. I am grateful to my colleague Robert Munman for suggesting the effects of reduction on contrast and tonal rendering, and the visual implications of these effects.

13. Both the Library of Congress and the Colorado State Historical Society have, or have exhibited, "used" Detroit postcards; the Chicago Historical Society has an excellent collection of postcards concerning the city and region, which has confirmed the suppositions I gleaned from the Detroit samples. Hal Morgan and Andreas Brown in their *Prairie Fires and Paper Moons: The American Photographic Postcard: 1900–1920* (Boston, 1981) have, despite their title, analyzed and reproduced only a subgenre of the postcard during this period: those that portrayed an "intimate" or personal image. Their collection is thus derived from amateur-made postcards and from those made by smaller studios. There is no mention of the Detroit Photographic Company, the Detroit Publishing Company, or the Photochrom Company, nor of the other large-scale postcard houses that dominated production during the very years Morgan and Brown allegedly survey. Especially jarring is the inclusion of messages, all of them charming, but also few of them in any way representative of the type of message contained on the commercial postcard of the same period. For a more accurate compendium of information on the American postcard, see Miller and Miller, *Picture Postcards.*

14. *Catalogue of the W. H. Jackson Views (Formerly Denver, Colorado). Published by the Detroit Photographic Company* (Detroit, ca. 1898–99), p. 2.

15. *Catalogue of . . .* (Detroit, 1898), no pagination on this page.

16. See the panorama on the inside front cover of volume 1 of *The Pittsburgh Survey* (New York, 1914). In this case, the Company was forced to pay Pittsburgh photographer William Campbell

a copyright-infringement fee for the panorama, probably because the original agreement forbade republication. The record of settlement with Campbell is in Box 3 of the William Henry Jackson manuscript files at the Colorado State Historical Society.

17. The process was painstaking. Photochrom was an "asphaltum" rather than a halftone, gelatin- or gum-base (like Woodburytype), or "fatty inks" process (like Albertype). The pictures were thus printed from fine-grain lithographic stones with a light-sensitive asphaltum coating, and this process occurred for each color intended for the final image. The Detroit Photographic Company used nine or ten stones per photograph in order to get the extraordinarily realistic color images that made the process worth its labor-intensive production system. Each master photograph had to be converted into plates, which were then retouched and made into color separations. See Burdick, *Handbook,* pp. 5–6, 54–55; Burdick's description is based on information provided by the Swiss parent company.

18. This was the case with the famous view of the train, seen from below, in the Canyon of the Rio Las Animas, where the Photochrom version revealed a significant portion of previously masked lower foreground. An interesting sidelight to the Aäc process was the pressure it placed on the photographer to remember or record the various color tonalities of the original scene. A passage in Jackson's 1903 diary records this process in painstaking detail: "left hand bldg dull yellow roman brik. see note year ago—1st on left corner—ok dull yellow—next cool light grey—2 next darker grey. low double house buff yellow, white base, next light gray. yellow gray to corner. church green and brown" (*Diaries,* June 22, 1903, Mt. Vernon Place).

19. See "Photographic Trips of Denver Years."

20. Burdick, *Handbook,* p. 3; Jackson, *Time Exposure,* p. 325; *Catalogue P: List of Photographs of American Scenes and Architecture Published by*

the *Detroit Publishing Company* (Detroit, n.d., ca. 1906, p. vi, inside back cover.

21. See Miller and Miller, *Picture Postcards,* p. 146, for their estimate of the number of Detroit negatives; Jackson, *Diaries,* September 29, October 4, October 5, November 11, October 3, 1901; New York Public Library Manuscripts Collection.

22. Jackson, *Diaries,* November 11, 1901; on the costs of other negatives, see the "Publication Permit" file in the Detroit Manuscripts Collection of the Colorado State Historical Society. Thomas E. Marr of Boston, for example, sold six views of Arnold Arboretum for fifteen dollars.

23. Jackson, *Diaries,* October 9, November 11, 1901.

24. Ibid., October 14, 17, 21, 1901. The negatives are marked in the Detroit Company negative register books where, in pencil, they are designated as "Vromans *[sic]* negatives"; the registers are held in the Manuscripts Collection of the Colorado State Historical Society. These, like many other of the Detroit Company's purchased views of the West, have caused great confusion among photographic historians; Beaumont Newhall and Diana Edkins incorrectly attributed them to Jackson in their 1973 monograph, publishing a number as illustrations. Vroman continued to market these concurrently with the Detroit Company's issues.

25. See notes 22, 24 above.

26. See letters and contracts, T. E. Marr, in Detroit Company files in Manuscript Collection, Colorado State Historical Society; a suggestive letter from a photographer named Hall, dated May 3, 1900, is also in the file. On the restriction, see *Catalogue P,* p. iv. Livingstone's lobbying efforts in favor of a strong copyright law are documented in the Manuscripts Collection of the Colorado State Historical Society.

27. The process by which this took place can be traced not only in the negative registers but in more complete form through examination of the negatives themselves, where such telling details as thumbtacks at the corners of the original prints, or even the texture of the wall on which the originals were tacked, can often be seen. In some cases I was able to trace the convoluted history of an image by comparing these negatives with prints deposited for copyright, wherein can be seen details often lost as the original negative broke or was destroyed and replaced by another. I am grateful to the staffs of both the Prints and Photographs Division of the Library of Congress and the Photographs Collection of the Colorado State Historical Society for allowing me access to their negative vaults to examine the negatives at length.

28. Besides examining a significant number of Detroit Company postcards and larger views, I have also depended on postcard-collecting historian Jeff R. Burdick, who has listed some sixty-nine sample "modernizations" of postcards. See Burdick, *Handbook,* p. 8.

29. On these replacements, the Detroit Company negative registers in the Colorado State Historical Society are the best witnesses. In 1899, for example, the Detroit Company copyrighted a set of three of Jackson's panoramas of Yosemite, all 15½-by-69 (now located in copyright deposit files, Prints and Photographs Division, Library of Congress); in 1906 the Company copyrighted a new set, probably by Husher.

30. This was the case not only with Hall and Clarence Jackson but with plant manager Edwin Husher and Henry G. Peabody, both of whom photographed the Tent City at Coronado Beach, California. See Detroit Company files, Manuscript Collection, Colorado State Historical Society.

31. See Burdick, *Handbook,* esp. pp. 18–27, 61–66.

32. Harvey appears as a contributor in the Detroit Company negative registers; a representative sample list of the postcard views can be found in Burdick, *Handbook,* pp. 19–27, 62–66.

33. Earl Pomeroy discusses this phenomenon to some extent in his *In Search of the Golden West* (New York, 1957).

34. See Jackson's "Photographic Trips of Denver Period" for information on the railroad work.

35. A number of these C&NW views have Jackson numbers imprinted on them; Jackson listed a C&NW trip in 1899 in his itinerary of "Photographic Trips of Denver Period."

36. The first view is, in some ways, an arresting reconstruction of William Inness's "Lackawanna Valley" painting, on which so much attention has been lavished, in particular by Leo Marx in his *The Machine in the Garden* (New York, 1964), and Barbara Novak, in her *Nature and Culture: American Landscape and Painting, 1825–1875* (New York, 1980). But this photograph lies, I think, outside the argument between Marx and Novak, because by 1900 American culture had moved so convincingly out of a state of doubt about the relationship between technology and nature. Jackson's picture is not part of the nineteenth century's discussion of the role technology might play in nature—rather it is an affirmation of the resolution of that argument, a celebration of the intersection between domesticating technology and picture-postcard, domesticated nature.

The second view, made probably in 1902 by Jackson, appears in at least two guises: as Detroit no. 14295, and in a severely cropped version, Library of Congress laser disc number LC-VFID 06370.

See Jackson, *Diaries,* October 11, 1901. An exception to the lack of wilderness views is a series of extraordinary mammoth-plate views of the Canadian Range, probably made by Jackson in 1903 and reproduced as 8-by-10 negatives, where they are marked with Jackson's initials. These, however, are closer to the baroque sublimity of Ansel Adams than the Romantic sublimity of Jackson's nineteenth-century views with the Survey—they are views that are meant, per-

haps, to replace the window in an urban bureaucratic office space. See "Down the Bow River, Alberta, Canada" (Detroit no. 015167) and "Mt. Temple from Saddleback, Alberta, Canada" (Detroit no. 015171-dup) as mammoth plates, and the series of 8-by-10 negatives surrounding Detroit no. 14599.

37. See the Detroit Company Negative Registers.

38. All these negatives have Jackson's initials, numbers, and the year of production scratched on them; possibly the Company was beginning to demand proof of authorship at this point. Jackson's 1903 trip is detailed in a fragmentary diary held in the New York Public Library's Manuscripts Collection.

39. Jackson himself made a number of views of working "factory farms" in California and elsewhere, views like "Raisins Drying, Fresno, Cal.," held in the Library of Congress. This was a picture Jackson had worked very hard to make and which, his 1901 diary reveals, was on his list of required views for that trip. In fact, it appears that the picture had been commissioned by the Southern Pacific Company.

40. I have written about, and reproduced, a number of Detroit Photographic Company urban street views in *Silver Cities: The Photography of American Urbanization, 1839–1915* (Philadelphia, 1984), pp. 100–101, 110, 122, 267–269.

41. See the *Denver City Directory* for 1907.

CHAPTER NINE

1. Gertrude Stein, *The Making of Americans* (New York, 1934), p. 398.

2. Robert Spurrier Ellison to William Henry Jackson, June 14, 1924, in Ellison Papers, the Western History Collection, Denver Public Library. Ellison was prominent enough to merit an entry in *Who's Who* by the 1930s; by that time he had published a number of self-funded monographs.

3. Ibid.

4. See Ellison to Jackson, July 24, December 29, 1924; Jackson to Ellison August 3, August 21, December 24, 1924. In fact, the portfolio turned out to have been made not in 1878 but in 1873.

5. See Jackson, *Time Exposure: The Autobiography of William Henry Jackson* (New York, 1940), p. 330; Ellison Papers. Jackson, *Diaries,* Manuscript Collection, New York Public Library, esp. five-year calendar (small leather book with short entries).

6. See Jackson to Ellison, March 10, 1925; Jackson, *Diaries; Time Exposure,* pp. 331–332.

7. Jackson to Ellison, March 10, 1925.

8. Ellison to Jackson, March 21, 1925.

9. Howard Driggs, preface to William Henry Jackson and Howard R. Driggs, *Pioneer Photographer: Rocky Mountain Adventures with a Camera* (Yonkers-on-Hudson, N.Y., 1929), pp. iv–viii. Ellison was not the only Westerner whose interest in the past was linked to a relentlessly entrepreneurial present; this was also the case with A. J. Durlacher, who befriended Jackson through the Explorers' Club and who was himself an executive with the Mena Grande Oil Company in Venezuela. See Jackson's letters to Durlacher, taped into an inscribed copy of *The Pioneer Photographer* now in the collection of Kenneth C. Burkhart and Priscilla J. Barclay of Chicago.

10. These events are recounted in Jackson's narrative of the trip, found in the small memorandum book filed with the *Diaries* in the Manuscript Collection of the New York Public Library.

11. Jackson, *Diaries,* June 27, 1925.

12. Ibid., July 3, 1925; Robert Ellison, *Jackson of the Yellowstone* (Casper, Wyo., n.d., ca. 1926); the portfolio eventually ended up in the Lilly Rare Book Library of Indiana University, Bloomington.

13. Ellison's motives are borne out by later acts; shortly after Jackson's death, he apparently wrote an acquaintance inquiring after the availability of Jackson's copies of Moran drawings and

paintings, and the possibility of buying them at bargain rates. See H. C. Bretney to Robert S. Ellison, July 16, 1942, in Ellison Papers.

14. Jackson, *Photographs of Yellowstone National Park and Views in Montana and Wyoming Territories. Department of the Interior, U.S. Geological Survey of the Territories . . . W. H. Jackson, Photographer* (Washington, D.C., 1873); Robert S. Ellison's copy in Lilly Rare Book Library, Indiana University.

15. Jackson, *Diaries,* 1874 narrative compared with original text; 1871 narrative and text, compared with typescript—and typescript partially disassembled to reveal underwriting crediting Crissman with photographs; on Driggs, see esp. *Diaries,* July 5, 1927.

16. See Ellison, *Independence Rock: The Great Record of the Desert . . . [including] "Old Independence Rock," (A Poem) by Addie E. Holmberg . . ., with Illustrations by William H. Jackson* (Casper, Wyo., 1930); on the cover of *Fort Bridger, Wyoming, A Brief History,* published by the Historical Landmark Commission of Wyoming (in which Ellison was a major force), the author's caption for the cover picture was "Old Fort Bridger, 1843–1857. From a sketch by W. H. Jackson, who first saw the fort in 1866. He was also official photographer for the Dr. F. V. Hayden U.S. Geological Survey, 1870–1880"; Jackson, *Diaries,* 1924–1940.

17. The 1924 painting, now apparently lost, was reproduced in Clarence Jackson's *Picture Maker of the Old West* (New York, 1947), p. 24. A later version, made for the Oregon Trail Memorial Association ca. 1930, is held in the Scott's Bluff National Monument, Scott's Bluff, Nebraska, as Jackson no. 23. The original is owned by the Gilchrease Institute; another version, made in the seventies or eighties, is held by the Nebraska State Historical Society.

18. See Jackson's diaries and the letters to Ellison, as well as letters to oil executive A. J.

Durlacher of the Mena Grande Oil Company of Maracaibo, Venezuela, held by the collection of Kenneth C. Burkhart and Priscilla J. Barclay, Chicago, for more specific information on the Explorers Club and on painting commissions during this period.

19. Jackson-Ellison letters, 1929–1934.

20. Jackson to Ellison, March 28, 1934.

21. Jackson to Ellison, January 29, 1935.

22. Driggs's description comes as part of a fascinating autobiographical foreword to his *Westward America* (New York, 1942), pp. v–vi; Jackson, *Diaries,* January 14, 1929; Jackson, *Time Exposure,* p. 332.

23. See Jackson, *Diaries,* 1929–1935, esp. July 18, August 19, 20, 1929; July 1, 1930; June 26, 27, 30, July 10, 1932; May 25, June 7, July 4, and passim, 1934; on 1937 trip, see postcard, Jackson to A. J. Durlacher, postmarked July 6, 1937, and letter to Durlacher, October 3, 1937, both held in the collection of Kenneth C. Burkhart and Priscilla J. Barclay, Chicago.

24. See Jackson, *Diaries;* LeRoy and Ann Hafen reported on their experiences with Jackson on the later "trail drives" in their introduction to Jackson's 1866–1874 diaries, *The Diaries of William Henry Jackson* (Glendale, Calif., 1959), pp. 11–13 and dedication (p. 5); see also Jackson's letters to A. J. Durlacher.

25. On this tourist phenomenon, two excellent books have been written: Earl Pomeroy's *In Search of the Golden West: The Tourist in Western America* (New York, 1957); and Warren James Belasco's *Americans on the Road: From Autocamp to Motel, 1910–1945* (Cambridge, Mass., 1979), esp. pp. 14–15.

26. Late in 1930, Jackson reported a meeting of the Board of Directors at which "the subject most discussed was about carrying on another year . . . but Miss [illegible] seems to be getting interested in the work of the association and will help to finance it for another year." Reports of the Association's fund-raising and financial matters are interspersed in Jackson's *Diaries* during these years; his report on the Board of Directors' meeting is dated November 24, 1930. Driggs listed himself as collaborator with Jackson for *The Pioneer Photographer;* after his name he listed his appointment as "Associate Professor of English Teaching, New York University." This follows Driggs's pattern of trotting out his credentials in press releases, newspaper articles, and the like.

27. Jackson, *Time Exposure,* pp. 332–333; *Diaries,* 1929–1934, passim.

28. These paintings and drawings are now held in the Scott's Bluff National Monument, Scott's Bluff, Nebraska.

29. Actually, Jackson even "improved" the background by splitting "Split Rock" more visibly.

30. The possibility exists that, indeed, Jackson *did* use the original sketches as bases for the paintings. But it is more likely that he simply traced the older images onto the canvas of his new paintings in order to retain the sketches for future use or sale.

31. Jackson, *Diaries,* November 25, 1930.

32. Ibid., June 5, 1929; November 25, 1930; June 27, 1932; January 2, 1934; Jackson to Ellison, February 24, 1937 ("I have settled down to complete the series of water colors to be reproduced in book form of rather large size . . . that the Stokes Company have promised to publish as soon as prepared. Something of this kind has been in contemplation ever since I began making these pictures and it looks now as though it would go through"); Jackson to Ellison, September 28, 1939, concerning a potential ghost writer for an autobiography. *Time Exposure* was first published by Van Rees Press, then reissued in a second edition by G. P. Putnam's Sons shortly thereafter. See Jackson to Ellison, September 20, 1940.

33. Driggs's introduction to *The Pioneer Photographer* is as applicable as the quote here, taken from *Westward America,* p. v.

34. Jackson to Ellison, May 12, 1935; Jackson, *Time Exposure,* p. 334; Jackson, "Photographic Trips of Denver Period—1879–1898" (typescript held by Amon Carter Museum, Fort Worth), p. 5.

35. Daniel Boorstin has written the definitive study of the pseudo-event, in *The Image: A Guide to Pseudo-Events in America* (New York, 1964).

36. Jackson, *Time Exposure,* pp. 334–335; Jackson to Ellison, April 10, October 29, 1936. Though Jackson never mentioned it, probably the Parks Director was approached by one of his assistants, Fritiof Fryxell, who in 1934 had written a laudatory squib on Jackson, "Mount of the Holy Cross," *Trail and Timberline* (January 1934), pp. 5–15.

37. Two of the murals are still hanging in the Interior Department Museum; the other two have been misplaced—last seen in the offices of Interior Department officials, they have moved often enough to have disappeared from the inventory. The Interior Department has provided materials on the Jackson murals, including a pamphlet produced around 1970 and a typescript explanation of Jackson's four paintings. Bronson became an author and illustrator of children's books.

38. See Jackson, *Time Exposure,* p. 335.

39. Ibid., p. 339.

40. Jackson's diaries and letters of this period reflect his pleasure in the event of his artistic ascendancy.

41. Jackson's letter to Ellison and his reply have apparently been lost, but the gist of their discourse is implied in Jackson's letter to Ellison, September 28, 1939, in which Jackson recounts the choosing of Brown and Putnam's editorial demands.

42. Jackson, *Time Exposure.*

43. Jackson to Ellison, September 20, 1940.

44. This loss of control is perhaps most poignantly recorded in a letter Jackson wrote to his Explorer's Club friend, A. J. Durlacher, on De-

cember 27, 1939. There Jackson confessed that "I began to realize I was setting too fast a pace." The routine of honorary dinners, talks, showings of his new "kodachrom slides" of the West, and the like, had so exhausted and unnerved him that he "went to bed for a week in the LeRoy Sanatorium. . . . Spent the week in entire seclusion—no callers allowed. It was rest what *[sic]* I needed." Still, just weeks later, he rather plaintively added, after recounting a further round of "occasions," that he was "holding off from these things as much as I can." (Jackson to Durlacher, December 27, 1939, held in the collection of Kenneth C. Burkhart and Priscilla J. Barclay, Chicago).

45. A copy of this tape is now held in the oral history archive at the Colorado State Historical Society; a second, in the Western History Collection of the Denver Public Library.

46. William Stott's *Documentary Expression and Thirties America* (New York, 1974) represents the finest analysis of the documentary mode in America; in addition, it contains a wealth of information about such otherwise discredited versions of "documentary" as the government oral history tape described here.

EPILOGUE

1. Gertrude Stein, *The Making of Americans* (New York, 1934), p. 402.

2. Clarence S. Jackson and C. W. Marshall, *Quest of the Snowy Cross* (Denver, 1952); Clarence S. Jackson, *Picture Maker of the Old West: William H. Jackson* (New York, 1947); *Pageant of the Pioneers: The Veritable Art of William H. Jackson* (Minden, Neb., 1958); Howard R. Driggs, *The Old West Speaks . . .* (New York, 1956); Aylesa Forsee, *William Henry Jackson—Pioneer Photographer of the West* (New York, 1964); Helen Markley Miller, *Lens on the West: The Story of William Henry Jackson* (Garden City, N.Y., 1966).

3. Adams's own comment on the conversion of his nature photographs into room dividers reveals that he had gone far beyond this point—for him, the photograph offered not simply a replacement for lost nature but a commodity, to be treated as one of the elements of good office design: "Another highly functional form of the big enlargement is the screen. Perhaps the most satisfactory form is the three-panel, this combines interest-ing design possibilities and is self-supporting and adaptable to various spaces." (Ansel Adams, *Ansel Adams, An Autobiography* (Boston 1985), p. 189).

4. That the myth of regenerative landscape, located in "the West" remains central to American culture despite the supposed encroachments of a "pluralistic" society is to be found by interviewing recent immigrants to the United States—Poles, Vietnamese, Thais, Haitians, Guatemalans—whose image of America is powerfully derived from the entire genre of Westerns. Indeed, many of those I have interviewed describe their first experiences as similar to that of the Danish-American reformer–photographer Jacob Riis, who spent most of his savings to buy a six-shooter to protect himself in the wilds of New York City in 1869.

5. As this is written, two of Louis L'Amour's novels are on the paperback bestseller list, and Larry McMurtry's extraordinary anti-Western, *Lonesome Dove,* has just been released to supermarkets.

193.
"120. Castellated Rocks near Monument Park," *1874.* NAA

Primary source materials on William Henry Jackson abound in a wide variety of archives and libraries, as a reader of the notes to this book will already have noted. The photographs themselves comprise the largest resource on Jackson; in most cases the original negatives still exist and offer a wealth of information. Jackson's earliest photographs, from Omaha in 1867–1868, are scattered, and the negatives have disappeared. Indian photographs from this period, however, were collected in the 1870s in two archives—the American Indian collection in the U.S. Geological Survey (USGS), which went to the Bureau of American Ethnology and then the National Anthropological Archives of the Smithsonian Institution; and the Blackmore Collection, which is now held by the British Museum.

The negatives for Jackson's 1869 trip with Arundel C. Hull along the Union Pacific were subsumed into the USGS collections when Jackson joined the Hayden Survey in 1870. The Survey negatives are held in the National Archives; copy negatives and some original prints are held by the USGS in Denver. These include not only Jackson's own photographs but a number of negatives made by other photographers, traded for or purchased later, for inclusion in the Survey archive. These include negatives by J. Crissman, Timothy H. O'Sullivan, and Charles Roscoe Savage, among others.

Once he left the Survey in 1879, Jackson amassed a huge collection of negatives under the name of his company, first W. H. Jackson & Co., Phot., then the W. H. Jackson Photographic and Publishing Company ("the

W. H. J. P. & P. Co.," as the most common logo went). These negatives, which include not only those Jackson made but also those he traded for, commissioned, purchased, or ordered made by his employees or assistants, existed in a wide variety of formats—particularly the more popular images. When Jackson left Denver, he took most of them with him to Detroit, where they formed the basis of the Detroit Photographic and Detroit Publishing Company's negative archive. After the Company went bankrupt in 1924, Jackson's negatives and the large archive of negatives made, bought, or copied into the Company archive remained the property of R. B. Livingstone, Jr., until their transfer to the Edison Institute of Detroit. They were then divided in half; those depicting scenes west of the Missis-

sippi were transferred to the Colorado State Historical Society, and those of the East went to the Prints and Photographs Division of the Library of Congress.

These two institutions still serve as the principal archives of Jackson's post-Survey work, although the Edison Institute, now of Henry Ford's Greenfield Village, has retained a significant collection of Detroit Company positives, some Jackson prints, and a large collection of "Kodaks" made by Jackson and others on the World's Transportation Commission trip. The Colorado State Historical Society holdings include not only the more than forty thousand negatives but a major collection of prints from all eras of Jackson's production. The Prints and Photographs Division of the Library of Congress, as well, has developed a huge archive of Jackson and Detroit Company prints, in part through transfers from the Copyright Deposit Division. These have recently been reorganized, and the process of restoration has begun, under the supervision of George Hobart. Because the Detroit negatives are so extensive, the Library of Congress had, until recently, almost no way of providing access to the materials. In the seventies and early eighties, I was able to do a great deal of research by examining the original negatives—there were, at the time, a relatively small percentage of positive prints from those glass plates. Since then, however, the Division has converted the entire Detroit Company archive to video disk, from which the images can be seen in positive, accessed by file or negative number, and scanned. The Colorado State Historical Society has recently begun another sort of project, involving the computerization of all information on the negatives themselves, allowing researchers access through a wide variety of information bases.

In addition to these sources, a number of other museums hold significant collections. The Amon Carter Museum in Fort Worth, Texas, for example, has an extensive set of Jackson prints from all eras, in particularly good condition. Especially vital, however, because they contain materials available nowhere else, are the collections in the Western History Room of the Denver Public Library and the Prints and Photographs Department of the Chicago Historical Society. The former holds an extensive collection of Jackson Company sample books, completing the body held at the Colorado State Historical Society. In addition it holds representative examples of a high percentage of the publications in which Jackson's photographs appeared during the Denver years. The Chicago Historical Society recently acquired the only known extant photoprints of the World's Columbian Exposition portfolio trade for Daniel Burnham. Other valuable collections include the Lilly Library of Indiana University, which retains Robert Spurrier Ellison's copy of the USGS portfolio, with Jackson's notes from the twenties, as well as other material related to Jackson's relationship with Ellison; the Rare Books Library at the University of Chicago, which has excellent representative Survey portfolios, as does the Rare Books and Manuscripts Room at the Library of Congress; and the New York Public Library, which holds some interesting examples of Jackson's work in the Rare Books and Manuscripts Collection.

Nonphotographic archive material on Jackson is also scattered at a variety of sources. The Colorado State Historical Society and the Rare Books and Manuscripts Collection of the New York Public Library together hold the extant diaries, which cover most of the Survey years (copies at both collections, more extensive at the New York Public Library), the World's Transportation Commission trip, and the years after retirement (the latter at the New York Public Library). The USGS documentation is amassed at the National Archives as Record Group 57, Hayden Survey. Some has been microfilmed; much has not. The World's Transportation Commission materials are scattered: the diaries are located at the New York Public Library, as are Jackson's letters to his wife; scrapbooks and snapshots are held by the Edison Institute. The Detroit Photographic and Detroit Publishing Company materials, in fragmentary form, are held by the Colorado State Historical Society, including the Company negative register books, some of which contain extensive data concerning the sources of photographs, their reproduction, and the like. A file of copyright deposit materials in a miscellaneous box of the Manuscripts Collection includes a number of contracts with photographers. Jackson's own diaries for these years, incomplete at best, are located at the New York Public Library. Later materials are located at a number of locations. Jackson's paintings and memorabilia are found at the Scott's Bluff National Monument, Scott's Bluff, Nebraska. The correspondence with Ellison is held in the Western History Room of the Denver Public Library. Jackson's letters to Gilchrist are found in the Manuscripts Collection of the Colorado State

Historical Society, along with a copy of the audiotape made at the Department of the Interior in 1941. The late diaries, along with some daybooks, memoranda, and the like, are held in the Rare Books and Manuscripts Division of the New York Public Library. For further information, readers are referred to the notes to the text.

It is worth noting the materials not yet found, most of them probably permanently lost: the business records of the W. H. Jackson Company; Jackson's letters to his wife and family for all years other than 1896–1898; the bulk of business records for the Detroit Photographic Company; and virtually all the paintings by Jackson from the nineteenth century.

Jackson's photographs, reports, and other contributions dot the Hayden Survey publications list, beginning with his *Preliminary Report of the United States Geological Survey of Wyoming, and Portions of Contiguous Territories, (Being a Second Annual Report of Progress) [1870 Survey]* (Washington, D.C., 1871). The most elaborate of these official reports is the *Twelfth Annual Report of the United States Geological and Geographical Survey of the Territories. A Report of Progress of the Exploration in Wyoming and Idaho for the Year 1878* in two volumes, with an addendum volume of maps and panoramas. (Washington, D.C., 1883). This is the relevant report on Yellowstone Park; volume 2 contains a large number of Jackson's pictures extremely well reproduced as steel engravings, and a number of color chromolithographs by Moran that are reductions of his work for Prang's portfolio

of 1876. All the Survey *Bulletins* and *Reports* are crucial sources, however, not only for reproductions of Jackson's pictures but for a larger picture of the Hayden style of exploration and science.

The Survey reports themselves follow a tortuous path of changing titles and oddly altered punctuation, numbering, and dates. Hayden published single reports covering each annual Survey exploration season in which Jackson was a participant, from 1870 to 1878. The first, cited above, was listed as a "Preliminary Report," though no "final" report was forthcoming; the same was the case with 1871's *Preliminary Report of the United States Geological Survey of Wyoming, and Portions of Contiguous Territories, Being a 5th [sic] Annual Report of Progress by F. V. Hayden, United States Geologist* (Washington, 1872). For some reason, Hayden chose at that point to "normalize" the report numbers so that they would correspond with the number of seasons he had been in the field. After that, the Reports followed a pattern: the *Sixth Annual Report of the United States Geological Survey of the Territories, Embracing Portions of Montana, Idaho, Wyoming, and Utah. Being a Report of the Progress of the Exploration for the Year 1872* (Washington, 1873); the *Annual Report of the United States Geological and Geographical Survey of the Territories, Embracing Colorado, being a Report of Progress of the Exploration for the Year 1873, by F. V. Hayden, United States Geologist* (Washington, 1874); the *Annual Report of the United States Geological and Geographical Survey of the Territories, Embracing Colorado and Parts of Adjacent Territories; being a Report of Progress of the*

Exploration for the Year 1874 (Washington, 1875); the *Ninth Annual Report of the United States Geological and Geographical Survey of the Territories, Embracing Colorado and Parts of Adjacent Territories: being a Report of Progress of the Exploration for the Year 1875* (Washington, 1877); the *Tenth Annual Report of the United States Geological and Geographical Survey of the Territories, Embracing Colorado and Parts of Adjacent Territories, being a Report of Progress of the Exploration for the Year 1876* (Washington, 1877); the *Eleventh Annual Report of the United States Geological and Geographical Survey of the Territories, Embracing Idaho and Wyoming, being a Report of Progress of the Exploration for the Year 1877* (Washington, 1878); and finally, after a hiatus of five years, the *Twelfth Annual Report,* cited above.

These official documents formed only one part of the output of the Hayden Survey, however. Equally important, though for different reasons, are the portfolios, albums, and illustrated "books" that the Survey produced for publicity purposes. These include the invaluable *Catalogue of Stereoscopic 6 × 8 and 8 × 10 Photographs* (Washington, D.C., 1871), reproduced in a later edition as the *Descriptive Catalogue of the Photographs of the United States Geological Survey of the Territories for the Years 1869 to 1875, Inclusive. Second Edition. W. H. Jackson, Photographer. . . . Miscellaneous Publications—No. 5* (Washington, D.C., 1875). This version has been blessedly reprinted by Raymond Dworczyk/The Q Press (Milwaukee, 1978). Both editions contain reproductions from the Survey *Re-*

ports. Perhaps more important, though for different reasons, is Jackson's *Descriptive Catalogue of Photographs of North American Indians* (Washington, D.C., 1877). This catalogue is the most important of all Jackson's studies of Indians—its entries are clear exegeses of the ideologies behind the photographs themselves, and its printing under the imprimatur of the Hayden Survey added tremendous authority to its conclusions. Hayden also published Jackson's "Notice of the Ancient Ruins in Arizona and Utah," in Ferdinand Vandeveer Hayden, *Bulletin of the United States Geological and Geographical Survey of the Territories* (Washington, D.C., 1876). Essentially a separate publication of the version told in the *[Eighth] Annual Report [1874]*, this monograph was published and bound in with the report as well as being available alone.

Hayden's more elaborate and pictorial materials include his *Camp Life in the Rocky Mountains* (New York, 1871). One hundred fifty copies of this work were advertised, to be sold by subscription only, containing nineteen 6-by-8s and twenty-eight "vignettes" (stereo halves) with text, for ten dollars. No copies have been reported, but the book was advertised opposite the title page of the Survey's 1871 *Catalogue*. Similar, and similarly elusive, was Hayden's *The Rocky Mountain Album* (New York, 1872). Advertised as a five-hundred-copy edition at thirty dollars, containing sixty to a hundred "of the most striking and instructive views of Western Scenery, size 6 × 8," this, too, was probably never published—at any rate, no copies are known to exist; it was advertised in the face of the 1871 *Catalogue*. Successfully produced was *The Grotto Geyser*

of the Yellowstone National Park, with a Descriptive Note and an Illustration by the Albert-type Process (Washington, D.C., 1876). This is a 15-by-20 folio, all that was left of Hayden's first planned Albertype portfolio. Hayden reports in his Introductory Note that

about two years ago [1873–1874] it was the purpose of the writer to prepare an illustrative work on the scenery of the Yellowstone National Park, and other portions of the West. About 20 photographic negatives, 11 × 14 inches in size, were selected by Mr. William H. Jackson, Photographer to the Survey, for this purpose, and forwarded to the Albert-type Company in New York City. Before the work could be completed a fire occurred in the building occupied by the company, which destroyed all the negatives. About 200 prints of the "Grotto Geyser" were saved. This print seemed, to the writer, to be too valuable to be entirely lost, and on that account he has taken this method to preserve it in a more permanent form.

That same year (the U.S. Centennial possibly explaining the output), Hayden and painter Thomas Moran coproduced *The Yellowstone National Park and the Mountain Regions of Portions of Idaho, Nevada, Colorado and Utah. Described by Professor F. V. Hayden . . . Illustrated by Chromolithographic Reproductions of Water-Color Sketches by Thomas Moran, Artist to the Expedition of 1871* (Boston, 1876). The work contained fifteen high-quality chromolithographs made by the prestigious publishing firm of Louis Prang; many of them resurfaced as illustrations to the lavish two-volume final *Report* of 1883. They reveal quite clearly Moran's interrelationship with Jackson's photographs. Finally, in 1880, Hayden published his grand popularization of the Survey's work, *The Great West: Its Attractions and Resources,*

Containing A Popular Description of the Marvelous Scenery, Physical Geography, Fossils, and Glaciers of this Wonderful Region; And the Recent Explorations in the Yellowstone Park, "The Wonderland of America," by Prof. F. V. Hayden, LL.D, Formerly United States Geologist. Also, Valuable Information To Travellers and Settlers Concerning Climate, Health, Mining, Husbandry, Education, The Indians, Mormonism, The Chinese; With the Homestead, Pre-emption, Land, and Mining Laws. By a Corps of Able Contributors. Handsomely Illustrated with Engravings and Maps. Sold Only By Subscription (Philadelphia, Pa., 1880). This is a vital resource. It contains a huge number of picturesque illustrations, some credited to Moran, that seem to define the popular vision of the West and serve as a primer in what Jackson competed with in the way of other visual media.

As actual photographs, Jackson's work appeared in a series of portfolios sponsored by the Survey. The most widely distributed appears to have been Jackson's *Photographs of the Yellowstone National Park and Views in Montana and Wyoming Territories. Department of the Interior, U.S. Geological Survey of the Territories . . . W. H. Jackson, Photographer* (Washington, D.C., 1873). The University of Chicago's Rare Books Collection holds what may be a second portfolio, listed by its library as *Photographs of the U.S. Geological Survey of the Territories for the Years 1869–1876, Inclusive* (Washington, D.C., 1876). This may have been a single manufactured portfolio or a later compilation of Survey photographs. In her extensive but unreliable bibliography to Edkins and Newhall's *William Henry Jackson* (Fort

Worth, 1974), Diana Edkins lists a portfolio entitled *Views of the Yellowstone*, which she alleges is the portfolio "presented to Congress as proof of the wonders of Yellowstone" (p. 152). However, no such portfolio was given to Congress, and Edkins gives no source for a copy; the portfolio is not listed in the *National Union Catalogue*, although a single portfolio with such a date was once offered for sale to the Amon Carter Museum.

Jackson's photographs were published in a tremendous number of books, magazines, pamphlets, advertisements, railroad timetables, and the like from the 1870s until well after his death. The following list is incomplete but reveals some of the range and variety of outlets; it is arranged in rough chronological order.

Crofutt, George A. *Crofutt's Transcontinental Tourist's Guide*. New York, Chicago, published annually, 1868–1877. These quintessential tourist guides, sold by the American News Company and on every major tourist railroad to or in the Western United States during the period, contained vital information on routes and statistics on everything from the area of the Truckee Meadows to the number and type of buildings in Corinne, Utah. Crofutt prided himself on having traveled the roads he wrote about, and excoriated firms like Appleton's as "great big Dead Beats" who "employ penny-a-liners to sit in their office—never go out of the city—and compile 'guides.'" (from the preface to the 5th ed.). It was extensively illustrated with views adapted from Jackson's photographs, as well as those of C. R. Savage, A. J. Russell, and others—see

Crofutt's letter to Hayden, February 16, 1872 (RG 57, reel 2, frames 373–375) referring specifically to "one of your Yellowstone views—it is 'no. 200—the Valley of the Yellowstone' with mountains in the distance white in spots with snow." This view and one of "The Falls of the Yellowstone" appear as "Annexes 35 & 36" of the later *New Overland Tourist Guide*, where they are credited as from photographs "made by Prof. Hayden, the great explorer of the West."

Crofutt, George A. *Crofutt's New Overland Tourist and Pacific Coast Guide*. Chicago, published annually, 1878–1884. This is the later version of Crofutt's *Tourist's Guides*, containing much the same material in expanded and better organized form, but still illustrated with wood engravings from photographs by Jackson and others.

Crofutt, George A. *Crofutt's Overland Tours. Consisting of Nearly Five Thousand Miles of Main Tours, and Three Thousand Miles of Side Tours*. Chicago, 1888. This, the last [?] of Crofutt's tour guides, is laced with engravings from photographs by Jackson, Savage, and Muybridge, covering the three areas he discusses—Colorado and the Union Pacific Railroad, Utah, and California, especially San Francisco—including Yosemite and a portion of Muybridge's panorama from Stanford's mansion.

Thomas, Windham, Earl of Dunraven. *The Great Divide: Travels in the Upper Yellowstone in the Summer of 1874. With Illustrations by Valentine W. Bromley*. London, 1876. Some of these engraved illustrations were taken directly from Jackson's pictures.

Carpenter, F. D. *The Wonders of Geyser Land: A Trip to the Yellowstone National Park*. Black Earth, Wisconsin, 1878.

Centennial State, 1876–1882: A Memorial Offering of the Business Men and Pioneers of Denver, Colorado. Denver, 1882.

Ingersoll, Ernest. *Knocking 'Round the Rockies*. New York, 1882. This was a compilation of a number of articles by Ingersoll over the previous decade.

Ingersoll, Ernest. *The Crest of the Continent: A Record of A Summer's Ramble in the Rocky Mountains and Beyond*. Chicago, 1885.

McClurg, Virginia Donaghe. *Picturesque Colorado*. Denver, 1887.

Perry Park, Colorado. Denver, 1890.

Gems of Colorado Scenery. Denver, no date, c. 1890. Later editions of this work slowly replaced Jackson's views with others by a number of unnamed Colorado photographers.

The City of Denver, Its Resources and Their Development. A Souvenir of the Denver Times. Denver: Denver Times, 1891. A very large, 14-by-19 leatherette-bound volume of 101 pages, including ads at the end and index and short biographies; 196 pictures of "leading citizens."

King, Moses, and M. F. Sweetser. *King's Handbook of the United States*. Buffalo, 1891.

Buckman, George Rex. *Colorado Springs, Colorado, and its Scenic Environs*. Colorado Springs, 1892, 1893. Buckman was the secretary of the Colorado Springs Chamber of Commerce, and this lavish and quite large (60 pp.) booster book went through two editions. The first edition and the second differed in their

views; both mixed photogravures or Albertypes, tipped in on thick stock, with halftones and booster text.

Harper, R. L. *The Denver Athletic Club*. Denver, 1893.

A Souvenir of the Beautiful Rio Grande . . . The Scenic Line. Denver, 1893.

Wood, Stanley. *The Story of the Ancient Missions and Churches of America*. [Chicago, Denver?], 1894.

Wonder Places. The Most Perfect Pictures of Magnificent Scenes in the Rocky Mountains . . . The Master-Works of the World's Greatest Photographic Artist, W. H. Jackson Selected from Thousands of Negatives as the Gems of the Collection. Denver and Chicago, 1894.

The Cañons of Colorado. From Photographs by W. H. Jackson. Denver, [probably 1896–1898]. A sheet of 16 photographic views that folds to 20-by-13; the images are bad halftones.

Goodwin, J. M. "The Snake River Country: A Wild Part of Idaho," *Overland Monthly*, 2d series, 31 (January 1898): 3–13. This essay included Jackson's photographs of "Natural Bridge, Shoshone Falls" (in which Moran can be seen atop the bridge) and "Twin Falls." Both these views were evidently made during the 1892 excursion with Moran.

Among The Rockies: Pictures of Magnificent Scenes in the Rocky Mountains, The Master-Works of the World's Greatest Photographic Artist, W. H. Jackson, Selected from Thousands of Negatives as the Gems of the Collection. Denver, ca. 1900. This is a truncated second edition of *Wonder Places,* containing 30 pages of photographs, some of them composites and multiple-photograph arrangements, badly reproduced on mediocre paper with a paper cover.

Higgins, C. A. *Grand Cañon of the Colorado River. Published by the Passenger Department of the Santa Fe Route*. Chicago, 1892.

Higgins, C. A. *New Guide to the Pacific Coast*. Chicago, 1894, 1895, 1897. This was probably the first version produced by Rand McNally.

Higgins, C. A. *The Land of Sunshine*. Chicago, 1892. "Illustrated by J. T. McCutcheon," but engravings are actually from Jackson's negatives.

Higgins, C. A. *To California and Back*. Chicago, 1897, 1903. The second of the Rand McNally/Sante Fe collaborations using Jackson's photographs engraved and signed by R. McNally. The other illustrators were listed (J. T. McCutcheon, Carl N. Werntz, John W. Norton, James Allen McCracken); Jackson was not. In the 1903 edition, the publisher was Doubleday, Page and Co., and it included a large number of photographs credited to the Detroit Photographic Company, as well as views of the pueblos credited to Vroman.

Higgins, C. A. *To California over the Santa Fe Trail*. Chicago, 1903, 1904, 1905, 1907, 1909, 1910, 1911, 1914 ("379 thousandth"), 1915, 1917. Reprints of 1897, updated.

Ellison, Robert Spurrier. *Fort Bridger, Wyoming, A Brief History . . . with illustrations in part by William Henry Jackson*. Casper, Wyo., 1931. This was one of the "monographs" using Jackson's paintings as illustrations.

Ellison, Robert Spurrier. *Independence Rock: The Great Record of the Desert . . . [including] "Old Independence Rock (A Poem) by Addie E. Holmberg . . . with Illustrations by William H. Jackson*. Casper, Wyo., 1930.

Driggs, Howard R. *The Old West Speaks . . . Including Water Color Paintings by William Henry Jackson*. New York, 1956. This work contains 37 watercolor sketches, dates ranging from 1930 to 1940; some of them are more finished versions of paintings used in Ellison, *Fort Bridger, Wyoming*. Driggs was Jackson's collaborator on *Pioneer Photographer*.

Driggs, Howard R. *Westward America*. New York, 1942. This Driggs work included 40 of Jackson's watercolors as its illustrations.

Also vital was the wealth of primary source material found in the nineteenth-century photographic magazines. Some of these—notably *The Philadelphia Photographer, Wilson's Photographic Magazine, The Photographic World,* and *Anthony's Photographic Bulletin*—maintained ongoing relationships with Jackson, publishing letters and essays by him and, in later years, photographs and photoreproductions. Both Anthony and Company and their archrivals, the Scovill Company, published *Catalogues* that are of great value in attempting to understand the range of equipment, general methods of photographing, and the like. Two vital essays on the general subject of landscape photography are George Washington Wilson, "On Out-Door Photography," *Philadelphia Photographer* 6, no. 61 (January 1869), pp. 66–68; and the more extensive chapter on "Outdoor Photography" in Wilson's textbook for photographers, *Wilson's Photo-*

graphics (New York, 1881; reprinted, New York, 1973).

Many of these journals also published reviews of Jackson's work; it was the practice for ambitious photographers to send samples of their work or (as occurred in Jackson's case with both *Anthony's Bulletin* and *Wilson's*) to visit the editorial offices with sample portfolios. These reviews and reports include "William Henry Jackson," *The Photographic World* 1 (1871), pp. 72–73; Edward L. Wilson, "Stereoscopic Views of the West," *The Philadelphia Photographer* 10 (1873), p. 64 (a wildly positive review of Jackson's work); Wilson, "Editor's Table: An Admirable Lantern Exhibition," *Philadelphia Photographer* 10, no. 109 (January 1873), p. 32; "Government Photography in America," *Anthony's Photographic Bulletin* 4, no. 11 (November 1874), p. 366; Wilson, "Editor's Table: United States Geological Survey of the Territories," *Philadelphia Photographer* 12, no. 133 (1875), p. 30 (this one includes discussion of the photographs and a laudatory review mentioning Jackson's proof of the ascendence of American landscape photography); "Photographs of Rocky Mountain Scenery, and its Prehistoric Ruins," *Anthony's Photographic Bulletin* [1876], p. 187; Wilson, "Interesting American Scenery," *Philadelphia Photographer* 13, no. 148 (April 1876), pp. 120–122; Wilson, "Scattered Photography in the Great Exhibition: Government Buildings," *Philadelphia Photographer* 13, no. 154 (October 1876), pp. 292–295; A. J. Treat, "A Celebrated Photographer and His Work," *Wilson's Photographic Magazine* 26 (1889), pp. 378–379; and Wilson, "William Henry Jackson, Landscape Photographer," *Wilson's Photographic*

Magazine 30 (old numbering), no. 437 (May 1893), pp. 228–231.

In addition, newspapers, popular magazines, and some scientific journals commented on Jackson's work. Two significant mentions appeared on page 1 of the *New York Times:* "The Hayden Survey. A Visit to the Offices of the Surveying Corps" (*New York Times,* April 27, 1875, p. 1) included a tour of Jackson's Washington facilities; "The Hayden Survey, Beyond the Settlements" (*New York Times,* July 27, 1875, p. 1) does not mention Jackson by name but discusses a visit to the Los Piños Indian Agency. In the scientific journals, see Frank H. Bradley, "Explorations of 1872: U.S. Geological Survey of the Territories under Dr. Ferdinand V. Hayden: Snake River Division," *American Journal of Science and Arts,* 3d series, 6, no. 33 (September 1873), pp. 194–206; Josiah Dwight Whitney, "U.S. Geological Survey of the Territories, Ferdinand V. Hayden, Geologist in Charge. Photographs of 1873," *American Journal of Science and Arts,* 3d series, 6, no. 36 (December 1873), pp. 463–466; and Ferdinand Vandeveer Hayden, "The Yellowstone Region," *Science Record,* 1873, pp. 515–529.

One of the most eccentric entries in this category is "Photography at the World's Fair," a letter from J. F. Ryder, to the editor of *Wilson's Photographic Magazine* (September 1893), pp. 422–423. In the letter, Ryder declares himself not a friend of Jackson's but complains about Arnold's work and suggests they should hire Jackson instead. It was possibly a fabrication by Jackson or Wilson or both:

Jackson published a significant number of essays, letters, how-to articles, and reminis-

cences, as well as two autobiographies. Probably the most important of his early essays was "Field Work," *Philadelphia Photographer* 12, no. 135 (March 1875), pp. 91–93. This is essentially a reminiscence of Jackson's introduction to outdoor work, with the intention of teaching Americans the nature and virtues of field work, on the grounds that "in England and upon the Continent the outdoor men lead in the race, and count among their ranks some of the best talent in the land; but with us, outside of a few that can be counted upon the fingers, all have gone under the skylight." *Anthony's Photographic Bulletin* also published a number of short letters by Jackson reporting on the quality of equipment he'd purchased from the parent company; one of these was published in vol. 5, no. 12 (December 1874), p. 419; another in vol. 7, no. 1 (January 1876), p. 31. Four of Jackson's pictures were published, tipped into the text, as "Picturesque America," *Wilson's Photographic Magazine* 26 (1889), opp. p. 17; others appear as well; for example, a halftone to accompany "William Henry Jackson—Landscape Photographer," *Wilson's* 30 (1893), p. 229; and elsewhere.

Jackson's connection to the World's Columbian Exposition is documented in a number of manuscript materials at the Chicago Historical Society. These include World's Columbian Exposition, *Minutes of the Executive Committee, World's Columbian Exposition, 1892–1895,* vols. 1, subvols. 35, 36 (handwritten minutes of the meetings of the Executive Committee); *Minutes of the Board of Directors, World's Columbian Exposition, 1892–1905,* vol. 2, subvol. 44 (bound volume of handwrit-

ten minutes of the meetings of the Board, which presided over the Executive Committee); *Minutes of the Council of Administration, World's Columbian Exposition, May–November, 1893,* vol. 2, subvols. 48–51 (bound volumes of minutes of the Council meetings); and *Department of Photography, Trial Balance Sheets* (17-page typescript). The more general context of the Fair is to be found in the many guidebooks and commemorative albums and books published during that period, including Ben C. Truman, *History of the World's Fair* (Philadelphia, 1893); Hubert Howe Bancroft, *The Book of the Fair* (Chicago, 1894); J. W. Buel, *The Magic City* (St. Louis, Mo., 1894); Julian Ralph, *Harper's Chicago and the World's Fair* (New York, 1893); and John McGovern, ed., *Halligan's Illustrated World. A Portfolio of Photographic Views of the World's Columbian Exposition* (New York, 1894).

To understand the Detroit Photographic and Detroit Publishing Company, the first place to go is the collection of catalogues published between 1898 and 1906. These include the following, copies of which are all located in the Prints and Photographs Division of the Library of Congress: Detroit Photographic Company, *Catalogue of the W. H. Jackson Views (Formerly Denver, Colorado). Published by the Detroit Photographic Company* (Detroit, n.d., ca. 1898–1899); *Catalogue J.,—Part Two. Plain, Platinum and Hand Colored Photographs of American Scenery and Architecture; Scenic, Architectural and Marine Views Published by the Detroit Photographic Company . . . Catalogue F* (Detroit, 1899); and section 1 of *Catalogue P: List of Photographs of American Scenes and Architecture published by the Detroit Publishing Company* (Detroit, 1906).

In 1917, Jackson gave an "Address at the Witenagemote Club, Detroit, Michigan" on the subject of his past as a photographer. Apparently the first in the string of autobiographical materials he produced during the last twenty-five years of his life, this is held in the National Anthropological Archives at the Smithsonian. Probably his first attempt at published reminiscence was "First Official Visit to the Cliff Dwellings," *The Colorado Magazine* 1, no. 4 (May 1924), pp. 152–160. In 1926, he wrote "Photographing the Rockies Fifty Years Ago," *The Colorado Magazine* 3, no. 1 (1926), pp. 11–21; three years later, he wrote his first autobiography, with Howard R. Driggs: *The Pioneer Photographer: Rocky Mountain Adventures with a Camera* (Yonkers-on-Hudson, N.Y., 1929). His second autobiography, written with the shadowy "Mr. Brown," was *Time Exposure: The Autobiography of William Henry Jackson* (New York, 1940).

Jackson's materials formed only one part of the source materials for this book. I also examined the archives of Eadweard Muybridge's and Carleton E. Watkins's work (and the manuscript materials as well) located in the Bancroft Library at the University of California, Berkeley, and the photographs of other government photographers—Hillers, Beaman, and O'Sullivan, especially—located in the National Archives and in the Prints and Photographs Division of the Library of Congress.

To develop the cultural context surrounding Jackson's work, the most vital source I used was the travel literature produced during Jackson's lifetime, including reminiscences, booster books, travel guides, tour books, and (later) articles in travel-oriented periodicals. In addition to the many that used Jackson's photographs as illustrations— or as the basis for illustrations—these included Abbé Em. Domenech, *Seven Years' Residence in the Great Deserts of North America* (London, 1860); William Gilpin, *The Central Gold Region, The Grain, Pastoral, and Gold Regions of North America* (Philadelphia, St. Louis, 1860), *Mission of the North American People, Geographical, Social, and Political* (Philadelphia, 1873), and *The Cosmopolitan Railway, Compacting and Fusing Together All the World's Continents* (San Francisco, 1890); Albert D. Richardson, *Beyond the Mississippi: From the Great River to the Great Ocean* (Hartford, Conn., 1867); Samuel Bowles, *Across the Continent: A Summer's Journey to the Rocky Mountains, the Mormons, and the Pacific States* (Springfield, Mass., 1868); Mark Twain's *Roughing It* (New York, 1871); Ernest Ingersoll's *Crest of the Continent: A Summer's Ramble in the Rocky Mountains and Beyond* (Chicago, 1885); Karl Baedeker, ed., *The United States, With an Excursion into Mexico: A Handbook for Travellers—1893* (Leipzig and New York, 1893); Walter A. Wyckoff, *The Workers: An Experiment in Reality* (New York, 1898); Frances Hodgson Burnett, *Two Little Pilgrims' Progress: A Story of the City Beautiful* (New York, 1895); Clarence Day, *Life With Father* (New York, 1920); Rudyard Kipling, *American Notes* (New York, 1898); John Muir, *Our National Parks* (Boston, 1901); Owen Wister, *The Virginian* (New York,

1902) and *Owen Wister Out West* (New York, 1958); Theodore Roosevelt, *Hunting Trips of A Ranchman: Sketches of Sport on the Northern Cattle Plains* (New York, 1886), *The Wilderness Hunter: An Account of the Big Game of the United States and its Chase with Horse, Hound, and Rifle* (New York, 1900), and *Theodore Roosevelt, An Autobiography* (New York[?], 1913); Robert Louis Stevenson, *Across the Plains* (London, 1913); Zane Grey, *The Last Trail* (New York, 1909), *The Heritage of the Desert* (New York, 1910), *Riders of the Purple Sage* (New York, 1912), *Desert Gold* (New York, 1913), *The Light of Western Stars* (New York, 1914), and *The Rainbow Trail* (New York, 1915); and George Reiger, ed., *Zane Grey: Outdoorsman: Zane Grey's Best Hunting and Fishing Tales*. Periodicals that focused on nature and the landscape and provided valuable contextual data included *Outing, Country Life, Sunset, Overland Monthly Magazine, Touring Topics,* and *Holiday.*

Any study of a historical figure might logically begin with a list of previous biographies and studies of the subject, but with William Henry Jackson this is problematic. The tremendous amount of primary material involved, the inherent conflicts among such sources, the diversity of images, and the presence of a large body of unreliable data from such sources as Jackson's son Clarence and Howard Roscoe Driggs all have conspired to confuse rather than clarify Jackson's history. In addition, the interest in Jackson among amateur historians, collectors of photography and Western Americana, and nostalgia buffs has created quite a bit of misinformation. Two amusing works are the "novelized" biographies of Jackson: Aylesa Forsee, *William Henry Jackson—Pioneer Photographer of the West* (New York, 1964), and Helen Markley Miller, *Lens on the West: The Story of William Henry Jackson* (Garden City, N.Y., 1966).

The closest thing to a scholarly study of Jackson has been Weston Naef's essay in Weston Naef and James N. Wood, *Era of Exploration: The Rise of Landscape Photography in the American West, 1860–1885* (Boston, 1975). Overall, this extensive catalogue to a major exhibition of nineteenth-century Western photography offers groundbreaking and sophisticated analysis. Naef's essay on Jackson, however, is quite short, presents often-seen images, and considers Jackson a relatively minor figure. In addition, there are a number of errors of fact, dating, and the like. Beaumont Newhall and Diana E. Edkins's *William Henry Jackson* (Fort Worth, 1974) contains a valuable chronology that is, for the most part, accurate. However, its opening essays are uninformative, the bibliography is filled with errors, and the book reproduces a large percentage of photographs incorrectly attributed to Jackson, including the cover picture, actually by Charles Roscoe Savage. This problem of authorship was addressed in a short essay originally intended for internal museum use only: Richard Rudisill, "A Problem in Attribution," *Research Report No. 1* (Santa Fe, 1975). Rudisill reported that up to half the images in the Newhall–Edkins book were not by Jackson; since that time, further research suggests that the proportion is even larger. An article by Donald E. English—"William Henry Jackson, Commercial Photographer," *Colorado History,* 1983, #1&2, pp. 62–68—contains solid speculations on Jackson's Denver years. Somewhat more sprawling is Terry William Mangan's *William Henry Jackson's Rocky Mountain Railroad Album: Steam and Steel Across the Great Divide* (Silverton, Colo., 1976). Mangan was for many years affiliated with the Jackson Collection at the Colorado State Historical Society. This lavishly reproduced "limited edition" photobook has much rich information on the railroad work, including valuable datings of photographs thanks to the collaboration of Mangan, railroad historian Jackson C. Thode of the D&RG, and collector Richard A. Ronzio of the Climax Molybdenum Company. By cross-checking the names, numbers, and types of railroad stock, especially engines, the team was able to date precisely a number of problematic pictures. The text itself, however, is directed primarily to railroad enthusiasts and collectors of Western Americana. Mangan's earlier and more general text, *Colorado on Glass* (Denver, 1975), contains some extremely valuable information on Jackson; unfortunately, none of it is footnoted. A relatively recent study debunking Jackson's influence on the passage of the Yellowstone Park Act of 1872 is Howard Bossen, "A Tall Tale Retold: The Influence of the Photographs of William Henry Jackson on the Passage of the Yellowstone National Park Act of 1872." *Studies in Visual Communications* 8, no. 1 (Winter 1982), pp. 98–109; Bossen's research, however is not nearly as sophisticated as that

done by Aubrey Haines in his two works on Yellowstone. Both these authors render obsolete the previously accepted source, James F. Kieley, "William Henry Jackson, Yellowstone's Pioneer Photographer," *National Parks and Conservation Magazine* (July 1972), pp. 11–17. Kieley had been personally acquainted with Jackson, and the experience apparently hurt rather than helped him.

Two catalogues of Jackson photographs are extremely helpful in sifting through archival materials. On the Survey years, the USGS *Caption List for USGS Jackson Negatives* (Denver, no date, available upon request) is the typescript of the combined work of USGS researchers for many decades. Its information is enormous, but it is also riddled with typographical errors that often include dates and other vital information, and with difficult-to-decipher overlayerings of information and misinformation. Often the actual USGS or National Archives prints with their mounts are more helpful because certain handwriting samples can be recognized (such as Jackson's own and that of the celebrated Nellie Carico, who until her retirement in the 1970s was an extraordinary, nearly unerring source of information on Jackson's negatives), and earlier material has been crossed out. Nonetheless, this typescript is a vital raw source, containing as it does some direct reminiscences of Survey members, including Holmes and Jackson, in the agglomeration of material. The second is the *USGS annotated copy of Jackson's 1875 Catalogue* (Denver, no date, available as a photocopy upon request). This reproduction of the catalogue, like the caption typescript, provides some helpful information not found elsewhere, some of it drawn from Jackson himself.

The history of landscape photography in America has received wide if rarely deep coverage. Two exhibition catalogues are rewarding: Weston Naef and James N. Wood, *Era of Exploration,* has suggestive essays on patronage, the railroads, government sponsorship, and the like. Eugene Ostroff's *Western Views and Eastern Visions* (Washington, D.C., 1981) contains an excellent if short essay and a wealth of intelligently chosen and arranged illustrations, including woodcuts and lithographs as well as photographs. A solid though brief survey of the entire issue of Western landscape photography of the nineteenth century can be found in Karen and William R. Current, *Photography and the Old West* (New York and Fort Worth, 1978); the text has important essays on a number of lesser figures, including Arundel C. Hull. Estelle Jussim and Elizabeth Lindquist-Cock have attempted an intellectual's survey of the genre, in *Landscape as Photograph* (New Haven, 1986), with only partial success. Instead, the work has taken as its task what Rosalind Krauss has justly attacked as "the treatment of Western survey photography as continuous with painterly depictions of nature." Krauss presents her alternative in a controversial, richly suggestive article: "Photography's Discursive Spaces: Landscape/View," *Artjournal* (Winter 1982), pp. 311–319. Far more rewarding than Jussim and Lindquist-Cock's attempt, though equally determined in its desire to unify photography and painting, is Barbara Novak's *Nature and Culture: American Landscape and Painting, 1825–1875* (New York, 1980). A more rudimentary version of Novak's analysis is found in her review of Naef's Era of Exploration exhibit at the Metropolitan Museum: "Landscape Permuted: From Painting to Photography," *Artforum* (February 1975), pp. 40–45.

Some of the best work has been done on subtopics. Richard Masteller's "Western Views in Eastern Parlors," *Prospects* 6 (1981), pp. 55–71, is a masterful article on stereography in and of the West. Weston Naef has written an essay on the question of a photographic luminism in "New Eyes"—Luminism and Photography," in John Wilmerding, ed., *American Light: The Luminist Movement, 1850–1875* (Washington, D.C., 1980). His text begins to introduce the idea of an Eastern landscape photography, a subject as yet unchronicled. Van Deren Coke has surveyed New Mexican photography generally in his *Photography in New Mexico from the Daguerreotype to the Present* (Albuquerque, 1979), but the work on Jackson is, unfortunately, riddled with factual errors. Mark Klett, Ellen Manchester, JoAnn Verberg, Paul Berger, and Rick Dingus have produced a supremely suggestive work in *The Rephotographic Survey* (Albuquerque, 1985), the presentation of years of photographic work rediscovering the sites of the most famous Western landscape photographs and then photographing them with equipment as close as possible to the original in its angle of view, depth of field, sense of space, and so on. The result tells us much about the past and the present.

Studies of specific Western landscape photographers other than Jackson have re-

cently been produced, and all are rich. Probably the oldest ambitious study of an American landscape photographer was Robert B. Haas, *Muybridge, Man in Motion* (Berkeley, 1976); a more limited but equally rewarding study of this photographer is Anita Mozley, *Eadweard Muybridge: The Stanford Years* (Palo Alto, Calif., 1972). Two studies of Timothy H. O'Sullivan have appeared: Joel Snyder's *American Frontiers: The Photographs of Timothy H. O'Sullivan, 1867–1874* (Philadelphia, 1981) and Rick Dingus's *The Photographic Artifacts of Timothy O'Sullivan* (Albuquerque, 1982). Snyder's is the more sophisticated and more historically grounded analysis; Dingus, a photographer with the Rephotographic Survey, has produced a more fragmentary text. The illustrations in both books are superb. On Carleton E. Watkins, Peter E. Palmquist's *Carleton E. Watkins, Photographer of the American West* (Albuquerque, 1983) is extremely well researched, and, as Martha Sandweiss points out in her opening essay, it helps to counter Weston Naef's overly categorical analysis of Watkins in his *Era of Exploration.* Less exhaustive or more popular in their aims are studies of A. J. Russell, Jack Hillers, and Charles Roscoe Savage. Barry B. Coombs has presided over the production of a picture book on Andrew Joseph Russell, *Westward to Promontory: Building the Union Pacific across the Plains and Mountains—a Pictorial Documentary* (Palo Alto, Calif., 1969). Don Fowler has edited Jack Hillers's diary in *Photographed All the Best Scenery: Jack Hillers' Diary of the Powell Expeditions, 1871–1875* (Salt Lake City, 1972). Possibly the only work on Charles

Roscoe Savage thus far is found in Nelson B. Wadsworth, *Through Camera Eyes* (Provo, Utah, 1976), a general study of photography in Utah. On F. Jay Haynes, a glib study is Freeman Tilden, *Following the Frontier With F. Jay Haynes* (New York, 1964).

The history of photography has undergone tremendous growth in the past decade; the result has been a wealth of new information and some very important general studies. The appearance of Naomi Rosenblum's *A World History of Photography* (New York, 1984) has signaled the maturity of the subject—at last, we have an exhaustive and reputable history of the medium. In addition Beaumont Newhall's oft-revised version of a 1940s exhibition catalogue, previously the standard textbook on the subject, has undergone a new and extensive rewrite in *The History of Photography* (New York, 1982). Still a crucial text is Helmut and Alison Gernsheim, *The History of Photography* (London, 1969). Michel Braive, *The Photograph: A Social History* (New York, 1966) still offers material of value. A more controversial and suggestive text is Gisele Freund, *Photography and Society* (Boston, 1980); equally rewarding is Estelle Jussim's *Visual Communication and the Graphic Arts: Photographic Technologies in the Nineteenth Century* (New York, 1974).

On subsectors of the medium, a number have proved important to this book. Robert Taft's *Photography and the American Scene: A Social History, 1839–1889* (New York, 1938), is, despite its copyright date, a fresh and rewarding source. Reese Jenkins's *Images and Enterprise: Technology and the American Photographic Industry* (Baltimore, 1975) is crucial in its analysis of the busi-

ness of the photography business. A recent and extremely welcome addition in this area is the surprising work by William and Estelle Marder, *Anthony: The Man, the Company, the Cameras* (Amesbury, Mass., 1982), which offers encyclopedic information on all aspects of this giant of the industry. Collectors and amateur historians, the Marders join William Culp Darrah in proving that some of the best history can be produced outside the usual professional channels. Darrah has continued to present the findings of a lifetime of study with *Cartes de Visite in Nineteenth Century Photography* (Gettysburg, Pa., 1981) and *The World of Stereographs* (Gettysburg, Pa., 1977); the latter supersedes but does not supplant Darrah's older *Stereo Views: A History of Stereographs in America and Their Collection* (Gettysburg, Pa., 1964). William Welling's *Photography in America: The Formative Years, 1839–1900* (New York, 1978) offers an eccentric chronological organization that alternately obscures and rewards.

On the Detroit Photographic/Detroit Publishing Company, a valuable work has been written by a postcard collector: Jeff R. Burdick, *The Handbook of Detroit Publishing Company Postcards: A Guide for Collectors* (Essington, Pa., 1955). It contains valuable information, often hidden beneath lists and categories seemingly more appropriate for the deltiologist. On postcards in general, many books have been written, most aimed at the collector. A refreshing, if eccentric, exception, is Hal Morang and Andreas Brown, *Prairie Fires and Paper Moons, The American Photographic Postcard: 1900–1920* (Boston, 1981), which—despite its name—covers only a minuscule subsector of

the production during the period, but does so with a taste for rewarding analyses.

The theory and analysis of the landscape has been a steadily growing topic for scholars, finding its outlet in such disciplines as geography, American studies, history, and ecology. Without doubt the dean of American landscape studies is John Brinkerhoff Jackson, for many years editor of the essential journal, *Landscape*. He has published a number of collections of essays, including *American Space: The Centennial Years, 1865–1876* (New York, 1972), and *Discovering the Vernacular Landscape* (New Haven, 1984). A second force in the field is Wilbur Zelinsky, whose *The Cultural Geography of the United States* (Englewood Cliffs, N.J., 1973) offers an excellent introduction. He has also edited an important issue of *American Behavioral Scientist,* vol. 22, no. 1 (September–October 1978), containing essays by a number of scholars. Another recent and suggestive compilation is D. W. Meinig, editor, *The Interpretation of Ordinary Landscapes* (Oxford, 1979). An eccentric but suggestive ecologist, Yi-Fu Tuan, has offered an extremely interesting analysis of the process of human perception of the land in *Topophilia: A Study of Environmental Perception, Attitudes, and Values* (Englewood Cliffs, N.J., 1974). Finally, John R. Stilgoe's *Common Landscape of America, 1580 to 1845* (New Haven, 1982) has set a new standard for the integration of historical and geographical studies.

The field of Western history is so vast that at times it seems about to secede from its own discipline and set itself up as an independent confederation, drawing ecology, ge-

ography, American studies, and other scholarly areas into a new alliance in the process. In part this is because no historian can enter the West as a subject without recognizing that he or she must contend with myth as well as actuality; the process of wrestling with this problem has produced some great literature. The single most influential work has been Frederick Jackson Turner's essay "The Significance of the Frontier in American History," a statement that has become both history and myth since its presentation at the American Historical Association Convention in 1893. It is reproduced, with Turner's other essays on the West, in *The Frontier in American History* (New York, 1920). Since its publication it has engendered a host of studies in the area of the frontier—so many, in fact, that Ray Allen Billington has published an extremely helpful (if now somewhat dated) bibliographic pamphlet for the American Historical Association, entitled *The American Frontier Thesis: Attack and Defense* (Washington, D.C., 1971). Billington has also edited a small collection of essays on the subject, *The Frontier Thesis: Valid Interpretation of American History?* (New York, 1966). A larger anthology is Richard Hofstadter and Seymour Martin Lipset's *Turner and the Sociology of the Frontier* (New York, 1968). Hofstadter has written a marvelous biography of Turner in his *The Progressive Historians: Turner, Beard, Parrington* (New York, 1970).

The two standard histories of the American West have both been written by Turnerians. Turner's biographer Ray Allen Billington has produced *Westward Expansion: A History of the American Frontier* (New York,

1940, 1967); his teacher (and a Turner student) Frederick Merk has written a *History of the Westward Movement* (New York, 1978). Three anthologies offer samples of the work being done in essay form. The most rewarding is the most recent: Michael P. Malone, ed., *Historians and the American West* (Lincoln, Neb., 1983); Jerome O. Steffen, ed., *The American West: New Perspectives, New Dimensions* (Norman, Okla., 1979) is also rich. Older and less sophisticated, at least to a later generation, is John Francis McDermott, ed., *The Frontier Re-examined* (Urbana, Ill., 1967).

The American West as historical subject contains a number of subcategories—most particularly concerning the exploration era and the migration to the West. A masterful recent study of the central emblem of American westering is John D. Unruh, Jr., *The Plains Across: The Overland Emigrants and the Trans-Mississippi West, 1840–1860* (Urbana, Ill., 1978). Richard A. Bartlett has written *The New Country: A Social History of the American Frontier, 1776–1890* (New York, 1974); he has also produced a study of government exploration, *Great Surveys of the American West* (Norman, Okla., 1962), a work largely superseded by the magisterial work of William H. Goetzmann. Two studies of "culture" in the West are the now-dated Louis B. Wright, *Culture on the Moving Frontier* (Bloomington, Ind., 1955), and the more substantial and interesting Gunter Barth, *Instant Cities: Urbanization and the Rise of San Francisco and Denver* (New York, 1975). On the mental ecology of the West, the standard studies are Roderick Nash, *Wilderness and the American Mind*

(New Haven, 1967) and Hans Huth, *Nature and the American: Three Centuries of Changing Attitudes* (Berkeley, Calif., 1957).

Indians are the unspoken Other of the Westering experience; their study has recently come into its own with the publication of two major works. One is encyclopedic: Paul Prucha, *The Great Father: The United States Government and the American Indians* (Lincoln, Neb., 1984), a two-volume work. The other is Robert F. Berkhofer, Jr., *The White Man's Indian: Images of the American Indian from Columbus to the Present* (New York, 1978). Whereas the first presents a damning record, the second offers a damning analysis of white attitudes toward the Indian. In a vein similar to Berkhofer's is Raymond William Stedman, *Shadows of the Indian: Stereotypes in American Culture* (Norman, Okla., 1982). Smaller in scope but of particular relevance to this study is Clyde A. Milner II, *With Good Intentions: Quaker Work Among the Pawnees, Otos, and Omahas in the 1870s* (Lincoln, Neb., 1982). Two works in great measure responsible for the resurgence in interest in American Indian history are Black Elk, as told to John G. Neihardt, *Black Elk Speaks: Being the Life Story of a Holy Man of the Oglala Sioux* (New York, 1932; Lincoln, Neb., 1979), and the now-discredited Dee Brown, *Bury My Heart At Wounded Knee: An Indian History of the American West* (New York, 1970). Finally, Paula Richardson Fleming and Judith Luskey have produced a work of major import in *The North American Indians in Early Photographs* (New York, 1986); lavishly illustrated, this survey includes important work on Jackson's Indian photographs.

Western development occurred concurrently with the technological development of the nation, in particular with the history of the railroad. To study Jackson without studying the railroad as well would have been unthinkable. For a day-by-day history of the construction of the Union Pacific Railroad, I have depended on Charles Edgar Ames, *Pioneering the Union Pacific: A Reappraisal of the Builders of the Railroad* (New York, 1969). Ames, a descendent of the Ames brothers who helped fund the road, has a distinctly partisan view, but it is never hidden and is easily recognized. Two rewarding studies of the railroad take a broad cultural history approach. They are Wolfgang and Schivelbusch, *The Railway Journey: Trains and Travel in the Nineteenth Century* (Oxford, England, 1977, 1979), which offers one of the most intriguing and wide-ranging studies of nineteenth-century technology and its implications, and John R. Stilgoe's *Metropolitan Corridor: Railroads and the American Scene* (New Haven, 1983). Economic history has pervaded the methodology of railroad study in the United States; a number of works take this tack, with greater or lesser comprehensibility. George Rogers Taylor and Irene D. Neu have explored the economic implications of the railway map in *The American Railroad Network, 1861–1890* (Cambridge, Mass., 1956). Econometric historian Robert William Fogel has written two controversial works of relevance to this study: *The Union Pacific Railroad: A Case in Premature Enterprise* (Baltimore, 1960), and *Railroads and American Economic Growth: Essays in Econometric History* (Baltimore, 1964).

There have been a number of books written on the narrow-gauge railroads through Colorado and the Rockies, and they provide both information and a sense of the flavor of Rocky Mountain railroading during Jackson's Denver years. Forest Crossen's *The Switzerland Trail of America: An Illustrated History of the Romantic Narrow Gauge Lines Running West from Boulder, Colorado: The Greeley, Salt Lake and Pacific and The Colorado and Northwestern, later the Denver, Boulder and Western* (Boulder, 1978) is an impressionistic but valuable example. Works that have assisted me in dating Jackson's Colorado pictures include R. A. Le Massena, *Colorado's Mountain Railroads*, 4 vols. (Golden, Colo., 1963, 1964, 1966); and Gordon Chappell, "Narrow Gauge Transcontinental I: Scenic Line of the World," *Colorado Rail Annual, 1970*, no. 8, pp. 3–99. John B. Hungerford's pamphlet, *Narrow Gauge to Silverton* (Reseda, Calif., 1974) offers a chronology of the D&RG Western's Silverton branch.

Railroads were the agents of transportation; by the eighties, they had spawned a new species of American, the Western tourist. Studies of tourism range from the theoretical to the specific. Two suggestive anthropologies of tourism are Valene L. Smith, ed., *Hosts and Guests: The Anthropology of Tourism,* (Philadelphia, 1977), which includes Dennison Nash's essay, "Tourism as a Form of Imperialism," an extremely important text; and Dean McCannell's *The Tourist: A New Theory of the Leisure Class* (New York, 1976), which treats the tourist as the paradigmatic figure of modernity. A book that straddles anthropology and his-

tory is John A. Jakle, *The Tourist: Travel in Twentieth-Century North America* (Lincoln, Neb., 1985). The standard and still authoritative study of American tourists in the West is Earl Pomeroy's *In Search of the Golden West: The Tourist in Western America* (New York, 1957). Most extensive on the nineteenth century, it weakens on twentieth-century materials; into the breach has recently come Warren James Belasco's *Americans on the Road: From Autocamp to Motel, 1910–1945* (Cambridge, Mass., 1979). Discussions of federal policy toward the Western lands during the twentieth century are found in Donald C. Swain, "The National Park Service and the New Deal, 1933–1940," *Pacific Historical Review* 61 (August 1972), pp. 312–332.

The transformation of American landscape was also one aspect of a larger transformation of American culture between the Civil War and the end of the second decade of the twentieth century. This process is perhaps best analyzed in two general texts: Robert H. Wiebe, *The Search for Order, 1877–1920* (New York, 1967); and Alan Trachtenberg, *The Incorporation of America: Culture and Society in the Gilded Age* (New York, 1982). Two other surveys of the period take more historical approaches and themes: Thomas Cochran and William Miller, *The Age of Enterprise: A Social History of Industrial America* (New York, 1961), which includes especially salient chapters on commercial farming; and Ray Ginger, *Age of Excess: The United States from 1877 to 1914* (New York, 1975). Other works on more specific topics in the era include Philip Appleman, ed., *Darwin* (New York, 1979); Reid Badger, *The Great American Fair: The World's Columbian Exposition and*

American Culture (Chicago, 1979); Neil Harris, ed., *The Land of Contrasts, 1880–1901* (New York, 1970); H. Wayne Morgan, ed., *Victorian Culture in America* (Itasca, Ill., 1973); Larzer Ziff, *The American 1890s: Life and Times of a Lost Generation* (New York, 1966), especially "The Tinkle of the Little Bell: Magazines"; Harold U. Faulkner, *Politics, Reform and Expansion, 1890–1900* (New York, 1959); and John F. Kasson, *Amusing the Million: Coney Island at the Turn of the Century* (New York, 1978).

Concurrent and integral to this change was the movement of America toward a sense of international power. In addition, more than a few historians have seen a connection between aspects of American expansion to the West and the later imperialist tendencies of the nineties and after. In this area I have depended on the following works: Thomas A. Bailey, *A Diplomatic History of the American People* (New York, 1964); the extremely helpful bibliographic essay by Dennis E. Berge, "Manifest Destiny and the Historians," in Michael P. Malone, ed., *Historians and the American West* (Lincoln, Neb., 1983); Foster Rhea Dulles, *America's Rise to World Power, 1898–1954* (New York, 1954); J. Rogers Hollingsworth, ed., *American Expansion in the Late Nineteenth Century* (New York, 1968); and William Appleman Williams, *The Roots of the Modern American Empire* (New York, 1969). Williams's text assumes an interrelationship between American imperialism and the American business consolidations of the era. This business and economic history forms another background for Jackson's work, and in that area I have depended on general surveys and specialized texts. In the his-

tory of the American economy during the salient era are the following: Robert Higgs, *The Transformation of the American Economy, 1865–1914* (New York, 1971); Ross M. Robertson, *History of the American Economy* (New York, 1973); Rendigs Fels, *American Business Cycles, 1865–1897* (Chapel Hill, N.C., 1959); Charles P. Kindleberger, *Manias, Panics, and Crashes: A History of Financial Crises* (New York, 1978); and Otto G. Lightner, *The History of Business Depressions* (New York, 1922). On American business during the period, see Alfred D. Chandler, Jr., *The Visible Hand: The Managerial Revolution in American Business* (Cambridge, Mass., 1977); Thomas C. Cochran, *Business in American Life: A History* (New York, 1972); C. Joseph Pusateri, *A History of American Business* (Arlington Heights, Ill., 1984); and Glenn Porter, *The Rise of Big Business, 1860–1910* (Arlington Heights, Ill., 1973).

On the family in American culture during the post–Civil War era, I have looked to a scattered list of works: Ann Douglas, *The Feminization of American Culture* (New York, 1977); Christopher Lasch, *Haven in a Heartless World: The Family Besieged* (New York, 1977); John S. Haller and Robin M. Haller, *The Physician and Sexuality in Victorian America* (New York, 1974, 1977); and two works on domestic architecture by Gwendolyn Wright—*Moralism and the Modern Home: Domestic Architecture and Cultural Conflict in Chicago* (Chicago, 1980), and *Building the Dream: A Social History of Housing in America* (New York, 1981).

My own allegiances lie firmly with the application of so-called American studies methodology to the Westering movement and to seeing the economic transformations

of American life as parts of a broader cultural fabric. In this regard two works stand above all others. William H. Goetzmann's *Exploration and Empire: The Explorer and the Scientist in the Winning of the American West* (New York, 1966) treats the subject with a magisterial sweep that is inspiring; beneath the engrossing narrative is a set of theories about the nature of cultural values and their transmission that remains persuasive today. Henry Nash Smith's *Virgin Land: The American West as Symbol and Myth* (Cambridge, Mass., 1950) seems, like Goetzmann's work, as if it were just completed; who would guess it has spawned an entire theoretical school of American studies and survived at least two redactions and the current attempt to recement its centrality to the study of American culture? But the generation of the "symbol/myth" school has had rich rewards. Probably the central example of early work in this school concerns the antecedents to the Westering myth: Leo Marx, *The Machine in the Garden* (New York, 1964) has been largely, and justifiably, discredited since its publication, most notably by Bruce Kuklick in an essay titled "Myth and Symbol in American Studies," *American Quarterly* (October 1972). Marx's attempts to anchor analysis in a two-tiered cultural model and to emphasize the legendary value of the high-literary tier has been largely avoided both by Smith and by the followers of the symbol/myth school. One of those in the thick of Smith's work is Alan Trachtenberg, whose essay "Myth, History, and Literature in *Virgin Land*," *Prospects* 3 (1977), pp. 125–134, reorients even as it reaffirms Smith's work. Trachtenberg has himself attempted with great success to integrate the

American West into a broader investigation of the reorganization of American life in the post–Civil War era in *The Incorporation of America.*

The general theory underlying this book is based on the integration of three areas: American studies methodologies, cultural and anthropological theory, and contemporary concepts of semiotics and deconstruction. While I have attempted to strip this work of all traces of the sometimes arcane languages of these theories, the concepts remain central nonetheless. In American studies, I owe a great debt to the teachers in the American Civilization Program at the University of Texas at Austin—William Goetzmann, William Stott, Robert Crunden, and Jeffrey Meikle—and to my colleagues at California State University, Fullerton, during my brief but intense tenure there—Karen Lystra, John Ibson, Alan Axelrad, and Wayne Hobson especially.

The notion of myth generally accepted in American studies during the heyday of the symbol/myth school is well drawn in Smith's *Virgin Land*. Richard Slotkin's *Regeneration Through Violence: The Mythology of the American Frontier, 1600–1860* (Middletown, Conn., 1973), often cited in this context, is too narrowly dependent on the suspect caricatures of Joseph Campbell's Jungian *Hero With a Thousand Faces* to have been of much use to this study. As other scholars have pointed out—particularly Trachtenberg (cited above) and Bruce Kuklick (in "Myth and Symbol in American Studies," *American Quarterly* [October, 1972])—the notion of myth inherent in this school of thought is too broad and imprecise in its definition, too tied to narrative, and

too dependent on early twentieth-century anthropological theorists like Frazier to afford accurate or usable schemata unaltered. The application of more contemporary anthropological theories of culture allows us to escape into interpretation, however. Particularly crucial to me have been the works of Clifford Geertz, especially *The Interpretation of Cultures* (New York, 1973) and *Local Knowledge* (New York, 1980). Karen Lystra's article on Geertz, "Clifford Geertz and the Concept of Culture," *Prospects* 8 (New York, 1983), pp. 31–48, affords an excellent model for the application of Geertz's anthropological theory to American culture. Peter Berger and Thomas Luckmann's *The Social Construction of Reality* (New York, 1966), while often arcane, still contains in its premises many of the notions of the process of culture building I have implied in this work. An exegetical apologia for Berger and Luckmann is R. Gordon Kelly, "*The Social Construction of Reality*: Implications for Future Directions in American Studies," *Prospects* 8 (New York, 1983), pp. 49–58. Equally important is the work of French semioticians and their successors, in particular Roland Barthes, whose *Image, Music, Text* (New York, 1974), and his essay "Myth Today" in *Mythologies* (New York, 1972) are central. A spotty but often rewarding text is Dean McCannell and Juliet Flower McCannell, *The Time of the Sign* (Bloomington, Ind., 1982). The works of Jacques Derrida and Michel Foucault have also found their way into this study.

Index

This book was designed by Arlene Putterman.
The text was composed in ITC Garamond Light and the display in Goudy Handtooled
by McFarland Graphics and Design, Dillsburg, Pennsylvania.
The camera work for the illustrations and the printing of the book were done
by Meriden-Stinehour Press in Meriden, Connecticut, and Lunenburg, Vermont.